THE PELICAN HISTORY OF ART

JOINT EDITORS: NIKOLAUS PEVSNER AND JUDY NAIRN

ARCHITECTURE IN ITALY 1400–1600

LUDWIG H. HEYDENREICH AND WOLFGANG LOTZ

Filippo Brunelleschi: Florence, S. Croce, Pazzi Chapel, commissioned 1429

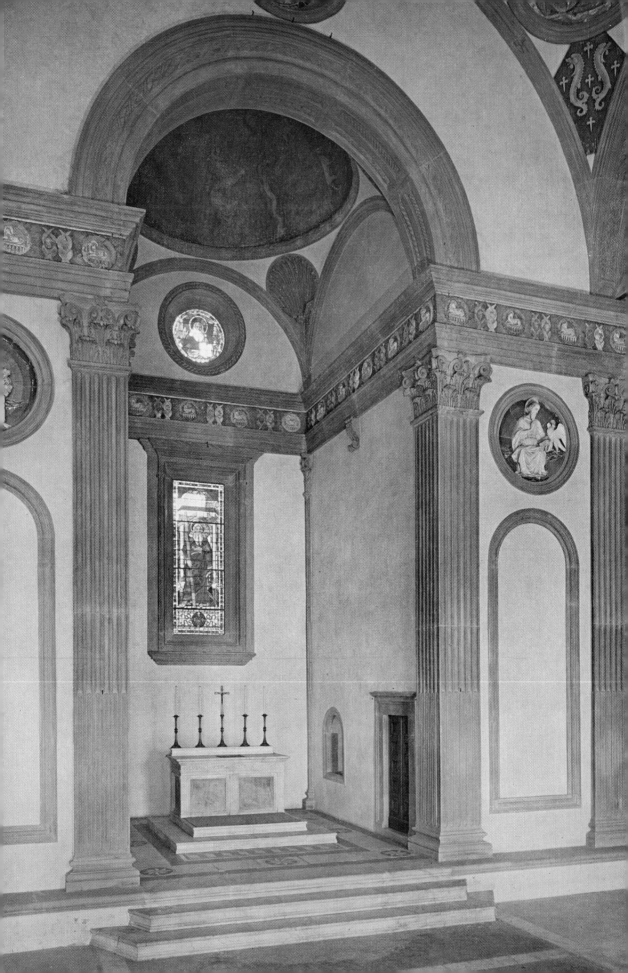

LUDWIG H. HEYDENREICH
AND WOLFGANG LOTZ

ARCHITECTURE
IN ITALY

1400 TO 1600

Translated by
Mary Hottinger

PUBLISHED BY PENGUIN BOOKS

Penguin Books Ltd, Harmondsworth, Middlesex, England
Penguin Books Inc., 7110 Ambassador Road, Baltimore, Md 21207, U.S.A.
Penguin Books Australia Ltd, Ringwood, Victoria, Australia

★

Text printed by Richard Clay (The Chaucer Press) Ltd, Bungay, Suffolk
Plates printed by Balding & Mansell Ltd, London
Made and printed in Great Britain

★

ISBN 14 0560.38 6

★

TO THE MEMORY OF
PIERO TOMEI
AND
COSTANTINO BARONI

CONTENTS

Part One
The Quattrocento
BY LUDWIG H. HEYDENREICH

CONTENTS

Part Two

The Cinquecento

BY WOLFGANG LOTZ

CONTENTS

CONTENTS

The Plates

LIST OF FIGURES

All the text figures were drawn or adapted for this book by Sheila Gibson, with the exception of the following (largely executed under Miss Gibson's superintendence): Figures 2, 12, 15, 19B, 26, 27, 29, 31, and 83 by Paul White; Figures 13, 16, 17, 21, 28, 32, 35, and 47 (plan) by Ian Stewart; Figures 8, 20, 22, 37, 38, 39, and 41 by Richard Boon; Figures 90B and 92 by Gerhard Krämer; Figure 82 by J. S. Ackerman and Frank Krüger; and Figures 18 and 52.

LIST OF PLATES

GFN Gabinetto Fotografico Nazionale, Rome

In a few cases, despite all efforts, it has been impossible to contact the owners of the copyright of photographs.

FOREWORD

The volume is dedicated to the memory of two architectural historians whose studies, published more than thirty years ago, have remained exemplary, both for the methods applied and the factual content. Costantino Baroni (1905–56) built the sound foundation from which research on Lombard architecture of the Renaissance has since proceeded. Piero Tomei (1913–42) in his L'Architettura del Quattrocento a Roma, a brilliant synthesis of historical data and visual observations, gave critical definition to the Renaissance of Rome as Caput Mundi.

The period this book deals with is among the richest in the history of Italian architecture. A volume in the present series cannot but offer a selection which necessarily reflects personal preferences and limitations. The reader will inevitably miss buildings and architects that have intentionally or by oversight been omitted.

The preparation and writing of the volume took an unusually long span of time. Considerable parts of the text, especially Part One, were written some time ago. Thus more recent publications could only be incorporated in the Notes and the Bibliography; this holds true – to give only a few examples – for such important contributions as those of Howard Saalman to Brunelleschi, summed up in his edition of Manetti's Vita of the artist, or for the many valuable studies on Florentine palace architecture by Büttner, Bulst, Goldthwaite, and others. The outstanding publication of Count Leonello Ginori on Florentine palazzi appeared only when this book was in the press, as also the new critical edition of Filarete's Treatise on Architecture by Anna Maria Finoli and Liliana Grassi.

The volume could not have been written without the friendly assistance received from the directors and staffs of a great number of libraries, archives, museums, and other institutions. Besides their 'home institutes', the Zentralinstitut für Kunstgeschichte in Munich, the Kunsthistorische Institut in Florence, and the Bibliotheca Hertziana in Rome, the authors are particularly indebted to the Gabinetto dei Disegni of the Uffizi, the Castello Sforzesco in Milan, the Staatliche Graphische Sammlung in Munich, the Avery Library of Columbia University, the Institute of Fine Arts of New York University, the Metropolitan Museum of Art, and the Vatican Library.

Large parts of the text were written while the authors were Temporary Members of the Institute for Advanced Study. They are deeply grateful to the directors of the Institute and to their friend Millard Meiss for having been able to work at Princeton procul negotiis ordinariis.

Among the numerous colleagues and friends to whom the authors are indebted for beneficial advice and suggestions are James S. Ackerman, Renato Cevese, John Coolidge, Christoph L. Frommel, Howard Hibbard, Richard Krautheimer, Milton Lewine, Giuseppe Marchini, Henry A. Millon, Loren Partridge, Kathleen Garris Posner, Ugo Procacci, Marco Rosci, Piero Sanpaolesi, Klaus Schwager, John Shearman, Craig Hugh Smyth, Christof Thoenes, the late Rudolf Wittkower, and Franz Graf Wolff Metternich.

The difficult task of translating the German text into English was accomplished by Mrs Mary Hottinger. The authors feel that the queries and objections put to them by Mrs Hottinger frequently helped to clarify and even to correct their work.

FOREWORD

Kathleen Garris Posner and Richard J. Tuttle took upon themselves the self-denying task of reading the galleys of Part Two. Their remarks resulted in many substantial improvements. Miss Sheila Gibson who prepared the line drawings as well as the co-editor, Mrs Judy Nairn, and Miss Susan Stow of the publisher's London office had an essential part in giving the book its final shape. Finally, the authors have to thank Sir Nikolaus Pevsner: they are fully and most gratefully aware that only because of his patience, encouragement, and wisdom could they reach their goal.

July 1972

<div align="right">

LUDWIG H. HEYDENREICH
WOLFGANG LOTZ

</div>

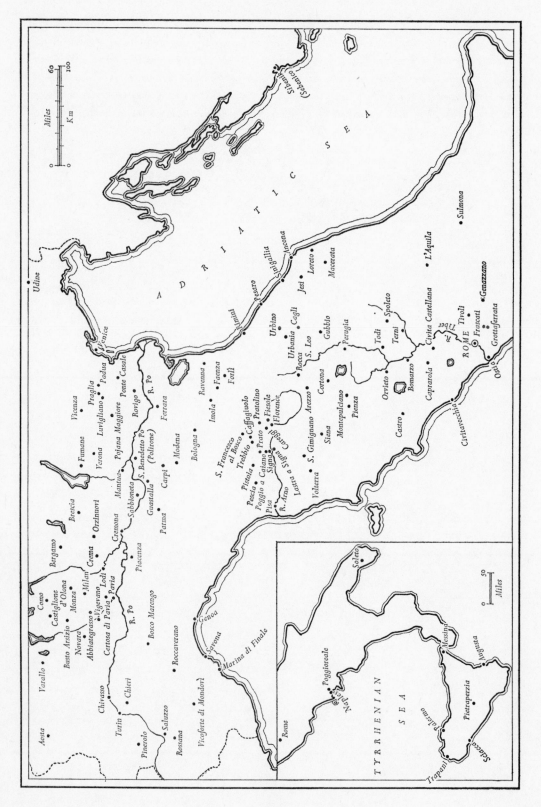

Miles
Km

60 100

ADRIATIC SEA

Sebenico
(Sebenico)

Sulmona

Udine

Ancona
Sinigaglia
Loreto L'Aquila
Jesi Macerata
Pesaro Genazzano
Spoleto Civita Castellana Tivoli
Rimini Urbino Cagli Frascati
Venice Urbania Todi Terni ROME Grottaferrata
Vicenza Praglia Rocca S. Leo Gubbio Perugia R. Tiber Ostia
Fumane Padua Luvigliano Ravenna Orvieto Bomarzo Caprarola
Verona Pojana Maggiore Ponte Casale Faenza Cortona Castro Civitavecchia
Brescia Mantua Rovigo R. Po Forlì Fiesole Montepulciano
Orzinuovi Sabbioneta Ferrara Imola S. Gimignano Arezzo Pienza
Bergamo Cremona S. Benedetto Po Modena Bologna S. Francesco Pratolino
Como Castiglione Guastalla (Polirone) Carpi Parma al Bosco Trebbio Prato Florence
Monza Crema Lodi Bosco Marengo Pistoia Pescia Poggio a Caiano Signa Volterra
Varallo Milan Pavia Certosa di Pavia Piacenza Pisa R. Arno Lastra a Signa Caiano
Novara Abbiategrasso Vigevano Roccaverano
Busto Arsizio Chivasso R. Po
Aosta Turin Chieri Genoa Soleto
Pinerolo Saluzzo Savona Messina Augusta
Rossana Vicoforte di Mondovi Marina di Finale Poggioreale Pietraperzia
Rome Naples TYRRHENIAN
Palermo SEA
Sciacca
Trapani

50
Miles

TYRRHENIAN SEA

xxvii

PART ONE

THE QUATTROCENTO

BY

LUDWIG H. HEYDENREICH

BRUNELLESCHI

WHEN the dome of Florence Cathedral was completed in 1436, Alberti praised it as the first great achievement of the new art, equalling or even surpassing antiquity.[1] With that, he spoke for the whole of his generation, and it is important in this connection to remember that the admiration Brunelleschi reaped even in his lifetime was paid to the artist no less than to the engineer.[2] Indeed, the unique importance of Brunelleschi can only be fully appreciated if the creative power of his design is seen as the product of a ceaseless interaction between aesthetic and technical considerations. The dome of the cathedral bears most eloquent witness to it (Plate 1 and Figure 1).[3]

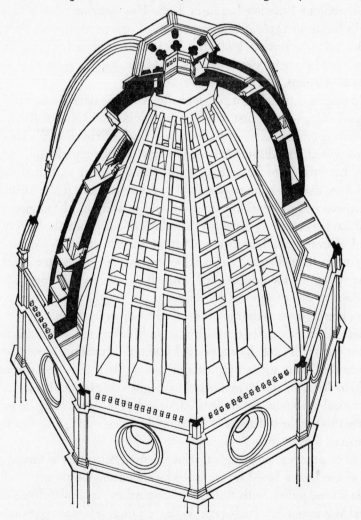

Figure 1. Filippo Brunelleschi: Florence Cathedral, dome, 1420–36, construction

As far back as 1367, the Opera of the Duomo had approved a model designed by a commission of eight artists, and declared it binding on all future work. From that time on, every master mason of the Duomo was sworn to respect this model, including Brunelleschi himself when he appeared on the scene half a century later. The model for the dome of 1367, which still adhered to Arnolfo di Cambio's design, can be visualized, within limits, from the dome of Orcagna's tabernacle in Or San Michele.[4] The grandiose project was conceived in the spirit of classic Gothic; to give it visible shape involved the devising of technical means for the construction of the dome. Thus for fifty years there was here a practical problem which was almost a spiritual challenge. By 1410 the choir had risen so far that the great apses were roofed in and the drum of the dome raised to the springing level. The programme of the competition announced in 1418 was therefore the constructional technique of the dome. It dragged on for two years, the final winners being Filippo Brunelleschi and Lorenzo Ghiberti with a model worked out in collaboration.[5] Building began in 1420. The superintendence soon passed into Brunelleschi's hands. In 1436, after sixteen years of uninterrupted labour, the dome was finished. Then came the lantern, built after Brunelleschi's model of 1436. The foundation stone was laid just before his death in 1444, and building was continued and completed by Michelozzo, Manetti, and Bernardo Rossellino.

While the original model of 1418, and the working details – especially the use of suspended scaffolding – were first prepared by Brunelleschi and Ghiberti in collaboration, the actual superintendence of the building was in Brunelleschi's hands in 1426. In 1432 Ghiberti retired. The dispute between the two for the superintendence described in later sources has proved to be a legend, but there is sober and unambiguous documentary evidence that the huge responsibility of the enterprise fell to Brunelleschi as the more experienced and more gifted architect, and that he, and he alone, must be given the credit of having mastered the gigantic task. Scholarly studies of every phase of the building and of every detail of its construction are available.[6] What follows here is a mere summary of Brunelleschi's main achievements. He solved the chief problem by applying the system of the double shell with all the details it involved (simplification of the overdone means of support by reducing the weight of the masonry; ingenious brickwork in herringbone technique borrowed from antique buildings; substitution of the inadequate horizontal cable-chains by carefully calculated stone ribs connecting and strengthening the shells) and he supervised building operations down to the smallest detail, and supplied exact models for every shape of brick. The vast size of the dome – 40 m. (130 ft) in diameter and 56 m. (185 ft) in height to the foot of the lantern – involved countless practical problems. Brunelleschi designed all the scaffolding, invented a special hoisting apparatus for the transport of building materials into the area of the dome, and obtained a special licence for it.[7]

In this field of practical building superintendence, Brunelleschi turned to account a knowledge of mechanics based on studies which seem uncommonly profound for the time (endless screw, pulley with multiple transmissions, statics of dome construction). Yet whatever was devised and achieved on the technical side was no more than a means to the aesthetic end. Even in the last stage of building, Brunelleschi seems to have

slightly expanded the outer contour of the dome, and thus to have given it its final form.[8] The wonderfully vital tension of the curve, the emphasis on the forces pulsing in it given by the ribs and the lantern, have brought its creator imperishable glory.

The dome of the cathedral of Florence was the perfect realization of a conception which was thoroughly medieval, though already inspired by the spirit of antiquity. The generation which planned it, however, lacked any means of giving its conception visible shape, and thus the dome of Florence Cathedral remains, actually and symbolically, what Alberti called it – the first work of the new style. The manner of building proves that the traditional knowledge of a medieval masons' lodge had been enriched by the insights gained by one man in his study of theory and practice. By actively defending and carrying out his own, personally conceived design in face of the Duomo building commission, he was also defending, perhaps for the first time in history, the standpoint of the solely responsible architect against the anonymous authority represented by the Opera. Looked at from this point of view, it becomes historically interesting that certain rights in the use of his own inventions conceded by the Duomo to Brunelleschi approximate very closely to the modern notion of the patent.[9] In this recognition of 'intellectual property' we see the change in the relations between the architect and his patrons.

How could so strong a personality be formed and develop precisely at that time? If we consider the course of Brunelleschi's career with this question in mind, one fact will stand out which, to my knowledge, has not received sufficient attention, namely the many years of humanistic schooling which preceded his artistic training.[10] He was born in 1377, the son of a wealthy and respected notary of Florence, who held high offices and was entrusted with diplomatic missions.[11] We know from the sources that Brunelleschi's father, with a view to a similar professional career for his son, gave him the higher education of his class, which included the liberal arts. There is documentary evidence of young Filippo's extraordinary brilliance. It was only when he began to feel drawn to the visual arts that his father placed him with a well-known goldsmith. Bearing in mind that Brunelleschi was enrolled in the goldsmiths' guild in 1398, when he was twenty-one,[12] and accepting the usual apprenticeship of six years before passing master, he must have begun his artistic training about 1393, that is, when he was sixteen. That age would leave time enough for a thorough liberal education beforehand. Since we also know that Brunelleschi continued his comprehensive technical studies – especially in mathematics and mechanics – in later years, we may conclude that, thanks to his special gifts, he developed his own way of combining theoretical and scientific knowledge with practical studies, and thus developed, autodidactically, the intellectual faculties which are so peculiar to his creative work as an architect.[13] By deepening his knowledge in the disciplines of the quadrivium and systematically turning it to account in his professional work, he fulfilled in himself that new blend of the liberal and mechanical arts which pointed the way to the 'applied sciences' of our own day.[14] To my mind, it was this synthesis which was a determining factor in Brunelleschi's genius. It enabled him to invent the science of perspective construction with all it entailed for the new feeling for proportions and visual harmony in the organization of masses and

space;[15] but it also enabled him to devise the most astonishing technical appliances and structural forms in practical building.[16] In a brilliant study, Sanpaolesi has shown how far this new 'practical science' of Brunelleschi's can be derived from the sources of practical and theoretical study available to him, and how decisively it moulded the style and character of his art.[17] This 'practical science' rests on a perfect understanding of medieval and classical traditions, in so far as they were accessible to him, and thus his art, in which these principles are applied, is based on the same synthesis.

One important result of Brunelleschi's self-education was unquestionably the discovery of perspective construction.[18] Alberti reduced it to a clear theory, which he formulated in his treatise on painting. But as his preface shows, the original impulse came from Brunelleschi. It was Brunelleschi who took the decisive step of discovering a practical application for the medieval theory of optics in the realm of art. He invented that method of geometrical construction by which it is possible to produce an accurate rendering of a system of objects as it appears to the eye, and to determine the *proportional* relations of the individual objects perceived by means of the mathematical laws contained in this *prospettiva*. What Brunelleschi really had in mind here was above all the applicability of these rules in architecture. Although his perspectives of the baptistery and the Piazza della Signoria were actually pictorial in character, their main object was certainly to give the illusion of a solid building. The use of linear perspective in architectural design is a component element of Brunelleschi's style, and an essential factor in its novelty.[19]

Brunelleschi's first public building, the Foundling Hospital in Florence, begun in 1419, was already fully representative of his personal style (Plate 2).[20] Recent research on the building has led to the surprising realization that the simple aisleless church of the hospital was carried out entirely in the current idiom of the transitional style (corbels of the open timber roof). It is only in the other parts of the building that the new apparatus of form makes its appearance, so that the date of the turning-point in Brunelleschi's style may be fixed between 1419 and 1420. The new elements of form to which he rigidly adhered all his life, and which he only varied in proportion and degree of sculptural volume, are: unfluted column shafts, eight-volute Corinthianesque capitals, restrained, but clearly moulded profiles of architraves, friezes, and door- and window-frames, fluted pilasters framing corners, roundels in the spandrels, shallow domes in the bays of the loggias, groin-vaulting in those of cloister walks, and coved or flat ceilings in the interiors. All these formal elements reveal the desire to achieve a kind of classical order offering a sharp contrast to the Late Gothic syntax current at the time which can be seen in the hospital loggias of S. Matteo in Florence and S. Antonio at Lastra a Signa[21] built not long before (c. 1410). To a type of building which was very much a type belonging to these years (the highly interesting history of the rise of modern hospital building in the fifteenth century still remains to be written) Brunelleschi gave a new form in two respects: firstly in the regularity of the plan (Figure 2) and the architectural elements and motifs, and secondly in its artistic structure. The decorative features employed by him were derived almost exclusively from the formal repertory of pre-Romanesque and Romanesque architecture in Tuscany, especially in Florence

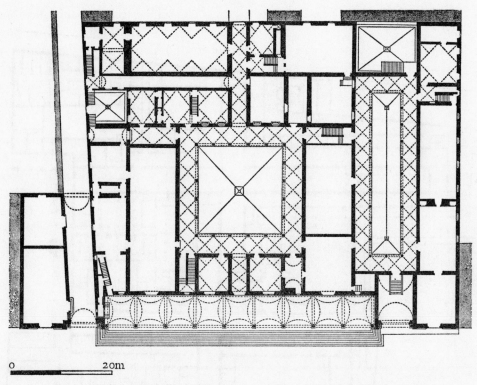

0 20m

Figure 2. Filippo Brunelleschi: Florence, Foundling Hospital, begun 1419, plan

itself.[22] The *renovatio* of architecture lay in the precise, almost austere purification of these medieval forms, which was immediately felt by contemporaries. Further, it was characterized by a practical mathematical ratio in the proportions. The *dispositio* of the whole organism is governed by proportion throughout; its elements are the square and the circle, and its composition is determined by a centralizing arrangement. This *ordo*, by means of which a multiplicity of spatial units is mathematically evolved from a module and grouped in a perfectly symmetrical whole, creates that absolute harmony which was the culmination of the new concept of beauty.[23] The spreading vista of the building, which we become aware of at first sight of the façade, continues in the interior; we feel it on entering the courtyard or any single room. A comparison with so intricate a spatial organization as the hospital of S. Maria Nuova (Figure 3)[24] shows how clear and immediately intelligible the layout of the Innocenti is, and that was all to the good for the utilitarian purpose of the building. Finally, by his placing of the building Brunelleschi set a standard which was to determine the whole future layout of the piazza. Brunelleschi's Innocenti inspired the portico of the Servites, which dates from about 1518 and is by Antonio da Sangallo the Elder, and the loggia of the Annunziata, which followed in 1600 and is by Caccini.

Brunelleschi received the commission for S. Lorenzo almost at the same time as that for the Innocenti.[25] The Prior of the foundation, Padre Dolfini, had planned an enlargement of the old foundation on the model of the great monastic churches, and had begun

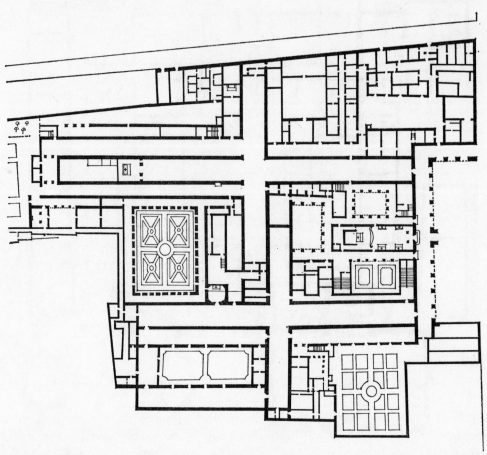

Figure 3. Florence, Hospital of S. Maria Nuova, fourteenth century and later (after a plan of the eighteenth century)

the building of a new choir on those lines. In 1421 Brunelleschi was called in as adviser on the suggestion of Averardo de' Medici, the patron of the church, and at once made his authority felt in the planning. True, he had to allow for the parts of the building already begun, but his genius in exploiting the exigencies of the site is all the more admirable. His plan evolves from the square of the crossing, and all the other elements are derived from it in clear order and proportion (Plate 3 and Figure 4A). With the annexes of the Sagrestia Vecchia and its counterpart – later the Sagrestia Nuova – to the apse, with the side chapels carried round the transepts, a centralizing note is given to the basilican plan (cf. Figures 79 and 80). Thus the traditional and schematic design of Padre Dolfini was transformed into a new, unexpectedly rich and delightful composition. The scenographic widening of the spatial picture, which can be felt even in the ornamental pattern of the ground-plan, comes to full expression in the elevation; the structure of the interior can, as it were, be read off from the decorative articulation; every detail has its clearly appointed function.

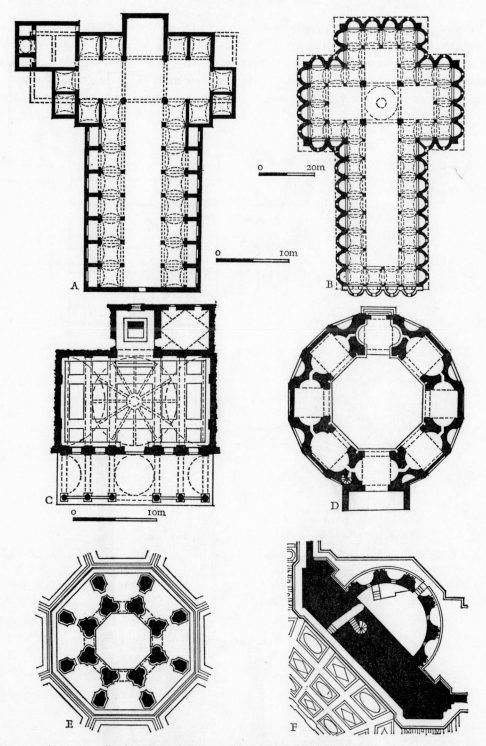

Figure 4. Filippo Brunelleschi: Plans of Florentine churches: (A) S. Lorenzo, begun 1421; (B) S. Spirito, begun 1436; (C) Pazzi Chapel, commissioned 1429; (D) S. Maria degli Angeli, 1434–7; (E) Cathedral, lantern, model 1436, executed 1445–67; (F) Cathedral, exedra, 1438 ff.

9

The Sagrestia Vecchia has always served as an exemplary demonstration of the logical evolution of a Brunelleschian space (Plate 4 and Figure 5). It is a plain cube, with the 'zone of change' of the pendentives forming the transition into the inscribed circle of the dome. The pendentive is a characteristic invention – or more precisely a rediscovery – of Brunelleschi's and is of the greatest importance for the whole development of modern

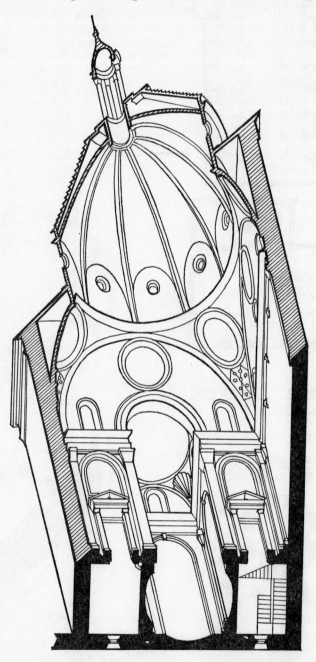

Figure 5. Filippo Brunelleschi: Florence, S. Lorenzo, 1421 ff., Sagrestia Vecchia

architecture. The form evolved as it were by necessity from the configuration of Brunelleschi's design. Wherever he may have found his model,[26] the decisive point is that he reintroduced the pendentive in this new aspect of an abstract mathematical concept of space. And from it Brunelleschi derived the structure of his domes, the so-called *volta a vela* (the 'umbrella dome') over the cube of the sacristy, the small one over the little choir of the sacristy, and the dome over the crossing.[27] The strictness of this structure is made visible in the articulating members, the motifs of which – the concentric double arcades, the order of pilasters, the entablature and the springing of the dome – arise of themselves quite logically from the composition. This inherent logic of Brunelleschi's structural members also explains the introduction of the famous imposts between the capitals and arches of the nave, which, in the strict sequence of the elevation, correspond to the entablature of the walls.[28]

As a whole, S. Lorenzo is a happy blend of the formal austerity of Romanesque architecture with Gothic spaciousness. With the means of a new and rational handling of form, a spatial composition has been created which has been studied down to the smallest detail and is governed by a single scale of proportions. In the novelty of its structural members, just described, in the austere purity of its forms, and in the simple harmony of its proportions, S. Lorenzo corresponds exactly to the contemporary idea of a work which could hold its own beside antiquity.[29]

In S. Spirito (Plate 5 and Figure 4B), begun in 1436, Brunelleschi developed further the type of the centralizing basilica, particularly as he was not, as in S. Lorenzo, hampered by existing parts of the building.[30] His original project envisaged a most splendid complex; the façade was to look out on to the Arno, with a monumental piazza in front of it stretching down to the river bank, so that fishermen, looking up from their boats, would have the church before them. This superb plan was rejected, to the later regret of the clients, it is said.[31] All the same, Brunelleschi's proposal to erect the new church on the side of the old one was accepted, so that the church and the monastery remained untouched for the time being.[32] The old church was not demolished till 1481. The new building was turned round by 180 degrees, so that its entrance front faces the present Piazza S. Spirito.

Only parts of the external walls were erected in Brunelleschi's lifetime, the first column-shaft being delivered the year he died. Yet those parts of the building were finished which were of essential importance for the plan of the whole, a building which Brunelleschi himself called 'a church fulfilling his intention concerning the composition of the edifice'.[33] With this type of basilica with centralizing features, a type of church was created which expressed the ideal of its epoch. Once more the square of the crossing is the module for the whole composition, and its parts are still more exact in their proportional integration than those of S. Lorenzo. The way he continues the aisle round the transepts and the west front, and the wreath of semicircular chapel niches, which were originally visible from the outside, is of the greatest boldness. The building, perfectly symmetrical even in plan, thus evolves in strictly observed proportions: while in S. Lorenzo arcade and clerestory are in the ratio of 5 : 3, in S. Spirito the ratio is 1 : 1. The closer setting of the columns caused by this considerably enhances the impression

of sculptural massiveness, which is still further emphasized by the sturdier columns and by the deep mouldings of the arches and cornices.[34] In the exterior, the homogeneous external shell of S. Lorenzo is replaced by powerful piers framing the niches. In a general way, as compared with S. Lorenzo, S. Spirito is a far more massive structure, the spatial effect of which mainly arises from the powerfully sculptural quality of its individual members.

In S. Spirito too, the architect has obviously aimed consciously at the effect of a scenographic vista. Yet its effect is not exhausted in one single 'perspective', with the observer standing perhaps at the entrance to the church; it is just as true and effective from several points in the building. From the entrance, the 'vista' of the nave stretches beyond the crossing to the chancel, but on the other hand the observer standing in the crossing can see the four arms of the cross in one coherent picture, and the 'corridors' of the aisles contribute their own scenic effects. Thus what we have here is a specifically architectural perspective which arises from an interplay of geometrically abstract and solidly concrete perceptions. The space is comprehended through the functions of its component members, as 'picture' and as 'mass'. That is how Brunelleschi's concept of the *composto dell'edifizio* should be understood.[35]

At the same time principles of design appear in S. Spirito, far more than in S. Lorenzo, which point the way to the whole of modern architecture; the functional forces at work in the members of the organism, which determine its character as volume and as space, are clearly revealed.

The Pazzi Chapel in S. Croce has at all times been regarded as the supreme example of Brunelleschi's art and therefore of the new style (Plates 6 and 7 and frontispiece). The most recent research has gone far to destroy this ideal picture.[36] The building dates are scanty. The commission was given in 1429. In 1433 part of the arcade of a cloister was demolished to make room for the new building. In 1442 Pope Eugenius IV lodged in a room above 'the chapel of the Pazzi'. There is no evidence of any energetic building activity before the forties; when Brunelleschi died, the building was only standing in the rough, and it is uncertain how much of it. The domes of the chapel and the porch bear the dates 1459 and 1461. Traces on the entrance wall show that the first plan provided for a façade without a porch. Thus the whole porch may have been added by Brunelleschi's successors; in that case the chapel, which had always been regarded as the fine flower of the master's art, would have to be relegated to his anonymous successors. On the other hand, the porch may be explained as Brunelleschi's own alteration of his plan, and so 'rescued' as his invention.

Let us first look at the general layout (Figures 4c and 6). The chapel was commissioned by Andrea Pazzi to serve both as the chapter house of the monastery and as the assembly room of the family. Brunelleschi erected the building on a site whose shape was largely determined by the existing parts of the friary of S. Croce.[37] It is precisely in the exploitation of the given situation that the inspired quality of Brunelleschi's composition makes itself felt: a rectangular hall is subdivided into three parts; over the central square a dome rises, the side bays are tunnel-vaulted. Thus the cubic 'cell' of the Sagrestia Vecchia has been developed into an oblong hall. The modelling of the walls, and even

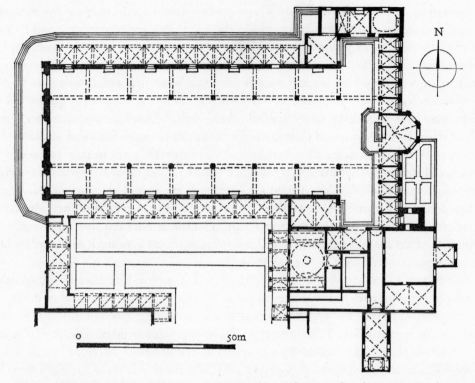

Figure 6. Filippo Brunelleschi: Florence, S. Croce, plan, with Pazzi Chapel, commissioned 1429

the pattern of the pavement, stress the strict logic which governed the evolution of the spatial organism, and it has remained a model of perfection down to our own day. The Pazzi Chapel ranks with the most famous buildings in the world. The logic of the structural elements permeates even the details; the pilasters on the façade wall are a little more slender than those on its inner side, in order to adjust their diameter exactly to the columns of the portico. With this subtle gradation of forms, based on the view of the façade from the entrance to the cloister, one is loath to detach the porch from Brunelleschi's total conception and consider it a later addition. That is why I regard a change of plan by Brunelleschi himself as being more likely. The portico, in form a continuation of the Gothic cloister arcades, seems to offer another example of the fertility of Brunelleschi's imagination: six columns support a tunnel-vault which is interrupted in the middle by a shallow dome, a motif which, as it were, sets the key for the chapter house. The construction required a horizontal architrave here, which is broken by the great central arch leading into the domed bay. The cornice and the attic are articulated with classicizing motifs – a fluted frieze and panels; the whole may have been crowned by a flat pediment.[38] In this architectural conception, where perfection is born of simplicity, the aim at a scenographic effect from the entrance to the cloister is unmistakable. A very remarkable feature is the heightening of the outer shell of the dome, so that the drum and helm rise freely above the façade and reach their full effect.[39]

The decoration of the Pazzi Chapel (Plates 7 and 13A) is the most ornate ever

employed by Brunelleschi; its beautifully proportioned structure is unquestionably based on his design, though it was executed for the most part long after his death.[40] The relief of the articulating mouldings is far deeper than that in S. Lorenzo. The play of colour harmonies in the majolica roundels on the walls and in the spandrels against the austere grey-white of the background is very subtly graded and is a delight to the eye (frontispiece). The evangelists, ponderous forms calculated with an eye to a *sotto in su* effect, may have been designed by Brunelleschi himself.[41] There are no precursors in the whole of the Romanesque and Gothic traditions for this combination of an architectural structural system with decoration in coloured majolica relief; it is an innovation of the epoch, and it was partly through its influence that the Pazzi Chapel became the proto-type of a form which developed with the greatest freedom and grace in the following generations and became a characteristic feature of Renaissance architecture. The same principles govern the portico, with its beautiful contrast between the heavy coffered vaulting and the majolica dome; for that reason I continue to regard it as Brunelleschi's own design, executed by a later generation.[42]

Brunelleschi's oratory of S. Maria degli Angeli (1434–7) is a completely centralized church (Figures 4D and 7), the first example in the new style and of capital importance for the development of this type of building in the succeeding epochs.[43] It was here that Brunelleschi first employed the pure type of construction on piers. The central space and radiating chapels are formed by a simple ring of eight fully developed piers. They support the drum and dome of the octagon and form the side walls of the eight chapels. On the outside they are connected by walls, so that a figure of sixteen sides is created with flat surfaces alternating with recessed niches.

While in the Sagrestia Vecchia and the Pazzi Chapel the walls merely enclose the space like a shell, S. Maria degli Angeli (Figure 7) is entirely conceived in terms of mass; it is the three-dimensional substance of the piers which shapes all the parts of the space. Brunelleschi could only have learned this kind of composition from the monuments of ancient Rome, and it may not be wide of the mark to suggest that this is a new kind of approach to antiquity which differs essentially from the first stage of his studies of the antique. In that first phase he was mainly concerned with investigating the building technique of ancient structures, and turned it to account in the dome of Florence Cathedral. In this later phase, it was the Roman monument as a whole which interested him. His own development had led Brunelleschi to recognize in the architecture of antiquity that sculptural treatment of architectural forms which came to govern his own work. The plasticity of the Pazzi Chapel, which is rather more marked than that of the Sagrestia Vecchia and S. Lorenzo, is still restricted to a more vigorous moulding of the articulating members. But in S. Maria degli Angeli this sculptural quality invades the very core of the building, since its very substance is modelled throughout. This pro-cedure, which appeared here for the first time, is also characteristic of Brunelleschi's other late works – S. Spirito, the lantern of the dome, and the so-called exedrae of the drum of the dome.[44]

In spite of this closer approach to antiquity, we must never so much as suspect, in any work by Brunelleschi, an intention to *imitate*. That idea is put out of court at once,

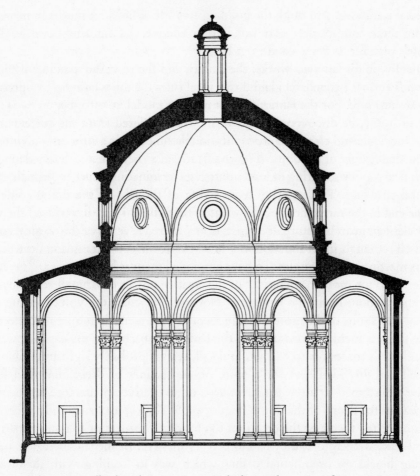

Figure 7. Filippo Brunelleschi: Florence, S. Maria degli Angeli, 1434–7, from an engraving

firstly by the completely independent handling of the decoration, which, in its purity
and restraint, contains no single truly classical motif, and still more by the layout of
his buildings, which is always dictated by the practical requirements of their sacred or
secular purposes. That is as true of the hospital of the Innocenti as of a religious building
such as S. Maria degli Angeli. The latter was endowed as an oratory dedicated to the
Virgin and the Twelve Apostles inside the Camaldolese house. The choir niche facing the
entrance was to be dedicated to Our Lady, while the altars of the Apostles were to be
distributed in couples through the six remaining chapels. (The eighth served as an
entrance.) A circular disposition of the chapels was therefore not only justified in this
case; it was even an advantage. Thus Brunelleschi with his central plan for the oratory
of the Angeli was by no means sacrificing the needs of religion and the liturgy to the
ideal building type of his time: on the contrary, he was making quite special allowance
for them.[45]

Thus S. Maria degli Angeli stands as a mature and very personal solution within the
development of Brunelleschi's style, which is, in its turn, a perfect synthesis of medieval

and classical traditions. Although the building was left unfinished, it set a standard both of architectural composition and building technique. Its influence can be felt in Bramante's plan for St Peter's and even later.[46]

And finally, in his last two works, the lantern and the so-called exedrae of Florence Cathedral (Plate 1), Brunelleschi laid down ideal rules for the whole field of decorative form in architecture. For the lantern[47] (submitted in model in 1436, begun in 1445, not finished till 1467), he discovered a new form which differed from the current type of columned aedicule and clearly expressed its double function as a structural member and an ornamental feature of the dome (Figure 4E); round an octagonal columned tempietto with a conical roof he set a ring of lower buttresses terminating in volutes which support the central structure. The superbly tense swing of the ribs of the dome comes to a harmonic end in the movement of the volutes. Brunelleschi here introduced the volute as a new element in architecture. It consists in an inspired reversal of the classical console, which itself – though in its function as a bracket – formed the transition between two members meeting at right angles. To have employed them as buttresses is an 'invention' which seems to me most characteristic of the creative power of Brunelleschi's logic and formal imagination. From the lantern of Florence Cathedral the volute set out on its triumphal way as one of the most versatile decorative elements in modern architecture.[48]

While the ornamental forms used on the lantern, in particular the capitals, were left to Brunelleschi's successors to execute in detail, we are probably right in thinking that he himself had provided here for a more ornate manner of decoration than he was otherwise accustomed to use.[49] A similar type of decorative architecture can be seen in the exedrae of the drum of the dome (Figure 4F).[50] They were structurally necessary in order to brace the thrust of the drum on the four free corners of the substructure; for structural reasons, therefore, they had to be very massive. Brunelleschi created for these supporting blocks an ornamental casing which was in keeping with their massive character. Niches with shells in deep relief are scooped out of the semicircular mass of the wall, and the mouldings employed on the pedestal and architrave are deeply under-cut. The most notable feature, however, is the coupled half-columns, a variant of the twin pilasters of the Pazzi Chapel enhanced to yet greater sculptural effect. This powerful and beautiful motif was here used for the first time in modern architecture.

In the same way as in the lantern, Brunelleschi seems to have made full allowance in calculating these members for the fact that they were to be placed at a great height and distance: the elongation of the base and of the capitals, and the thin abaci can only be explained through the calculation of their visual effect in distant perspective.[51]

In comparison with his churches, Brunelleschi's work in domestic architecture is remarkably meagre. The evidence for the many palazzi and houses he is said to have built is very scanty. Yet the details which have recently come to light on the brackets of the Innocenti church give grounds for accepting the Bardi, Lapi, and Busini palaces as his work, although in the simplicity of their conception they are not very enlighten-ing.[52] His great plan for a Medici palace was rejected and we know nothing about its design.[53] Thus the sole remaining example of his grandest secular architecture is the re-building of the Palazzo della Parte Guelfa (Figure 8): the great assembly hall, recently

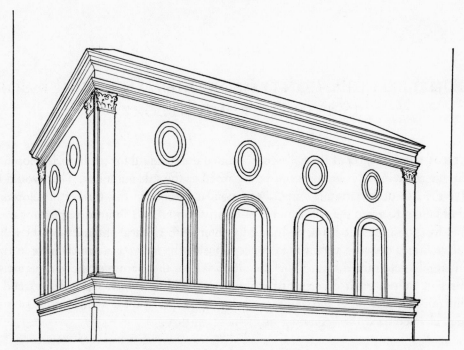

Figure 8. Filippo Brunelleschi: Florence, Palazzo della Parte Guelfa, begun *c.* 1420, elevation

restored, shows that Brunelleschi's canon of formal simplicity is perfectly suited to a room of the kind and endows it with monumental dignity.[54]

When Brunelleschi died in 1446, he was one of the most famous men in Italy.[55] He had set the art of building on new foundations. With his vast intelligence and profound culture he had evolved a new theory of building from traditional knowledge, both theoretical and practical; it contained basic and universally applicable principles, not only for structure and the shape of individual members, but for the total plan of a building. He had given a practical demonstration of this theory in his works, each one of which set a standard for its type. Brunelleschi gave to architecture a new rationality, since his 'perspective planning' subjected the building to a module which determined not only the ratios between the single members, but also its total visual effect. He was, moreover, the inventor or rediscoverer of architectural forms which following generations continued to respect; we may recall the most important: the pendentive, the drum, and the double-shelled dome;[56] the volute, coupled orders, concentric double arcades. He gave new laws to *ordo* and *dispositio*; in every one of his buildings we become aware of that inward logic of the structure as a whole which was to remain a supreme challenge to all future architecture.

BRUNELLESCHI'S CONTEMPORARIES AND SUCCESSORS IN FLORENCE: MICHELOZZO

ALTHOUGH the canon of Brunelleschi remained the standard for the later development of architecture in Italy, he must not be regarded as the sole authority. That would involve the risk of underrating important secondary trends in this further development and of failing to grasp the whole range of creative impulses. From the respect for traditional forms on the one hand, and the encounter with classical antiquity on the other, creative minds deduced very varied conceptions of the new style, which were in their turn largely determined by regional conditions. Thus there arose in the various artistic centres of Italy a great diversity of manners of building which showed no trend to uniformity till the end of the century, when they prepared the way for the classic style which characterized the beginning of the new century.

<p align="center">*</p>

Even in Florence itself, and at the height of Brunelleschi's work there, it is possible to distinguish a stylistic tendency which, no matter how much it may owe to the creator of the new style, went its own way and led to important solutions of its own. The most important representative of this trend is Michelozzo di Bartolomeo (1396–1472).[1] As the son of a tailor of Burgundian origin, Michelozzo grew up in far humbler circumstances than Brunelleschi. His name first appears in the records in 1410 as a die-cutter for the Florentine mint. He kept this office till 1447, and occasionally exercised his craft. We know nothing about his training as a sculptor and architect. He was repeatedly associated for long periods with Ghiberti and Donatello in their activity as sculptors, with Ghiberti in all probability as an experienced bronze caster and chaser.[2] The sculpture which can be definitely assigned to Michelozzo is characterized by simple and rather weighty forms and by adherence to a Gothic classicism. Though Michelozzo never attained the maturity of a Nanni di Banco or the perfection of a Ghiberti, he remained remarkably independent of the work of his great colleagues, even of Donatello, and developed an expressive style which found its successor in Luca della Robbia's unpretentious classicism.[3]

We can see a similar independence, limited of course by the scope of his talent, in Michelozzo's architecture. In comparison with Brunelleschi's, it shows a much closer adherence to the immediately preceding Gothic tradition, the Gothic classicism which appears in the Loggia dei Lanzi[4] or the monastery of S. Matteo. Between 1420 and 1427, Michelozzo built the little monastic church of S. Francesco al Bosco in the Mugello; in spite of its modest size it is important as a type of vaulted aisleless church.[5] Taking up Late Gothic models such as were to be seen in Tuscan country churches (e.g. Antella)

he has sought – in this case like Brunelleschi – to find a new classicizing design for this traditional type of building, but in doing so he has used means which are totally different from any Brunelleschi would have used. Thus the retention of the vaulted nave runs counter to the whole Brunelleschian canon. But on the other hand Michelozzo aims – and in this case with success – at giving the 'Gothic' vaulted space a classical aspect by means of its articulation. The hall is divided by very plain pilasters and heavy transverse arches; the spatial impression is massive, yet does not lack a certain austerity and dignity. The 'classicizing' Gothic console capitals (prototype in the Loggia dei Lanzi) are fully in keeping with the unadorned type of the building, and so are the plain pilaster strips and cornices on the exterior.

This formal idiom, which aimed at supreme simplicity, appears in a more mature and subtle form in the friary of S. Marco in Florence, which Michelozzo built in the thirties to the commission of the Medici.[6] The layout is perfectly lucid and beautifully proportioned (Figure 9). Vasari called S. Marco the most beautiful monastery in Italy[7] – and the restraint and economy of the decoration is fully in keeping with the grave unpretentiousness of the friary church. In the cloisters and the library (Plate 8) – the first library to be built in the Renaissance and the model for many that came later – there are new formal elements: the plain Ionic capital, which Brunelleschi hardly ever employed, and, in the cloister, the pedestals to the columns. In the refectory the stepped base at the entrance to the reading pulpit is worthy of notice; with its intentionally weighty and uncomplicated outline, it is remarkably well proportioned.

The church, which was very much altered in Baroque times, was originally a large, plain hall with a low-pitched open timber ceiling; the chancel was separated from the

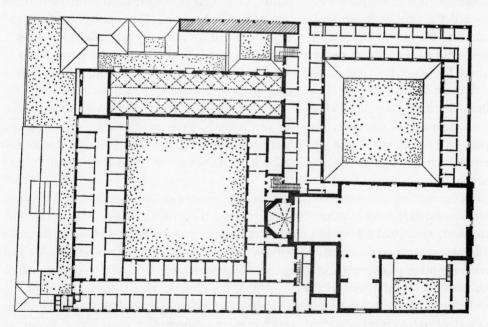

Figure 9. Michelozzo di Bartolomeo: Florence, S. Marco, late 1430s, plan at first-floor level

19

main space by a heavy transverse arch, similar to that in S. Francesco al Bosco and in the later sacristy of S. Croce (1445), also by Michelozzo.[8]

Michelozzo's chief religious work was the rebuilding and enlargement of the SS. Annunziata in Florence (begun in 1444).[9] Here too he follows his natural bent to the greatest simplicity in design, since he transformed the existing Gothic church with nave and aisles into a hall with chapels by inserting transverse walls between the nave pillars and the outer walls of the bays. What is more important, however, is that the rotunda he added to the east end is an exact copy of the temple of Minerva Medica in Rome. How Michelozzo ever conceived so bold an idea we can only surmise. In the forties, Brunelleschi's new canon of form was fully developed and – especially after his late work, S. Spirito and still more S. Maria degli Angeli – the problem of the assimilation of antique forms had become acute. In the same decade, too, Alberti's influence began to make itself felt and to effect a change in the attitude towards antique models (see pp. 31–2). Thus Michelozzo must have felt it incumbent on him to add to his monumental hall an equally plain and monumental chancel, and for that purpose the classical rotunda with niches – which Alberti may have made known to him – provided him with an ideal model. The fact that the donor, the Marquis of Mantua, had destined the 'tribuna' as a memorial for his father was certainly an essential reason for adopting a Roman prototype. For two and a half decades the chancel of the Annunziata was the subject of fierce controversy, for it seemed to infringe all the aesthetic and practical rules then governing the *convenienza* and *bellezza* of a religious building. Michelozzo left the building unfinished when he retired from work on it in 1455; in 1460 operations were temporarily resumed by Manetti, but only completed in 1470–3 under Alberti's super-intendence. It was defended by the patron, Ludovigo Gonzaga: prominent Florentines attacked the project, their spokesman being Giovanni Aldobrandini, who collected architects' views (among them the objections put forward by Brunelleschi in 1445!), along with those of the clergy and the citizens with the object of making the Marquis change his mind. Detailed descriptions were given of its ugliness and its unsuitability to the cult and the liturgy, and a counter-project submitted, which came from the 'Brunelleschian' Giovanni da Gaiole, sometime capomaestro at S. Spirito, and proposed an arrangement of the chancel similar to that in S. Lorenzo. But Ludovigo Gonzaga stood his ground, supported by Alberti, and thus in democratic Florence this highly personal 'undemocratic' conception of a pseudo-classical memorial chapel carried the day.

The Annunziata underwent such far-reaching alterations in the seventeenth century that the original layout can only be reconstructed from old drawings (Figure 10). The ornament, as befitted a Minorite church, was sober, and the great surfaces of the nave and transept walls were articulated only by the arcade openings of the side chapels and their enframing pilasters;[10] above was a plain entablature. This austere spatial picture was enlivened by the restrained ornament of the capitals, which we may imagine as similar to that in the vestibule and the sacristy. In the vestibule Michelozzo displayed his mastery of architectural ornament, which became a model of its kind. Quite in contrast to Brunelleschi's invariable standard type, his capitals are free compositions of great

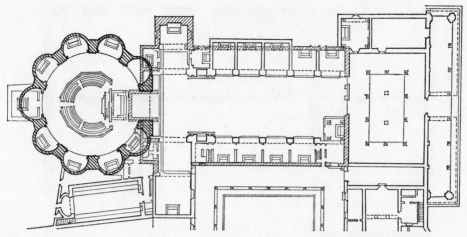

Figure 10. Michelozzo di Bartolomeo: Florence, SS. Annunziata, rebuilding and enlargement
begun 1444, plan

beauty (Plate 13, C and D); their clear tectonic structure shows in the softness of their
modelling the hand of the experienced sculptor.[11] His marble canopy in S. Miniato
(Plate 9) has four variations of capitals, and the great ciborium in SS. Annunziata, too,
executed by Pagno di Lapo (1448) after Michelozzo's design, is typically ornamental
architecture; it must have come to far greater effect in the plain hall of the original
building than it does today, when it is almost submerged in the luxuriant Baroque
decoration, especially as it is itself heavily overlaid with later embellishments. The taber-
nacles in the church at Impruneta might give us an idea of its original appearance.[12]
There appears here, for the first time in Florence, the fluted column, not contained in the
Brunelleschian canon, which Michelozzo had already introduced on the Brancacci tomb
at Naples.

It was Michelozzo's practical experience, his sense of tradition, and – last but not least
– his peculiar feeling for decoration which made him Cosimo de' Medici's favourite
architect. Vasari describes the close ties which bound patron and architect, and names
several buildings which Michelozzo executed or designed for Cosimo.[13] Among them
is the library of S. Giorgio Maggiore at Venice, which was destroyed in 1614; it was
certainly an important work and an outstanding example of its type, as we can see in
the masterly solution of the S. Marco library.[14] Michelozzo's most important com-
mission was the family palazzo in the via Larga, which was then on the outskirts of the
town. The Palazzo Medici (begun in 1444) (Plate 10 and Figure 11) became the proto-
type of the Tuscan Renaissance palazzo, and was repeated by Michelozzo himself in
a number of minor variants.[15] The design is based on that of the traditional type of the
medieval palazzo, but the component elements of the latter are reduced to clarity and
order and provided with a consistent system of articulation. Four ranges, presenting a
massive block to the exterior, enclose the square courtyard (Plate 11). The apartments –
halls, rooms, bedchambers – are distributed according to their use among the ranges and
storeys, the latter being connected by comfortable, though not showy staircases. The

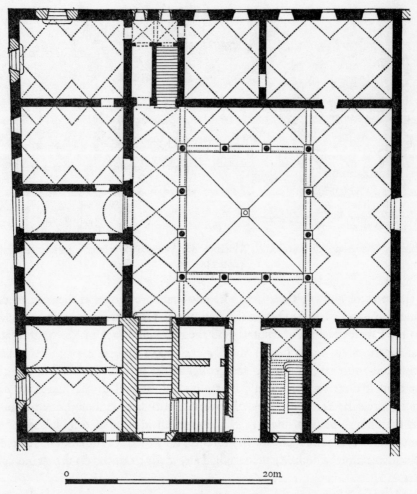

Figure 11. Michelozzo di Bartolomeo: Florence, Palazzo Medici, begun 1444, plan

monumental staircase had not yet made its appearance as a feature of secular design. The sequence of window openings is determined by the 'harmony' (*concinnitas*) of the façade, so that in the interior some of the windows are set asymmetrically.

The building materials and architectural forms are treated with the simplest means, and in such a way that they clearly stress the structural scheme of the building, to the exterior by the threefold grading of the masonry, from the boldly rusticated blocks on the ground floor to the smooth ashlar face of the top storey; then by the vigorous sweep of the window arches, the simple beauty of the bipartite windows, and by a raking cornice 'all'antica' which made its first fully-developed appearance in this building; in the courtyard by the noble arcading with superbly worked composite capitals and by the sgraffito decoration of the wall surfaces; finally, in the interior, by the rich, yet sober decoration, especially in the chapel, an architectural gem.

There first appear in the Palazzo Medici the large boldly rusticated blocks which evolved from the smaller blocks of the Trecento. Since this kind of building material

was rare and costly, the rusticated block became a status symbol; in the Pitti and Strozzi palaces it is explicitly used as an instrument of power politics. If Michelozzo, as it were, introduced it in the Palazzo Medici – and there would seem to be grounds for attributing the invention to him, since he later employed the technique in important variations (Palazzo Gerini, ground floor of the Palazzo Strozzino) – it would represent a very important contribution to the development of palatial secular building in the Renaissance.

Michelozzo gave further proof of his great experience in secular building in a number of large villas – remodelled for the most part – for the Medici at Careggi, Trebbio, Caffagiuolo, and Fiesole.[16] In the field of religious building he retained the aisleless church in several minor examples,[17] and even developed a variant of it in a later work, the church of S. Maria delle Grazie at Pistoia (he was paid for his plans in 1452).[18] To the main hall here he added a pseudo-tetrastyle choir (Plate 12), an invention which is a very brilliant development of Brunelleschi's basic scheme and which may have been influenced by late classical or pre-Romanesque types, such as S. Giacomo di Rialto in Venice.

All Michelozzo's buildings are works of considerable standing, which show that their author was the most important, and above all the most independent architect after Brunelleschi. He developed the aisleless church, which Brunelleschi never used, and thus became the pioneer of a plan-type of sacred building which is, with the basilican and the central plan, the most important in modern times. He left an equally deep mark on secular building, and his reputation in this field brought him commissions from Milan (design for the Banco Mediceo)[19] and Dubrovnik (Ragusa) (superintendence of the rebuilding of the Palazzo Comunale).[20] In his masterly use of traditional forms, in the adaptability which enabled him to evolve good compromise solutions for distant regions such as Lombardy and Dalmatia, but above all in his sensitive treatment of architectural ornament, Michelozzo was able to adopt ideas and turn them to good account as well as to transmit new ones. The styles of Manetti, Bernardo Rossellino, Giuliano da Maiano, and even of Giuliano da Sangallo are unimaginable without the support and influence of Michelozzo's artistic idiom in addition to that of Brunelleschi, and, as we shall see later, of Donatello.[21]

CHAPTER 3

BRUNELLESCHI'S CONTEMPORARIES AND SUCCESSORS IN FLORENCE: GHIBERTI AND DONATELLO

THE great variety in Michelozzo's architectural ornament may chiefly be explained by his inborn gift for sculpture. Quattrocento sculpture began much earlier than architecture to make use of classicizing forms and extended their application to architectural ornament as far as was required by the particular purpose in hand. It is, however, important to draw a clear distinction between ornamental forms primarily conceived for sculptural compositions as a decorative framework (capitals, consoles, friezes) and these ornamental forms conceived primarily as articulating structural members of a building.

In his reliefs on the first door of the baptistery, Lorenzo Ghiberti (c. 1380–1451)[1] developed an entire programme of idealized Renaissance architecture which was practically independent of Brunelleschi (e.g. 'Jesus in the Temple', 'The Last Supper', 'The Flagellation'); his St Matthew tabernacle on Or San Michele (1419–22) (Plate 14), in spite of its Gothic delicacy of structure, is almost classic in its individual details. In the reliefs for the second door (after 1425) he employs an architectural style whose purely classicistic formal idiom has been described by well qualified experts as akin to Alberti's ('The Story of Joseph', 'Jacob and Esau') (Plate 15).[2] The classical piazza which is the background for the miracle of St Zenobius seems almost like a premonition of the idealized architecture of Urbino. But as far as building practice was concerned, Ghiberti's conception of an architecture governed by a general theory of art remained for the moment without influence; a similar discrepancy can be seen in the ideal architectural scenery of painting, too.[3]

Donatello (1386–1466) is a different case. He was never an architect in the precise sense of the term.[4] But wherever sculpture was associated with architecture he showed a pronounced feeling for original and imaginative forms of architectural ornament. His work presents a kind of pattern-book of these ornamental details. Employed by Donatello, on the whole, with the utmost freedom and boldness, they stimulated – and at times even fascinated – architects on the grand scale. The tabernacle of St Louis of Toulouse on Or San Michele (Plate 16), which today houses Verrocchio's Christ and St Thomas, was finished as early as 1425[5] and is therefore a very important architectural invention which can be set beside Brunelleschi's early works. To my mind, its deep recessions, which are unusual for the period, would point to a sculptor as the author; the great pilaster order, resting on a richly decorated pedestal (the simulated straw matting between the consoles and the pedestal is a very 'sculptural' motif and characteristic of Donatello),[6] crowned with a frieze and tympanum, encloses a deep niche, which in its turn is enframed by a pair of columns with spirally fluted shafts and Ionic capitals and an elaborate arcade over the fine projecting architrave. The niche itself is given strong plastic accents by the massive shell and the enframed panels. It is im-

possible to say whether and how far Michelozzo collaborated in this tabernacle; to my mind it seems to reflect the bold spirit of Donatello. In any case the wealth of architectural ornament in it far surpasses Brunelleschi.

Michelozzo and Donatello were associated for many years;[7] their tombs in the Florentine baptistery, S. Angelo a Nilo at Naples, and the famous external pulpit on the Duomo of Prato show the wealth of the formal apparatus both had to draw on.[8] The composition of the Naples tomb certainly stimulated Brunelleschi in the façade of the Pazzi Chapel, and the coupled pilasters of the Prato pulpit and its wonderful bronze capital, are inventions of the highest order; they exercised a lasting influence on later formal developments. It is impossible to distinguish clearly between Donatello's and Michelozzo's share in these works; many a good idea of Michelozzo's probably lies hidden behind its magisterial execution by his much greater associate Donatello.[9] Yet it would be a mistake to underrate Michelozzo's share in the work, for where Donatello appears as the sole designer of architectural ornament his style is quite different. He completely subordinates the architectural setting to his sculpture and makes architecture, so to speak, its handmaid. The beautiful ornamental sculpture in Brunelleschi's Sagrestia Vecchia (Plate 17) shows how far Donatello would go with his sculpture in order to provide it with an effective frame in the extraordinarily vigorous modelling of the broad, slanting surrounds of his overdoors and medallions. It must of course also be remembered that these frames had to be created for their purpose in the austere and even articulation of Brunellsechi's space.[10]

The tabernacle in St Peter's, Rome, is now once more accepted, on good grounds, as a work executed under the influence and with the collaboration of Donatello.[11] Its date is definitely established as 1432-3, that is, at the time when Eugenius IV was gathering round him the best known architects of the day – Brunelleschi, Alberti, Donatello, Michelozzo, and the young Bernardo Rossellino, who was at that time engaged on the chapel of St Nicholas (or del Sacramento) which was demolished in 1540. The tabernacle of the Sacrament was probably made for it. Formally it is characteristically Donatellesque, in the bold combination of sculptural and architectural elements, the recession in depth, and the capricious use of architectural details (corbels and capitals). The composition is as unclassical as it could very well be, and yet there breathes in it a spirit which Donatello could only have felt in Rome, although the formal idiom, to a certain extent, remains typically Florentine. In the exuberance of its fantasy and the quite personal quality of its design, the idea of the tabernacle could only come from Donatello; it may have been executed in part by other hands.

This magisterial freedom in the use of architectural ornament reaches its height in Donatello's tabernacle of the Annunciation in S. Croce (Plate 18). Only a genius like Donatello could have succeeded in fusing into one grandiose and artistically perfect whole the elements of an architectural setting which are placed quite capriciously, and sometimes even in reverse (volutes for bases, exaggerated egg-and-dart in the frieze, masks in the capitals). Anticipating in a way Michelangelo's famous definition, architecture is here conceived as a kind of art of plastic relief, and all architectural elements are sculpturally shaped.

Finally, the architectural forms which Donatello used in the cantoria of the Duomo in Florence and on the high altar of S. Antonio, Padua (now broken up) – the latter certainly under the influence of medieval Venetian and Ravennate ornament – are of considerable importance for the architecture of later times, since the direct incorporation of classicizing details (incrustation, mosaics, colossal consoles, richly ornamented frieze) with the utmost freedom and in the greatest profusion, opened up new possibilities for architects to embellish their buildings with that *ornamento decoroso* which was alien to Brunelleschi's austere simplicity, but had been formulated as extremely desirable – indeed as an absolute rule – in Alberti's treatise on architecture.[12]

With Donatello (and in the field of architecture with Michelozzo) there sets in that development of rich and manifold ornament which aims at observing the law – again postulated by Alberti – of *varietà* in architectural design.[13]

To the following generations, the formal relationships between structure and ornament in architecture became one of the great problems of artistic design, and the way it was solved served to distinguish the various schools and masters. As we see them in the works of the great spirits of the first generation, the rich variety of architectural types – basilica, aisleless church, centrally planned church, palazzo, villa and other secular forms on the one hand, and the versatility in the application of ornament on the other – opened up a wealth of possibilities of combination and variation in building. Other formative factors were tradition and local material, the different interpretation of the antique, and, last but not least, the influence of patrons. Before turning to this second phase of Quattrocento architecture (roughly between 1460 and 1480) we must first become familiar with that great spirit who – though representing a type of a totally different kind – was the most important and influential architect of his time: Leone Battista Alberti.

CHAPTER 4

ALBERTI

THE work of Brunelleschi and Michelozzo matured in the practice of their art. Both gave their capomaestri and masons such precise instructions, furnishing them with models exact even to the smallest details, that their style is immediately and unmistakably recognizable from the general plan down to the details. Compared with them, the third personality who took a leading part in establishing the ideal programme of the new style is far more difficult to place in the roll of creative artists. For Leone Battista Alberti (1404–72) was never an architect by profession. On the contrary, he was the first to represent that type of the *uomo letterato* who was to play such an important part in the age of humanism, and who, himself a man of wide and versatile culture, set out to establish for the visual arts their new dignity and enhanced status as *artes liberales*. It was in this preoccupation with painting, sculpture, and architecture – truly the work of a dilettante – that Alberti elaborated important theories of those arts, which combine their aesthetic principles and the practical rules for artistic creation in one doctrine.[1] As an expert in this sense of the word, he felt called – and was fully qualified – to take an active part in practical problems of creative art. But in his practical work, he remained to the end the adviser who laid down the general lines and occasionally gave instruction for details – thus he made models for capitals in plaster or clay – but he never set one stone on another.[2]

It is true that Alberti's spirit can be felt in the buildings erected under his supervision, but in the execution they are the productions of other men, i.e. of architects and capomaestri who gave visible form to Alberti's projects. This was the origin of a style which differs widely from Brunelleschi's or Michelozzo's, since it lacks what might be called the craftsman's signature. Yet an attempt must be made to show how distinctive this style of Alberti's is, how highly it must be valued aesthetically, and what eminent historical importance it has.

Leone Battista Alberti[3] was born at Genoa on 18 February 1404. He was a natural son of Lorenzo Alberti, the descendant of an ancient patrician family of Florence which had suffered banishment. He enjoyed, however, all the rights of a legitimate son, and received, first at Genoa and later at Padua, an excellent education which befitted his standing, though it was extremely strict. In 1421 he began to study canon law at Bologna; he graduated in 1428 and took holy orders. At that time he made the acquaintance, among others, of Tommaso di Sarzana, who later became Pope Nicholas V. After a short stay in Florence connected with the repeal of his family's banishment, he continued his studies at Bologna and devoted himself from then on to the *discipline philosophiche*, which include science and mathematics. With his remarkable intelligence he gained wide knowledge in humanistic subjects. He began to write early in life; he was hardly twenty when he wrote his *Philodoxius*, an imitation of a classical satire which

was long believed to be the work of Lepidus. In 1429 came his treatise *De commodis et incommodis literarum*; in 1432 he began his *De familia*. Those are only his most famous works. His brilliant all-round knowledge, his personal vitality, and the stimulating influence that radiated from him very soon won him unusual respect throughout Italy. His manner of life was outwardly very simple – in 1432 he was appointed *abbreviator apostolicus* at the Vatican, which carried with it as a benefice the priorate of the church of S. Martino at Lastra a Signa near Florence – yet he was on terms of friendship or intimacy with many eminent members of the circle of the Medici, the Este, the Gonzaga, and the Montefeltro. In 1434 he went to Florence in the suite of Eugenius IV and remained there for two and a half years; it was at that time that he wrote his treatise on painting and probably his *De statua* also. Later, various missions took him to Bologna (1436), Venice (1437), and Ferrara (1438 and 1444). In 1444 he was back in Rome. With the elevation of Nicholas V he began his collaboration as adviser in the Pope's great projects for the restoration of Rome (1447–55). At the same time he also became architectural adviser to Sigismondo Malatesta (from 1450 on). The beginnings of his work *De re aedificatoria* may also be placed in the forties; it was practically finished in 1452. The second half of the fifties saw Alberti's designs for Giovanni Rucellai's buildings in Florence: the façade of S. Maria Novella, the Palazzo Rucellai, and the chapel of the Holy Sepulchre in S. Pancrazio. In 1459 Alberti accompanied Pius II to Mantua and revived his relations with Ludovigo Gonzaga. He supported Ludovigo in the bitter dispute about the choir of SS. Annunziata, Florence (see above, p. 20) and took over the superintendence of two new buildings endowed by the Duke of Mantua, S. Sebastiano and S. Andrea, directing operations mainly from Rome, where he died in 1472. His grave is unknown.

The decisive factor in Alberti's whole artistic practice was that his approach to antiquity and the Rinascità, to which he gives such moving expression in his treatises, was primarily literary in origin.[4] When, in his first years in Rome (i.e. from 1432), he began to take an interest in the monuments of antiquity, he was already a thorough-paced humanist and the author of treatises which had soon won fame.[5] On the other hand he had become acquainted in Florence with the great pioneers of the new art – Brunelleschi, Donatello, and others – and met them again in Rome. Above all, however, this was the time when the Popes – in Alberti's case Eugenius IV – were attacking the huge problem of the restoration of Rome, in which a mind as alert and eminent as Alberti's could not fail to take a personal interest. Still more, here, in the field of art, Alberti, the humanist philosopher, discovered a unique and ideal opportunity of giving practical expression to one of his basic ethical challenges: 'essere utile a tutti i suoi cittadini'. This is the standpoint which enabled Alberti to regard architecture as a supreme spiritual aspiration, joining letters and science, theory and practice, in a natural and fruitful union.[6] I am convinced that it was Alberti's first encounter with Rome that prompted him to turn to architecture, which he had always regarded with special interest, as an independent field of study.

We have, however, as yet no evidence of any active work by Alberti in architecture during these first years in Rome, especially as he left the city with Pope Eugenius in 1434

and did not return till 1444. Thus the pedestal for the equestrian monument to Niccolo d'Este at Ferrara (c. 1446–50), which is believed on good grounds to be based on a design by Alberti, may well be his first contribution to the formal repertory of the new architecture; no Florentine or Ferrarese could have invented a composition which is so un-Tuscan and so entirely inspired by antique monuments, and it reflects a distinctive personality which links it up with Alberti's later works, especially at Rimini.[7]

His relation to architecture, however, was only established in the following years, when Nicholas V consulted him in his urbanistic projects for Rome.[8]

The fact that Alberti was witness to, and partner in, these great schemes is the decisive fact which casts into the shade any question of his possible active participation in the various building enterprises launched by the Pope, for instance, the Fontana Trevi, the Tiber bridges, and especially the Vatican Palace.[9] Special scholarly research has recently confirmed the fact that there can never be an unambiguous answer to this question, particularly as far as the rebuilding of the Borgo is concerned.[10] A mere reference to these works will suffice, but a few remarks on the project for the rebuilding of St Peter's (Figure 12) may not be out of place. The peculiarly tradition-bound form of the so-called Rossellino choir, which, with the new east wall of the transept, was begun on a gigantic scale behind the apse of the ancient Christian basilica, is the product of a particular historical situation. Owing to its huge scale, colossal forms were necessary, but there was no prototype for them in the most recent building practice in Rome. Elements which could be pressed into service were therefore sought in the latest great buildings outside Rome – the cathedrals of Florence and Milan, S. Petronio at Bologna, and, last but not least, the torso of the cathedral of Siena. These elements were mainly the shape of the pillars, of the dome over the crossing, and of the vaulting otherwise. With the necessary adjustment of the *dispositio* to the requirements of St Peter's, there emerged practically the only plan which could have been imagined in 1450, and which is extensively described by Gianozzo Manetti. It is Günter Urban to whom we owe the most recent and fully convincing reconstruction of Rossellino's project (see below, p. 54).[11] Whether Alberti approved or disapproved of it must remain guesswork: Matteo Palmieri's saying that the Pope took Alberti's advice to stop work on the building already begun seems to show that he was at least sceptical.[12] Yet the project must have confronted Alberti seriously with the great problems of building arising here, such as the mastering of vast spaces by means of articulation and vaulting. He encountered this problem everywhere in Rome, for instance in the rebuilding of the Palazzo S. Marco, which will be discussed later. This preoccupation with great size, which was, so to speak, compulsive in Rome – and only in Rome – conditioned, too, the feeling for the single form, for order and ornament. Direct guidance from the works of antiquity presented itself to Alberti as a perfectly natural process. This explains his unshakeable conviction of the paradigmatic quality of antique building. For Alberti it included proportions and technique as well as decoration, and he had plenty of opportunity later to take up the passionate defence of his conviction.

We shall probably not go far wrong in assuming that Alberti's treatise on architecture, the idea of which may have been conceived as far back as the pontificate of Eugenius IV,

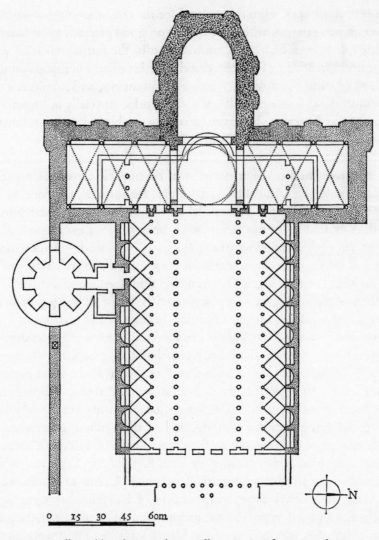

Figure 12. L. B. Alberti (?) and Bernardo Rossellino: Project for St Peter's, Rome, c. 1450

first took on definite shape in these years. In 1452 he showed the Pope a first version of the work.[13]

It was not until about 1450 that Alberti seems to have undertaken his first, quite independent commission, namely the rebuilding of S. Francesco at Rimini.[14] The real originator of the plan was the patron. Sigismondo Malatesta (1417–68) represents what may be regarded as the Renaissance prince in his most primitive form. He was not more than fourteen when, by bold and prompt action, he secured the lordship of Rimini, which had been bequeathed to him and his brothers but was being contested by his uncle, Carlo Malatesta. Having eliminated his brothers, he soon became sole ruler. The opportunism of the policy by which he strove to maintain his authority against his greater neighbours, Florence, Venice, Milan, Urbino, and Mantua, began well and led to the recognition of his status by the Emperor Sigismund (1433) and Pope Nicholas

30

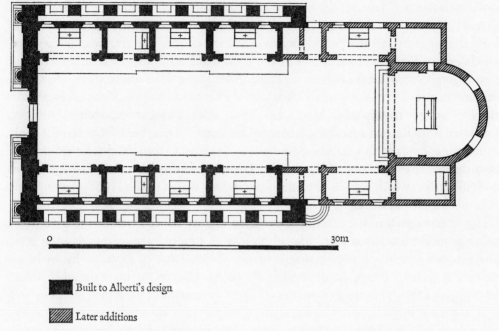

Built to Alberti's design

Later additions

Figure 13. L. B. Alberti: Rimini, S. Francesco, begun *c.* 1450, plan

(1450). But it brought him into growing conflict with his enemies, particularly the Vatican. He met his most implacable enemy in Pius II, who finally defeated him. With the greatest of political sacrifices he once more managed to achieve a reconciliation with the church under Paul II, but his strength was broken. He died at Rimini, aged only fifty, on 9 October 1468.[15] A man of power and lust, ambitious and intelligent, Sigismondo tried to emulate the Medici and the Este by making his capital a centre of humanistic culture, but he lacked the true dignity which gives single-mindedness, and so he failed to make of Rimini a centre of learning like Florence, Ferrara, Urbino, and wherever else the patrons themselves were men of culture and could make great demands and attain great ends. Even Sigismondo's cousin Randolfo Malatesta, the ruler of Cesena and founder of the famous Biblioteca Malatestiana, surpassed him there.[16]

Like everything else which Sigismondo initiated in this field, his plan of transforming the modest friary church and burial place of his ancestors, S. Francesco, into a resplendent monument to his own glory bore from the outset the stamp of extravagance. Huge niches in the façade (Plate 19) were planned to hold the sarcophagi of himself and his mistress, Isotta degli Atti, while the deep arcades on the long side were planned as tombs for the scholars and poets of his court.[17] The chapels inside were intended as memorials for Sigismondo, Isotta, their ancestors, or for purposes of liturgy and cult, with the existing parts of the building incorporated into the new plan (Figure 13).[18]

For this pantheon, which Pius II described as 'so full of pagan images that it seems like a temple for the worshippers of demons, and not for Christians',[19] Alberti devised a form which shows the closest approximation to antique monuments ever until then achieved in Renaissance architecture. The project can be reconstructed from Matteo de' Pasti's

foundation medal (Plate 20), from other contemporary reproductions, and from documentary evidence. In the latter we find several mentions of a wooden model and of detail drawings by Alberti.[20] The medieval aisleless church was retained, and so were the chapels of Sigismund and Isotta in the right hand wall of the interior, which had been begun before Alberti came on the scene. All that was done was to clothe the Gothic building in a shell consisting of the façade in the form of a temple front evolved from motifs of antique triumphal arches, and along the sides of a pillar-and-arch construction borrowed from Roman aqueducts. Instead of the current plain, straight end to the choir, an antique rotunda with a massive dome was to be added to the church, and would have been the dominating motif of the whole. The nave was to be covered with a barrel-vault in timber, which was, in its turn, to be covered with a pitched roof spanning both the side chapels and the nave.[21]

The finished parts of the exterior show what dignity Alberti was able to give to the rather primitive temple-of-glory idea of his patron, simply by his greatness as an artist. The precious building materials stripped from the churches of Ravenna by Malatesta are used with moderation, particularly in the incrustation of the main portal.[22] Alberti derived (not copied) his motifs from the antique monuments of the region (e.g. the Arch of Augustus at Rimini), and adapted them to his purposes by intelligent variation. The elements of his articulation, for example the fluted engaged columns, and especially his capitals (Plate 13B) are the product of an imagination schooled in antique forms but creating in its own freedom. Above all, Alberti battled with the architects to have his proportions respected, and defended them with the utmost firmness both in the dome and in the design of the roofing and façade.[23] The result is a monument in which features of Roman, Ravennate, and perhaps other architectural traditions of the Adriatic are fused into a completely unprecedented and independent unity by the force of a new stylistic will.

The surprisingly monumental impact of the church, which is actually not very big, is due entirely to the formal apparatus employed and its strong sense of volumes; it was this monumental effect that became a kind of ideal to its contemporaries, although the church was never finished. As for the great problem of the front elevation, Alberti's façade of S. Francesco at Rimini is the first composition of a façade as a unity, based on the use of great, simple forms.

The Tempio Malatestiano is a characteristic specimen of 'princely architecture'.[24] This imposing, absolutist manner of building would have been impossible either in republican Florence or in papal Rome.[25] The type of aisleless church, balanced, if not dominated, by a rotunda at the east end, which was already being built in SS. Annunziata in Florence, became at Rimini a representative monument of purely secular power, an impression which is enhanced by the fantastic ornament in the interior with its mystic and secret iconography.[26] The building, therefore, displays a 'new style' which is certainly absolutely distinctive on the one hand, yet cannot be entirely associated with the name of a single master on the other; it was the product of a collaboration between patron, adviser, and working architects. We shall see later that 'local styles' of this kind occasionally appear, but only where the political structure of the region favours them,

especially at Pienza, Urbino, and Mantua, where the intentions of the patron were a decisive factor in the design.

How deeply the traditional forces in a city can influence the idiom of an architect can be seen in the buildings which Alberti executed or designed for Giovanni Rucellai in Florence. These, begun at the earliest in the second half of the fifties, were continued till 1470.

Among them, Alberti's great artistic adaptability comes out again in the perfection of the façade of S. Maria Novella (Plate 21).[27] The order of pilasters and engaged columns which he set before the Gothic ground floor is a simple means of unifying the façade. The projection of the cornice over the great half-columns and their pedestals (a form unknown till then in Tuscany) are as Roman in inspiration as the deep arched recess of the main entrance. The high attic zone which separates the pilaster front of the upper storey from the lower tier is superbly proportioned. Yet Alberti sacrificed these proportions in order to incorporate the round window which remained from the Gothic building and weighs rather heavily on the attic. Finally the volutes which screen the lean-to roofs of the aisles and form a harmonious transition between the lower and upper storeys of the façade were an invention of great historical consequence. The double scrolls planned for Rimini are the preliminary – and still ornamental – version of this motif. The idea of converting it into an independent structural member first came to Alberti in Florence, and was clearly inspired by Brunelleschi's volutes on the lantern of the Duomo.[28] From S. Maria Novella on, the scroll became the most important element of composition in Renaissance and Baroque façade design.

But the most remarkable feature of the façade of S. Maria Novella is that, while the predominating tendency to design in large units is unmistakably Roman in origin, it is carried out with formal means which are mainly drawn from Tuscan tradition. The incrustation, the type of capital, the ornamental motifs, and even the scroll all have their prototypes in Florentine architecture, as we have seen. It is in this power of synthesis that we recognize Alberti's distinctive gift, and realize at the same time that his principles of style were applicable to many different purposes. The executant architect was Giovanni di Bertino, whose clear and delicate chiselling may be recognized in the delightful decoration of the small antechamber to the tabernacle in SS. Annunziata.[29]

In the Palazzo Rucellai, which was also executed by others, Alberti established the prototype of the pilaster façade (Plate 22).[30] The motif in itself had actually been used before in the idealized architectural background of paintings and reliefs, but this intentional combination of the pilaster system with the traditional rusticated front was Alberti's most personal achievement and had the greatest possible influence on later building, though more especially outside Florence. There are Roman echoes in this façade too: the plinth, with its paraphrase of the *opus reticulatum* in the pattern of the masonry, the rather broad proportions of the doors with straight lintels on S-scroll brackets, the small oblong windows on the ground floor, and the employment of the three orders. There is yet another important innovation – the gradation in the size and courses of the flat rustication in the various storeys, which gives an ornamental quality to the modelling of the wall surfaces. Here again a new structural system of supreme

quality has been created in terms of traditional Florentine building, and Alberti's 'synthetic style' has stood the test.

Alberti could work most freely however in the Chapel of the Holy Sepulchre which Giovanni Rucellai built in the church of S. Pancrazio adjoining his palazzo.[31] In the course of time the chapel has undergone many alterations. Originally, the long side next the church was open and supported on two fluted columns which (since 1807) have formed the entrance to S. Pancrazio: the corner pilasters and fluted frieze above them were part of the original building.[32] The original entrance to the Chapel of the Holy Sepulchre was therefore on its long side; the entrance columns are echoed by pilasters on the opposite wall which take the transverse arches subdividing the barrel-vault. As far as I know, this chapel is the first building in Florence to have a true barrel-vault, and this gives it special importance.

In the centre of this clearly proportioned hall stands the shrine of the Holy Sepulchre (Plates 23 and 25), its profusion of many-coloured and costly material intentionally set in striking contrast to the severe grey and white structure of the chapel. The inscription over the entrance to the chapel states that Giovanni Rucellai caused the shrine to be built in imitation of the Holy Sepulchre in Jerusalem. Any departures from this original can be explained by Alberti's obvious intention not to copy the still extant Gothic sepulchre, but to create his 'likeness' of it in the form of the antique Constantinian prototype which had been handed down in old descriptions and illustrations.[33] He derived the structural elements from the baptistery in Florence, which, in common with all his contemporaries, he believed to be late antique. On the aedicule he set a spiral-fluted onion cupolette, an unmistakable approximation to the original in Jerusalem.[34]

In its conception, the Chapel of the Holy Sepulchre is a humanistic *concetto* which bears the true Albertian stamp. The stonework was executed with the greatest care by other hands, but many of the individual motifs, among others the pilasters with seven flutings (from the Pantheon?), the heavy garlands of the window frames, and above all the barrel-vault of the chapel – not to forget the superb inscription of the sepulchre in Roman capitals – are all pure Alberti. In my own opinion, this little building is the most perfect expression of the spirit and style of Albertian architecture.[35]

The versatility of Alberti's style is again illustrated in the buildings commissioned by Ludovico Gonzaga at Mantua, where it attains an ultimate and superb expression. From 1460 to 1472 – that is, till he died – he superintended the building of the churches of S. Sebastiano, begun in 1460, and S. Andrea, begun in 1470.[36] S. Sebastiano (Plate 24) is a votive church which Ludovico began 'in the utmost haste', as the sources relate, in obedience to a call which had come to him in a dream. It was to replace a very old oratory which is recorded in the documents as far back as the tenth century, and was therefore pre-Romanesque.[37] The combination of an oratory with a votive church may have been responsible for the peculiar form of the centrally planned building, as well as for its division into two parts, an upper and a lower church, which, as a type, recalls the mausoleum of Theodoric at Ravenna. In any case, this building of Alberti's is one of the strangest works of Italian religious architecture ever erected in the Renaissance. Unfortunately, the church, which was never finished and had remained derelict for

centuries, was so greatly altered by the restorations and rebuildings carried out in 1925 in order to convert it into a war memorial that it is practically impossible to imagine it in its original state.[38] With the help of old engravings (Plate 25), the old parts may be reconstructed as an extremely massive, two-storeyed building on a Greek-cross plan. The lower church is a large, seven-naved crypt with piers, the upper an impressive cruciform spatial organization with very sparing use of pilasters or brackets; above the main compartments is a huge domical vault, 17 m. (56 feet) in diameter. Even during building operations, it collapsed, and as far as I know was never rebuilt to the original plan.

The unusual disposition of the interior is in perfect keeping with the equally unusual articulation of the exterior, especially of the façade. The massive superstructure rises on a basement storey, the five arcades of which were originally open and led into the vestibule of the lower church. The five loggia openings, set close but at rhythmic intervals, are answered by three middle portals in the recessed entrance wall which lead into the church and two large exterior niches in the wall of the tower. This vestibule, and from it the upper church, is reached by a double flight of steps at the side, which, in all probability, was not part of Alberti's design.

Four pilasters, very plain in the modelling, support the entablature which is broken in the middle by the tympanum of the arch rising above it. Thus if the basement is included, there is a peculiar central axis with four superposed openings, or blind arcades, which comes to an end in the arch. As a whole, the façade is a bizarre revival of late antiquity; there seem to be echoes of provincial Roman motifs, which are familiar from Spoleto and Orange (tympanum of arch) or Ravenna (palace and mausoleum of Theodoric); yet Alberti may have borrowed them from other Roman ruins unknown to us. The building is an experiment, full of capricious details, but a conception of genius as a whole; even in the travesty in which we now see it, the wide, almost austere spaces of the lower and upper churches give an impression of no common power. It may not be quite wide of the mark to suppose that the idea of a monumental Early Christian work also played its part in the conception.[39] The building was no less enigmatic to its contemporaries than it is to us, as can be seen from a letter written by the young Cardinal Francesco Gonzaga to his father in 1478 – he couldn't say whether Messer Alberti's fantastic mind had conceived this classic building as a church, a mosque, or a synagogue.[40]

The design for the second church which Alberti submitted to Duke Lodovico in 1470 – ten years later than S. Sebastiano – is all the more perfect; it is that of S. Andrea in Mantua (Plates 26–7). An imposing new building was required to replace a small church which was to be pulled down. Ludovico had already received a design from Antonio Manetti, and sent it to Alberti for his opinion. In reply, Alberti submitted an altered plan, which he himself called *sacrum etruscum*. The Duke accepted it, and Alberti went to Mantua, where Luca Fancelli, the executant architect commissioned for the building, made the model in 1471. The demolition of the old church was completed in February 1472, and the new building was begun. On 7 August of the same year Alberti died, so that the work passed entirely into Fancelli's hands.[41] He followed

Alberti's plans to the letter; in 1494 the barrel-vault of the nave was finished as far as the crossing, and thus, with the realization of Alberti's conception, the most important church built in the Quattrocento came into being. The whole, planned on simple and grand lines, is impressive in the extreme – the dominating nave, the modelling of its walls, and its alternating niches. The transepts were not part of Alberti's plan; in my opinion he had provided for a central composition to be added to the nave, which either – as in Rimini – would have been in the shape of a rotunda or, as seems more likely, would not have exceeded the width of the nave, and would thus have resembled the arrangement of the Gesù in Rome.[42] The huge barrel-vault over the long nave, with a span of 17 m. (56 feet), subdivided by beautiful transverse arches corresponding to the triumphal-arch rhythm of the pilasters, is slightly stilted in accordance with Alberti's rule, expressed in his treatise, that tunnel-vaults must be raised above the semicircle in exactly the proportion to which the projecting cornice would conceal them from sight.[43] Thus the spatial proportions are calculated and perfected by the employment of the laws of optical perspective. The modelling of the walls of the nave in their pseudo-rhythmical travée[44] stresses the force of the structure. We find formal elements already familiar from other buildings by Alberti: the tall pedestals of the piers, the doors closely enframed by pilasters, the beautifully moulded cornices. For the first time in the architecture of the century, I think, a most important feature makes its appearance here, namely directional lighting. The sources of lighting, direct and indirect, are distributed over the openings in the side niches and in the accompanying chapels, as well as from the rose window half concealed from the outside by the canopy of the façade. The lighting of the interior is thus very carefully graded and the total effect is sublime. The lighting follows the lines laid down by Alberti in his treatise; for the first time, with the exception of the Cappella Rucellai, it appears as a factor in design.[45]

The front elevation of S. Andrea is a characteristically 'theoretical' solution (Plate 27).[46] It can only be understood as an entrance porch intentionally kept low, for it is only in that way that its independence of the section of the church can be explained. In itself, it is a pioneer composition. The total wall surface is organized by four giant pilasters on high pedestals which support the cornice and the pediment. In the central bay there is a large arched recess with its own beautifully coffered vault, and the narrower side bays, with their three superposed openings (door, niche, window) may on the one hand have been inspired by the arch of Titus, or, on the other, be a more lucid variant of the same motif in S. Sebastiano. It is impossible to discover how Alberti had devised the facing of the wall of the church jutting out over the pediment of the entrance, yet the curious canopy ('ombrellone') in front of the central window probably figured in his design; it also plays its part in the directional lighting.

On the long sides of the exterior the buttresses and great blind arcades are worth attention. Even here the idea of the Etruscan temple can be sensed, and a kinship with antique and Early Christian monuments seems obvious.[47]

Alberti, it will be remembered, only lived to see the laying of the foundation stone of S. Andrea. In the Cinquecento the nave was raised as far as the crossing, and two and a half centuries passed before the building was in any way completed. Even today, part

of the exterior is still in the rough. The later sources show that the intention to continue the building in Alberti's spirit and, as far as possible, after his model never wavered.[48] Even as late as the eighteenth century, when the transepts and choir were erected, it was expressly stated that they 'were executed to the topmost cornice in accordance with the ancient model'.[49] Finally, the dome begun after a design by Juvara, but only finished in 1763, was given a shape which was totally different from Alberti's plan. Yet in spite of all later alterations, the spatial impression of the nave, one of the grandest in the whole of western religious architecture, is faithful to Alberti's conception in all characteristic features.

If we look back on Alberti's work in architecture as a whole, all the buildings erected under his supervision appear as 'exempla', which no practical architect of his age would have ventured with such boldness. True, there is an air of experiment about most of them, yet they are distinguished by a consistency of development which culminates in the grandiose finale of S. Andrea. Alberti's essential contribution to the architecture of later times consists in the new sense of monumentality he awakened, which evolved in his own mind out of a new and quite personal feeling for Roman antiquity. This sense found expression in his spatial organizations (nave, vault, large surfaces, giant orders) – S. Francesco at Rimini, the Rucellai Chapel, and S. Sebastiano and S. Andrea at Mantua are all spatial compositions of a most distinctive character – and in his use of architectural ornament: pedestals, shafts of columns and pillars, capitals, architraves, and sunk panels are always great in scale and sculptural treatment, i.e. they are conceived with a view to a monumental effect. And yet, with all its versatility, there is a constant feature in Alberti's formal language; however widely the works at Rimini, Florence, and Mantua may differ, and however much they may be influenced by the *genius loci*, they are unmistakably united by what we may call the super-regional style which, in my opinion, evolved out of Alberti's conception of antiquity and formed the bond between his building practice and his architectural theory. A series of interesting recent studies has shown how far the laws of proportion laid down in Alberti's Ten Books of Architecture can be demonstrated in his buildings.[50] The same applies to a number of individual architectural forms. This growing interdependence of theoretical reflection and practical design resolves the conflict – so long hotly disputed – between the man of letters and the artist in Alberti, or rather it ceases to exist. At the same time it helps to explain the specific character of Alberti's style. It may perhaps be best apprehended in that striving for *concinnitas* which pervades all his architectural work, however different the forms it may take on.

According to Alberti's doctrine, *concinnitas* is the supreme challenge by which the beauty of a building becomes manifest. It is based on the expert application of the fundamental laws of architecture contained in *numerus, finitio,* and *collocatio.* All factors of design, quantitative and qualitative, are comprised or united in it. *Concinnitas* sets no bounds to the architect's imagination, but subjects it to a supreme law of order which covers on equal terms the technical, artistic, and utilitarian requirements of his work.

From this standpoint Alberti's architectural theory is seen in its real and timeless significance as the first manifestation in literature of a new way of thinking in

architecture which consciously and deliberately set its sights beyond antiquity, however deeply it may be indebted to it. This way of thinking is also characteristic of Alberti's architectural works and their 'style'. We can hardly speak of a direct influence from Alberti's architecture, i.e. from his style, on the succeeding generation, but its indirect influence was all the greater. Alberti's real influence, however, consists in his having established universally valid standards of value which – whatever use they may have been put to – have remained through the centuries, and down to our own day, 'principles of architecture'.

FLORENCE 1450–1480

ALBERTI's formal repertory has its place beside that of the Florentine schools of Brunelleschi, Michelozzo, and Donatello as an important and enriching factor. The masters of the following generation, without exception, were accessible to these new directions; to the regional tradition a super-regional component was now added – that is the best definition of Alberti's influence. This situation helps to explain the wealth of variation[1] in Florentine architecture; we may even regard the bias to *varietà* as the specific characteristic of this phase of style. The profusion of examples may be divided into two groups and illustrated by a few examples.

One group comprises the work of the second generation pure and simple, among whom Antonio Manetti (1405–60) deserves to be mentioned first,[2] for he was first an associate and later the successor in office both of Brunelleschi (S. Lorenzo, S. Spirito, lantern of the cathedral dome) and of Michelozzo (SS. Annunziata). In the controversy over the choir of SS. Annunziata he actually took sides against Brunelleschi in favour of Michelozzo's new spatial conception; on the other hand he criticized Alberti's idea of a hemispherical dome and recommended a slight stilting above the semicircle. The steeper curve of the Annunziata dome which would have resulted would have produced an unsatisfactory compromise between the classical prototype (Minerva Medica) and the Florentine ideal (dome of the cathedral), which Manetti, however, fortunately for the building, was unable to bring off.[3] As a master of architectural ornament, Pagno di Lapo Portigiani (1408–70), the executant of the Annunziata tabernacle (1448), introduced the Florentine style at Bologna (Cappella Bentivoglio in S. Giacomo, c. 1458),[4] while Maso di Bartolomeo (1406–56),[5] Michelozzo's associate in the Palazzo Medici, was active at Rimini (Cappella di Sigismondo Malatesta, S. Francesco) and Urbino (portal of S. Domenico). These examples could be multiplied *ad infinitum*: Castiglione d'Olona, Chiesa di Villa; Pescia, S. Francesco, Cappella Cardini (1451) (Plate 28); Genoa, S. Lorenzo, Cappella S. Giovanni Battista (c. 1450) may be selected for mention. To my mind, however, it seems more important to draw attention to the second group of buildings, which is uncommonly characteristic from the standpoint of the problem of style at issue here. It comprises several important buildings, which, however, in spite of their very distinctive character, cannot be definitely ascribed to any one master.

In religious building, there are several works which are interesting as variants but not particularly outstanding aesthetically, such as S. Felice (Manetti?) and the sacristy of S. Felicità, to take only two examples among many. But one unusual work stands out: the Badia Fiesolana (Plate 29). There is a wealth of documents about this building, the design of which was obviously due to a large extent to its very cultured patron, Abbot P. Timoteo Maffei, a close friend of Cosimo de' Medici. They mention a large number of good capomaestri and masons, but no master is named for the building itself.[6] The

barrel-vaulted, aisleless church with side chapels gives a very powerful spatial impression which derives less from its size than from its proportions and lighting. The ornament is extremely delicate, but intentionally restrained (Plate 13E), and it stresses the austere dignity of the space.

This was a case in which the architectural appreciation of a patron was the guiding spirit of a work executed by an association of Florentine masters who exploited the potentialities of their time in no common fashion. On account of its quality the building – or at any rate the design – was formerly attributed to Brunelleschi, though the attribution is put out of court by the dates.[7] On the other hand, the design has also been attributed to Alberti, and many features of his Florentine style lead up to the Badia (tunnel-vault, seven-fluted pilasters, already prefigured in S. Pancrazio).[8] But it would be more to the point to leave the question of attributions open and take stock of the Badia as an achievement of Florentine architecture which a practically anonymous team of Florentine masters was capable of producing between 1450 and 1480. Brunelleschi, Michelozzo, and Alberti stood spiritual sponsors to it; many different personalities – patron and capomaestri – took part in its execution and deserve the praise.

This same mastery by an anonymous association comes out even more clearly in the secular building of the period. Countless houses, villas, and palazzi were built with that unerring instinct for simplicity, proportion, and dignity which is the characteristic and distinctive mark of Florentine taste. Beside the type of ashlar and rusticated masonry – Palazzo Gerini-Neroni (1460?) (Plate 30), Palazzo Antinori (1465), Palazzo Strozzino (c. 1466)[9] – we find the rendered façades with sgraffiti. The sgraffito can be traced far back into the Trecento in the form of plain ornamental bands, but one of its first developments into a decorative scheme can be seen in the courtyard of the Palazzo Medici (Plate 11). It was used later in a large number of palazzi and houses, and it must have given the view of Florence accents of colour which are quite lost today.[10] *Varietà* is also to be seen in the free treatment of sculptural ornament after the middle of the century, for instance in the Palazzo Pazzi-Quaratesi (1460–72) (Plates 13F and 31).[11]

No master can be named with certainty for any of these buildings, not even for the most imposing of them all, the Palazzo Pitti, which, by the grandness of its layout and the enlargements carried out on it uninterruptedly for four centuries, has come to stand as the symbol of Florentine palazzo architecture (Plate 32 and Figure 14).[12] The idea of this vast building was conceived by the patron himself. The Florentines showed Luca Pitti, a somewhat questionable plutocrat, a rare and lasting indulgence. We can feel in his wish to have a house so big that the Palazzo Medici could find room in its courtyard a need for self-aggrandisement which is remarkable in a city noted for its extreme reserve. That so inordinate an idea would find expression in a work of the highest rank is due less to the patron than to the inborn taste of the city of Florence.

In the Palazzo Pitti, every motif of the Palazzo Medici is repeated on a colossal scale. The rustication is huge, and so are the storeys, which are of equal height throughout. The windows are like portals. A new feature is the balustrades in the Ionic order set in front of the top storeys.[13] The core of the building with seven window bays can be distinguished even today by the candelabra-rings on the middle block; there are many

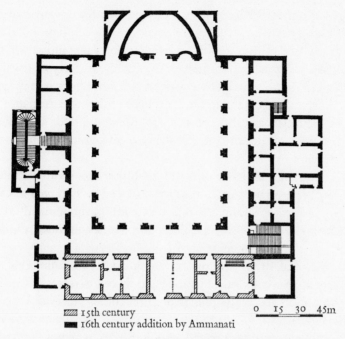

15th century
16th century addition by Ammanati

0 15 30 45m

Figure 14. Florence, Palazzo Pitti, begun 1458, plan

old paintings and drawings which show this original aspect. In Luca's time only this central block was begun – a plain double range of huge rooms in the upper storeys with a vast entrance-way on the ground floor. The great banqueting hall brings home to us the size of the original even today; the coved ceiling with penetrations and the mouldings of the great door surrounds have been preserved under ornament added later. It was the first vaulted banqueting hall to be built in Florence and remained the only example for a long time to come.[14]

What is un-Florentine in the building is its colossal scale; the great Roman palazzo projects may have influenced its conception. But the colossal scale had to be given formal expression, and that this was achieved with the formal elements of the Florentine tradition is the really important thing about the Palazzo Pitti. It was begun in 1458; that eliminates Brunelleschi from the project, and Michelozzo too, since he was not in Florence at the time; he can, however, also be counted out on stylistic grounds. Therefore the name of Alberti came up again, supported, as a special argument, by the horizontal division of the bipartite windows by an architrave which was originally provided for and can be reconstructed from the pilasters of the window surrounds, a feature which also occurs in the Palazzo Rucellai. The vaulting too might point to Alberti, especially the tunnel-vault of the androne, and also the fluted colonnettes of the balustrades, if they were part of the original design at all (present state, late sixteenth century). The latter has its counterpart in the androne of the Palazzo Venezia in Rome. Thus the Pitti Palace unites a number of stylistic features which bear the Alberti stamp, and we can well understand that many historians are not prepared to dismiss Vasari's claim for Luca Fancelli as the architect;[15] at any rate he was in Florence when the main

41

building was going on, and there is plenty of evidence for his close connection with Alberti, especially at Mantua.

And yet here, as in the Badia Fiesolana, the question of the authorship of the project is, to my mind, less important than the fact that this extremely distinctive work was the product of a collaboration by an anonymous team. For whoever may have originated the plan as a whole, the executant architects remain unknown. A glance at the varied modelling of the gigantic rustication or at the window and door surrounds, which are hewn direct from single blocks, provides evidence of a technical mastery which was also supreme artistic power.[16]

Here again the anonymous vigour of the Florentine school created a work which, for all its exaggeration, is governed by a strict sense of order. This *ordo* in the core of the building is the precious inheritance from the great progenitors of the new style, Brunelleschi, Michelozzo, and Alberti. Their successors continued to observe it as a supreme law.

Besides these works of latecomers on the one hand, and of anonymous production on the other, there appear between 1450 and 1480 three masters whose personalities are well known by tradition and whose works are particularly delightful specimens of this phase of *varietà*: Bernardo di Matteo Gambarelli da Settignano, called Rossellino (1409–63), his brother Antonio (1428–79), and Agostino di Duccio (1418–81).[17]

Bernardo Rossellino's activity is closely associated with three popes: Eugenius IV, Nicholas V, and Pius II. His work is distributed between Rome, Arezzo, Florence, and Pienza. He was specially appreciated for his technical skill, his artistic adaptability and insight, and, especially, for the speed and verve of his manner of working. Even in his first commission, the completion of the Misericordia façade at Arezzo, which was entrusted to him when he was barely twenty-five, he displays great skill (Plate 33). The elongated niches in the tympanum zone of the lowest storey (fourteenth century) introduce the forms of the new style which become dominant in the structural scheme of the upper stage, but are accompanied there by a Gothic motif in the curved frame of the panel with the relief. Bernardo's training by Brunelleschi and Michelozzo is obvious, while his own skill in stucco and ornament comes out in the charming balustrade of the second storey. At the same time (1433) Rossellino was employed by Eugenius IV in the building of the Chapel of the Sacrament in the Vatican Palace (destroyed in 1540), which in all probability housed Donatello's tabernacle of the Sacrament.[18] A remarkable detail, however, can be distinguished in the plan of the chapel (Figure 15); the engaged columns framing the apse seem to point to an unusual and charming arcading.[19]

Back in Florence Rossellino worked on the decoration of the Chiostro degli Aranci in the Badia (1436–7) (Plate 34), which gave further proof of his originality in the treatment of architectural ornament, here in the articulation of the loggia – flattened arches with pilaster strips.[20] In the following years he was chiefly occupied with sculpture, and in 1444–5 executed the tomb of Leonardo Bruni in S. Croce, a perfect manifestation of his quite distinctive ornamental style. It consists in the fine chisel-work executed with deep, slanting strokes, and gives his ornament a quite peculiar precision with beautiful effects of light and shade. In 1450–9 Rossellino was back in Rome, and as

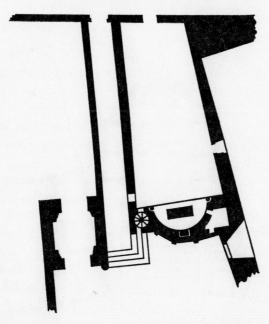

Figure 15. Bernardo Rossellino: Rome, Vatican, Chapel of the Sacrament (destroyed), 1433, plan

Pope Nicholas's 'ingegnere del palazzo' played an important part in his great building projects inside and outside Rome. It was at this time that Rossellino met Leone Battista Alberti. The humanist with his passion for architecture and the alert and gifted mason-sculptor collaborated closely and fruitfully in work commissioned by their common patron, in which theory and practice were united.[21] In 1457 Bernardo was back in Florence. He prepared a report on the crypt steps of S. Miniato, and there is reliable evidence that he also superintended the work on Alberti's Palazzo Rucellai, especially as Giovanni di Bertino, who, according to other documents,[22] was associated with Rossellino's workshop, was the capomaestro on the building. Thus the delicacy of the formal treatment is due to the excellent craftsmen available in Florence, who in their turn must have followed Alberti's and Rossellino's instructions with the greatest care.

Rossellino's quality can be best appreciated in his work at Pienza (1460–2), which was his crowning achievement.[23] Pius II – Aeneas Silvio Piccolomini – commissioned him to carry out his project of transforming his native village of Corsignano into an episcopal seat. A lively description of the project and its execution is preserved in Pius II's *Commentaries*. The nucleus of the plan, the principal piazza with the surrounding buildings – episcopal palace, family palace, and communal palace (Plate 35 and Figure 16) – was built in an astonishingly short time, considering the enormous technical difficulties that had to be overcome. Pienza was the first ideal city of the Renaissance to take on visible form. Pius II laid down very far-reaching wishes for the design of the buildings; the cathedral was to be built on the model of the South German hall churches, which he had seen and admired on his diplomatic missions for the Curia. The family palace had to be orientated in such a way that the garden front would open on to a certain view into the Orcia Valley and Monte Amiata, which the Pope loved and vividly

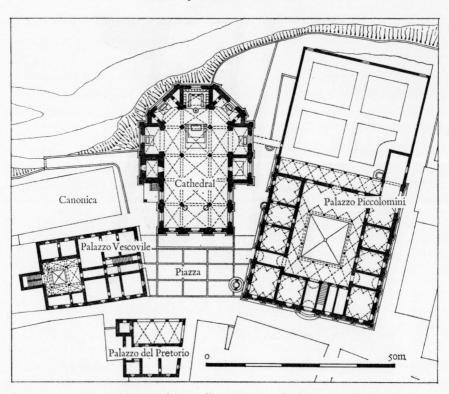

Figure 16. Bernardo Rossellino: Pienza, rebuilt 1460–2, plan

described in his *Commentarii*. The layout of the piazza is aimed at a conscious effect of optical perspective; the slanting walls of the palazzi flanking the cathedral enhance the general monumentality, which is calculated with great precision from a fixed standpoint and from that standpoint can be taken in whole, like a stage with wings. In detail, the four buildings show some carelessness in treatment – Rossellino had only local craftsmen to draw on, and was, moreover, under pressure from the Pope, who wished to see his plan take shape in the shortest possible time. Yet each is representative of an individual and important type. The cathedral, being a hall church, stands quite outside the Italian tradition, and it was a masterpiece of Rossellino's to fulfil his patron's curious desire with the technical means at his disposal (Plate 36). He found a masterly solution in a variant of the hall-type transept of Siena Cathedral. The façade too can be accepted as a happy compromise, since no better classicizing organization of the façade of a hall church could be imagined with the means available at the time.

The Palazzo Piccolomini is a somewhat coarsened, yet on the whole significant variant of the Palazzo Rucellai at Florence; it is an organic fusion of the type of town palazzo (piazza front) and garden palazzo (loggias on the garden front). The rustication of the lowest pilasters must also be noted as Rossellino's invention. In contrast to the Tuscan style of the Palazzo Piccolomini, the Palazzo Vescovile is characteristically Roman (Vatican wing of Nicholas V, Palazzo Capranica), while the Palazzo Comunale with its loggia and tower returns to the tradition of Tuscan public buildings.

Thus the *varietà* of the four buildings is a result of sound planning. Patron and architect took an equal share in the conception of this ideal city, but its richly imaginative execution must be credited to Rossellino alone. The Pope's death put a premature end to the execution of the scheme; if the other palaces which he had categorically ordered his prelates at Pienza to build had been executed, we should have had a genuine pattern-book of architectural forms of the period, as it can be visualized from the parts now standing (Palazzo Lolli, Palazzo Ammanati-Newton, Palazzo Gonzaga).[24]

In 1461, when he was still engaged on his work at Pienza, Rossellino received the high office of architect-in-chief to the Duomo of Florence. In that capacity he completed the lantern of the dome, and once more proved himself a master of architectural ornament. Though the general shape of the lantern had been laid down by Brunelleschi's model, the crowning cornice and the top, which were executed in Rossellino's term of office, show how carefully he had calculated the visual effect from a great distance by eliminating all small members.[25]

Bernardo Rossellino, who, with his family, conducted a large workshop for architecture and sculpture, was chiefly assisted by his brother Antonio. Bernardo is the most outstanding representative of that type of extremely gifted master who, thanks to an inborn artistic sense and intelligent receptivity, was able to master the most varied kinds of task. However varied his manner may be, it can be recognized quite easily because the craftsmanship bears the mark of his hand throughout. Yet it would be wrong to describe Pienza as a product of Rossellino's style; in this case style appears as the sum of a number of formative impulses: patron, adviser, and architect shared equally in the enterprise. Heterogeneous cases such as the Badia Fiesolana, the Palazzo Pitti, and the ideal city of Pienza again bear striking witness to how variedly the concept of style must be defined in the whole field of Quattrocento architecture.

As there is about all the great architectural conceptions of this period an experimental air which is the natural explanation of their *varietà*, so there also developed in architectural ornament a wonderfully varied decorative style which finds expression in countless examples all over Italy – chapels, sarcophagi, altars, pulpits, tabernacles – every one a masterpiece.[26] To single out one example for detailed description, we may take the chapel of the Cardinal of Portugal in S. Miniato, executed in 1461-6 under the superintendence of Antonio Rossellino (Plate 37). It has always been regarded as the supreme example of that intimate blend of architecture, sculpture, and ornament which gives birth to a true *Gesamtkunstwerk*.[27]

The three walls of the chapel, which is entirely open on the entrance side, are deepened by narrow niches with flat back walls. These niches contain the altar on the main front, the sepulchre on the left, and the bishop's throne facing it. The whole is a new iconographic variant of the funerary chapel, sumptuously enriched with costly material. Various kinds of stone – marble, serpentine, porphyry – the inlay of the floor, the wall and furnishing, and finally the bright colouring of the glazed terracotta in the dome impart to the whole a striking intensity of colour which contrasts most effectively with the light monochrome of the structural members of the building – pilasters, wall frames, niche soffits, and the sepulchre itself. Antonio Rossellino, Luca della Robbia,

Baldovinetti, and other masters took part in the work. Executed with supreme artistry and craftsmanship, the chapel of the Cardinal of Portugal presents in perfection the type of the Tuscan sepulchre of the Quattrocento, one of the most characteristic creations of sculptural architecture of the period, which soon spread all over Italy. Of all the countless works of this kind, special mention must be made of the tomb of Maria of Aragon in the church of Monte Oliveto, Naples, also by Antonio Rossellino, and of works by Desiderio di Settignano (Marsuppini tomb, S. Croce, Florence) and Mino da Fiesole (Salutati tomb, Duomo, Fiesole, Bernardo Giugni tomb, Badia, Florence).

The third master whose art excels in *varietà* is Agostino di Duccio (1418–81). Of Florentine origin, and above all a sculptor of great individuality, Agostino gained experience in architecture as well when he worked with Alberti at Rimini. His façade of the small church of S. Bernardino at Perugia (Plate 38), built between 1457 and 1461, is one of the most charming examples of decorative architecture of the Quattrocento. Tuscan motifs – such as arcades, tabernacles, profiles – are combined with Roman ones, as for example in the double door or the 'clipei'; in the details we feel the influence of Donatello's ornamental fantasy. The delicate polychromy of the wall – old rose and azure – carries on the local Umbrian-Perugian tradition.[28]

Finally, one more master, Giuliano da Maiano (1432–90),[29] deserves notice in the period between 1450 and 1480, although he was considerably younger than the others. His early works, the completion of the Palazzo Strozzino in Florence (after 1462), the Chapel of S. Fina in the Collegiata of S. Gimignano (1466), and a number of decorative works, are in the tradition of Brunelleschi and Michelozzo, but give promise of a quite personal feeling for design which, though as yet latent, points to a heightening of monumentality in form, e.g. the monumental treatment of the rustication in the Palazzo Strozzino or the Albertian pilasters of the Chapel of S. Fina. This tendency comes out more clearly in his design for the Benedictine abbey church of SS. Fiora e Lucilla at Arezzo (1470) and in the Palazzo Spannochi at Siena (begun 1473).[30] It is still more marked in Giuliano's chief work, the cathedral of Faenza (foundation stone laid in 1474, executed by local masters) (Plate 39 and Figure 17).[31] The alternating supports in this very large basilica, the employment of the plainest of ornamental forms, the shallow domes of the bays of the nave (Venetian influence?) give the interior a note of austere dignity which makes it a very characteristic counterpart to the Badia Fiesolana. The studied sobriety of the composition and proportions in both churches, which becomes almost oppressive in the spacious interior of Faenza Cathedral, are typical of this transitional style; it is as if the formal apparatus was still not quite up to the monumental intention. The same impression is given by the great pilgrimage church of Loreto (Plates 40 and 41), in so far as the interior still gives any idea of the original plan. The nave was vaulted under Giuliano's supervision (after 1481), the drum of the dome was erected, and the east front fortified.[32]

Alberti's S. Andrea – as yet (1480) only an idea – remained the one truly monumental spatial composition of the period. It was the next generation which elaborated that monumental form which we usually call the classic style. The pioneers were Francesco di Giorgio Martini and Giuliano da Sangallo, and it came to full expression

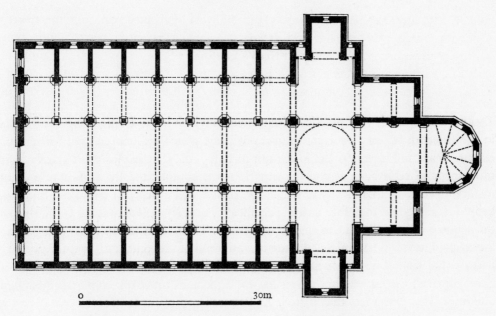

Figure 17. Giuliano da Maiano: Faenza Cathedral, begun 1474, plan

in Bramante. Outside Tuscany, however, two important centres became influential between 1450 and 1480 for their architectural endeavours on the grand scale: Rome and Urbino. However different the conditions may have been which produced these prefigurations of the monumental style, in the end they united in a synthesis which prepared the way for the classic style of the early Cinquecento. We shall now turn to these two centres.

CHAPTER 6

ROME

THERE were special, very practical circumstances which led to Rome being confronted in the fifteenth century by architectural problems which are unique in character and extent. While in Florence – and in the rest of Italy – the Renaissance was a purely ideal movement of rebirth, in Rome the situation was complicated by a most important material factor. Unlike Florence, where the rebirth had a rich and unbroken tradition behind it, and could therefore unfold organically, the city of Rome at the beginning of the century was a political and artistic wilderness. The schism and its consequences had interrupted its entire natural development; at the end of the fourteenth century, the city had a population of not more than 17,000, which lived for the most part in the lower-lying districts; the city within the walls was a place of ruins, and even the inhabited buildings were extremely dilapidated. As Petrarch complained: 'jacent domus, labant moenia, templa ruunt, sacra pereunt'.[1]

Thus with the return of the papacy to Rome, the restoration of the city became an imperative necessity, which united supreme ideal aims with the most elementary material needs.

It is, however, a remarkable and important fact that the execution of this great enterprise fell mainly to non-Romans. Both the patrons – the popes and the higher orders of the clergy – and the architects nearly all came from other cities: Eugenius IV (Condulmero) from Venice, Nicholas V (Parentucelli) from Sarzana, Pius II (Piccolomini) from Siena, Paul II (Barbo) from Venice, Sixtus IV (Della Rovere) from Savona, Innocent VIII (Cibo) from Genoa. The patrons' natural wish to summon or bring their working architects from outside was furthered by the lack of native craftsmen and artists. Almost without exception, the architects were natives of Tuscany or Upper Italy: Beltramo da Varese, Bernardo Rossellino, Francione, Antonio di Francesco da Firenze, Baccio Pontelli, Meo da Caprino, Jacopo da Pietrasanta, Giovanni de' Dolci, etc.[2]

But it was not only the patrons and architects who were working on foreign soil; most of their advisers were too. The restoration of Rome became of necessity a challenge which could not fail to fascinate and attract every man of learning, every technician, and every architect. The great humanists of the age such as Cyriacus of Ancona, Flavio Biondo, Gianozzo Manetti, and others were inspired by the task, and their share in the restoration was just as great as that of the patrons and architects. This was the climate of scholarship which gave birth to the type of the *Umanista-artista-letterato*, embodied in ideal form in Leone Battista Alberti, Fra Giocondo, and others. These learned counsellors were a third formative factor, and it is this specific form of collaboration which goes far to explain the fact that so-called 'masters' can so seldom be identified in the great buildings of Rome.

The humanists themselves were for the most part non-Romans. For all concerned,

therefore – humanists, patrons, and executants – Rome herself was the first tutor. It was only from the familiarity with its structure, its grandeur as a whole and in detail, that necessities could be discerned and standards gained which could serve as the foundation of new building projects. This study of the most ancient monuments of Rome, however, led to a specific experience that could only be obtained in Rome – the encounter with monumentality. In this city, where everything is on the grand scale, monumentality is a matter of course, and the necessity of always thinking in terms of the grand scale affects design down to the smallest detail. Rome is the source of what we call 'the grand manner'; it was rediscovered there, primarily in antique form.

The purpose of these introductory remarks is first of all to show how widely the component elements which make up the concept of *rinascità* in Rome differ from those in Florence. Further, they will justify a different method of dealing with architectural developments in Rome and the questions of style they involve. Our chief concern is the evolution of the most important architectural concepts and types. The generally insoluble question of attribution must take second place. Our method will therefore be systematic, not monographic.

The City: The Capitol, the Lateran, and the Vatican

The most urgent task was the clearance and replanning of the ruined city. Unlike the usual type of Italian town, Rome has no 'centro', round which settlements can form and gather (Figure 18).[3] Everything is there, but in many, widely scattered examples. The

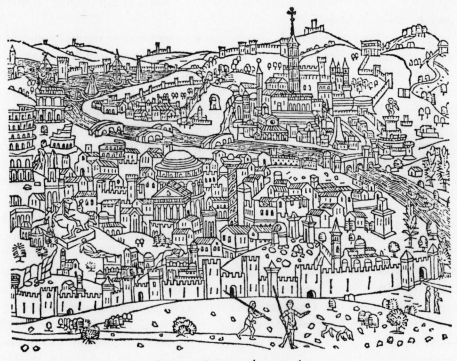

Figure 18. Rome, early engraving

great wall only bounds the city to the outside. Within its circle, there is, in the City of Seven Hills, a whole series of centres, the most important of which are the Capitol, the Lateran, and the Vatican. Then come the great religious buildings, in particular the titular 'station churches', with their piazzas, and then the markets. The restoration of roads, piazzas, bridges, and the water supply compelled patrons and architects to think and plan on the largest scale, and the problem of public and private building, from the palazzo to the common citizen's house, was also large in proportion.

The work of Martin V (1417–31), the first pope to reassume the pontificate in Rome, was limited to meeting the most desperate needs. He had the city wall restored and the Ponte Milvio and the Capitol repaired, he had churches roofed, and, above all, he put in hand the restoration of the two main churches, St Peter's and St John Lateran.[4] But his greatest achievement, which was also a proof of his far-sightedness as a city planner, was to reorganize and resuscitate the ancient office of *magistri aedificiorum et stratorum urbis* – in popular speech *magistri viarum* or *maestri di strada* – which had till then belonged to the commune. With the famous statute of 30 March 1425, he placed it under papal authority and gave the *magistri* the right, among other things, to demolish buildings which obstructed traffic. By incorporating the office in the administration of the Curia and by issuing the statute, Martin V put into his successors' hands an instrument for placing all city works under Curia control. Nicholas V made important additions to this statute and conferred still greater powers on the *magistri*. By his bull of 30 June 1480, Sixtus IV added to it the right of expropriation of land, and thus a most important rule of law was established for all time to come. The status of the *magistri viarum* was of capital importance for future developments; there are whole building complexes in Rome that can only be understood through its influence.[5]

Practically nothing of Martin V's work has survived except the pavement of the Lateran basilica. It was for this that he issued his notorious *breve* of July 1425, which empowered builders to strip marble and stone from all abandoned churches.[6] Even less respect was shown to ancient monuments, which were shamelessly plundered for the erection of new buildings. Thus the restoration of the city went hand in hand with the destruction of ancient Rome, a tragic conflict which was genuinely felt by the architects, and lamented in many writings of the period, but which was actually inevitable.[7] Preservation and destruction were evenly balanced; Pius II's bull of 23 April 1462, which was intended to put a stop to the destruction, was rather a dialectical challenge than an effective remedy.[8]

The work of Eugenius IV in Rome (1431–47) was greatly hampered by his ten years' exile (1434–43). Yet there gathered round him, for the first time, a group of notable humanists who actively propagated the idea of the restoration of Rome. Even during his term of office as Cardinal Legate, Eugenius was in close touch with Cyriacus of Ancona, and Flavio Biondo dedicated to him his famous *De Roma instaurata*. Alberti, whom he summoned to the Curia, was his constant companion and adviser. Among the practical projects carried out by order of Eugenius, the repair of the Tiber island bridges, and quite especially his restoration of the Pantheon, must be singled out; by this first act of restoration in the Renaissance, the forecourt was cleared of its shops and botteghe, the

dome was repaired, and the piazza paved.[9] Thus Eugenius IV must be credited with having prepared the way for the work of his successor.

Nicholas V (1447–55) was the first Renaissance pope to devise large and coherent projects for the restoration of the city, and in that way to promote architecture in the grand manner, subordinating all other arts to it.[10] We learn from the contemporary biography of the pope by Gianozzo Manetti[11] the five main aims of the *restauratio Romae*: the repair of the city walls, the restoration of the forty station churches, the transformation of the Borgo into a fitting centre for the Curia, the enlargement of the Vatican Palace, and the rebuilding of St Peter's. This general project covered a large number of subsidiary works, such as the regulation of the road system and the water supply, and repair work on the bridges and the Capitoline Hill, etc. Most of it remained unfinished owing to the shortness of Nicholas's pontificate, which Pius II already regretted deeply.[12] But in the nine years of his reign, uninterrupted and intense work went on, and we can therefore say that the basic conception of the patron's commission on the grandest scale was established there, to be passed on to future popes, Nicholas's successors, especially Sixtus IV, Julius II, and Sixtus V, who were the magisterial executors of their great predecessor's will.

In his extension of the statute of the *magistri viarum*, Nicholas gave proof of his feeling for town planning by ordering special attention to be given to the three main thoroughfares of Rome, the via Peregrinorum, the via Papalis, and the via Recta, where traffic-obstructing buildings were to be removed.[13] He gained the praise and gratitude of the people of Rome by the restoration of the Fontana Trevi, which enabled them to obtain fresh spring water for the first time for centuries.[14] Nicholas had to rest content in the main with works of restoration in the heart of the city – that is, the Rioni, the district enclosed by the bend of the Tiber, though the restoration of the Palazzo dei Conservatori on the Capitol was practically equivalent to a new building.[15] In connection with the Vatican City, however – the Borgo and St Peter's – Nicholas initiated a project which was to influence centuries to come. The three arteries which divide up the Borgo between the Castello S. Angelo and the Vatican area, the building of a monumental piazza in front of St Peter's, the enlargements of the papal palace, and the rebuilding of the church remained the immutable themes of all future planning. And even the few buildings erected during Nicholas's lifetime – the corner bastions of the basement and the rectangular superstructure on top of the mausoleum of S. Angelo, the great tower of the Vatican (Plate 42), and finally the new wing of the palace (Plate 43) – were models for later generations.[16] What failed in the plan for St Peter's, and probably led to the abandonment of the work – the development of the 'grand manner' (cf. p. 49) – was superbly mastered in other buildings with the means available at the time. The type of masonry of the plinth of the Vatican tower was used a little later, with some variation, by Alberti in the Palazzo Rucellai at Florence. The palace, in its original structure, with its plain cross windows, shows the simplest realization in monumental form of Roman domestic building (see p. 64 below), and the Capitol and the Palazzo dei Conservatori established types of Roman stamp for public buildings. This formal language remained the rule for Roman architecture till the end of the century, and was its distinctive mark.

Yet the style cannot be bound up with the name of any master, and this, as has already been pointed out, was and remained characteristic of Roman Quattrocento architecture. For the Vatican buildings – the tower and palace – the superintendents whose names are mentioned are Antonio di Francesco of Florence from 1447, and from 1451 Bernardo Rossellino; the names of several masters appear in the account books for work on the Capitol: Paolo di Mariano, Jacopo da Pietrasanta, Beltramo da Varese; further, count-less *maestri* appear in the accounts, among others the famous fortification engineer and technician, Aristotele Fieravanti of Bologna.[17] From this profusion of recorded names, Gianozzo Manetti selects only that of Rossellino, whom he describes as the Pope's adviser; other contemporary writers – Palmieri, and later Vasari – attach more im-portance to Alberti's share in the work.[18] But there is no early work by these masters which gives any clue to the recognition of their style in Rome; it is their later work which bears the stamp of their Roman experience. Thus the buildings erected under Nicholas V give us the first example of the very characteristic anonymity of the Roman style. In the grand projection of certain individual ideas we may feel the presence of great minds, but as a whole these projects were the product of corporative thinking and planning, in which patron, adviser, and architect took an equal share. The stylistic idiom, on the other hand, however characteristic it may be, remains without any personal stamp and, as we shall see, continued to develop along the same anonymous lines.

Neither the Spanish Pope Calixtus III (Borgia, 1455–8), who was elevated to the pontificate in his late seventies and had no feeling for the humanistic ideal of his pre-decessors, nor Pius II (1458–64), whose architectural energy was expended on his ideal city of Pienza, did much to further Nicholas's projects for Rome during their short pontificates. Paul II (1464–71) also confined himself to one, though important enterprise, the completion of his cardinal's palace, the Palazzo Venezia, and the continuation of some buildings in the Vatican, especially the Benediction Loggia which had already been commissioned by Pius II.

It was not until Sixtus IV (1477–84) was elevated to the papal throne that a true successor to Nicholas appeared, and it was he who carried on the restoration of Rome on the grand scale.[19] He continued the widening of the three main thoroughfares radiating from the Piazza di Ponte S. Angelo, and added a fourth which followed the Tiber northwards and corresponded to the present via di Tor di Nona; it provided a communication with the Piazza and Porta del Popolo. He built the Ponte Sisto, an important communication with Trastevere, which had been lacking till then. It is even within the bounds of possibility that the via Giulia, which was not built till thirty years later under Julius II, formed part of Sixtus IV's programme, for as the last and southern-most strand of the system radiating from the Ponte S. Angelo, it forms a coherent conclusion to the reorganization of the nucleus of the city.

Sixtus also continued work on Nicholas's project for the Borgo by laying out the Borgo S. Angelo, the northernmost of the three thoroughfares between the Castello S. Angelo and the Vatican, and widening the via Santa (or Borgo Vecchio).

Urbanistic considerations also played their part in the new buildings which Sixtus

commissioned or endowed on the largest scale. Squares and market places, religious and public buildings, palaces and private houses had to conform to the principle of order, and the *magistri de strada* were responsible for its observance. This was the principle which governed and guided the restoration of the city, which went on uninterruptedly from Alexander VI, who opened up the Piazza Navona as a great market place and widened the Borgo thoroughfares, to two peaks of activity under Julius II and Sixtus V, which, in their turn, usher in the town planning of the Baroque and neo-classical periods. Few cities have been so uninterruptedly reorganized as Rome has been, almost down to our own time, in this magnificent fusion of order and monumentality; the foundations of the principles by which the city grew were laid in the fifteenth century.

Ecclesiastical Buildings

The picture of the religious buildings of Rome as we see them today is mainly determined by the work of the sixteenth, seventeenth, and eighteenth centuries. The Quattrocento left scanty traces behind it. Besides, the immediate necessity was to preserve and complete the incalculable number of older, still venerated churches. Thus entirely new churches were the exception in the Quattrocento, and there were always special reasons for building them. But the restoration of the old buildings offered a splendid opportunity for practical experience. The casing of the columns of St John Lateran with pillars (under Eugenius IV)[20] was the first occasion of coming to terms with the colossal and gave the interior a new stamp; restorations such as that of S. Stefano Rotondo by Bernardo Rossellino[21] and S. Teodoro by Antonio di Francesco da Firenze[22] compelled the restorers to study the technique of antique and Early Christian vaulting and to devise appropriate details; the double portal with its lintel in S. Stefano Rotondo can only be explained as an adaptation to a pre-existing motif of which Rossellino could have had no experience in Tuscany.[23]

Experience of this kind, gained from the architectural tradition of the city of Rome, also left its mark on the new buildings of the Quattrocento, and though only few of them have survived, they show the important developments that were incorporated in them and prepared the way for many great innovations in the sixteenth and seventeenth centuries.[24]

The earliest Quattrocento church still standing is the monastic church of S. Onofrio on the Gianicolo, which was built between 1434 and 1444. However unpretentious it may look, its importance should not be underrated, for a type of building was actually created in it which shows features that remained characteristic of Rome. It is an aisleless church of two bays with groined vaulting, and a large semicircular apse undivided from the main space (Plate 44). The dome-like vault, the broad proportions, and the great simplicity of the articulation give the interior an effect based on spatial homogeneity. It stands in very marked contrast to contemporary buildings in Tuscany, which consist of an agglomeration of many separate compartments and, above all, avoid the vault.[25] The decorative scheme of S. Onofrio, which can only be seen in its original form in the restrained articulation of the chancel arch, is of Roman origin.[26]

In my opinion, the predilection for the vault may be taken as a prime characteristic of the Roman Renaissance, and I do not think it is merely by chance that the vaulting of the Gothic church of S. Maria sopra Minerva, which had till then only had a provisional roof, was carried out in the restoration of the fifties; considering its size, it was a remarkable technical feat too (executed between 1453 and 1468).[27] Of the work on the façade carried out at that time, only the main door has remained *in situ*; the spiral ornament edging the door frame is no more Tuscan than the festoons of the cornice, which are inspired by antique motifs, and the far-projecting tympanum. The architect is unknown.

The reason for the rebuilding of St Peter's was the ruinous state of the ancient basilica. The influence of the project, even while it was in the making, cannot be exaggerated. It was the greatest enterprise in religious architecture that had been embarked on in Rome since Constantine's basilica was built.[28] Very soon, the rising walls of the chancel and transepts began to speak their own eloquent language. Anyone who knew his business could form an idea of the whole complex from them and from the available ground plans. As was pointed out above (cf. p. 29), it is perhaps possible to recognize in many other buildings of the time a reflection of what was coming into being at St Peter's: the composite piers and the vaulting of the bays in the church of S. Giacomo degli Spagnoli (with engaged columns) (Plate 45),[29] the naves of the basilica of Loreto, and the cathedral of Pienza have certain features which point to the projects for St Peter's as they were being discussed during the fifties. We owe to Günter Urban the brilliant and at present generally accepted reconstruction of Rossellino's restoration project (Figure 12). The entire Constantinian basilica was to be preserved, but supported by new strong exterior walls. Towards the last the building was to be enlarged by vast transepts and a monumental choir – an ingenious conceit in that it made the claim of a true 'ristauratio' of the most venerable monument of Christianity.[3].

A later influence of the formal apparatus which developed in Nicholas V's St Peter's may be seen, in my opinion, in the Benediction Loggia (Plate 46), even though it was not placed where he had foreseen. Pius II had the foundations dug; in 1461 six columns were brought from the Porticus of Octavia to St Peter's; there is further documentary evidence that work on the loggia was proceeding in 1463 and 1464. Other documents record that a maestro Julianus Francisci de Florentia was commissioned in 1470 to 'perficere quattuor arcus dicte Benedictionis nunc existentes . . . secundum quod superedificare quattuor arcus ad altitudinem designatum scapellinis. . . .' (to complete four arches called of the Benediction, now existing, and in keeping with it to raise a superstructure of four arches to the height designated to the stonemasons) – thus the lower row of arches must have been practically finished.[31] But that implies that this whole system of arcades, which is entirely inspired by ancient prototypes, was already built between 1461 and 1464, and in its huge size[32] and in its structure – the tall pedestals of the half-columns, the deep moulding of the cornice and the balustrades – is the first appearance of a characteristically Roman Renaissance motif which was to have a great following. The ground floor of the façade loggia of S. Marco (Plate 47), which is about contemporary with it, does not yet show these specific formal elements; the half-

columns rise without pedestals straight from the dado; the width of the pillars and the timorousness of the arcading compose a far less powerful whole than the tense volume of the Benediction Loggia.[33] The appearance of the motif of the Benediction Loggia in the arcading of the great courtyard of the Palazzo Venezia, built in 1470, is a first outcome of it.

In summer 1464, a stone-cutter, Pagni di Antonio da Settignano, came to Florence to fetch the 'modello' of the Benediction Loggia. Thus the author of the design was at that time in Florence, and was probably a Florentine. Names have been put forward: Rossellino and Alberti, who were both in the service of Pius II, and Giuliano da Maiano, to whom Vasari attributes the loggia. But he was very young and was still unknown in Rome; Rossellino was not really a master of great form, as can be seen in his façade at Pienza, which has several Roman features but no monumentality. The monumentality which characterizes the Loggia actually points to Alberti, who, for that matter, gave a variant of its great entrance arcade in the façade of S. Maria Novella with Tuscan means. Yet the attribution remains pure guesswork.[34]

Most of the Roman churches of the Quattrocento were built during the pontificate of Sixtus IV; they gave the city its new countenance. A great many buildings had to make way for new ones, or suffer great alteration, like the portico of SS. Apostoli,[35] but the most important monuments have remained to bear witness to the fertility of invention of the period.

The first in this group is the parish church of S. Maria del Popolo. If we can blot out the swaying arches of Bernini's stucco ornament, a very clear spatial design comes to light; square piers with half-columns which support the archivolts of the arcades or the vaulting of the nave (Plate 49). The piers are squat and therefore look very massive, an impression which is heightened by the far-projecting and fully elaborated imposts. The plain groin-vault rests ponderously on its supports; the space, beautiful just because of its simplicity, is distinguished by massive power and breadth. The octagonal dome over the crossing rests on a deeply moulded cornice above simple squinches. The modelling of the walls of the nave is also restrained, as are the polygonal chapels in the aisles, which are deep enough to enhance the impression of breadth given by the interior.

According to the recorded dates, the building of the church was begun in 1472 and completed in 1480. The inscription on the façade gives the date 1477, which probably refers to the façade itself.[36]

If we look at the plan, its great resemblance to S. Maria sopra Minerva (Figures 19 and 20) stands out at once; the six bays of the Gothic basilica with piers and side chapels have been reduced to four, but the domed crossing is an enrichment. The chancel, with its one main and four subsidiary chapels, is the same in principle (the lengthening of the main chapel was not carried out till 1500 by Bramante). Thus S. Maria del Popolo presents the transformation of a classic Gothic basilica with pillars into the formal idiom of the new style, when the idea of the classical had undergone a marked change; the massiveness of the individual members, the strict development of the articulation, the emphasis on breadth, express a new conception of space which approximates more to Roman antiquity. This re-Romanization is actually akin to

Brunelleschi's work in Florence; while he turns back to those examples of the Tuscan proto-Renaissance which appeared antique to him, and confronted the classic Gothic type of S. Croce or S. Maria Novella with his S. Lorenzo, the architect of S. Maria del Popolo had antiquity itself before his eyes. It is in this unmistakable assimilation of Roman antiquity that the great importance of S. Maria del Popolo resides.

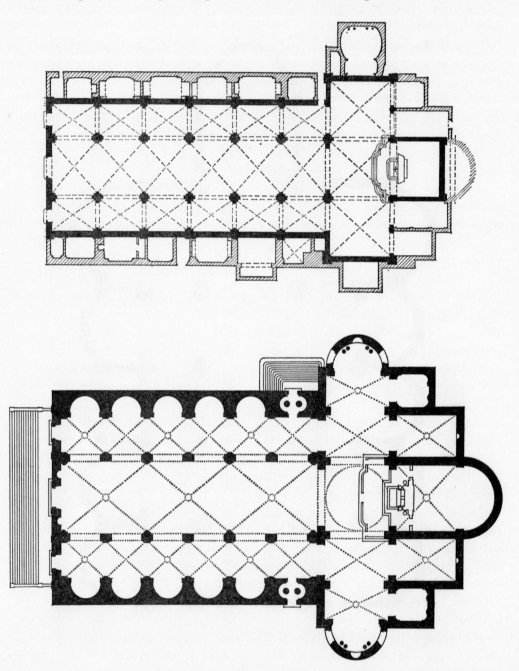

Figure 19. Rome, S. Maria sopra Minerva, under construction 1280, and S. Agostino, 1479–83, plans

The fine articulation of the façade (Plate 48) stands in curious contrast to the markedly sculptural character of the interior. To my mind, we are justified in feeling that another master was at work here. Since Brunelleschi's façades were never executed, and since Alberti's façade for S. Francesco at Rimini and Rossellino's front of Pienza Cathedral were added to aisleless or hall churches, the front of S. Maria del Popolo remains the

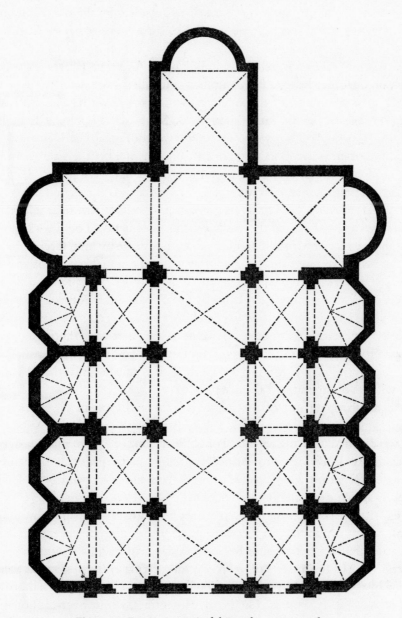

Figure 20. Rome, S. Maria del Popolo, 1472–80, plan

first basilican façade of the Quattrocento. Here the architectural spirits of Tuscany and Rome seem to have entered upon a happy union; the subtlety of its composition and the proportions of the wall surface point, in my opinion, to the Florentine tradition, while the individual formal elements come from Rome – the tall plinth with the projecting bases of the pilasters, the arrangement of the inscription panels on both sides of the main door, the composition and ornamentation of the doors.

This remarkable church cannot be ascribed to any master; the old traditional attribution to Baccio Pontelli has become untenable, since he only began work in Rome in 1481.[37]

For the second important religious building, S. Agostino (Plates 50 and 51 and Figure 19), on the other hand, a large number of detailed documents have come down to us which give some idea of the architects who worked on it. This church, which seems extraordinarily big in comparison to S. Maria del Popolo, was built in the astonishingly short time of four years. The donor was the French Cardinal d'Estouteville: the foundation stone was laid in 1479; in the summer of 1481 the aisle and nave were vaulted and in November and December the last touches were put to the façade; in 1483, as the inscription on the façade states, the church was finished. The name of the master architect – *magister architector* – is given as Jacopo da Pietrasanta, whom we have already met as capomaestro of the work on the Benediction Loggia.[38] But since the model for the loggia came from Florence and was not made by him, it remains uncertain whether the master architect of S. Agostino was also the actual creator of its design.

The plan again takes up the scheme of the Gothic basilica with piers and side chapels, but in a very different arrangement from that of S. Maria del Popolo. The nave, with its pairs of piers, is lengthened; the piers are more closely set, and a half-column is set only against every second pier and is carried up as a pilaster to the springing of the rib-vaults, each of which takes in two bays. Thus the upward drive of the spatial composition is far stronger than in S. Maria del Popolo. This verticality is further stressed by the crossing, with its exaggeratedly slender piers.

The unusual scooping out of the semicircular side chapels in the exterior walls is remarkably similar to the system of S. Spirito (the chapels, originally visible from the exterior, were walled up in the seventies) or of the tribuna of SS. Annunziata in Florence. Formal elements of Roman provenance (vaulting, piers, pedestals of columns) are blended with others from Florence (radiating chapels, dome on pendentives). The result is an interior which cannot compare with that of S. Maria del Popolo, yet has an impressive effect of its own, even though it has been greatly impaired by the tasteless restoration carried out in the nineteenth century. S. Agostino deserves special attention as the first attempt in Quattrocento Rome to design a space on a monumental scale.

The great space of the nave required powerful external buttresses, and as these had to be screened by the façade, the problem of its composition was very much more complex than that of S. Maria del Popolo. Unlike the Florentines, whose over-cautious approach to the façade resulted in no Florentine basilicas having any façades at all,[39] it must be admitted that the Romans attacked the question very boldly. It was a happy thought in the case of S. Agostino to make the transition between the lower and upper tiers of the

façade by inserting an attic zone with sides sloped like a pediment. It was probably hoped that this transition would suffice, but the buttresses remained visible and so ugly that it was necessary to add the scrolls, which are extremely slovenly in execution and disproportionately big, and were rushed through in two months after the façade was finished. Without the scrolls, the composition of the façade is far more coherent, even though it is crude and simple in comparison with the refined design of S. Maria del Popolo. The shifting of the side doors out of their axis, the extremely inept and clumsy angle-mouldings of the door surrounds, and the lack of proportion between the powerful relief of the pediment cornices and the flat pilasters show a lack of true architectural feeling. Yet neither the difficulty in mastering very large surfaces nor the boldness of the experiment must be underrated. Imitations of better quality show that there was a great deal to learn and many valuable suggestions to be drawn from the experiment (S. Giacomo degli Spagnoli, Rome; S. Francesco al Monte, Florence; S. Pietro, Modena; S. Cristina, Bolsena).[40]

The experimental touch which is peculiar to most of the new buildings of this decade can also be felt in S. Maria della Pace, which was endowed by Sixtus IV as a votive and memorial church. It was begun after 1478 and completed by 1483.[41] Since then it has undergone radical alterations which make it difficult to reconstruct its original

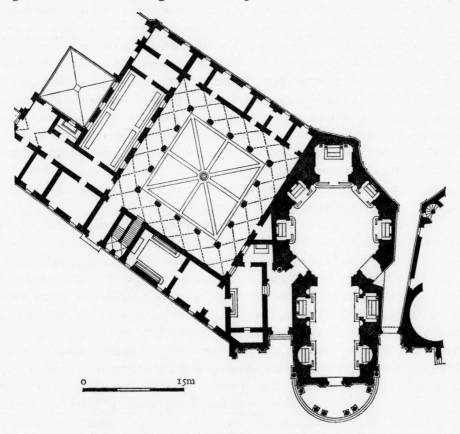

Figure 21. Rome, S. Maria della Pace, after 1478–1483, plan

appearance. In my opinion, the type of Renaissance memorial church which spread all over Italy in endless variations was first created in this church, apart from a few prototypes – SS. Annunziata in Florence; S. Francesco at Rimini; S. Maria delle Grazie at Pistoia. That is what gives this unpretentious little church its importance.

The main idea was to place in front of the actual memorial church, which was centrally planned,[42] a short aisleless hall to act as a kind of vestibule, so that anyone entering the chancel from it would obtain a profounder and more impressive spatial experience (Figure 21). S. Maria della Pace is a good solution of the problem. The hall, which consists of two square vaulted bays, leads into the adjoining, higher octagon, which is roofed with a wide dome (Plate 52). Side chapels accompany the vestibule and chancel. All the individual details are again thoroughly Roman in character; the Doric order of the alternating niches and pilasters and the two-storeyed elevation of the octagon with its dome create a whole of great charm.

It would seem as if the Cinquecento predilection for the aisleless church had already made itself felt in Rome at the end of the Quattrocento. In any case, the two most notable religious buildings with which the Quattrocento comes to an end are churches of that type: S. Pietro in Montorio and the Sistine Chapel.

S. Pietro in Montorio was built in the eighties to replace an older building (Figure 22). It was already in use in 1494, and in 1500 it was consecrated by Alexander VI.[43] The interior consists of a space with two rectangular groin-vaults and three semi-circular chapels on either side (Plate 54). The latter produce a simple and well-proportioned articulation with piers and arcades. The pilasters which receive the vaulting are more massive than those in between, and the projection of the cornice over them is in higher relief – a carefully considered motif which is emphasized by the pilaster stumps between the cornice and the springing of the vault. The nave leads into the square crossing, which is roofed, not by a normal dome, but by a heavy shallow dome, again a very subtle and unusual invention which unifies the entire space and ensures an easy transition to the chancel, which is also vaulted and has a polygonal apse. On the long sides, the crossing ends in two large, semicircular apses, so that what we have in S. Pietro is a maturer solution of S. Maria della Pace.

While there is something experimental about all the buildings discussed so far, which prevents them being quite satisfying even in what has been achieved, S. Pietro in Montorio created a perfect and deeply impressive spatial organization, although it has been much impaired by the ugly modern decoration. S. Pietro can stand comparison in every way with its sister church in Florence, S. Francesco al Monte,[44] which was built about the same time, and presents, as it were, the Roman version of this type of church, which was to become the great architectural theme of the following century.

The façade is distinguished by its subtle ornament and its harmonious proportions (Plate 53). Since the problems of a basilican plan did not arise, all that had to be done was to model a plain wall surface. The division into two storeys was given by the order of pilasters in the interior; the plainness of the pilasters must not blind us to the extraordinarily fine chiselling of the mouldings and in the slight projections of the middle cornice and the pediment.

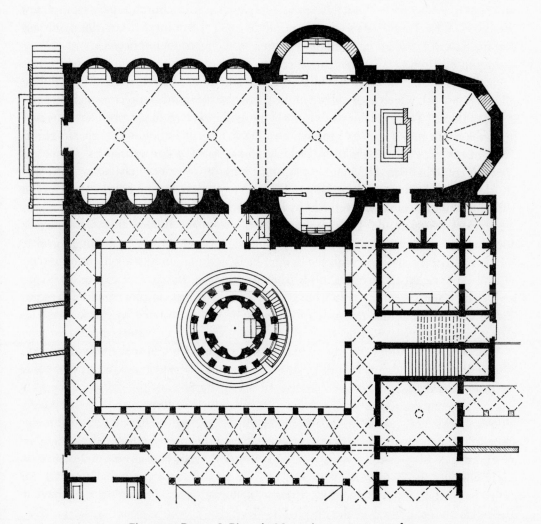

Figure 22. Rome, S. Pietro in Montorio, *c.* 1480–1500, plan

In my opinion, we may perhaps see in S. Maria della Pace, and can certainly see in S. Pietro in Montorio, the influence of a style which was neither Roman nor Florentine – it is the style of Urbino which, as will be shown later, comes out in the peculiar delicacy of the detail, and above all in a quite specific feeling for space. S. Pietro in Montorio is very characteristic of both (the capitals of the interior should be noticed). Thus we shall probably not go far wrong in accepting the attribution of the work to Baccio Pontelli. He came to Rome at the time from Urbino, where he had met Laurana and Francesco di Giorgio, and it was under their influence that he had given up tarsia-work and wood-carving for architecture.[45] In the Roman records he certainly appears as a fortification engineer, but that he was working in other fields and had made a name for himself is indirectly proved by Vasari, who ascribes practically all the buildings of the

Quattrocento to him.[46] If there is anything in Rome which recalls the artistic atmosphere of Urbino, and therefore Pontelli's probable style, then it would seem to be S. Pietro in Montorio, unless Francesco di Giorgio might be taken into consideration; his name and the question of his share in building in Rome in the eighties and nineties will occupy us later in connection with the Cancelleria.

Finally, as the last in the series of Roman Quattrocento churches, comes the Sistine Chapel (Plate 55), which evolved out of the particular liturgical and ceremonial purposes it had to fulfil.[47] This explains its simple oblong without choir or annexes. Yet however plain the room may look, its proportions give it a peculiarly powerful spatial effect. That, of course, applies only to its architecture; its famous decoration and furnishing does not come in here. The huge bastion-like exterior is just as imposing, and the impression is also due to its proportions, quite apart from the magnificent brickwork. The building, begun in 1473, was finished in 1481, when the artists were already at work on the frescoes. Giovanni de' Dolci is named as the architect, though to judge by other documentary evidence he was rather a superintendent of works than an architect proper. If he is really to be credited with the design, he would rank with the important artists, and would have left more traces of his work behind him. Baccio Pontelli, whose name is given by Vasari, was not yet in Rome. Thus the authorship remains uncertain, and the Sistine Chapel is another example of the anonymous teamwork which initiated so much great building in Rome.

As a kind of digression, we may add to the religious buildings the Ospedale di S. Spirito (Plate 56), which was built by order of Sixtus IV between 1474 and 1482.[48] It is the most remarkable public building commissioned by Sixtus. The origin of the plan (Figure 23) must be sought in the great prototypes outside Rome, above all S. Maria Nuova in Florence, which became the great model for the whole of Italy.[49] But the Ospedale Maggiore in Milan had also already been begun, and hospital building in general was coming to the fore in all the big towns.[50] From Florence the architect certainly adopted the cross-shaped ground plan of the three wards grouped round the chapel in the centre, which was thus visible to all the inmates. The original arrangement can be clearly recognized in the hospital at Florence, in spite of countless later alterations. The great achievement of Sixtus IV's architects is the splendid amplitude and artistic shaping of the great plan. The main entrance, which even today leads through the chapel with its curiously Lombardesque 'tiburio' octagon, strikes the dominant note of the building; the wards for men and women stretch to right and left;[51] a third wing, erected only under Alexander VII in the seventeenth century, was in my opinion already provided for in Sixtus's project, as the disposition of the plan as a whole – especially the situation of Sixtus IV's courtyards – gives reason to suppose. A large number of functional additions (ventilation plant, kitchen facilities, accommodation for doctors and nursing staff) cannot be considered here, but are essential factors in the execution of the building.[52] It is rare for a functional building to be designed with so strong a feeling for beauty; the other great example is the monumental Milan hospital. The long outside wall, articulated by its arcaded loggias, stretches along the via S. Spirito; its front is a masterpiece in the solution of the corner. The individual forms

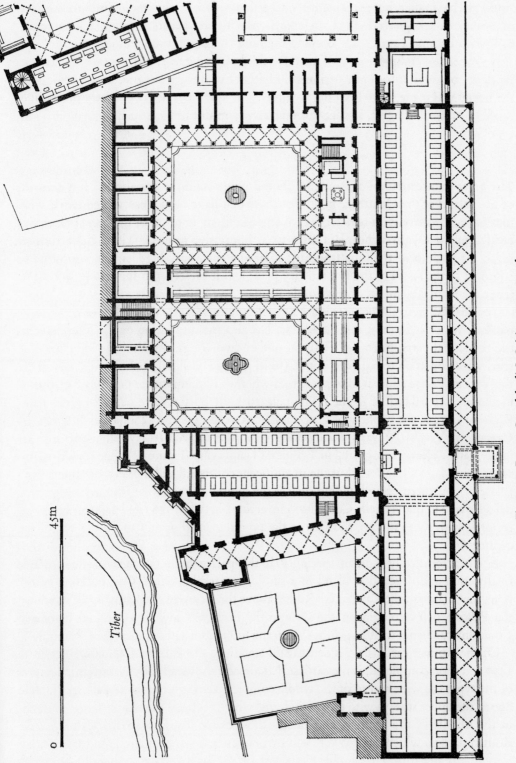

Figure 23. Rome, Ospedale di S. Spirito, 1474–82, plan

Tiber

45m

0

could not be simpler, but the unadorned technique of the brickwork has become a factor of beauty in the general effect. In common with the Milan hospital, the Ospedale S. Spirito became a model for hospital building throughout the western world.

No executant architect can be named for this building either. It is too early for Baccio Pontelli, to whom it has been attributed. Neither can Andrea Bregno, in whose bottega the portal was made, have been the architect. Though the style is extremely distinctive, it offers, as usual, no clue, so that this question too must remain open.

Palazzi

The great transformation of Rome in the following centuries has also left few remains of the palazzi of the Quattrocento.[53] But those that have been preserved convey a clear idea of the intensity with which the problem of display in terms of the great palace was tackled in the Quattrocento, and with what impressive results.[54] Three characteristics mark the palazzo of the Quattrocento: it is, as a rule, very big; its plan continues to conform to the *insula* of the Roman city plan; and it preserves in the articulation of its front the formal elements of the simple Roman dwelling-house.[55]

The adaptation to the *insula* (Figure 24) determines not only the outline of the Roman palazzo, which is in most cases irregular, but also the disposition of the interior area: the residential parts, often built only in one or two wings, usually have loggias at the rear, which open on to a garden court. (In its general outlines, Nicholas V's project for the Vatican Palace adheres to this scheme; wherever circumstances permitted it appears in the greater palazzi of Rome.) The palazzo built by the Cardinal-Vice Chancellor Rodrigo Borgia, the nephew of Calixtus III, between 1458 and 1462 (also known as the Cancelleria Vecchia)[56] was specially admired in this respect. Its layout, adapted to the *insula*, can be clearly recognized in Tempesta's engraving (Figure 25). The façade underwent many later alterations, but the magnificent courtyard still shows the original plan (Plate 57). Furthermore, a building such as the sprawling palazzo of Cardinal Domenico della Rovere in the via della Conciliazione, erected between 1485 and 1490 and recently restored with some success, shows that the type remained dominant till the end of the century.[57]

A characteristically Roman speciality is the palace built on ancient ruins, where fortification and decoration blend in a single, remarkable effect. One building of the type, the palazzo of the Cavalieri di Rodi[58] above the forum of Augustus, is still standing; the Palazzo dell'Orologio on the Campo de' Fiori was built by Cardinal Francesco Condulmer, a nephew of Eugenius IV, on the foundations of the theatre of Pompey.[59]

Of the Roman cardinals' residences still standing, the Palazzo Capranica, begun in 1450 and soon completed, is the earliest.[60] It already shows all the characteristic features of the type: the wide spread of the whole complex, the high basement with large, plain floors, the upper storeys with cross windows, which replaced the old bipartite windows in the middle of the century, and finally the massive tower, a special feature of the Roman palazzo which has not yet been mentioned and which often, as in this case, has a loggia at the top. The simple treatment of the wall surface in mainly brownish

Figure 24. Layout of an insula

Figure 25. Rome, Cancelleria Vecchia, 1458–62, engraving

rendering, the window and door surrounds in light travertine, can be found all over Rome. Actually this is the ancient Roman type of house, familiar for years past, but developed into monumental proportions. It can be seen in countless variations from the small bottega to the rich merchant's house. Two examples may be mentioned here – the Casa Mattei in Piscinula and the Casa Bonadies.[61] The type finds its most monumental expression in the palazzo of Cardinal Pietro Barbo, the Palazzo Venezia (Plate 58 and Figure 26).[62]

The building of this huge complex took over fifteen years. It was begun in 1455 at the south-east corner of the block (in the Piazza Venezia) and was only extended to its present size after Pietro Barbo's elevation to the pontificate (1460); it was practically complete in 1471. The first plan took the requirements of a cardinal's residence into account, among them the large garden court, the so-called Palazzetto (Plate 59). It was not until the second stage of building that the great state apartments were added; they are among the finest spatial designs of the century, as is the large but unfinished cortile (Plate 60), in which the arcading was given genuinely antique shape and proportions. It is best to leave aside all questions of detail in order to comprehend the unity of the building as a whole. Monumentality is achieved with the most economical means;

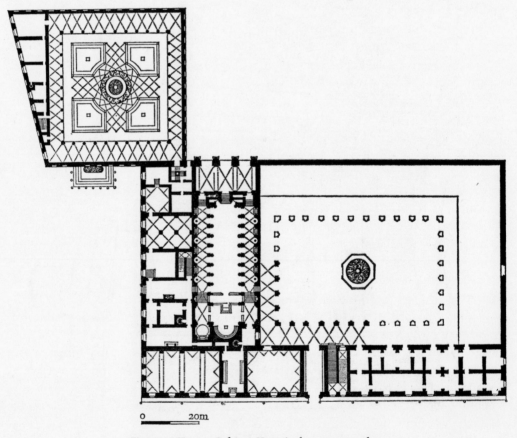

0 20m

Figure 26. Rome, Palazzo Venezia, begun 1455, plan

the palazzo and the church it surrounds form one organic whole. The huge front, with square openings in the plinth, round-topped windows on the ground floor, cross windows in the piano nobile, and small square windows in the top storey, is relieved by fine variations of form and by the rhythm of the bays, which does not at all detract from their firm compactness. While in the Palazzetto del Giardino the ornamental motifs are comparatively rich, and the loggia arcade is wide open, the architecture of the great courtyard is classic in its austerity and sense of volume. The arcades are so closely akin to those of the Benediction Loggia that we may believe the design to come from the same author; he must have been influenced by the spirit of Alberti which, to my mind, can also be felt in the invention of the majestic coffered tunnel-vault of the great entrance (Plate 61), which is imposing just because of its simplicity.[63]

In the Palazzo Venezia Quattrocento architecture attained to perfection the 'grand manner' adequate to it – by monumentality achieved through harmony in the proportions and economy in the means. No detail is allowed to impair the scale; the impression of monumentality comes solely from the power of volume, as can be seen in the great entrance and the arcades in the great courtyard.

No architect can be named for the building. A whole list of those who collaborated appears in the account books, among them names which are known to us from other buildings, for instance: Jacopo da Pietrasanta, Meo da Caprino, Giuliano di Francesco da Firenze (Giuliano da Sangallo?). On the other hand, the name of Francesco del Borgo, the *scriptor apostolicus*, appears in 1466 as the *architectus ingeniosissimus* of the Palazzo Venezia. As the Pope's representative, Francesco del Borgo was the responsible superintendent of the works and all contracts. He may also have passed on the Pope's own ideas and wishes for the building. But he cannot be accepted as the originator of the scheme as a whole. Even the attribution to Giuliano da Maiano, which goes back to Vasari, is untenable.[64] Any attempt to discover a single master for the Palazzo Venezia should be abandoned.[65] It is a characteristic example of that cooperation between patron, consultant, and working architects which is so frequent in Rome and is indirectly proved by the many names appearing in the sources and the account books. In view of this co-operation, it is probable that Alberti was called in too. Motifs such as the coffered barrel-vault of the great entrance and the arcades of the courtyard seem, to my mind, to reflect his spirit. But it would be a mistake to attribute to him any controlling authority. Although there is no master architect for the Palazzo Venezia, however, the style is extremely distinctive and represents a climax in the development of the Roman palazzo, down to the treatment of the details.

We meet the same distinctiveness of style, although under totally different conditions, in the second chief monument of the Quattrocento which follows immediately on the Palazzo Venezia, namely the Cancelleria (Plate 62 and Figure 27).[66] A first glance at the building is enough to show that here, within a surprisingly short time, a complete revolution of style has taken place. There are barely fifteen years between the completion of the Palazzo Venezia and the beginning of the Cancelleria, and the terms of reference were exactly the same. Like the Palazzo Venezia, the Cancelleria was to be a cardinal's residence enclosing a titular church. But in the execution of the plan, young

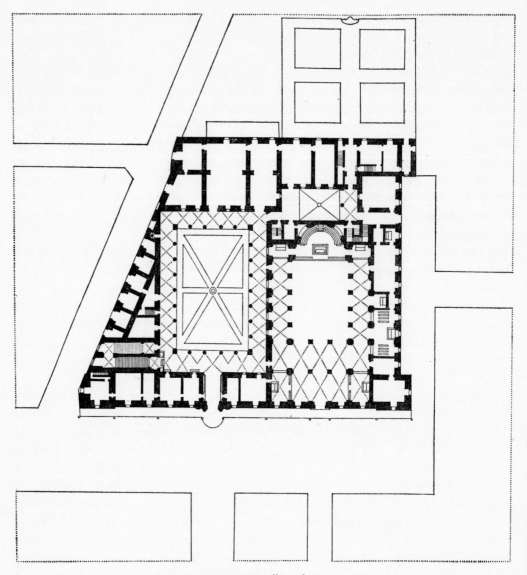

Figure 27. Rome, Cancelleria, begun *c.* 1485

Cardinal Raffaello Riario broke with all tradition. Appointed titular bishop of S. Lorenzo in Damaso in 1483, he had both the palace built by his predecessor in the middle of the century and the old basilica entirely demolished in order to make way for a completely new building. Work was already going on in 1485. A considerable part must have been standing in 1489. In 1492 the shops on the ground floor in the via Pellegrini were let, though work was still going on in the upper storeys. In 1495, the façade was finished, since the inscription which runs along it bears that date. In the same year the Chapter entered into possession of the new church. In the second stage of building, between 1503 and 1511, some extensions were put in hand; a few windows

68

bear the inscription EPS HOSTIENS (Bishop of Ostia), a dignity conferred on Riario in 1511.

The mere fact that Riario had the old church pulled down is typical of his revolutionary methods. The whole building is marked by this striving for novelty, for something not sanctioned by tradition. What is new is the plan and the general contour, which is dictated by purely aesthetic considerations. The large wall surfaces are framed by slightly projecting corner bays, which produces a unique solution in the via Pellegrini and creates a new order of the façade on the present Corso. A further innovation is the aesthetic incorporation of shops and botteghe along the ground floor of the Pellegrino block. In this motif, derived from the *insula* of the ancient city, a functional form became an artistic motif for the first time, as far as I know. It also contributed a valuable economic factor, and as such was much admired and imitated later. Finally, the composition of the façade is a further innovation, with its abandonment of rendering and the employment of flat rustication with pilasters in rhythmic sequence. Up to then, this classicistic arrangement had only been used by Alberti in the Palazzo Rucellai, by Bernardo Rossellino at Pienza, and, with some variation, by the architect of the Palazzo Ducale at Urbino.[67] All the individual motifs in the composition of the façade are new too. The shape of the windows comes from an antique form, rare in its own time and never employed later, which is preserved in the Porta Borsari at Verona, but was probably also to be found in Rome.[68] The inscription running along the whole frieze is of Albertian and Urbinesque provenance and had not been seen in Rome before.

The same holds good of the courtyard which, with that of Urbino, is probably the most beautiful of any built in the Early Renaissance (Plate 63). Unlike the cortili of the Tuscan palazzo, where the strong projection of the cornice actually emphasizes the space as an enclosure, the courtyard of the Cancelleria is a wide open space, which, like that of Urbino, prevents any shut-in feeling. Among Roman predecessors, the cortile of the Palazzetto of S. Marco resembles it most, but the latter is a garden court, while it is precisely the closed top storey of the Cancelleria court which stamps it as part of the palazzo. Here too most of the motifs are new; the rosettes, of course, can be seen in the Cancelleria Vecchia, but there is in the capitals, the corner pillars with ringed shafts, and all the other details a refinement of craftsmanship which is perhaps only equalled in S. Pietro in Montorio.

Owing to the entire formal novelty of the Cancelleria, it was long regarded as one of Bramante's first works. Raphael's name was also connected with it. Later research has proved that when Bramante and Raphael reached Rome, all the main parts of the building were already standing. Thus the architect of the Cancelleria must be sought for in the generation which was active in Rome between 1485 and 1495. To speak of a late influence from Alberti is to generalize too far. After all, the building was not planned until fifteen years after his death. The account books yield no names. The objection to the conjecture of Italian scholars who name Bregno and Antonio da Sangallo[69] lies, to my mind, in the connection with the distinctive style of Urbino, which may even extend to the use of the end projections in the hospital at Urbino. Present research, which is still in progress, seems to confirm that Francesco di Giorgio Martini was in

Rome between 1486 and 1491, but Baccio Pontelli was also trained at Urbino. The appearance of Urbinesque forms in two Roman buildings, S. Pietro in Montorio and the Cancelleria, at approximately the same time can hardly be pure chance. Can they be the product of the encounter between the classical spirit of Urbino and similar trends in Rome?

With that we enter on the period which, in the three leading artistic centres of Italy – Florence, Rome, and Urbino – saw the maturing of that sense of the classic which, after the turn of the century, led to the great metamorphosis of style which was to find its ultimate expression in the work of Bramante and Raphael. Its pioneers were, each in his own way, Francesco di Giorgio Martini, the two elder Sangallo, and Cronaca. In my opinion the Cancelleria represents the transition to the classic style of the early Cinquecento, which, in the Roman region, can only be satisfactorily explained by the combined influence of Roman, Florentine, and Urbinesque formal idioms. The following chapter, which deals with architecture at the court of Urbino, may support that argument. In any case, the Roman palazzo of the Quattrocento found its grandiose apogee in the Cancelleria.

The style of the Cancelleria greatly influenced the buildings which immediately followed it. It was repeated, with simpler means, in the Palazzetto Turci.[70] And yet other motifs entered Rome; the most peculiar is the facet-cut masonry in the Palazzo Santacroce[71] (c. 1500), which suggests southern rather than northern origins.

URBINO

APART from Pienza, the ideal city of Pius II, no architectural monument of the Quattrocento reflects the spirit of its patron more clearly than the Palazzo Ducale at Urbino (Plate 64). Federico da Montefeltro spent more than thirty years on building his residence, which, both in plan and in its decoration and furnishing, was executed entirely to his instructions. It was to become the most important, and still more the most richly imaginative, creation of its kind.[1]

The remarkable respect which Federico enjoyed even among his contemporaries was certainly paid in the first place to his success in the field and his statesmanship, but it culminated in the admiration of his mind, his knowledge, and his culture. A true humaneness stamped his character and his actions. The beautiful and lifelike picture of Federico drawn by Vespasiano da Bisticci has withstood all historical criticism. The tributes to this extraordinary personality, who incorporates in our eyes the ideal of the *principe umanista*, extend from Benedetto Baldi to Dennistoun, and all the evidence that has recently come to light – especially Federico's letters – confirms their judgement.[2]

The Palazzo Ducale is the visible expression of a sense of glory ennobled by high intellect, and in it Federico raised a fitting monument to himself. The building accompanied his whole life, grew, as it were, with him, and passed through such transformations on its way that it is just in them that we can recognize the controlling initiative of its patron.

When Federico became lord of Urbino in 1444 at the age of twenty-two, he first took up his residence in the old palace of the Signori (Palazzo del Conte Antonio) on the southern slope of the town. The moment at which he conceived the idea of building a new palace for himself cannot be exactly dated, yet it is probably connected with the consolidation of his authority, and with his success as a condottiere, which led to a growing demand for his services. It was partly that success which enabled him to plan on the grand scale.[3] In my opinion that may have been about 1450. What Federico first had in mind was a spreading palazzo in the 'new style', which would incorporate older parts of the building still standing, in a similar way to what he had seen at Mantua as a young man. Two buildings on the southern hill between the Palazzo del Conte Antonio and the old Castellare were the starting-points of the new project. Between 1450 and 1465 there arose the first, already very large palace which, as a rectangular block with an interior courtyard, was fully in keeping with the type of contemporary palace for princely display. The core of this first building is the Appartamento della Iole,[4] a range of rooms which shows all the characteristics and forms of its day. The working architects were, in the first place, Maso di Bartolomeo and his assistants Pasquino da Montepulciano and Michele di Giovanni da Fiesole (il Greco), who had, between 1449 and 1451, built the portal of the church of S. Domenico, which faces the palace. The

decoration of these rooms shows that they were originally intended to be state apartments. The reception hall (Sala della Iole) passes straight into Federico's hall of audience (Sala dei Guerrieri),[5] which is followed by two smaller rooms. The south wing joins the eastern wing of the Appartamento della Iole at right angles, the west wing joining it in its turn to form three sides of a quadrangle which is only open to the north.[6]

This first part of the building is remarkable for two features: first its impressive size, then the peculiar elegance of its ornament. The mainly Florentine and Lombard craftsmen who built it were under a vigilant supervision which helped to form and refine their style. It is extremely interesting to follow this development of quality; it can only be explained by the action of a *genius loci* which led to restraint in decoration and to the avoidance of any overcrowding of motifs without the surrender of imaginative variety; the countless window and door frames, the corbels and friezes, bear eloquent witness to this development. In this first period of building, and especially after 1460, it is the 'spirit of Urbino' that is speaking, and it was a stimulating idea to recognize in this process of stylistic development the collaboration of Piero della Francesca, whose ideal architecture, in his 'Flagellation of Christ', painted for Federico, looks like prototypes for the decorative apparatus of the Palazzo Ducale.[7]

The maestro responsible for the general plan in this first period of building is unknown. In 1450 Federico had very few models to go by; in Florence, the foundation stone of the Palazzo Medici was laid in 1444; at Mantua, the Gonzaga were just beginning to remodel their residence; in Rome, building had hardly begun. Thus in a general way the new style was just getting into its stride, and there was very little to be seen. The conception of the palazzo must therefore be attributed to Federico; who advised him we do not know. There was a sincere friendship between him and Alberti, whom Baldi mentions as one of his advisers. For many years Alberti visited Federico at Urbino. Yet there is good reason to believe that their friendship only began later, during the pontificate of Pius II.[8] In the last resort, therefore, we are thrown back on Maso di Bartolomeo as the first architect in charge; if we accept Marchini's attractive arguments, he was assisted for a short time, perhaps about 1465, by Giorgio da Sebenico, whose hand can be recognized in a number of delicately worked capitals (later used instead at Urbania).[9]

Be that as it may, in spite of the imposing size of the first building, and of the great care that was lavished on it, it remains entirely bound to the formal idiom of its time. That will become clear to any visitor to Urbino who can realize the radical change of plan which determined the second building stage of the Palazzo Ducale, for the splendour of its architectural conception offers a striking contrast to the previous parts of the building.

Very little had been done up to that time to take full advantage of the unique site. True, the palazzo, like its medieval predecessors, stood on the slope of the southern hill, and as a compact block (comparatively small windows distributed over large wall-surfaces) dominated the scene. But its disposition ignores the natural setting and has no kind of direct relationship to it. The first great idea in the change of plan consisted in the studied setting of the new parts of the building against their natural background, which

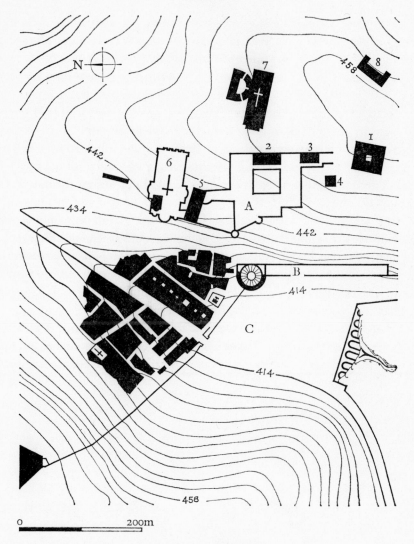

Figure 28. Urbino, plan

1	Palazzo del Conte	A	Palazzo Ducale
2–4	Medieval buildings	B	La Data
5	Old Castellare	C	Il Mercantale
6	Cathedral		
7	S. Domenico		
8	Ospedale S. Chiara		

became the leitmotif governing all technical problems. It gives the whole organism a new meaning and a new value. The plan shows the greatness and importance of this conception of the extension (Figures 28 and 29). The new wing was added to the still open north side of the quadrangle. The first part to be monumentally conceived was the vast throne-room, but at the same time the extension to the west slope of the hill created that group of rooms, the Appartamento del Duca, which was the most beautiful and

imaginative spatial composition of the Quattrocento. Finally, with the erection of another transverse wing (Sala della Veglie), the last medieval building still standing, the Castellare mentioned above, was incorporated in the general layout; the wall running from the Castellare to the northern tower left room for a charming garden terrace (*giardino pensile*), and thus a delightful conclusion to the whole was achieved.

These alterations gave the palazzo two important fronts: to the west, the grand loggia façade, flanked by turrets and looking out over the open country, is set in perspective in such a way that anyone approaching it along the western road sees it as a single picture (Plate 65);[10] to the east there is the town front which forms, with its transverse wing, a most decorative side of a piazza which was to be closed on the third side by the huge mass of the church.

With this extension, the whole building became that grandiose complex which has been so vividly described by Baldassare Castiglione: 'nel l'aspero sito d'Urbino edificò un palazzo, secondo la opinione di molti il più bello che in tutta l'Italia si ritrovi; e d'ogni cosa si ben lo fornì, che non un palazzo, ma una città in forma di palazzo pareva'[11] (In the rugged place of Urbino he built a palace which is, in the opinion of many, the most beautiful that can be found in all Italy; and he furnished it so well with every fitting thing that it appeared to be, not a palace, but a city in palace form). All the evidence points to Federico da Montefeltro himself as the originator of the alteration in the total conception of the residence.[12] In my opinion it may have been the Pienza plan which

Figure 29. Luciano Laurana: Urbino, Palazzo Ducale, designed 1464, plan of first floor

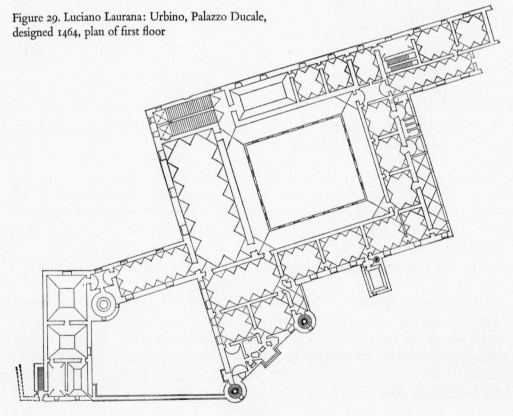

suggested the idea to him. As we know, Pius had adapted the layout of the piazza to the view into the country; huge sums were spent to create the foundations for the choir and the palace garden – for the sole purpose of opening a view on to the Orcia valley and Monte Amiata. Work began in 1458 and was finished in 1464. Reading the description of the family palazzo of Pienza which Pius II gives in his *Commentari*,[13] we find, beyond a general resemblance between the projects, many a detail which is akin to Urbino: the layout of the spacious staircase (an entirely new feature which is not yet mentioned by Alberti in his treatise), and the arrangement of the rooms on the first floor, with a great hall, chapel, and study leading into the loggia from which the view opens. All this is repeated, with certain modifications, in the new wing of the palazzo of Urbino (Figure 29). The massive substructure that was necessary for the turreted front and garden terrace, if only for the aesthetic effect, entailed far greater difficulties than those at Pienza.

The turret front as such, on the other hand, with its loggia repeated on several floors, is a motif which may have been suggested to Federico, as is often believed, by the triumphal arch of the Castel Nuovo in Naples;[14] the metamorphosis into a loggia, however, is a unique and inspired variant. The second terrace garden on the west front, the Cortile del Gallo, is there for purely aesthetic purposes; the incorporation of the square, tower-shaped projection enlivens the long façade and tempers its original, probably somewhat monotonous hugeness. The space gained here was used as a terrace garden.[15]

The centre, both real and ideal, of the old and of the new building is the courtyard (Plate 66). The visitor, attuned to grandeur by the two exterior views of the building – the turreted loggia front from the country and the piazza front from the town – enters the palace by way of a spacious, but austere, barrel-vaulted archway, and feels the great courtyard as a kind of solemn prelude to what awaits him in the interior. Unlike the high and comparatively enclosed courtyards in Florentine palazzi, the courtyard of Urbino is a wide open space surrounded by arcades. While in the Tuscan courtyard the columns are uniform throughout, including even the corners, Urbino has strongly stressed pillars at the corners. Thus there is a feeling that this space, which is closed on all sides, is formed by the meeting of four quite independent and fully developed façades. Before the attic storey was added in the sixteenth century, the courtyard seemed still more open, spacious, and airy. The choice simplicity of its articulation gives it a monumental dignity. By the use of the most subtle devices of perspective – the pattern of the pavement, the slight shift of the windows behind the arcades on the south side facing the entrance,[16] creating the optical illusion of centrality – the first general glance round the courtyard on entering is guided so that it presents a total view as self-contained as a picture.

By way of the spacious and lavishly ornamented stairs (Plate 67) – as far as I know one of the first examples of monumental staircases[17] – the visitor enters the interior of the palazzo and ascends to the piano nobile, where the treatment of the new parts of the building bears the same personal stamp as the exterior. Disregarding for the moment the majestic Sala del Trono (Plate 68), that personal stamp is to be seen above all in the Appartamento del Duca, which, in its combination of state and private rooms (Sala

d'Udienza, Anticamera, Stanza da Letto, Studiolo, Cappella del Perdono (Plate 69), and Tempietto delle Muse), offers so unusual and brilliant an *ambiance* as (especially since as an invention it contains a whole humanistic programme) can only have been conceived by the Duke himself. From the Studiolo, Federico could enter the loggia direct, and, like Pius at Pienza, take in the whole view before him.[18]

This bold project required, for its realization, an equally bold architect. Federico found one in Luciano Laurana (1420/5–1479), a Dalmatian trained in Venice whom he had met at Pesaro in the service of the Sforza.[19] A document which came to light only recently shows that Laurana had prepared a model of the palace as early as 1465;[20] though often absent, he was in charge of building operations till 1472. The document of 1468, in which Federico confers plenipotentiary powers on Laurana as architect-in-charge, is one of the most instructive of the period;[21] it bears witness, above all, to the great specialized knowledge of a patron who, since there was no great master available at Florence at the time, recognized the foreigner's quality and took him into his service. What makes Laurana a great architect is not only his remarkable mastery of the technique of masonry,[22] but also his extraordinarily fine feeling for masses and proportions. This can be seen in the interesting arrangement of the different parts of the building, in the composition of the two fronts, and in the artistic treatment of the interior. True, there were many masters from northern Italy and Florence who worked with and under Laurana – Francesco di Simone's Sala delle Veglie is a masterpiece of Florentine decoration, and so are the fireplace and doors by Domenico Rosselli, Ambrogio Barocci, and others.[23] But the general disposition of the rooms, their proportions, and above all their vaulting, are Laurana's own remarkable achievement. His masterly treatment of the technique of vaulting comes out best in the throne-room (Plate 68); it is the peculiar beer-barrel-shaped curve of the vault that gives the huge hall those sublime proportions which make it one of the most beautiful rooms of the Renaissance.[24]

And finally the ornament which underlines the structure – capitals and door and window surrounds – is one of the most precious things produced at the time; the formal idioms of Venice, Tuscany, and northern Italy are fused in a new language which is a synthesis of the best of the abundance then available in Italy. The spirit of Piero, which can already be sensed in the Palazzo della Iole, is still at work here; the decoration is characterized by a temperance in profusion and a most subtle craftsmanship in the chiselling; in spite of all its *varietà*, it becomes an artistic whole in which the name of any single master becomes irrelevant.[25]

This 'second style' of Urbino developed between 1464 and 1472 under Laurana's supervision.[26] As has already been pointed out, it is a synthesis in the genuine sense of the word, for its component elements bear the stamp not only of regional traditions of form and the manners of various artists, but above all of the ideas of the patron and his artistic advisers, Piero della Francesca and Laurana. If we start from the setting of the whole complex against its background of landscape and city, it will be seen that the peculiar quality of the style is based on its specific feeling for space and for the relationship between structure and ornament. The tiny rooms of the Cappella del Perdono (Plate 69) and the Tempietto delle Muse[27] are, in their ancient Roman structure (tunnel-

vault and apse), just as important inventions as the huge throne-room with its unique vault and majestic proportions. Another innovation is the monumental treatment of the stairs, where not only Pienza but Venice may have had an influence.[28] But the greatest innovation of all is the splendidly designed courtyard; in view of its size, buildings then being planned or erected in Rome at the time may have played a part (Nicholas V's project for the Vatican and perhaps the plans for the Palazzo Venezia).[29] What remained unfinished was the articulation of the town front; the projected scheme of decoration – flat rustication with stressed joints, framing pilasters, unusually large doors and windows (both of the same size!) with horizontal lintels – was one of the outstanding façade designs of the century.[30]

An architectural conception of this size and imaginative quality could not fail to captivate the next generation, which was called on to continue the work, and stimulate it to give of its best. It is another proof of the unerring artistic judgement of the patron that he sent to Siena for Francesco di Giorgio Martini as successor to Laurana. Francesco was an architect of standing, best known, like his predecessors, as a fortification engineer, but highly skilled in painted and tarsia decoration.[31] The first thing Francesco di Giorgio took in hand was the completion of the huge casemates in the substructure of the Giardino Pensile; he also started the vast stables on the west front of the palazzo which extended to the so-called Data (Piazzale), where Francesco's command of vaulting in brick found ample scope.[32] All in all he completed the programme of the exterior and interior which Laurana had begun and prepared in drawings; the second storey of the courtyard, including the inscription, the layout of the Corte del Pasquino, the decoration and furnishings of the rooms, and above all the tarsia decoration were his work.[33]

Francesco di Giorgio Martini's continuation of Laurana's work was a most important training for him. His cathedral, the original aspect of which was long concealed by Valadier's alterations, can now be reconstructed from eighteenth-century drawings which have recently come to light. With Alberti's S. Andrea at Mantua and the Duomo of Faenza it ranks among the outstanding spatial compositions of the time.[34] I shall return to it in my last chapter.

On the rear of the Hospital of S. Chiara, now lamentably muddled up and disfigured, Francesco di Giorgio developed, for the first time as far as I know, the two projecting end pavilions as an element of composition, and thus created a type of façade which was to have many successors (e.g. at Mantua the Domus Aurea of the Palazzo Ducale).[35]

Finally, Francesco's church of S. Bernardino, built as the memorial chapel of the Montefeltro to replace the mausoleum originally planned for the Corte del Pasquino, is an ecclesiastical building of the greatest importance,[36] since it created a new type of princely sepulchral chapel. The dominating architectural motif is the square, domed choir, to which the nave, a somewhat squatly proportioned room, merely serves as a vestibule (Plate 70). Like the tribuna in SS. Annunziata in Florence, planned as a memorial chapel of the Gonzaga, S. Bernardino reverts to an antique prototype. Salmi has rightly pointed out how much the peculiarly ponderous and unadorned monumentality of the church owes to S. Salvatore at Spoleto; in particular, the very effective motif of the free-standing corner columns comes from there.[37] To its contemporaries,

the inscription in Roman capitals running round the building at the height of the cornice enhanced the impression of a sepulchral monument in the antique manner.

To sum up, we can realize from these observations the extremely important part played by the architecture of Urbino between 1455 and 1480. Federico da Montefeltro assembled for his palace all the maestri available at the time, so that here, as nowhere else, there is a blend of the most heterogeneous traditions of style, including that eastern component (with Giorgio da Sebenico and Laurana) which, in my opinion, was an essential contribution to the development of the feeling for spatial composition at Urbino.[38] This sense of space appertains specifically to Urbino; it can be seen in painting, first in Piero della Francesca, then in Signorelli, the Umbro-Tuscan, and finally in Raphael.[39] It was Laurana who developed its architectural expression at Urbino with a subtlety of means which can be best appreciated in the throne room and the great courtyard. The feeling for monumental space which was awakened in Split (Spalato)[40] in his native country is combined with his impressions of the new style at Venice (and Rimini?),[41] so that Laurana was, as it were, the predestined architect in chief for the Urbino projects. The meeting with Piero – the mathematician of proportions and the master of perspective in painting – must have been particularly fruitful. As regards Alberti's work at Urbino, he must have given as much as he received; we cannot imagine his conception of S. Andrea at Mantua without all he saw and learnt at Urbino.[42]

In my opinion, the 'style of Urbino', as I have tried to show, can be clearly discerned in the architectural development of Rome during the eighties.[43] Francesco di Giorgio's share in it (Cancelleria?) would have to be more clearly identified. Baccio Pontelli's training at Urbino remained an indispensable foundation of the style which matured in his later work in Rome. Nor must it be forgotten that Bramante too spent his early years at Urbino, and acquired his first practical experience there.

The gradual amalgamation of heterogeneous artistic traditions in a new, unified style which took place at Urbino can be clearly distinguished, and actually traced in stages, in a number of isolated motifs. Only a few examples can be given here. In the superb portal of S. Francesco delle Scale at Ancona by Giorgio da Sebenico, the formal idiom of the Adriatic coast about 1450, still Late Gothic, yet interspersed with typical Renaissance details,[44] comes out clearly. The Palazzo Comunale at Pesaro (Plate 71), probably also by Giorgio da Sebenico, which preceded the replanning of the palace of Urbino, shows in the structural forms of its portico-loggias and the ornament of the central portal a very distinctive transitional type in which a tendency to compact mass effects (first appearance of rusticated pillars) is blended with the Adriatic love of ornament.[45] The Urbino style makes its appearance in the upper storey; the difference between this and the older parts of the building becomes clear from a comparison between the window surrounds in the main front and those looking on to the Corso. As Marchini has proved, capitals and columns which are used in the Corte Ducale of Urbania were originally intended for the palace of Urbino (i.e. for the first set of buildings). Echoes of the early-fifteenth-century International Gothic style can be clearly recognized in the treatment of the ornament.[46]

Of the great palazzo at Gubbio, only a few scattered parts of Federico's building have

survived, but they show unmistakably the connection with Urbino; the splendid tarsie from the Studiolo – a worthy variant of the Urbino Studiolo – are in the Metropolitan Museum, New York.[47] Finally at Jesi, Francesco di Giorgio completed the work proceeding on the Palazzo Comunale. The sober dignity of the courtyard (Plate 72) is akin to the forms used by Francesco in the Duomo of Urbino.[48]

The chapter on Urbino and the Marches would be incomplete without at least a mention of an important form of architecture in the province, namely fortifications.[49] The prominent architects of the period, Laurana, Francesco di Giorgio, Baccio Pontelli, etc., created great works of this type, the particular fascination of which lies in the peculiar blend of functional and aesthetic form. The fortified area is surrounded by walls and bastions so rich in imagination that the functional purpose can obviously not have been the sole determining factor; a main feature of the plan must have been the creation of an impressive total picture. The most famous work is probably the Rocca S. Leo (Plate 73); other examples are the fortifications of Sinigallia and Cagli.[50]

MANTUA

FEDERICO DA MONTEFELTRO was not the only prince in Italy whose rule was grounded in the principle of *buon governo*. Ludovico Gonzaga, the Marquess of Mantua, was descended from a house in which the love of learning and art was traditional. His grandfather, Gian Francesco I, laid the foundation of the famous family library about 1400; his father, Gian Francesco II (1407–44), was the founder of that *casa giocosa* which was to become, under the leadership of Vittorino da Feltre, the most distinguished centre of humanistic education in the country. It was Ludovico's ardent wish to attract the best artists to his court.[1] His letters reveal the patient intensity with which he besieged Andrea Mantegna until he persuaded him to settle at Mantua in 1460.[2] Ludovico's connection with Alberti has been discussed above.[3] Luciano Laurana was called in to work on the Castel S. Giorgio, and there is evidence that he was at Mantua as late as 1466.[4] Laurana may have had a great influence on the architectural development of Mantua; Mantegna and Alberti certainly did. Luca Fancelli held office as architect-in-chief to the court.[5] It was his main, and not easy, task to reconcile the wishes of the patron with the suggestions of his advisers and to give them visible form.

In the same way as Urbino, Mantua developed a style of its own between 1460 and 1500. One of the outstanding characteristics of that style is a delight in the fantastic. The predilection for fantastic forms can be observed even before the Albertian stage, and connects Mantua, as we shall see, with the artistic feeling of northern Italy, both of Lombardy and Venice. But the Mantuan love of decoration took on a distinctive cast very early; one example is the bizarre ornament of the Casa di Giovanni Boniforte da Concorezzo (Plate 74), which derives only in part from Venetian Late Gothic, and the Major Domus of the palace (thirteenth-fourteenth-century) is also rich in unconventionalities.[6] In the second half of the fifteenth century, it was Alberti and Mantegna who took up this tradition, and in their hands it underwent a remarkable development. This bent to the fantastic was a natural trait of Mantegna's, as can be seen by the famous excursion 'in the antique manner' which he made with friends to the Roman ruins on Lake Garda in September 1460; Samuele da Tradate, the Corteggiano, acted as Imperator, and the humanist Feliciano was cicerone.[7] It was the dream-world of Poliphilo's *Hypnerotomachia* or the frame-story of Filarete's treatise, which can be seen here in action, as it were;[8] a homage to antiquity in the Roman manner which finds eloquent expression in Feliciano's *Jubilatio*[9] and is very different from the Tuscan approach to the antique.

The same unconventionality can be felt in the gaiety of Ludovico Gonzaga's correspondence with Luca Pacioli, when he signed himself, in his letter of 24 April 1472, as the 'disciple of the maestro' and sent him a sketch by Mantegna to explain his wishes, as patron, for the construction of the courtyard in the Castel S. Giorgio. Fancelli was fervid in his thanks for the masterly exposition, which had not only clarified his own particular

task, but would also be of the greatest service to him when the time came for him to explain his patron's ideas to illustrious visitors.[10]

This is the standpoint from which the importance of the architectural imagination of Mantua can be appreciated; it makes the huge, bewildering complex of the palace comprehensible. The palace covers more than eight acres, three of which are built over; there are fifteen courtyards and garden courts, and over five hundred rooms, the largest of which (Sala degli Arcieri, Sala dell'Armeria, Sala del Manto) are vast in their proportions. Mantegna's paintings transformed the Camera degli Sposi into what looks like an open summerhouse, but the particularly fantastic touch is that it was possible to ride up to the door of the painted chamber by way of the spiral ramp (Laurana?) and then, as it were, enter into an illusory open space. It is clear from the Duke's letter to Mantegna of 4 May 1459 that the latter had laid down very definite lines for the architectural composition of the rooms he was to paint, and in the same letter the Duke assures him that the chapel of the palace is to be built as he wishes, and that he will find it ready when he begins work on the painting.[11]

These details make it clear that the task confronting the architect-in-chief at the court of Mantua was no easy one. It was Luca Fancelli who had to realize the unconventional plans which were laid before him, namely Alberti's *tempio bizzarrissimo* of S. Sebastiano, the inspired conception of S. Andrea, and the rebuilding of Castel S. Giorgio.[12] Yet where he was working according to his own ideas, his own originality also comes out. The coupled columns, which unquestionably suggested the same motif in Giulio Romano's designs for the Palazzo del Te, first appeared in the courtyard of the palace at Rovere. Casa via Frattini 5 (Plate 75), with its statue niches in the attic zone, which is quite reliably attributed to Fancelli, reveals an imagination of an unusual quality, possibly stimulated by Mantegna.[13] Unfortunately, only a very small part of his most important secular building was ever executed. The Nova Domus of the palace (Plate 76), built by Fancelli on the commission of Duke Francesco, Ludovico's son, would, if the whole project had ever been completed, have been an unusually rich and remarkable work: a huge quadrangular block of buildings with turret-shaped corner projections was to have surrounded a spacious garden court. Only one range – the lake range at the back – was built. It was skilfully restored not long ago. This huge two-storeyed front has seven bays in the centre and three in each of the corner projections, which are heightened by an attic storey and a loggia. It gives a good idea of the post-Albertian style at Mantua. The pilaster system itself probably goes back to Alberti, and acts as a giant order by bracketing four superimposed rows of windows in two storeys. In spite of an undeniable monotony, increased by the absence of doorways, this elevation has a monumental dignity of its own, and it would certainly have become more attractive by the projected decoration which was to set off the different materials employed (brick and limestone, frieze in terracotta) and would have treated the surfaces in colour too.[14]

The use of the corner projection which appears about this time in the Vatican Belvedere and the S. Chiara hospital at Urbino was, I believe, tried out for the first time here in the field of the monumental palace. That was the importance in the history of architecture of the Nova Domus; it created a type which was to have many

successors.[15] The relations between Mantua and Urbino were at all times very close. Francesco Gonzaga had a copy made of the palace of Urbino, and asked Federico da Montefeltro for advice, so that he must have known S. Chiara too;[16] he knew the Belvedere through his brother the Cardinal. The turreted corner projections may have been inspired by the Venetian type of palace which lasted from the Fondaco dei Turchi into the Renaissance.[17] The *genius loci* of Mantua also helped Fancelli to find a personal solution of this important architectural conception.

The Mantuan style of the Quattrocento achieved its most perfect expression in Mantegna's house adjoining S. Sebastiano.[18] It has been rightly pointed out that this building was not conceived as a dwelling-house in the usual sense of the word: on the contrary, what was created in it for the first time – and in this was another child of Mantegna's fantasy – was the idea of the artist's house, the *casa dell'artista*, which was to be a studious retreat and also to serve for exhibitions of his own art collection which was, for the most part, antique.

The execution dragged on throughout the whole of Mantegna's time at Mantua. The documents are somewhat contradictory; already in 1473 the supply of roofing material is being discussed; on the other hand the inscription on the foundation stone bears the date 1476; thus the house must have been built in several stages. Work was still going on in 1484 and 1494, and in 1496, when the Madonna della Vittoria was housed in it, it must have been far advanced. It was probably never finished.

This unique building is representative of a conception of the *rinascità* which blends all the best that could be drawn from the teachings of Alberti and his successors (Francesco di Giorgio).[19] But above all there breathes in the Casa di Mantegna the spirit of its owner; the union of the cube and the circle in the courtyard (Plate 77), the insertion of the niche portals in the curved wall surface, the proportions, and finally the inscription *Ab Olympo*[20] all serve the dominating idea of the building; it was to be a place dedicated to the Muses and the cult of antiquity. What monumentality in the smallest space!

It is on the basis of these personal ideas of Mantegna's work in architecture that I share the opinion of scholars who believe that he collaborated in the design of his own funerary chapel in S. Andrea.[21]

The characteristically Mantuan predilection for the free play of the imagination in architectural design seems to have been paramount in the neighbouring city of Ravenna too. The original and unusual conception of the Bracciaforte tomb can still be recognized under the disfigurements due to modern restoration. The beautiful barrel-vault of S. Maria in Porto has also that peculiar quality which can be seen in the Grotta of the Castel S. Giorgio at Mantua; it was built rather later, in the first decade of the Cinquecento, yet its style belongs to the end of the Quattrocento.[22]

It therefore seems to me quite natural that even the practitioners of the *architettura fantastica* – to use an expression of Vasari's – in the following century should have found at Mantua a particularly congenial field of action. The immediate predecessors of Giulio Romano, he himself, and his successors from Bertani to Viani, carried on the Mantuan manner, from the secret garden of Isabella d'Este by way of the Palazzo del Te to the Appartamento dei Nani, in which this kind of fantasy lapsed into Mannerist bizarrerie.

VENICE

ARCHITECTURAL developments in Rome and the monuments of Urbino and Mantua show the extent to which a strong local tradition or *genius loci* can affect the formation of distinctive regional styles. The rise of such styles is characteristic of the Quattrocento. The richest and most remarkable is that of Venice.[1]

The peculiar plan of the city was determined from the outset by its situation – the lagoon.[2] The separate blocks of houses arose on countless islets; these smallest of urbanistic units grew into the seventy-two *confini* (districts), and their size and situation were adapted to the larger areas of land and waterways. The *campo* (market-place) and *campiello*, with the church, campanile, and well[3] form the nucleus of the *confini*, with the streets and courtyards grouped round them. Two facts of a purely technical kind governed the Venetian building: the foundation on pile-grids[4] and the necessity of access both from land and water.

These are the fundamental factors which lead to that curious interpenetration of traffic way and building which can only be seen in Venice. Waterways (*canalozzo, canale, rio*), streets (*riva, fundamenta, sotto-portico, salizzada, calle, ruga, borgo, orcolo, ramo*), squares (*piazza, piazzetta, campo, campiello*), and bridges (*ponte, ponte sospeso, cavalcavia*) influence, or even determine, the shape of buildings to such an extent that important features of Venetian architecture are the product of their interplay.[5]

That is the explanation of a whole series of architectural motifs which are used in Venice, as nowhere else, as elementary structural forms. There is, for instance, the predilection – which goes back, in the last resort, to pile-grids – for supports and rows of supports, and particularly for columns and arcades in every possible form. There is also a tendency to build, if not insubstantially, at any rate skeleton-wise; this can be seen in the breaking-up of wall surfaces by multiple openings; further the absence of cellars or basements, which are replaced by the 'water-storey', the characteristic feature of the Venetian palazzo; and finally the street front is subsidiary to the water front (except in buildings facing on a piazza with the rear on a rio). Apart from very minor exceptions, there are no monumental street vistas, since the traffic system makes them impossible, just as there are no main thoroughfares or crossroads.[6] On the contrary, the perpetual twists of the alleys, and the surprising number of picturesque glimpses which present themselves to our eyes as soon as we enter anything like an open space, are an urbanistic fact which the imagination of the architect had to reckon with just as much as with the alternation between narrow waterways and wide vistas on the canal and riva.

These vistas (*vedute*) arise of themselves from the physical structure of the city. They are peculiar to Venice, and their charm resides not only in their multiplicity of forms, but also in their effects of light and shade. Between the cramped and the spacious, the dark and the bright, the transitions are sometimes imperceptible, sometimes striking in

their contrasts. If *vedute* painting is so closely associated with Venice, we may suspect, conversely, that the Venetian architect had a special feeling for the visual picturesqueness of his buildings. That comes out very clearly in the Renaissance. The most monumental examples of this pictorial planning of piazza and campo, of which there are countless examples, are the Piazza and Piazzetta of St Mark's and the great Campo of S. Giovanni e Paolo.

While the physical nature of the site – the lagoon – was, as it were, the material factor which determined certain elementary forms of Venetian architecture, the other determining factor was spiritual: it was Venice's close and lasting connection with the East. The glory and wealth of the city were based on her power in the Adriatic – Venice's *mare nostrum*; the annual festival of the *Sposalizio del Mare*, the symbolic marriage of the Doge with the sea, celebrated from the twelfth century on, was the spectacular manifestation of this claim to sovereignty. In taking over this supremacy from the older centres of Ravenna, Aquileia, and Grado, Venice fell heir to their traditions. Her religious architecture is mainly influenced by Byzantium and the East, and Dyggve and Fiocco[7] have shown convincingly that typical forms of the Ravennese palazzo recur, too, in Venetian secular building. Finally, however, what Venice shares with the East is the delight in lavish surface decoration, especially in polychrome ornament.

In church building, the cruciform plan with dome or domes prevails. Few examples have survived from medieval times; the type is most clearly represented by the nucleus of St Mark's and by S. Giacomo di Rialto. There were also churches of pure basilican plan, e.g. the predecessors of the present SS. Apostoli, S. Pietro in Castello, S. Zaccaria, etc.[8] Today the cathedral of Torcello is the only church to represent the grandiose composition of the medieval basilica with columns between nave and aisles carrying a straight entablature instead of arches. Finally there were aisleless churches in several variants; two annexes of St Mark's present good examples, the barrel-vaulted chapel of S. Isidoro and the baptistery, which consists of a series of domed square bays (both of the fourteenth century). The joy in the display of oriental splendour, the use of costly kinds of coloured stone, the accumulation of decorative members (e.g. the massing of columns in the façade of St Mark's) are characteristic of Venetian architecture even in the Middle Ages. In the fourteenth century, the ostentation of communal prosperity – with Venice at the apogee of her political power – took fresh impetus, and this was expressed above all in the massive forms of the monastic churches (S. Maria Gloriosa dei Frari and SS. Giovanni e Paolo) and in the decoration and furnishing of public spaces and public buildings (Doge's Palace, Piazza, Campi).

The typical Venetian mansion had already developed in the Middle Ages. The best example is the Fondaco dei Turchi.[9] This Romanesque predecessor of the Renaissance palazzo grew out of a fusion of Byzantine and Ravennate prototypes (e.g. the roofs ending in gables) and created that 'disembodiment of the structural plane' (Swoboda[10]) which was to remain characteristic of Venetian architecture. In the same century the basic scheme of the Venetian palazzo was established in the Loredan and Farsetti-Dandolo palaces; the end projections were abandoned but the division of the front into

three parts was retained. This remained the basic scheme of the Venetian palazzo for centuries. It was continued in the palaces of the Gothic period; the reconstruction of the Palazzo Barozzi, adjoining S. Moise, shows how spacious such plans could be.[11] The last offshoots of this Gothic type are the Cà d'Oro, and the Palazzo Foscari (Plate 78) with its neighbour, the Palazzo Giustinian (begun about 1450). Thus the ground plan and elevation of the Venetian palazzo had been established long before the Renaissance in all their essential features. The ground floor consists of two parts: the porticato on the water-side with the great water-entrance and adjoining store-rooms, and the small courtyard which is entered from the calle. The first storey is occupied by the great hall, which, sometimes angled into an L, runs through the whole floor and opens in large arcades on the main front. The other rooms are distributed at the sides of the sala and on the top storey.

Not only the palazzi, but also the simple terrace houses developed fixed forms which are a typically Venetian variant of the very old Roman scheme (Figure 30): the ground

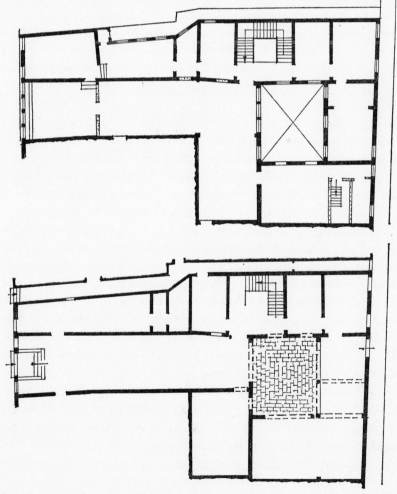

Figure 30. Ground- and first-floor plans of a typical Venetian house (Palazzo Gussoni)

floor with its portico and shops, from which a staircase leads into the upper living-rooms. By the systematic planning of terrace houses (*casette di schera*), the fifteenth century imposed some system and order on the street plan.[12]

Finally, a number of details must be pointed out as characteristic of Venetian secular building: the tall chimneys, generally funnel-shaped and often lavishly decorated, the many forms of balconies, roof terraces, and loggias, and the suspended bridges or passages (*ponte sospeso* or *cavalcavia*) spanning a creek or a street and occasionally connecting two neighbouring houses. What has almost vanished today is the many private gardens, with their crenellated outer walls, which were a characteristic component of the general view of the city. (A relic can be seen at the back of the Palazzo Dario, another in the garden wall of the Palazzo Sanudo, adjoining S. Maria dei Miracoli in the Calle dei Castelli.)[13]

With this wealth of existing special forms and types, both in religious and secular building, the new style necessarily proceeded on quite different lines from those followed in other Italian provinces. Firstly, the new style arrived in Venice rather late. Even in 1452, that is, at a time when Brunelleschi's and Michelozzo's buildings in Florence were far advanced, the great Doge Francesco Foscari had his palazzo (Plate 78)[14] built entirely in the Gothic forms of the Cà d'Oro,[15] while the work on the chancel of S. Zaccaria, which was begun in the same decade, belongs entirely to that characteristic transitional style which we encounter in the Porta della Carta and the Arco Foscari (begun after 1438) of the Doges' Palace.[16]

It was not until 1460 that three buildings introduced real features of the new style, though each in its own way. The Porta dell Arsenale,[17] erected under Doge Pasquale Malipiero, manifests the true spirit of the *rinascità*, since an antique Roman monument (standing, characteristically, on Venetian territory) – namely the triumphal arch of Pola – served as model. That did not prevent Veneto-Byzantine capitals of the twelfth century being applied as trophies on the columns; these too may have seemed antique enough to the builder. Thus the building of this extremely ostentatious entrance is proof that the notion of a classical triumphal monument had been assimilated along with the antique form.

Totally different conditions presided over the two other buildings. In 1460 the Duke of Milan, Francesco Sforza, had bought from the Corner family an unfinished palazzo on the Canal Grande, which had just been begun by Bartolomeo Buon. After having examined the plan submitted to him, Francesco Sforza rejected it, explaining to his agent that it was his express wish that the building should be given a form 'which shall be modern ["a la moderna"] and executed according to the fashion of our own parts [i.e. Milan], and we have no doubt that our project shall please everyone as an innovation in this city. Yet, take note that the façade on the Canal Grande shall be in the Venetian manner'.[18] This statement is of the utmost importance for our conception of style, because it proves nothing less than the fact that the patron intended to 'import' the Lombard 'maniera moderna' to Venice and to combine it with the local building tradition, the 'Venetian manner'.

The whole project proved unsuccessful for many reasons;[19] it was never brought to

execution and abandoned definitely after the death of the Duke (1466). But neverthe-less, the scanty remains of the ground floor of the Cà del Duca, as they still stand today, enable us to reconstruct the idea of the building, if we compare them with Filarete's design for a 'Palazzo nel Palude' in his Treatise on Architecture (Plates 79 and 80).[20] This drawing and its description in the text, written c. 1461/2, reflect with certainty the project for the Cà del Duca and we recognize the clear tendency to transform the Venetian structure of the building by means of a Lombard system of decoration. Thus, all in all, the Cà del Duca, though it has remained a torso, has a great deal to say about the assimilation of imported stylistic idioms into the traditional Venetian types. The Duke's architect in charge was Benedetto Ferrini, working however, as we believe, under the direction of Filarete, who was then the chief architect of the court of Milan and whose formal language is characterized by the 'amalgamation' of various regional styles. We shall return to this interesting phenomenon later.

The third building of this early group, S. Giobbe, shows the infiltration of Florentine forms. The new church was begun soon after 1450 in memory of S. Bernardino, who had preached there in 1444. In the sixties the large chancel chapel was added, and much was finished by 1471.[21] It is there that we find for the first time the use of structural elements derived from Brunelleschi, and with it the rise of that austere and simple manner of spatial composition which is characteristic of the Florentine style. The poly-chrome structure of the domed Cappella dei Martini, executed immediately afterwards (1471–6) by the workshops of Rossellino and Robbia, also shows Florentine masters displaying, in a way, their stock of native decorative forms.[22]

In the succeeding decades (i.e. the seventies, eighties, and nineties) there was a great development of building activity in Venice. It is difficult to find some systematic way of dealing with this period for two reasons: the large number of types which developed both in religious and in secular building, and the difficulty of identifying the executant maestri.

All these works have one thing in common: they maintain the Venetian tradition of splendour and brilliance. Colour and light are drawn into the total effect by the lavish use of coloured-marble incrustation or by the decorative patterns of openings in the walls. The organization of large sites too is obviously aimed at a pictorial effect. The Procurazie Vecchie (begun in 1496)[23] with its fifty uniform arches and the Torre dell'Orologio (1496–9)[24] closing the north front, and the monumental bell-stage (1500–17) crowning the campanile[25] on the south, turned the Piazza S. Marco into a grandiose stage setting, dominated by the church. The three huge flagstaffs in front of the façade give the finishing touch to this impressive view. The Campo di SS. Giovanni e Paolo is another architectural 'picture' which could only be created in Venice with its com-bination of picturesque surface accents (Scuola di S. Marco) and sculptural monu-mentality (pedestal of the Colleoni statue). Jacopo de Barbari's woodcut of Venice gives an excellent idea of this townscape, which derives its peculiar charm from the ubiquitous alternation of close clusters of volume and wide spaces (Plate 81).[26]

In the field of ecclesiastical building, however, three main types developed – the basilica, the domed church, and the aisleless church – which are present in many variants.

The simple and still essentially Late Gothic forms of the basilica of S. Giovanni in Bragora (before 1475),[27] with characteristically sturdy columns on pedestals, pointed arcades, and triple-canted roof in the interior takes on monumentality in S. Zaccaria.[28] The two stages of the new building (1444 and 1458–1500) overlap so far that it is hardly possible to trace the stylistic development at all clearly, or to draw any real line of demarcation between the work of Antonio Gambella ('proto'-architect from 1458 to 1481), Giovanni di Antonio Buora (evidence of work on the interior in 1480), and Mauro Codussi ('proto' from 1481 on), not to speak of the sculptors who collaborated in the decoration of the façade (Plate 82). The Venetian predilection for loose aggregations of equal spatial units, which is particularly marked in the domed churches, is obviously responsible for the somewhat strange composition of the choir (Plate 83), with the great free-standing coupled columns of the ambulatory and the strongly stressed apses. The three great vaulted bays of the nave with their massive, rather ungainly columns on very tall pedestals and their profuse decoration lead up to this somewhat stagey choir; the effect is splendid, but it is slightly overpowering. In the façade, the scheme of S. Giovanni in Bragora is enriched with an overloaded display of Renaissance forms, and it is astonishing how the surface, loosened up as it is by square panels in the dado zone, blind arcading and window openings in the upper stages, is drawn together in an effective unity by the system of orders and the cornices, themselves composed of many parts.

The church of S. Michele in Isola (Plate 84) at first seems to offer a complete contrast, though it is the work of the same architect, Mauro Codussi. Its date is the seventies.[29] It is, if the expression may be used, a humanist building, as can be seen from the correspondence between the Camaldolese Father Dolfin, who was famous in his day, and the patron of the church, Pietro Dona.[30] The façade reflects the spirit of Alberti in the simplicity of its proportions, in the clean-jointed, flat white blocks of stone,[31] in the quiet articulation by means of pilasters and cornices, and the clear crown of the three pediments. A not very happy compromise was found for the attachment of the segmental pediments to the central block, since the pediments cut into the pilasters of the zone of the round window, yet there is hardly an Early Renaissance façade which managed without some compromise of this kind. As a whole, the façade of S. Michele is the clearest expression of the new style that Venice has to show in the fifteenth century. That is why it is my personal conviction that the façade of S. Zaccaria, so clear in its composition in spite of its many component parts, must be attributed to Mauro Codussi.

In the interior of S. Michele in Isola, the special forms dictated by the requirements of the liturgy in a monastic church have been developed with great imagination. The nave and aisles, domed presbytery, main apse, and side apses are interrupted behind the first bay from the west by a singing gallery in the form of a bridge (coro pensile); thus the first bay acts as a vestibule, and it leads up to a delightfully decorative close in the substructure of the coro pensile which has been elaborated as though it were the real entrance to the church; the side turned towards the church has also been given the aspect of a beautiful gallery. The effect of the interior therefore depends in large measure on

the peculiar isolation of the individual bays and on the alternation of light and dark in the succession of these 'spatial cubes'.

S. Michele has also been planned with a view to a pictorial effect. The church, monastery, and campanile (1456–60), one of the first Venetian church towers to be built in the Renaissance, forms a most picturesque group, and the reflection in the water was undoubtedly taken into account in this vista.[32]

The aisleless church of S. Maria dei Miracoli was built between 1481 and 1489.[33] The 'proto' was Pietro Lombardo. Here too the special function of the building as a nunnery church had a determining influence on its architectural form. The interior (Plate 86) is a hall with a coffered barrel-vault which leads to a choir raised to form a gallery, which is domed and ends in a semicircular apse.[34] The cryptlike space under the choir serves as a vestry. A generous donation provided funds for costly ornament. The marble facings are of choice quality and are arranged in an ornamental pattern following the grain of the marble. Though the articulation of the interior is unmistakable, the prevailing effect arises from the radiant colouring of the walls; this precious facing gives the plain, and not very large room – it is only 33·5 by 11·5 m. (110 by 38 feet) – a peculiarly festive yet solemn monumentality. About the same time, or a little earlier, the Cappella del Perdono was built at Urbino; we can see in it, though on the smallest scale, the same principle of precious incrustation. It was finished in 1483, and the fact that an ornamental motif from Urbino which could have no meaning in Venice – Federico da Montefeltro's emblem of the flaming cannon ball – should appear on a pilaster in S. Maria dei Miracoli shows that there was a connection between the two architectural centres.[35] It seems quite natural to me that the Cappella del Perdono, which ultimately goes back to a design of Laurana's – that is, of a Dalmatian master trained in Venice – should have been in the minds of the patron and architect of S. Maria dei Miracoli, yet the sparkling variation of the idea is proof of the talent of Pietro Lombardo.

The exterior (Plate 85) corresponds to the interior. The surface decoration was carried out in unused material from the S. Marco Opera. The two orders of the façade, the lower with a horizontal entablature and the upper with arches, are distributed over the surface in the rhythm c b a b c. There are echoes of Tuscany in this structural scheme, yet as a whole it has been transposed into Venetian polychrome, with, maybe, some influence from Ravenna. The semicircular pediment, which corresponds to the barrel-vault inside, is an effective crown to the façade. The long side, facing on to the canal, is entirely conceived with a view to that pictorial effect which is so often to be seen in Venice, and so is the choir with its dome and minaret-shaped turrets, faced in white.

The combination of an aisleless church with a domed choir appeared in many variants in Venice: perhaps in S. Rocco[36] (of which only the fifteenth-century part of the choir still survives); then in S. Maria della Visitazione (by Spavento, 1493–1524), and in S. Sebastiano (by Scarpagnino).[37]

It was not until the end of the century that Venice began to take up again the Byzantine type of the square with inscribed cross and central dome and to transform it with the means of the new style. The first two buildings – both of capital importance

for developments in the sixteenth century – are S. Maria Formosa and S. Giovanni Crisostomo.

S. Maria Formosa,[38] one of the eight oldest churches in Venice, was rebuilt in 1492 by Mauro Codussi on the plan of its twelfth-century predecessor, which was itself copied from the 'corpo di mezo' of St Mark's. The present exterior and dome, like the campanile, belong to the sixteenth and seventeenth centuries. Inside, the Greek cross of the older church has been transformed into an abbreviated Latin cross, and a spatial grouping of great originality created. The structural scheme is still rather meagre: the piers of the crossing, raised on pedestals, are dwarfed by the width of the room, the mouldings and cornices are thin and remarkably flat. But the spatial conception as a whole is bold; it is a pseudo-five-aisled plan with groin-vaults in the nave and small domes over the corresponding bays of the lower aisles; chapels with transverse barrel-vaults are attached to both sides of the latter, and the walls between them are pierced by curious bipartite windows. The three-bay nave leads to the dome over the crossing. The arms of the transepts are of the same height as the nave. The aisles are continued beyond the transepts; they also have small domes and lead again into outer chapels with a transverse barrel-vault, but now in addition semicircular apses. In this way a large number of cubicles unite in a single spatial group, yet owing to the thinness of the supports, this conglomeration of single cells gives the impression of a unified space entirely dominated by the main motif, which is the cruciform plan of nave, transept, and choir. There is an experimental air about the whole, and we can note many a compromise, such as the triple division of the attachments to the piers of the crossing (especially in the upper cornice zone), the mouldings of the arcades, and so on. But these imperfections in the execution mean little in comparison with the importance of the invention: a domed church in the formal idiom of the new style.

Even in the church of S. Giovanni Crisostomo (Plate 87 and Figure 31), begun in 1497, Codussi[39] does not progress far beyond S. Maria Formosa in the treatment of the formal apparatus, except for the introduction of composite capitals. The piers are perhaps even more slender, and this impression is reinforced by their tall pedestals. But the spatial composition is more unified, and there is light in the interior, which was the real aim in contrast to the darkness of medieval domed churches. From this building it is only a step to S. Fantino and S. Felice, in which the domed cruciform church of the Venetian Cinquecento found its first classical expression.

It has been shown how far the spatial cell – the 'cube' – domed or with some sort of domical vault was a special aim of Early Renaissance architecture in Venice.[40] The principle has been named the *cuba* principle by Hubala, a nice term, as it combines the memory of the Cuba at Palermo, just such a domed single cell, though a Byzantine one, with the memory of the word cube. The principle of the *cuba* then also appears very clearly in a number of small single buildings, such as the Cappella Gussoni in S. Lio or the Cappella Corner in SS. Apostoli;[41] these are important variations on the theme which had been announced as early as 1421 in Brunelleschi's Sagrestia Vecchia in S. Lorenzo. It will be remembered that Brunelleschi's inspiration for this basic form of the Florentine Renaissance – cube with dome on pendentives – had come from

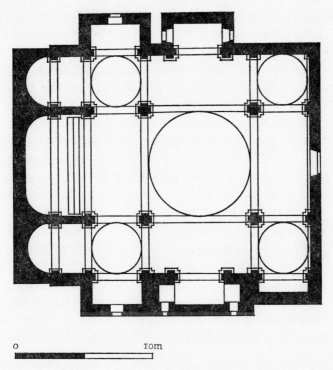

o 10m

Figure 31. Mauro Codussi: Venice, S. Giovanni Crisostomo, begun 1497, plan

Byzantine medieval building, for instance the baptistery of Padua. The form now returns, half a century later – rationalized in the sense of the new style – to its original home, but in process of assimilation it went through a most delightful readaptation to the old Venetian formal tradition: the exteriors of the Cappella Corner or of the choirs of S. Maria dei Miracoli and S. Rocco are far more closely akin to the domes of St Mark's than to their Tuscan prototypes; the interior too, where Tuscan ornament is replaced by the richer decoration of Venice, presents a perfectly distinctive picture, as can be seen in the Cappella Gussoni. The Cappella Corner, with its dome on four columns, represents the genuine assimilation of the tetrastyle domed spaces of medieval Venice and its metamorphosis into the terms of the new style.

While architects such as Mauro Codussi and Pietro Lombardo were still engaged, as it were, on elaborating a Venetian formal idiom, the completion of this synthetic process can be seen in the works of the youngest of the Quattrocento architects, Giorgio Spavento. His S. Salvatore is the first pure example of that type of domed church which was the starting-point for the masters of the following centuries.[42] In a similar fashion the architects of the Quattrocento also contributed to the development of another architectural scheme which is a specifically Venetian creation: the *scuola*.[43] The scuola developed in the thirteenth century as a social and charitable institution, and in the fifteenth and sixteenth centuries there were built those splendid halls which have become famous firstly as monuments in their own right, and secondly for the paintings in their interiors. Two of them, those of St Mark's and of S. Giovanni Evangelista, are among

the outstanding works of architecture in Quattrocento Venice, while the third, that of S. Rocco, though conceived in the spirit of the Quattrocento, is actually a creation of the Cinquecento.[44]

An ostentatious façade, great halls on the ground floor and the upper storey, and above all monumental staircases, are the main aesthetic accents of the scuola.[45] The façade of the Scuola di S. Marco[46] (rebuilt after a fire in 1487–90 under Giovanni di Antonio Buora, assisted by Pietro Lombardo and others; architect-in-chief in 1490–5 Mauro Codussi) is perhaps the most picturesque architectural composition of the Quattrocento (Plate 88). The pictorial foreshortening in the doorways, the splendid colouring of the wall surfaces, the insouciance of the proportions are evidence enough. Mauro Codussi built the great staircase in 1495; it was the first of its kind, but was demolished in the nineteenth century. It can be reconstructed from the staircase of S. Giovanni Evangelista (Plate 89), discussed below. The huge hall on the ground floor, divided into nave and aisles by columns, belongs to this first stage of building; on its long side, to the right, the *scalone* leads to the upper hall.

Still older parts of the Scuola di S. Giovanni Evangelista[47] have survived. The *sala terrena*, a simple oblong room, dates from the first half of the century, as the Gothic windows show. The beautiful *septo marmoreo*, a kind of entrance court to the courtyard, was built in 1481; with its scenic wings, as it were, it is a characteristic example of the Venetian taste for little open-air stage-settings. (The great entrance porch to the scuola was not built till 1512.) The most magnificent part of the scuola, however, is the great staircase built by Mauro Codussi in 1498 (Plate 89). It takes in the whole long side of the ground floor, and leads in two huge straight flights to the domed landing which is also the anteroom to the great hall on the upper floor. Once more, in this layout – it corresponds very closely to the staircase in the Scuola di S. Marco, built just before – the Venetian delight in grand architectural vistas comes out. The restraint in the articulation of the flights of stairs is effectively counterbalanced by the decorative treatment of the landing: the tetrastyle space with its shallow dome is a beautifully elaborated *cuba*; the great twin window creates an island of light of a quite distinctive kind.

The *scalone* in the Scuola di S. Giovanni, as a specifically Venetian masterpiece, provides a good transition to a similar, and just as purely Venetian work, the Scala dei Giganti in the courtyard of the Doge's Palace (Plate 90).[48] When rebuilding became necessary in the palace after the great fire of 14 September 1483, Antonio Rizzo was put in charge of the work.[49] He carried it out with the assistance of a large team of Lombard masons; it consisted mainly of the remodelling of the upper storeys of the east wing and the construction of the monumental outdoor staircase. Rizzo was engaged on the work till 1498, with repeated increases of salary, and must thus be regarded as the architect-in-charge. The articulation of the long façade on the courtyard was no easy task. By a rhythmic grouping of windows and arcades, and by a prolific application of ornament in relief, the surface takes on a charm which is pictorial rather than architectural. To a Tuscan eye and Tuscan feeling, the structural elements are extremely capricious; most of the details – mouldings, cornices, pediments, and architraves – cross and recross with little respect for 'order' in the architectural sense. Yet the specifically picturesque aspect

of the whole is largely due to the freedom of its composition, the colour of the material, and the wealth of forms and motifs.

The huge façade of the range looks like a vast backdrop for the monumental staircase, which gives the courtyard, and with it the entire building, its central accent. Serving for purely official purposes – it was on the upper landing that the solemn ceremonies of the enthronement of the Doges and the reception of distinguished visitors took place[50] – the flight is in axis with the Arco dei Foscari; the *via majestatis* leads from the Porta della Carta through the porch towards the stairs like the approach to the great steps of a throne. Looked at from this standpoint, the Scala dei Giganti is, in layout and form, the first monumental example of its kind.[51]

A humbler sister of the Scala dei Giganti can be seen in the Venetian *scala aperta* (Plate 91), a form which is as popular and far more widely used there than elsewhere.[52] It had many variants; unfortunately only a few have survived, for instance the beautiful flight of steps in the courtyard of the Cà d'Oro or the outdoor stairs of the Palazzo Lion-Morosini on the Corte del Remer (Canale Grande, rio S. Giovanni Crisostomo).[53] A special case is the great spiral staircase, the only surviving example of which is the beautiful Scala del Bovolo in the Palazzo Contarini (calle della Vida) (1499, Giovanni Candi?), but, according to Paoletti, it was a current feature of Venetian building in earlier times.[54]

As has already been pointed out, the use of pure Renaissance forms did not set in till the last third of the century, even in Venetian palazzo architecture of the Quattrocento. The Late Gothic type of the Cà d'Oro and the Palazzo Foscari survived for a very long time. The intentional blend of Venetian with Milanese idioms of style in the Cà del Duca (Palazzo Sforza) is an exception. The monuments can be classified in three main types, the first represented by the Palazzo Contarini dal Zaffo-Angaran, the second by the Palazzo Dario, and the third by the Palazzo Corner-Spinelli.

The Palazzo Contarini dal Zaffo (Canale Grande)[55] still adheres to the structure of the Romanesque, i.e. Byzantine type, though the articulation of arcades and windows has been transposed into the Renaissance idiom, and the triple division of the façade is stressed by pilasters. This type appears in countless variants, even in street fronts of a less opulent kind, for instance in the palazzetto in the via Garibaldi (Castello no. 1581).[56] A special variant with more lavish architectural ornament is the Palazzo Gussoni (rio della Fava) (Figure 30).[57]

The Palazzo Dario (Canale Grande) (Plate 92), on the other hand,[58] with its rich incrustation, aims at the colour effects of S. Maria dei Miracoli. But even here there are echoes of older traditions; a characteristic example is the oddly asymmetrical arrangement of the upper storeys, which can also be seen in the Cà d'Oro and the Palazzo Foscari. In the basement, on the other hand, a symmetrical arrangement is created by the central entrance and side windows.

The Cà del Duca showed, as we have seen, a first infiltration of Tuscano-Lombard features. A similar process can be observed towards the end of the century in the Palazzo Corner-Spinelli (Canale Grande).[59] There are two motifs which distinguish this building from the types usual up to that time: the facet-cut rustication, and the enormous

twin windows united under a single arch and with a round opening in the tympanum (Plate 93). The relationship between the narrow corner pilasters and the compact block of the façade, with its large windows and narrow wall surfaces, is not very happy, yet the dominating impression is that of a monumentality which no previous palazzo façade had to show. It is therefore not surprising that this building should have been attributed to Mauro Codussi, who, as a native of Bergamo, was most likely to have been familiar with this formal idiom. Other writers ascribe the building to Antonio Rizzo, who used facet-cut rustication, unusual in Venice, in the gloomy and ponderous water-front of the west wing of the Doge's Palace, though in this case with obvious reference to the use of this part of the building as a prison.[60] Whoever may have been the architect of the Palazzo Corner-Spinelli, he created that monumental type of façade which was to appear not much later, in classical clarity, in the Palazzo Vendramin-Calerghi[61] and the façade of the Scuola di S. Rocco.

A peculiar transitional form appears in the Palazzo Camerlenghi, actually a work of the sixteenth century, in which the type of the Palazzo Contarini dal Zaffo is retained, but enriched by massive masonry in the basement storey. Its formal idiom still derives from the Quattrocento.[62]

The pleasure in a festive exterior, the taste for open and diffuse forms, relieve the Venetian palazzo and dwelling-house of that self-contained gravity which characterizes Tuscan, Urbinian, and even Roman palazzo architecture. It has been pointed out how, for that reason, a whole series of formal elements of Venetian palazzo architecture was destined to inspire a new type of building which arose towards the end of the century in all regions, namely the Renaissance villa.[63] Since the sea provided Venice with a natural zone of defence, the individual building in the city required no defences of its own. The antique and Byzantine type of house with an open porch and end projections survived, in an unselfconscious tradition, but adapted to its own purposes. The theory that this extraordinarily delightful Venetian type should have been turned to account in the development of villa architecture in Italy is very convincing. Quattrocento designs (Villa of Innocent VIII in the Vatican, Villa Medici of the Badia Fiesolana, Villa Le Volte at Siena, and down to Poggio Reale), in which the open 'undefended' villa replaced the fortified country seat, actually contain many echoes of motifs from Venetian secular architecture, which had in its turn spread into the neighbouring territories on the terraferma.[64]

The radiation of Venetian architecture into the regions under Venetian supremacy can only be touched on here. Religious building spread to churches such as S. Niccolo at Carpi (begun 1493), S. Francesco at Ferrara (begun 1494), S. Sepolcro at Piacenza (begun 1488) (Figure 38).[65] The abbey of Praglia, too, for which Tullio Lombardi prepared a project in 1490, probably with the help of his father Pietro, is one of the earliest examples of this Venetian type.[66]

Finally, in Dalmatia, the native country of architects as important as Giorgio Orsini da Sebenico and Luciano Laurana, the cathedral of Šibenik (Sebenico) (Plate 94) is the typical example of a composite style, in which Veneto-Italian and Oriento-Dalmatian traditions meet and mingle; in its formal idiom Late Gothic features are also blended

with others of the Renaissance. All the parts which determine the appearance of the building today were begun after 1477, in particular the peculiar barrel-vault of the aisles and the dome over the crossing.[67]

Venetian palazzo architecture also spread far into the terra ferma. Its characteristic features – the façade with the central loggia and balconies and rhythmical fenestration – may be traced in the neighbouring towns, from Padua by way of Vicenza and Verona to Piacenza. The forms show certain variations due to the use of brick, the local building material; charming examples of the kind are the Palazzi da Schio (Plate 95) and Thiene at Vicenza,[68] a house in via Altinate at Padua,[69] or the Palazzo del Banco d'Italia at Verona.[70]

In naming these cities, we have reached the frontier of that other great artistic province of northern Italy which developed its own widely influential regional style: Lombardy.

LOMBARDY

LOMBARDY is a widespread land stretching from north to south between the great Alpine lakes and the banks of the Po, and west to east from Novara in Piedmont to the Venetian boundary at Verona. Its chief centre is Milan, which succeeded Pavia as the capital of the Visconti and Sforza. But besides Milan – apart from smaller towns with a marked local character, such as Lodi, Crema, Vigevano, etc. – there are important subsidiary centres, such as Brescia, Bergamo, Pavia, and Cremona. It has already been mentioned that Mantua too belongs geographically to Lombardy.

As the northernmost province of Italy, Lombardy was at all times the main entrance route into the country, and as such, a dynamic field of political interests. As a territory of transit, it was also particularly open to artistic influences from east, west, north, and south. On the other hand, it developed an important architectural tradition of its own from Roman times; the huge monuments of Late Roman Imperial Milan, one of the capitals of the Empire – S. Lorenzo, S. Simpliciano, etc. – are still to be seen, and a technical detail, the general use of brick as a building material, was a permanent factor in building practice. Several characteristic features may be distinguished from the very beginning in this Milanese-Lombard tradition; firstly, a persistent preference for complex plans or spatial groupings (Milan, S. Lorenzo; Como, S. Fedele; Milan, Duomo); further a feeling for the treatment of walls in large surfaces, which is largely due to the technique of brickwork; and finally, a tendency to spread which comes out both in the stress on the horizontal in interiors under rather low vaulting (Milan, S. Ambrogio) and in the stress on breadth in the composition of façades both of churches and palazzi. From the fourteenth century onwards another characteristic appears and develops, namely a pronounced taste for prolific decoration which, as in Venice, does not articulate the surfaces, but rather weaves a web of colour over them.

Late Gothic died hard. As building patrons, the last Visconti – Gianmaria and Filippo Maria (d. 1447) – were quite overshadowed by their great father, Giangaleazzo, the initiator of the rebuilding of the cathedrals of Milan, Monza, and Como and the founder of the Certosa of Pavia.[1] It was only when the Sforza came into power that the great new development was ushered in by Francesco Sforza's buildings (1450–66) and became general under the universal patronage of Ludovico il Moro.

The gigantic Duomo of Milan, with its many complex problems of constructional technique, kept the Late Gothic tradition alive throughout the century. The Opera of the Duomo was the arena in which masters from south and north met to hammer out their theories and practice in heated disputes[2] which echo still in Cesariano's edition of Vitruvius, published as late as 1521.[3] The competition for the design of the tower-like dome over the crossing, the *tiburio*, which went on from 1487 to 1490, and attracted not only local masters, but even Bramante, Leonardo, and Francesco di Giorgio, resulted in

a decision in favour of the Gothic style: in their reports, Bramante and Francesco di Giorgio emphasize that *conformità* and *bellezza* require the tiburio to be in harmony with the general form of the building. In actual fact the dome over the crossing was finally executed as a purely Gothic structure after designs by Amadeo and Dolcebuono, with Francesco di Giorgio's advice and corrections (Plate 96); it stands entirely within the tradition of the Lombard central tower, the first example of which is the tower of the Certosa of Chiaravalle.[4]

The great project of the Certosa of Pavia is also sustained by the spirit of tradition; it was a younger sister-foundation of the Duomo of Milan.[5] The rebuilding of the monastery was begun in 1396; when Francesco Sforza came to power in 1450, only the foundations of the church had been laid. From 1429 Solari was the architect-in-charge, assisted after 1459 by his son Guiniforte; the work was finished in 1473 (Plates 97 and 98 and Figure 32). In style, the plan of the Certosa takes up the Lombardo-Romanesque tradition, though the height of the Duomo of Milan has been intentionally reduced and its buttressing system abandoned. The new spirit finds expression in the geometrically determined proportions, namely the evolution of the spatial organism out of the basic form of the square. The treatment of the exterior wall surfaces, which arises of necessity from the technique of brickwork, also shows conservative features: the dwarf galleries are a visible transposition of Romanesque forms into the idiom of the new style.[6] Thus, just as we have seen in Tuscany and Venice, the starting-point of the development of the new style in Lombardy was the native Romanesque tradition. The tower of the Certosa is also a superb transformation of its ancestor at Chiaravalle.

When Antonio Averlino, the Florentine master known as Filarete, and Benedetto Ferrini entered the service of Francesco Sforza in the fifties, to work in the first place on his fortresses, they found themselves confronted by very experienced and self-reliant local masters. The imposing round corner towers were just being added (1455–7) to the great, spreading Castello Sforza in Milan (Plate 99), and it was there, in my opinion, that facet-cut masonry was used for the first time in the new architecture, possibly as the assimilation of a motif from the imperial fortresses of the Middle Ages.[7] In the Certosa of Pavia too the Tuscan masters found a building scheme of vast size which was already in full swing.

We may not go far wrong if we see in Filarete's[8] design for the Ospedale Maggiore an endeavour to cope with the huge task entrusted to him by a deliberate fusion of both traditions, the Tuscan and the Lombard. He had been sent to Florence by Francesco Sforza for the sole purpose of studying the plans of the famous hospital of S. Maria Nuova, and he did all that lay in his power to discover a new unity of functional and aesthetic forms in his project. Although it remained unfinished,[9] the general plan of the Ospedale Maggiore in Milan is the archetype of a whole building species (Figure 33). The principle of the cross-shaped wards, used – as far as I know – for the first time in S. Maria Nuova in Florence (middle of the fourteenth century), is doubled; between the two rectangular main wings stands the great square courtyard with the church. The description of the plan in Filarete's treatise on architecture shows how carefully all the practical and hygienic needs of a hospital were provided for, down to the very details.[10]

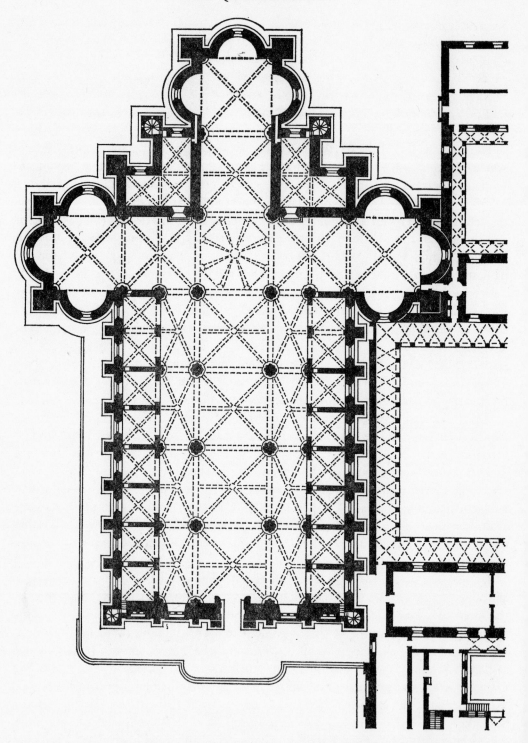

Figure 32. Giovanni and Guiniforte Solari: Certosa di Pavia, 1429–73, plan

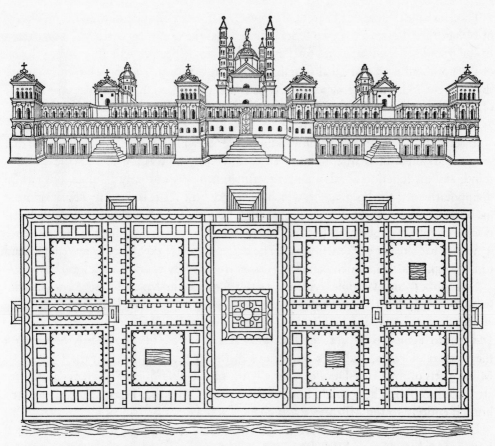

Figure 33. Antonio Filarete: Milan, Ospedale Maggiore, designed *c.* 1460–5, elevation and plan

As an architectural composition, the building stands as a pure product of Lombardy, but it is filled with the spirit of a Florentine *razionalità*.

In this connection a word or two may be said about Filarete's treatise. If we disregard the stylistic helplessness of the *autore illiterato*, and accept with indulgence the illogicality in the treatment of the subject, Filarete still has one cardinal virtue – the attempt to represent architecture as a unified whole, as an urbanistic, or even a social challenge. That attempt should not be underrated. True, the island city of Sforzinda – and also the copy of the ancient port – were supposed to be built to the orders of a Renaissance prince, and it is impossible to disregard, in most of the details of its execution, the spirit of a half-medieval, half-Machiavellian, but entirely despotic will to power. That the town is conceived, not only aesthetically but also functionally, as a unity, with every single building in a definite relationship to the whole, goes beyond Alberti and gives Filarete's 'idea' an eminent historical importance.[11] The treatise very soon awakened the interest of the most important rulers of the time; Giangaleazzo Sforza and Piero de' Medici received dedicated copies; Matthias Corvinus and the King of Naples had copies or Latin translations made. Francesco di Giorgio and Leonardo da Vinci turned to Filarete's ideas on town planning in their own later urbanistic projects.

These urbanistic ideas of Filarete, however, could only find expression in the Duchy of Milan; for Filarete, Francesco Sforza himself was the exemplar of the building patron in the grand style; his schemes for Pavia and Milan, his improvements and regulation of the Lombard road and canal systems all bear an urbanistic stamp. It is not by chance that Filarete, in his treatise, describes the patron as the father, the architect as the mother of a building; it is in the spiritual union of both that the work is conceived to which, as it were, the architect gives birth.[12]

In actual fact, Filarete never enjoyed the authority which he attributes to himself, that is to the architect-in-charge, in his treatise. Obviously he was not of a practical turn o mind, and his function as a building superintendent was not only humble, but rich in disappointments; the hospital, on which he worked till 1464, is the only commission of his on which there is certain evidence, though even there he had to suffer the collaboration of Guiniforte Solari; his possible collaboration in the designs for the Sforza palace in Venice has already been mentioned. The death of Francesco Sforza in 1466 put an end to his work in Milan, which had always been troubled by friction with local masters.[13]

Nor is there any tangible evidence of the activities in Milan of Benedetto Ferrini (c. 1430–1479). Before 1456 he was engaged on work on the Castello, which cannot be clearly distinguished, and he remained in the service of the Sforza till 1479. In 1461 he was sent to Venice to inspect and draw the Palazzo Sforza; in 1469 he was working on the Certosa of Pavia, and later on various castles in the dukedom. In the Castello of Milan, parts of the Corte Ducale, especially the so-called Loggia of Galeazzo Maria, are attributed to him. The formal idiom of these parts shows that Ferrini too had adapted himself entirely to the Milanese tradition.[14]

Looked at from this point of view, the two buildings in Milan which are attributed in the older literature to Michelozzo take on a new significance: the Portinari Chapel adjoining S. Eustorgio (Plate 100) and the Banco Medico, now demolished; both were built in the sixties.[15] The donor of the chapel and probably patron of the palace too was Pigello Portinari, the manager of the Medicean Bank in Milan. When he died in 1468, the chapel was practically finished. It represents, technically and aesthetically, the transposition of the Sagrestia Vecchia of S. Lorenzo into the formal idiom of Milan. The basic idea – the spatial cube with a hemispherical dome – is retained, but everything has been enriched with ornament in the Lombard style. The same is true of the beautiful brickwork of the exterior; with its aedicule-shaped corner turrets and its drum and dome of tiburio type, crowned with a conical roof and spire, it presents a new and original solution. The interior too, with its polychromatic blurring of the structure, its balustrade of the drum, and its prolific ornament, has a pictorial effect which is far removed from the structural austerity of the Sagrestia Vecchia. The only structural element of Brunelleschi's building that can be recognized is the concentric double arcade on the east front.

The Banco Medico too, known only from Filarete's drawing (Figure 34), represents – and this is the decisive point – a deliberate blend of Florentine and Lombard forms. For the patron could have had a replica of the Palazzo Medici in Florence built without any qualms; there are examples of these 'imitations' in other towns (e.g. Imola).[16]

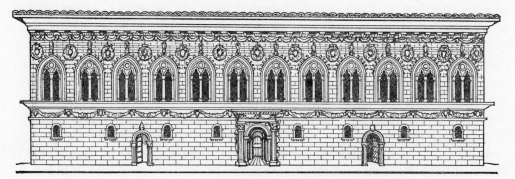

Figure 34. Milan, Banco Mediceo (demolished), 1460s, after a drawing by Antonio Filarete

Instead of that, the idea was obviously a deliberate approximation to the building tradition of the guest city; just as Francesco Sforza had wished to see Milanese and Venetian forms united in his Venetian palazzo, the Cà del Duca, the Medici may have intended to pay their respects, as it were, to the Milanese manner. Looked at in this way, the Portinari Chapel and the Medici Bank take on an individual importance as manifestations of 'architectural chivalry', and bear witness to the wealth of inventiveness in the architecture of the time. In comparison, assimilations of purely Tuscan forms, as in the Chiesa di Villa at Castiglione d'Olona, commissioned by Cardinal Branda Castiglione, are of little importance; besides, they had no successors.[17]

The native Milanese style of the first Sforza period was determined in all its essentials by the Solari family:[18] Giovanni (b. 1410), who had already been at work for the last Visconti, his son Guiniforte (1429–81), whom we have met as his father's assistant on the Certosa and as superintendent on the Ospedale, and Guiniforte's son Pietro (1450–93). Giovanni continued to work into the seventies; in 1460 he was succeeded by Guiniforte as *deputato* of the Certosa di Pavia, and in 1470 as *ingegnere ducale*. Guiniforte, who had executed the nave of the Certosa on older plans, gave proof of his originality in his design for the crossing and choir; this complex spatial group, evolving out of the juxtaposition of simple units, may be regarded as the ideal expression of the Lombard feeling for the new style.

In 1463, Guiniforte set to work on his first independent commission: S. Maria delle Grazie (Plate 101).[19] As a monastic church, its plan is related to the buildings of the late Trecento, for instance the Carmine at Pavia, but the design of the interior has been modified in one important respect: the supports are shaped as columns, and not as piers. With the great size of the bays, this gives a feeling of spaciousness which sets the building apart from its predecessors. The Renaissance forms used in the structure – composite capitals, short pilasters receiving the transverse arches – all look very tentative, but the spatial organization as a whole, with its great breadth and a height which is much reduced in comparison with the Certosa, shows a certain originality in spite of its meagreness. The choir, replaced at the end of the century by Bramante's new building, originally consisted of a simple main apse with two subsidiary apses. The exterior, in brick, with the triple grouping of the windows and the buttresses reduced to pilaster

strips, is a good example of a wall articulation which had, in its turn, evolved out of Lombardo-Romanesque forms.

The church of S. Pietro in Gessate, begun by Guiniforte about 1475, is a variation on the same theme.[20] Compared with S. Maria delle Grazie, the bays are wider, so that, given its low height, the space looks like that of a hall composed of a series of communicating compartments held together by the domical vaulting. The polygonal shape of the side chapels creates in the exterior a stimulating rhythm of slanting wall-planes. The alternation of pointed and round window arches has also been retained.

As an example of the persistence of this first phase of the Early Renaissance in Lombardy, we might mention the double church of S. Maria Incoronata in Milan; its northern part was begun by Giovanni Solari about 1451, its southern part completed by his grandson Pietro about 1487.[21] Further, the church of S. Salvatore at Pavia, begun in the seventies by an unknown master, deserves notice because of its peculiar variation of the Romanesque system of composing plans in square units and its restrained ornamental articulation.[22]

This quiet, at times almost jejune kind of building in brick was unquestionably the dominant feature of Lombard building;[23] it was very widespread in the province. In striking contrast to it there stands the lavish pictorial and sculptural ornament which was occasionally applied. If the terracotta decoration of the Ospedale Maggiore and other buildings, such as the so-called Lazzaretto and the Cappella SS. Leonardo e Liberata next to S. Giovanni sul Muro (architect: Lazzaro Palazzo)[24] is kept within moderate bounds, in the work of Giovanni Antonio Amadeo of Pavia (1477–1522), chiefly active as a sculptor, it takes on fantastic and exuberant forms. In the Cappella Colleoni in the Duomo of Bergamo, built between 1470 and 1473, he gave the first example of his strange and extravagant manner of decoration (Plate 102).[25] The complex and excessively subdivided forms of the windows and doorways stand out from the chequered surface of the façade. Lacking any unifying common measure, this host of dwarf pilasters and columns, towering above each other in tabernacles, ends up as an extremely primitive conglomeration of small units which cannot form an organic whole. In comparison with this method of mere accumulation, the Venetian surface ornament, which is certainly related to it, looks far more orderly. We may be sure that Mauro Codussi of Bergamo learned from the Colleoni Chapel to keep his ornament in hand and to give his buildings that Albertian orderliness which is particularly noticeable in the decorative system of S. Zaccaria in Venice.[26]

The façade of the Certosa of Pavia, the original composition of which (about 1470) by Solari corresponded almost exactly to the section of the church (reproduced in a fresco by the Borgognone brothers), was abandoned in 1492 in favour of its present form. Nothing remains of the first phase but the reliefs and small figures of the lowest register; all the rest belongs to the second building period (executant masters, Amadeo and Mantegazza), who, in their attempt to group the great surface in structural units, already show the influence of Bramantean order (for literature, cf. Note 5).

Not many examples of secular building of the period have survived in Milan. In the past few decades many an old building has been sacrificed to the *piano regulatorio*;

the only representative town mansion of the first half of the century to have survived is the Casa dei Borromei, with its brick façade beautifully relieved by a fine marble portal, and its courtyard a good example of the Lombard pleasure in decoration. The second half of the century can only be illustrated by the Ospedale Maggiore and some parts of the Castello Sforzesco: the Rocchetta and the Corte Ducale with Ferrini's loggia. The Casa dei Notai is also a relic of the time.[27]

After Francesco Sforza's death there was a short period of stagnation in Milanese building. The 1470s were mainly occupied with the continuation of the schemes put in hand under Francesco. It was not until Ludovico il Moro took over the government (1477) that building entered on a new phase of activity that brought with it a complete metamorphosis of style. It was Ludovico who took Bramante and Leonardo da Vinci into his service.

By this summons to Milan, we may say that Donato Bramante[28] was transported into an environment which fostered his architectural imagination in every way. A native of Urbino, Bramante had become familiar with the disposition of plain, monumental forms in Laurana's Palazzo Ducale and the works of Francesco di Giorgio, ten years his senior (Duomo, the hospital of S. Chiara, S. Bernardino). Above all he had gained an insight into the solution of important spatial problems; how great may have been his actual share in the work, say, of the Cappella del Perdono, will always be guesswork.[29] At Mantua, which he at any rate passed through on his way to Milan, he became familiar with Alberti's great projects, which were being carried out under the super-intendence of Luca Fancelli. In Milan itself, where Bramante must have begun work about 1480, two experiences awaited him. The first was his encounter with the rich tradition of Lombard architecture, which ranged from such majestic buildings of antiquity as S. Lorenzo with its annexes, and the huge basilica of S. Simpliciano, to the Duomo and the Certosa; the second was his meeting with the greatest genius of the age, the most sensitive seismograph of all that was going on in the art of his time: Leonardo da Vinci. For nearly twenty years the two men worked as *ingegneri ducali* at Ludovico's court; there they came into contact with other famous masters of the age such as Francesco di Giorgio and Giuliano da Sangallo, who had been summoned to Milan as consultants. Bramante and Leonardo were in constant touch with the local architects Amadeo, Agostino de Fonduti, Dolcebuono, and others. From all these circumstances, one important fact emerges: a man like Bramante, himself a born architectural genius, found everything at hand that tradition and the new style had to offer – in Tuscany, the Marches, and in Lombardy, which included Roman and Byzantine antiquity as far as it was visibly present in the monuments of Milan. It was on this broad foundation that Bramante formed his 'pre-Roman' style as a first synthesis of the potentialities of the Quattrocento, which also embraced all the achievements of the local styles. All Bramante's works in Lombardy are governed by this law of a 'synthetic language of form'.

About 1476 it was decided to add to the small pre-Romanesque centrally planned church of S. Satiro in Milan an oratory in honour of the miracle-working picture of the Virgin – S. Maria presso S. Satiro.[30] But it was not until 1478 that the site could be acquired which was necessary for the right part of the aisleless plan. Then work went

ahead quickly; in 1482 the gilding and painting of a wooden tabernacle was already under way. Bramante's name first appears in the documents in December 1482, in connection with the enlargement of the church to its present size; that he was already in charge of the first building period can only be deduced from its style, yet its formal idiom admits of no other conclusion. The oblong room (Figure 35) is an inspired variant of Brunelleschi's Pazzi Chapel. The latter, which is too often – and mistakenly – described as a centrally planned building, is a rectangular room formed of a central, domed square with barrel-vaulted bays to left and right. Exactly the same principle has been applied in the oratory of S. Maria presso S. Satiro, with the difference that the barrel-vaulted arms to left and right of the domed space comprise three bays. Thus an impressive spatial composition comes about which is dominated by the contrast between the central dome and the two equal barrel-vaulted arms. The monumentality of the interior is enhanced by a simple, yet consciously studied articulation of the walls; the row of shell-hooded niches along the walls – a very brilliant variant of the flat niches in the choir of the Sagrestia Vecchia and the series of chapels in S. Spirito in Florence – is Albertian in its simplicity; the great shells recall the niches in S. Marco in Rome, the splendid coffered barrel-vault S. Andrea at Mantua, which Bramante knew not only from the model, but from the vestibule of the façade, which he had seen. The space thus created is of great and distinctive beauty. On one narrow side it led into the centrally planned church of S. Satiro.[31] The new facing of this small, pre-Romanesque building is a masterpiece of Quattrocento restoration (Plate 104); the maturity of the individual forms suggests that it was only completed during the second stage of building. Every detail speaks of the reverence which Bramante, the restorer, felt for this monument of the past. There is a clear insistence on the compactness of the small building which comes from the exterior niches scooped out of the thickness of the enclosing walls, and from the pilasters and cornices in the upper storey, which underline the solidity and massiveness of the whole.

While the oratory was being built, the idea arose of enlarging the church into a basilica. In 1482, the confraternity in charge of the building purchased the site between the present via Falcone, where the oratory now stands, and the present via Torino, on to which it now faces. The building of the sacristy was taken in hand immediately after; Bramante appears both as witness to the deed of purchase of the site, and in the building contracts, in the latter side by side with Agostino de Fonduti, who was commissioned for the terracotta work in the sacristy. The change of plan is unusual and bold (Figure 35); what had been the oratory became the transept of a church with nave and aisles; its very short nave (five bays) stretches to the present via Torino. Thus the façade was turned to the south and the new choir to the north. Work on the enlargement must have gone ahead speedily; in 1486 Amadeo was already put in charge of the execution of the façade under Bramante's supervision; however, only the plinth was built, and the rest was not completed till 1871.

The present interior of S. Maria presso S. Satiro has been very much disfigured by the later raising of the floor and the utter neglect of the walls and vaulting. Yet the grandeur of the initial conception can still be felt at first sight (Plate 103). The prevailing im-

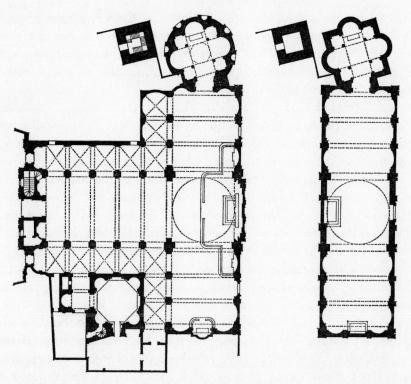

Figure 35. Donato Bramante: Milan, S. Maria presso S. Satiro, begun 1478, plan

pression is of horizontal spread; the weighty barrel-vault spans a broad, short nave; the massive pillars with their attached pilasters look almost like walls, so that the dark, low aisles hardly appear in the general spatial effect. What dominates the whole is the nave, and thus even here, in a formal idiom deriving from Alberti and Piero, a constant feature of Lombard architecture is retained – its broad and comparatively low proportions.

The sober terracotta ornament harmonizes with the simple structural elements of the piers and pilasters; the capitals are richly varied, even to figured composite formations. One remarkable detail, to my mind, is that Bramante has given the pilasters seven flutings, another Albertian motif.

This stimulating invention culminates in the famous illusionistic chancel.[32] The exigencies of the site left no room for a chancel, and thus the first example of illusionistic Renaissance architecture came into being. From the entrance to the church – the view-point – the observer imagines he sees a fully developed rectangular chancel continuing the structural system of the nave; its barrel-vault seems to prolong the vault of the nave beyond the dome. The principle of a scenic illusion to be obtained from a definite view-point has been carried out with perfect consistency; we have already seen it as an essential characteristic of Renaissance architecture beginning with Brunelleschi, and continuing by way of Rossellino's layout of the piazza of Pienza and Alberti's spatial organization of space, and the court of Urbino. Its extreme form in Bramante's feigned

chancel also reveals the comparative inflexibility of an Early Renaissance space of the kind; it is conceived from an ideal angle of vision and comes to its full effect only from that angle. The moment the observer leaves this 'calculated' viewpoint and approaches the choir, the whole construction collapses into flat relief, although even then it remains fascinating as an architectural backdrop.

Tuscan and Lombard traditions are also blended in a successful synthesis in the sacristy of S. Maria presso S. Satiro. While in the church it is the spatial proportions which have the greatest appeal, the dominating effect in the sacristy comes from the masses; the structural elements of the small, high octagon, the piers broken round the angles, the profiles of the niches, the heavy mouldings of the cornice and balustrade zone, and the arcading in the upper storey are very compact and their massive effect is increased by the high relief of the lavish ornament. Agostino de Fonduti was working here under Bramante's instructions, and one can clearly feel how his Lombard love of ornament had been held in check by his master's sense of architectural order.

We may also visualize a similar moderation in Amadeo's design for the façade, which was no doubt stricter in its structure than the bizarre ornament of the Cappella Colleoni at Bergamo (Plate 102).

No reproduction can render the simple dignity of the choir front on the via Falcone. Here, for the first time, a classical language of form has been found for brickwork; it is based on the application of simple, but carefully calculated proportions and groupings; the treatment of the wall surface with its panels sunk between the pilasters is of great refinement; the attic zone is beautifully enlivened by moulded frames, which vary in size according to the structure of the wall below. In the zone of the pediment and architrave, the quiet and delicate ornament reflects the spirit of Urbino.

Though the church of S. Maria presso S. Satiro is small, both its interior and exterior have a monumentality which is achieved solely by the purity of the constituent elements. In this, his first work, Bramante already gives evidence of his perfect mastery of his art, and this is further confirmed by his magisterial solution of the very difficult planning problem it presented.

When Bramante was summoned to Pavia in August 1488 to report on the great scheme for the rebuilding of the cathedral, he found the plan already far advanced.[33] True, the minutes of the meeting speak of a 'plan prepared in the last few days', so that considerable alterations to the original design may be taken for granted. Yet it seems to me doubtful whether we can recognize the hand of Bramante in the building as it was erected and in the surviving model of it. Cardinal Ascanio Sforza, Duke Ludovico's brother, was an ambitious patron. It looks as if he wished to unite in his cathedral the best of all the architectural ideas that had been tried out in the most important buildings of the recent past. The huge octagonal domes which had been built at Florence, Bologna, Siena, and finally at Loreto, with the object of enriching the basilican plan with a dominating central motif, were prototypes for the cathedral of Pavia just as much as the elaborate naves with side chapels which could be seen in S. Spirito in Florence or at Loreto. It was laid down that the great theme of the centralized basilica was to appear 'in its most modern variation'; the ground plan of the model shows clearly how

abstract and intellectual the conception actually was; the corner sacristies make the plan look like a piece of geometrical ornament.

It will probably never be possible to estimate the extent of Bramante's share in this peculiar plan. I have the feeling that there is more in it than the whim of a patron who summons the best available specialists to carry it out. When Leonardo and Francesco di Giorgio were also invited to Pavia in 1490 as advisers, a model (by Cristoforo Rocchi) was already in existence (Plate 105); it subsequently underwent many alterations, but they were probably restricted to details of form or proportion; as a whole the plan bears

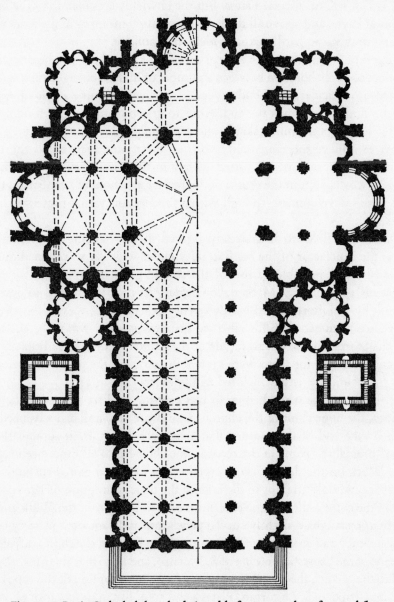

Figure 36. Pavia Cathedral, largely designed before 1490, plan of ground floor

all the marks of a basic idea which was consistently adhered to in the execution (Figure 36). Bramante's influence on the project may perhaps be recognized in the severe and simple forms which distinguish the mighty substructure of the crypt (Plate 106) and the lowest storey of the exterior. In comparison with the complicated details of the model, they bear the mark of moderation, of restriction to simple structural units. The idea of a composite plan, both centralized and basilican, probably corresponded very largely to Bramante's conception of an ideal architecture. A reflection of the intense preoccupation with new forms of religious building of the time can be seen in Leonardo's architectural drawings, which will be discussed later. But the unwieldy articulation of the interior of the Duomo of Pavia, and above all the lack of structural meaning in the piers with their multiple architraves, can hardly express ideas of Bramante.

The Duomo of Pavia, like other enterprises of the kind which will be discussed later, as the product of a collaboration between a number of masters engaged on it, shows how far Lombardy in particular, at the end of the Quattrocento, became a field of experiment in architectural ideas, in which the endeavour to group complex spatial units, often of considerable size, appears unmistakably and repeatedly. This attempt may be regarded as an effort to achieve monumentality with all the means available at the time; the experiments led to results which varied widely in form and quality, and found their expression, as we shall see, in the works of the Bramante school of Lombardy. Bramante took part in this development, though with a moderation which preserved him from any excess.

While Ludovico il Moro had already figured in the building of S. Maria presso S. Satiro as the benefactor of the confraternity under which it was carried out, he was in every way the responsible patron of the second great enterprise of the decade in Milan, the enlargement of S. Maria delle Grazie.[34] In 1493 he decided to demolish the chancel built by Guiniforte Solari hardly twenty years before; we can therefore realize the importance he attached to his scheme. The new chancel was to be the memorial chapel of the Sforza. The nave and façade of the church were to have been rebuilt after its completion; designs for them were invited in 1497, but the project was not realized owing to the political events which led to Ludovico's fall in 1499.

Thus at the very time when Leonardo was painting his Last Supper in the refectory of the priory, the huge choir of the church arose (Plate 107) and had advanced so far in the rough by the end of the century that a bell was hung. Even though there is no mention of Bramante's name in the records, the choir has at all times been regarded as his work. Work on the decoration dragged on so long and passed through so many hands, that we can only attempt to distinguish the basic conception of Bramante's plan. His share in the composition of the exterior is easy to recognize: the plinth and the first storey with its rectangular, slightly curved panels display Bramante's mastery of decoration in the delicacy and economy of the motifs. As an interior, the choir is a last variation on the theme of the Sagrestia Vecchia of S. Lorenzo, and since that was built as a memorial chapel to the Medici, there may have been a conscious adoption of the type by way of the Portinari Chapel in S. Eustorgio (Plates 4 and 100). But in the choir of S. Maria delle Grazie, the whole has been transposed into huge dimensions. The space is immensely

wide, and so flooded with light from the great niches and the rows of windows in the drum that the walls seem no more than a thin shell. This curious relationship between the thinness of the material substance and the vast space it encloses is confirmed by the plan; it seems to set the extreme limits within which a spatial composition of this character and this construction could be set up. There can be no doubt that the architect was primarily concerned with an ultimate intensification of the experience of space: all the structural and sculptural elements – pilasters, cornices, and ornament – are there to serve this spatial design. The choir of S. Maria delle Grazie is the last and most magnificent work that could be carried out with the technical and formal means of the Quattrocento. But at the same time it marks the utmost limit of the attainable; an Italian architect venturing at that time to think and plan in such dimensions would simply find himself thrown back on that epoch which had succeeded to perfection in mastering monumentality, though under different aspects – Roman antiquity.

When Bramante suddenly vanished from Milan without leaving a trace in 1493, and Ludovico had him searched for in Florence and Rome – he returned to Milan the same year – it seems to point to a first spontaneous effort on Bramante's part to seek contact with the world of Rome; it may have been his meeting with Francesco di Giorgio and Giuliano da Sangallo, the indefatigable draughtsmen of antique monuments, which prompted him to make the journey. It would be worth while to seek for traces in Bramante's last works in Milan of a first, immediate experience of Roman antiquity. The scale of the cloisters of S. Ambrogio,[35] with their layout in classical orders (Doric court and Ionic court), unquestionably based on a design by Bramante, might possibly be interpreted as a first reflection of his encounter with Rome; the structure of the range called the Canonica,[36] too, is quite different from anything previously built in Milan. The decisive point, however, is that Bramante must have felt, in his last work in Milan, the urge to see Rome, the only place where his feeling for monumentality could find a response. And when Ludovico Sforza fell in 1499, he seems actually to have made straight for Rome.

Bramante's first plans for St Peter's are still largely based on the experience he had gained in Milan. The richly ornamental composition of spatial groups, which is what the famous parchment plan actually represents in the last resort, is the direct product of abstract conceptions of the ideal central plan, which evolved out of the study of North Italian monuments (S. Lorenzo, Milan) and was transposed into the rationalized structure of the Tuscan school.[37] Leonardo's architectural drawings, which will be discussed later, reflect this language made up from a combination of elements in all its variations. Further, the parchment plan is a kind of abstract scheme without any relevance to practical execution; the piers are far too thin to guarantee the stability of this gigantic complex. It was only from his personal contact with Roman antiquity that Bramante gained the experience, and with it the ability, to begin, and to complete in part, the great commissions which were entrusted to him in Rome. In the whole history of architecture there are few metamorphoses of style so radical and so evident in the work of a single artist as that which appears in the 'ultima maniera' of Bramante in Rome. This metamorphosis will be dealt with in the second part of the present volume.

The influence of Bramante in Milan and Lombardy became dominant in the last twenty years of the century. It was an age of eager building, and many works were started which got no further than their beginnings, or were slowly completed in the course of the following century. The spirit of Bramante can be felt both in the fertile imagination of his church designs and in their individual formal elements. Only the most important can be named here.[38]

In Milan itself, Giovanni Battagio da Lodi built the centrally planned church of S. Maria della Passione (1482–5), a massive octagon articulated by piers and with four chapels on the main axes;[39] the articulation and ornament of the exterior is characteristic of the idiom which derives from Bramante, but it is transmuted into a rich capriciousness. When Martino Bassi set a nave in front of the church between 1573 and 1591, the result was a work which preserves the Lombard tradition throughout – derivative evidently from the Duomo of Pavia. It has a very beautiful sacristy; the paintings on the coved ceiling are by Borgognone.

In contrast to the octagon of S. Maria della Passione, the church of S. Maria presso S. Celso, begun in 1493 by Giovanni Giacomo Dolcebuono and continued later with the assistance of Cristoforo Solari and Amadeo, has a central plan with a centre on four piers.[40] The ambulatory was not built till 1525; at the same time work was begun on the nave and aisles, so that the original plan of the building can hardly be made out today; it corresponded very closely to Leonardo's type with four piers and four apses.

The same fondness for exciting plans and prolific ornament can be seen in the Incoronata at Lodi (foundation stone laid on 5 May 1488) and S. Maria della Croce near Crema (begun 1493), both after designs by Giovanni Battagio.[41] While the former reverts to the type of the sacristy of S. Maria presso S. Satiro, though transforming its decoration into painting, the sanctuary of Crema is a simple round church with four subsidiary centres arranged Greek-crosswise and covered with curiously shaped domes. The composition of its exterior in polychrome terracotta is one of the most characteristic examples of the Lombard feeling for ornament (Plate 108). To complete this catalogue of types, we might add the Madonna di Piazza at Busto Arsizio;[42] it was actually built at the beginning of the Cinquecento, yet as a scheme it belongs entirely to Quattrocento *varietà*; the exterior a simple cube, the interior vaulted with an octagonal dome, so that four triangular spaces remain in the lower storey which function as chapels. Centrally planned buildings of the kind, varied in every conceivable way, are strewn all over Lombardy and show surprising differences not only in the arrangement of their plans, but also in their structural articulation; besides the pilasters broken round the angles (sacristy of S. Satiro, the Incoronata, Lodi) there are free-standing corner-columns (Sanctuary, Crema; S. Maria Coronata, Pavia). On the whole, the superstructure with the tiburio-shaped dome prevails, but there are perpetual variations in detail.[43]

In this connection a very capricious example of a façade composition on Bramante's lines must be mentioned – the monumental front of the church of S. Maria Nuova at Abbiategrasso.[44] The façade, standing in a cloistered courtyard, is set before a huge, barrel-vaulted *pronaos*; an arch of the lowest storey bears the date 1497. This important invention is utterly different from the entrance arches to the Canonica of S. Ambrogio,

although they too bracket two storeys. While in S. Ambrogio a single giant order of pilasters carries the arch, in S. Maria Nuova there are two superimposed orders of coupled columns. This is an unmistakable assimilation of a Romanesque portal motif (Verona, Venice),[45] which has been transposed into the idiom of the new style and obviously used for its perspective effect. Through this purely decorative architecture the cloisters are given a visual accent of great charm. We may suspect that Bramante was the author of this original and bold invention, although there is no documentary evidence to support it. The delicacy of the ornament too suggests his guiding spirit.

Finally, the layout of the Piazza Ducale at Vigevano, which Ludovico il Moro undertook about 1494 to beautify the town of his summer palace, is a piece of town planning in which Bramante, as *ingegnere ducale*, certainly took part. In spite of its present ruinous condition, there is still in the piazza a breath of the great idea by which a single plan was to take in the palace, the cathedral, and the public buildings. From that point of view, Vigevano takes on considerable historical importance as one of the few town plans of the Quattrocento which can still be reconstructed.[46]

Bramante's manner has also left its mark on the exterior of the cathedral of Como. That applies in particular to the façade and side walls, the rich decoration of which was executed by Tommaso and Giacomo Rodari (end of the Quattrocento).[47] The portals on the north and south fronts, especially the so-called Porta della Rana, are entirely covered with Amadeo's overloaded ornament. On the chancel, however, with its giant order, Bramante's rules have been observed. Though it was not built till 1513–19 (by Tommaso Rodari and Cristoforo Solari in collaboration), it still belongs very largely to the same phase of style as the Duomo of Pavia.

We know of no palazzo built by Bramante during the years he spent in Lombardy, but his influence on the secular building of the period can be clearly seen in the work of other men. Amadeo's Palazzo Bottigella at Pavia takes up the motif of the order of pilasters used by Bramante in the painting of the Casa Fontana Silvestri in Milan;[48] here too the broad cornice with its terracotta ornament gives greater stress to the horizontal than to the vertical dominants of the structure. Where no pilasters are employed, the characteristic breadth of the Lombard façade comes out more clearly, for instance in the Palazzo Ghisalberti at Lodi, where the pointed window arches still adhere to the generation of Filarete, or the Palazzo Fodri at Cremona, where the mezzanine cornice with its circular windows bears the stamp of the school of Bramante.[49]

The Palazzo Raimondi at Cremona, on the other hand, with its coupled pilasters, the tile-like square bosses of the masonry, and the plain but beautifully moulded cornices and window surrounds, has an artistic quality of its own (Plate 109). The architect, Elviso Raimondi, known only by this building, was able to refine formal elements of the Bolognese-Ferrarese manner with the Bramantesque feeling for harmonious proportions, and thus created a work which is a model of those regional achievements which appear so often and so surprisingly at the time.[50]

A similar summit of regional architecture is the loggia of the Palazzo Comunale at Brescia (Plate 111). It would be rewarding to consider the communal palazzi and the Logge di Consiglio of the Quattrocento as a whole. It seems to me that the ambitions

of the rival cities were specially fired by this theme, and the architects stimulated to a special display of their imagination. The Palazzo Pubblico at Pienza (1458–62)[51] is one of the earliest solutions of the problem; its specific interest lies in the combination of loggia and palazzo. The Palazzo Prefettizio at Pesaro (loggia before 1465)[52] shows the first example of the rustication of free-standing piers, a motif which reappears between 1483 and 1495 in the massive structure of the Palazzo del Podestà at Bologna;[53] these peculiar rusticated piers *in modo rosarum* are combined with powerful engaged columns. The Palazzo del Consiglio at Verona, built at very irregular intervals between 1474 and 1493, is another example of originality of form (Plate 110). The traditional ascription to Fra Giocondo has proved untenable; whether Antonio Rizzo worked on the building remains a matter for conjecture. In the clarity of its composition and the delicacy of its ornament, the Verona loggia is one of the outstanding works of the Lombardo-Venetian style. Its rather later sister-building – cooler and simpler in its ornament, but enriched with a splendid landing on the staircase – is the Loggia del Consiglio at Padua, begun in 1501.[54]

From this series the Loggia of Brescia stands apart (Plate 111).[55] No reproduction can render the impression of concentrated energy radiating from the columns, which are partially embedded in the wall, and the projections of the entablature above them. This gives the wall an extraordinary three-dimensionality, which is reinforced by the roundels with busts in the spandrels and the lions' heads in the frieze. The interior of the Loggia is a huge hall; the capitals of the columns are unusually ornate and of outstanding workmanship. In the accounts between 1492 and 1508, a certain Filippo Grassi appears as the executant; there is also evidence of his work as a stonemason on S. Domenico at Cremona. Yet it is difficult to credit him with an invention worthy of a great artist. The Loggia of Brescia is one of those works of the end of the century which impressively herald the grand style of the classic age. In a general way, Brescia is distinguished from the other Lombard cities by a peculiar nobility, which was already expressed in its medieval buildings – Duomo Vecchio, S. Salvatore, Broletto, and above all the Torri della Pallata and del Popolo, with their immense rusticated basements.[56] In 1424, Brescia, which till then had belonged to the Visconti, came under Venetian rule, and this soon affected its art. In the balcony of the Loggia del Monte di Pietà, there is a motif of Venetian palazzo architecture of a type that also appears in the secular building of Verona and Vicenza.[57] It seems almost by chance that a 'giant order' appeared in this building, since a passage between two plain blocks required an enframing motif.

The readiness with which art at Brescia laid itself open to Venetian influence, only to transpose it into a regional idiom, can be seen in the very original church of S. Maria dei Miracoli, begun in 1488 by a Maestro Jacopo. The vaulting forms of the Venetian inscribed cross plan are, as it were, reversed, the crossing and corner chapels being barrel-vaulted, the transepts domed. Once again, the squat proportions seem to me to point to Lombardo-Bramantesque influence. The gallery built for the display of the miracle-working image gave rise to the unusual 'oriel' on the exterior of the façade. As a whole, S. Maria dei Miracoli is a very strange, not to say unique solution which could only be achieved in an area of experiment such as Lombardy.[58]

In its particular wealth of fantasy, Brescian architecture has a certain resemblance to that of its neighbour city of Mantua; in the antique busts of the loggia of the Palazzo Municipale, of the portal of the Archivio Notarile, or the Palazzo Pellizzari, we can feel something of the *romanità* of Alberti and Mantua.

CHAPTER 11

EMILIA AND ROMAGNA

EMILIA, a spreading and mostly level territory between the Po and the Apennines, possessed, like Lombardy, an ancient tradition of building in brick, and, as a natural adjunct to it, of ornament in terracotta. The forms of the new style were largely determined by the adaptation to this material, except where the use of stone required other forms.

At Bologna, most of the important churches were taken in hand in the thirteenth and fourteenth centuries; this work culminated in the gigantic project for S. Petronio. Building began in 1390. It was to have far excelled the Duomo of Florence in size and beauty. The great enterprise (Figure 37), conceived by Antonio di Vicenzo,[1] one of the greatest architects of the turn of the century, kept the Gothic tradition alive throughout the Quattrocento; the architects of Bologna remained pledged to it for a very long time. A good example of this survival is the church of S. Giovanni al Monte,[2] started in 1440 'ad similitudinem ecclesie sancti Petroni novi'.[3] Its groin-vaulted basilican interior is subdivided into a nave and aisles by octagonal piers of Gothic provenance (Plate 112). The dome (built in 1496) rests on squinches, the façade (designed in 1474) shows Venetian influence in its segmental pediments. In contrast, the little church of Corpus Domini,[4] built in 1478-80, shows more marked features of a new style; its ornament is developed entirely in brick and terracotta (Plate 113); the semicircular pediments of the façade are again Venetian in origin. A still more ornate façade is that of the little oratory of S. Spirito (1481-97);[5] its proportions are so arbitrary that it might be a shrine rather than a church. The same type, with the same broken, stepped-back pediment, can be seen in a purer form in the church of S. Pietro at Modena (after 1476).

The huge aisleless S. Giacomo Maggiore[6] received its individual – that is, Venetian – stamp only when it was vaulted in 1493 with four shallow domes. An importation of purely Florentine forms, on the other hand, can be seen in the Cappella Bentivoglio behind the ambulatory, built soon after 1458. It has always been ascribed to Michelozzo's pupil, Pagno di Lapo Portigiani (1408-70),[7] who settled at Bologna in 1453. Another typical Bolognese feature is the loggia along the south front, built between 1477 and 1481; the columns are the work of Tommaso Filippi; the terracotta ornament may be by Sperandio.

Bologna is one of the most important centres of Quattrocento palace architecture. Here, too, the fusion of Gothic and new forms is characteristic; this comes out very clearly in a comparison of the work of Bolognese architects such as Fieravante Fieravanti (1380-1447) and his son Aristotile Fieravanti (1418?-86),[8] with that of contemporary Florentine masters such as Pagno di Lapo and Francesco di Simone. Fieravante worked on S. Petronio from 1437 to 1444 and played a decisive part in the building of the Palazzo del Comune. His son Aristotile continued this work into the sixties, though he

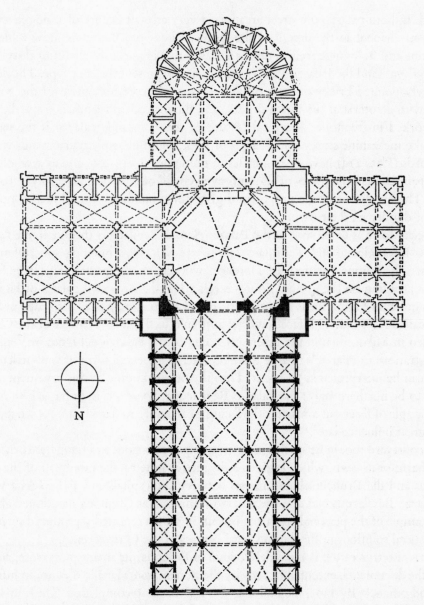

Figure 37. Antonio di Vicenzo: Bologna, S. Petronio, begun 1390, plan of the wooden model (the black parts roughly represent the executed parts of the church)

was often called away from Bologna to act as expert in engineering projects and as a specialist in the building of campanili and on defects in them. In 1466 he was summoned to Hungary by Matthias Corvinus and later went on to Russia, where he became famous as master of works at the Kremlin and the church of the Annunciation in Moscow.[9]

Side by side, and sometimes in collaboration with him, Pagno di Lapo of Florence was at work at Bologna. According to the documents he took part in the building of the portico of the Palazzo Bolognini-Isolani, and he is also named as the architect of the Palazzo Bentivoglio, demolished in 1507, on which Aristotile Fieravanti had also

worked. In both palazzi, the street arcades – a very ancient feature of Bologna – are an important element in the design of the façade. Thus both buildings show a blend of Florentine and Bolognese architecture as it was in that phase of the transitional style. The Palazzo Fava[10] and the Palazzo Pallavicini-Fibbia[11] represent the later type. The delicate and finely pointed brickwork sets off the elegant terracotta ornament of the window arches with acroteria at the top and sides, and the individual members (capitals, bases, etc.) worked in freestone. A typical feature of the Bolognese palazzo is the narrow, frieze-like mezzanine storey under the roof with round or semicircular windows. The courtyards (Plate 114) have open arcades in the upper storey too, and as a whole look more spacious than the three- or four-storeyed cortili of Florence, especially as they are lower. The excellence of the proportions gives these buildings, for all their simplicity, an aloof dignity of their own.

A special form is to be seen in the Palazzo Sanuti-Bevilacqua (begun about 1480).[12] Marsilio Infrangipane and Tommaso Filippi are named as building superintendents. Francesco di Simone Ferrucci, of Florence, worked on the portal. The long front – without arcading on the ground floor – is related to the rusticated palazzi of Florence; what is quite un-Florentine is the prismatic cut of the masonry to a sharp edge or point, the so-called facet-cut. This facet-cut first appeared in the corner towers of the Castello Sforzesco in Milan, then in the basement storey of the Palazzo del Duca in Venice; in the illustrations to Filarete's treatise there repeatedly appears a form of wall-articulation which can be interpreted as facet-cut. Thus the original home of this ornament would appear to be northern Italy: the Palazzo Bevilacqua, however, is, as far as I know, the first example of facet-cut ashlar for the facing of an entire palazzo front. As we shall see, it had great influence later.[13]

The courtyard too, in its spaciousness, its noble proportions and temperate ornament, has a charm of its own, which is given a distinctive note by the rare form of the fluted columns and the Brunelleschian imposts between the capitals and arches. As a whole, the Palazzo Bevilacqua – as also the Palazzo Raimondi at Cremona mentioned above – is an example of the personal wealth of invention which repeatedly produced surprising architectural solutions in the various local centres of the Quattrocento.

That is also true of the Palazzo del Podestà of Bologna; its arcade piers were, according to the documents, executed in 1485 by the stonemason Marsilio d'Antonio Infrangipane and others.[14] By 1495, the building was approaching completion. The four-leaved pattern of the bosses (*bugne al modo rosarum*) of these pillars is unique; the heavy half-columns set before the piers, the projections in the cornice with its balustrade, and the upper storey with rusticated window surrounds and pilaster articulation are impressively monumental, and many details point to a relationship with the Loggia of Brescia, but seem, beyond that, to anticipate such stylistic peculiarities as those of Antonio da Sangallo. The architect of this imposing building, work on which lasted into the sixteenth century, is unknown.

In comparison with the city of Bologna and its great diversity of architectural forms, Ferrara stands for the type of the more uniformly designed princely capital. The general picture of the town was determined to a large extent by the work of the Este.[15]

Ferrara too possessed a tradition of brickwork and terracotta ornament; the latter is characterized by a quite local fantasy – love of vegetal elements, garlands, swags, etc. – which are also to be seen in the decorative parts of Ferrarese painting (Cosma Tura, Francesco Cossa, and Ercole Roberti).[16] On the other hand, the Renaissance made a true state entry into Ferrara, in a humanistic form, as it were; the council held in the city by Eugenius IV in 1438 brought Alberti, among others, to Ferrara, where he was soon on terms of close friendship with Meliaduse d'Este and later with Niccolo, and especially Leonello d'Este. He often returned to the city, for instance in 1443, and an echo of his influence may be seen in the Arco di Cavallo and the campanile of the Duomo.[17]

The two great patrons of Ferrara, however, were Borso I (1413–71) and Ercole I (1471–1505). Under Borso, who developed the town to the west by what is known as the Addizione Borso, the remodelling of the Palazzo Schifanoia as a summer palace was taken in hand in 1462; it has become famous mainly for its frescoes by Francesco Cossa.[18] The building superintendent was the court architect, Pietro di Benvenuto degli Ordini. The great brick façade has the characteristic Ferrarese windows with jutting round arches beautifully ornamented with terracotta; the portal too, which is believed to have been built after a design by Cossa, shows typical motifs of Ferrarese ornament.[19] Another important work by Pietro di Benvenuto is the Scala Aperta in the Ducal Palace, which clearly shows influences from Verona and Venice; it was built in 1481, that is, in the time of Ercole.[20]

This was the artistic environment in which the artist was trained who was to give the town its architectural countenance in the last decade of the century, and who deserves notice as an outstanding representative of Quattrocento architecture in Italy: Biagio Rossetti (1447–1516).[21] The descendant of a well-known Ferrarese family, Biagio was apprenticed to Pietro di Benvenuto and was his assistant on the Palazzo Schifanoia. In 1483, after Pietro's death, he succeeded him as *architetto ducale*. Of the buildings he planned in the eighties, the original aspect of the Palazzo S. Francesco-Pareschi, which underwent far-reaching alterations in the eighteenth century, can only be reconstructed from an old drawing which shows that Rossetti's formal repertory implied a knowledge of the palazzo architecture of Bologna; the richly ornamented twin windows with three acroteria only appear in this form in Bologna (e.g. Palazzo Bentivoglio or Bevilacqua); the design of the portal, on the other hand, with its balcony and great coat-of-arms, is a monumental development of a Ferrarese type which first appeared in the Palazzo Schifanoia. The only example of Rossetti's early religious work to have survived is the campanile of S. Giorgio (1480–5); the simplicity of its structure is an exemplar of the cool classicism which is the chief characteristic of Rossetti's style.[22]

The great development in Rossetti's work set in in 1492, when Ercole commissioned the plan for the Addizione Ercole. Although it is the most important systematic piece of town-planning in the whole Quattrocento, the Addizione Ercole had not received the attention it deserves, apart from local literature, until Bruno Zevi provided the one adequate analysis of the idea and execution of a great enterprise. The Addizione Ercole was a planned extension of the city towards the north on a large site enclosed by a wall with seventeen towers and four gates.[23] The line of demarcation from the old town is

the street called the Giovecca; the main axes of the new town are the via Prione from east to west and the via degli Angeli from north to south; their crossing and the Piazza Nuova are the main centres of the plan.[24]

Biagio Rossetti was the architect-in-charge. Apart from the girdle of walls, he built or superintended the building of four churches and eight palazzi within the site of the Addizione Ercole.[25] Further, in the old town, he supervised the building of S. Francesco, S. Maria in Vado, and the choir of the Duomo, and built, in addition to his own house, Ludovico Moro's summer palace. We can only select the most important works for comment from this unusually rich and diverse œuvre.

In church building, Rossetti displays an intelligent eclecticism, making use both of Lombardo-Venetian and of Tuscan models, and blending them with a strict, at times deliberately cool classicism – perhaps his heritage from Alberti – in imposing spatial compositions.

In S. Francesco[26] he takes up the type of the Duomo of Faenza, which expanded the Brunelleschian scheme by the great but shallow domes without pendentives in the nave and a rhythmic alternation of supports. Rossetti abandoned the alternating supports and covered his nave with a series of huge shallow domes on pendentives; the transverse arches of the bays stand on corbels in the clerestory, so that the horizontal architrave runs without hiatus. The bays in the transepts are also domed, as are the compartments of the aisles. The terracotta ornament of the arcades and architrave gives the space its characteristic stamp. The exterior (Plate 115), especially the façade with its pilasters and volutes, reflects the somewhat sober classicism of its creator.

In the basilica of S. Maria in Vado, Rossetti employs a flat roof in the nave, groin-vaults in the aisles, a shallow dome over the crossing, and a barrel-vault in the transepts. The elevation of the interior, with the tall pedestals to the columns and the pilasters in the crossing, again shows Venetian influence.[27] The original appearance of the exterior has foundered in later alterations.

S. Benedetto was seriously damaged in the Second World War and very much disfigured in the rebuilding. As a basilica with alternating supports, with a high dome on a drum over the crossing, with alternating domes and barrel-vaults in the nave, with little domes in the aisles and semicircular outer chapels, the plan is a remarkable blend of Venetian and Tuscan elements; the 'tiburio' externally is purely Lombard in origin.[28]

Rossetti's eclecticism comes out most strongly in the Carthusian church of S. Cristoforo (Plate 116).[29] It is a basilica with piers, its square plan only recognizable by the considerably shortened pilasters in the clerestory. The bays are vaulted with huge shallow domes, and the crossing is stressed by a dome, which is, however, invisible from the outside. The blank arcading of the exterior with its delicate terracotta ornament is characteristic of Rossetti's classicism, with all that it owes to the older tradition of brick building. The formal idiom of Rossetti, which is a strange blend of eclecticism with creative power, comes out most effectively in the structural system of the apse of the Duomo,[30] which is impressive just by reason of its simplicity; it is the only work by Rossetti in which we may feel a trace – faint, it is true – of Bramante's influence; the

elevation of the interior with the fine gradations of projections and recessions, and the two storeys of blind arcading on the exterior, seem to me to point to a knowledge of S. Maria presso S. Satiro.

Like his religious architecture, Rossetti's secular work is inspired by imaginative eclecticism. Here too we can only select a few examples.

The point of departure for all later building is the traditional Ferrarese type, carried into the Quattrocento in the Palazzo Schifanoia and enriched in the Palazzo S. Francesco-Pareschi with formal elements from Bologna. The Casa Rossetti (built in the nineties) (Plate 117)[31] shows in the coupled round windows with arches in high relief the same features as the Palazzo Schifanoia. The Palazzo Bevilacqua, one of the main buildings in the Piazza Nuova, takes up Bolognese motifs in the ground-floor loggia and in the two-storeyed arcading of the courtyard; the Palazzo Rondinelli, in the same piazza, keeps to the same basic forms.[32]

In contrast to this architectural uniformity in the Piazza, the confrontation of different types where the via Prione crosses the via degli Angeli is deliberately aimed at an effect of *varietà*; the Palazzi Prosperi-Sacrati and Turchi-Di Bagno, unfortunately not carried beyond their beginnings, show by their imposing solution of the corners (balcony over ornamented pilaster on a rusticated base in the one, two orders of coupled pilasters in the other) how far the crossroads was grasped as a unit of composition.[33] The dominating building of the group, the Palazzo dei Diamanti,[34] was the only one to be completed. Built for Sigismondo d'Este, it is the most ornately decorated palazzo in the town (Plate 118). The Palazzo Sanuti-Bevilacqua certainly served as a model for it, but the differences are important and deliberate. The masonry blocks – 8,500 of them have been counted – with which it is faced through all storeys are faceted, i.e. cut to actual points. We owe to Zevi the important observation that the axes of the facets are tilted in different directions in the three storeys – slightly upward in the first, level in the second, and slightly downwards in the upper storey. The long façade is framed by corner pilasters carved like candelabra; the corners of the building and the sides of the doorway have bases like truncated pyramids, projecting as if for middle and side pavilions; they unite the lowest five courses of the masonry in a single plinth, with the windows of the ground floor resting on its thin string-course. A fully elaborated cornice separates the lower from the upper storey; above the upper storey there is the Bolognese mezzanine with oval lucarnes.

In the carefulness of its composition the Palazzo dei Diamanti is the most consciously elaborated example of its type. None of its successors had such subtleties to show. It was at the same time the peak of Rossetti's architecture.

In the Palazzo Giulio d'Este, the Ferrarese twin-window type is varied in more ornate form than in the Casa Rossetti, and embellished with balconies of Lombardo-Venetian provenance. The so-called Palazzo di Ludovico Moro, not begun till about 1500, represents the country house standing in its own grounds in good proportions and forms.[35]

Rossetti's work continued into the second decade of the sixteenth century. His life (1447–1516) coincides in time with those of Bramante (1444–1514) and Giuliano da Sangallo (1445–1516). Compared with Bramante's genius and even Giuliano's superior

power, Rossetti's work suffers by its eclecticism. Yet his capacity for blending many and heterogeneous elements in a personal idiom should not be underrated. The type catalogue of his many-sided *œuvre* makes Rossetti one of the most interesting representatives of those local architects of the Quattrocento who were perfectly capable of making use of all the factors governing design in their generation, yet remained bound to their own vernacular and lacked the power of synthesis which was the gift of only a few masters of the end of the century – Francesco di Giorgio Martini, Giuliano da Sangallo, Leonardo da Vinci, Simone del Pollaiuolo, known as Cronaca, and, towering above them all, Bramante.

A younger representative of this type of architect was Bernardo Zaccagni (*c.* 1460–*c.* 1530), of Parma. The major part of his work, which culminated in the Steccata, falls into the sixteenth century, but his S. Giovanni Evangelista (1489–1510), a basilica with piers, derives straight from the formal repertory of the end of the Quattrocento, brilliantly united in an imposing, if somewhat sober composition.[36]

A third architect of the kind was Alessio Tramello, who was active at Piacenza about the turn of the century. The town, on the south bank of the Po, has always had considerable political and economic importance. Historically allied to Lombardy and subjected in the fifteenth century to the Visconti and Sforza, its architecture also has Lombard features. The huge Duomo of the twelfth–thirteenth century was a prototype for the Milano-Pavese architecture of the transitional style, whereas the church of S. Maria di Nazareth (1480) by Lazzaro Palazzi and the Palazzo Landi (1488) by Battagio and De Fondutis are importations from Milan.[37] Tramello's work only began towards the end of the century. The date of his birth is unknown; he appears in the records as an architect between 1488 and 1521, so that he may have been a little younger than Rossetti.[38] His name is associated with two churches, both strikingly original: S. Sepolcro and S. Sisto. The monastic church of S. Sepolcro[39] (the monastery begun in 1502, the church after 1510) has a most unusual plan (Figure 38). Three square bays are interrupted by narrow, oblong barrel-vaulted bays; in the aisles, there is a corresponding alternation of oblong and square compartments, the squares being covered with little domes. Thus a peculiar kind of conglomeration of groups arises which is related to the Venetian *cuba* system (see p. 90); if it was really designed in 1488, it is of the greatest historical importance. The polygonal outer chapels, on the other hand, tend rather towards the Milanese type (S. Pietro in Gessate). The uncomplicated structure of the monastic buildings, especially of the Palazzo del Commendatore, also reverts to Milanese motifs of the Bramante school.

S. Sisto,[40] begun in 1499, with a vaulted tower of 1514, is a basilica with columns (Plate 119); its special features are the pseudo-double aisles and the double transepts. The nave is roofed with a continuous barrel-vault, the square compartments of the aisles have domes. Between the aisles and the semicircular exterior side chapels there runs a narrow aisle-like passage, separated from the aisle itself by strong square piers. This unusual arrangement is given another accent by one of the transepts with its tiburio immediately behind the façade, which serves as a vestibule. Two tetrastyle tempietti added to left and right, with semicircular niches of the type of the sacristies of the Duomo of Pavia,

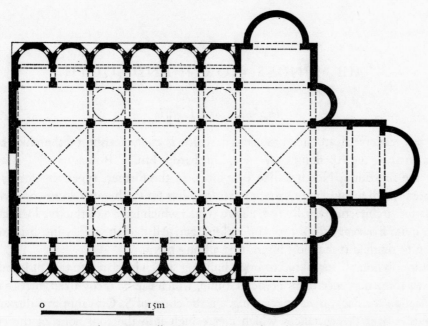

Figure 38. Alessio Tramello: Piacenza, S. Sepolcro, begun after 1510, plan

increase the oddity of the plan. The main transept adjoining the nave to the east is domed over the crossing. Both domes have dwarf galleries of the Milanese type in the drum, and are powerful sources of light for the interior. Since the barrel-vault of the nave is lighted by round windows in the gallery, the interior of S. Sisto owes its spatial effect largely to the directional lighting. Thus there is a peculiar blend of Lombard and Ferrarese formal idioms; the exterior, in plain brickwork, has only a very economical decoration to offer, and it gains its ornamental effect from the two tiburii.

In his late work, the centrally planned Madonna di Campagna,[41] Tramello works entirely with the sober, large-membered articulation of the Bramante school of Lombardy.

Rossetti, Zaccagni, and Tramello have their own historical importance, since they carried to extremes, out of the wealth of potentialities available at the time, the ancient North Italian love of complicated plans such as were unknown in Tuscany and even in Rome. Thus we can understand why their buildings lack the tendency to formal simplification which is to be found in the work of their more important contemporaries Giuliano da Sangallo, Leonardo da Vinci, Cronaca, and especially Bramante. On the other hand, the wealth of fantasy their work has to show had an unmistakable effect on the Mannerist trend of style in the Cinquecento.

THE FRINGES, NORTH AND SOUTH

Piedmont and Liguria

THE great variety of architectural design which is characteristic of the chief artistic regions north of the Apennines – Venice, Lombardy, Emilia, Romagna – is less noticeable in the remaining North Italian provinces. In the former, types and forms were elaborated which furnished important starting-points for further developments, whereas in the latter, architecture hardly rose above works which have a distinctive local charm, but are quite irrelevant to historical development. All that the following brief survey can do is to single out the most interesting among them.

Piedmont is notable for a kind of brick building which is related to that of Lombardy yet shows some influence from French Gothic, which can be recognized, first of all, in a predilection for decorative tracery, e.g. on the choir of S. Giovanni at Saluzzo. The steep gables over the entrances which pierce high into the roof zone of the church façades are typically Piedmontese, yet must also be regarded as an echo of the French manner, while the finials (*gugliette*), with their conical spirelets of bricks placed at an angle, are Lombard in origin. The parish church of Rossana and the cathedral of Chivasso[1] are typical examples; the façade of the cathedral of Pinerolo[2] shows the same forms, but the spirit of the new style can be felt in their reduction to measured proportions. A perfect specimen in purely Piedmontese style is the small, centrally planned baptistery of Chieri Cathedral (Plate 120).[3]

Lombard and French forms of decoration also come together in secular building. This can be seen in the priory of S. Orso at Aosta (1494–1506) (Plate 121)[4] and in the Palazzo della Porta at Novara.[5]

Compared with the formal repertory of the buildings already mentioned, developed as it was out of local traditions, the alien character of the Duomo of Turin (1491–8) stands out at once (Plates 122 and 123 and Figure 39).[6] Built by Meo da Caprino under the protectorate of Cardinal Domenico della Rovere, the brother of Pope Sixtus IV, the general scheme of the building closely follows Roman models, especially S. Agostino. It is a basilica with cross-shaped piers and radiating chapels, a transept, and a dome on squinches and a coved ceiling. The cool restraint of the interior is less Roman; it is here, and in the articulation of the exterior, that influences from Tuscany and Emilia can, to my mind, be felt. The Duomo of Faenza has on the side walls a very similar order of pilasters on a high plinth which had also been intended for the façade. In Turin Cathedral the coupling of the pilasters on the façade, the general breadth of the proportions, and the tendrils of the brackets again point to Rome. In its composition, the façade of Turin Cathedral is related to Rossetti's practically contemporary façades at Ferrara, and thus provides an interesting illustration of the possibilities of variation on the theme.[7]

In comparison with this purely Quattrocento idiom, the parish church of Rocca-

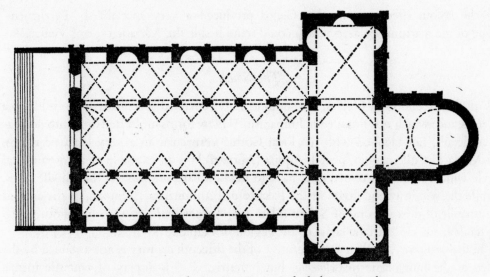

Figure 39. Meo da Caprino: Turin Cathedral, 1491–8, plan

verano, built at the beginning of the Cinquecento, is an interesting derivative of the
Milanese Bramante school[8] with its tetrastyle interior and the broad planes of its façade.

There is less native tradition in Liguria than in Piedmont. The influence of neighbour-
ing Tuscany was felt fairly early, along with that of Lombardy and Piedmont. It was this
mingling of styles that produced the Cappella di S. Giovanni Evangelista in Genoa
Cathedral, which is the most telling example of the Early Renaissance in Liguria. The
façade was built by Elia and Giovanni Gaggini between 1450 and 1465, the interior by
Giovanni dell'Aria in 1492–6. While the structural members are Tuscan in origin, the
ornament is a blend of Lombard and Piedmontese exuberance.[9]

The Quattrocento palazzo has, to all practical purposes, been crowded out of the
general view of Genoa by the new buildings of the sixteenth and seventeenth centuries.
All the same, there are two palazzi which enable us to obtain some idea of the stylistic
idiom and the splendour of this early type: the former Palazzo Doria in Vico d'Oria
and the Palazzo Andrea Doria in Piazza S. Matteo.[10] The courtyard of the former
(Plate 124) shows that a chief ornament of the Cinquecento palazzo of Genoa – the
monumental staircase – already had a predecessor in the Quattrocento such as was
unknown elsewhere in Italy. In my opinion, it was rivalry with the arch-enemy and
competitor, Venice, which created this delightful local style; in Genoa, the *scala aperta*
of the Venetian palazzo is set, or rather composed, into a cortile of Tuscan design – an
important contribution to the Quattrocento catalogue of architectural forms. The stair-
case of the Palazzo Cambiaso is very similar; we can see in both cases the characteristic
Genoese attenuated columns on tall pedestals.[11]

The reconstruction of the Palazzo Andrea Doria (Plate 125) presents a picture of an
enchanting blend of many ornamental motifs: incrustation from Tuscany, window sur-
rounds from Piedmont and Liguria, and loggia arcades from Venice and Lombardy are all
present. The Moorish note which echoes through the whole composition, particularly

123

in the colour effects, shows that Genoa produced a very specialized 'Tyrrhenian' type of the maritime palazzo which could stand beside the Adriatic type of Venice.[12]

The South

With the exception of Naples, the south of Italy remained practically inaccessible to a Renaissance which was founded in humanism.[13] New forms infiltrated only into decorative details, but blended with the local Gothic vernacular in a very barbaric idiom. S. Maria di Collemaggio, near L'Aquila (Abruzzi),[14] is an example of an ornamental style which, in the last resort, goes back to the Lombard tradition of the Middle Ages, while the windows and doors of the Palazzo dell'Annunziata, Sulmona, or the curious campanile of the cathedral of Soleto (Plate 126)[15] are variants of a Gothic idiom which extends from the Adriatic coast to the region of Naples.

In the same way, Sicilian architecture[16] of the fifteenth century is not sustained by the idea of the humanistic *rinascimento*, but is restricted to a display of fantastic forms. S. Maria della Scala at Messina (Plate 127)[17] is quite characteristic. The fondness of the south for rusticated walls – which can also be seen in Naples (see below, p. 128) – produced, in this case, a lower storey which is unusual in a church; in the articulation of the top storey, the rusticated blocks on the pilaster strips are facet-cut to a point, while the window-sill blocks are cushion-shaped. Diamond-cut blocks also appear in the Giudecca at Trapani, in the Castello of Pietraperzia, and in the Palazzo Steripinto at Sciacca.[18] Some writers have found in this ornamental motif a connection with Spanish architecture, but that makes its appearance later.[19] To my mind, it is rather the imposing walls of Hohenstaufen castles in the south of Italy which first brought home the prestige value of rusticated blocks. When rustication came to the south in its North Italian and Tuscan forms, it passed through a local renaissance in a region where facet-cut blocks appealed to a native taste for odd and fantastic forms. This question will be taken up later.[20]

The porch on the south side of the Duomo of Palermo[21] and the porch of S. Maria delle Catene at Palermo[22] are typical examples of a kind of architecture which sprang from Spanish-Angevin roots. In secular building, the palazzi Aiutamicristo (Plate 128) and Abbatelli at Palermo, the latter with an imposing ashlar front flanked by two corner towers, represent the peculiar blend of South Italian and Spanish forms; their courtyards are closely akin to the courtyard of the Palacio Velada at Ávila.[23]

However interesting these local forms may be as the product of different artistic traditions, they have no bearing whatever on the great themes and motifs which developed in the rest of Italy in the course of the centuries.

Naples

One city in the south, and one only, took an active part in the Renaissance movement, and that was Naples.[24] It was there that, under the Aragonese régime, a princely residence of truly humanistic stamp was built. In the brief seventy years of their rule, bur-

dened as it was by the troubles of tyranny so admirably described by Jacob Burckhardt,[25] only a fraction of the over-ambitious plans of the royal patrons was realized, and even of that, a large part soon fell victim to destruction, but the few works that have survived or can be reconstructed are an eloquent testimony to the greatness and distinction of Aragonese architecture in Naples.

The Neapolitans, who had always felt the Angevins as aliens, received Alfonso of Aragon with rejoicing. His entry into Naples in 1443 took the form of a triumph 'all'uso romano',[26] which revealed the imperialism inherent in his claim to sovereignty as a successor of Manfred of Hohenstaufen.

It is this idea which inspired Alfonso I's triumphal arch; it was originally planned as a free-standing monument, but was, in the end, erected in 1452 as a gatehouse between the two round towers of the Castelnuovo (Plate 129).[27] In the same year, Pietro di Martino da Milano was summoned to Naples; in the documents there appears, along with his own and those of other masters, the name of Francesco da Zara, i.e. Francesco da Laurana. By 1458, when Alfonso died, the lower arch was completed; its formal kinship with the triumphal arch of Pola is obvious.[28] This would support the idea that the design is to be ascribed to the two Dalmatian architects – Pietro da Milano and Francesco da Laurana.[29] The relief panel in the attic storey, the upper arch, originally intended to contain the equestrian statue of Alfonso (by Donatello?),[30] and the crowning storey with niches and tympanum are somewhat later additions which came about quite naturally as work went on. Yet there is a medieval prototype for these superposed zones; to my mind the type of the Arch of Alfonso, whatever it may owe to antique models, owes just as much to the gatehouse of Emperor Frederick II's bridgehead at Capua, which was still standing at the time; as a symbol of imperial power, in classical form, it offered a model worthy of imitation.[31]

It is this incorporation of both Roman and Hohenstaufen *antichità*, blended with the native southern delight in profuse decoration, which gives the Arch of Alfonso – the upper parts were only completed between 1465 and 1472 – those characteristics which make it the most outstanding example of the Aragonese *rinascità*.

Given the humanistic bias of the House of Aragon,[32] the relations between them and the northern centres of learning became very close. They extended to Rome, Urbino – Federico da Montefeltro was gonfaloniere to Alfonso I and Ferrante I – Mantua, and Milan, and quite especially to Medicean Florence. It was to Florence that the kings chiefly turned for advice and ideas; above all, they summoned to Naples the architects recommended to them, and entrusted them with the execution of their projects.

The famous letter from Pietro Summonte to Marcantonio Michiel,[33] though not written till 1524, gives a vivid insight into the building activities of the Aragonese rulers, including their urbanistic schemes, which provided for a complete renovation of the city sanitation (water supply) and a new street system adapted to the natural terrain. The restoration of Rome and the Addizione Ercole at Ferrara gave them ideas in plenty. Besides, Filarete's twenty-five books on architecture, which arrived in Naples in manuscript at the beginning of the eighties,[34] and Francesco di Giorgio Martini's treatise, which is known to have been available in Naples by 1489 at latest, must

have been the subject of intense study, as will be shown in detail later (see p. 132).

One component part of this systematic replanning of the city is the Porta Capuana (Plate 130). Giuliano da Maiano, summoned to Naples in 1485, made the design and was handsomely paid for it; it was executed by local craftsmen. The structure, simpler and clearer than that of the Arch of Alfonso, makes it one of the most beautiful monuments of the period in Naples.[35]

Summonte's letter also gives an account of Giuliano's most remarkable work in Naples, the palazzo-villa of Poggioreale, which has not survived.[36] It was begun in 1487 and erected at great speed – the patron, Prince Alfonso, was able to give a 'house-warming' banquet in it in the summer of 1488. This villa incorporates the ideal of the princely dwelling of the time. Peruzzi's drawings and Serlio's (slightly modified) illustrations make the plan perfectly clear (Figure 40); a symmetrical group of four distinct ranges – projecting to the outside in pavilions – surrounds a covered courtyard for banquets and games and thus forms a clearly planned complex; adjoining it is an open space with a large fountain flanked by loggias, which leads to an extensive flower-garden.[37] According to the documents, Giuliano da Maiano was the architect-in-chief, and enjoyed the special favour of the patron. He must therefore be accepted as the author of this original design; yet I cannot but feel in the plan of Poggioreale an echo of Luca Fancelli's Nova Domus at Mantua, begun in 1480 (work suspended in 1484). The four corner pavilions and the layout of the courtyard and garden are anticipated there in very similar form.[38] The princes and nobles took a very keen interest in their respective building schemes, and gave each other advice; Francesco Gonzaga and Lorenzo de' Medici asked to see the plans of the Palazzo Ducale of Urbino;[39] and Lorenzo, for his part, was eager with his advice to Alfonso of Aragon. In 1488 he sent Giuliano da Sangallo to Naples with a plan for a palace, and after the death of Giuliano da Maiano

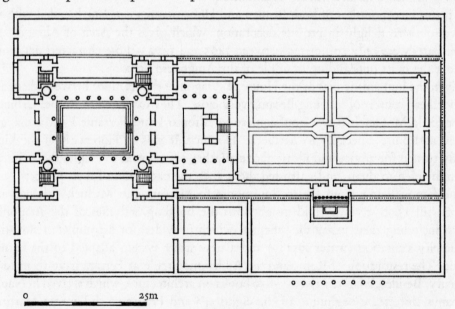

0 25m

Figure 40. Giuliano da Maiano and others: Naples, Poggioreale (destroyed), begun 1487

(1490) recommended Luca Fancelli as architect-in-chief;[40] he went to Naples, but was engaged for work on the Castel Capuano. If we are to believe Summonte, Alfonso entrusted the supervision of the building of Poggioreale to Fra Giocondo da Verona, who had been living in Naples since 1487. Francesco di Giorgio, too, who was also a guest of the king's at the time, had, according to Summonte, acted as adviser for Poggioreale.[41] Given this lively exchange between architects and patrons, it follows quite naturally that the individual parts played by all concerned in a plan of the kind can no longer be distinguished. Without wishing to belittle the merits of Giuliano da Maiano, it might be well to keep in mind the possibility that the plan of Poggioreale was a collective endeavour, and that many minds participated in its final design.[42]

Many of the ideal schemes of the period were never carried out or were left unfinished. Poggioreale was the only one to take on visible shape. It was for that reason that even while it was being built, it attracted general attention and was admired. Much later Serlio quoted it in his treatise as the exemplar of its kind.[43] After the overthrow of Aragonese rule (1495) the beautiful palace was neglected and abandoned to decay until the last remains were demolished in the nineteenth century to make room for a cemetery.

A great many other buildings which were to have lent brilliance to the Aragonese court were never executed or remained as torsos, for instance the Villa della Duchessa by the Capuan Gate.[44] The most important was the great palace for government offices which was to have been built near the Castelnuovo and to have been the great administrative and commercial centre.[45] In his description of the building Serlio makes use of a terminology which recalls to my mind the description of the Palazzo Pretorio in Filarete's treatise (Book X, as part of his ideal city).[46]

The small number of palazzi built in Naples in the second half of the century shows how far their designs are based on Tuscan or even North Italian models. A notable feature is the preference for a rustication of the façades; the foremost example is the Palazzo Cuomo (Plate 131), which now houses the Museo Filangieri. The date of its erection, between 1464 and 1490, coincides with Giuliano da Maiano's stay in Naples, and there are good grounds for attributing the work to him;[47] it was executed by local workmen. The very high, almost windowless upper storey is composed of ashlar blocks with deep-cut joints, quite a frequent pattern in Naples; in a preliminary form – ornamented blocks – it already appears in the Palazzo Penna, the porch of which bears the date of 1406, and later in pure form in the Palazzo Caraffa di Maddaloni (porch dated 1466) and in the Palazzo d'Aponte e de Curtis, now demolished, which was probably only built about the turn of the century.[48]

As was pointed out above, the very varied use of rustication in the south can, in my opinion, be explained by the impressive presence of the Hohenstaufen monuments; the mighty language of their masonry could not fail to appeal to the need of prestige felt by the new age, the more so as it had received a kind of sanction from many a great building in Central Italy – the Palazzo Rucellai in Florence; the Palazzo Piccolomini at Pienza; the Palazzo Ducale at Urbino.[49]

The Palazzo Sanseverino, of which only fragments have survived, is chronologically

a mystery; according to the foundation inscription it was begun in 1470. If that date is accepted for the design of the façade, this would be the earliest example of diamond-cut blocks in a palazzo front, eleven years before the Palazzo Bevilacqua at Bologna and twenty years before the Palazzo Diamanti at Ferrara.[50] The question whether the priority in the employment of this form is to be awarded to north or south is not easy to answer. The earliest use of diamond-cut blocks altogether leads, of course, to northern Italy, to the round towers of the Milan Castello (1455) and the Cà del Duca in Venice (1460-4), where the blocks are prism-cut. Roberto Sanseverino, the man for whom the Naples palazzo was built, was a comrade in arms of his uncle Francesco Sforza and succeeded him as Governor of Milan. Moreover he spent many years in the north as a condottiere in Venetian service. Thus it seems to me fairly obvious that he was quite familiar with the grandiose masonry of the Milan Castello, which had already impressed his father-in-law, Federico da Montefeltro, that he had seen it there, and ordered it to be used in the building of his palace in Naples.[51] Owing to the curious stereometric effects it produces, the diamond-cut block found favour in the south; the technique was applied to the Palazzo Siculo – not demolished till the present century – and Sicilian examples have already been mentioned.[52]

As to church building, there were few projects of any importance in fifteenth-century Naples. Many a building – such as the memorial chapel of the Aragonese rulers mentioned by Summonte – never got beyond the plans; others, such as the ex-voto church of S. Maria della Pace, erected in 1450, were short-lived[53] (S. Maria della Pace was destroyed by earthquake in 1456). Smaller sacred buildings, such as the Piccolomini, Terranova, and Tolosa Chapels in S. Anna di Monteoliveto with altars by Antonio Rossellino and Benedetto da Maiano, are faithful imitations of Tuscan architecture though with a rather weak treatment of details.[54]

On the other hand, a few buildings erected in the last years of the century must be mentioned for their very peculiar stylistic characteristics.

The crypt-like aisled Cappella del Soccorso in the cathedral (Plate 132), begun in 1497 by Tomaso Malvita da Como, a fellow-apprentice of Francesco Laurana,[55] has classicizing features; the shell-headed niches recall those of Bramante in S. Maria presso S. Satiro in Milan.

At the beginning of the sixteenth century, the church of S. Caterina a Fornello[56] was begun, but work was continued into the twenties. Yet its design shows such far-reaching analogies with that of the Madonna del Calcinaio at Cortona that the latter must unquestionably have served as a model. Possibly a similar design by Francesco di Giorgio was still available in Naples, and was used by the architect of S. Caterina a Fornello.

The unmistakable trend to classicism in articulation which can be seen in this church also comes out in three other buildings characteristic of the transition to the Cinquecento in Neapolitan architecture; the chapel of Giovanni Pontano, the humanist (begun in 1492),[57] the façade of S. Maria della Stella,[58] a little votive church built by Giovanni Mormando, and the rebuilding of the outer walls of SS. Severino e Sosio.[59]

All three buildings are akin in the austerity of their forms. The absence of any profuse

ornament, the plain pilasters which articulate the walls, and a high, unadorned cornice on the one hand, the massive walls in which niches could be embedded on the other – all these are unmistakable characteristics of a classicistic style aiming at a simplification of the formal apparatus, and thus clearly distinguished from everything that went before.

A similar articulation of flat surfaces by pilasters can also be seen in S. Aurea at Ostia, but it is also frequent in Central Italy. It may therefore not be quite beside the mark to place this group of buildings within the range of influence of Fra Giocondo, or perhaps rather within the phase of stylistic development which he represents. In any case, it is very remarkable that even in Naples there was at the end of the century a relinquishment of *varietà* in decoration and a trend to structural clarity or even austerity. In this, Naples followed the trend which was a general characteristic of the transition to the Cinquecento throughout Italy. It finds its chief expression in the great masters who, towards the end of the century, summed up in their work the wealth of potentialities offered to them by the new style in all its regional variants: these are – besides Bramante, already known to us – Francesco di Giorgio Martini, Giuliano and Antonio the Elder da Sangallo, Simone del Polluaiolo (il Cronaca), Leonardo da Vinci.

FROM THE QUATTROCENTO TO THE CINQUECENTO

THE diffusion of the ideas and forms of the new style as they had been realized by Brunelleschi and Alberti, Michelozzo and Donatello, caused, as we have seen, the rise of very heterogeneous regional styles in the various provinces of Italy. The developments in Rome, Urbino, Mantua, Venice, Milan, Bologna, and Ferrara differed because they had their roots in the local traditions. Special interest attaches to Rome, which was for generations the vital centre of the knowledge of antiquity and its monuments.[1]

The first characteristic of Quattrocento architecture that is common to all the artistic provinces of Italy may be seen in that *varietà* of forms and types in which solutions of the great architectural problems – town planning or single buildings, churches or palaces – were ceaselessly sought and found. This variety reached its climax about the end of the century. A comparison between S. Andrea at Mantua, S. Bernardino at Urbino, S. Maria dei Miracoli in Venice, or S. Pietro in Montorio in Rome and the cathedrals of Pavia and Faenza, S. Francesco at Ferrara, or S. Maria at Loreto shows the enormous range of design in churches. The Nova Domus at Mantua, the Palazzo Bevilacqua at Bologna, the Palazzo Strozzi in Florence, and the Cancelleria in Rome show the same thing in the field of secular architecture.

This *varietà*, which also gave great scope to decoration,[2] does not only extend to form; it also came into play in the themes of creative architecture. It gave rise to those humanistic *concetti* which took shape in the urbanistic projects for the restoration of Rome, the ideal city of Pienza, the 'social' town planning of such men as Francesco Sforza and Ercole d'Este, in single monuments such as the memorial chapels of Ludovico Gonzaga (SS. Annunziata, Florence; S. Sebastiano, Mantua) and of Sigismondo Malatesta (S. Francesco, Rimini), and finally in secular architecture (Palazzo Ducale, Urbino; Scala dei Giganti, Venice; Nova Domus, Mantua). Within the wide scope of these enterprises, which, as has been said, gave rise to architecture of the most manifold types, both in form and subject, the search for monumentality in form becomes more and more obvious in the last quarter of the century. But monumentality implies simplification, and that is the trend which is clearly marked in the work of a few architects who rise so far above the common run of their generation that they may be called the pioneers of the classical style.

The greatest of them all, Donato Bramante, has already been considered; his genius took in the whole wealth of tradition and fused it into a unity which heralded a new age of architecture.[3] Besides this native of Urbino who worked in Lombardy, there were in Tuscany three other masters who must be mentioned, for their work is characterized by the endeavour to achieve monumental form. They are Francesco di Giorgio Martini, Giuliano da Sangallo, and Simone del Pollaiuolo, known as Cronaca.

We have already encountered Francesco di Giorgio Martini (1439–1501)[4] at work in

Urbino. A native of Siena, he was equally gifted as a painter, sculptor, architect, and engineer, and in his time had a great name. Most of his training in sculpture came from Vecchietta, with whom he visited Rome in 1464. In painting, he worked up to 1475 with Neroccio, his father-in-law. We know nothing about his training as an architect. In 1469 he was employed as a hydraulic engineer by the city of Siena,[5] where he probably gained his first conception of architecture, but he got his real training as an architect at Urbino, where the documents show him to have lived from 1472 to 1482, although he was employed for long periods elsewhere.[6] From Urbino he also superintended the building of the Madonna del Calcinaio at Cortona (begun 1484) (Plates 133–4 and Figure 41).[7] In this cruciform, aisleless church, Francesco di Giorgio developed an important type; the massive walls with recessed, semicircular chapels, the barrel-vault of the nave, the dome on squinches over the crossing with a high drum, are the chief structural accents of the ponderous spatial organism, yet it is flooded with light from the very large windows on the long sides and the round windows in the front and apse. Through this lighting the simple structural members give the feeling of intentional restraint. A characteristic motif of Sienese origin is the subdivision of the storeys with noticeably narrow string-courses.[8] The ornament is reduced to what is strictly necessary, even to the plain reeded capitals of the pilasters. The intention of enhancing the monumental effect by this simplicity is obvious.

The same effect on a very much larger scale was certainly given by the Duomo of Urbino (Plate 136), which, though altered in the eighteenth century, was begun under Federico da Montefeltro, i.e. before 1482, and more or less completed in the late eighties.[9] There too, as the extant drawings show, the articulation was most economical, the whole design aimed at a simple, but monumental spatial effect.

How powerful such effects could be even in the sober technique of brickwork can be

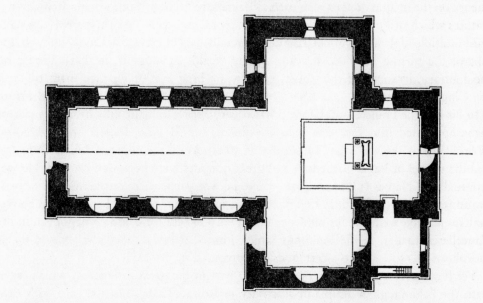

Figure 41. Francesco di Giorgio Martini: Cortona, Madonna del Calcinaio, begun 1484, plan

seen in the Palazzo della Signoria at Jesi, which was begun in 1486 after a design by Francesco di Giorgio; with its *impeccabile geometricità* it achieves an extreme of formal simplification.[10]

If we look at a church like S. Bernardino, Urbino (Plate 70), with these buildings in mind, it becomes difficult to ascribe it to Francesco di Giorgio, especially as it is utterly different in kind, especially in the interior, and it has been supposed by many historians that Bramante, in his youth, had a hand in it. But Francesco's illustrations to his treatise, and still more his drawings, show how profoundly he had studied the monuments of antiquity, even to late classical and Early Christian times. It is just in them that the recourse to powerful, but simple formal elements in the desire to increase monumental effects comes out clearly. It is elements of this kind (S. Salvatore, Spoleto) which have been employed in S. Bernardino. Thus this memorial church, with its conscious adoption of antique forms, is organically part of his work, and in my opinion brings it to a remarkable conclusion.[11]

The ideas of Francesco di Giorgio in his architectural theories present a notable comparison with the austere and conscious simple design of his finished buildings. His treatise on architecture throws a very illuminating light on the transition between the architectural theories of the fifteenth and sixteenth centuries.[12] Its subject matter is rooted in the tradition of the Quattrocento, as the endless variety of his sacred and secular works proves; to use the picturesque term of the age, the *fantasticare* on an architectural theme which can be seen in Filarete and Luca Fancelli[13] is developed in an abundance which is only surpassed by Leonardo da Vinci, whose systematic classification of building types will be discussed below. On the other hand we can recognize in these ideal designs of Francesco di Giorgio many features which point to the coming century, whether in the plans for sacred (Plate 135) and secular buildings which may have had their influence on the imagination of such men as Baldassare Peruzzi,[14] or in single architectural features which strike the note of central themes of Cinquecento architecture[15] (e.g. stairs with multiple flights, polygonal, round, or pseudo-oval courtyards). Oddly enough, the text of the treatise has little bearing on the wealth of ideas in the illustrations; on the contrary, its tone is rather sober, and gives a brief hint of the two main types of the Cinquecento treatise, *The Canon of Orders* and *The Manual of Architectural Forms*.

In his lifetime Francesco di Giorgio had a very great name. In 1485 his native city of Siena appointed him *Ingegnere della Repubblica*, and in 1498, Master of the Duomo Works. In 1490 he was called to Lombardy to report on the dome of Milan Cathedral and the model of Pavia Cathedral, and great honours were bestowed on him. He was repeatedly in Naples (1492–5, 1497), where he was particularly outstanding as a fortifications architect and military engineer, and in Rome.[16] It is, as I mentioned above, perhaps possible to detect his influence in S. Pietro in Montorio and perhaps even in the Cancelleria, that is, in the buildings which immediately preceded the stylistic metamorphosis of 1500, and to a certain extent prepared it.

Yet Francesco, who died in 1501, had no part in the great movement which set in with the beginnings of Bramante's activity in Rome. That is not the case with Bramante's contemporary, Giuliano da Sangallo (1443–1516).[17] His work reflects a genuine

problem of generations. Giuliano di Francesco Giamberti, called 'da Sangallo' after the district of his home in Florence, came from the *Arte dei legnaiuoli*, the guild which included the sculptors, architects, bricklayers, carpenters, and masons. He had plenty of commissions as a cabinet-maker and wood-carver, and even as a sculptor, and – later with the help of his brother Antonio, who was ten years his junior – managed a large workshop which undertook all kinds of commissions in wood and stone connected with the building trade. As far as I know, Giuliano was the first Florentine architect to go to Rome as a very young man, and to stay there for many years. Thus he acquired a technical and artistic training which was unusual for that time.

According to the title-page of his book of drawings (Codex lat. Barberinus 4424, Vatican Library)[18] he arrived in Rome as early as 1465; from 1467 to 1472 he appears in the Vatican account-books, and he was obviously working as a foreman under his master Francione.[19] Although his share in the work cannot be distinguished in detail – he may have been engaged on the Benediction Loggia in 1470, and probably on the Palazzo Venezia – one thing is certain, that he spent seven years in Rome, and perhaps more.

This experience in Rome, and a knowledge of the monuments of antiquity acquired by long and detailed study, gave Giuliano an advantage over his contemporaries and colleagues when he returned, as a master, to his native city in the seventies. Not more than twenty years ago P. Sanpaolesi's excellent restoration of the courtyard of the Bartolomeo Scala palazzo (in the complex of the Cinquecentesque Palazzo della Gherardesca in Borgo Pinti) made it possible for the courtyard to be seen in its original form (Plate 137). This may well be the first commission which young Giuliano executed after his return from Rome. The unusual shape of the courtyard can be explained by the purely humanistic *concetto* from which it arose. Bartolomeo Scala, an eminent statesman, patron, and man of letters in Medicean Florence,[20] wished his residence to be planned not as a city palazzo, but as a garden villa. In 1472 he acquired the site, which was at that time still *fuori le mura*. In his income tax return for 1480 he already mentions the house as his residence; thus it must have been built between those two dates. If Bartolomeo selected the young Giuliano da Sangallo as his architect, it is evidence of his vigilant and unerring taste. Giuliano obviously accepted his patron's special wishes: the courtyard is not a Florentine *cortile*, but is something like a peristyle in the antique manner. The arcades with attached pilasters, the figure cornice, and the relief ornament in the attic storey breathe Roman air and recall many an imaginative reconstruction of antique monuments in Sangallo's sketchbook. The subjects of the twelve reliefs come from an early poem by Bartolomeo della Scala, *Cento Apologi*, and are moralizing allegories (*psychomachiae*) on mythological themes. We may fairly ascribe these reliefs to Giuliano da Sangallo himself.[21]

By its curious themes, the commission gave Giuliano the opportunity of putting his inventiveness to the test. He soon had another chance of doing so. The competition for the villa of Poggio a Caiano, which Lorenzo de' Medici had announced at the beginning of the eighties, was won by Giuliano, even over the head of his own master Francione. The design, with the clear and well-proportioned disposition of the plan (Figure 42)

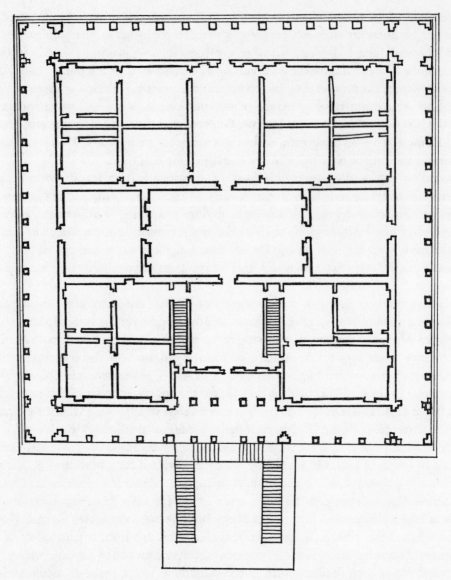

Figure 42. Giuliano da Sangallo: Poggio a Caiano, designed early 1480s, plan

and the classical forms of the elevation (Plate 138), is enough in itself to explain the patron's enthusiasm. Poggio a Caiano is the earliest and most perfect example of that new type of humanist villa which was to go through such a superb development. The monumental conception of the whole – arcading in the lowest storey with a beautiful balustrade, a classical portico with a figured and coloured frieze, and a sculptured pediment – breathes the spirit of Rome, but remains Tuscan in its treatment of form. In the interior too the shape of the vaulted salone is, to my mind, Roman in inspiration (Plate 139); the stucco ornament certainly bears the emblems of Leo X, and must therefore be assigned to a later date, yet it may be assumed that a barrel-vault – till then

unknown in Florence – was planned for this dominating central room, even from the beginning. The new pozzolana technique of curved terracotta coffers Giuliano had learned from antique monuments.[22]

Giuliano must have gained the special good will of the Medici with Poggio a Caiano, for he owed the commission for his first church to Lorenzo il Magnifico. Another architect had already won the competition for the votive church of the Madonna delle Carceri at Prato,[23] but Lorenzo overruled the decision and appointed Giuliano da Sangallo architect-in-chief (1484). In this case too the work of the master amply justified his decision. The centrally planned church of the Madonna delle Carceri – which is entirely within the tradition of Brunelleschi – wins from the handling of its structure and ornament the monumentality which characterizes both its interior and exterior. In the interior (Plate 140), the decorative scheme of the Pazzi Chapel is carried, so to speak, to its logical conclusion; the strong relief of the structural members, the evenly bevelled corner pilasters, the ampler, yet still restrained use of ornament both in the figured capitals and in the superb majolica frieze, and in the beautifully balanced proportions of the transepts and crossing – all these motives combine to give a spatial impression of great dignity. The articulation of the exterior is just as clear; the coupled pilasters (with Alberti's seven flutings, as in the interior) form a structural framework for the large, simple coloured incrustation which decorates the walls.

In the design of the atrium of the church of S. Maria Maddalena de' Pazzi, which was built at the beginning of the nineties, Sangallo employs a still simpler formal apparatus (Plates 13G and 141).[24] The Ionic order and the horizontal entablature, interrupted only by the entrance arch, are an almost classical development of the portico of the Pazzi Chapel. In S. Maria Maddalena de' Pazzi too, the whole takes a distinctive monumentality from the austere purity of its forms. In the rebuilding of the originally Cistercian interior, already begun in the eighties, Michelozzo's aisleless nave of SS. Annunziata is retained.

The endeavour to exploit and blend the achievements of his great predecessors – Brunelleschi and Michelozzo, and in details Alberti – is characteristic of Giuliano's particular kind of mind. His design for the church of his native district of Sangallo[25] – a rectangular hall with side chapels – is based on a combination of Michelozzo's aisleless church of SS. Annunziata with the centralized, longitudinal scheme of the Brunelleschian type (S. Lorenzo, second phase, and S. Spirito). From this point of view it is significant that Giuliano, in the controversy about the façade of S. Spirito (1486), was a passionate – if unsuccessful – partisan of the Brunelleschian scheme with its four entrances,[26] which simply arose, in defiance of tradition, from the purely formal structure of the plan, and that in a drawing in his Sienese sketchbook he conceived a paraphrase of the plan of S. Spirito by developing a plan with double aisles, with domes over the bays, a scheme which is most illuminating in the consistency of its Brunelleschianism (Figure 43).[27]

Giuliano's mastery of the balance of structural and decorative features finds full expression in the sacristy of S. Spirito (Plate 13H), which he built in collaboration with Cronaca.[28] The design of the portico is entirely Giuliano's. The great force of the structural elements – a dense sequence of strong columns carrying a heavy coffered

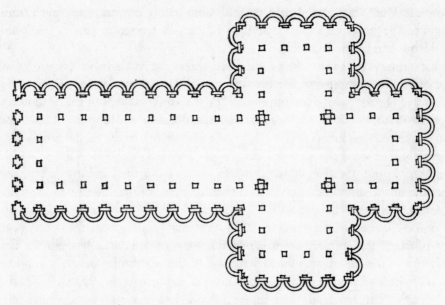

Figure 43. Florence, S. Spirito, plan drawn by Giuliano da Sangallo

barrel-vault (Plate 142) – imparts a feeling of supreme immanent power; it is an invention which, I believe, was employed here for the first time, and serves to enhance the impression of monumentality. The vestibule of the sacristy of S. Spirito, certainly born of Roman memories, is the prototype of the monumental androne which developed in the Cinquecento, especially in the huge entrance to the Palazzo Farnese by Sangallo the Younger.[29] The spirit of Alberti presides over the octagon of the sacristy, which is a masterpiece of architectural and sculptural articulation.[30]

In palazzo architecture too, we meet the same highly developed sense of structural and ornamental forms. In the Palazzo Gondi (begun in 1490) (Plate 143)[31] Giuliano introduces a new system into the traditional Florentine type of rustication; by grading the blocks according to their size and situation, it turns the whole wall into an ornamental pattern. The cushion-shaped blocks, finely dressed with bevels and concealed joints in the lower storey, and the cross-shaped links between the window arches up above show how fresh charm can be won from a familiar technique.[32] The flight of steps built into the courtyard is another innovation in Florentine palazzo design.[33]

In the Casa Horne[34] Giuliano da Sangallo, probably once more in collaboration with Cronaca, introduced yet another composition of the façade; a rendered wall surface with quoins and window surrounds. Here too we can feel the desire for classicistic simplification.

Giuliano's peculiar gift for retaining the local vernacular which had developed in Florentine palazzo architecture, while modifying it so as to obtain fresh possibilities of effect, finds its climax in the Palazzo Strozzi (Plate 144 and Figure 44).[35] In the Palazzo Pitti the roughly dressed blocks, employed by Michelozzo in the Palazzo Medici and developed in the Palazzo Geroni, had become fieldstones of immense size. But in the Palazzo Strozzi the principle of a refined and ornamental treatment of the stone is

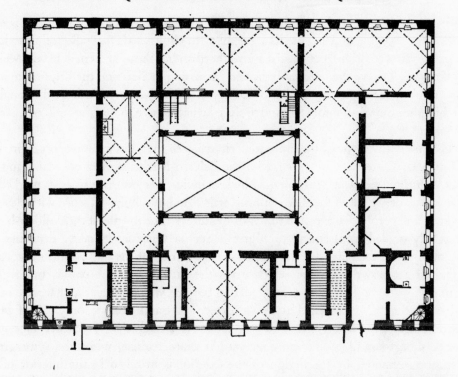

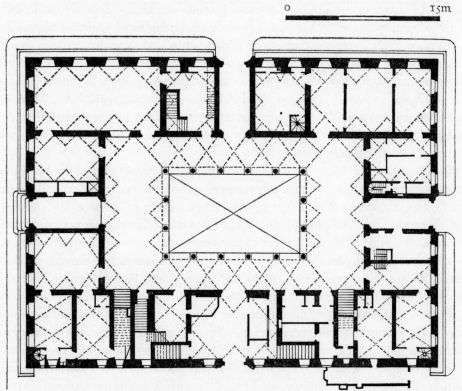

Figure 44. Florence, Palazzo Strozzi, designed 1489–90, plan of two floors

applied, after the same fashion as in the roughly contemporary Palazzo Gondi. Between the end of 1489 and 1490, payments were made to Giuliano da Sangallo for a model of the palace. Its execution later passed into other hands – those of Benedetto da Maiano and Cronaca. But we shall probably not go far wrong in ascribing the original conception of this majestic plan to Giuliano da Sangallo. The patron was shrewd enough to give him the commission for the model, since he had an eye to the goodwill of Lorenzo de' Medici.[36]

The conservative type of the Florentine city palazzo found its most perfect expression in the Palazzo Strozzi. Compared with the Palazzo Medici on the one hand and the Palazzo Pitti on the other,[37] this huge block, standing free on three sides, is marked by a classical clarity. Each of the three fronts is articulated by a huge entrance with close-set voussoirs and regular fenestration in the three storeys. The profile of the cushion-blocks is carefully graded from course to course in such a way that its curve decreases imperceptibly with the height of the elevation. The setting of the single blocks according to their size follows a scheme which gives the surface an unobtrusive, but regular ornamental pattern. The edges are rounded in bowtels which soften the sharpness of the angles. The building is crowned by a bold cornice in the antique style, only part of which was executed. The arrangement of the rooms is clearer than in earlier Florentine palazzi; the grouping round the courtyard is more regular, while the symmetrical fenestration required by the design of the exterior is matched in the interior of the rooms. The layout of the loggia rooms and passages on the first floor is superb; thus to my mind what we have here is an anticipation of the flights of apartments, two deep, which were a characteristic feature of Cinquecento and Seicento palazzi. Another innovation is the double flights of the rather large staircases which unite the storeys.

Both motifs, together with the monumental entrance-way, recur in the design for the King of Naples' palace which is contained in Giuliano's Roman sketchbook (Figure 45). There, and still more in the ideal plan for a Medici palazzo in Florence (Uffizi, Arch. Drawing, No. 282), we can feel the inspiration which Giuliano derived from the design of classical Roman villas.[38]

The expulsion of the Medici from Florence after the death of Lorenzo the Magnificent made Giuliano leave the city too. He accepted an invitation from Cardinal Giuliano della Rovere, the future Pope Julius II, whom he had met in Rome in the eighties, to enter his service. The building of the Palazzo Rovere at Savona (Figure 46)[39] (today, unfortunately, badly disfigured) came in the nineties; it is another important example of Giuliano's Tusco-Roman classicism. The façade, articulated by pilasters, marks the Palazzo Rovere as a successor of the Palazzi Rucellai and Piccolomini at Pienza; the scheme of the Cancelleria too has an echo in the superimposed pairs of windows within the separate compartments of the façade. Yet there is a remarkable modification of the design in the proportions and arrangements of the panels (three in the lowest storey) and the central accent in the façade given by the enlargement of the entrance porch. Finally, in his use of facing with coloured slabs, Giuliano also reverts to a Ligurian-Genoese tradition. Yet on the whole the classical trend dominates, and is particularly noticeable in the articulation of the lowest storey and the projecting sculpture of the porch.

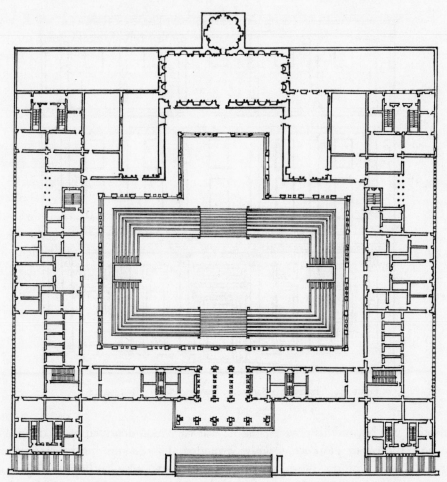

Figure 45. Giuliano da Sangallo: Design for a palace for the King of Naples

On the other hand we must admit that the Palazzo Rovere at Savona marks the utmost limits of Giuliano's powers. The building he executed for Giuliano della Rovere in Rome – the Palazzo Rovere by S. Pietro in Vincoli – and the cloisters of the abbey of Grottaferrata, or even the dome of the basilica of Loreto,[40] show that building in the truly grand, monumental style was beyond his grasp, which was not the case with his greater contemporaries. Giuliano della Rovere must have felt this; after his elevation to the papacy he transferred the superintendence of his building schemes to Bramante. Giuliano da Sangallo was left empty-handed and returned to Florence a disappointed man. The Gondi Chapel in S. Maria Novella,[41] where Giuliano tried to employ great formal motifs, is proof of the limitations of his powers; it cannot stand comparison with Bramante's courtyard in S. Maria della Pace and his designs for the Belvedere.

When the papal throne was again occupied by a Medici in the person of Leo X, Giuliano was given a last chance of taking part in the great movement in Rome initiated by Bramante. In 1514, after Bramante's death, he was appointed supervisor of works at St Peter's, though in collaboration with Raphael.[42] It will be shown later that this

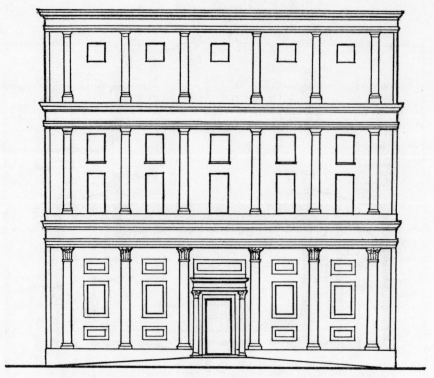

Figure 46. Giuliano da Sangallo: Savona, Palazzo Rovere, 1490s

commission was beyond his powers, and he was very soon deprived of his office. Once more he returned to Florence, deeply wounded. His designs for the façade of S. Lorenzo (1515–16) (cf. pp. 186–7) are the work of a man who has been unable to keep abreast of the times. Thus Giuliano's life ended in a resignation which was not without a touch of tragedy. But his buildings up to 1500, each of them a product not only of great ability but also of imaginative intelligence, are among the most outstanding monuments of the period. Nor must his drawings be forgotten. Along with those of Francesco di Giorgio Martini they contain the most abundant documentation of architectural drawing as it was at the end of the century.[43]

Giuliano's brother Antonio, his junior by ten years, has been somewhat neglected by historians of architecture.[44] During the lifetime of his elder brother, who managed the workshop, Antonio's own activity was unjustifiably overshadowed; the superb coffered ceilings of S. Maria Maggiore and of the great Council Hall in the Palazzo della Signoria are masterpieces of their kind.[45] But above all, in the church of S. Maria di Monserrato in Rome[46] Antonio created in an aisleless church a unified space which, in the strong and austere modelling of its elements, especially the entablature, presents the most important example of this type of church built in Rome before 1500; it had an enduring influence on its successors built by Sangallo. Antonio came into his own only after his brother's death; his buildings in Montepulciano,[47] which will be discussed later in another connection, show the independence with which Antonio mastered the

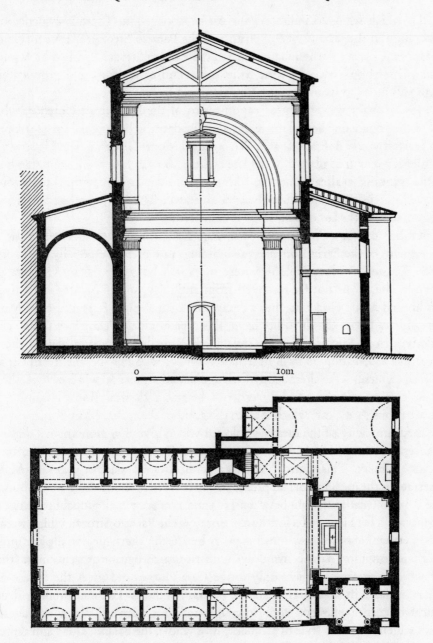

Figure 47. Cronaca: Florence, S. Salvatore al Monte, begun late 1480s, section and plan

teaching of Bramante, and created a formal idiom which one is tempted to denote as Tuscan classic.

The last of the three architects discussed here, Simone di Pollaiuolo, surnamed Cronaca (1457–1508),[48] may be called a pupil of Giuliano, although no documentary evidence of his apprenticeship in Florence has survived. But on his return to Florence after ten years in Rome (1475–85), he soon became an intimate associate of Giuliano da

Sangallo, which seems to indicate some earlier connection. There is evidence of this collaboration in the sacristy of S. Spirito and the Palazzo Strozzi; it is probable in the Casa Horne. Cronaca's crowning cornice in the Palazzo Strozzi – praised by Vasari and by many after him – owes its fame to its perfection of structure and proportion, but perhaps still more to its mastery of constructional technique.

In 1495 Cronaca was appointed capomaestro of the Duomo of Florence, which is proof of the good name he had made. No definite date can be assigned for the beginning of his greatest work, S. Francesco (S. Salvatore) al Monte (Plate 145 and Figure 47), but there is every reason to place it in the late eighties. By 1493 the walls were standing; in 1500 the commission already mentioned met to consider damage to the foundations due to subsidence; in 1504 the church was consecrated. Thus in design and execution it belongs mainly to the last decade of the Quattrocento.

A number of very illuminating drawings by Cronaca has survived with exact measurements of the Early Romanesque buildings in Florence, especially the baptistery and SS. Apostoli.[49] These buildings were medieval, but were felt by Cronaca, as by everybody else, to be not far removed from antiquity, and in his studies of them he shows himself a true Florentine and a disciple of Brunelleschi. S. Francesco al Monte is in the same tradition. On the other hand, this type of aisleless church with side chapels also derives from Michelozzo and Giuliano da Sangallo. However Tuscan the strict pietra serena articulation on its light rendered background may be, the treatment of the individual elements – the alternation of triangular and segmental window tops, the free-standing corner columns of the sacristy – betray a classical Roman training. The forms are robust, yet clear, which is all to the good of the spatial effect, for it is precisely the studied simplicity of the means employed which gives it a monumental dignity. In S. Francesco al Monte the sacred architecture of Quattrocento Florence comes to an impressive climax. This church, together with Antonio da Sangallo's S. Maria di Monserrato, is the most important predecessor of the aisleless church of the Cinquecento.

The Palazzo Guadagni, built between 1504 and 1506, can in all probability be ascribed to Cronaca.[50] There is a model for the top storey of the Palazzo Strozzi, which was never executed, where another new motif appears beside the alternating triangular and segmental window tops, namely windows with rusticated ogee-arch surrounds. It is this motif which appears elsewhere only in the Casa Horne, and gives the façade of the Palazzo Guadagni its characteristic stamp. Further, in the cool refinement of its structure – rusticated corner pilasters, roof loggia, sgraffito ornament – there are classicistic features which are in the style of Cronaca. As a whole, the Palazzo Guadagni represents a new type of the Florentine palazzo which, given the conservative spirit of the city, was to remain the favourite throughout the Cinquecento. Raphael's Palazzo Pandolfini was as isolated in Florence as its equally inspired Quattrocento predecessor, Alberti's Palazzo Rucellai, and the classical Roman type, which set out on its conquest of Italy with its first appearance (Palazzi Caprini, Vidoni, etc.), is represented by a single and not very remarkable example: the Palazzo Uguccioni.

Epilogue: Leonardo da Vinci

The wealth of ideas which shaped the great themes of Quattrocento architecture finds an astonishingly exhaustive record in the architectural studies of Leonardo da Vinci (1472–1519).[51] Leonardo studied architecture all his life; he never built anything, yet his great experience and knowledge of the subject brought him a great name. He expressed his own opinion of his architectural capacity twice, once in his application to the Duke of Milan (1481) and once in the draft of a letter to the superintendent of the Opera of the Duomo of Milan (1490). A document of the same date names Leonardo together with Bramante and other masters as *pictor et ingeniarius ducalis*. We know from the Duomo account books that Leonardo entered for the competition of 1487–90 with a model for the dome of the cathedral, but withdrew it just before the jury met. He is often mentioned as an expert. His advice was sought for the rebuilding of Pavia Cathedral (1490) and for damage in the fabric of S. Francesco al Monte, Florence (1500). In 1502 Cesare Borgia appointed him chief building surveyor for his territory, the Romagna; at that time he designed a gigantic bridge over the Bosphorus for Sultan Bajazet II.[52] In 1504 he spent two months at Piombino as adviser to its ruler Appiano for the improvement of the fortifications of this city. In 1506, the lieutenant of the King of France in Milan, Charles d'Amboise, spoke very highly of 'some architectural designs' which Leonardo had made for him; he was speaking of a palazzo in Milan for which Leonardo's designs have been preserved.[53] During his stay in Rome he made plans for an extensive Medici residence in Florence, but they did not advance beyond the first sketchy stages and led to no practical result. Even in the last years of his life, which he spent in France, he worked on a scheme for a great palace at Romorantin which was to have been built for François I's mother (1518). None of these projects was ever realized. There is no building which we can confidently regard as Leonardo's own work.[54]

On the other hand, his sketchbooks and sheets abound in architectural drawings from every period of his life. They show that he brought zeal and expert knowledge to his architectural work. They cover the whole realm of architecture – fortifications, town planning, sacred and secular building, and the systematic theory of architectural form and structure. No architect up to the time of Leonardo bequeathed to the world so rich a heritage of architectural ideas and designs. With the drawings of Francesco di Giorgio, Giuliano da Sangallo, and Cronaca, Leonardo's studies are among the first records of architectural drawing in the Renaissance, and afford a clear and abundant insight into the architectural ideas of the period. In their method and the wealth of subjects they treat, Leonardo's drawings are in many ways more informative than those of the other three.

At quite an early date – certainly not later than the eighties – Leonardo seems to have conceived the plan of reducing his architectural ideas and studies to a clearly defined system. One of his sketchbooks – MS. B, Institut de France (Plates 146 and 147) – was originally intended as a pattern-book of architectural types. Further, other architectural

studies of his (MSS. A and B, Codices Atlanticus (Plate 148A), Arundel, and Trivulzio) show a definite and extremely significant principle of method; they are preliminary studies for a kind of pattern-book which was to have formed part of a projected treatise on architecture.

Surveying these studies as a whole, what comes to light is the outline of a theory of architecture in the grand style which was to have fused in one comprehensive theory of form and structure all the architectural knowledge of the period.[55] There are quite a number of sketches in Leonardo's manuscripts which are obviously preliminary studies for this project (Plate 148), and his preparatory work for definite practical schemes would also have been included in it. Besides the urbanistic projects, there are the ideal designs for centrally planned and longitudinal churches which are, in effect, a complete programme of every imaginable spatial composition. It is a collection of Renaissance building types which could not be surpassed in accuracy and abundance.

It is here that we can see Leonardo as the bond of genius between the Middle and Upper Italian architectural traditions. All his designs bear the stamp of the effort to transpose the complex forms of the centrally planned buildings of medieval Lombardy into new, more coherent and disciplined architectural organisms by means of his own Tuscan feeling for clarity and structural logic. What results is a regular catalogue of compositions which extends from the simple spatial groupings of the Early Renaissance to the more complex forms of the High Renaissance and is a unique exposition of the magnificent development of Italian architecture in the Quattrocento, which culminated in Milan. For seventeen years, Leonardo and Bramante worked side by side in Milan as court architects, exchanging ideas and practical experience. No drawing of Bramante's has come down to us which could explain the metamorphosis of his style between his entirely Early Renaissance work in Milan and his 'Roman style' of after 1500. This gap is closed by Leonardo's notes, and for that reason, if for no other, as evidence of the architectural ideas of the period, they are of supreme importance, for there is no other, whether in writing or drawing.

But even beyond that, they are of the utmost value in two respects. Firstly, the essential forms of orthographic and perspective projections of the Renaissance can be grasped for the first time in the drawings of Leonardo. In addition to the separate types of ground-plan diagrams, they illustrate the various manners of perspective rendering of interiors and exteriors down to the perspective section. Moreover, for the rendering of architectural compositions, Leonardo developed a special method of draughtsmanship which is only to be found there, but is related to those principles of formalized graphical representation which are illustrated in other branches of his scientific and didactic drawing, e.g. in mechanics and anatomy.[56]

While the first main section of the treatise was to have covered the theory of architectural types and forms, of sacred and secular buildings, and of architectural proportions and ornament, the second was planned as a theory of architectural construction. Leonardo made extensive preliminary studies for this part too, and one or two chapters, e.g. *The Cause of Dilapidation in Buildings* and *The Theory of the Arch* (Plate 148F), were far advanced.

As a whole, Leonardo's projected *Treatise on Architecture*, the probable contents and range of which can be fairly well reconstructed from the extant preparatory studies, forms the extremely important link between the Early Renaissance architectural theories of such men as Alberti, Filarete, and Francesco di Giorgio, and those of the High Renaissance – in particular Sebastiano Serlio's treatise – which develop the type of the pattern-book under new aspects. In one respect Leonardo's treatise differs fundamentally from its predecessors. It was planned in the first instance as a classified collection of technical drawings which were merely explained by an accompanying text. Thus even here, as in his handbooks on mechanics or anatomy, Leonardo was faithful to his conviction that drawing, in the unambiguousness of its statement, was a more reliable method of communicating knowledge than the word, which can only describe. I think we may assume that this new idea of a didactic treatise in pictures – perhaps transmitted through Bramante and Baldassare Peruzzi – may have had an influence on Cinquecento books of designs, particularly that of Sebastiano Serlio.[57]

It is not easy to do historical justice to Leonardo's phenomenal status in architecture. The extreme sobriety of his feeling for architecture as an art, the almost mathematical abstractness of his variations on architectural types, the total neglect of the classical repertory of form[58] set him apart from the important practical architects of his generation, although he was in constant touch with them. On the other hand, the wealth of his ideas, assimilated or invented, proves that he noted with a keen and watchful eye every potentiality the period offered. That is as true of his town-planning schemes as of his designs for sacred and secular buildings and his invention of individual forms. Quite often his drawings look like anticipations of ideas which were only realized later; thus the central plan in MS. B, 57 verso (Plate 148B), which can be dated in the nineties, corresponds very closely to Bramante's first scheme for St Peter's,[59] while the sketch of a church façade in Venice (Plate 148C), steep and compact in its proportions, or the palazzo sketch on the cover of the *Treatise on the Flight of Birds* (*c.*1505) (Plate 148E), with its coupled order embedded in the wall, point to stylistic formulas which were to be characteristic of the first quarter of the Cinquecento. On the other hand, there are ideas which were undoubtedly suggested to Leonardo by existing buildings: the mausoleum in the Print Room of the Louvre (Collection Vallardi) and the huge palazzo façade for Romorantin (Cod. Atl. 217^{v-b}, 1518) make us feel the influence of the Roman Bramante. On the sheet of designs for portals, also datable in his last years in France (Cod. Atl. 279^{v-a}), the coupling of triangular and segmental tympani in the last type – executed in pen and ink – even has Mannerist features. And finally, Leonardo's Teatro da Predicare (MS. B fol. 52 and MS. 2037 fol. 5 recto (Plate 148D), before 1500) is an architectural fantasy based on a very unusual modulation of classical prototypes which appears nowhere else.[60]

We shall perhaps best evaluate Leonardo's architectural studies at their true worth if we consider them as variations, personal and brilliant, on the architectural themes pursued by his contemporaries. As these drawings and notes extend over his whole life, they span just that most significant period from the eighties of the fifteenth to the second

decade of the sixteenth century, when the principles of the classic style were developed and brought to maturity. Leonardo's architectural studies offer a unique opportunity to grasp this genetic process in the thoughts and reflections of one of the greatest artists of the time; it is on this – essentially – that their paradigmatic value and supreme historical importance depend.

PART TWO

THE CINQUECENTO

BY

WOLFGANG LOTZ

CLASSICAL ARCHITECTURE IN ROME: BRAMANTE

'BRAMANTE was the first to bring to light good and beautiful architecture which from the time of the ancients to his day had been forgotten.' With this remark Palladio justifies the inclusion of Bramante's Tempietto in Book IV of his Treatise on Architecture, which, with this sole exception, dealt with ancient temples only. The Tempietto of S. Pietro in Montorio, Rome, is the first classical building to have been erected in the city. Bramante himself worked later on schemes which were not only far bigger, but were also more important for future developments. But the rebuilding of St Peter's and the Belvedere Court of the Vatican were only completed several generations later; to identify Bramante's hand in them would mean a laborious work of discrimination between many superimposed strata. The same might be said of Raphael, who succeeded Bramante in the work on St Peter's; his buildings too, with a single exception, have suffered drastic alterations. Thus it is not by chance that Palladio includes a reproduction of the Tempietto as the only illustration of the new style; after 1550, when he was working on his treatise, most of the buildings representative of the new style had been so much altered that only the Tempietto was there to give an immediate insight into Bramante's work.

Yet there can be no doubt about the influence of Bramante and Raphael on Italian Cinquecento architecture. Their pupils, particularly Baldassare Peruzzi, Giulio Romano, Sansovino, Sanmicheli, and the Sangallo family, established and gave standing throughout Italy to the classical style, which had made its first appearance in Rome. It is fairly easy to define Bramante's and Raphael's influence, but when it comes to forming a judgement of the works which gave the new style its imprint, we have to rely largely on indirect sources, such as drawings made when work was in progress, account books and contemporary descriptions, buildings by pupils and disciples, and the illustrations in the various architectural treatises. This is especially true of the treatise of Sebastiano Serlio of Bologna, which contains in Book III, first published in 1537, in addition to the Tempietto, reproductions of Bramante's designs for St Peter's and the Vatican Court. Serlio's source was Baldassare Peruzzi, who worked on these buildings under Bramante and Raphael.[1] Any attempt to gain some idea of the work of Raphael and Bramante from this complex material must always make allowances for later corrections.[2]

Bramante's personality made a deep impression on his contemporaries. In his 'School of Athens', Raphael depicted his teacher in the guise of Euclid demonstrating the principles of geometry. Another pupil, Cesariano, relates: 'My teacher, Bramante, was an artist of the first order. He was also familiar with the work of the Italian poets. Though he could not write, he had a wonderful memory and spoke with ease and eloquence. Originally court architect to Duke Ludovico Sforza, he later restored many papal buildings, especially under Julius II. And so he became the pre-eminent architect, rebuilder, and recreator of the basilica of St Peter.'[3]

The Tempietto of S. Pietro in Montorio

Bramante's Tempietto of S. Pietro in Montorio (Plate 149 and Figure 48), a peripteral rotunda, was a foundation of the King of Spain built in 1502 on the traditional site of the martyrdom of St Peter. The rotunda in itself was not an entirely new conception: round buildings had existed in the Quattrocento.[4] But the Tempietto is the first Renaissance building in which the cella is surrounded in the ancient manner by a colonnade bearing an architrave. As in the ancient models, the intercolumnar intervals are equal all the way round; thus the arrangement of the columns gives no indication of where the altar stands inside the cella. There is yet another breach with Quattrocento tradition:

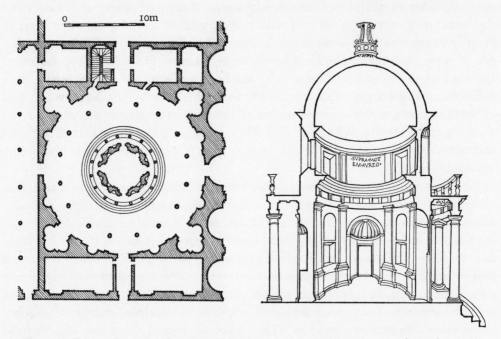

Figure 48. Donato Bramante: Rome, S. Pietro in Montorio, Tempietto, 1502, plan and section

the interior is too small for the visitor to feel that its actual purpose was to create a space. The interior diameter of the cella is only about 4·5 m. (14 feet 6 in.). About half the pavement is occupied by the altar and the altar steps, so that there is little room for any congregation beyond the officiating priest and the altar-servers. While the centrally planned buildings of the previous period were primarily conceived as enclosed spaces for the celebration of the rites of the Church, the liturgical fitness of the Tempietto is quite subsidiary; the real 'content' of the building is its exterior. The Tempietto is there to be seen, not used; it is a monument in the traditional sense, not a church. That is probably the idea that underlies Serlio's curious remark that the building is 'not big, but was erected solely in memory of St Peter the Apostle'.[5]

For the new conception of the Christian memorial building exemplified in the

Tempietto, the architectural types of the preceding period could not be used, but the circular colonnade on its raised plinth had been preserved in two ancient specimens in Rome and Tivoli.[6] Thus there is in Bramante's work a new interpretation of the architectural problem involved and a new, quite unprejudiced comprehension of ancient architecture. The Tempietto may be regarded as a memorial monument, whose cella-shaped interior houses the altar.

Beyond its general design, the Tempietto also follows ancient models in its vaulting; the dome, hemispherical in section, is executed in cemented masonry.[7] But while in the rotundas of antiquity the dome springs straight from the main order, Bramante has inserted a drum-shaped intermediate storey, the height of which is about equal to the radius of the hemisphere. Thus, as in the Pantheon, a logical and living relationship is established between the circle of the ground-plan, the height of the cylinder bearing the dome, and the hemisphere of the dome itself. At the same time the entablature of the colonnade is prevented from cutting into the exterior view of the dome.

According to Serlio, Bramante's plan was not executed in full. The Tempietto was not to have stood, as it stands today, in a square courtyard; it was to have been surrounded by a circular cloister of sixteen columns. Serlio states that the diameter of the columns in this cloister was to be one and a half times that of the columns in the colonnade, and the height was to have been in the same ratio. Thus, for the spectator standing in this cloister, the view of the Tempietto would have been framed in its columns and entablature, and he would almost certainly have taken the columns in the colonnade as equal in height to those of the cloister. In that way the Tempietto would have gained in monumentality; it would have looked higher and wider, and the surrounding courtyard more spacious.

In spite of the regularity of the design, the Tempietto is calculated for yet other effects of perspective. When the door is open, the spectator standing in front of the building sees the altar, with the crucifixion of St Peter in the predella, enframed in the entrance to the cella. The relief of the crucifixion is at his eye-level.[8] This picture brings home the iconographic significance of the building. If the original plan reproduced by Serlio had been carried out, the colonnade would have appeared in the frame of the cloister, and the altar with its representation of St Peter's martyrdom, i.e. the event in memory and on the site of which the monument was erected, would have appeared as a picture within the picture. From the entrance to the courtyard, both pictures would have been taken in at one glance.

In its formal idiom and structure, as well as in its design as a memorial chapel, the Tempietto is closer to the essential nature of ancient architecture than any religious building of the Quattrocento. Bramante had far outstripped the compromises between medieval Christian tradition and antique form admitted by the fifteenth century. His training at Urbino and his study of architectural theory, especially in the work of Alberti, led him to the vernacular of his works in Lombardy; the classical language of his late style, developed when he was nearly sixty and first expressed in the Tempietto, was the product of a very conscious coming to terms with the ancient architecture of Rome.

Yet this late style is not a complete break with Bramante's Lombard style. In spite of all its formal innovations, the conception of the Tempietto is closely akin to the sham perspective of the choir in S. Maria presso S. Satiro. In the Roman work, the exterior and interior views were united in a single picture; the product is a three-dimensional structure, not a feigned architecture in flat relief, and is the consequence of the totally different architectural problems involved. In Rome, as in Milan, the spectator is assigned one definite standpoint, which is the only one to present the right view. In both cases the structure must be seen as a motionless picture, not as a space in which the spectator moves. Both buildings look as if they had been composed in the visual pyramid defined by Alberti. In the Tempietto, the consequences of this kind of composition stand out more clearly, since the smallness of the building would have allowed only one spectator to occupy the 'correct' viewpoint.

The Cloister of S. Maria della Pace

In 1500, soon after his arrival in Rome, Bramante designed the cloister of S. Maria della Pace (Plate 151).[9] A comparison with the cloister of S. Ambrogio in Milan shows a growing assimilation of ancient forms; the result was the Tempietto, built two years later. In Milan, the lower arcades stand on columns, in Rome on piers, yet the Roman system of pier, pilaster, and arch is very similar to that of the upper storey in Milan. In Rome, alternating pillars and columns support the architrave of the upper tier, the pillars standing on the axis, the columns over the keystones of the lower storey. A preliminary stage of the doubling of the number of arcades in the upper storey can be seen in the courtyard of S. Ambrogio and the sacristy of S. Maria presso S. Satiro. On the other hand, the plain architrave and the sequence of the orders – Corinthian over Ionic – already point to the classical style of the Tempietto.

The cloister is a point of transition in Bramante's *œuvre*; in the development of urban architecture in Rome, coming after the Cancelleria, it could not but present an innovation of capital importance. This was the first time since the courtyard of the great Palazzo Venezia that the structural technique and forms of antiquity were employed on a modern project.

Buildings for Julius II

Julius II, who was elevated to the throne of St Peter in 1503, had spent the ten years preceding his elevation away from Rome. The buildings erected under him in Rome and at Savona, his native city, were designed by Giuliano da Sangallo. After his patron's elevation to the pontificate, Sangallo was justified in expecting new and more important commissions; in 1504 he left Florence for Rome, where Bramante's Tempietto and the cloister of S. Maria della Pace had been built during the Cardinal's exile. About 1500 there was nothing in Florence to compare with them. When Vasari says that the brothers Giuliano and Antonio da Sangallo represented Tuscan architecture better than any other architects, and applied the Doric order more correctly than Vitruvius, he lays his finger

on both the merits and the weaknesses of their style. No architect preserved more faithfully the heritage of Brunelleschi and Alberti than Giuliano da Sangallo, and none of his contemporaries drew the monuments of antiquity with greater application and precision than he. Yet Sangallo's design for the loggia of the Pope's tuba-players (Plate 150), made in 1505, shows how completely he lacked the deeper understanding of antiquity which had enabled Bramante to create a synthesis pointing beyond the Quattrocento. The drawing could be taken for a reproduction of an ancient triumphal arch if the decorative detail and the inscription were not there to show the purpose of the design. It was never executed; in 1507 Sangallo returned to Florence. It was not he but Bramante who designed the great buildings for the new Pope.

Under Julius II the Papal State, the Patrimonium Petri, became the supreme state in Italy; for the first time for centuries the papal throne ranked as a great European power. The new conception of the status and task of St Peter's successor is also manifest in the works of art which Pope Julius II left behind him. With the ceiling of the Sistine Chapel, the new St Peter's, the Vatican Palace, and the Pope's tomb, Rome, for the first time since Late Roman times, became the centre of western art. Even the generation in which these works were created realized that they bore witness to a new claim to universality by the papacy. As Guicciardini points out, the very name which the Pope chose on his elevation was an expression of that claim. Julius felt himself to be as much a successor of St Peter as an heir of the Caesars, and as a building patron too he did everything in his power to reinstate Rome as *Caput Mundi*.

The Belvedere Court of the Vatican

The first of Julius's great projects was the Belvedere Court of the Vatican (Plates 152–5 and Figures 49–51), begun with Bramante as architect-in-chief; the first payments made to him are dated 1505.[10] The structure bridged the dip between the old papal palace next to St Peter's and the originally separate villa which Innocent VIII had built between 1485 and 1487 on the northern slope of the Vatican hill. Julius II had the ground rising towards the villa terraced, connected the terraces by a system of steps, and bounded them on both sides by multi-storey loggia corridors. By one of Julius's portrait medals we can see that he himself felt the dimensions of the project to be outstanding; the reverse bears a view of the new courtyard, which is described as '1000 feet in length and 80 in height'.[11]

The purpose of the building was also unusual. The papal collection of ancient sculpture, to which the Laocoön had recently been added, was deposited in a square courtyard between the old villa, i.e. the actual Belvedere, and the north side of the new cortile. The two upper terraces of the latter were to serve as a garden; the lower courtyard, occupying about half of the area, was to be used for tournaments and pageants. The narrow side of this lower courtyard forms the north front of the old palace with the Pope's private apartment, Alexander VI's Appartamento Borgia, and above it Raphael's Stanze, painted under Julius II. The Stanze are on exactly the same level as the upper terrace of the court, which is 1000 feet distant. This terrace came to an end in a one-

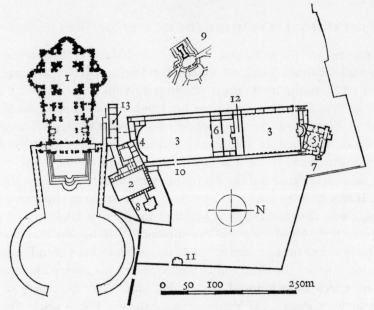

Figure 49. Rome, Vatican, Cortile del Belvedere and adjoining structures, plan

KEY

1. St Peter's
2. Cortile di S. Damaso with Loggia
3. Cortile del Belvedere
4. Exedra of Pius IV
5. Statue Court
6. Library of Sixtus V
7. Bramante's circular staircase
8. Palace of Sixtus V
9. Casino of Pius IV
10. Porta Julia
11. S. Anna dei Palafrenieri
12. Braccio Nuovo
13. Sistine Chapel

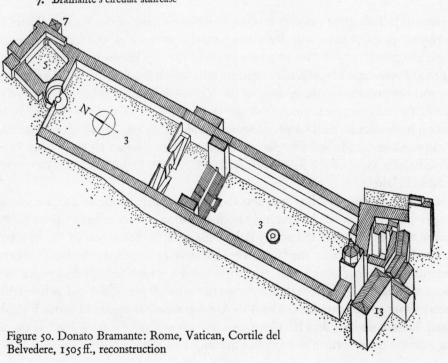

Figure 50. Donato Bramante: Rome, Vatican, Cortile del
Belvedere, 1505 ff., reconstruction

Figure 51. Donato Bramante: Rome, Vatican, Cortile del Belvedere, 1505 ff., exedra

storey façade facing the old villa, with a semicircular recess in the middle (Figure 51). The staircase leading from the terrace to the exedra no longer exists. The steps were shaped in concentric circles, the outermost circle circumscribing both the lowest and the uppermost steps. Given the limited space, neither the steps nor the platform they led to had any practical purpose; their function was primarily aesthetic. The exedra was the final note in the artistic crescendo of terraces and stairs which the courtyard presented when seen from the opposite narrow side. This is what Serlio means when he says of the exedra that it 'was built in the form of a theatre'. In the same way as in the Tempietto the viewpoint of the spectator of this 'theatre' can be precisely situated; from Raphael's Stanze a general view can be obtained of the whole site, which rises in terraces from the lower court to the exedra. The design has one thing in common with that of the Tempietto, namely that this viewpoint, which also offered the best view of the pageants in the lower court, was situated outside the court, so that the view was framed by a window. In the Tempietto, however, the eyes rest on a solid building, while in the Belvedere they rest on the open space of the courtyard.

There is irrefutable proof in the sources that the conception of the Belvedere Court originated with Bramante. In this building he applied the principle of perspective composition to a work of architecture comprising landscape and architecture, hill and valley, garden and fountain, and fused the whole into a picture. There were Quattrocento predecessors for some of the features of the composition.[12] But the true model for the Belvedere Court is to be found in antiquity. The descriptions by Tacitus and Suetonius of Nero's Golden House, the remains of the Temple of Fortuna at Palestrina, the long oblong of the hippodrome in the imperial palace on the Palatine, and Hadrian's villa at

Tivoli have so many elements in common with the Belvedere Court that there can hardly be any doubt of its true meaning. The papal residence on the Mons Vaticanus, as the hill is called in the inscription on Julius II's medal, was, as a whole, to rival the imperial palaces on the hills of Rome. The inscription reflects perfectly the other political and artistic ambitions of the Pope.

The court itself was never given the form that Bramante had in mind. For fifty years building went on in all essentials according to the original design, but about 1580 Sixtus V finally abandoned Bramante's idea by building a connecting wing across the court to house the Vatican library. Yet no Roman building had a greater influence on the secular architecture which followed than the Belvedere Court. It largely determined the idea of the relationship between architecture and landscape which developed in the sixteenth century. The continuation and alteration of the building compelled all the leading architects of Rome, from Raphael to Domenico Fontana, to come to terms with Bramante's ideas and formal language. There are countless working drawings, vedute, and engravings which have preserved the varying forms of the whole structure. From the time of Julius II it has been one of the wonders of the world.

In the building itself, the only part to have retained its original form is the east portal leading into the lower court (Plate 158). In its combination of neat brickwork, rusticated travertine, and monumental inscriptions in capital letters, the Porta Julia too can rival antiquity. It is not by chance that the inscription is so placed that the letters PONT. MAX. appear immediately above the porch itself, for the Pope shared the office of Pontifex Maximus with the emperors of antiquity. The formal repertory of the porch was drawn upon again and again in the sixteenth century, but its force of expression and monumentality were never equalled.

The three-storey logge on the long side of the lower courtyard, of which Julius II had only begun the eastern one, have been altered out of all recognition, while the intermediary terraces are largely concealed by later additions. The original execution has been preserved in the drawings of one of Bramante's pupils (Plate 157). The single-storey logge of the upper court, although later walled up and topped by a second storey, retain the original alternation of wide arcades and narrow bays which are set with two Corinthian pilasters (Plate 156).[13] Details such as the window surrounds and flattened rustication date from about 1560; the tall pedestals of the pilasters and the projecting entablatures over the pilasters, on the other hand, have remained in their original form.

The Logge

One item in Julius II's programme for the Vatican was the four-storey façade begun by Bramante, which was set in front of the old papal palace to the east, i.e. facing the city. It can be seen today in the west wing of the Cortile di S. Damaso, but has been deprived of its original function as the main façade, as it was recorded by Heemskerck, among others (Plate 159). The lower range was concealed towards the city and St Peter's by walls, and is therefore treated as a plinth; the second and third ranges consist of piers and arcades, the topmost storey of columns with an entablature.[14] The orders follow the

usual sequence – Doric, Ionic, Corinthian. For the first time in the Renaissance the city front of a palace is treated as a system of free-standing supports and logge, and not as a wall. Here again Bramante shows more consistency and insight in the employment of the Roman system of supports and orders than his predecessors. The famous decoration of the interior in stucco and fresco by Raphael and his pupils was only completed under Julius's successor, but it is in perfect keeping with Julius's intentions. The interior of the logge, decorated with subjects from the Old and New Testaments, was intended to rival, as a Christian *domus aurea*, the *domus aurea* of Nero, which had been recently discovered. Its façade was meant to dominate the view of the city.

New St Peter's

Julius's building programme was to find its crowning achievement in the new St Peter's. As Alberti had already reported, the basilica of Constantine was dilapidated and in need of restoration, but Julius's predecessors had shrunk from interfering with the old building. Neither the choir outside the old apse begun by Rossellino for Nicholas V, nor the foundations of the transept laid after the same plan, impinged on the old building. Even the first pier of the new building, the foundation stone of which was laid in the presence of Julius II on 18 April 1506, stands outside the old apse; it joins up with the masonry of the Rossellino choir, but the Pope made it quite clear that he meant to demolish the basilica of Constantine. As early as January 1506 he had communicated to Henry VIII and the lords spiritual and temporal of England his decision 'to renovate the very dilapidated church of St Peter the Apostle in Rome from its foundations up and to provide it in seemly fashion with chapels and other necessary rooms'.[15] Since the means of the Curia were insufficient, the recipients of the letters were asked for contributions.

Vasari's and Condivi's biographies of Michelangelo gave it to be understood that the Pope's plans grew out of the discussion of his tomb, to be planned by Michelangelo. The first site envisaged for it was the Rossellino choir; in the course of the discussions the Pope resolved to rebuild the church and selected Bramante's plans from those submitted (Figure 52A). Both Vasari and Condivi relate this at second hand; both strive to cast the brightest light on their hero, Michelangelo. Their version must therefore be accepted with some reserve, though we have no other sources for the course events took.

The exact plan on which work was begun is equally obscure. It was certainly the work of Bramante, who remained, till his death in 1514, *architetto della fabrica di S. Pietro*. The earliest reproduction of his plan is on the reverse of a portrait medal of Julius II which was probably struck when the foundation stone was laid (Plate 160). This showed, above the Mons Vaticanus, the exterior view of a domed building whose plan must be imagined as a Greek cross. On the ground floor, apses projected from the arms of the cross; in the corners of the cross there are minor domes, while there are towers on both sides of the façade. Whether the remarkable stress on the horizontals and the sobriety of the ornament are due to the medallist or to Bramante it is almost impossible to say. On the other hand, there is every reason to believe that the representation of the main dome accurately renders Bramante's intentions.

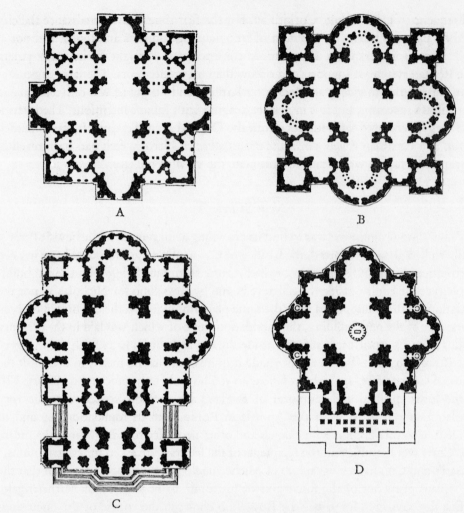

Figure 52. Rome, St Peter's, projects: (A) Bramante, 1506 ff.; (B) Peruzzi, c. 1520; (C) Antonio da Sangallo the Younger, 1539 ff.; (D) Michelangelo, 1546 ff.

A second source for Bramante's ideas is a parchment plan in the Uffizi (Plate 161). It belonged to Vasari, and on the back of it there is a note by Antonio da Sangallo the Younger, who began to work on St Peter's in 1510 and became superintendent of the fabrica in 1520; according to this note, this is a plan 'by Bramante that was not executed'. This is the only known drawing for which there is reliable evidence that it is by Bramante's hand. It tallies with the medal in the general form of the crossing, the transepts, minor domes, and campanili. But as the sheet shows only half of the Greek cross, it cannot be determined, as it can in the medal, whether the other half duplicated the one shown, or has to be imagined in some other form. Neither the plan nor the medal includes the parts of Rossellino's choir at the west of old St Peter's, which were still standing when the foundation stone was laid.[16]

Julius II died in 1513, Bramante in 1514. By that time, after the partial demolition of the nave of old St Peter's, the great crossing arches and the arm of the cross which joined

the western pier of the new building had been vaulted, but the other parts were hardly begun. For the vault of the west choir, Rossellino's still-standing walls were used; to the outside they were faced with Doric pilasters, while the piers of the crossing had Corinthian pilasters. A plan in the Soane Museum in London reproduces this stage of the work (Plate 162). In addition to the reproduction of the west choir, it differs in two respects from the parchment plan: the piers of the crossing have been strengthened and the western minor domes abandoned. Sangallo's statement that the parchment plan reproduces a design that was never executed is therefore proved correct. The plan in London further proves that the parts of the building standing about 1514, which varied greatly in height, were not to be continued as a purely centrally planned building; the pair of piers drawn to the east of the crossing can only be interpreted as the beginning of a nave.

As Serlio tells us, Bramante left the building unfinished, and 'there were already cracks in the four arches and piers'. In view of this condition, which is confirmed by other sources, we can understand why Serlio described the dome which was to be erected above these piers as 'bold rather than well considered'. All the same, he reproduces the design for the dome in plan and elevation, since 'it was a great revelation to architects' (Figure 53).[17] The exterior and the outline of the dome tally with the hemisphere on a colonnaded drum which appears on the medal of 1506.

Figure 53. Donato Bramante: Project for St Peter's, 1506ff., dome, plan and section

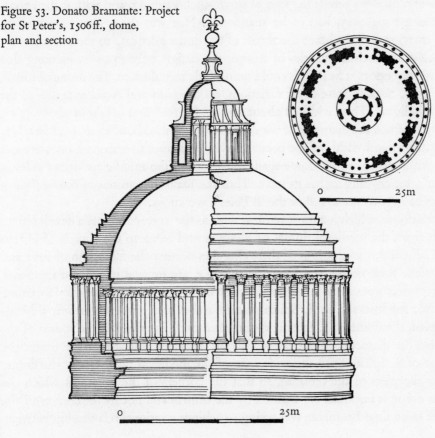

0 25m

0 25m

For the construction and size of a dome of this kind there was only one model in the western world: the Pantheon. This is also recalled by the steps at the foot of the dome. In all probability Bramante intended to vault his dome with cemented masonry, like the Tempietto; the single-shell hemisphere which Serlio reproduces could only have been constructed in that way. The account books show that the Roman method was actually applied to the arches between the piers at the crossing. The complex curve of the double-shell construction at Florence, which Giuliano da Sangallo still employed at Loreto, could not be brought into line with Bramante's endeavours to achieve simplicity of spatial form and exterior view. For that reason he decided on the single-shell method from the outset; the reversion to the Pantheon was far more than an archaeological reminiscence. If Serlio, with all his admiration for the greatness and beauty of the design, is still doubtful whether it could be executed, he is probably only expressing the general feeling of his contemporaries. He explains tactfully that Bramante's calculations in statics were utopian. 'As the elevation shows,' he goes on, 'the great mass and weight of the dome was to rest on four soaring piers; any prudent architect would do well to place a mass of this kind on the ground, and not so high up.' The hemisphere of the Pantheon dome is supported by a solid cylinder; hence, in Serlio's sense, it literally stands 'on the ground'.

Later, Bramante's piers were reinforced again, while the shape and structure of the dome was radically altered; the idea of single-shell vaulting, and with it the execution in cemented masonry, had to be abandoned. Nor was the system of subsidiary arches and exterior walls to brace the thrust of the dome adequate to the purpose.

Nevertheless, the artistic qualities of Bramante's design were so overwhelming that not one of his successors at St Peter's could quite elude its influence. The dome of today, finished in 1590, rests, in spite of all variations, on the piers and crossing arches of the first stage of building. Their width of about 24·5 m. (75 feet) and height of about 49 m. (150 feet) determined the diameter of the dome as we see it – about 42 m. (128 feet) – as well as the height and width of the present nave. Bramante's measurements were not laid down without reason; his dome spans the width of the middle and inner aisles in old St Peter's, his crossing arches its nave. Thus the main dimensions of the basilica of Constantine have been preserved in the St Peter's we know.

Bramante's dome, which is almost twice as wide as the nave, continues a development which leads from the medieval domes of Florence and Siena to the church of Loreto and Pavia Cathedral; the crossings of these churches occupy the full width of nave and aisles. But while their domes are domical vaults, i.e. are formed of pointed segments, Bramante's project goes back in its form and structure to traditions of the Florentine Quattrocento; for instance, in S. Spirito round arches and pendentives bear a hemisphere. In plan, the dome of S. Spirito appears as a circle inscribed in the square of the crossing; thus its diameter equals the width of the nave. But Bramante unites the circular type of S. Spirito with the wide span of the medieval type. Under the dome, he chamfers the piers of the crossing, so that the corners of the square in which the circle of the dome is inscribed are formed by the centres and not by the corners of the piers. At the same time Bramante was trying to achieve a rational relationship between

the height and the width of the dome. The height of the arches of the crossing is double their span, the total height to the crown of the lantern would have been double that of the arches, and thus the ratio between the span and height of the arches and the total height of the dome would have been 1 : 2 : 4.[18]

In the execution, the piers of the dome were not only reinforced, as a reference to the parchment plan will show; they were also articulated differently (Plate 163). Between the double pilasters of the intrados new niches were inserted, while on the exterior surfaces of the piers, the niches are three times as broad and deep as they appear in the parchment plan. If we try to visualize the elevation of the parchment plan, the pilasters would act primarily as an articulation of the wall *surface*. In the execution, however, their structural function was stressed; it is not the total pier but the pilasters which seem to be bearing the weight of the crossing. That is why the wall between the pilasters was hollowed out, as far as possible, in niches. We may assume that the unusually great projection of the capitals and cornices goes back to the alteration in the design.

A characteristically Bramantesque feature was the stepped base of the Corinthian order, about 3 m. (10 feet) high (Plate 163), which was covered up later when the floor level was raised.[19] This gigantic platform would have raised the order of pilasters far above the spectator's eye-level when he was standing in the church; he would actually have looked up into the structure from below, and be permanently separated from the perpendicular wall by the enormous projection of the steps, i.e., by a distance prescribed by the architect. As in the Tempietto and the Belvedere Court, the spectator was not to feel that he was standing in the building, but that he was looking into it; the Roman orders, the arches, and the dome are primarily conceived as a spatial picture, or as a series of spatial pictures. Their effect in their static or structural function was secondary.

The projects for St Peter's made after Bramante's death show that it was not clear whether the parts already begun were to be completed as a basilica or on a centralized plan. Bramante's interest must have been entirely concentrated on the dome commanding the exterior and interior views. The instructions given to his pupils and successors in drawings and models, as we know from Serlio's illustrations, were concerned only with these views, while the rest of the building took second place for the time being.

The dome was to rise above the tomb of St Peter and crown the Mons Vaticanus. By order of Julius II, nothing was changed at the tomb itself or in the emplacement of the high altar above the confessio. But however the remaining parts of the church of the Apostle may have been planned, it was very different from old St Peter's. Beyond its significance as a place of liturgy, new St Peter's was to be a monument, a funerary monument in the tradition of the ancient mausolea and early Christian martyria.[20]

Bramante's design combined a number of older ideas. Centrally planned buildings on a Greek cross plan with a high dome over the crossing and smaller subsidiary domes figure in Leonardo da Vinci's drawings. As we have seen, Bramante combined Brunelleschi's pendentive and hemispherical form with the type of dome in which the diameter exceeds that of the nave. The giant order of the piers at the crossing had a predecessor in S. Andrea at Mantua. Another Albertian feature is the high plinth of the base which 'forces' a perspective view. Further, Alberti and Francesco di Giorgio Martini

after him had provided the theoretical arguments for the use of circular forms in church architecture, and, indeed, Bramante's hemispherical dome was to be erected over a circular plan. Bramante also followed Alberti's suggestions in the use of coffers for the decoration of the shell of the dome and the arches of the crossing.

But the influence of Bramante's design cannot be explained if we see it merely as the sum of Quattrocento experience. The formal repertory of the building, pilasters and niches, arches and domes, was not new, but Bramante was the first to invest these forms with the monumentality they were to have from that time on. There was no work of architecture in antiquity or the Quattrocento from which this repertory could be derived in its entirety, but Bramante had become familiar with the clarity of proportional relations, the simplicity of great spatial organizations in the Pantheon and the Basilica of Maxentius, and it was in these ancient buildings that posts and lintels expressed the forces at work in the mass of the building with the same power and clarity as in Bramante's crossing.

The revival of the antique which Serlio and Palladio extol as Bramante's achievement must not be understood as a revival by imitation. The dignity of St Peter's as the mortuary church of the Apostle from whom the Popes derived their authority demanded supreme dignity in its architectural forms. From the time of Dante, Petrarch, and Alberti, the Roman ruins were, in Italian eyes, the acme of beauty and dignity. 'Roma quanta fuit ipsa ruina docet' was Serlio's motto. Bramante fused the expressive force of ancient architecture with the tradition of the Christian liturgical and memorial building, and the result was a form which remained the ideal of church building till the age of classicism. Benvenuto Cellini wrote of Bramante: 'He began the great church of St Peter entirely in the beautiful manner of the ancients. He had the power to do so because he was an artist, and because he was able to see and to understand the beautiful buildings of antiquity that still remain to us, though they are in ruins.'[21]

The Choir of S. Maria del Popolo

Besides the Tempietto, the only sacred building by Bramante that has been preserved unaltered is the choir of S. Maria del Popolo, which was also commissioned by Julius II (Plate 164). To the square chancel, for whose walls the Pope had commissioned monuments for two cardinals, Bramante added an oblong bay and an apse. The architectural forms – the Tuscan cornice, the shell-vaulted apse, the coffering of the tunnel-vault over the chancel bay – could not be plainer, but just because of that Bramante's principle of design comes out most clearly. The spectator looks into the apse through the triple recession of the jambs, and this 'picture' is framed in its turn by the attached pilasters and the arch of the chancel bay. Unlike those of the Pantheon, the coffers of the vault are oblong, not square; they too guide the eye to the apse. The same purpose is served by the peculiar kind of lighting through slits in the wall and the lowest coffer of the vault. Actually, the spectator is not expected to enter the apse; seen from the altar, i.e. from a distant viewpoint, it unites in a single picture the monuments and Pinturicchio's frescoes in the chancel vault.

Many details recall the choir of St Peter's, which was vaulted by Bramante at the same time. There too the apse was shaped like a shell, and the unadorned windows over the main cornice and the coffers of the vault appear.

The Palazzo Caprini (Raphael's House)

Bramante's other churches in Rome, the centrally planned S. Biagio alla Pagnotta and SS. Celso e Giuliano, have been demolished, and can only be reconstructed from later drawings. His Palazzo di Giustizia never got past its beginnings; its site is on the via Giulia, which was laid out by Julius II and which is the first straight street to pierce the huddle of houses of medieval Rome. A palazzo built by Bramante for the Caprini family and in 1517 acquired by Raphael has also been pulled down. Its façade, which can be seen in an engraving (Plate 165) and several drawings of the sixteenth century, was as important for the development of the palazzo as St Peter's was for religious architecture.[22] For the first time, the ancient Roman order appears as a half-column on the wall, which thus becomes the background of a relief. The distinction between structural articulation and space-filling background was made still more obvious by the coupling of the half-columns, the projection of the architrave, and the forceful jut of the balconies under the windows. The same clear distinction came out in the rusticated ground floor between bearing blocks and plain, space-filling wall. The main entrance was a tall rectangle, the lower openings above the shop doors to its left and right were horizontal oblongs; in the piano nobile the emphasis on the central bay was omitted, as it is in a Roman temple façade. The Doric order in the piano nobile, generally confined to the ground floor, shows that in this case the ground floor was regarded merely as a plinth. The rustication too must be understood in the same way; the seemingly rough-hewn blocks, the 'unfinished' door lintels and keystones, support the 'perfected work of art',[23] the artist-architect's 'order' with its columns, plain walls, and articulated entablature. In this way the arrangement of shops and workshops on the ground floor of urban dwellings, which had been traditional since ancient times, was given a meaning in the whole architectural pattern. Even the baseness of the material used for the rustication appears to be significant in this context; it is not roughly hewn freestone, but a type of stucco coating of the brick front, which was, according to Vasari, an invention of Bramante himself.

The Santa Casa of Loreto

Another example of Bramante's use of the ancient orders can be seen in the marble incrustation of the Santa Casa of Loreto, commissioned by Julius II and begun in 1509 (Plate 166).[24] As in the Belvedere Court, the articulation is of the triumphal arch type. The coupled half-columns, with their bases and entablature, stand like a structural scaffolding in front of the recessed strata of the wall with its reliefs and portals. Thus, in the same way as in Raphael's house, a distinction is made between supporting and filling elements. In accordance with Serlio's theories, the Santa Casa of the Virgin is given the Corinthian order.[25]

Summary

No other Renaissance architect exercised so widespread and immediate an influence as Bramante. Even during his lifetime, the lead in architecture passed from Florence to Rome, and chiefly because of his work. As early as the first third of the sixteenth century, the new style made its appearance not only in Florence, Padua, and Venice, but in Spain, France, and Germany.[26] This new style has been called High Renaissance, and has been taken to be a continuous development from the Early Renaissance. That view, however, becomes problematical in the light of Bramante's work. True, his late Roman buildings have certain features in common with his work in Lombardy, but it is only the works executed after 1500, i.e. after his arrival in Rome – the Tempietto, the Belvedere Court, the plans for St Peter's, the Palazzo Caprini, and the Santa Casa – that show the new assimilation of antiquity which determined the new classical style. That style, therefore, can hardly be conceived as the result of an uninterrupted and general process of development.

The new style did not at first take hold in Florence and the north of Italy; it was introduced there by Bramante's and Raphael's pupils. Obviously, this style must be regarded as Bramante's personal achievement.

The Designs for St Peter's after Bramante's Death

In 1513, soon after his elevation, Leo X called Giuliano da Sangallo, then aged seventy, and Fra Giocondo, then nearing eighty, and appointed them collaborators with Bramante in the Fabbrica di S. Pietro.[27] We can hardly imagine that the Pope thought of dismissing Bramante from his post. Fra Giocondo had previously laid the foundations of a Seine bridge in Paris; thus he was probably called in as an expert on statics, since the piers of Bramante had been built on unstable ground. Sangallo's appointment must be taken as a similar move. In any case, building had progressed slowly since 1511. In the last years of Julius II's reign, the building grants had been reduced, and at times were entirely stopped owing to the expenses for the Pope's campaigns. On 1 August 1514, three months after Bramante's death, Raphael became architect-in-chief of St Peter's.[28] Fra Giocondo died in 1515; in the same year Sangallo left in order to design the façade of S. Lorenzo in Florence. Giuliano's nephew, Antonio da Sangallo the Younger, was appointed Raphael's assistant. Baldassare Peruzzi of Siena was also working on the building from 1520 at the latest.

Bramante's successors were faced with a difficult task. The shifting of the foundations and the cracks in the piers were a matter of general knowledge; in a general way too the public felt that the scheme was too ambitious, or even impracticable.[29] Since there was no definite plan which would have served as a guide to the continuation of the work, the new Pope had to consider how one could be established. Raphael's first official work was to make a model in wood. Further, an unusually large number of drawings has survived from this stage of building, and their attribution and dating has ever since been one

of the most fascinating and difficult problems in art history (Plates 167–73).[30] The number of these sheets, and the variations between them, reflect the bewilderment which reigned among the architects after Bramante's death, and also the conflicts between generations and trends which confronted each other after 1514.

What is common to all these plans is Bramante's piers for the dome, whether it is the centre of a centrally planned building or the crossing of a basilica. The point at issue was the kind of building – a Greek or a Latin cross – and the shape of the arms. Four solutions were put forward for the latter:

(a) Plain apses between the subsidiary domes as shown in the parchment plan, but the west choir begun by Rossellino and completed by Bramante to be retained.

(b) Ambulatories to be carried round the apses of the transepts, but Rossellino's choir to remain in its original form without an ambulatory.

(c) The Rossellino choir, like the transepts, to be provided with an ambulatory, but the latter not to be opened towards the interior by an arrangement of columns and piers.

(d) All the arms of the cross to have identical ambulatories, which would entail the demolition and rebuilding of the west choir.[31]

Apart from the shape of the arms of the cross, the purely central designs are mainly distinguished by their exteriors. The following variants occur:

(a) Square plan with slightly projecting towers at the corners.

(b) The towers and the apses provided with ambulatories to stand out boldly.

(c) The apses of the arms of the cross, but not the towers, to project from the square of the ground plan.[32]

The largest number of variants is to be found in the plans for the nave:

(a) The nave and the inner aisles of old St Peter's to remain as the nave of the new building.

(b) A new, double-aisled, seven-bay nave; tunnel-vault on plain, square piers.

(c) Double-aisled nave of seven bays, the supports with niches on the model of the piers of the dome.

(d) Double-aisled nave, five bays.

(e) Triple aisles, five bays with a simplified form of pier.

(f) Single aisles, five bays, chapels instead of outer aisles.

(g) Single aisles, five bays, with the nave groin-vaulted after the manner of the Basilica of Maxentius.

(h) Single aisles, three bays; a dome over the middle bay of the nave, and tunnel-vaults with penetrations in the first and third bays, i.e. a nave on the triumphal arch principle.[33]

The façades of the basilican plans have a portico as wide as the nave with all the aisles, with or without flanking towers; some of the plans provide for a deep vestibule. The exterior view of the purely central design recalls that of the foundation medal.

This list, which could be increased by several variants, is certainly not very entertaining. It reflects not only the bewilderment of Bramante's successors, but also the more theoretical than practical frame of mind of the architects at work. Peruzzi and Giuliano da Sangallo made perpetually new combinations of all the variants mentioned. Moreover

Peruzzi explored architectural ideas developed for St Peter's in theoretical studies without any idea of realizing them. This is the expression of an unmistakably mannerist attitude; a final and binding solution is evaded rather than sought, and intricacy seems more attractive than simplicity. In comparison, Bramante's effort to achieve simplicity, to create immediate comprehensibility in the forms and clarity in the relationships, stands out as a characteristic of the classical style.

CLASSICAL ARCHITECTURE IN ROME: RAPHAEL

SERLIO's statement that Bramante had left no finished model for St Peter's at his death is confirmed by Leo X's papal writ of 1514 appointing Raphael as architect-in-chief of the works.[1] According to this writ, it was Bramante who had proposed Raphael as his successor, since his work as a painter was famous. He had also, according to Bramante's praise, given proof of architectural talent and he had already designed the model for St Peter's. We may assume from this way of putting the matter that Raphael had, up to that time, not, in fact, performed as an architect, and that Bramante's judgement was based on Raphael's painting and on casual conversations between the two.[2]

In 1514, Raphael had completed in the Vatican the Stanze della Segnatura and d'Eliodoro. They are a milestone in the history of architectural painting, since the interiors represented in the frescoes appear, in quite unprecedented fashion, to be part of a far greater spatial context, which is left to the spectator's imagination. Looking at the 'School of Athens', for instance, we are given no hint of the height or width of the wall in which the statues of Apollo and Minerva stand; to obtain an idea of its size, the spectator would, as it were, have to step into the picture and look about him. While the full extent of the spaces represented by Quattrocento artists can be grasped at first sight, the width, height, and depth of Raphael's spaces are merely the sum of the impressions of a spectator changing his viewpoint several times – in imagination at least.

The Chigi Chapel in S. Maria del Popolo

This new conception of space is also a feature of the only religious building by Raphael which has been preserved in its original state, the Chigi Chapel in S. Maria del Popolo (Plates 175–7 and Figure 54).[3] The chapel is entered through an arch in the aisle, and in the interior of the chapel three blind arches respond to this arch. This system of arches supports a dome on pendentives. In its proportions and details the whole looks like a reduced reproduction of the crossing of Bramante's St Peter's. As in St Peter's, the diameter of the dome is greater than the entrance arch; that is why the spectator can only obtain a full view of the space when he has entered the chapel and looked about him, for it is only then that the view into the dome opens. Its mosaics are an integral part of the total composition.[4]

Like Bramante's choir, the Chigi Chapel was added to S. Maria del Popolo as an annex. Like the Tempietto, it is roofed by a dome. As we have observed, the interiors of Bramante's churches must be seen from a distance; it is only then that the full effect of their monumentality can be felt. All the spectator needs – even with the Tempietto – is a single glance; this will take in all that really matters. But in the Chigi Chapel, he has to look in several directions, as can be realized by the placing of statues in the four

niches in the piers of the dome. The spectator has to stand *in* the space, not just *facing* the space.

Two important innovations make the distinction perfectly clear. Raphael has abandoned the tall bases of Bramante's piers in St Peter's and of the pilasters in the cella

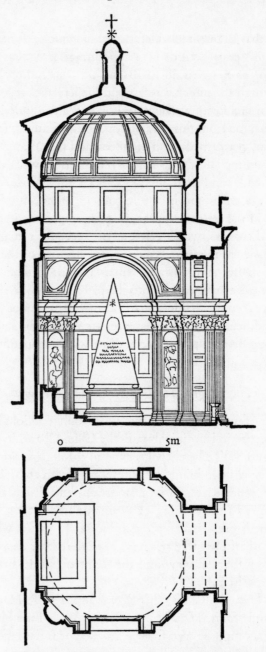

Figure 54. Raphael: Rome, S. Maria del Popolo, Chigi Chapel, begun *c.* 1513, section and plan

168

of the Tempietto. Further, while the walls and dome of the Tempietto are bare of ornament, and can therefore only be taken in as a stereoscopic picture in relief, Raphael himself designed mosaics for the dome of the Chigi Chapel with figures floating on a blue ground and the Almighty in the centre. Of the statues in the niches at least one was made after Raphael's design.

Thus the visitor to the Chigi Chapel stands on the same level as the base of the pilasters. The decoration of the wall between the pilasters shows that it is not conceived as a part of the architecture; on the contrary, compared with Bramante's walls it looks almost transparent. In the feigned openwork of the dome, the constellations and the Creator are seen through the interstices of the architectural framework. In Bramante's interiors, walls and orders form one indivisible whole; in Raphael's, the wall between the orders is, as far as possible, dissolved. The architecture of the building is to be understood as a scaffolding of structural members.

Palazzi

According to Vasari, Raphael planned the palazzo of the papal notary Giovanbattista Branconio dall'Aquila, which was demolished in the seventeenth century to make room for Bernini's colonnades in front of St Peter's.[5] Like that of the Palazzo Caprini, the façade was of five bays. But in the Palazzo dall'Aquila, the ground floor, which was to be let out in shops, was not rusticated, but articulated by an engaged Tuscan order and blind arches (Plate 174). On the upper floor, Raphael broke with the tradition which had descended from the Palazzo Rucellai by way of the Cancelleria to the Palazzo Caprini, and abandoned the classical order. The windows of the piano nobile were surrounded by boldly moulded aedicules with alternating pediments. Thus the weighty, jutting forms of the upper floor responded to the open arches of the lower. Between the aedicules, round-headed niches were recessed in the wall; thus the convex engaged columns of the ground floor were in contrast with the concave forms on the main floor. Similar contrasts can be seen in the piano nobile itself: rising pediments and hanging swags, the looser forms of the stucco ornament beside the architecturally stable forms of the aedicules, the projections of the column and the recess of the niche. If we look back to the strict system of Bramante's palazzo, with its clear differentiation between supporting and space-filling elements, the façade of the Palazzo dall'Aquila cannot but appear restless and illogical. Yet even there, definite principles have been consistently applied. The classical order only appears where there is a true relationship between load and support, i.e. where the wall is actually pierced by openings, namely on the ground floor and in the window aedicules of the piano nobile. Bramante's double order was a fiction in so far as the classical system of post and lintel was merely a screen in front of a solid wall. The design of the Palazzo dall'Aquila treats the wall of the upper storey entirely as relief, in accordance with its structural function. That is why there is no articulation of the angles, which Bramante had faced with three-quarter columns.

The Palazzo Vidoni-Caffarelli, although Raphaelesque in style, was probably not designed by Raphael himself. The original façade was of seven bays; the lengthening and

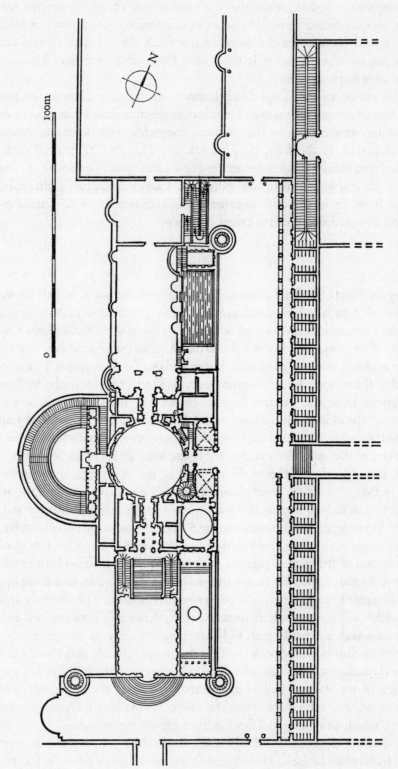

Figure 55. Raphael: Project for the Villa Madama, Rome, before 1520

the top storey belong to a later stage of building (Plate 178).[6] In this case the ground floor is treated as a rusticated plinth; the coupled Tuscan columns of the piano nobile also recall Bramante. But apart from the lintels, the joints in the rustication are entirely horizontal; the coupled columns stand on a common base, and there are no pediments over the windows. Throughout the façade, the horizontals are emphasized, but for that very reason, the coupled order takes on greater importance as the only vertical feature. Unlike Bramante's palazzo, the Palazzo Vidoni minimizes the axial relationship between the two storeys; the predominantly horizontal ground floor and the predominantly vertical upper floor appear unconnected, while the harmony of Bramante's façade lies in the coordination of five vertical units.

Raphael's late paintings abandon the calm and harmonious monumentality of classical art and show the new anti-classical style. The patron of the Palazzo Branconio dall'Aquila was the executor of Raphael's will. Vasari's attribution therefore seems very credible, the more so as its façade was one of the first examples of this new style in architecture. On the other hand, the Palazzo Vidoni – the only Roman palazzo of that phase of style to have survived – harks back to the pattern established by Bramante, although its architect failed to achieve the forcefulness of Bramante's design.

The Villa Madama

In the last years of his life, Raphael was working on plans for the villa of Cardinal Giulio de' Medici, later Pope Clement VII, on Monte Mario.[7] The superintendence of the works was entrusted to Antonio da Sangallo the Younger, who had also been an

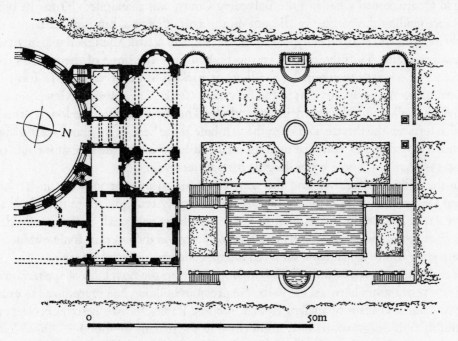

Figure 56. Raphael: Rome, Villa Madama, begun c. 1516, plan before restoration

assistant of Raphael at St Peter's since 1516. A plan of his shows the state of the design about 1520 (Figure 55). The centre of the villa was to be a large round courtyard. In addition to the living rooms, the villa was to have a theatre, stabling for two hundred horses, a huge hippodrome, and spreading gardens with ornamental waters. From the south, i.e. from the valley between the Vatican and Monte Mario, a great open stairway was to lead up to the main entrance of the villa. That programme could only be compared at the time with that of the Belvedere Court in the Vatican, which it was obviously intended to rival.

After the elevation of Clement VII, the Curia hardly had the means to continue the work on the Belvedere Court; thus the group of buildings on Monte Mario remained unfinished. The finished part was burnt down in the Sack of Rome. After a minimum of restoration, the villa passed in 1536 into the hands of Margaret of Parma, the daughter of Charles V, and it is from her that it takes its name, Villa Madama. What we see today is the product of a modern restoration; the only surviving parts of the original building (Figure 56) are the stump of the rotunda, five rooms and a loggia of three bays, and parts of the garden.

One factor which is essential to the comprehension of the villa is its situation on the slope of the hill (Plate 180). The idea of terraces had already been applied in the Belvedere Court, but while in that case parts of older buildings had to be included in the plans, there were no restrictions on the choice of a site for the Villa Madama. The site ultimately chosen prevented any clear distinction between the building and the surrounding landscape; the fusion of architectural and natural forms must have been intentional from the beginning. That is why the principle of symmetry, which was the rule in Quattrocento villas and the Belvedere Court, was abandoned. True, the buildings surrounding the cortile are laid out on the axes of a cross, but each remains a perfectly independent structure adapted to the terrain, and actually designed with a view to its particular site. Thus the theatre was to be built into the slope of the hill and to be screened off towards the court by the *skene* or backdrop; i.e. it was not to form part of a whole scenic perspective, as in the Belvedere Court. There was no viewpoint from which the villa could be taken in as a whole. The hippodrome, the loggia, and the garden terraces, the theatre, and even the vestibule at the head of the stairs, were planned in such a way that they could be used simultaneously or singly; the spectator could only grasp the plan as a whole by visiting its parts in succession.

In the Villa Madama we find the same emphasis on interior views as in Raphael's Chigi Chapel, the same abandonment of a structural system governing the whole as in the Palazzo Branconio dall'Aquila. In the cortile, large and small orders stand side by side (Plate 179); the garden loggia pilasters are Tuscan in the interior, Ionic outside. The two terrace fronts which have survived are modelled on different systems.

Yet the importance of the villa is not entirely due to the novel use of the terrain and the new relationship between the parts. No previous building had reproduced so exactly the function and form of ancient Roman models. Raphael's own description leaves no doubt that his design consciously conformed to the scheme he found in Pliny's letters. The theatre in Sangallo's drawing is an archaeologically correct specimen of the Roman

type. It would have provided an adequate setting for the performance of the humanistic comedies written for the court of Leo X, which, in form and content, rival those of Terence and Plautus. The revival of the architectural types of antiquity goes hand in hand with that of Roman literature.

Further, there is no post-Roman building which reproduces so perfectly the atmosphere of a Roman interior as the garden loggia of the Villa Madama (Plate 181). The immediate model was the stucco and fresco decoration of the Golden House and the Baths of Titus, which had been rediscovered about 1500. In them, as in the loggia, structure blends with ornament in one indissoluble whole. The dome over the central bay, the groin-vaults over the side bays, the extension of the side bays into apses, the system of wall piers and wall niches – there were precise models for all these details in the ruins from the age of Nero and the Flavians. And it was those buildings that Raphael, in a letter to Leo X, called the supreme achievement of the art of antiquity.[8] In the same letter, he says of Bramante's buildings that they came very close to antique architecture without ever having its wealth of *ornamenti*; the significance of that remark becomes evident in the Villa Madama. What Raphael meant was not ornament alone, but the ancient work of art as a whole; what he aimed at in his loggia was to restore the ancient unity of architecture, painting, and sculpture. Lavish though it is, structure and ornament are perfectly balanced there, each part clarifies, determines, and supplements the other, every point of view leads to another, equally significant vista.

The terrace gardens, in spite of centuries of neglect, still communicate something of that fusion of landscape and architecture which was characteristic of the whole villa. The waters from the three springs on the hillside collect in three niches hollowed out of the retaining wall of the main terrace. The type of fountain, composed of fragments of Roman sculpture, was often repeated in the Cinquecento. From those fountains the water is conducted to a large basin on the lower terrace which forms a fish-pond used also for watering horses. The grouping of the arches and niches of the retaining wall follows the pattern of a triumphal arch.

St Peter's

An unlucky star presided over Raphael's work on St Peter's. Leo X was far less interested in the new building than his predecessor. The ambitions of the Medici Pope were concentrated above all on the façade of his family church of S. Lorenzo in Florence and the rebuilding of the Florentines' church of S. Giovanni in Rome. Thus work on St Peter's proceeded slowly, as it had done in the last years of Julius II's life. Yet the pontificate of Leo X was of great importance for the building; it was then that a method was found for the work on St Peter's which was to remain essentially the same till the building was completed. While in Bramante's time planning and superintendence were united in one person, in 1516 the office of coadjutor was founded to carry responsibility for the planning and execution of the working drawings. Antonio da Sangallo the Younger, who held the office from 1516 to 1520, was promoted architect-in-chief after Raphael's death.[9]

Bramante's method probably adhered entirely to the conventions of the Quattrocento,

as described, for instance, by Alberti. The project was, as a general rule, laid down in a model; after the plan had been marked out *in situ*, the project was discussed in detail with the masons and stone-cutters, and in certain cases full-size patterns were made for mouldings, capitals, and similar details. In the early part of the sixteenth century the method of work changed, since, besides the model and plan, increasing use was made of elevations for planning and execution. There are reasons why the parchment plan of St Peter's is the only hand-drawn plan that can be attributed with certainty to Bramante, while a surprisingly large number of drawings has been preserved from Raphael's term of office. Raphael, who prepared his paintings in systematic and accurate drawings, must have realized that the planning of the building which he took over from Bramante could not be mastered with a model and a plan alone (Plate 170). Nor could the complex relationship between the piers of the dome, the transepts, and the nave, the dovetailing of old and new, be reproduced in perspective section, a process which Leonardo da Vinci, and still more the Bramante circle, had developed in order to reproduce the spatial configuration. The linear perspective calculated for a single viewpoint necessarily entails distortions of size and spatial relations. That was the reason why Raphael had to seek for a rendering in which the masons could read off all the structural members in their right proportions, though on a smaller scale.

These new methods were the orthographical projection and the vertical, i.e. non-perspective, elevation. Its first correct definition is to be found in the memorandum already mentioned which Raphael addressed to Leo X in 1519.[10] Raphael begins by pointing out that the architect does not draw in the same way as the painter. What the architect needs is a representation which will permit him 'to master all the dimensions of a building and to see all its parts without distortion'. Three views, Raphael continues, are necessary to a complete representation, namely a ground plan, an elevation, and a section with orthogonal projection. This is the only way to allow all the parts of a building to be correctly presented.

This memorandum is significant not only for the history of architecture. Raphael formulates in it with perfect clarity that total abandonment of Bramante's perspective configuration of space which we have already seen in the Chigi Chapel. What became important was not a single view of a building, but all its aspects; no member must be deprived of its significance, and interior and exterior views must be drawn separately. The designing architect no longer needed to give verbal explanations to familiarize the master-masons with the details of his plan; a trained assistant in the office was now in a position to prepare the working drawings after the original designs and to superintend their execution.[11]

The problems which awaited solution after Bramante's death, and the divergent proposals for the continuation of the building, have already been mentioned. Even before the ratification of his appointment, Raphael was commissioned to prepare a new general design with a corresponding model. The model has been lost; in all probability it reproduced the plan which Serlio gives as Raphael's design.[12] The same plan appears in a rather more exact form in the Mellon sketchbook made by a member of the office; it also contains the corresponding section and front elevation (Plates 169 and 170).[13]

At the beginning of his text to Raphael's plan, Serlio points out that several parts of Bramante's model were incomplete, and that Raphael, in designing his plan, made use of those left behind by Bramante. Serlio then goes on to discuss the purely central plan by Baldassare Peruzzi (Figure 52B), again stating that it incorporates what Bramante had left behind. A comparison between these illustrations and texts shows that Raphael's basilican plan is the first complete reproduction of a plan for St Peter's to have come down to us which we know was intended for execution. Raphael was superintendent of the works from 1514 to 1520. The plan, section, and elevation in the Mellon sketch-book, copied by a pupil, tally exactly with the three views called for in Raphael's memorandum.

This plan stands out from all its competitiors by its matter-of-fact clarity. An aisled nave of five bays is set in front of Bramante's domed space. This gives the building a longitudinal axis, while the actual façade is a broad, two-storeyed portico. Bramante's system of pilasters is employed for the piers of the nave and aisles, and, with corresponding variations, for the interior articulation of the aisle chapels; thus all the supports are of the same basic form. On the side of the nave and aisles they are faced with double pilasters, under the archivolts with niches. The height of the nave was fixed by Bramante's arches at the crossing; its breadth was to be reduced from 23 to about 19·3 m (69 to about 58 feet 6 in.) by the reinforcement of the piers.[14] The system of minor domes was restored, though it had been decided about 1514 to remove the two western ones at least.[15]

Beside the nave, the most important feature of the design was the ambulatories round the transepts. These one-storey passages appear in most of the plans made after Bramante's death. It is uncertain whether they had already been introduced by Bramante or came in only under his successors. In itself the motif was statical in nature. We know that the foundation of the piers proved inadequate soon after the elevation of Leo X. But there must also have been some anxiety as to whether Bramante's transepts would resist the thrust of the dome. For that reason it was decided to set the outer walls, which were exposed to the thrust, nearer to the piers of the dome than was originally intended. The ambulatories made it possible to reduce the interval between the crossing and the apses, and at the same time to double the exterior walls of the apse itself. The thrust of the dome could be conveyed over the vaults of the transepts to the lower, tunnel-vaulted ring of the ambulatories, and from them to the outer walls.

The elevation of the arms of the cross is given in Sangallo's drawings (Plates 171 and 172).[16] The giant order of the crossing is continued in the piers of the transepts; the columns between the piers form a minor order. Above their architrave there was to be a kind of triforium of blind arcades, and a group of three windows was to be inserted in the clerestory. The ambulatories, like the choir of S. Maria del Popolo, were to be lit by slanting shafts in the outer wall.

Exterior views of the ambulatories show a Doric order with engaged columns and aedicules; the insignia of Leo X appear on the metopes. According to the elevation shown in the Mellon sketchbook there were to be Doric columns on the ground floor of the towers and the lower ranges of the front. The giant order of four engaged

Corinthian columns and the gigantic pediment which screened the Benediction Loggia in the centre of the façade are a complete innovation.

There is something odd about the way in which Bramante's designs have been transposed and developed in this project. His system of pilasters on their tall plinths was, like the dome, retained without alteration, but a wealth of smaller members was added to the giant order. The exterior now has a richly articulated Doric system with a powerful relief effect. The clear and simple relation between the interior and exterior views, which Bramante had aimed at, is abandoned. The walls enclosing the arms of the cross are no longer the outer wall, but are separated from it by a new stratum of space – the ambulatories round the transepts and choir, the chapels in the aisles. Thus the interior assumes an autonomy which it did not have in Bramante's plan, nor does the composition of the exterior give any hint of the system governing the interior. Here, once again, we encounter the principle of the independence of the individual views or members of a building which we have already encountered in the Villa Madama and the Palazzo Branconio dall'Aquila.

Raphael had no intention of altering Bramante's dome or the shape and structure of the vaulting. The single-shell vault without a timber roof which appears in the Mellon sketchbook could only be executed in cemented masonry, and even the steps leading to the crown of the nave and transept tunnel-vaults would have had to be cast. Thus in the use of Roman forms and methods the projects agree; yet Raphael went a step further. The exterior view of his church was to be completely dominated by the ancient system of posts and lintels. Both in the ambulatories and the façade, free-standing or engaged columns are surmounted by a Doric architrave; the façade, like that of a classical temple, consists of columns and a pediment. Further, this arrangement is an obvious correction of the system of S. Andrea in Mantua; in the Mellon section of St Peter's the giant order of the façade corresponds exactly to that of the nave, so that the apex of the pediment is at the same height as the apex of the vault, while at Mantua the height of the interior structure does not tally with that of the exterior. Moreover, the classical order is not applied to the wall as a flat ornament, as it is at Mantua; it has become free, and looks like a structural scaffolding of the building.

With its nave, its tall towers, and its colossal front, this project surpassed that of the first phase of building both in scale and grandeur. Considering the financial distress of the Curia under Leo X, it was still more utopian than the centrally planned church begun by Bramante for Julius II. Yet Raphael's design, ratifying Bramante's final scheme, was a return to the traditional T-shaped design of old St Peter's. Raphael's new St Peter's would, like the old church, have been a processional way from the portico of the façade to the Apostle's tomb under the crossing. By deciding on the basilican plan, Bramante's project was relieved of that utopian factor which is inherent in any purely central plan for the solution of liturgical problems. St Peter's is more than the burial place of the Apostle; it is one of the seven churches which every pilgrim to Rome must visit. Moreover at least since the fifteenth century it has functioned as a cathedral, since the Vatican is the official residence of the Pope. The Roman pilgrimage churches, like most western cathedrals, are basilican in plan. Late in the fifteenth century this form

had also been chosen for the church of Loreto, which contains the Santa Casa and is related to St Peter's in many of its functions. Raphael's combination of a dome with a nave stresses the function of St Peter's as a church, while the centrally planned building designed by Bramante was to have been a triumphal monument to the Apostle and his successor, the reigning Pope.

*

Antonio da Sangallo, who succeeded Raphael at St Peter's in 1520, set forth the defects of Raphael's project in a famous memorandum.[17] The design, he says, provided for only *one* large chapel in addition to the small chapels in the aisles, and that was the west apse. The piers in the nave were heavier than those in the crossing, and the engaged Doric columns on the exterior were too tall in proportion to their circumference; in the interior the relationship between the tall pedestals of the piers and the niches in them was unsatisfactory. The lighting of the nave was inadequate; the space behind the west apse provided no real solution, since it was not connected with the interior of the apse.

What is most enlightening in this memorandum lies less in the details than in the fact that Sangallo accepts the general shape of Raphael's design and also abides by the connection between the nave and the dome.[18] His colleague Baldassare Peruzzi, on the other hand, made a design, which has been handed down by Serlio, proposing a return to the original idea of the purely central plan, with four minor domes, turrets, and the arms of the cross all of the same shape (Figure 52B). Serlio says of this plan that the church was to have had four entrances in the apses of the arms of the cross, with the altar standing in the middle. In later designs Peruzzi too decided on the basilican plan and tried to find a solution in which the vaulting and lighting system of the Roman baths would be retained in the nave.

The building of St Peter's progressed very slowly during Raphael's term of office. Yet the designs created in this period had a determining influence on the development of the new style. It is worthy of note that Antonio da Sangallo the Younger, however critical his judgement of Raphael's design may have been, adopted Raphael's idiom in his own work. As will be seen later, the new style was by no means the only one practised at the time. It only appears in the work of architects who were active in Rome in the twenties of the sixteenth century, and had seen, or even collaborated in, Raphael's new interpretation of Bramante's ideas.

The immediate consequence of the Sack of Rome of 1527 in Rome itself was an artistic vacuum. Like St Peter's, every building enterprise of note came to a standstill, and new buildings were not to be thought of. It was only under the pontificate of Paul III (1534–49) that a new florescence occurred. But the Roman buildings of the forties and still more of the fifties have a stamp which clearly distinguishes them from the classic style of Bramante and Raphael. The development of style in the thirties and forties was determined by Florence and northern Italy.

OTHER EARLY-SIXTEENTH-CENTURY BUILDINGS IN ROME AND CENTRAL ITALY

ROME

Palazzi

THE pontificates of Julius II and Leo X were of particular importance for the general aspect of Rome. These were the years in which Rome caught up with Florence, where during the great extension of the city in the fourteenth century broad, straight streets leading from the centre to the new city walls had been laid out.[1] The new Borgo Alessandrino had already been erected between the Vatican and Castel S. Angelo under Alexander VI; Julius II had two more streets laid out parallel to the Tiber, on the west bank the via Lungara, which connects the Vatican with the old Trastevere quarter, and on the city side the via Giulia, named after the Pope – the torso of the Palazzo di Giustizia begun by Bramante stands in this street (Figure 92). Leo X then constructed the via Leonina (now called Ripetta) connecting the Ponte S. Angelo with the Porta del Popolo, the northern entrance to the city. The centre of this system was the Castel S. Angelo and the bridge it dominated. The Campo Marzio, enclosed by the great curve of the Tiber, became more and more the centre of the city. The new cardinals' palazzi built there were more habitable than their rather more fortress-like predecessors of the fifteenth century, such as the Palazzo Venezia or the Cancelleria; they are also more urban, since their fronts are aligned with the street frontages. Among this group are the Palazzi Corneto (now Giraud-Torlonia), della Valle, Sora-Fieschi, and Giovanni de' Medici (now Lante).

In the patrician palazzi, too, the aesthetic effect of the façade and the cortile became more important than their defensive strength. Thus the Savelli had their ancient family fortress, the ruins of the Theatre of Marcellus, restored as a palazzo by Peruzzi. New buildings, such as the Palazzo Vidoni-Caffarelli, or Peruzzi's Palazzo Massimi, are not different in type from the cardinals' residences.

Hand in hand with this urbanization of the palazzi of cardinals and the aristocracy there went a rise in the architectural ambitions of the ordinary citizens' dwellings and business premises. The houses of the humanists and bankers working at the Curia rivalled the palazzi of the nobility. The best example of a humanist's house of the time is the recently restored palazzo which the consistorial advocate Melchiorre Baldassini had built for himself to Antonio da Sangallo the Younger's design about 1520 (Plate 182 and Figure 57). Even for Vasari the house was 'the most comfortable dwelling in Rome, and the first in which the stairs, the cortile with its loggias, the entrances and fireplaces are designed with the greatest charm'.[2]

The Palazzo Baldassini shows marked differences from the preceding type, which is illustrated by the Palazzi Caprini, dall'Aquila, and Caffarelli (Plates 165, 174, 178). In

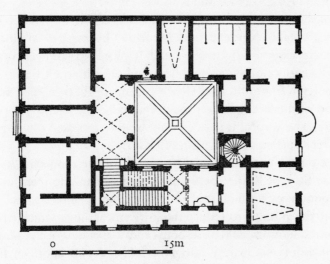

0 15m

Figure 57. Antonio da Sangallo the Younger: Rome,
Palazzo Palma-Baldassini, *c.* 1520, plan

these, the five- or seven-bay façade has two main storeys, the ground floor houses the
botteghe which were let as shops or workshops, while on the piano nobile there were
the private apartments and state rooms of the owners. The intermediate storeys, the
mezzanine over the botteghe and the second mezzanine over the piano nobile, can
hardly be seen in the façade; the windows were made as small as possible and
subordinated to the scheme of the two main storeys.

An idea of the classic palazzo courtyards can be obtained today from the Palazzo
Caffarelli; the ground floor consists of three arcades on each side, which are supported
by massive, plain piers.[3] In such cases the late Quattrocento had generally employed
columns; in more ostentatious buildings such as the Cancelleria, the arcades were
carried right round the cortile, while smaller buildings have a two-storeyed loggia only
against the front range. It may be that the shape of the supports, and the regular
arcading on all sides and its restriction to the ground floor in the cortile of the Palazzo
Caffarelli represented an innovation. About 1520 it became customary to face the pillars
with pilasters towards the courtyard; the model was probably Bramante's Belvedere
Court. An early example of this new type is the Palazzo Baldassini; on the entrance side
the cortile has a two-storeyed loggia, with three arches; the pilasters facing the piers on
the ground floor are Tuscan, on the piano nobile Ionic.

The most splendid design for a cortile in the classic phase has only been preserved in
a drawing. It is Bramante's plan for the Palazzo di Giustizia with its square courtyard,
each side consisting of five arcades.[4] Towards the court, the pillars were to be faced with
engaged columns after the model of the Theatre of Marcellus. Antonio da Sangallo the
Younger gave the pillars of the Palazzo Farnese, begun in 1517, the same form; the later
history of this cortile, which was given its final form by Michelangelo, will be discussed
further on.

The façade of the Palazzo Baldassini is also an innovation. Instead of the botteghe on the ground floor there are barred windows, their sills resting on brackets (Plate 182). On the piano nobile Sangallo abandoned the articulation by engaged columns and aedicules which is so characteristic of Bramante's and Raphael's palazzi; an ornamental band serves both as the cornice of the ground floor and the window-sill of the piano nobile, while the balconies in front of the windows, customary till then, have been eliminated. The main accent of the façade lies on the portal with the engaged Doric columns and their entablature. The vertical is stressed only by the rusticated travertine quoins; the windows are mere openings in the plain brick surface.

The botteghe on the ground floor disappeared for the most part from the Roman palazzo after the Sack of Rome; obviously they had come to seem undignified. The ground-floor rooms now open on to the cortile and are used by the retainers and clients of the patron. It was possible to reduce the lower mezzanine, which had till then provided room for the indispensable storerooms and workshops of the botteghe, or, as in the Palazzo Baldassini, eliminate it altogether. The second floor, on the other hand, became more important. At the same time, more space was left for staircases and greater attention paid to lighting and comfort. This development can be followed very closely in the buildings of the second quarter of the century; it introduces a type which, in its general appearance, recalls the Florentine palazzi of the Quattrocento rather than the Roman palazzi of the early Cinquecento. The most splendid example of the type is the Palazzo Farnese, begun by Cardinal Alessandro Farnese and enlarged after his elevation to the papacy in 1534. Sangallo's new façade is a maturer, more ornate version of the façade of the Palazzo Baldassini.

Even in our own day the Campo Marzio is the most densely populated part of Rome. Few of the buildings have preserved their original appearance. The correction of the street and river systems in the nineteenth century, with all the demolitions and renovations it entailed, made further inroads into the old buildings still standing. There has, however, been preserved in the Palazzo Alberini-Cicciaporci one of the banking houses after which the via de' Banchi was named; it led from the Ponte S. Angelo to the former papal mint. In 1515 the builder, Giulio Alberini, let the palazzo, then under construction to the Florentine bankers Bernardo da Verrazzano and Buonaccorso Ruccellai, though pledging himself to complete the building 'well and decently, and according to the design'.[5]

The old attribution of the Palazzo Cicciaporci to Bramante or Giulio Romano must be abandoned because of its date of building; it cannot be given to Raphael because of its style.[6] On the other hand, these names are enough to give a hint of the high standing and artistic lineage of the architect. The façade differs from those built by Bramante and Raphael primarily by the remarkably shallow relief of its articulation (Plate 183). The flat rustication of the ground floor and the pilaster strips of the piano nobile look like engraved ornament; an absolutely unprecedented flat framework appears in the upper storey. A plain band separates the botteghe from the openings in the mezzanine, and the rusticated basement is topped by the same jutting cornice as that in the Palazzo Caprini. Another remarkable feature is the material, namely roughcast brickwork in

both upper storeys; freestone is used only for cornices and quoins. The rustication of the lowest storey consists, like that of the Palazzo Caprini, of stucco.[7]

The arch of the portal is of the same height and width as the blind arches which frame the botteghe and mezzanine; it leads into a tunnel-vaulted vestibule of exactly the same height as the arcade of the cortile. This relationship between façade and cortile is new. Both in the Palazzo Caprini and the Palazzo Caffarelli the mezzanines were carried across the portals, so that the entrances leading into the cortile were no higher than the botteghe. Since there is no mezzanine over the portal in the Palazzo Cicciaporci, the central bay is strongly accentuated; at the same time it was possible to establish a consonance between the portal and the cortile. This was the first step to the development which led, not much later, to the complete elimination of the botteghe and mezzanine in the Palazzo Baldassini.

Churches

Church building in Rome in the early sixteenth century was governed, as it was throughout Italy, by the centralized plan.[8] Not only Bramante's Tempietto and his two demolished churches, SS. Celso e Giuliano and S. Biagio della Pagnotta, both situated near the Banchi, but five other centrally planned churches were begun in the city before the Sack of Rome: under Julius II S. Eligio degli Orefici, the church of the goldsmiths, and S. Maria di Loreto in the Forum of Trajan, both vaulted much later; under Leo X the church of the Florentines, S. Giovanni dei Fiorentini, and that of S. Maria in Porta Paradisi, now part of the hospital of S. Giacomo degli Incurabili; and, over a circular plan, the church of S. Salvatore by S. Luigi dei Francesi, begun during the same period by a French architect commissioned by François I, which, however, did not progress beyond its first beginnings.[9] In fact none of these churches has been preserved in its original state.

The domes of S. Maria di Loreto[10] and S. Maria in Porta Paradisi[11] rise from octagonal bases, i.e. they are domical vaults; in both, the transition from the square substructure to the octagon is effected by deep niches in the corner of the square.[12] This type of dome structure is characteristic of the turn of the century. It can be compared with that of the domes of S. Maria della Pace in Rome, the sacristy of S. Spirito in Florence, and the church of the Santa Casa at Loreto, which just preceded it. The exteriors of both the Roman churches are provided with remarkably slender, flat pilasters (Plate 184); in their proportions and the shape of the capitals they recall the contemporary façade of S. Maria dell'Anima, which also has the same fine brickwork.[13]

The architect of S. Eligio degli Orefici, doubtless influenced by Bramante's designs for St Peter's, adopted for his dome the hemisphere on pendentives.[14] The plan, a Greek cross with very short arms, was an innovation, and not only in Rome; it became the model for many family chapels of the late Cinquecento. The shape of the dome, which was not built till about 1530, is exactly the same as that of the Chigi Chapel. The church, however, has been altered out of all recognition.

The predominance of the centralized plan is the expression of the religious building as a free-standing monument which was characteristic of the turn of the century and found its classic form in Bramante's Tempietto. The preference for programmes which admitted a centralized plan is unmistakable. Even in the drawings of ancient buildings the interest of the time was concentrated on the rotunda. The ideal of the free-standing Christian 'temple' could hardly be transposed into reality within the bounds of the city of Rome. One reason for the centrally planned buildings of the early Cinquecento being drastically altered or entirely demolished is that, by the end of the century, the centralized plan was regarded as pagan and unsuited to the Christian church.

CENTRAL ITALY

S. Maria della Consolazione at Todi

The pilgrimage church of S. Maria della Consolazione at Todi (Plates 186 and 187 and Figure 58), begun in 1508, two years after the foundation stone of new St Peter's had been laid, has always been regarded as a simplified version of Bramante's plan for St Peter's. The church stands a little below the town on a terrace which commands an incomparable view of the Umbrian landscape. Crowned as it is with a dome and dominating the scene, offering the same aspect on all sides, consisting in plan and elevation of simple, geometrical forms – the square, the circle, and the semicircle – nowhere was the ideal of the centralized plan as Alberti had first defined it realized in

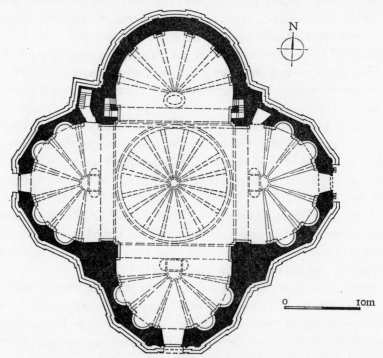

Figure 58. Cola da Caprarola and others: Todi, S. Maria della Consolazione, begun 1508, plan

purer form than in this church, and there is no other centrally planned Renaissance church which so harmoniously unites its liturgical function as a place of pilgrimage and worship, its political function as a monumental foundation of the community, and its standing as a work of art.[15]

In the contracts of 1508–9, which allocated the preliminary works, the executant architect is named as Cola da Caprarola. The only information we have about him is that he worked previously on papal buildings in Latium. The church was many years in building; the vaulting was not begun till 1568, and the dome was not closed till 1606.[16]

The plan of the Consolazione is a square with apses on all four sides. Only the apse containing the miraculous image is semicircular; the other three are polygonal, both inside and outside, and all have portals. Whether the purely centralized plan was intended from the beginning, it is as impossible to say as with Bramante's St Peter's. The contract of 1509 provides only for three apses, and explicitly avoids any commitment for the plan of the fourth side. This remarkable indecision may be indirect confirmation of the fact that the plans for St Peter's were not settled either at the time; nor does a binding model seem to have existed at Todi, at any rate in 1509.

As a pilgrimage church housing a miraculous image, the Consolazione is of the same type as S. Maria delle Carceri at Prato (Plate 140), built some twenty years before. That the square plan with apses, and not the Greek cross, as at Prato, was decided on is certainly due to the influence of the plans for St Peter's, even if at Todi a nave was envisaged instead of the fourth apse. Yet the simplicity and clarity of the exterior view recall the Tuscan centralized compositions of the late Quattrocento rather than Bramante's far more complex system as it is represented on the medal and in the parchment plan. Towers and subsidiary domes were not used at Todi; the staircases and the sacristy are accommodated in the corners of the square and are invisible from the outside. Except for the three entrances, all four sides of the church are articulated in the same way, and the elevation and structure are clear at the first glance. The thrust of the dome is carried over the vaulting of the apses to the exterior walls. The real weight of the dome rests on the arches of the crossing; this is brought out in the colossal piers of the crossing in the interior, and on the exterior by the corners of the square projecting between the apses.

Many details – for instance the flat pilasters, the shape of the windows and capitals on the exterior, the reeded capitals in the interior, the repeated projection of the entablature over the pilasters – are most closely akin to S. Maria del Calcinaio at Cortona (Plates 133 and 134), a church which Cola da Caprarola certainly knew. The giant pilasters of the crossing may already show the influence of the articulation of the piers of Bramante's dome.

The ornament of the vaulting ribs and transverse arches is in the style of the end of the century. The tall drum of the dome with its coupled pilasters cannot reproduce the original plans; it already presupposes the Roman domes of the later Cinquecento.

The Madonna di S. Biagio at Montepulciano

Ten years after the Consolazione, the Madonna di S. Biagio was begun at Montepul-
ciano (Plates 185 and 188 and Figure 59). It occupies a very similar site, and the history
of its foundation is also in many ways similar to that of Todi. It is therefore probable
that the design was ultimately determined by the peculiarity of the site. In Rome, the
same years saw the beginning of the Villa Madama, which also stands on an open hill-
side. All these buildings stand witness to a new relationship between architecture and
landscape: they are intended to be seen against a background of nature. At the same
time the building imparts to the site a new and enhanced significance.

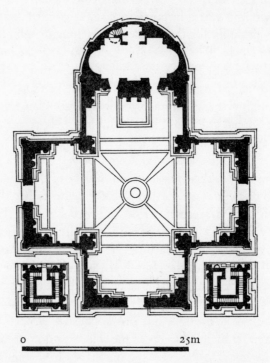

o 25m

Figure 59. Antonio da Sangallo the Elder: Montepulciano,
Madonna di S. Biagio, begun 1518, plan

The architect of the Madonna di S. Biagio was Antonio da Sangallo the Elder, the
brother of the builder of S. Maria delle Carceri at Prato. Antonio had collaborated with
Cola da Caprarola on the fortress of Civita Castellana in 1494; the authorities of
Florence, his native city, had employed him for the most part on fortifications. In 1517
he had submitted a model for the logge of the Piazza SS. Annunziata in Florence, though
it is uncertain whether the idea of repeating Brunelleschi's Ospedale façade on the
opposite side of the square originated with the architect or the building committee. This
piazza holds an important place in the history of town planning; the total picture of the

uniformly articulated façades becomes more important than the individual building. Sangallo's loggia remains so faithful to Brunelleschi's forms that only the details betray that it was built a century later.[17]

The church of the Madonna di S. Biagio was built so quickly that Clement VII was able to consecrate it in 1529. Antonio da Sangallo, who died in 1534, probably began the vaulting of the dome, the first of the great Cinquecento domes to be completed.[18] Baccio d'Agnolo, the Florentine architect, designed the lantern in 1544; his son Giuliano di Baccio continued the campanile, whose top storey, added in 1564, is most likely not that of the original plan. A second campanile never got beyond the ground floor.

The plan of the church, a Greek cross, recalls the Madonna delle Carceri, built nearly thirty years before; so do the portals and the windows and pediments of the exterior. As at Prato, the square of the crossing appears above the arms of the cross as the base of the dome, but the dome itself already shows the 'Roman' type, i.e. the cylindrical drum faced with pilasters both in the interior and exterior, and the hemispherical shape. There is an echo too of the plans for St Peter's in the double towers of the façade, and in the peculiar placing of the sacristy in an oblong space enclosed by a semicircle behind the high altar,[19] which, seen from the outside, looks like a one-storeyed choir. Thus, unlike the arrangement at Todi, one side of the church is distinguished as the front, and the opposite arm of the cross as a chancel; this gives the church an unmistakable orientation. That is, of course, true only of the exterior; in the interior, apart from the portals and the altar, all the arms of the cross are of the same shape. The sacristy does not figure in the spatial picture.

The vaulting system is the same as at Prato: a dome on pendentives over the crossing, tunnel-vaults over the arms of the cross. The system of the walls supporting the tunnel-vaults is quite unprecedented. As the plan shows, the weight of the vault is concentrated on the corners of the building. The corners of the crossing project into the interior like free-standing pillars. Instead of the flat pilasters of Prato and Todi, there are deeply modelled Doric pilasters and engaged columns crowned by a jutting entablature. This scheme runs consistently round all four walls. The relief of the order is given greater force by the fact that the walls beside the piers of the crossing are treated as deep altar niches, so that the function of the wall as a boundary of space can hardly be felt.

The walls enclosing the interior of the Consolazione look two-dimensional; the pilasters are so flat that they resemble an engraved device of verticals and horizontals. At Montepulciano, the pilasters and engaged columns project from the wall in three dimensions, and the order regains its ancient function of support. That, however, only holds good of the interior; as the absence of engaged columns and the low relief of the pilasters show, the exterior is conceived as a membrane-like shell supporting nothing, and, as at Todi, acts as pure surface. This comes out most clearly in the framework of the attic. The system of the crossing piers in the interior only reappears in the tower; there too the weight is imagined as resting on the corners, and the distinction is made between supporting members and filling wall. In the upper storeys, which have less weight to bear, the relief of the order is of course reduced and the intermediate panels widened.

The Madonna di S. Biagio was begun in 1518. Whatever reminiscences of the centralized composition of Prato, Cortona, and Todi it may awaken, the new features just mentioned cannot derive from those sources. Details such as the towers of the façade and the sacristy behind the altar reveal unmistakably a knowledge of Raphael's plans for St Peter's, and in Raphael's buildings, e.g. in the Chigi Chapel, the distinction is made between the order as support and the wall as filling, as in the interior of S. Biagio. For the articulation of the towers Sangallo adopted practically verbatim the exterior elevation of Raphael's transepts of St Peter's. Much of the magnificent effect of the interior comes from the use of the Doric order on a low plinth, and this again looks back to Raphael, and not to Bramante.

The Palazzo Pandolfini in Florence

There were other members of the Sangallo family who felt the influence of Raphael or were working for him at the time. Antonio the Younger, the nephew of the architect of Montelpulciano, had become Raphael's assistant in the office of St Peter's in 1516. His cousin, Gianfrancesco da Sangallo, began the Palazzo Pandolfini in Florence before 1520, after a design by Raphael.[20] This building plays a special part in the history of Florentine palazzo façades (Plate 189); it is a fusion of the Florentine type, represented by such buildings as the Palazzi Medici and Strozzi, with the Roman type developed by Bramante and Raphael in the early decades of the Cinquecento. The great Florentine palazzi of the late Quattrocento have three main storeys, rusticated throughout, the windows being framed merely by the voussoirs of the round arches. The Palazzo Pandolfini, on the other hand, has two storeys, like Raphael's Roman palazzi, and their windows have aedicules, i.e. they are given pediments on columns.[21] The great breadth is also of Florentine provenance; except for the Cancelleria, no Roman façade ever had as many as nine bays, as was originally planned for the Palazzo Pandolfini. The absence of shops on the ground floor is a Florentine feature too.

In the same way as in the previous palazzi, the round arch of the entrance does not rise above the ground-floor windows. Its shape and size are an innovation. It is only here that rustication is employed; it projects from the smooth surface of the wall. The keystones above the top of the entrance are so tall that they reach the cornice, and the horizontal blocks on both sides of the round arch are almost as wide as the opening itself. True, the portal in this way certainly remains organically bound to the façade, yet the central bay of the façade is effectively distinguished from the others. Moreover, since the balustrade over the portal is broader than those to left and right, the middle window in the piano nobile too was to have been wider than the others. In that way the central bay in both storeys would have been strongly stressed, an innovation of great consequence which went beyond the Palazzo Caffarelli, and for which there was only one preliminary stage in Rome, namely in the Palazzo Cicciaporci.

*

Finally, the designs for the façade for S. Lorenzo in Florence, made by the aged Giuliano

da Sangallo in the last year of his life, also show the influence of Raphael (Plate 190). These drawings, dated 1516, are closely akin in style to the church of Montepulciano, designed by Sangallo's brother. The most Raphaelesque idea is to set in front of the façade an order of coupled Doric columns as a kind of portico, with its balustrade crowned with an entablature.[22] There was no predecessor for the proportions and details of this order, either in previous Florentine buildings or in Giuliano's earlier designs. The source of this new and highly monumental style is to be sought in Rome.

A Doric double order which is the almost exact counterpart of Giuliano's design is to be found far away from Florence in the ground floor of the façade of S. Bernardino at L'Aquila in the Abruzzi (Plate 191), a work, dated 1527, by Cola dall'Amatrice, who was also active as a painter.[23] The alternating pediments over the portals and the niches are reminiscent of the drawings for S. Lorenzo. By this time the tall pedestals under the columns in the façade of S. Bernardino were of course antiquated; they make one feel that the architect was only familiar with developments in Rome up to about 1515, but not with the Chigi Chapel and Raphael's later designs. For the upper storey, with only his own imagination to guide him, Cola tried, with no great success, to work the new, classical apparatus of form into the medieval scheme for church façades customary in the Abruzzi.

Another building dating from the same time which shows the new classical repertory of form is the mortuary chapel of the Caracciolo di Vico family in S. Giovanni a Carbonara in Naples (Plate 192).[24] This domed family mausoleum resembles the Chigi Chapel in form and function. Yet it is illuminating to note how differently the Neapolitan architect handles his theme. The walls are entirely encrusted with marble, and the tombs and the altar are housed in apse-like niches between which the walls are faced with coupled Doric half-columns on tall pedestals. The spatial effect resembles that of Bramante's Tempietto rather than that of the Chigi Chapel; the treatment of the wall is not far removed from that of the encasement of the Casa Santa of Loreto. The architect must have been familiar with Bramante's buildings, for there is an echo of him in the peculiar disposition of the portal of the chapel, which is cut into the chancel wall at a splay, and gives the visitor a precisely calculated prospect of the altar.

BALDASSARE PERUZZI AND ANTONIO DA SANGALLO THE YOUNGER

BALDASSARE PERUZZI

LIKE Bramante and Raphael, Baldassare Peruzzi (1481–1536) was originally a painter. Serlio writes that Peruzzi, as he was making perspective drawings of columns and other members of architecture, was so enraptured by the proportions of the columns that in the end he 'confined himself to architecture and excelled all others in that field'.[1] This may be an invention, but the close connection between architecture and perspective representation implied in it is one of the fundamental features of Peruzzi's art. His *œuvre*, like that of Bramante, shows quite clearly the inseparable bond between perspective and architecture in the building practice of the early Cinquecento.

When he came from Siena to Rome about 1505, Peruzzi was probably familiar with the ideas of Francesco di Giorgio Martini.[2] There is an echo of the latter's work in Peruzzi's predilection for drawing as a means of artistic expression, in his bias towards theory, and in the versatility of his interests. In addition to ancient and medieval plans, his sketches contain fortifications, road plans of Tuscany, and designs for stage scenery.

Peruzzi's first building in Rome was the villa which his fellow-Sienese Agostino Chigi built between 1509 and 1511. It stands on the Lungara, the bank of the Tiber between the Vatican and Trastevere which was at that time being built up. The Farnesina of today stands beside Bramante's works as the most important building of the first decade of the century; it is also the first suburban villa of the Cinquecento.[3] It is typical for Peruzzi in that it neither continues nor inaugurates a tradition. It is distinguished from the villas of the late Quattrocento – Poggio a Caiano, Poggioreale, and Innocent VIII's Belvedere – by the fact that two sides of its exterior appear to be a two-storeyed palazzo. The articulation of these 'urban façades' with Doric pilasters and oblong windows was an innovation in Rome; the Cancelleria and the buildings derived from it still have round-headed windows on the ground floor and the main storey. A notable difference from the Cancelleria is that there is no rhythmic pilaster grouping and no marble incrustation. The garden front of the Farnesina (Plate 194), a five-bay loggia flanked by projecting wings, is one of the earliest examples of that U-shaped plan which survived, especially in France, as the *cour d'honneur*. The fourth front, which looks out on the Tiber, is like the urban fronts with the exception of the loggia of the ground floor.

Like the façades, the plan is asymmetrical (Figure 60). Half the ground floor is occupied by the two loggias, which meet at right angles; this was to open the view on to the garden and the river. They contained the famous frescoes by Raphael and his pupils: in the garden loggia the Cycle of Psyche (Plate 193), in the loggia overlooking the river the mythological horoscope of the patron and the Triumph of Galatea.[4] Unlike the Villa Madama, built ten years later, in which stucco plays an important part, the

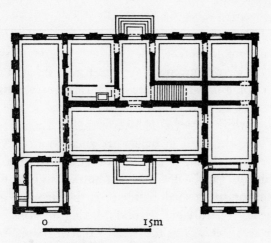

Figure 60. Baldassare Peruzzi: Rome, Villa Farnesina,
1509–11, plan of ground floor

decoration of the Villa Farnesina is almost entirely painted, as it is in Raphael's Stanze, which belong practically to the same period. Along with the Stanze, the Farnesina frescoes are the most important examples of that architectural painting in perspective which, according to Alberti, gives the painter his supremacy over the architect.[5] It is perhaps not by chance that Peruzzi the painter executed with his own hand the decoration of his patron's state apartment in the piano nobile. The mere name of the room – Sala delle Colonne – shows how completely it is dominated by its architectural painting (Plate 195); the actual subjects of the frescoes are the gods of Olympus. The perspective illusion is calculated for a viewpoint not far from the entrance. On both short walls heavy piers faced with pilasters alternate with wide-set columns, and the visitor is made to feel that he is looking out on to balconies and over the Roman landscape from the spaces between the columns. There is no socle zone; piers and columns seem to stand direct on the floor, so that the spectator sees only supporting members and an illusory open space. There is not, as there is even in Raphael's Stanze, a continuous pedestal. In the Chigi Chapel in S. Maria del Popolo, built soon after the Villa Farnesina for the same client, Raphael gives the pilasters similar low bases. In both cases the effect is the same; the spectator no longer 'looks into' or 'up to' the building, as he would with a picture, but stands in the midst of the supporting structure.

In the history of perspective painting, the Sala delle Colonne occupies a curious position of transition. The fixing of the viewpoint is still entirely in the tradition of Bramante. Yet Peruzzi goes beyond Bramante in that his perspective cannot really be taken in at one glance; it is in relation to all four walls of the room, and while the illusionist enlargement of the actual space might be regarded as a secular counterpart to the choir of S. Maria presso S. Satiro, Peruzzi goes a step farther by representing the open space beyond the walls. Stylistically the painted architecture clings to Bramante's forms; the treatment of the Tuscan order follows line for line the rules of the Tempietto, and we may also assume that there was a Bramante source for the pilaster-faced piers.

189

Yet for all the precision and elegance of its details, the real charm of the Villa Farnesina resides in its astonishingly well-planned composition as a whole: the leisurely sequence of the rooms, the comfortable staircase, the two open loggias of the ground floor, in which painting seems to have transcended architecture, as it has in the closed Sala delle Colonne. It would be doing the architecture of the Farnesina less than justice to regard it as painter's architecture, or merely as a foil to the frescoes. The Renaissance has no other building to show which achieves such perfection in the unity of architecture and painting which had been the ideal of Italian art since Giotto's Arena Chapel. In all probability Vasari was also speaking of the unity of the arts when he called the Farnesina 'non murato ma veramente nato' – not built, but born. This ideal was within the scope of the Farnesina, a comparatively small building; in the far more monumental project of St Peter's, the same artist hardly got beyond thinking up plans.

Peruzzi's fame as an architect is overshadowed by that of Bramante and Raphael, since a great deal of his work consisted of perishable decoration for stage scenery or pageants. The importance of Peruzzi's work in stage 'prospects' for Cinquecento architecture can hardly be overrated. For instance, he probably took a leading part in one of the most famous enterprises of the kind, the wooden 'theatre' on the Capitol in Rome which Leo X erected in 1513 on the occasion of the admission of his nephews Giuliano and Lorenzo de' Medici to the Roman patriciate.[6]

This rectangular theatre was covered by a costly cloth representing the sky; its façade was in the form of a Roman triumphal arch whose sculpture was imitated in grisaille. Behind the steps of the auditorium, which provided seating for over a thousand people, there rose walls more than 15 m. (50 feet) high, on which huge pictures were hung between golden pilasters; above the pilasters there was a frieze of vine-scrolls, sea-gods, and the emblems of the Medici. The programme of the occasion is characteristic of the temper of the age: on the first day a solemn High Mass was celebrated before a great altar on the stage; and on the second Plautus's *Poenulus* was performed on the same stage. 'But the most astonishing thing was the "prospettiva", namely the scenery of the commedia; for many kinds of buildings, various loggias, strange porticoes and windows were represented with supreme art and fantasy.'[7] There is no doubt that a stage setting like that described by Vasari also served as the background to the High Mass.

A few of Peruzzi's drawings for this kind of stage setting have been preserved (Plate 196); they show an oblong piazza faced with that repertory of 'modern' and 'antique' buildings, loggias, obelisks, temples, or amphitheatres which was to remain characteristic of stage scenery till the eighteenth century, and was also used by Poussin for his mythological fables. Serlio's treatise on architecture contains precise directions for stage settings of the kind. 'Splendid and royal' buildings were prescribed for the setting of the *scena tragica* and 'buildings of the common order' for the *scena comica*. The front of the stage with the steps was to be carried out in wooden relief; the actual prospect consists of two canvases, one for the buildings whose façades stretched along the sides, and another for the scenic prospect in the middle. It is clear from this that the actors played their parts *in front of* the prospect and there were no wings.[8]

When Antonio da Sangallo the Younger became superintendent of the *fabrica* of St Peter's in 1520, after the death of Raphael, Peruzzi was given the office of *coadjutore* which Sangallo had held up to that time. He must have played an important part in the discussions about the continuation of the building. Many drawings, whose chronology is controversial, throw light on his ideas and suggestions. The building itself progressed very little during this time. Neither Sangallo nor Peruzzi had Bramante's genius for inspiring others; they did not succeed in evolving a definite plan out of the many and often divergent suggestions put forward, nor in convincing the Pope that such a plan was feasible. Yet this irresolute kind of speculating on every conceivable solution at this stage of the planning must have been felt, especially by Peruzzi, as a welcome stimulus. Many of his projects go far beyond the bounds set by the situation; they arise from a peculiar conception of architecture as a 'science'. Speculative 'experiments' are developed from special circumstances, in the same way as in a university lecture room. Thus beside the purely central composition which has come down to us through Serlio, there was the basilican plan in the Uffizi drawing no. 14, with its three alternatives for the aisles and five variants for the side chapels (Plate 168).

The same fundamental bias to speculation also appears in Peruzzi's curious interest in the method of architectural drawing. It is in part due to him that the rendering process of the modern architectural drawing was developed during his activity in the *fabrica*. His drawing Uffizi no. 2, the perspective section of a project combining plan and elevation on one sheet, has always been famous (Plate 167); this plan tallies substantially with the plan reproduced by Serlio. The art of its composition makes a drawing of this kind, quite apart from its immediate purpose, a work of art *sui generis*. The draughtsman is as much concerned with the problem of architectural drawing as with the actual erection of the building itself. Further, the sheet shows very vividly that Peruzzi's interest was concentrated on the interior; even where he could have drawn the exterior – for instance on the apse of the transept – he preferred the plan of the ambulatory, i.e. an interior form. Peruzzi's interest in the spatial picture means a departure from that conception of the centralized composition as a monument which underlies Bramante's designs for St Peter's. The organic unity of interior and exterior, the total visibility which is the distinguishing characteristic of Bramante's Tempietto too, in spite of all its perspective calculations, was now a thing of the past. It is certainly not by chance that practically all the designs for St Peter's made in the twenties and thirties of the century deal with the plan and the interior view.

After the Sack of Rome, Peruzzi fled to his native city of Siena. True, he was reinstated in his office of coadjutor in 1530, but he only returned to Rome for good in 1535, a year before his death.[9] Thus he seems to have had little influence on the subsequent history of St Peter's. At Siena, where he was given the distinguished office of City Architect, he was mainly engaged on fortifications, including the fortifications near the Porta Laterina and the Porta S. Viene. At the same time he built the Palazzo Pollini and the Villa Belcaro, now greatly altered.

An outstanding characteristic of Peruzzi was his power of discovering novel solutions for unusual problems. This talent enabled him to meet the wishes of the building

authorities of S. Petronio at Bologna, and to submit, beside a 'Gothic' scheme with flamboyant tracery (Plate 197), a design in classical form.[10] It gave him the idea of proposing a church on an elliptical plan for the acute-angled site of the Roman hospital of S. Giacomo degli Incurabili,[11] a heresy in the eyes of those theoreticians of the Cinquecento who, as disciples of Alberti, acknowledged only the circle or the regular polygon as ideal forms. This predilection of Peruzzi's for difficult or eccentric problems also comes out in the designs for the remodelling of the great dome of Siena Cathedral on its six piers and of the Gothic church of S. Domenico at Siena. To call these designs utopian is to do them less than justice; they display an interest in the methods of architectural planning which has broken away from the intellectual theories of Alberti and from the meticulous rules in Vitruvius's treatise.

The Palazzo Massimo delle Colonne (Figure 61), Peruzzi's last work in Rome, was begun in 1532 to replace a palazzo belonging to the same family which had been damaged in the Sack of Rome.[12] A preliminary design by Peruzzi in the Uffizi shows the scheme of the adjoining streets, which was altered in the nineteenth century. The building stood on the via Papale, which was about 4·5 m. (12 feet) wide and was the route of the papal processions. A street of the same width led up to the façade. In the old palazzo there was a 'loggia in front of the great hall'; thus the idea of planning the ground floor of the new building as a loggia may have originated with the client, who wanted the characteristic feature of the family palazzo renewed. According to Peruzzi's design, the middle of the loggia was to be in line with the central axis of the street leading to the façade, not with that of the façade. The function of the façade in the context of the street was more important to the architect than its symmetry.

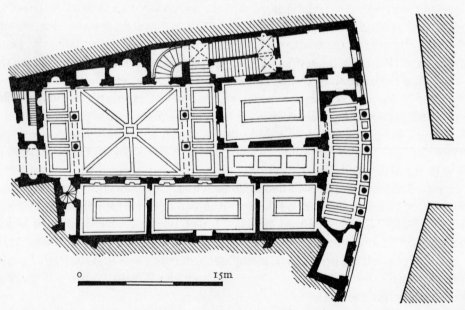

Figure 61. Baldassare Peruzzi: Rome, Palazzo Massimo delle Colonne, begun 1532, plan of ground floor: as executed

While the preliminary design preserves as far as possible the lines of the original walls and makes no alteration in the old cortile (Plate 198B), less consideration to existing parts of the building was shown in the execution; even the cortile was altered. The changes in plan went hand in hand with a regulation and slight enlargement of the site. In this way a more convenient place was found for the staircase, and the façade was widened in both directions. Oddly enough, some land was added from the plot adjoining the left-hand boundary, so that a door had to be broken into the old wall; the wall appears still unaltered in the preliminary design. Apses were added on the short sides of the loggia; perhaps they can be explained as an attempt to create the 'vestibulum' of the ancient authors after the pattern of the Early Christian narthex. Above all, however, the façade was given the curve which made it famous (Plate 198A).

The result of this change of plan was a gain not so much in space as in clarity of the composition, in artistic unity. Although the façade with its loggia and the cortile are not in line, each is symmetrical in itself. The overlapping of the façade on to the neighbouring site makes the palazzo look more sumptuous than it really is. The convex loggia projects beyond the frontage of the neighbouring houses, so that the palazzo dominates the view of the street on both sides. Its function as the focus of the street which opens in front of it is also stressed. A comparison of the design and the finished building makes one feel that the change of plan was dictated by artistic, not practical considerations.

The elevation of the façade is surprising in its contrast between the free-standing columns of the loggia and the flat walls of the three upper storeys. The interior separation of the storeys comes out clearly in the façade. Ever since Alberti's Palazzo Rucellai, one of the four floors had been treated as a subordinate part of one of the three orders: but Peruzzi must have felt how illogical it was to transfer the system of the Roman orders to a palazzo façade. He certainly uses the column on the ground floor, where it supports a 'genuine' architrave, but in the upper storeys he even abandons the aedicules which Bramante and Raphael had employed as window surrounds, and returns to simpler Quattrocento forms. How far he conceived the façade as a surface can be seen not only in the flattened, practically engraved joints of the rustication, but in the windows of the third floor; their surrounds look like leather, drawn out from within and applied to the wall like strapwork.

In this palazzo the ideal of a rebirth of antiquity has been replaced by a different conception of architectural beauty. The effect of the façade does not come from its harmonious balance, but from its wealth of contrasts. The architrave of the ground floor rests on columns in the middle, on pilasters at the sides; the spacious loggia is flanked by solid walls; the heavy balconies of the windows in the piano nobile bear down on the inter-columnar spaces; above the deep shadow of the architrave of the Doric order there rises the shadowless wall of the upper floors, whose flat rustication contrasts with the lavish decoration in the interior of the loggia (Plate 199).

The relationship between the façade and the cortile must be understood in the same way. The entrance to the palazzo leads through a corridor which runs from the *centre* of the façade to the *side* of the courtyard (Plate 200). The façade has four, the courtyard three storeys. The Doric order appears in single columns in the courtyard, in coupled

columns on the façade. In the former it carries a tunnel-vault, in the latter the ceiling is flat.

We have already noticed the breach with the classical canon of form in Raphael's Palazzo Branconio dall'Aquila. But while Raphael interprets the classical vocabulary of form in a new and undogmatic fashion, Peruzzi, in the Palazzo Massimo, combines the highly classical ornament of the loggia with the entirely unclassical windows of the upper storeys. The elimination of the classical canon here makes way for the introduction of older motifs, for instance the window surrounds of the piano nobile and the plain crowning cornice. Thus a consistent line of development leads from Peruzzi's earlier façade of the Farnesina to the late Palazzo Massimo, while the classical style, as it appears in certain details of Peruzzi's work and especially in his designs for pageants, is an intermezzo.

We can see how little interest Peruzzi took in the revival of the Vitruvian canon of columns by what Cellini tells us he said of Vitruvius: 'Vitruvius was neither a painter nor a sculptor; that is why he had no eye for what really makes the beauty of architecture.'[13] Nor has Peruzzi's architecture laid the foundation of rules or types: its charm resides in his faculty of finding inventive solutions for single architectural problems. His sketches are notable for their almost playful fantasy.

Antonio da Sangallo the Younger

Antonio da Sangallo the Younger (1484–1546) differed entirely, in both his origins and his artistic personality, from his near-contemporary Peruzzi, who was his colleague at St Peter's.[14] He was a Florentine, Peruzzi a Sienese. Sangallo must have been familiar with building technique from an early age through his mother's brothers, Antonio the Elder and Giuliano; thus he came to architecture from the craft of building, and not, like Peruzzi, from painting. In the account books of St Peter's he first appears as the carpenter who set up the centerings for the arches of Bramante's great dome. Owing to their unusual height and novel function – they were the negative forms for the concrete work – they required a good deal of technical skill. With them, Sangallo founded his reputation and probably his considerable fortune. In 1512, the *carpentario*, then aged about thirty, acquired a house in Rome, while Peruzzi's friends, as late as 1527, had to appeal to the municipal council of Siena for a pension for the famous but impoverished master. In 1516 Sangallo was appointed assistant to Raphael at the office of St Peter's.[15] Raphael, who must have appreciated the practical common sense of his Florentine assistant, probably familiarized him with the problems of planning and drawing. Thus the *carpentario* became an *architetto*, and began to take an interest in architectural theory. His book-plate in the 1513 edition of Vitruvius by Fra Giocondo is dated 1520.[16]

Sangallo, by that time the foremost building expert, and a compatriot of the reigning Pope, entered on Raphael's heritage at St Peter's in 1520. He remained architect-in-chief till his death in 1546. He also continued Raphael's Villa Madama, which had been begun under Cardinal Giulio de' Medici.

It was not as easy for Sangallo to make his way in other places as it had been in the

fabrica of St Peter's. In the competition for S. Giovanni dei Fiorentini in Rome, announced by Leo X in 1518, he was ousted by his compatriot Sansovino. As late as 1527 he was defeated by Sanmicheli in the competition for the high altar in the cathedral of Orvieto. After the Sack of Rome, when many of his contemporaries fled, Sangallo remained. In the later years of Clement VII's pontificate, and especially under Paul III, all the important building projects of the Curia were entrusted to him.

While the design submitted by Raphael in the competition for S. Giovanni dei Fiorentini has been lost, drawings of those entered by Sansovino, Sangallo, and Peruzzi have been preserved.[17] It seems that all the competitors first thought of a central composition, a 'monument' which should dominate the bank of the Tiber visibly from all sides, with the Borgo and the Castel S. Angelo opposite, and which, as the church of the Florentines, should proclaim the glory of the Medici Pope; about 1520, a centrally planned church must have seemed a matter of course. One of Sangallo's schemes for the

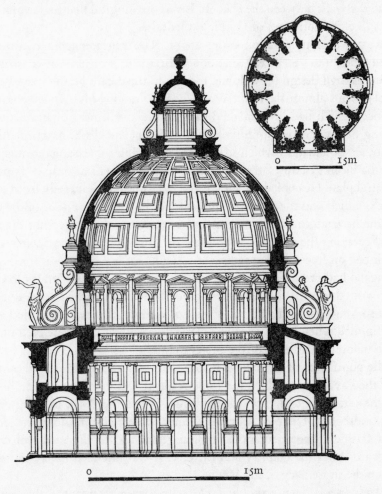

Figure 62. Antonio da Sangallo the Younger: Project for S. Giovanni dei Fiorentini, Rome, *c.* 1520, section and plan

plan, preserved in the drawing Uffizi 199, was published, with the corresponding elevation, in an engraving made by Antonio's pupil Labacco (Figure 62). It was a circular, domed space surrounded by sixteen round chapels and an exterior wall, also circular. This rotunda, as Labacco's elevation shows, was to have a pedimented façade of four coupled columns. It has been seen that during the continuation of work on St Peter's after Bramante's death, Raphael had abandoned the purely centralized composition as it appeared at Todi and Montepulciano. In his design for S. Giovanni, Sangallo, like his uncle, keeps to the central plan, but the stress on the façade itself testifies to the influence of Raphael's design for St Peter's, which Sangallo follows very closely in the details (Plates 169–72). The shape of the dome and the lantern repeats Raphael's design almost literally, though it lacks the stepped rings round the springing of the dome. This difference is not merely one of form; Bramante's stepped rings were to diminish the sideways spread of the dome, and, as in the Pantheon, concentrate its weight on its base-ring. Sangallo's idea was to convey the thrust by means of huge volutes on to the walls between the chapels. It was only logical that these volutes should carry statues like the buttresses of Gothic cathedrals.

In that way a curious paradox came about. The engineer who constructed the centerings in Bramante's St Peter's abandoned Bramante's manner of construction ten years later in his own design for a dome, though in the details he followed Bramante's and Raphael's forms almost slavishly. Was Sangallo drawing his own conclusions from the experiences which had been made during the reinforcement of Bramante's piers? Or is the ring of low chapels a reminiscence of Brunelleschi's S. Maria degli Angeli? There is another explanation which seems more plausible: that Sangallo was trying to transfer the basilican system of the ambulatories of St Peter's as exactly as possible to a purely central plan. He copied the façade and exterior almost literally from the design for St Peter's, which was the ultimate authority, as he did the contour of the dome; at the same time he tried to improve Bramante's construction by reviving the medieval technique of carrying the weight of the dome on to buttresses in the outer wall instead of making it rest on free-standing piers.

After Sangallo had prepared a wooden model for Sansovino's design for S. Giovanni, which had won the prize, he also supervised the work on the foundations, which dragged on so long, owing to the sandy soil of the site, that not even the foundation walls were finished when Leo X died in 1523. These foundations were used many years later for the uninteresting nave of the present church.

During the pontificate of Clement VII, Sangallo was mainly employed on the fortifications of the Papal State, which the Pope realized was the first thing to be taken in hand after the catastrophe of the Sack of Rome. When the Pope, in 1534, created his cousin Alessandro first Duke of Florence, Sangallo was commissioned to design the Fortezza da Basso, a large pentagonal building attached to the medieval city walls, fortified towards both the country and the city. It was intended for a garrison which should ensure the supremacy of the Medici.[18]

Antonio had already been active in 1508 as Bramante's assistant in the construction of the Pope's naval fortress of Civitavecchia. This stronghold still has the rectangular

plan with round corner towers which was the favourite design of the later Quattro-
cento. In the twenties and thirties of the Cinquecento, polygonal bastions replaced the
round towers, since the far heavier shells of the new artillery rebounded more readily
from them than from the massive round walls of the old system. The Fortezza da Basso
shows the new type fully developed, and Antonio had contributed fundamental ideas to
its structure. The vaults of the bastions were calculated from the outset for the emplace-
ment of the new heavy artillery, which was now posted on, and no longer in, the
towers. This innovation already appeared in Bramante's fortress of Civitavecchia.

In Florence, and later on at Perugia, Sangallo was commissioned to build free-standing
strongholds to ensure the authority of the sovereign over the cities. The medieval gates
and towers of Rome, Ancona, and Loreto had to be adapted to new developments in
artillery. Here too Antonio always made use of the polygonal bastion, while Peruzzi, in
his forts at Siena, which were built to serve the same purpose, experimented with
complex and novel combinations of curved and angled walls.

In his first palazzi, Antonio employed the formal vocabulary of Bramante and
Raphael, as he did in his design for S. Giovanni dei Fiorentini. The three-bay façade of
the Zecca, the papal mint, in Rome, with the triumphal arch motif articulating its piano
nobile, was probably erected about 1530 (Plate 201). Leaving the Baroque alterations
out of account, the articulation is revealed as a near-faithful copy of Bramante's walls
in the Upper Belvedere Court, with the exception of the framed tondi between the
coupled pilasters. The rusticated plinth on which this piano nobile rests seems, in spite
of its vertical oblong windows, too low for a ground floor and too high for a mere
plinth. The idea of connecting the very high pedestals of the pilasters of the piano nobile
by a cornice of their own was not very happy either.

In a design for the mint of the Farnese dukedom of Castro, Antonio later modified
the motif (Plate 202): the great blind arch of the piano nobile is reduced to a lower,
round-headed opening which corresponds to the square-headed windows between the
coupled pilasters, while the four pilasters stand on a continuous band. The modelling
of the walls is much shallower throughout, and the forms are less exuberant. The design
may stand as an example of the somewhat prosaic dignity which is characteristic of
Sangallo's later work. The farther the style is removed from its sources, the more it
loses freshness and power, and a fundamentally puritan bias comes out more obviously.

*

The elevation of Paul III in 1534 gave fresh impetus to the building activities of the
Curia. Once again the Pope was mainly concerned with fortifications. In the Papal
State, the fortresses of Ancona and Loreto were reinforced, a new fortress was built at
Perugia, and the fortifications of Piacenza, the capital of the new Farnese duchy, were
brought up to date. But during the pontificate of Paul III the Sala Regia and the Cappella
Paolina in the Vatican Palace were built too, and work went on vigorously on the
Belvedere Court, after a collapse in Bramante's east wing had nearly cost the Pope his
life. The old ground-floor piers were reinforced, and alterations carried out on the upper
storeys.

The superintendent of all these works was Antonio da Sangallo. A letter of 1536 from Paul III lays down his duties.[19] In the same way as under the preceding popes he was appointed life-superintendent of the Fabrica of St Peter's and of all other building enterprises projected or in progress in the Papal State. His total annual salary was seven hundred and twenty ducats, of which the office of St Peter's was to bear three hundred. Two years before the Pope had raised Peruzzi's salary for St Peter's to three hundred ducats a year, so that the two architects now received the same salary. Peruzzi returned from Siena to Rome in 1535, but died in the following January. After his death, Sangallo's authority was unassailable; he alone could say that he had worked in the Fabrica with Bramante and Raphael.

St Peter's

After the Sack of Rome work on St Peter's came practically to a standstill. In the first years of Paul III's pontificate, apart from necessary works of maintenance, nothing was built but a wall between the area of the new dome and the surviving parts of Constantine's nave. From 1529 to 1540 the costs for the building amounted to 17,620 ducats,[20] of which 7,000 went for the salaries of the two architects. As late as 1536 Sangallo had to complain to the Pope about the dilatoriness of the payment.[21] In order to fill the building coffers, the Pope resorted to the same measures as his predecessors: he confirmed and increased the indulgences of Julius II and Leo X. At the same time he founded a confraternity for the promotion of building. In 1536 he approached the King of France and the German Emperor, and in 1540 the King of Poland, for subsidies. In his letter to the latter he declared that the church was less splendid now than Constantine's old basilica. The troubles of the times were responsible for the cessation of work on the building.[22] Marten van Heemskerck preserved, in his famous *vedute*, the view of St Peter's at the time (Plate 203). The picturesque group of the Early Christian nave, Nicholas V's choir, and the arches of Bramante's dome looked more like a ruin than a new building.

The Pope's efforts were successful. Between 1540 and 1546, 162,000 ducats could be spent on the building,[23] nearly half of which came from Spain. Thus part of the gold of the Incas, which the Conquistadores brought home from the new continent, was built into St Peter's. In particular, this money was used for two costly measures which played a fundamental part in the further history of the building. The first was that in 1539, as always at the beginning of a new stage of building, a model was commissioned, and was executed by Antonio Labacco after Sangallo's design (Plates 205 and 206 and Figure 52c). It is both the first and the largest of the models for St Peter's to have been preserved; the costs came to over 5,000 ducats, and the model was over four years in the making.[24] This model no more determined the ultimate design of the church than its predecessors, yet, after twenty years of irresolution and experiment, it formulated once again a plan which the Pope approved and which was binding on all the authorities of the Curia.

The raising of the floor of the new church by about 3·20 m. (12 feet 6 in.) above the

pavement of the old basilica was a far more costly process and played a far more important part in the progress of the building.[25] The reasons for an operation which, considering the size of the building, was a very serious matter, are to be sought in aesthetic rather than in structural considerations. It did little to reinforce the piers; the layout of the chapels in the crypt (Grotte Vaticane) of today, which was rendered possible by the raising of the pavement, was made at a later date. Yet with the suppression of Bramante's tall podium under the pilasters there came a development in St Peter's which had been foreshadowed twenty years before in Raphael's Chigi Chapel and Peruzzi's Villa Farnesina. Piers, columns, and pilasters were now to be conceived primarily as a structural scaffolding; their function as articulation of the enclosing walls was neglected. The structure is more important than the spatial impression. About the same time Serlio formulated the new ideal of beauty in his Fourth Book: 'Columns whose bases rest on the floor of the building are far more beautiful than those which stand on a pedestal.'

The raising of the floor also led to a change in the great piers of the dome. The wide round-headed niches on the outer sides, which are to be seen in all plans of the first stage of building, were now walled up. They would have been hardly visible above the new floor. It was then that the piers were given the square form, chamfered on the side under the dome, which we see today (Figure 83).

Sangallo's new model of 1539 was a peculiar compromise between the central and the basilican plan (Plates 205 and 206 and Figure 52c). The dome, the Greek cross, and the four corner towers had to be taken over from the preceding stage of building, but the façade of this completely central structure is pushed out to double the distance on the east, so that there is now an almost independent façade flanked by two huge towers and only loosely connected with the nucleus of the building.

At first sight this solution seems to do justice to all the diverging tendencies, since it has Bramante's Greek cross surmounted by the dome within a longitudinal general plan. But the disadvantages of such a composition are obvious. The doubling of the length of the east arm splits the building; an independent façade is a contradiction in terms. Besides, in view of the lack of funds the project remained utopian.

In the elevation the incongruities stand out even more clearly. The height of the façade towers is artificially increased in order to establish a relationship with the dome, but the other towers rise like stumps from the roof and look merely superfluous. The articulation of the arms of the cross is just as unsatisfactory; their countless engaged columns, loggias, and aedicules are pulled together inadequately by the weak horizontals of the cornices.

Sangallo had already abandoned Bramante's structural ideas – though not his formal repertory – in his project for the dome of S. Giovanni dei Fiorentini. The model of 1539 carries this development a step farther. In section, the dome recalls that of Florence. The contour is that of a pointed arch, yet this steep dome rests, like Bramante's hemisphere, on pendentives and a drum; the interior, like that of the Pantheon, is coffered. On the outside, the base of the dome is surrounded by two tiers of arcades, the lower of which forms the drum, while the upper serves only to conceal the springing of the dome and to give it the outer appearance of a hemisphere.[26]

As regards the exterior ends of the arms of the cross, which played so great a part

after Bramante's death, Sangallo decided on the same ambulatories for the choir and the other arms, and this would have involved the final removal of Rossellino's choir. Yet he made the walls of the ambulatories so thick that they themselves look like independent spaces connected with the arms of the cross by narrow openings. The tendency to create new and confusing spaces, as Michelangelo rightly observed later, can be seen also in the introduction of galleries over the ambulatories.

A fresco by Vasari in the Cancelleria shows the state of St Peter's at that time (Plate 204). To the left there is the Quattrocento choir vaulted by Bramante; in the middle, the great vault of the south arm of the cross, and in front of it the exterior wall of the ambulatory, designed by Raphael and continued at a leisurely pace by Peruzzi and Sangallo after 1520. To the right the nave of old St Peter's rises above one of the Early Christian mausolea and the obelisk of Nero's circus. The fresco, made a year before Sangallo's death, shows that under his direction considerable progress had been made in the vaulting of the area around the crossing, and especially to the east. When Michelangelo took over after Sangallo's death, he radically altered the plans for the exterior elevation and the eastern part of the church, but he retained Sangallo's complex – yet structurally sound – system of subsidiary vaults around the core.[27]

Michelangelo's criticism of Sangallo's model, which has come down to us through Vasari, strikes straight at the weakness of the design. Sangallo tried to be on the safe side all the way round. He retained the formal repertory of Bramante and Raphael twenty-five years after Raphael's death, since it was regarded as peerless; he chose the Gothic construction for the dome which he, as a Florentine, was familiar with, instead of the ancient and as yet untested construction by Bramante, though he tried to salvage Bramante's 'more beautiful', unmedieval hemispherical contour for the exterior view. He provided the classical centralized plan with a separate façade. The walls were reinforced to gain stability and the decorative parts multiplied to increase the richness of the exterior. But all these efforts led to nothing but duplication and sterile repetition, not to a fusion of the structure with the surface of the building.

The Palazzo Farnese and Other Works

Sangallo's most important surviving work is the Palazzo Farnese (Figure 63), the first of a long series of papal family palazzi in Rome. Its effect in the general view of the city, its courtyard, and its furnishings were unsurpassed by any later building.

The palazzo we see today is the product of a complicated and not yet fully elucidated building history.[28] In 1495 the later Pope, Paul III, had acquired an older cardinal's residence on the site of the present building, which he had thoroughly renovated from 1517 on. Even this first Palazzo Farnese, which Pope Leo X visited in 1519, is described in a contemporary document as great and costly;[29] yet before 1530 the Cardinal embarked on an enlargement of it.

Under Clement VII, Alessandro Farnese was the most powerful member of the College of Cardinals; his retinue numbered more than three hundred persons. According to Vasari the Cardinal decided on a plan for an alteration with two staircases

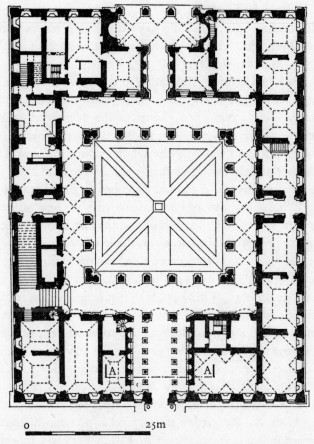

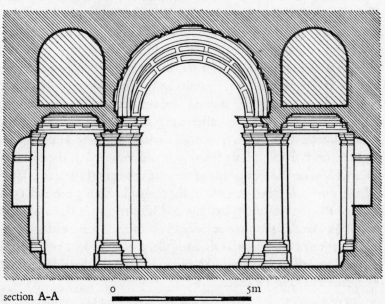

section **A-A**

0 5m

Figure 63. Antonio da Sangallo: Rome, Palazzo Farnese, plan, and section of vestibule

submitted by Antonio da Sangallo. The idea was that the two sons of the Cardinal, Pier Luigi and Ranuccio Farnese, should have apartments befitting their rank with separate entrances. This project, certainly modified after Ranuccio's death in 1529, seems to have been carried on rather slowly.

After the election of Cardinal Alessandro to the papacy, in 1534 Sangallo 'entirely changed the original design, seeing that he now had to make a pontiff's rather than a cardinal's palazzo. Thus, having razed some of the neighbouring houses and the old stairway, he remade the stairs anew and ascending more commodiously, and he enlarged the court on every side, and similarly the whole palace.'[30] There is evidence for these changes in a number of drawings by Sangallo and his circle. A sheet in a French sketchbook, now in Munich, gives the ground floor before the alteration (Plate 207); Sangallo's drawing Uffizi 248 shows his final scheme with the new stairs (Plate 208). While both drawings represent the aisled vestibule and the two rooms on its right, they differ entirely in the arrangement of the rooms on the left side.[31]

Work on Sangallo's revised project seems to have made slow progess during the first years of the new Pope's reign. In 1540 the new stairs were not yet built, although the old ones had been demolished.[32] In 1541 Duke Pier Luigi Farnese, now the owner of the palazzo, concluded a new agreement with the contractors: old vaults were to be pulled down, new vaults to be made; mouldings were to be altered; provision was made for demolitions and new foundations; the prices for the carving of the mouldings and the new roofs and ceilings were to be determined later because Sangallo 'does not yet know how they are to be made'.[33] Now the building advanced rather more speedily. In January 1546 a stone-carver reported to Sangallo that one corner of the façade was then 7·7 m. (23 feet) high; on the garden side the cellar was finished and the walls of the ground floor were under construction.[34] In March 1547, six months after Sangallo's death, 'the front façade is almost completed up to the top cornice; only the cornice is missing; the colonnade all around [i.e., the court] is in place'; the kitchens on the garden side of the ground floor are finished, the piano nobile of the right wing will 'shortly be habitable'.[35] Nevertheless four years later Vasari wrote in the first edition of his *Lives* that 'the Palazzo Farnese, where the new stairs and ceilings were made after the revised design [of Sangallo], will never be unified nor seem to be by the same hand'.[36]

Sangallo's 'new design', developed after 1534 and not yet entirely worked out in 1541 when the contract was made, practically entailed a new building. Of the first palazzo of 1517 ff. only the vestibule (Plate 209 and Figure 63), the two rooms to its right, and three arcades on the façade side of the court remain (Plate 210). They show the forceful Raphaelesque style characteristic of the Sangallo family around 1520. The engaged columns of the piers in the court had a close analogy in the ambulatory of the southern apse of St Peter's; they are equally close to the Doric order in S. Biagio at Montepulciano, designed by Antonio da Sangallo the Elder in 1519. The fleur-de-lis ornament on the capitals in the two old rooms recalls the heraldic dolphins of the Pandolfini in their palazzo in Florence.

The clause 'new vaults to be made' in the contract of 1541 probably refers to the vaulting of the ground-floor portico in the façade wing of the court.[37] For some reason

the old vaults were no longer considered adequate for the more ambitious 'new design'. When Vasari says that 'the court was enlarged on every side', he may refer to the heightening of the portico. Heightening the vaults must, however, have involved the heightening both of the arches between the piers and of the mouldings from which the arches spring. This would explain a unique trait of the Farnese court, namely the double mouldings of the piers (Plate 211). They are without precedent in ancient Roman architecture, and no treatise of the sixteenth century offers an analogy. The irregularity could best be understood as an ingenious response to the intricate problem that confronted Sangallo: the low piers of the first building phase had to be joined to the higher vaults of the 'new design'. The same device had of course also to be applied to the piers which were newly built after 1541 around the court. The resulting effect is that austerity combined with splendour for which the court has so often been praised.

In comparison with the Raphaelesque ground floor, the Ionic order of the piano nobile, executed according to the 'new design', looks impersonal; its capitals are somewhat petty, and the half-columns cannot compete with the powerful piers and the forceful entasis of the Doric order.[38] The piano nobile shows Sangallo's later style, which lacks the power and freshness of his early work.

The façade built according to the 'new design' of 1541, with its thirteen bays, outdid all the other private palazzi in Rome, even in size (Plate 212).[39] The palazzo is conceived as a free-standing rectangular block with four façades and a square cortile; its ground floor forms the base to two upper storeys which are practically equal in importance and form. In the façades the Florentine rustication has been abandoned, likewise the Roman order of pilasters or columns. While a preliminary plan by Sangallo still allows giant pilasters for the two upper storeys, in the execution the flat wall surface is only enlivened by quoins, window surrounds, and cornices. In the treatment of detail, Sangallo reverts to the formal repertory of the first quarter of the century, as in St Peter's. Entirely in the Raphael tradition, and anachronistic at the time of building, are the aedicules of the piano nobile with their alternating pediments. In order to adapt the aedicules to the round-headed windows of the third storey, their architrave is eliminated except for impost blocks over the columns.

The effect of Sangallo's façade comes from its size, not from its design. With its uninterrupted mouldings and the long row of identical openings, it is in the tradition of the Palazzo Medici, while Bramante and Raphael had adopted for their façades the tradition of the Palazzo Rucellai.

Sangallo's façade was given its ultimate form by Michelangelo. Antonio's design for the crowning cornice did not appeal to the Pope; thus in 1546 a competition was launched to provide another, and Paul III decided on Michelangelo's design (Plate 213). It is typical that the Pope invited three painters to compete alongside Sangallo and Michelangelo, namely Perino del Vaga, Sebastiano del Piombo, and Vasari. The greater concern for visual effect rather than for 'correctness' in the theorists' sense can also be seen in the fact that Michelangelo's design for the cornice was first tried out with a model ten feet high, i.e. as big as the cornice was to be, over a corner of the palazzo before the commission was formally confirmed.

The finished cornice diverges only in height from Vitruvian theory, and, it may be added, from Sangallo's design. Yet the whole effect of the façade is due to the massive projection of the cornice and the deep shadow it casts. The flatness of Sangallo's façade was furthermore modified by Michelangelo, who designed the middle window of the piano nobile and the armorial bearings above it.

Unlike the façade and courtyard, the famous aisled vestibule (Plate 209 and Figure 63) preceded Sangallo's 'new design' of 1541. Here, where there were neither great masses nor great surfaces to be dealt with, we see Sangallo at his best. The lavish detail looks neither playful nor overdone. The ancient structural and ornamental forms are adequate to the function as an entrance hall. An aisled vestibule had already occurred in Raphael's projects and Sangallo's drawings for the Villa Madama (Figure 55). In the Villa Madama, the hall was to open as a loggia towards the entrance steps; in the Palazzo Farnese, the visitor entering by the portal is impressed by the unexpected spaciousness and the wealth of ornament. In form and detail, the ceiling recalls Peruzzi's loggia in the Palazzo Massimo. But while Peruzzi separates tunnel-vault and flat roof and sets them in contrast, Sangallo unites them in a logical system of aisles.

A special problem arose in the planning of the Palazzo Farnese with the placing of the staircase. It appears that its curious arrangement parallel to the left-hand side of the palazzo was a last-minute decision. It entailed several blind windows in the side façade, but considerable space was saved in the main range towards the piazza.

The rear range of the palazzo was barely begun when Sangallo died in 1546. A plan dated 1549 shows the ground floor as it then was, with the alterations Michelangelo had made, or had it in mind to make. Michelangelo's idea of building a second staircase in the right wing was probably felt to be too expensive and was therefore abandoned. The garden front, built after Michelangelo's death, diverges still more from his designs. He had intended to open the three bays of the piano nobile between courtyard and garden in the form of a loggia so as to get a view on to the garden, the Tiber, and the hills on the other side. However, this storey was closed during building; it contains the gallery later decorated by the Carracci. On the other hand, loggias were introduced on the ground and top floors of the garden front, and the passage between the courtyard and the garden loggia was lavishly decorated in the same style as Sangallo's entrance hall. The work on the two lower storeys, superintended by Vignola, was completed in 1568;[40] an inventory of the palazzo made in that year already mentions the 'galleria'.[41] According to the stately inscription by the second Cardinal Alessandro Farnese, who was owner of the palazzo at the time, the loggia of the top storey, designed by Giacomo della Porta, was not completed till 1589.

Thus three generations of the family contributed to the palazzo. Artistically too it is a collective work, with contributions from the generation of Raphael down to that of Giacomo della Porta. By far the larger part of the building as it now stands goes back to Antonio da Sangallo, but it was by Michelangelo's top storeys in the courtyard and the façade that it became the most splendid of all Roman palazzi.

*

No architect superintended the work on St Peter's as long as Sangallo. Yet if there is little in the church today which bears the mark of his work, that is not merely a matter of circumstances. The qualities to which Sangallo owed his rapid rise in the Fabrica, his technical talent, his power of grasping the ideas of Bramante and Raphael, his practical and sober turn of mind – those very qualities were an obstacle to the continuation of the huge torso which confronted Sangallo when he took office. Benvenuto Cellini's gibe that Sangallo's buildings lacked greatness and distinction because he was neither a sculptor nor a painter, but only a master carpenter,[42] renders precisely, and in the idiom of the time, what distinguished Sangallo from Bramante, Raphael, and Peruzzi. His buildings and designs are practical and made to last, but what they lack is architectural imagination. Yet it was just by reason of those qualities that he was very much in demand for fortifications and utilitarian building. No architect of the time travelled more than he, or was active in more various enterprises. His fountain at Orvieto was looked upon as a peerless marvel and it is thanks to Antonio that the dome of Loreto, which his uncle had erected on inadequate foundations, was preserved. At the end of his life he restored the ancient cutting between the basin of the Velino and the Tiber valley at Terni.

As a draughtsman he was indefatigable. The Uffizi alone contains nearly a thousand sheets by his hand: meticulous working drawings for the model of St Peter's and rapid sketches for Montecassino, reconstructions of the tomb of Theodoric at Ravenna and trigonometrical computations for the Porta S. Spirito in Rome.[43] In technique, his drawings are always precise, economical, and methodical; he never loses sight of the given situation, the specific conditions of the commission. His method of representation is that of the expert; he consistently keeps in mind the distinction between plan, section, and elevation first recommended by Raphael for architectural drawings. Yet no drawing of his could stand as an independent work of art, as so many of Peruzzi's can. Sangallo's interest was concentrated on the building as such, not on the architectural rendering. He was probably never greatly interested in 'prospettiva'. In his work the separation of architecture from painting is fulfilled. From that time on, these two arts, till then so closely related, went their own ways.

LOMBARDY AND THE VENETIAN TERRAFERMA

Cesare Cesariano

DURING the first quarter of the Cinquecento Lombardy and Emilia, like Venice, remained faithful to the architectural forms of the late Quattrocento. The North Italian predilection for small-scale ornament and coloured incrustation was an obstacle to the adoption of the monumental style of Rome. The situation only changed when the great native families of architects and sculptors, the Lombardi, Solari, and Buon, were ousted by artists who had worked in Rome. In 1524 Giulio Romano came to Mantua, in 1529 Jacopo Sansovino to Venice, and at about the same time Michele Sanmicheli arrived at Verona. It was with their work that the new style found its way into northern Italy.

Lombardy retained the old forms longest. With the departure of Leonardo and Bramante, Milan had lost its eminence. After the fall of the Sforza, Lombardy had become the scene of the struggles between France and the house of Habsburg; between 1500 and 1535 the dukedom changed hands seven times. All the important building enterprises suffered from the unsettled political situation. The great churches of S. Maria della Passione and S. Maria presso S. Celso in Milan, which were begun before 1500, were not completed till nearly 1600, and the cathedrals of Pavia and Como only in the eighteenth and nineteenth centuries.

Only one Milanese building of the early Cinquecento, the atrium of S. Maria presso S. Celso (Plate 214), begun in 1513 after a design by Cesare Cesariano, can stand comparison with the contemporary architecture of Rome.[1] Cesariano (1483–1543) published a commentary to Vitruvius at Como in 1521 in which he calls himself a disciple of Bramante, and in the precision of its composition and the classical purity of its forms, his atrium indeed recalls Bramante.

The arcading on pillars was an innovation in Milan; in the cloisters of S. Ambrogio Bramante had employed columns throughout. The detail of Cesariano's pillars, the half-columns fronting them on the courtyard side with their tall bases, and the careful moulding of the entablature can hardly be explained without the prototype of Bramante's cloister of S. Maria della Pace, and the coupled pilasters and pediment on the street front of the atrium recall another building of Bramante's circle in Rome, S. Maria di Loreto. One detail is unique: the beautiful Corinthian capitals, cast in bronze, on the courtyard side. This atrium seems to be the only building of Cesariano's that has survived. His designs for the façade of the church were never executed,[2] and the fortifications which he built in Milan in the thirties, when he was Imperial Architect, were demolished.[3]

The Steccata at Parma

The cities of Parma and Piacenza, which had belonged to the lords of Milan, the Visconti and the Sforza, in the Quattrocento, were incorporated in the Papal States in the early Cinquecento, and were therefore spared the troubles of Lombardy. This relative political security explains the unusually short time of building of the Madonna della Steccata, the most important Cinquecento church in Parma.[4] It is a typical centrally planned church which houses a miraculous image of the Virgin. Its Greek cross plan (Figure 64) and the absence of a campanile are reminiscent of the Consolazione at Todi.[5] It is quite understandable that as early as the second half of the Cinquecento the design should have been attributed to Bramante.[6] But the Steccata was not begun till 1521, seven years after Bramante's death. The architect-in-chief was Giovanfrancesco Zaccagni, the master mason his father Bernardino, who built the foundations and the rising walls after a *disegno* – i.e. a model or drawing – of his son's.

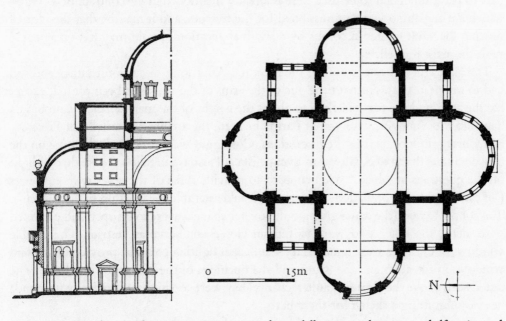

Figure 64. G. F. and Bernardino Zaccagni: Parma, Madonna della Steccata, begun 1521, half-section and half-plans (before alterations) at ground and upper levels

Bernardino Zaccagni (*c.* 1460–1530) had worked on the Benedictine church of S. Giovanni Evangelista at Parma. It is a large basilica with pillars instead of columns which follows the prototype of the neighbouring Romanesque cathedral in its plan and the structure of its vaulting.[7] The Steccata itself is not without medieval reminiscences of the kind. Unlike the Consolazione, tunnel-vaulted compartments have been inserted between the arches of the crossing and the apses, and low square chapels added outside at the corners of the crossing. Thus the thrust of the dome is not, as at Todi, carried

direct to the outer walls; the scheme must rather be regarded as a simplified version of the parchment plan for St Peter's.

The exterior view rises in three levels from the apses and corner chapels over the chancel roof to the dome (Plate 215). The comparatively low drum is almost entirely concealed by the members in front of it. One recalls the medieval dome of Parma Cathedral, which 'sinks' in similar fashion behind the roofs of the transept and choir.[8]

In the interior (Plate 216), the cruciform plan comes out clearly; the corner chapels are only accessible through low doorways and do not affect the general spatial impression. The pilasters of the arches of the crossing and the transverse arches are ornamented with frescoes, as is customary in northern Italy. The arrangement of the windows is obviously calculated with a view to the painting of the interior.[9] The crescendo from the diffuse but abundant light in the apses through the slightly darker area of the transitional bays to the radiant brilliance under the dome corresponds exactly to the iconographic programme of the frescoes. The shimmering gold leaf of the transverse arches and the gilding of the copper rosettes in the tunnel-vault have a special part to play; the metal to be used here is already mentioned in the contract of 1531, by which Parmigianino was commissioned for the frescoes, and it may be that the idea of making the vault lighter in colour by a lavish application of gold may have originated with the artist himself.[10]

The Zaccagni did not complete the Steccata. After long discussions, father and son had to resign in 1525. At that time one of the arms of the cross had been roofed, except for the apse, and the rest had risen to about the height of the main cornice. Antonio da Sangallo the Younger, who was at Parma in 1526, the architect Tramello of Piacenza, and Correggio took part in the discussions. Correggio was working at the time on the frescoes in the dome of S. Giovanni Evangelista at Parma. Sangallo's report throws light on the questions involved.[11] He proposed to provide three of the apses with entrances ('in case the whole population of the town should assemble for worship in the church'). Two of the towers (the name given to the corner chapels) were to be open and provided with altars, the other two were to remain closed and serve as vestries. The double windows of the apses were unnecessary – sufficient lighting could be provided by round windows in the apses and the drum and the openings of the lantern of the dome. The outer walls above the already-vaulted chancel bay were too high and statically unsound: he was submitting a sketch for these parts.

In the further work on the building, very few of these recommendations were respected:[12] all the corner chapels remained closed, the church was given only one portal, the large windows in the apses were retained, and the crown of the dome was closed so that the lantern is blind. Just as little attention seems to have been paid to Sangallo's design for the roof zone, which was probably an attempt to forestall the 'sinking' of the dome.

Sangallo's report is as enlightening as the reaction it provoked in the building commission, which can be deduced from the building itself. The Steccata was built at the same time as the Madonna di S. Biagio at Montepulciano (Plates 185 and 188). Both buildings have the same function, and their plans are closely akin. At Montepulciano,

the emphasis lies on pilaster and column, on capital and entablature; the wall surface between these members is bare. At Parma, both the pilasters and the transverse arches in the interior are the boundaries of wall surfaces, and it is on these that the visitor's eye lingers. The difference is certainly due to the difference between brickwork and stonework, but that is not a satisfying explanation. 'Pure' monumentality, the Roman conception of the 'temple', which achieves its effect solely by its architectural forms, is incompatible with the North Italian love of coloured ornament and great frescoes in the vaulting. The building commission did not object to the structural function of the corner chapels as abutments to receive the thrust of the dome being concealed both in the exterior and interior, nor to the apparent 'sinking' of the dome: these points of Sangallo's criticism fell on deaf ears, for the criteria applied in the report by the 'architetto della fabrica di S. Pietro in Roma' were simply incomprehensible to the building commission. The round-headed windows which Sangallo called 'heretical' were sanctioned by old custom at Parma; the medieval tradition was more deeply rooted and longer-lived there than in Central Italy. Sangallo's ideas of 'perfezione' and 'proporzione' had different meanings for him than for the readers of his report. What the commission was concerned with was not the 'classical' articulation of the building, but the architectural framework of the frescoes, the unity of space and colour, of wall and decoration, and in that respect no Italian church of the time can challenge the Steccata.

Tramello at Piacenza

Alessio Tramello, who was called in as consultant by the building commission of the Steccata in 1525, had also been working since 1522 on a centrally planned church, the Madonna di Campagna at Piacenza (Plates 217 and 218).[13] Tramello planned it, and superintended work on it till it was completed. The building commission forced no *pentimenti* on him. His central church is more homogeneous but also more prosaic than the much bigger Steccata.

The plan is a Greek cross with flat terminations to the arms (Figure 65).[14] As in the Steccata, chapels are added to the corners of the crossing, but they are domed and open into the church. In that way more light and air is given to the interior than in the Steccata. The main dome rests on free-standing pillars and not on solid walls, and both outside and inside the vertical articulation is more clearly stated. The outer shell of the main and minor domes is, after the Lombard manner, octagonal and topped with a high lantern. Further reminiscences of Lombardy come out in the tall, broad windows in the drum, through which the light passes almost unhindered. This abundance of light is a drawback for the decorations which cover walls and vaulting: Pordenone's frescoes in the dome almost vanish in the brilliant light. Tramello's church, however, is inferior to the Steccata in care for gradations of architecture, painting, and lighting.

In spite of the similarity in their plans, the two churches have very different antecedents. The five-domed scheme of the Madonna di Campagna grew out of a system that Tramello had already employed in the nave of S. Sepolcro at Piacenza (Figure 38);

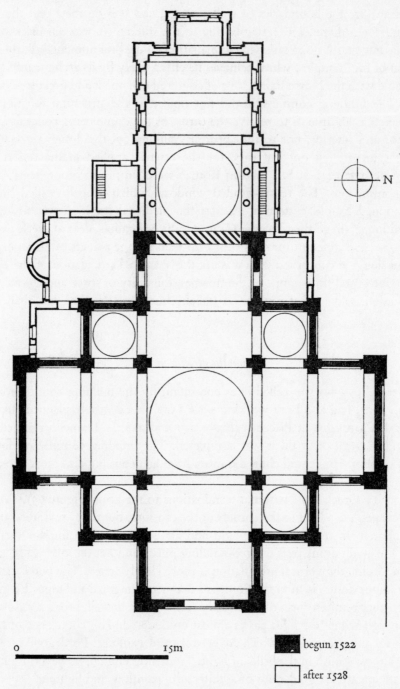

0 15m

■ begun 1522

□ after 1528

Figure 65. Alessio Tramello: Piacenza, Madonna di Campagna, begun 1522, plan

its prototypes are Byzantino-Venetian. On the other hand, the Steccata cannot be imagined without some knowledge of Bramante's design for St Peter's. A comparison between the two churches shows how essential a part the round forms of dome and apse play in enhancing the monumental effect of the 'Roman' central plan. At the same time, such a comparison brings out how widely North Italian buildings of this kind differ from the Roman type.

Falconetto at Padua

The work and personality of Giovanni Maria Falconetto have many things in common with those of Cesare Cesariano. Falconetto, born in 1468 at Verona, also began his career as a painter; like Cesariano he had also been to Rome.[15] Falconetto's drawings and reconstructions of ancient buildings correspond to Cesariano's Commentary on Vitruvius; some of them came into the possession of Palladio. From 1524 till his death in 1535, Falconetto was engaged on architectural work for the city of Padua and for the Venetian humanist Alvise Cornaro, who lived there. It is in the buildings which he designed for Cornaro that we encounter for the first time the classicism which is so characteristic of Venice and the terraferma, the most important representative of which was to be Palladio.

A loggia and what is known as the Odeon (Plate 219 and Figure 66) have survived from Cornaro's town palazzo in the courtyard of the present Palazzo Giustiniani. The five-bay loggia forms the back of the courtyard, the three-bay front of the Odeon occupies the middle of one long side. Both buildings look like illustrations to a treatise on ancient building. The classical orders have seldom been imitated so closely as in this *forum Cornaro*, which was to be the meeting place of the client's friends; it also served for theatrical performances.[16]

Yet the correctly classical apparatus of form does not create a three-dimensional articulation of the fronts. The relief of the pilasters and niches is strangely shallow; in the loggia the relationship between the engaged Doric columns facing the pillars of the arcades and the Ionic pilasters of the upper storey remains a little vague. The relationship between wall and order recalls Roman buildings of the turn of the century, for instance the Cancelleria. The octagonal room in the middle of the Odeon, with its flat walls alternating with niches, shows that Falconetto had visited Rome about 1500; there are rooms of a very similar shape in the parts of the Golden House which had recently been discovered. The brilliant stucco and fresco decoration of the loggia and Odeon is one of the finest works of the 1530s, and in no way inferior to the decoration of the Villa Madama.[17] An inscription over the architrave of the loggia contains the name of Falconetto and the date 1524. A little later, Falconetto designed two town gates for Padua: the Porta S. Giovanni bears the date 1528, the Porta Savonarola that of 1530, and Falconetto is again named as the architect in the inscriptions.

In both gates the archways have domical vaults. The high attics served as a parapet for the cannon mounted over the vault. Both sides of the Porta Savonarola and the city side of the Porta S. Giovanni (Plate 221) are articulated, like a Roman triumphal arch,

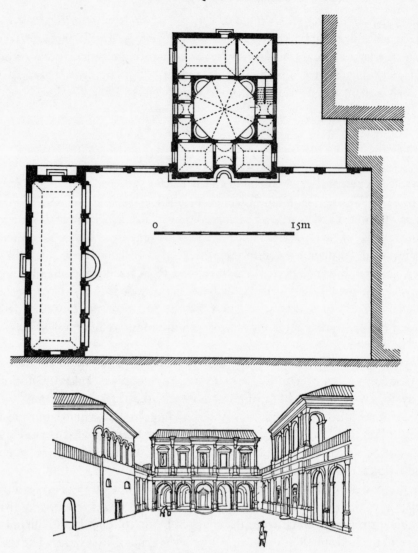

Figure 66. Giovanni Maria Falconetto: Padua, Odeon and Loggia
Cornaro, 1524, plan and sketch

by four columns on high pedestals; in both gates the lateral doors on the outer side are
blind. The rusticated outer side of the Porta S. Giovanni has a flat order of pilasters,
which would certainly have suffered less under bombardment than the almost free-
standing columns of the Porta Savonarola. It is interesting that Falconetto should have
abstained from rustication in the later gate and also articulated the outer side as a tri-
umphal arch: the ancient Roman form meant more to him than the defensive strength
of the gate. There was no prototype in antiquity for the combination of rustication and
pilasters, while the smooth-faced ashlar and the columns could find their sanction in
Roman arches. The side openings of the Porta S. Giovanni are treated as aedicules and
crowned with elaborate pediments. Over the side archways the Porta Savonarola has

straight – hence 'more correct' – lintels, and in the panels above there are roundels with busts; the Arch of Constantine has circular reliefs in the same place.

Alvise Cornaro certainly had a considerable share in the design for the remarkable villa of the bishops of Padua at Luvigliano which has traditionally been attributed to Falconetto (Plate 220).[18] The terracing of the hill on which it stands and the loggias on the piano nobile look back to Bramante's Belvedere Court, the massive rustication of the ground floor to the Porta Julia. There is a striking contrast between the orders and the rustication, which is entirely in the manner of Bramante; the order of the piano nobile triumphs over the 'as yet unshaped' natural forms of the base.[19]

The villa was not completed till after Falconetto's death. Comparing the somewhat coarse detail with that of the buildings at Padua, we can see how much the effect of Falconetto's work owes to its careful and delicate detail. Falconetto's view of antiquity was, so to speak, near-sighted; his prime interest was in detail, and in his own buildings he indulged in it as faithfully as he could. In the city gates he was able to adopt the form of the ancient triumphal arch *in toto*, yet even there scholarly theory seems more important than the living work in hand. It is no coincidence that Falconetto's reconstructions of the Roman theatre at Verona, which have come down to us in a codex of the Biblioteca Comunale, are reminiscent of architectural utopias of the nineteenth century.[20]

It is clear that the commissions from Cornaro first enabled Falconetto to devote himself to architecture. Cornaro's intellectual interests were mainly concentrated on Stoic philosophy – at the end of his long life he wrote a treatise on self-control. And the buildings he commissioned from Falconetto, however faithful they may be to antiquity, are not without a prosaic touch. It may be said that this orthodox interpretation of antiquity illustrates one extreme of the post-classical movement of about 1530. We shall see the other extreme in the 'heretical' works which Giulio Romano, thirty years his junior, was executing at the same time for the Duke of Mantua. In both cases architect and patron were of about the same age. Thus the difference in style may well be a difference of generations too, nor is it mere chance that Cornaro, the Stoic humanist, employed Falconetto, whereas the capricious extravert Gonzaga Duke of Mantua employed Giulio.

CHAPTER 19

SANMICHELI

MICHELE SANMICHELI (1484–1559) is the only great architect of the Italian Renaissance who may have known ancient Greek buildings. As military engineer to the Republic of Venice he was active on the fortifications of Corfu, Crete, and Cyprus. Apart from Venice his main activity was at Verona. He visited Rome when he was young, and Bramante's Roman works formed his style.[1]

He belonged to a family of stonemasons which originated on Lake Como. His father had settled at Verona, where he worked on the Loggia del Consiglio. Little is known of his son's training and early travels. In 1509, at the age of twenty-five, Sanmicheli became chief architect of Orvieto Cathedral, which seems to show that his training as a stonemason was completed. He erected an altar in the cathedral and worked on the upper parts of the façade, but his designs for the campanile were never carried out. In the documents of 1513 we read that 'Sanmicheli had been sent to Rome with a design for the façade in order to obtain Antonio da Sangallo's advice'. The office of works of the cathedral must have appreciated Sanmicheli; in spite of a chronic scarcity of funds, he received in 1521 the large bonus of 100 florins over and above his salary in order 'to prevent him leaving Orvieto, which would mean that work on the building would come to a standstill'.[2]

The anxiety of the cathedral building commission was not quite unfounded. In 1526, Sanmicheli had travelled through North and Central Italy with Antonio da Sangallo the Younger for several months in order to work out a detailed report on the state of the papal fortifications.[3] In 1530 at the latest he entered the service of Venice; in 1531 a letter from the Consiglio dei Dieci, the most important authority in the Republic, states that Sanmicheli was 'indispensable for the fortifications built in all our lands and towards the sea'.[4] At that time his salary was 120 ducats a year; later it was raised to 300 ducats.

Our blitz-hardened time is only too apt to forget that until the eighteenth century fortifications were just as much part of the duties of an architect as religious and domestic building. All the cities of the Middle Ages and the Renaissance were fortified: Giotto designed part of the city walls of Florence, Francesco di Giorgio, Dürer, and Leonardo wrote treatises on fortifications, and city gates by Bramante, Sangallo, and Falconetto have already been mentioned. While most of these constructions fell victim to later extensions of the cities, Sanmicheli's gates at Verona give a vivid idea of their functions. His Porta Nuova and Porta Palio are among the masterpieces of the Renaissance.

Sanmicheli was in charge of the maintenance and modernization of the walls of his native city for more than thirty years. The fortress of Verona protected Venetian territory against attack by land; its citadels were no less important for the security of the republic than the coastal forts on the islands of Cyprus and Crete.

City Gates

In the Porta Nuova (Plate 222 and Figure 67), built in the thirties, the actual archway is combined with two artillery towers at the sides in a transverse block.[5] The powerful outer walls were a protection against artillery fire, and at the same time served as abutments to take the recoil of the guns mounted on the vault. There may be echoes of the Porta Maggiore in Rome in the rustication of the façade; Serlio observes that the vigorous rustication of gates and fortifications is the best expression of their purpose. When two side passages were pierced in the nineteenth century, the gate forfeited its character as a defensive structure. The city side was greatly altered at that time. On the outer side, only the central part was rusticated originally; the adjoining wall surfaces were smooth. The coupled Doric order, the pediment, the trophies and inscriptions make this front the real show side. In addition to the main archway, the city side has four narrower passages for foot traffic and two windows for the wide ramps that lead up to the roof through the thickness of the wall. The triglyph frieze, restricted on the outer side to the middle, on the city side runs over the whole breadth of the gate to the coupled pilasters at the corners.

As its plan shows (Figure 68), the Porta Palio, built some twenty years later, was not intended as an emplacement for artillery.[6] For that reason three archways could be made on the outer side and the pediment over the centre left out (Plate 223). In the interior

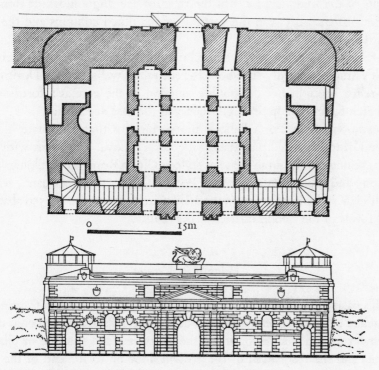

Figure 67. Michele Sanmicheli: Verona, Porta Nuova, 1533–40, plan and elevation

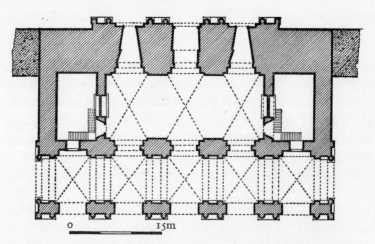

Figure 68. Michele Sanmicheli: Verona, Porta Palio, *c.* 1555–60, plan

of the gate, the passages meet in a grain-vaulted hall opening on to the town in five arches. The scheme of the articulation shows familiarity with Falconetto's gates at Padua, but Sanmicheli couples the columns, and, as he had already done in the Porta Nuova, replaces the slender Corinthian order by the heavier and sturdier Doric. The block of the gate is broader and the horizontal members stronger than in the Porta Nuova; the architrave does not project. The very flat rustication emphasizes the horizontal joints of the masonry, but not the relief of the single block of stone. There is a harmonious balance between the verticals of the fluted columns and the horizontal courses of the wall.

Unlike Falconetto's gates, which still echo medieval gatehouses with their tall attics, Sanmicheli's structures hardly rise above the encircling walls. But the Doric order, with its strong relief, brought out the double function of the gate as a fortification and a triumphal arch far more convincingly than was the case at Padua.

The decoration of the Porta Palio is more vigorous than Falconetto's, more harmonious and better balanced than that of the Porta Nuova. The latter, with its striking rustication, belongs to the same phase of style as Giulio Romano's buildings at Mantua. The harmony and monumentality of the Porta Palio, on the other hand, are typical of Sanmicheli's late style. In other ways too Italian architecture about 1550 abandoned the emotional forms of the second quarter of the century.

Palazzi in Verona

Sanmicheli's palazzo façades recall the scheme of Bramante's Palazzo Caprini. In Rome itself, the scheme had disappeared as early as Raphael's Palazzo Branconio dall'Aquila, but the terraferma and Venice continued the use of engaged columns or pilasters in the piano nobile and the rustication of the ground floor up to the end of the eighteenth century.

In the palazzi of the terraferma the courtyard plays a very minor part as compared with Rome or Florence. The building lots are for the most part oblong, and their depth is sometimes three or four times the width of the façade. The courtyard is often no more than a long passage leading from the street to the servants' quarters at the back. Thus 'great' architecture is confined to the façade and the salone in the piano nobile.

Of the four palazzi built by Sanmicheli at Verona, only one, the present Palazzo Guastaverza, can be dated with certainty. The patron, Bonaventura degli Onorii, obtained permission to begin building in 1555.[7] The Palazzo Pompei (originally Lavezola) probably belongs to the same date.[8] The Palazzo Canossa was built some twenty years earlier; building was in progress in 1533.[9] The date of the unfinished Palazzo Bevilacqua can only be determined on stylistic grounds.[10]

The façade of the Palazzo Bevilacqua has five bays to the right and one to the left of the entrance (Plate 224). The façade would be symmetrical if one assumes that four of the eleven bays originally planned are lacking.[11] The sumptuous ornament and complex composition are unique in every sense, and not only in Sanmicheli's work.

The ground floor has rusticated Tuscan pilasters, the piano nobile fluted Corinthian half-columns. On both floors wide and narrow bays alternate, on the piano nobile also high and low round-headed windows. An unprecedented feature is the device by which Sanmicheli transforms his rhythm of wide and narrow bays (b–a–b–a, etc.) into a system of three bays grouped as a triumphal arch. Of the four half-columns of a b–a–b bay, the inner and outer pair have either straight or spiral flutings;[12] in the neighbouring group, the relationship between the pairs is reversed. Thus the triple groups are linked together over the whole façade. The result is a system which can be read off both as b–a–b etc. and as A–B–A.[13]

The lavishness of the decoration is in keeping with the complexity of this scheme. The balustrade stretching across the whole width of the piano nobile rests on jutting modillions; these modillions are at the same time to be understood as triglyphs of the Doric order on the ground floor. The sills of the ground-floor windows are ornamented with a meander pattern; they rest on winged, sphinx-shaped corbels. The keystones over the windows are carved to represent antique busts. Winged figures fill the spandrels of the great windows on the piano nobile, and garlands wind from capital to capital over the small windows. In the rich scroll frieze of the main entablature and on the corbels of the ground floor there appears the pinion of the eagle, the emblem of the Bevilacqua.

The motifs of the decoration may be ancient, but nothing could be less like antiquity than their composition. In the *horror vacui* of the façade, in the complexity of its

convoluted patterns, in the ambiguity of its forms, we can sense that same 'heresy' as can be seen in Peruzzi. A characteristic feature is the difference in the relationship between openings and order in the two storeys. In the piano nobile the columns are raised high above the window-sills by tall pedestals standing on the balustrade; on the ground floor, the relationship is reversed, and it is the windows that are raised so high that their sills reach nearly half way up the pilasters.

The façade is one of the most important examples of the reaction against the high classical style; it owes part of its charm at any rate to a thoroughly classical formal repertory used to express something utterly unclassical. The works of Sanmicheli which are most akin to the Bevilacqua façade are the early Petrucci Chapel at Orvieto, which is discussed below, and the Porta Nuova. The chapel shows the same love of rhythm in the composition and the recession of the wall behind order and ornament. The Porta Nuova is echoed in the treatment of the rusticated Doric order. Thus the Palazzo Bevilacqua was probably one of Sanmicheli's first works at Verona.

The façade of the Palazzo Canossa is much quieter (Plate 225).[14] The triumphal arch motif of wide and narrow openings is replaced by bays of equal width. The piano nobile has coupled pilasters, the order has completely vanished from the ground floor, and the relief of the wall is shallower throughout. The three central bays of the ground floor open on to the street like a pillared loggia; Sanmicheli may have seen this motif in the Palazzo del Te at Mantua, which was built not long before. The antecedents of the coupled pilasters in the piano nobile are the coupled columns of the Palazzi Caprini and Caffarelli in Rome. But unlike Bramante and Raphael, Sanmicheli deprives the single bays of their independence by carrying the mouldings of the window imposts and the bases of the windows right across the whole storey and making them run behind the coupled order. There are no projections. Thus the front of the piano nobile seems to consist of two flat strata, one in front with the pilasters, their bases and entablature, and one behind with the windows, their cornices, and the flat course under the openings of the mezzanine.

The focus of the composition of plan and elevation (Figure 69) is the three-bay loggia of the façade. The portal of this *atrio* leads to a deep vestibule which is of the same width and length as the loggia. The vaulting of these two units supports the salone of the piano nobile. The vestibule, in its turn, opens into the courtyard loggia; the staircases are situated at its sides.[15] This middle block is of two storeys, flanked by four-storeyed side wings. There are servants' staircases to the two mezzanine floors. One detail may throw light on the ingenious combination of plan and elevation: the vaulting of the courtyard loggia is slightly lower than that of the adjoining vestibule; in that way it was possible to insert, above the loggia, a low mezzanine floor which communicates with the intermediate floors of the wings. The openings between the lower and upper loggias of the cortile front are therefore truly mezzanine windows; the corresponding windows in the façade, on the other hand, are blind, since the vault of the vestibule rises behind them.

Sanmicheli again employed the tripartite scheme for the plan of the later Palazzo Pompei. Once again the façade has seven bays (Figure 70); the width of the vestibule and salone is determined by the three central ones. But in this case the two units occupy

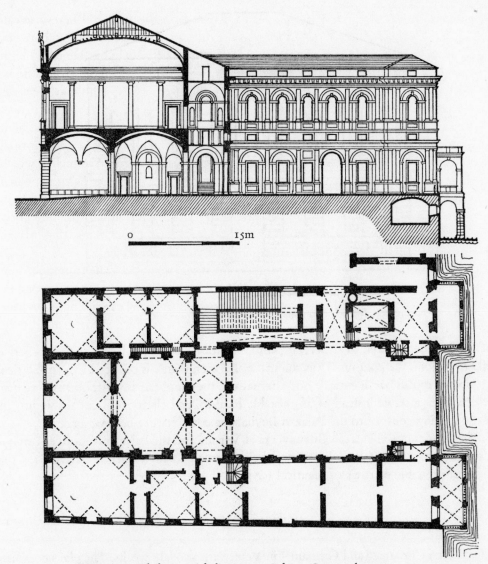

Figure 69. Michele Sanmicheli: Verona, Palazzo Canossa, begun *c.* 1532,
section, elevation, and plan of ground floor

the entire depth of the block; the vestibule and loggias of the Palazzo Canossa have
been suppressed. Though equally careful in arrangement, the plan and elevation are less
differentiated; there are no mezzanines, and the decoration, especially in the courtyard,
is very quiet. This greater simplicity may be due to the instructions of a thrifty patron,
but the famous façade also shows that the artist handled his artistic means more eco-
nomically than in his early buildings. The piano nobile has fluted Doric columns, like
its near contemporary, the Porta Palio; they cut across the springing line of the round
window arches, but the order of columns and the wall surface are more clearly dis-
tinguished than in the Palazzo Canossa. There is no hint of the complex rhythm and the
horror vacui of the Palazzo Bevilacqua. The scheme could not be plainer. On each side

219

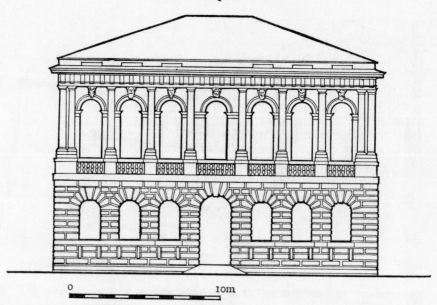

Figure 70. Michele Sanmicheli: Verona, Palazzo Pompei, *c.* 1555, façade

of the broader middle bay there are three identical, narrower bays; at the corners a pilaster adjoins the column. Thus the triumphal arch theme is replaced by symmetrical grouping, motifs are identical, not alternating, the emphasis is on frame and centre, which gives a stable instead of an unstable balance, and clarity replaces ambiguity. A more striking contrast to the Palazzo Bevilacqua could hardly be imagined.

The façades of the Palazzo Guastaverza at Verona and the Palazzo Roncali at Rovigo also show that in his later life Sanmicheli returned to his earlier preference for the classical principle of rows of identical bays.

Palazzi in Venice

The Palazzi Cornaro[16] and Grimani[17] in Venice are also late works. The plans conform to the usual Venetian scheme (Figure 71); from the main entrance in the façade a long passage leads to the courtyard at the back of the very long and narrow building plot. The situation of the Palazzo Grimani on the Canal Grande may be the reason why the ground floor is not astylar; its Corinthian pilasters support the Corinthian columns of the piano nobile (Plate 226). The outer bays of the façade are flanked by coupled orders which, in their turn, enframe the triumphal arch motif in the centre. This detachment of the side parts is as new as the close grouping of the three central bays. The fluting of the columns, the cornices of the mezzanine floors, and the balustrade are reminiscent of the Palazzo Bevilacqua, but the composition, though equally ornate, is much less complex. As in the Porta Palio, vertical and horizontal members, stressed centre and enframing sides, are in perfect balance, so that the whole gives an impression of stability and calm. Hardly another architect of the Cinquecento handled the ancient orders with

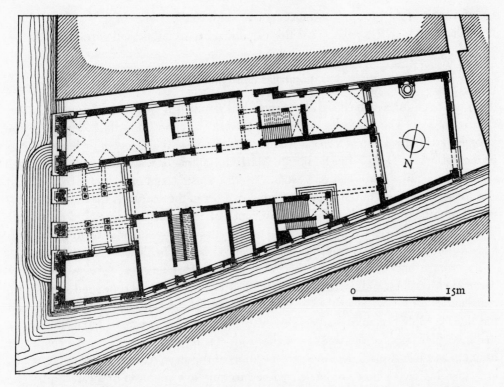

Figure 71. Michele Sanmicheli: Venice, Palazzo Grimani, begun *c.* 1556, plan of ground floor

such mastery, or made them so expressive, as Sanmicheli. The Doric is absolutely right in the Porta Palio; in the façade on the Grand Canal it would have looked grim and heavy. The Corinthian pilasters on the ground floor are a deviation from the rule which would, in their place, have dictated the Doric or at most admitted the Ionic; the repetition of the order on the piano nobile is again a breach of the rule. But the use of the more ornate Corinthian order in both storeys, with the heightening of its relief from the flat pilaster to the round column, is precisely the feature which gives the Grimani façade its distinction and splendour.

In both storeys the pilasters and columns cut across the entablature of a smaller order. The smaller pilasters are not fluted. Thus here again there is a new and effective distinction between the flat wall of the façade and a great order set in front of it. This motif, which was to play so great a part in Palladio's work, can hardly be derived from Michelangelo's giant order in the palazzi on the Capitol. The precursors of the minor order in the Palazzo Grimani are rather to be sought in a series of North Italian buildings, beginning with Alberti's façade of S. Andrea in Mantua, and continuing in Sanmicheli's Veronese palazzi.

And finally the palazzo presents the aesthetic and practical solution of a problem which had already preoccupied Sanmicheli in the Palazzo Canossa. The high arch of the main portal leads into the tunnel-vaulted 'nave' of the vestibule; the lower side entrances lead into flat-roofed 'aisles', which rise as far as the entablature of the minor order. Thus

the elevation of the group of entrances corresponds to the section of the triple vestibule. No other Cinquecento palazzo has this organic unity of façade and entrance hall.[18]

Churches and Chapels

Two of the churches which are unquestionably Sanmicheli's work are round, the other two octagonal. The Cappella Petrucci at Orvieto and the Cappella Pellegrini in the church of S. Bernardino at Verona are mortuary chapels; the chapel at Fumane belongs to the villa of the Della Torre family; S. Maria di Campagna is an important pilgrimage church three miles south-east of Verona. This list illustrates in many ways the function and form of religious building in the second quarter of the century – the indifference to parish or monastic churches, the predominance of memorial building, and finally the preference for the centralized plan. The predilection for the circular form also shows how deeply Bramante's Tempietto had influenced Sanmicheli's work.

The small funerary chapel of the Petrucci in S. Domenico at Orvieto, probably Sanmicheli's earliest architectural work,[19] consists of an octagonal room and a miniature choir under the sanctuary of the Gothic church (Figure 72). The altar of the chapel, and the double flights of steps leading down to it, show that it was in regular use. The striking articulation of the walls by niches and Tuscan pilasters in so small a chapel, its function as a burial place, and even the position of the altar, recall late Roman hypogea in Rome. It may be that Sanmicheli wished to imitate a confessio or a catacomb. The idea would provide the simplest explanation of the peculiarities of the Petrucci Chapel.

The plan and function of the circular Pellegrini Chapel at Verona (Figure 73)[20] also recall late Roman mortuary buildings, especially the imperial mausolea attached to old St Peter's. Like them, it is connected with the church only by a small antechamber; there is no articulation of the exterior; the interior, with its triumphal arch motif and fluted columns, repeats the formal repertory of the Palazzo Bevilacqua, which was built about the same time. Above the wide spacings of the main order, the drum has free-standing columns; a hemispherical cupola rests on their architrave – an arrangement which looks back to Bramante's design for the drum of St Peter's.

The Madonna di Campagna[21] is the only great Cinquecento church to realize Alberti's ideal of a free-standing, round 'temple' (Figure 74). True, the church does not stand in the 'forum', as Alberti had intended, but outside the city walls, like the centrally planned churches of Todi and Montepulciano; like them, it houses a miraculous image. A low Tuscan colonnade surrounds the base of the gigantic cylinder; the smoothness of its walls is broken only by the Ionic pilasters and the windows of the drum (Plate 227). The restraint of the exterior does not prepare the visitor for the subtle refinement of the interior, an octagon with pillars and arches bearing an octagonal domical vault which is concealed under the hemisphere of the outer shell (Plate 228). Following an ancient Venetian tradition, the exterior shell of the dome is of wood. In the interior, three of the bays on the transverse and longitudinal axes open as portals, while the fourth leads into the choir. Altars mark the intervening bays. The choir is actually a second, smaller, centrally planned church on a Greek cross plan. The

Figure 72. Michele Sanmicheli:
Orvieto, S. Domenico, Petrucci
Chapel, *c.* 1516, section and plan

Figure 73. Michele Sanmicheli: Verona,
S. Bernardino, Pellegrini Chapel, probably
begun in 1527, plan and section

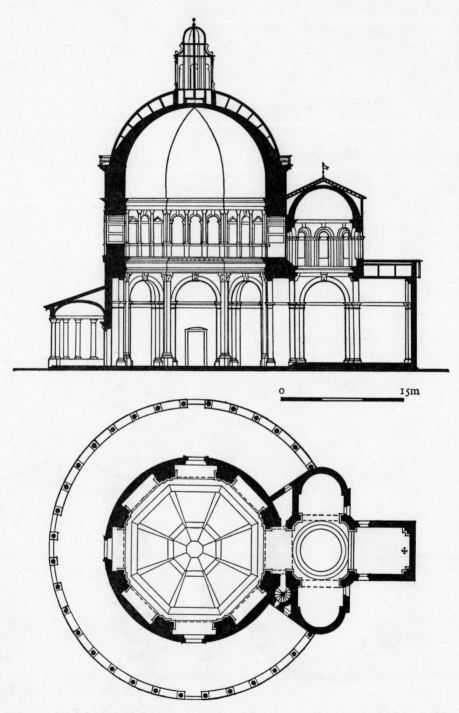

Figure 74. Michele Sanmicheli: Verona, Madonna di Campagna, begun 1559, section and plan

hemispherical dome over the crossing touches the drum of the main vault. The transverse axis of the choir is smaller and its dome lower than that of the big cylinder; seen from the outside, the choir looks like a subsidiary annex.[22]

If one enters the church through the portal on the town side, the miraculous image in the choir chapel is seen in the frame of the arch opposite. The broad, high octagon which surrounds the viewer is like the first of a series of rooms with the high altar standing at its end. The lengthwise sweep from the door to the altar is hardly less important for the general effect than the height of the main dome.

The strong stress on the longitudinal axis, however, conflicts with the principle of a purely centralized plan. The miraculous images at Todi and Montepulciano stand under the dome, though not under its centre. In the Madonna di Campagna, the dome, in the exterior view, certainly keeps its place as the crown of the building, but in the interior the high altar is set so far out of the octagon that the arrangement of dome and altar may be called eccentric.

In view of the Madonna di Campagna, it is easy to understand why the architects of the Renaissance, for all their admiration of the Pantheon, shrank from adopting the circular form for their great churches. Except for its portico, the exterior view of the Pantheon is neglected; in a Renaissance pilgrimage church the exterior and interior were equally important. The ancient vaulting technique with concrete was unimaginable at Verona about 1550; Sanmicheli had no alternative but the double shell. For static reasons, the contour of the two shells had to differ.[23] The foot of the heavy inner shell had to be set comparatively low, that of the lighter outer shell comparatively high.

The architect whose aim it was to realize in the Madonna di Campagna the ideal of a 'modern' Pantheon had to take into account the aesthetic conditions which a Renaissance pilgrimage church had to fulfil, and the structural possibilities at his disposal. The compromise, and in particular the discrepancy between the exterior and interior, are and remain unsatisfying.[24] From the outside, the Doric peristyle looks too low, the cylinder rising above it too high; the balustrade is not weighty enough for the necessary transition between the dome and the cylinder; the plain zone between the windows in the drum and the balustrade – which corresponds to the difference in height between the spring of the interior and exterior domes – looks senseless.

Yet these weaknesses were innate in the choice of the architectural composition. They became inevitable as soon as an 'ideal' rotunda was to be crowned by a dome visible from a great distance. Plans such as the quatrefoil or the Greek cross permit a genuine gradation of the building both horizontally and vertically. Their rectangular crossing can be closed by a dome on pendentives; the reduction of volume from the cube of the substructure by way of the cylinder of the drum to the hemisphere of the dome is satisfying both structurally and aesthetically. A domed building on a circular plan admits no gradation of the kind, since drum and dome have to be of the same diameter.

On the other hand, the conscious care devoted to plan and structure are entirely in keeping with Sanmicheli's other buildings. The removal of the altar from the main unit of space recalls his early Petrucci Chapel at Orvieto; he had already got to grips with the problem of the centralized plan in the Pellegrini Chapel. It is quite possible that in the

building of the Madonna di Campagna, Sanmicheli's plans were really respected, and they were available at the laying of the foundation stone in 1559. The responsibility for the partly very crude detail and the awkward lantern must rest with the craftsmen.[25]

Of all the architects of the Cinquecento, Sanmicheli cultivated the heritage of Bramante longest and most intensely. His central compositions are inconceivable without the prototype of the Tempietto, his palazzo façades without that of the Palazzo Caprini. It would, however, be a mistake to regard Sanmicheli as a mere copyist or epigone. His Palazzo Bevilacqua is no less 'modern' than the contemporary post-classical buildings in Rome. His gates and the Pompei and Grimani façades are among the few buildings of the Cinquecento which created new types for others to follow. They offered new and practical solutions of building problems, they fulfilled the ideal of a meaningful use of the ancient orders, so that the modern function of the building could be given adequate expression.[26]

The true heir of Sanmicheli was to be Palladio: without him, Palladio's development cannot be imagined. Sanmicheli's treatment of ornament, his avoidance of colour effects, his interest in the composition of the façade, his adoption of the Roman rotunda, his form of drum and dome developed out of Bramante's design for St Peter's – all these features were continued in Palladio's work.

In concluding this chapter, the most beautiful of the Baroque churches in Venice must be mentioned. The dome of S. Maria della Salute consists, like that of the Madonna di Campagna, of a spherical outer and an octagonal inner shell. In both churches, a large octagon is combined with a centrally planned choir; the plans of the two choirs are also akin. By surrounding the octagon with an octagonal ambulatory, Longhena created the harmony which Sanmicheli's rotunda lacked; it is obvious, however, that the architectural principles of the Madonna di Campagna had their effect on the planning of the Salute.

GIULIO ROMANO

AT Mantua, the works of Giulio Romano (1499?–1546),[1] who was a little younger than Sanmicheli, are contemporary with Sanmicheli's buildings at Verona. Both architects owe their determining impulses to Rome, Sanmicheli obviously to the Bramante circle, and Giulio Romano as Raphael's favourite pupil to Raphael. He collaborated in the Vatican Stanze and Logge and in the Villa Madama. After Raphael's death he took over the workshop in collaboration with Giovanfrancesco Penni.

Giulio Romano was one of the few great architects of the century to be born in Rome. The inseparability of structure and decoration which was so characteristic of Raphael's mature style is also a fundamental trait of Giulio's work. His buildings are conceived as an aesthetic whole, and in many cases the share of the architect in the whole can hardly be distinguished from that of the stucco-worker or fresco-painter. To that extent, Giulio is the most important representative of the trend which has been called 'painter's architecture'. He shares with Peruzzi the conscious contrasting of classical and anti-classical form. Both Giulio and Peruzzi show their knowledge of the canon of the orders, but often employ quite heretical forms in the same building. Contemporaries admired as fertility of invention the surprise and shock imparted by this style, and its contradiction in terms. For the connoisseur the work now became a riddle, an experiment, in which the artist and the viewer shared equally.[2]

From his arrival at Mantua in 1524 till his death, Giulio was responsible for all the artistic enterprises at the court of the Gonzaga. His masterpiece was the Palazzo del Te, a large *villa suburbana*, which he designed and decorated with the assistance of his pupils. But he also made plans for new districts in the city, superintended the alteration of the ducal residence, and set the scenes for the state reception of the Emperor Charles V and the new duchess. Art at Mantua in the second quarter of the Cinquecento is practically synonymous with his name. As Vasari tells us: 'Nobody in that city could build without an order from Giulio.'[3]

Giulio's particular architectural thinking is revealed in two buildings in Rome erected before he left to settle in Mantua: the Villa Lante on the Gianicolo[4] and the Palazzo Maccarani in the Piazza S. Eustachio.[5] Like Bramante's Palazzo Caprini, the Palazzo Maccarani has five bays, the ground floor is rusticated, and the piano nobile is articulated by a coupled order (Plate 229). But in the Palazzo Maccarani, the openings on the ground and mezzanine floors are oblong. The string course lies like a beam on vertical strips of rusticated blocks, and the gigantic voussoirs of the botteghe are wedged in between these strips. The window-sills of the piano nobile rest exactly on those points in the string course where it is not supported by the ground floor. A similar contradiction can be seen in the entrance doorway, where the voussoirs of the straight lintel project far out from the façade.[6] At first it looks alarmingly unsteady, until

it becomes clear that they are held fast by the parts of a broken pediment. In addition to orthodox window frames, there are in the piano nobile quite illicit pilasters without capitals, and on the upper floor segmental arches over the windows instead of straight entablatures. The courtyard, enlarged and altered, preserves the original articulation of the piano nobile on its long side. True, the coupled pilasters have capitals, but in themselves they are unusually slender, and therefore 'too tall'. The surrounds of the mezzanine openings are to be looked at as vertically sliced balusters. The charm and fancifulness of this architecture can only be appreciated by the expert who is familiar with the classic repertory of form and its use in the Palazzo Caprini, and he alone can grasp the eccentricity of the Palazzo Maccarani.

Giulio's summons to Mantua was arranged by Baldassare Castiglione, the Gonzaga's agent for cultural affairs in Rome. He recommended Giulio, argued out the terms of his appointment, and actually travelled to Mantua with him in 1524. The Marchese, later Duke Federigo II, born in 1500, as the son of Isabella d'Este, was familiar with the great art of the Renaissance, and loaded Giulio Romano, who was his contemporary, with tokens of his favour. In August 1526 the artist was appointed *Superiore Generale* of all public buildings; even before that the Duke had presented him with a house, and granted him the citizenship of Mantua. Four months later he appointed him *Superiore delle Strade*.[7] The salary for this position, which Giulio retained till his death, was 500 ducats a year, while Sangallo and Peruzzi, as architects of St Peter's at that time, were paid 300 a year. The new quarters planned by Giulio made Mantua a modern city. Vasari called the new streets 'dry, clean, fair, and pleasing'.[8]

The site of the Palazzo del Te was on an island outside the city walls which had, from time immemorial, housed the stables and provided pasturing for the famous Gonzaga stud. According to Vasari, Federigo's first idea was to have a mere pied-à-terre for refreshments and rest after riding. It was from these modest beginnings that Giulio Romano evolved the elaborate scheme of the present building (Figure 75).

The letters exchanged between the client and the artist during building show Giulio as architect, artist, contractor, and clerk of the works. They show how eager the client was to have the building completed as soon as possible; again and again Giulio had to explain delays due to the lack of reliable workmen, to sickness, and to work elsewhere. Federigo's persistence becomes easier to understand if we think of all the villas of the time which remained unfinished or took decades to complete. Most likely the Marchese wished to outvie his sister Eleonora of Urbino, with her great villa near Pesaro. By the end of 1534 the structural and decorative work on the Palazzo del Te was practically finished.[9]

Vasari speaks of 'a square building with an open turfed courtyard and four entrances. The first entrance, which is seen at once by the visitor coming from the town, leads into a very large loggia opening on to the garden; two other portals lead into various rooms decorated with painting and stucco'.[10] These brief sentences, which are followed by seven pages on the furnishings and the iconographical programme, are no real preparation for the surprises the villa has in store. Firstly the proportions are unusual. The exterior looks like a low, single-storeyed block, four times as wide as it is high.[11] Both

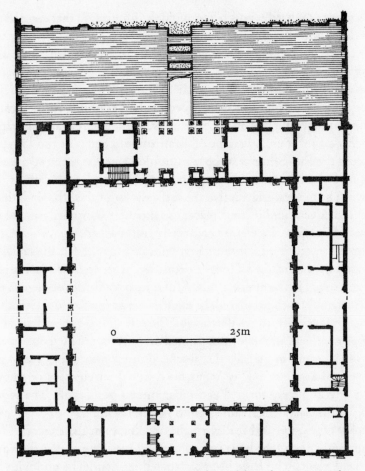

Figure 75. Giulio Romano: Mantua, Palazzo del Te, begun 1525, plan

façades looking towards the town have a giant order of Doric pilasters (Plate 230), but the intervals between the pilasters and the portals are unequal, so that different systems collide at the corners. Porches and windows are vigorously rusticated, and the detail is just as bizarre as in the Palazzo Maccarani. The 'very large loggia' on the town side described by Vasari leads into a tetrastyle vestibule which has flat-roofed aisles and a tunnel-vaulted nave. The scheme of the triple vestibule occurs as the 'atrium' in Fra Giocondo's 1511 edition of Vitruvius; Giulio Romano probably adopted it from the projects for the Villa Madama, which he knew well.[12] The combination of columns, architrave, flat ceiling, and coffered tunnel-vault (the model for the coffers was the Basilica of Maxentius, not the Pantheon) is obviously intended to recall ancient buildings. But the first impression the visitor receives is not that of a 'classical' kind of architecture; the columns and pilasters are coated with a thick crust of rustication. One is led to imagine the marble columns, apparently still in the rough, as they would be when smoothed. The architrave over the columns has been carefully smoothed, but in the centre of each intercolumnar space there is a quite unmotivated 'keystone' with

a rusticated surface. It is hardly possible to avoid the impression that these keystones were 'by mistake' left undressed. This 'unfinished' effect seems almost stranger to the expert than to the general visitor; after all, the dressing of columns and architrave was routine work for the stonemason.

In the corners of the courtyard, as on the exterior of the palazzo, different systems collide (Plate 234). The wall surfaces between the half-columns on the north and south sides are of the same width, but on the east and west sides there is an alternation of wider and narrower wall sections, a variant of Bramante's scheme in the Upper Belvedere Court. Between the half-columns, rubbly rustication and fine ashlar stand side by side.[13] On two sides of the courtyard the triglyphs of the entablature look as if they were slipping down. The general effect is that the surface is unfinished; the individual member does not seem to have found its final place; the situation is provisional and unstable. As in the Palazzo Maccarani, the viewer constantly feels tricked.

The coloured ornament which must have further brought out the fantastic and rest-less composition of the façade no longer exists. What an essential part it played in the total effect can be seen in the interior, which, in spite of centuries of neglect and repeated repainting, is tolerably well preserved. In the frescoes of the Sala dei Cavalli (Plate 231), the Duke had his favourite horses portrayed. They stand life-size and uncannily alive in front of the pilasters and niches of the painted architecture. The niches contain figures of the gods of Olympus in grisaille, i.e. intended to produce the effect of marble. The mixture of several kinds of reality is just as essential an element of this style as the juxtaposition of completely formed and quite amorphous details. The wooden beams of the ceiling in the Sala dei Cavalli seem to be intertwining.

The interplay of illusion and reality reaches its climax in the frescoes of the Sala dei Giganti. The visitor feels that he is surrounded by tottering walls; they are the rocks collapsing on the giants who have been conquered by Zeus. The god with his thunder-bolt appears high above the clouds. A monopteros, carried by the clouds, is hovering at an inaccessible height in the crown of the vault – Olympus in the guise of a Tempietto. The picturing of chaos and terror recalls Hieronymus Bosch. There is not a single vertical or horizontal accent for the eye to rest on; the bounds of the hall seem to yield to the frightful pressure from above. The architect has abandoned the language of architecture. All he cares about is the expressive value, the emotion which the room is to awaken in the visitor.

The Sala dei Giganti was created thirty years after Bramante's Tempietto and fifteen after the Sala delle Colonne in the Farnesina. Looked at from this standpoint, Bramante and Peruzzi seem closer to the master of the Parthenon than to Raphael's pupil.

The whole garden front of the Palazzo del Te is arcaded (Plate 233); the central part contains a three-bay loggia, the vaulting of each bay being supported on four columns (Plate 232). In this loggia, the visitor, emerging from the riot of the Sala dei Giganti, is surrounded by light walls and white-stuccoed columns. The columns are impeccable in form and proportion. The vaulting recalls the decoration of the Augustan age. Giulio Romano here displays his familiarity with Alberti and the principles of classical archi-tecture. The segments of a huge entablature with classical mouldings lie over the groups

of columns, so that there is no immediate connection between columns and round arches. A similar combination of columns, architrave, and round arch is to be seen in the lower loggias on both sides of the central section, which actually form shallow balconies. As can be seen from the plan, this is a purely aesthetic 'curtain wall', like the Gothic triforium.

If we stand in front of this façade, the rusticated tetrastyle vestibule can be seen through the portal of the loggia and across the courtyard. The contrast is intentional. Wherever one turns in this building, there are clashes of finished and unfinished, orthodox and heretical, fortissimo and pianissimo. It seems as if the forces at work, the conflict between order and chaos, were held suspended for a moment by the architect's spell.[14]

In the city residence of the Gonzaga Giulio designed, in addition to a number of interiors, the so-called *Estivale*, the south front of the present Cortile della Cavallerizza (Plate 235).[15] The building, erected in 1538–9 and originally free-standing, was intended as a kind of terrace for performances and tournaments. The seven-bay façade[16] returns to the scheme of the Palazzo Caprini, but in the Duke's palazzo the piano nobile is also rusticated, and in the strangest fashion. Still more, there is movement even in the calmest of classical orders. The Doric columns twist spirally about their own axes.[17] Their rusticated bases project from this wall, needing the support of brackets which are wedged in between the arches of the ground floor. Under the weight of the string courses the arches are bent into a segmental shape, and the pediments over the windows of the piano nobile become flat relieving arches. Here again the relationship of supporting and supported members is one of frozen movement, and not of enduring harmony.

Giulio's position and influence remained unchanged when Cardinal Ercole Gonzaga became regent during the minority of Francesco III after Duke Federigo's death in 1540. For the first time, Giulio Romano was faced with problems of religious architecture: he was entrusted with the renovation of Mantua Cathedral and the abbey church of S. Benedetto Po (Polirone), not far from Mantua. Neither building tells us clearly what was the condition before renovation and what is Giulio's part in it.[18] In the cathedral (Figure 76) the medieval outer walls were preserved, and work was confined to the double-aisled interior. The flat-roofed nave with its Corinthian columns and architrave recalls old St Peter's. The inner aisles have lavishly decorated tunnel-vaults, while the outer ones have flat coffered ceilings (Plate 236). This curious alternation between flat ceiling and tunnel-vault is continued in the chapels off the outer aisles; from every second bay a round arch leads into a vaulted chapel. From the adjoining bays architraved passages lead into flat-roofed units.

In S. Benedetto, also, the exterior was renovated. For the façade and sides of the church (Plate 237) Giulio adopted the triumphal arch motif of Bramante's upper Belvedere Court. In the interior, the vaulting of the thirteenth century was retained, but the medieval system of alternating heavier and lighter piers was completely altered. The major piers were faced with pilasters; the minor ones were removed, and each was replaced by two low columns which, with their architrave, form a minor order. In the

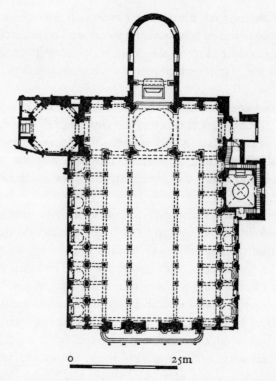

0 25m

Figure 76. Giulio Romano: Mantua Cathedral, after 1540, plan

middle of the bay, the architrave is broken by round-headed arches in the same way as in the outer aisles of Mantua Cathedral.

It is illuminating that so fertile and inventive an artist should have adopted in these buildings traditional forms from the Early Christian basilica and Bramante's Belvedere Court. The forms of the Palazzo del Te are calculated for a near view; given the large scale and the liturgical requirements of the two churches, Giulio had to turn to other means if he was going to produce the effects of contrast which are typical of his conception of architecture. The contrast between vaulted and flat-roofed aisles in the cathedral, the confusing composition of the interior of S. Benedetto, the mixture of old and new elements, are no less surprising than the suite of rooms in the Palazzo del Te. But the studied effects of surprise and contrast look petty in buildings the size of S. Benedetto, for on that scale the eye needs clarity, balance, and permanence.

It is true that Giulio's hands were bound in these commissions: existing parts of buildings had to be worked in and the old frontages had to be maintained. Yet if both churches awaken conflicting feelings in the viewer, that cannot be entirely ascribed to external circumstances. The element of caprice which plays such a determining part in Giulio's style cannot be transposed into the key of monumentality.

The style, however, was ideally right for Giulio's own house, which Vasari admired at Mantua in 1541.[19] The ground floor houses the workshops, the piano nobile the living rooms whose frescoes have recently been rediscovered. Behind the attic a low

mezzanine floor is concealed. The façade is entirely in the palazzo style (Plate 238), a demonstration of the architect's relation to the court and the nobility. The ground floor appears as a rusticated base, and the portal with its depressed arch interrupts the row of square windows. It is remarkable that Giulio has refrained in the piano nobile from using engaged columns and pilasters; the articulation consists of blank arches with the window frames and pediments recessed in them. The keystones of these arches support the crowning cornice, which is richly ornamented, but does not project. The simple and apparently logical system is interrupted only in the central bay, where the string course of the ground floor is pushed up by the voussoirs of the doorway, so that a horizontal band is suddenly transformed into the gable over the portal. Above the pediment which gives a marked stress to the central bay on the piano nobile, a shallow niche with a small statue takes the place of a window. Finally, the relationship of arch and pediment is reversed in the two storeys; in the portal, the pediment frames the arch, in the piano nobile the arch frames the pediment.

The blind arches of the piano nobile, in spite of their comparatively shallow relief, make the façade the most striking in the whole length of the street. It has a *grandezza* which no Florentine or Roman artist's house of the sixteenth century possesses. Yet it shows no advance over Giulio's earlier buildings in Rome and Mantua. It is a strange fact that there is no real development in Giulio's style. Till his death he employed the forms which, by the virtuosity of their treatment, had made him Raphael's most beloved pupil.

By 1540 these forms were out of date in Rome. When Giulio died in 1546, Mantua was on the way to becoming a provincial town; the age of the small princely courts was approaching its end. Compared with contemporary Roman architecture, or with the palazzi of Palladio and Sanmicheli, Giulio Romano's late work is not free of a touch of provincialism.

The 'Mantuan style' which Giulio did so much to create had less influence on Italian architecture than on that of the transalpine countries. Through Primaticcio, who worked for a short time on the Palazzo del Te, Giulio exercised a lasting influence on the Fontainebleau school, and in 1536 the Duke of Bavaria had his palace at Landshut built in the Mantuan style.[20] In Italy itself, Giulio's style was continued into the seventeenth century, but only by his Mantuan successors. Today the Estivale is the narrow side of an oblong courtyard; on the three sides which were built later, Giulio's pupil G. B. Bertani adopted the motif of the twisted columns with slight alterations.[21] The courtyard was just finished when Rubens arrived at Mantua, and in his predilection for rustication and twisted columns we may see a late throw-back to Giulio Romano.

CHAPTER 21

JACOPO SANSOVINO

IT is one of the oddities of Italian art history that it was a Florentine architect who gave the main square of Venice its final form (Figure 77), and that this Florentine succeeded the last of the many Lombards who had worked as architects of the Venetian Republic in the Quattrocento and Cinquecento.

Jacopo Tatti, surnamed Il Sansovino (1486–1570), began as a sculptor in Andrea Sansovino's workshop in Florence. According to Vasari, he was in Rome from 1506 to 1511, where he lived in Giuliano da Sangallo's house, but returned to Florence in 1511 and stayed there until 1518. For the state entry of Leo X in 1515 Sansovino designed a wooden façade for the cathedral of Florence as a facing to the incomplete Gothic

Figure 77. Venice, Piazza S. Marco, plans (A) before c. 1530, (B) c. 1600

façade, and he worked on the triumphal arches erected on the same occasion.[1] The Pope, impressed by Sansovino's work, engaged him for the façade of S. Lorenzo, for which Giuliano da Sangallo and Raphael also were then preparing the designs. Later the commission passed to Michelangelo.[2] In 1518 Sansovino returned to Rome, and soon after won the competition for S. Giovanni dei Fiorentini over the heads of Peruzzi, Raphael, and Antonio da Sangallo the Younger. In 1520 he was paid for a model of the church, but the actual building, which Sangallo directed, never rose above its foundations.[3]

Of all these projects we have only documentary evidence. According to Vasari, Sansovino's façade for Florence Cathedral had coupled Corinthian columns on tall pedestals; it was articulated like a triumphal arch, with statues in round-headed niches and reliefs. There are good reasons why this description should recall Giuliano da Sangallo's designs for the façade of S. Lorenzo (cf. pp. 186–7), for the formal repertory in both cases is that of the Bramante circle. The precursor of the combination of coupled columns, statues in niches, and reliefs may have been the Santa Casa at Loreto (Plate 166), on which Sansovino's teacher Andrea had worked for a long time.

When Sansovino went to Venice after the Sack of Rome, his acquaintance with Cardinal Grimani and Pietro Aretino was all to the good. In the first few years he was busy on strengthening the domes of St Mark's, which had, for many years past, been supported by provisional structures. In 1529, after the death of Bartolomeo Buon of Bergamo, Sansovino succeeded him as *Proto dei Procuratori di Supra*. The office was the most eminent the republic had to bestow on an architect, and the holder was responsible for the never-ending work on St Mark's, and for the Procurators' Offices on the Piazza, the Procurazie Vecchie (Plate 81), begun by Bartolomeo and completed by Sansovino in 1538. At first his salary was eighty ducats, but in 1530 it was raised to a hundred and eighty and in 1540 to two hundred.[4]

The Procurators were also responsible for the Library of St Mark's, originally housed in the church, and later removed to the Doges' Palace. In 1537 the Procurators decided to house the library in a large new building, projected since 1532 and intended to face the Doges' Palace on the Piazzetta. Not much is known about the genesis of the plan, but Sansovino was certainly appointed architect-in-chief from the very beginning.

The reconstruction of the Piazzetta was as important for Venice as Michelangelo's slightly later replanning of the Capitol was for Rome. The Capitol and the Piazzetta had been places of execution in the Middle Ages; they now became the forum for acts of state. In both cases the project comprised not only the façades, but also their relationship to the width and depth of their site. In both cases the ground floor is designed as a loggia; it is hardly possible to know in either case whether the decision was based on local custom or on rules laid down by Vitruvius and Alberti. In Venice, the housing of banks and goldsmiths' workshops in the loggias of the new building is in keeping with the principles of these theorists.[5]

Sansovino's Library of St Mark's is not as high as the Doges' Palace facing it, but each of its two storeys is higher than the corresponding loggia of the Gothic building. The delicate Gothic tracery of the Doges' Palace faces the ponderous articulation of the library, where the massive cornices emphasize the horizontals just as much as the broad,

flat wall over the loggias of the Doges' Palace. For all their differences, the two façades look equally weighty.

The library was begun in the corner adjoining the campanile (Plate 239).[6] Three bays of the narrow side on the Piazza and the adjoining arcade of the main front on the Piazzetta seem to have been complete by 1540. In December 1545, the vault covering five bays of the upper storey collapsed, though it was strengthened by tie-rods. The Procurators suspected negligence in the supervision of the works, and Sansovino was removed from office and spent a short time in prison. He himself attributed the disaster to an unusually severe frost. In the end the Procurators granted him a loan of a thousand ducats to make good the damage, which was to be repaid at the rate of a hundred ducats a year. He also had to stand guarantee for any costs in excess of the estimate.[7] A year later, the damaged parts were reconstructed, but the masonry vaults of the upper storey were replaced by a timber roof with false vaulting underneath. In 1547 Sansovino was reinstated in his office as Proto. By 1554 the sixteen arches on the Piazzetta were completed and the interior decoration well advanced. In 1558 the books were moved in. The last five arches on the Molo were not built till 1583–8, under Vincenzo Scamozzi.

On the ground floor of the library a tunnel-vaulted loggia runs in front of botteghe. The shape and moulding of the piers, which are faced with Doric half-columns, recall the Doric order in the courtyard of the Farnese Palace before its alteration.[8] Sansovino certainly knew the Roman palazzo, which was begun in 1517. The combination of pilaster and engaged column in the corner piers of the library recalls another building of the Sangallo group, which must have been familiar to Sansovino: the Madonna di S. Biagio at Montepulciano, begun in 1518. Thus it is not merely a coincidence that Sansovino's Doric order produces the same effect of splendour and monumentality as the Roman buildings of Raphael's time. Sansovino enhanced this effect by placing reclining figures in the spandrels of the arches, in the way of the Roman triumphal arches, and giving the entablature the unusual height of one third of that of the columns. In the general view of the Piazza, the ponderousness of the entablature is an essential feature in the effect of the library.

In the fenestrated walls of the upper storey, the openings had to be narrower and the wall surfaces wider than in the open loggia on the ground floor. Sansovino gave the round-headed windows small, free-standing columns as supports; the entablature of this smaller order is cut across by the engaged columns – also Ionic – of the main order. The smaller columns are fluted, the larger ones smooth. The bases of the latter rest on independent pedestals, those of the small order on the coping of the window balustrade.[9]

The crowning cornice with its balustrade is still more weighty and ornate than that of the ground floor. The putti and garlands of the frieze are a 'Roman' motif. Sansovino produced in it a variation of the terracotta frieze which was placed over the upper storey of the Farnesina in 1521, and the small windows of the mezzanine too are worked into the decorative scheme in the same way as in the Farnesina.

From the central bay of the ground floor a tunnel-vaulted staircase leads up to the main storey, whose rooms occupy the whole width of the building and for that reason have windows on both long sides. The main hall is in the corner facing the campanile.

It corresponds to seven arches of the façade and may be regarded as one of the most outstanding and beautiful interiors of the Cinquecento (Plate 240). In the long walls, round-arched windows alternate with lower, painted niches, above which the window imposts are continued as mouldings. In the same way as in the Ionic order of the façade, there is therefore a consonance between two similar systems of different height. The decoration of the sham vaulting is also remarkable; it is divided into squares by ornamental bands, each of which contains a painted tondo. The scheme proceeds from the sections of the walls, but it does not become architectural painting. On the other hand, in the vestibule leading into the main hall, painting is entirely subordinate to structure; stone pilasters support the ornate coffered ceiling, and even the windows are framed in stone aedicules. The vigorous relief of this wall structure provides the transition between the three-dimensional forms of the façade and the painted walls of the salone.

The magnificent decoration was the work of Titian, Tintoretto, and Paolo Veronese, and of the sculptors Alessandro Vittoria and Danese Cattaneo. The whole may well have been designed by Sansovino himself.

As pointed out already by Vasari and Palladio, Sansovino's library naturalized the new Roman style in Venice. Palladio called it 'the richest and most ornate building since antiquity',[10] and Jacob Burckhardt still regarded it as 'the most splendid work of secular architecture in modern Europe'.[11] For the first time in Venice, the classical orders were correctly applied, and the relationship of weight and support in columns, pillars, and entablatures was clearly articulated.

Until the sixteenth century the campanile of St Mark's indicated the junction of the Piazza and Piazzetta. On both sides the buildings abutted on to the tower. It is true that Sansovino adopted for the main façade of the new library the frontage of the older, humble buildings, which had been determined by the campanile, but he left a space between the corner of the new building and the campanile. The front of the library on the Piazza was not constructed on the foundations of the building which had preceded it but set back, so that the Piazza now became wider by about 24 m. (80 feet) at the campanile and 13 m. (43 feet) at the other corner of the square (Figure 77). At the other end of the Piazzetta, Sansovino demolished the workshops and shops which flanked the two columns. Only then was the view opened on to the Canal Grande and S. Giorgio Maggiore.[12]

On the side of the campanile facing St Mark's was erected the loggia designed by Sansovino and begun in 1537, which served as the assembly room of the patricians during the Councils of State.[13] The Loggetta, originally called the Ridotto dei Nobili, is a one-storey, three-bay hall; on the façade, round-arched openings alternate with free-standing coupled columns. The scheme – a variant of the triumphal arch motif – can be seen in Giuliano da Sangallo's designs for the façade of S. Lorenzo in Florence. Sansovino had obviously used it before in his wooden sham façade for the cathedral of Florence.

The Zecca, the mint and treasury of the Republic,[14] situated on the Molo, was built about the same time as the library and Loggetta. On the ground floor of the Zecca, the

pillars and arcades consist of rusticated blocks of marble (Plate 241). The Doric columns of the upper storey seem to be composed of alternating broad and narrow drums; they stand in niches and not in front of the wall. The scheme of the ground floor is another derivation from Bramante's Palazzo Caprini. But while Bramante doubled the columns in the piano nobile, Sansovino doubled the window lintels. The threefold horizontal of entablature and window lintels, and the absence of any ornament, invest the façade with a strange and sombre monumentality which gives perfect expression to the function of the building.

The third storey was not added till about 1560, probably by Sansovino himself. In this storey the engaged columns do not stand in niches. The 'bands' by which they are clamped to the walls stretch sideways to the window jambs, and the windows themselves are crowned with pediments. A comparison between the two storeys shows how greatly this apparently trivial alteration impairs the general look of the façade.[15]

Vasari regarded the façade of the Zecca as the first appearance of rustication in Venice; in this connection he lays stress on the *fortezza* of the building. *Fortezza* is also the epithet that Serlio repeatedly uses for rustication.[16] In the Zecca, the rustication, and the emotions it is expected to arouse in the spectator, are in perfect keeping with the function of the building. Similar expressive trends can be observed in Giulio Romano's buildings, which were erected not much earlier, though Giulio Romano's use of rustication is far more capricious than Sansovino's. It is very probable that the Mantuan works were familiar to Sansovino – it is certain that he knew Sanmicheli, who was in the service of the republic – and rustication plays an important part in Sansovino's work.

Sansovino's Palazzo Corner della Cà Grande (Plate 242 and Figure 78) was built in the thirties of the century, about the same time, therefore, as Sanmicheli's Palazzo Canossa at Verona (Plate 225).[17] It is tempting to regard the two palazzi as variations on a single theme, just as Bach's sons composed variations on themes of their father. The basic theme is again Bramante's Palazzo Caprini: the ground floor of both façades is rusticated and the piano nobile articulated by a coupled order. In contrast to

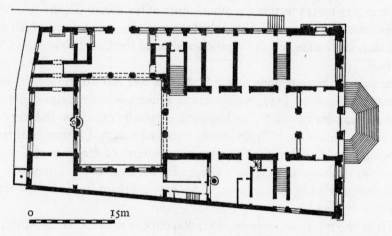

0 15m

Figure 78. Jacopo Sansovino: Venice, Palazzo Corner della Cà Grande, 1530s, plan

Sanmicheli, who uses shallow relief for coupled pilasters, cornices, and window surrounds, Sansovino allows the articulation to project vigorously from the wall. The pilasters are replaced by columns, the windows of the ground floor are provided with aedicules, those of the mezzanine floor are framed by capriciously large brackets; in the upper storeys, the bases of the columns and the balustrades are separated by recesses. Thus the bright, projecting members stand out against the shadowed wall.

In both palazzi the three central bays of the ground floor are opened to form an entrance hall. This motif first occurs in Giulio Romano's Palazzo del Te and is probably derived from it. In the Palazzo Corner the vaulting of the entrance hall is independent of the bays of the façade. From the hall a long passage leads into a courtyard which is unusually spacious for Venice and, truly Venetian in situation and function, stands on the rear, short side of the building. The courtyard is striking not only for its size, but for the careful and identical articulation of all four walls – probably a reminiscence of Sansovino's early years in Rome. The extensive use of rustication in the articulation of the courtyard probably also goes back to the impression he received from the Palazzo del Te.

In the Palazzo Corner Sansovino created a type which was to be a model for the palazzi of the great Venetian families till the eighteenth century. We can judge how unusual the size and sumptuousness of this palazzo was in the sixteenth century from the mere fact that the family who occupied it soon went by the surname of 'Corner della Cà Grande'.

To the end of his life Sansovino continued to employ the classical repertory of form which he had made his own in Rome. Certain characteristic elements of form are recurrent in his late work: the coupled columns occur in the façade of S. Geminiano on the Piazza, which was demolished under Napoleon I, but often appears in *vedute* by Guardi and Canaletto, and in the aisled hall of the Scuola Grande della Misericordia,[18] which has in both storeys of the façade the triumphal arch scheme of the Loggetta; and in the façade and courtyard of the Villa Garzoni, near Ponte Casale, Sansovino repeats the Doric order of the library.[19] Unlike Michelangelo and his contemporary and friend Titian, Sansovino did not develop a late style, and his last works are less important and original than the library or the Palazzo Corner. The forms that were innovations in the thirties, and were certainly created to a large extent by Sansovino or under the influence of his work, soon became public property in Venice, and Sansovino's late works are at times difficult to distinguish from those of his pupils and successors. Yet Sanmicheli's Palazzo Grimani shows that this formal repertory offered possibilities for new and brilliant solutions of traditional architectural problems.

CHAPTER 22

MICHELANGELO

WHEN Michelangelo Buonarroti (1475–1564) received his first architectural commission in 1516, his fame had already spread beyond the frontiers of Italy. Four years before, he had completed the frescoes in the Sistine Chapel; for the past ten years he had been engaged on the tomb of Julius II, a work which was to occupy him in all for twenty years.

To the end of his life Michelangelo described himself as a sculptor, and always tried to put forward that pretext in order to refuse commissions for buildings or paintings. Wherever he accepted such commissions, the sculptor's manner of thinking and working becomes obvious. Yet it would be a mistake to regard Michelangelo's buildings as a sculptor's architecture and to take that as the sole explanation of their highly personal character. Bramante and Raphael were active as painters, Giuliano da Sangallo and Jacopo Sansovino as sculptors, Palladio as a stone carver, before they took up architecture. Thus Michelangelo's career is in no way exceptional. The universality of his work is in keeping with a tradition that can be traced at least as far back as Giotto and Giovanni Pisano, if not farther. Besides, Michelangelo himself painted the illusionist architecture in the Sistine Chapel and he designed the architectural framework projected for the sculpture in Julius II's tomb. When seen in this connection, his insistence on his training as a sculptor seems rather to be an early sign of modern specialization than a relic of earlier customs.[1]

FLORENCE

The Façade of S. Lorenzo

During the pontificates of the Medici popes Leo X (1513–21) and Clement VII (1523–34), Michelangelo was at work on three important projects connected with S. Lorenzo, the family church of the Medici in Florence. The interior had been finished about 1470. For the façade, which has remained in the rough, Brunelleschi had planned a marble facing after the model of S. Miniato or S. Maria Novella. After the state re-entry of the Medici into Florence in 1515, Leo X decided to complete the façade, so that it should stand as a monumental witness to the renewed glory of his house. Vasari writes that the Pope ordered Raphael, Baccio d'Agnolo, and Andrea Sansovino to submit designs. They have vanished; on the other hand, several designs for the marble facing of the façade by Giuliano da Sangallo, whom Vasari does not mention in this connection (cf. above, pp. 186–7), have been preserved. Giuliano died in October 1516. In December 1516 Michelangelo, who had probably taken part in the discussions during Giuliano's lifetime, received a commission from the Pope for a wooden model of the

façade. In January 1518 the agreement for it was concluded in Rome.² Some of the vicissitudes of the model, the product of a year of labour, can be traced in Michelangelo's drawings.

Even before the agreement was signed, new quarries were opened in the Carrara Hills for the supply of marble. Michelangelo spent more than two years in building a road to the quarries, organizing the work in them and supervising transport to Florence.

In his first designs he adopted Sangallo's scheme: the contour of the façade corresponds to the basilican cross-section of the church, the two-storey nave rises above the single-storey aisles. The classical vocabulary of form characteristic of Roman buildings of the second decade of the sixteenth century also recalls Giuliano's – paired free-standing columns, round-headed niches, aedicules, the central pediment – and the sumptuous decoration with reliefs and the life-size statuary to which, as we know from the sources, the Pope attached great value.

The model described in the contract of 1518 is probably identical with the one preserved in the Casa Buonarroti (Plate 245). It differs in two respects from the first designs. Instead of the flat marble facing planned at first, a two-storey vestibule was to cover the whole width of the church façade; from outside it would have looked like a second transept. It was also to have been far richer in statuary than was originally planned. The contract mentions eighteen life-size statues – twelve in marble and six in bronze – and nineteen reliefs, thirteen of them with life-size figures. The whole of this huge programme was to be completed in eight years.

The closest analogy to this wealth of sculpture is to be found in the Gothic cathedrals of Tuscany. But while Giovanni Pisano had at hand a large workshop of many – in the medieval sense – 'anonymous' workers, the statuary and reliefs of the S. Lorenzo façade, as the contract implies, were all to be the work of Michelangelo. Considering the new conception of the style and personality of the artist and the demands which Michelangelo made on the quality of his own work, the practicability of the scheme must have seemed doubtful from the start. True, Michelangelo regarded the scheme as no more visionary than his first studies for the tomb of Julius II. The design of the façade had a great deal in common with them; in both cases the architectural members between the huge statues and reliefs would merely have acted as their frame and foil. Only once had Michelangelo been able to represent in its entirety this conception of the relationship between the human body and the architectural framework, and that was in the Sistine frescoes. That he was prevented from translating them into the reality of stone and bronze was not entirely due to the changing moods of his patron or to financial and political difficulties.

The actual problems involved in the design can no longer be recognized in the Casa Buonarroti model. In 1518, when the contract was signed between the Pope and the artist, there were wax models of the statues and reliefs in the niches. They have vanished, and in the 'empty' façade the classical rhetoric of the columns and round panels looks like an academic study in style. It is therefore no matter for surprise if historians were very long reluctant to identify this model with Michelangelo's design.

The New Sacristy of S. Lorenzo

In spite of all the laborious and costly work, the design of the façade was abandoned in 1520 on grounds which have not yet been clarified. To make up for this, the Pope granted Michelangelo a commission for the tombs of the princely members of the house of Medici in S. Lorenzo. Brunelleschi's Old Sacristy was the family mausoleum of the older generations of the family; it therefore seemed reasonable to turn the New Sacristy on the opposite wing of the transept, which had been planned long before, into a mausoleum too.[3]

Though identical in plan, there is a great difference between the elevations of the two

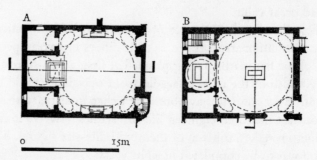

Figure 79. (A) Michelangelo: Florence, S. Lorenzo, New Sacristy, begun 1519, plan; (B) Filippo Brunelleschi: Florence, S. Lorenzo, Old Sacristy, after 1421, plan

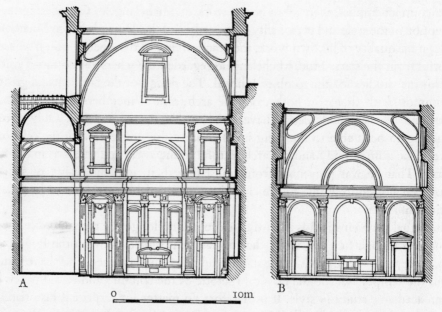

Figure 80. (A) Michelangelo: Florence, S. Lorenzo, New Sacristy, begun 1519, elevation; (B) Filippo Brunelleschi: Florence, S. Lorenzo, Old Sacristy, after 1421, elevation

chapels (Figures 79 and 80). In the New Sacristy (Plate 244), an attic storey has been added between the pilaster order and the pendentive zone. The dome is hemispherical, and not, like Brunelleschi's, a shallow umbrella vault. It is the first Renaissance dome to reproduce the coffer motif of the Pantheon. The great height of the space makes it look sparer and narrower, the more so as the order of pilasters, which was restricted to the wall of the choir in the Old Sacristy, is carried round all four walls in the New. Finally, Michelangelo filled the bays between the grey pietra serena pilasters with powerfully profiled architectural ornament, which, with its paired pilasters, niches, pediments, and volutes, contrasts with the main order both in style and scale.

Even Vasari felt that Michelangelo's complicated scheme was at odds with the tradition of the Quattrocento and the rules of classical architecture. This can be illustrated by a comparison between Brunelleschi's and Michelangelo's doorways. The doors of the Old Sacristy (Plate 17) are framed in columns and pediments; the columns stand on the same level as the observer, and their height is calculated in such a way that it is possible for him to feel a relationship between it and his own, or even to imagine himself framed in the aedicules. The round-arched terracotta reliefs over the doors differ from the aedicules in material, colour, outline, and depth – they are typical wall-ornament. On the other hand, the door frames of the New Sacristy (Plate 243) are meagre and almost abstract, their marble frames supporting tall, oblong tabernacles, also of marble, framed in pilasters and crowned by segmental pediments. Thus the low door becomes a subsidiary member dominated by the taller tabernacle above it. The tabernacles and their frames are so heavy that the lintels on which they rest have to be supported by brackets, thus forfeiting their true function and becoming the bases of the tabernacles.

By suppressing the aedicules of the doors, Michelangelo has made it impossible for the observer to discover a measurable relationship between architecture and the human body. The architecture bears its own scale within itself, namely in the over-life-size figures on the sarcophagi, which tower over the observer in exactly the same way as the weighty tabernacles under which he enters the sacristy. It is a feature of this architecture that it dwarfs the beholder.

Raphael's Chigi Chapel in S. Maria del Popolo, Rome (Plates 175–7), was still under construction when Michelangelo began work on the New Sacristy. The visitor enters the Chigi Chapel under one of the four arches which support the dome, so that the relationship between architecture and the human body is made clear and comprehensible. The image of God the Father in the summit of the dome in the Chigi Chapel is also related to the spectator in gesture and scale. But the architecture of the New Sacristy is as remote from the observer as the statues, which inhabit a different sphere from him as he stands looking up at them. No image in human likeness looks down on him from the dome; the ribs between the coffers guide the eye irresistibly into the lantern, whose windows are so large that the light devours the solid forms. Thus the lantern looks immeasurably high.

The Medici Chapel is the only architectural interior to have been designed by Michelangelo himself and executed under his personal supervision. When he moved to Rome in 1534, the decoration and statuary were not yet finished. The seated and

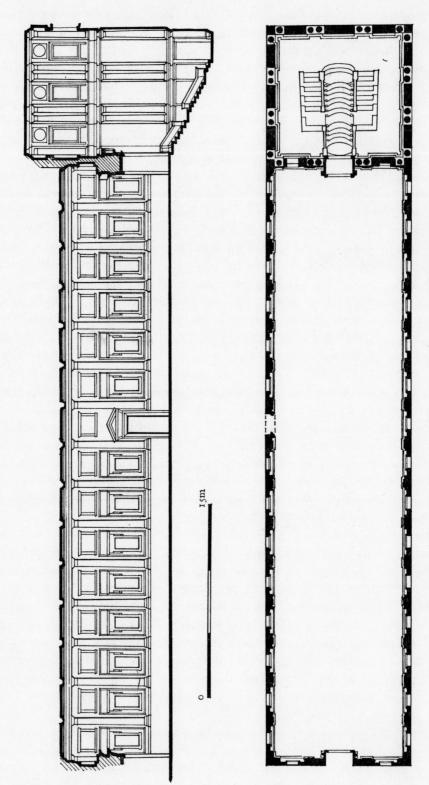

15m

0

Figure 81. Michelangelo: Florence, S. Lorenzo, Library, begun 1525, section and plan

reclining figures on the tombs were not put in place till 1545, and in 1559 the idea of completing the decoration of the chapel in accordance with Michelangelo's ideas was finally abandoned. The double tomb planned for the entrance wall and its marble architecture were not executed.

The Laurentian Library

Immediately after his elevation in 1523, the second Medici Pope, Clement VII, commissioned Michelangelo to prepare designs for a library to be installed in the west cloister wing of S. Lorenzo. The Biblioteca Laurenziana (Figure 81), as it stands today, contains the manuscripts and books belonging to the famous private library of the Medici, founded in the fifteenth century, which Clement removed from the family palazzo to the cloisters and opened to the public.

Work began in 1525. When Michelangelo left Florence in 1534 it was not yet finished. It was continued by Tribolo, Vasari, and Ammannati on verbal instructions from Michelangelo, and had progressed so far by 1571 that the library could be opened. Thus the present building combines parts executed by Michelangelo himself with others built much later in a more or less correct interpretation of his instructions.

According to the Pope's instructions, the two-storey Quattrocento cloister was to remain unaltered by the addition of the library. That explains certain features of Michelangelo's project. The reading room was to constitute a new third floor added upon the older parts of the cloisters, since there was no other way to provide it with adequate lighting; its walls were to stand on those of the pre-existing upper storey.[4] Thus the length and width of the hall were fixed in advance. In the upper storey, between the cloister and the Old Sacristy, a vestibule, called the *ricetto*, was separated off to house the staircase leading to the reading room. The position of this anteroom, which is contiguous with the high wall of the transept, involved difficulties of lighting. In Michelangelo's first project, the reading room and the ricetto were equal in height; the windows of the ricetto were to be placed either in the vaulting or in skylights. But the ricetto as we see it today is lighted by windows in the clerestory.

The reading room (Plate 248) is 46·20 m. long, 10·50 wide, and 8·40 high (152 by 35 by 28 feet). The furnishings and decoration are original. There are two blocks of seats separated by a central passage; their backs serve as reading desks for the benches behind them. The books lie chained on the desks. The desks are lighted from both sides by the comparatively close-set windows in the long sides. The windows are framed in pilasters, and the system of bays they form governs the articulation of the ceiling and the floor. The pilasters bear the cornice, which is carried without projections round the room and supports the cross-beams of the heavy wooden ceiling.

These pilasters, which articulate the walls and correspond to the beams, are a heritage of the Quattrocento. But no Quattrocento interior has any such treatment of the wall-bays between the pilasters to show. It consists of a triple recession of layers, the farthest back containing the window frames, a middle one with the quadrangular blind frame of the upper storey and the tall oblong panels in which the windows are set, and a front one

with the pilasters and their running base. The mouldings of the frames are of pietra serena, the wall surfaces of white stucco. This back and forward movement imparts to the wall a quite unprecedented depth of relief. The difference of function between supporting members and walls between them becomes perfectly clear in the juxtaposition of three- and two-dimensional forms. At the same time Michelangelo solved a structural problem. In view of the older walls of the storey beneath, he had to reduce the weight of the reading-room walls as much as he possibly could. By the system of the frames and layers in the articulation of the walls, the volume and weight of the intervening bays between the pilasters was reduced to a minimum. Thus the pilasters act as the fronts of the pier-like sections of the wall between the windows, which actually support the ceiling and take on a genuine structural function.

When Michelangelo left Florence in 1534, only the walls of the reading room were standing; the floors, the seats, and the ceiling were not added till *c.* 1550. But the designs for them were so precise that both the structure and the ornament of the reading room may be regarded as Michelangelo's own work. The ricetto, on the other hand, remained a torso till the twentieth century. The top range we see today was completed in 1904, and it was only then that the three windows looking on to the cloisters were finished, while in the interior, the articulation, which on this range till that time had only been completed on the south wall, was carried round the other three walls. The staircase was built in 1559 by Ammannati; Michelangelo had sent him a clay model of it in 1558.

The Ricetto

The first designs, made in 1524, show two flights of stairs placed against the side walls of the ricetto and forming a bridge in front of the reading-room door. In 1525 Michelangelo decided to remove the stairway to the middle of the vestibule; it was to start in three flights and unite in a single flight in its upper part. An attempt was made by Tribolo about 1550 to carry out this plan, using the steps lying in the ricetto, which had been made according to Michelangelo's instructions. It came to nothing. Although Ammannati used some of the steps in his construction, the staircase of today cannot be identified with the scheme of 1533–4, since the older steps had to be fitted with pieces of different stone. Besides, in answer to Vasari's inquiry in 1555 about the design for the staircase, Michelangelo replied that he had forgotten all about it. Thus the clay model sent to Ammannati in 1558, after which the staircase was built, is a new design made by Michelangelo between 1555 and 1558.

Ammannati certainly endeavoured to translate Michelangelo's ideas into reality as far as he possibly could. But the scanty material he had at hand, the comparatively small clay model and Michelangelo's instructions, could give no more than a general idea of the form; the details were left to his judgement.

The staircase takes up half of the floor of the ricetto, which measures 9·50 by 10·30 m. (31 by 34 feet). The lower section of nine steps is in three parallel flights (Plate 247). The treads of the central flight are convex, while those of the side flights, separated off by balustrades, are straight. The three lowest steps of the central flight are wider and higher

than those above them; they lie like concentric oval slabs on the floor of the ricetto, the lowest step surging outwards. At the ninth step the three flights unite in a landing for the top section of the staircase. The convex tenth step lies on the landing in the same way as the lowest step does on the floor of the ricetto.

The room in which the staircase is housed, almost perfectly square in plan, is just as unusual as the staircase itself. Its extraordinary height (about 14·6 m. or 44 feet) is a result of the alteration in the plan mentioned above, after Michelangelo's proposal to use skylights for the lighting of the ricetto was rejected. For the middle storey of the three, Michelangelo had projected paired columns from the start. The columns stand in narrow recesses in the wall; in the bays between the paired columns there are deep oblong niches with projecting pediments, while the panels above are ornamented with flat, blind frames (Plate 246). The strangeness of this articulation consists in the fact that the wall is not treated as a plane. The sections of the wall that frame the paired columns project so far that they appear as three-dimensional blocks. On the narrow sides of the recesses there are pilasters corresponding to the columns.

Each of the four walls is crowded with six free-standing columns and three massive wall-bays. The space seems to be bounded by three-dimensional elements, and not by a continuous wall. The shell of wall behind these members is so thin that it can just be made out on the plan; in actual fact the timber roof intended for the ceiling was not to have rested on the outer walls, but on the paired columns. In the third storey, which was added after the revision of the scheme, the system of the main storey is reduced to two dimensions; paired pilasters stand over the columns, and square frames over the recesses. While the play of forces in the main storey stands out clearly, it can only be read off in the third storey in its projection on the wall-plane.

The richly modelled main storey stands on the much plainer walls of the lowest, which contains the staircase and the entrance door. The low doorway is flanked by huge volutes which stand out from the wall under the columns and belong to the middle rather than to the lowest storey. In the same way as in the New Sacristy, the rising walls seem inconceivably high to the visitor standing in the lowest storey; he cannot conceive a rational relationship between them and his own height. The bases of the paired columns stand above the level of the staircase, and their capitals far above the lintel of the reading-room door. Thus still greater prominence is given to the columns of the middle storey, whose unbroken verticals control the whole effect of the room, while the horizontal cornices, with their many projections, hardly affect the general impression at all.

The verticals of the walls are in contrast with the horizontal strata of the steps. But even in the staircase the beholder seems to be faced by superhuman forces. The width of the steps increases from the top downwards, so that to anyone descending the staircase it seems to be flowing out into the room, while to anyone mounting it, the lowest steps seem to be flowing towards him. The dramatically agitated, rounded and weighty forms which characterize the staircase bear the imprint of Michelangelo's latest style, while the articulation of the walls goes back to an earlier phase. The walls were approaching completion when Michelangelo left Florence in 1534.

The contrast between the high anteroom and the long reading room was not intended at the start. In the first designs there is an order of paired columns on the walls of the reading room too. It was only after the change of plan which involved the heightening of the ricetto that Michelangelo decided on the quieter system of pilasters and the cornice without projections for the reading room. The motif of the paired columns was confined to the ricetto, and so gave it a far greater expressive force.

Even contemporaries realized that the composition and details of the Laurenziana were a revolutionary breach with tradition. That is true not only of its formal vocabulary. If the spatial organization of the ricetto seems oppressive, steep, and overpowering, if the columns look as if they were wedged into the wall, it is because the architecture is meant to awaken definite emotions in the observer. In his sonnets, Michelangelo has expressed his vision of the figure imprisoned in the block, which the sculptor liberates. Similar ideas find visual expression in the relationship between wall and column in the structure of the Laurenziana. The dramatic force of the stairway, which has been described so often, is one of these innovations. Bramante's open-air stairway in front of the Belvedere exedra in the Vatican led to no destination outside its own concentric steps (Figures 50 and 51). In the ricetto stairway the lower treads swell outwards while the upper ones seem to draw the observer irresistibly upwards into the reading room by the force of their own diminuendo. Another characteristic feature is the transformation of the traditional aedicule motif in the middle storey of the ricetto; the framing pilasters broaden upwards, so that the wider upper part of the frame looks heavier than the narrower lower part. The divergence between this slant of the frames and the vertical edges of the wall again awakens a feeling of a huge weight cramped in space.

We have already seen a similar emotional appeal in the architectural forms of Giulio Romano's Palazzo del Te, which was built at the same time. Giulio Romano leaves the observer uncertain whether the building is still under construction or already in decay. His bizarre ideas are meant to nonplus the observer in the same way as 'black humour' does. But for Michelangelo the forces working in the stones are a parable of the tragedy of human life.

Like Giulio Romano, Michelangelo adopts the formal vocabulary of Bramante and Raphael, but the new meaning he gives it can only be understood when it is compared with its prototype, the classical model. Thus the motif of paired columns had already made its appearance in the Palazzo Caprini; but unlike Bramante's beautiful balance between horizontals and verticals and between two storeys which, for all their differences of form, are equally weighty, the horizontal members in the ricetto are formally so weak that the paired columns of the main storey dominate the whole room.

In classical architecture, the column is the image of the harmonious balance of forces created by the architect. There are reasons why it often appears in illustrations to treatises in anthropomorphic form. Like man, it can be represented as a free-standing organism independent of its surroundings. The columns of the ricetto can hardly be comprehended as independent individuals if only because they are paired. Although they stand free of the wall, they give such a strong impression of a vertical scaffolding that they

could be compared with Gothic piers. Finally, by their height and position in the wall, they achieve a dramatic expressiveness which is quite unclassic.

ROME

The Medici Pope Clement VII died not long after Michelangelo settled in Rome. His successor, Pope Paul III Farnese, entrusted to Michelangelo during his pontificate the most important building schemes Rome had to offer.

In December 1537 Michelangelo was awarded Roman citizenship on the Capitol. A month later work was begun on the rearrangement and reconstruction of the Capitoline buildings after the transferral there of the equestrian statue of Marcus Aurelius from the Lateran by papal order. Michelangelo was to continue work on the Capitol till his death. Although it was not completed till the seventeenth century, the piazza with its three palazzi must be regarded as the most important town-planning scheme in Rome during the sixteenth century, and Michelangelo's most important work in the field of secular architecture.

In 1546, after the death of Michelangelo's younger contemporary, Antonio da Sangallo, who had kept his position as domestic architect to the Farnese after the elevation of Paul III, Michelangelo took over the superintendence of the Palazzo Farnese and the office of architect-in-chief of St Peter's. Work on St Peter's had been in progress since 1506, and on the Palazzo Farnese since about 1516. Michelangelo altered both buildings, and he largely defined their present shape. The dome of St Peter's, which was executed for the most part after his design, stands as a magnificent witness to the renewed strength of the Catholic Church after the troubles of the Reformation. It dominates the view of Rome and was the model for countless other domes *urbis et orbis*.

The Capitol

Since medieval times, the seat of the city government of Rome had been in the Piazza del Campidoglio, the square which had been formed after the decay of the ancient temples in the shallow depression between the two knolls of the Mons Capitolinus.[5] The east side of the piazza was occupied by the castellated Palazzo del Senatore, the nominal head of the city administration. On the north side was the long flank of the Gothic church of the Franciscans, S. Maria in Aracoeli. Facing it was the fifteenth-century Palazzo dei Conservatori, with the offices of the guilds in the ground floor. A steep path led down into the city from the open west side.

Michelangelo altered the façades of the Senatore and Conservatori palazzi, but left the palazzi themselves in their original place. Further, by 'duplicating' the Palazzo dei Conservatori on the north side, he reduced the size of the piazza and eliminated the church from the general view.

The development of the plans for the rebuilding of the Capitol has never been satisfactorily elucidated. In the sources, Michelangelo's name does not appear till 1539,

when the statue of Marcus Aurelius was put in place and a retaining wall built below S. Maria in Aracoeli. In 1544 a three-bay loggia and a flight of steps were added to the transept of the church; in that way the church, which was also used for the official religious services of the city authorities, was provided with a new approach from the piazza. Soon afterwards, the double stairway in front of the Palazzo del Senatore was begun; in 1550–3 a three-bay loggia and stairway were added beside the Palazzo dei Conservatori (Plate 249). This system of three great stairways is obviously executed after a uniform scheme which may have existed when Michelangelo set the equestrian statue in its place. It is likely, though not proved, that this plan already provided for the alterations to the two palazzi.

The last stage of building, which gave the piazza the form we see today, was begun in 1561, three years, that is, before Michelangelo's death, when Pope Pius IV had earmarked considerable funds for the purpose and ordered a thoroughgoing restoration of the Palazzo del Senatore. The base and placement of the Marcus Aurelius statue were again changed, the balustrade along the west side of the piazza was built, and the new façade of the Palazzo dei Conservatori begun in 1563. A patrician friend of Michelangelo's, Tommaso dei Cavalieri, was put in charge of the work on the Palazzo del Senatore, and the working drawings for the Palazzo dei Conservatori were made by the architect Guidetto Guidetti 'in accordance with Michelangelo's instructions'. The works commissioned by Pius IV were certainly based on a comprehensive plan by Michelangelo. It is probably this scheme which has come down to us in Étienne Dupérac's engravings (Plate 250), which were published after Michelangelo's death. They show the Capitol 'quod S P Q R impensa ad Michaelis Angeli Buonaroti eximii architecti exemplar in antiquum decus restitui posse videtur'. The engravings, of course, can hardly be taken as an exact reproduction of a drawing by Michelangelo's own hand; so far as we know, he never embodied his ideas in a definitive design for any of his buildings. Dupérac certainly tried to combine the recognizable parts of the as yet unfinished buildings with what he knew or conjectured about Michelangelo's intentions. He obviously rendered correctly the outstanding features of the project.

The simplest explanation of the discrepancies between the engravings and the actual buildings (Plate 251) is that Michelangelo's successors had to fill in the gaps according to their own judgement. Dupérac's engraving was probably the authority for the parts built later.

The façade of the Palazzo dei Conservatori was completed in 1584, that of the Palazzo del Senatore about 1600. The executant architect was Giacomo della Porta. The old tower of the Palazzo del Senatore was damaged by lightning in 1577 and re-erected in its present place by Martino Lunghi in 1583, in the same place as in Michelangelo's plan but not to his design. In the same years Porta completed his work on the *cordonata*, the ramp leading up to the piazza, with its balustrade. The building called the Palazzo Nuovo, the 'duplicate' of the Palazzo dei Conservatori, was not built till the seventeenth century, between 1603 and 1654.

It is in the palazzi on the Campidoglio that the so-called giant order made its first appearance in Roman Renaissance secular building. The eight great pilasters of the two-

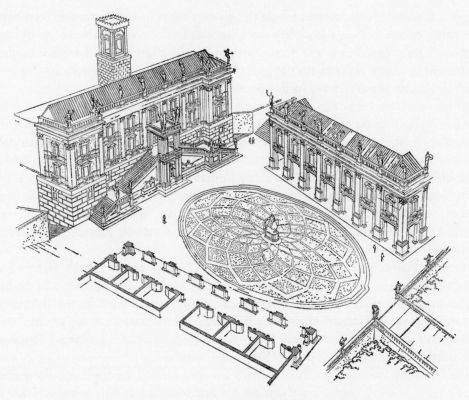

Figure 82. Rome, Capitoline Hill, angled view and plan

storey Palazzo dei Conservatori rise to bear the main cornice irrespective of the horizontal division behind them. The columns and cornices of the ground-floor loggias form a subsidiary system to the primary one. Michelangelo's giant order provides a solution both simple and radical to a problem which had preoccupied architects since the time of Alberti, namely how to combine the antique system of columns or pilasters and cornices with the division of storeys in a modern palazzo, with its windows and string courses, in such a way that the vertical members rising from the ground would be able to support the cornice, as they do in classical architecture.

As the plan shows (Figure 82), the pilasters are the fronts of piers whose intervals correspond to the sequence of the ground-floor rooms. The partition walls between the rooms combine with the piers to form a uniform system of load-bearing walls which recalls the framework of modern concrete buildings. The construction was so stable that it enabled Michelangelo to provide the ground-floor loggia with a flat stone ceiling and to dispense with arches and vaulting. The ceiling over each bay is supported by four columns, two on the façade, and two in the rear wall of the loggia. These columns with the partition walls of the adjoining rooms form the 'skeleton' of the ground floor. Yet each bay of the loggia is a practically independent structural unit inserted into the giant order. The functions of the greater and lesser orders can be read off on the façade itself. The pilasters and crowning cornice lie in the foremost plane of the wall, the strips

of piers appearing left and right beside the giant pilasters in an intermediate one, while the string course of the ground floor and the wall of the piano nobile are in the rear. There are no projections in the main cornice over the pilasters; on the other hand the cornice of the lesser order clasps the pier-strips at the side of the pilasters. At this point the pier absorbs the architrave of the ground floor.

In the same way as in the reading room of the Laurenziana, the material employed for the supporting members differs from that of the non-bearing walls. For pilasters, columns, cornices, and pier-strips travertine is employed, for the rest fine brickwork, so that instead of the harsh contrast of dark grey members and white surfaces so characteristic of Florence, there is the softer Roman contrast of light grey and brick red.

In the three-storey Palazzo del Senatore, Michelangelo treated the ground floor as the rusticated base for the giant order.[6] The pilasters of the latter form a kind of screen to the older building, which is largely preserved behind the façade; they have no structural function.

The double-ramped stairway leading up to the piano nobile rises in front of the ground floor, so that it does not cut across the great pilasters. The stairway and the high placement of the giant order are an expression of the status of the Palazzo del Senatore. It towers above the façades of the side buildings, which 'stand on the ground'. The visitor who approaches the Capitol from the cordonata faces the equestrian statue and sees behind it the high portal of the Palazzo del Senatore.[7]

On plan, the fronts of the Palazzo dei Conservatori and its duplicate, the Palazzo Nuovo, are at acute angles with that of the Senatore and at obtuse angles with the cordonata balustrade. Thus the piazza is trapezoid in plan, a result of the preservation of the frontages of the two old buildings. But the strict symmetry of the twin palazzi, which is, together with the giant order, the real innovation in the scheme, makes the observer first perceive the piazza as a rectangle. As Dupérac's engravings show, Michelangelo's plan for the palazzi had provided for three concentric rings of oval steps leading down to the middle of the piazza; the pavement surrounded by the oval was to have had a stellate pattern radiating from the base of Marcus Aurelius's statue. Owing to the combination of the oval and trapezium, the spandrels in the corners of the latter give the illusion of being of equal size, which means that the trapezium is seen as a rect-angle. Further, since the longitudinal axis of the oval is at right angles to the Palazzo del Senatore and the balustrade of the cordonata, the observer simply assumes that the transverse axis too meets the fronts of the side palazzi at right angles; hence the latter look parallel. Thus the oval ornament of the pavement makes the observer overlook the 'irregular' trapezoidal form and see the piazza as a regular figure, i.e. as a rectangle.[8]

The ornament of the pavement has another and immediately visible function. The great oval, which contains the oval base of the statue, and the lines of the ornament radiating from and sweeping back to it, make the statue look far bigger than it is. This illusory magnification is a characteristic of Michelangelo the sculptor. By 'monu-mentalizing' the scale of the statue, i.e. by adapting it to the scale of the surrounding buildings, the statue of the Roman emperor becomes the real theme of the architectural composition. Moreover, the numerous other statues associated with the project, such

as the river-gods of the stairway of the Palazzo del Senatore or the figures on the balustrade, become integral parts of the scheme.

In the history of town planning, Michelangelo's reconstruction of the Capitol occupies a place of its own. Its situation on the historic hill in the centre of ancient Rome was unique; it could find a parallel nowhere else. The piazza has no definite antecedents[9] and has found no successors. The Piazzetta in Venice and the Campidoglio are among the most beautiful and the most splendid examples of the characteristically Italian municipal square spreading in front of the town hall. Each of these piazze is bounded by relatively uniform façades; it is, in fact, a kind of 'piazza-salone'. The ancient statue of the Emperor became the model for all the equestrian figures which were erected as symbols of absolutist power in the open squares of European capital cities from the late sixteenth century to the nineteenth.

The Palazzo Farnese

Michelangelo's share in the Palazzo Farnese has been discussed in an earlier chapter. When he took charge of the building in 1546, the rear wing of the court was just begun; in the façade wing of the piano nobile a few rooms to the right of the central axis were ready for occupation. Michelangelo left unaltered Sangallo's Ionic order of the loggia on the court side, but the entablature was heightened and decorated by a frieze with garlands, masks, and fleurs-de-lis. The heightening of the entablature made it possible to raise also the vault of the loggia, which thus springs from an unusually high level (Plate 252). The result is the spacious, hall-like corridor in front of the state rooms of the palazzo, which find their climax in the great salone. The present size of the salone was probably already defined by Sangallo, but its pavement and ceiling were only completed around 1550. The room has five windows on the main and three on the side façades, and its height corresponds to two storeys of the façade; thus the windows of the third storey are the openings of the clerestory of the salone.[10]

Michelangelo also designed the crowning cornice of the façade and the top storey of the court (Plates 211 and 212). His work on the Palazzo Farnese has been recorded in contemporary engravings. A view of the recently completed façade with the piazza in front of it was published by Lafreri in 1549 (Plate 213). The engraving shows, in the pavement of the piazza, a large chequered pattern, with the width of its square fields corresponding to the bays of the façade. We know that houses standing on the site of the present piazza were acquired by the Farnese before 1549. Thus the layout and size of the piazza are closely related to the building itself. The geometrical pattern in the engraving would have given the piazza a clear and definite scale governed by the architecture; it is as much a part of the architectural composition as the oval ornament in the pavement of the Campidoglio. Thus the engraving may illustrate an unexecuted design for the pavement of the Piazza Farnese by Michelangelo. The same is true of a project for the rear wing of the court which is reproduced in an engraving dated 1560 and ascribed to Michelangelo himself (Plate 253). This project was to open the piano nobile in the rear wing as a loggia. According to Vasari, Michelangelo had planned a

bridge to unite the gardens behind the palazzo with the Farnesina gardens on the other side of the Tiber, which were rented by the Farnese at the time. Just as the piazza in front of the palazzo was to play its part in the architectural composition, the open space behind it was to enter into the architectural whole. The purpose of the three-bay loggia was on the one hand to reveal to the spectator standing on the piano nobile in the façade range a view over the river and gardens, and on the other to make the court visible from the gardens. It is characteristic of Michelangelo that only the piano nobile was to be provided with open arcades and that the top floor, which is articulated by pilasters and windows, was not. If the observer standing in the court has the feeling that he is in a room entirely enclosed by walls, that is due to a great extent to the shape of the floor of the court.[11]

St Peter's

When Michelangelo succeeded Sangallo as architect-in-chief of St Peter's in 1546, he embarked on a task which, to many of his contemporaries, seemed beyond human powers.[12] The administration of the Fabbrica of St Peter's took it for granted that the building would be continued at enormous expense in accordance with the model made by Sangallo in 1539–43 (Figure 52c). It must have been a shock to them when Michelangelo, immediately upon taking up office, had two models made which presented a totally different design. It was only by the support of the Pope that he was able to get his scheme accepted. For that matter, even the successors of Paul III always took Michelangelo's part in his clashes with the officials of the Fabbrica. Since he refused in advance any payment for his work, his position was invested with a very high moral prestige. Eventually he received 50 ducats a month, but the payment was made by the papal treasury rather than the Fabbrica. Thus he was free from pressure by petty officials.

Michelangelo solved the structural problems which had proved insoluble to his predecessors. He promoted building operations with such unswerving resolution that at his death the completion of the building could be regarded as certain. When he died in 1564, the south arm of the cross was finished, in the north arm only a part of the vaulting was incomplete, and there was little work left to do on the drum of the dome. The north and south arms built by Michelangelo form the transept of the present church.[13] The west arm of the cross, the present chancel, was built in the late sixteenth century after the demolition of the Rossellino–Bramante choir; in accordance with Michelangelo's project, it is identical in plan and elevation with the other two arms.[14]

Sources for the evolution of Michelangelo's project and the progress of work during his term of office are his own sketches, documents, accounts, and many views of the unfinished building, as well as three engravings by Dupérac which appeared soon after Michelangelo's death and reproduce the plan, section, and elevation of St Peter's (Plates 254 and 255). The interpretation of these sources is still to a certain extent controversial. As in the case of the Capitol, Michelangelo left no definitive and binding model. Dupérac's engravings show the north and south arms of the cross as executed

by Michelangelo; the attic is shown after its alteration under Michelangelo's immediate successors. There is no doubt that Dupérac's reproduction of the west arm corresponds to Michelangelo's intentions. Contradictions in the drawing of the eastern façade, on the other hand, make it probable that no definite plans for this part had been made when Michelangelo died.[15]

The first thing to strike one in comparing Michelangelo's plan with the plans of his predecessors is the strengthening throughout of the outer walls (Figures 52D and 83). This is a result of the radical simplification of the structural system. The four great piers of the dome are not surrounded, as they were, by a host of rather confusing subsidiary chapels, but by the square of the outer walls, from which only the apses of the arms of the cross project. The ambulatories of the arms of the cross as well as the campanili have been eliminated, the arms shortened, and the eight 'counter-piers' which receive the sideways thrust of the dome merged with the outer walls (Plate 257).

When Michelangelo declared that he had restored Bramante's plan,[16] that can only be taken literally in so far as the dome, like that of Bramante, was to rise above the intersection of a Greek cross with tunnel-vaulted arms terminating in apses. What Michelangelo did not adopt was Bramante's system of minor domes, which, in their structural function and spatial multiplicity, definitely recall antique thermae. The balanced grouping of minor domes and campanili, of higher and lower chapels, was incompatible with his goal of simplicity in structure and unity in the whole. The outer walls were now raised to the same height all round and were articulated by the same paired giant Corinthian pilasters which Bramante had designed for the piers of the dome in the interior (Plate 256). The attic over the main cornice was also carried round the

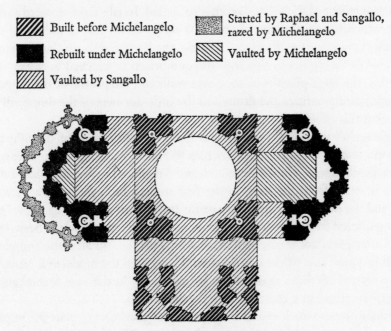

Figure 83. Rome, St Peter's, construction 1506–64

whole building, and it conceals the vaulting of the arms of the cross. A pedimented portico was to be added to the east arm of the cross as a façade; its columns were to be of the same height as the pilasters articulating the walls and the pediment would have risen only slightly above the attic.

The perfect concord between interior and exterior is a definite innovation in the design. The articulation of the outer walls is identical with that of the walls bounding the interior. The true 'façade' of the building is actually its whole exterior. Michelangelo restored Bramante's purely centralized plan, since his own would have presented the same view on all sides. The entrance portico would hardly have interrupted the continuity of the exterior walls.

In 1558–61 Michelangelo had a wooden model made for the main dome which has been preserved (Plate 258). The dome itself was erected by Giacomo della Porta in 1588–91 (Plate 259). Like the dome projected by Michelangelo, it is double-shelled, but it is steeper than Michelangelo's hemisphere and slightly pointed.[17] Since Porta altered the outer shell of Michelangelo's model in the same sense, Dupérac's engravings, which show the model before this alteration and in its relation to the building as a whole, reproduce Michelangelo's ideas better than the model itself and the finished dome.

In its hemispherical form – though not in its structure – Michelangelo's dome is reminiscent of the Pantheon and of Bramante's project of 1506 (Figure 53 and Plate 258). Like Bramante's, it rises above a colonnaded drum. But in Michelangelo's dome, the columns of the drum are paired and flank the windows instead of screening them. To the eye the rhythmic sequence of paired columns and windows looks like a continuation of the paired pilaster motif of the outer walls. While the verticals dominate the drum, the hemisphere of the cupola gives the impression of a resting form in which the upward movement of the verticals comes to an end. Its ribs taper upward and lead to the point at which the foot of the lantern cuts across them. Just as the dome rests on the horizontal cornices of the drum and its attic, the lantern rests on the horizontal ring of the summit of the dome. In this way an equilibrium is achieved between verticals and horizontals; the huge pilasters of the outer walls and the profile of the dome, as well as the festoons on the attic of the drum and the little dormers of the dome, all play a role in achieving this effect.

Michelangelo's model of 1558–61 was the product of years of thought and experiment. Soon after taking up office he wrote to Florence asking for the measurements of the Brunelleschi dome. Unlike Bramante and Sangallo, he obviously had a double-shell structure in mind from the start. In the first studies, both shells have a steep 'Gothic' outline, and the early drawings for the drum and lantern recall the cathedral of Florence. It can be gathered from Dupérac's engravings that the ratio of height between the dome and the lantern was not finally settled till after 1561, i.e. till after the completion of the model. It is typical that Michelangelo should have used the model as a 'visual reference' and have revised his plans again at the last moment; in this case formal and structural considerations stood in a close reciprocal relationship.

The minor domes which appear in Dupérac's engravings are quite incompatible, both in outline and detail, with Michelangelo's style. The formal vocabulary points to

Vignola, who was Michelangelo's successor at St Peter's. Various attempts have been made to explain the discrepancy. It is not unlikely that Michelangelo meant to omit the minor domes; in that case what Dupérac reproduced was one of Vignola's new and personal ideas.[18] On the other hand, the possibility that Michelangelo had planned minor domes, but left no designs for them, must be taken into account. In that case, Vignola would have 'completed' Michelangelo's design for Dupérac.[19]

The minor domes which were executed were designed by Porta; the northern one was erected shortly before the main dome, the southern one soon after. They are not substantially different from the design shown in the engravings, but the profile is steeper, the drum and ribs have vigorously projecting outlines, and instead of the insignificant lantern Porta copied Michelangelo's lantern on the New Sacristy of S. Lorenzo.

The main dome of St Peter's is sustained by Bramante's piers (Plate 163), and, as Bramante intended, it dominates the exterior view of the church. Michelangelo devised the practical methods by which Bramante's ideas were realized, and it is due to him that the ring of walls enclosing the interior was merged with the dome in one artistic whole, within which the individual members have a perfectly clear structural and aesthetic function. The mutual response between the paired pilasters thrusting up from the ground and the mighty entablature is found again in the interlacing of verticals and horizontals in the attic of the drum. This polarity of upward-soaring and supporting members at rest finds its ultimate expression in the dome. The steeper, taller outline of Porta's outer shell makes the completed dome rather lighter and the verticals rising to the dome rather more pronounced than Michelangelo had intended, yet the dome we see today is so far in accord with Michelangelo's ideas that we may contemplate it as his work.

Late Architectural Projects

In 1559 Duke Cosimo I of Tuscany applied to Michelangelo for designs for the church of the Florentine colony in Rome – the building begun under Leo X had never risen above its foundations.[20] A wooden model was made after the design selected by the Duke which has come down to us in two engravings and several copies of drawings. Preliminary studies by Michelangelo's own hand have also been preserved (Plate 260). These projects had no influence on the present church, which was built under the supervision of Giacomo della Porta.[21]

Michelangelo's final project (Plate 261 and Figure 84) provided for a circular domed area surrounded by eight lower vestibules and chapels, alternately rectilinear and oval.[22] The plan looks like a conglomeration of eight huge wall sections whose inner faces, each set with paired columns, form the cylinder under the dome; from them emerge the walls surrounding the subsidiary chapels and vestibules. The oddly amorphous shape of the piers of the dome is due to the configuration of the enclosed space. The conception of the design does not originate in the 'positive' form of the piers, but in the 'negative' form of the space, the angular shape of the vestibules and choir, and the oval of the diagonal chapels.

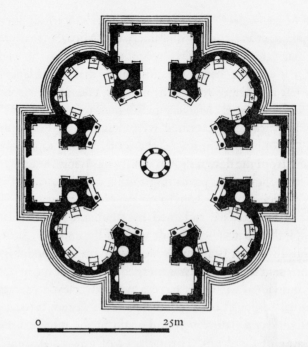

0 25m

Figure 84. Michelangelo: Final project for S. Giovanni dei Fiorentini, Rome

The eight subsidiary chambers are not connected with each other, but are only open towards the centre in eight arches, which are equal in height but not in width. Broad arches in the main bays lead to the vestibules and choir; those of the oval chapels in the diagonals are narrower.[23]

While the conception of the interior is founded on space, that of the exterior proceeds from the plastic volume of the building. The hemisphere of the dome rises above a ring of walls of alternately rectilinear and curved outlines. The rectilinear vestibules and the choir project rather farther to the outside than the oval chapels of the diagonals; thus the exterior view resembles centrally planned buildings of the Greek cross type. The articulation consists only of plain Tuscan pilasters; the attic and the drum of the dome are not articulated. The dome is closely akin to that of the Pantheon. The profile is semicircular, there are steps at its base, and the shell is uninterruptedly smooth.[24]

The memorial chapel of the Sforza in S. Maria Maggiore, begun about 1560 and consecrated in 1573, is the only building in which Michelangelo was able to realize his late conception of space (Figure 85).[25] The measurements are unusually large for this type; height, width, and depth measure about 18 m. (60 feet) each.[26] These proportions would have been ideally suitable for a square or a cross-shaped plan with a dome over the crossing. But Michelangelo brings the 'crossing' forward, close to the wall of the aisle of the church, with which it is connected by a narrow and short tunnel-vault. The transepts of the chapel have vaulted apses; in plan their walls are noticeably flattened segments of a circle which adjoin the *outer* side of the crossing piers (Plate 263). The fourth arm of the cross, which houses the altar, is rectangular in plan, and the

258

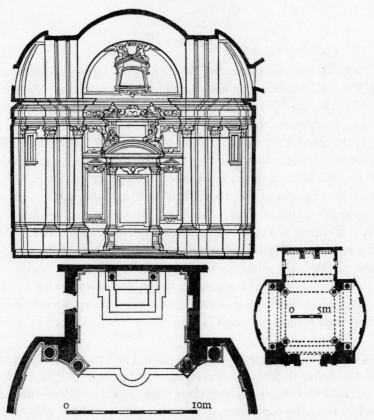

Figure 85. Michelangelo: Rome, S. Maria Maggiore, Sforza Chapel, c. 1560–1573,
section, plan, and detail of plan

width of the tunnel-vault is greater than its depth. Free-standing columns are set in front of the diagonal faces of the crossing piers. The vault over the crossing looks like a swelling sail. Between the narrow springers of the arches and the capitals of the columns, huge impost blocks are inserted (Plate 264). Their mouldings are continued in a flattened form round the walls.

The architecture of the time provides no analogy to the seemingly random curve of the crossing vault and the apses; they discourage geometrical definition. These curves are not determined by the geometrical form of wall-planes or arches, but by the enclosed space, by the configuration of the volume bounded by walls and arches. One element of the 'content' of this space consists in the travertine columns, 9.5 m. (30 feet) high, which stand free in the space like monuments.[27] The monochrome of the walls, the markedly low relief of their articulations, the abundant light streaming from high windows,[28] the peculiarly smooth transitions between the sections of the vaulting – these are all means which help to bring home to the observer the sculptural quality of the space. As the plan shows, that interior is extended as far as the available area allows; at the same time the flattened segmental curves of the apses and vaulting convey to the observer the impression that the shallow shapes of the walls and arches define the available space with the greatest possible economy.

The Porta Pia

The Porta Pia (Plate 262) is named after Pope Pius IV (1559–65); it stands at the end of the present Via XX Settembre, an ancient traffic artery which the Pope had widened and levelled (Figure 92).[29] Michelangelo's name appears in the agreement concluded with a building contractor for the gate; according to Vasari, the Pope had selected the least costly of the three designs submitted by Michelangelo. After the deaths of Michelangelo and the Pope, work was still in progress. In their present form, the outer face and the attic of the gate date from the nineteenth century; we cannot gain from Michelangelo's drawings any idea of the attic he had designed himself.[30]

Michelangelo's preliminary studies, which are only concerned with the frame of the passageway, derive from the type of the aedicule portal. In the execution, the passageway is the central bay of a three-bay front, its high relief standing out against the smooth brick planes at the sides. The straight lintel bending into obtuse angles at the corners is spanned by a flattened lunette after the fashion of a relieving arch; the cornice above it, supported by the framing pilasters of the passageway, is spanned in its turn by a broken segmental pediment, which is again crowned by a much broader triangular pediment.

The treatment of the detail is equally compressed and unusual. The vertical flutings of the pilasters rise beside the horizontal strata of the passageway jambs; the segmental pediment rolls inwards into volutes. A garland hangs on these volutes with the ponderous marble block bearing the papal inscription floating above it. The cornice and capitals are represented by plain blocks. However difficult the analysis and description of these forms may be, it would be a great mistake to regard them as mere improvisation on Michelangelo's part. As the many drawings show, they are the fully ripened fruit of precise preliminary studies. They are, of course, quite alien to the classical orders: in detail and composition they could not be more personal.

In the distant view from the city, the accumulation of heavy, shadow-casting forms leads the eye to the pediment group over the passageway. On the other hand, the passageway itself, when one walks through it, seems oppressively cramped and low in comparison with the height and weight of the pediment. The preliminary drawings themselves show the contrast between a cramped opening and a strong and weighty frame which can be seen in the doorways of the New Sacristy.

S. Maria degli Angeli

Pius IV also commissioned Michelangelo to convert the tepidarium of the Baths of Diocletian into a church. The interior (Plate 266), which is about 59 m. long, 24 m. wide, and 30 m. high (194 by 79 by 99 feet), is unique in one respect, namely that the ancient vaulting and the eight granite columns, 14 m. (46 feet) high, which support the vaulting, have remained unaltered.

The initiator of the enterprise was a Sicilian priest who, as early as 1541, had

conceived the idea of converting the great hall in the centre of the vast remains of the baths into a church to be consecrated to the Virgin and the Angels.

In a papal bull dated 1561, Pius IV assumed the responsibility for the building. The church was to contain the Pope's tomb, and the adjacent buildings were ceded to the Carthusian Order for the erection of a monastery.[31] The name of the new church, S. Maria degli Angeli, tallies with the Christian name of the Pope, Giovan Angelo; moreover the thermae were situated on the Strada Pia, which leads to the Porta Pia.

It was already noted with surprise in a contemporary account that Michelangelo placed the high altar on the transverse, not the longitudinal, axis of the great hall, so that the hall seems to be the transept of the church. The square rooms in front of the short sides and the rotunda opposite the new chancel were converted into vestibules and provided with porches. In this way it was possible to reduce the rebuilding to the insertion of partition walls and the construction of the lengthy chancel of the Carthusians. The high altar in front of the chancel was flanked by two free-standing columns, so that the chancel was practically cut off from the hall.

In the eighteenth century the church was renovated in a Late Baroque style: new columns were set up at the entrance to the chancel and between the hall and the vestibule, the portals of the short sides were replaced by large altars, and polychrome ornament was applied to the walls. Further, an ornate stucco entablature was carried round the hall. Michelangelo's spatial organization remained practically unaltered, but the impression the church makes on the visitor of today is not the one he intended. The walls and vault were originally stuccoed in white, and the only note of colour was struck by the reddish granite of the eight giant columns standing in front of the walls.

As in the Sforza Chapel and the plans for S. Giovanni dei Fiorentini (Plates 260–1 and 263–5), Michelangelo obviously conceived the interior space as the true aesthetic subject of his design. He abandoned decoration and colour just as consistently as he relegated the chancel and vestibule to subordinate chapels which are of no importance in the spatial picture. Free of additions and coloured ornament, the shape of the great hall was to stand out in 'white' purity. The fenestration plays its part too. The round vestibule is illuminated only by the lantern, the chancel windows are few and small, but the eight great ancient openings of the clerestory remained practically unaltered.[32] The subsidiary rooms are shadowy, but the huge hall is flooded with daylight falling from above.

Michelangelo's remodelling is far removed from any attempt at an archaeological restoration of the interior of the hall. He probably knew perfectly well that antique interiors – even those of the thermae – were decorated with polychrome stucco or marble: the brightness and variety of the Baroque decoration of S. Maria degli Angeli approximated far more closely to the original state of the tepidarium than the austere monochrome of the sixteenth-century church.

*

In spite of all their differences, the designs for S. Giovanni dei Fiorentini, the Sforza Chapel, and S. Maria degli Angeli show that interest in spatial configuration which is characteristic of Michelangelo's late architectural works. These unique spaces have no

true forerunners or successors in the Cinquecento. Their plans are no longer combinations of simple geometrical forms – the square, polygon, semicircle, Greek cross. The curve of the apses of the Sforza Chapel consists of a random segment of a circle; in plan, the diagonal chapels of S. Giovanni dei Fiorentini are in the new elliptical shape first used by Peruzzi; the contours of the dome piers of S. Giovanni elude any kind of geometrical definition.

The monochrome of these interiors was an essential part of their particular quality. It has been preserved in the Sforza Chapel, and there is documentary evidence of it for S. Maria degli Angeli; in St Peter's and S. Giovanni it can be deduced from the reproductions of Michelangelo's designs.

The motif of columns standing free in front of the wall appears in unprecedented monumentality in the 'column monuments' in the Sforza Chapel. In S. Maria degli Angeli extant antique columns were used by Michelangelo in a similar way. The motif recurs in the columns of the loggias of the Capitoline palazzi. Free-standing columns appear in the preliminary studies for the Porta Pia as an alternative to the pilasters which were eventually executed.

Since Vasari, what has been regarded as characteristic of Michelangelo's work lies in the unconventionally novel and quite personal forms. Whether that is praise or blame will depend on the critic's outlook. Michelangelo's 'licences' arise from his independent approach to the commission in hand; they are not arbitrary, but the expression of his disregard of traditional schemes and the traditional apparatus of form. Michelangelo's architectural projects are never visionary – on the contrary, they take full account of the client's wishes and local conditions. Works left unfinished at his death, such as the dome of St Peter's or the Capitol, were finished practically as Michelangelo had conceived them, less from respect for the 'divino' than because Michelangelo's design was regarded as the best solution of the task in hand.

ROME 1550–1600

THE PERIOD FROM 1550 TO 1575

IN comparison with Brunelleschi, for instance, Michelangelo devised no new types; his buildings are so extraordinary in their dimensions, or bear so unmistakably the imprint of his hand, that no newcomer could fall heir to his style. In the works of the generation of Roman architects which succeeded Michelangelo, his influence is mainly traceable in the decorative detail. For the most part, however, that generation continued the heritage of Raphael, Peruzzi, and especially of Antonio da Sangallo the Younger.[1]

That also applies to the two architects who succeeded to the superintendence of the work on St Peter's after Michelangelo's death. Pirro Ligorio and Jacopo Vignola had been engaged on papal buildings before; they had also worked for the two great cardinals whose architectural enterprises during the pontificates of the period surpassed those of the Curia in size and importance. Ligorio's Villa d'Este at Tivoli and Vignola's Palazzo Farnese at Caprarola are princely country seats in every sense of the term. In the age of dawning absolutism the type of villa which had developed in the late Quattrocento, and which had already achieved monumentality in the Villa Madama, became indispensable as a complement of the city residence. The development culminates, of course, in Versailles, the country residence of the French kings. Like the great palazzi in the city, the country houses were planned to accommodate the large retinue of the owners who dwelt there during the summer months and who used them as the stage for receptions and other festivities. The fortifications which were essential down to the early sixteenth century, even for papal residences, could now be dispensed with; they were replaced by spreading gardens and ornamental fountains.

In Rome itself, a number of cardinals built summer residences in the second half of the sixteenth century, and their size and importance can be judged by the seventeenth- and eighteenth-century plans of Rome. The only one still standing is the present Villa Medici, begun by Cardinal Ricci. The Farnese Gardens on the Forum and the Palatine succumbed to the archaeological excavations of the nineteenth and twentieth centuries. The Villa d'Este on the Quirinal hill was incorporated in the new papal palace about 1600. As a rule, the villas were secluded from the streets by high walls; their main fronts – in museum-like fashion decorated with antique reliefs and statues – faced the gardens (Plates 267 and 270). Antique statues stood at the intersections of garden paths, and the whole complex included grottoes, fountains, waterfalls, and quickset mazes.

Pirro Ligorio

Pirro Ligorio's architectural work – he was born about 1510 at Naples and died in 1583 at Ferrara – has not yet been fully investigated.[2] He began work as a painter. Paul IV, himself a native of Naples, appointed him Surveyor of the Works at the Vatican Palace, an office which he retained under Pius IV. He was obliged to resign his appointment as architect-in-chief of St Peter's after a year's work, since, as Vasari relates, he had not kept strictly to Michelangelo's plans. After 1565, Ligorio seems to have been employed only by the house of Este, till 1567 in Rome and later at Ferrara.

Ligorio was a dedicated antiquarian, epigraphist, and excavator, and his detailed compilations are one of our main sources for the knowledge and interpretation of antiquity in the sixteenth century. There is a flavour of nineteenth-century historicism about his own buildings, since what he aimed at was a 'scientifically accurate' reproduction of antique architecture.[3]

It is from that point of view that his remodelling of the Belvedere Court in the Vatican must be understood (Plates 152–5 and Figure 49). Work on Bramante's project, which, after the Sack of Rome, was restricted to the maintenance of what was left standing, progressed vigorously under Julius III and Pius IV. In the upper court, the exedra was reduced in size by the insertion of a corridor and given an upper storey. Bramante's round staircase, the radius of which was calculated for the original form of the exedra, was removed and replaced by a double stairway with straight steps planned by Michelangelo. Under Pius IV a semi-domical vault, known as the Nicchione, was built over the exedra. Further, the west wing of the upper court was built and all the façades were coated with stucco. An inscription running round the whole records the achievements of Pius IV.[4]

In the lower court, the steps to the upper terrace, already planned by Bramante, were executed, and the west wing begun.[5] The insertion of semicircular steps on the narrow side under the Stanze provided seats for an arena for open-air tournaments; an engraving of 1565 shows the ceremonial opening of this arena on the occasion of the wedding of one of the Pope's nieces.

Ligorio had published in 1553 a small volume, *Antichità di Roma*, describing the construction of antique circuses. With its surrounding buildings, the Belvedere Court too became a 'circus' with exedrae on both sides. The wall behind the theatre steps of the lower court was to be enriched by a lavish decoration of statuary *alla antica*. The stucco on the façades of the upper court is also in keeping with antique practice, when brickwork was entirely coated with stucco.[6]

Further, Ligorio began for Paul IV a small villa on a rise in the Vatican gardens which is known as the Casino di Pio IV (Plate 269 and Figures 49 and 86). On the whole, the structure and decoration are pretty well preserved; no other building gives so clear an idea of the peculiar character of the Roman villa in the Cinquecento.[7]

At the centre of the complex is an oval courtyard (Plate 271); the surrounding wall is interrupted on the narrow sides by the small gatehouses through which the visitor

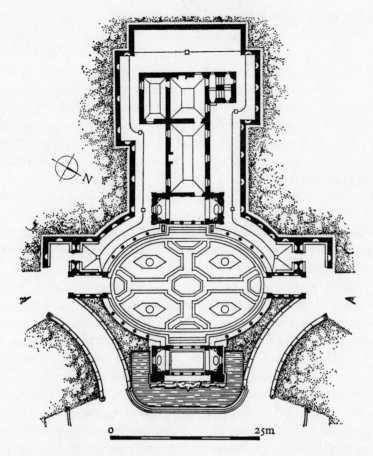

Figure 86. Pirro Ligorio: Rome, Vatican, Casino di Pio IV, begun 1559, plan

enters the villa, and on the long sides by architraved loggias. The loggia on the uphill side serves as a vestibule to the actual two-storey Casino; the lower loggia opposite, a one-storeyed hall, has a tall, pedimented attic. The façades over the two loggias look like pages out of a picture-book (Plate 270). Instead of an articulation by pilasters and half-columns, the walls are covered with reliefs, inscriptions, escutcheons, statuary, aedicules, and festoons. Ligorio probably found the model for this decoration in buildings of the early Empire. In his compilations there are records of diggings he made at Hadrian's Villa at Tivoli, which show that he was familiar with many buildings which are no longer extant.

In his design for the Casino, Ligorio may also have had in mind Pliny the Younger's famous letter with the description of his villa, Laurentina. That can be seen not only in the elimination of monumental exteriors and the turning of the main fronts to the court, but also, and especially, in the oval shape of the courtyard itself.[8] Finally, there are reminiscences of antiquity in the materials employed, the lavish use of tessellation, the costly marble columns, and the stucco coating of the brickwork. The profuse stucco and fresco ornament in the interior, on which Federigo Barocci, Santi di Tito, and Taddeo

265

Zuccari collaborated, comprises secular themes treated *alla antica* and religious subjects.

In Rome, Pius IV's Casino is the most important example of those antiquarian trends which we have already seen in Raphael's Palazzo Branconio dall'Aquila and Peruzzi's cortile of the Palazzo Massimo. Ligorio harks back to the poetic and formal tradition of antiquity in the same way as Raphael in his designs for the Villa Madama, but while Raphael assimilated the heritage of antiquity in his own masterly fashion, Ligorio's villa looks like a book of quotations in which antique forms are reproduced with a maximum of accuracy. The result is an engaging curio. Further, a comparison with the Villa Madama shows the Casino as an example of the closer-knit, compacter formal idiom of the middle of the century.

A second summer seat on which Ligorio worked is the Villa d'Este at Tivoli, already mentioned. Unlike the small Vatican Casino, it is a building of considerable size. The main emphasis lies on the fountains and the gardens rather than on the actual architectural forms (Plate 268). The villa was under construction from about 1565 until the death of the client, Ippolito d'Este, in 1572.[9]

Dupérac's famous engraving of 1573 shows the whole group in bird's-eye view. At the top of the hill stands the Cardinal's palazzo; below it, on the slope and in the flat land further down, are the gardens, divided by a central walk into nearly identical halves. Zigzag paths lead up from the garden beds to the terrace in front of the palazzo. The slope with its terrace looks like a great ornamental pattern composed of lozenge-shaped parts, and the many and various fountains which are the glory of the villa are embedded in the geometry of the gardens. The first impression the visitor was meant to receive as he moved along the paths was indeed that of a geometrical pattern; the paths led to the grottoes, which contained mythological, dynastic, or heroic scenes. The antique torsos of the Este collection were 'restored', i.e. adapted to this programme, and placed in the grottoes. The best known example of programmatic architecture is the so-called Rometta (Plate 272), which appears in the top right-hand corner of the Dupérac engraving. It is a representation of the ancient city of Rome, with a miniature Tiber flowing round an island. The figure of Rome enthroned in the centre of a group of ruins has a counterpart in the large, seated figure of the Tiburtine Sibyl in the 'Fontana di Tivoli'; in the 'Fontana di Aniene' there is a reclining figure of the near-by river Aniene from which the water for the entire villa is drawn.

The architectural setting of the fountains and grottoes is rusticated throughout. The pavement is pebble-mosaic, and the walls are encrusted with 'sponge-stone', the calcareous deposit of the streams flowing in the neighbourhood of Tivoli. There are also rusticated fountains in the cryptoporticus, the lowest storey of the palazzo. At every point there is a deliberate fusion of art and nature.

No clear idea of Ligorio's part in the work on the villa can be gained from the documentary sources, but his employment as the antiquarian of the house of Este, the learned programme, and the stylistic kinship with Pius IV's Casino leave little room for doubt that he was the originator of the design of the villa. He had greater freedom to work on a generous scale here than in the Casino of Pius IV or the Vatican Court, where he was bound by pre-existing parts of the building.

Geometrical gardens with labyrinths and zigzag paths, rusticated grottoes and fountains are recorded in Rome and Florence as early as the first half of the sixteenth century;[10] the importance of the Villa d'Este lies in the fact that the entire repertory typical of the villa in the later sixteenth century has here been realized for the first time on a large scale and to an overall plan. Though considerably impaired, the iconographical and architectural programme has been preserved to the present day, in spite of later changes including the removal of the antique sculpture and the romantic decay of the villa.[11]

The villa, as a new type, was less dependent on traditional usage and established requirements than churches and palazzi, so that the personality of the architect and his patron had greater freedom of expression. Apart from Michelangelo, there is hardly a more personal design in Cinquecento architecture than that of Pius IV's Casino. Ligorio's wilfulness, as Vasari hints, was the reason for his dismissal from his work on St Peter's, and therefore, in all probability, for his removal to Ferrara. His extremely personal style was not very well suited to monumental building.

Vignola

The monumental buildings left unfinished by Michelangelo were not continued by Ligorio, but by Vignola, who was appointed to St Peter's at the same time as Ligorio in 1564, though at first at only half Ligorio's salary. Giacomo Barozzi (1507–73), generally known as Vignola from his birthplace near Bologna, was probably brought to Rome by the younger Cardinal Alessandro Farnese. In all probability it was the patronage of that powerful cardinal that finally brought him to St Peter's and the Capitoline palazzi. Unlike Ligorio, in whose work decoration is more important than structure, Vignola kept strictly to traditional standards and elements of architectural composition. His formal repertory continues the Sangallo tradition. His Emilian origin is traceable only in a few decorative details.

Vignola's treatise on the five orders, published in 1562 and repeatedly reprinted and translated, became the vademecum of the architects of the seventeenth and eighteenth centuries. As long as columns and pilasters remained essential features of the more monumental kind of building, Vignola's *Regola*, in its simplicity and precision, was indispensable, and it came to the end of its usefulness only when stone was ousted by the new building materials – iron, glass, and concrete.

The *Regola delle Cinque Ordini* is not a treatise in the sense of Vitruvius and Alberti. Except for a short introduction, the book contains only thirty-two plates with explanatory captions. Each order is illustrated by four to six plates; each plate shows two columns with their architraves. These plates are followed by illustrations of pillared arcades with half-columns of the respective order and details of the bases, capitals, and mouldings. The unit of measurement is given by a *modulo*: in the actual work of building, all that had to be determined was the ratio between the *modulo* and the local unit of measurement.

As Vignola explains in his foreword, he had, after an exhaustive study of ancient

buildings, selected the proportions 'which are generally regarded as most beautiful and most pleasing to the eye'. He goes on to say that his plates are patterns for the working architect. In the large engravings, details stand out clearly, while the rough woodcuts in Serlio's treatise, which had appeared twenty years earlier, were of little use to the practising architect. The success of Vignola's book shows that the *Regola* fulfilled a need. In the second half of the sixteenth century, a standardization took place of the very forms illustrated in the *Cinque Ordini*. While the architects of the late Quattrocento and early Cinquecento drew single capitals or architraves and varied them in their own practice, later in the century certain examples, such as Bramante's capitals in St Peter's, were accepted as the rule and copied again and again.[12]

Vignola, like many other Renaissance architects, began as a painter. In 1538 and 1539 he received payments for work in the Vatican. In 1541 Paul III appointed him architect of S. Petronio in Bologna,[13] but he was not able to take up the appointment till 1543, since from 1541 to 1543 he was at work with his fellow-countryman Primaticcio at Fontainebleau on casting bronze figures of the antique statuary in the Vatican from plaster moulds. Vignola's seven years' term on S. Petronio has left little trace on the building; on the other hand, two designs for the façade have been preserved which, like Peruzzi's drawings, made twenty years before, are an odd mixture of Gothic and Renaissance forms. The façade was never built since the building commission could come to no decision on any of the large number of designs submitted.[14]

His first biographer, Egnatio Danti, writes that Vignola did work on the Palazzo Bocchi in Bologna. An engraving dated 1545 probably shows the design for the façade which was begun in that year (Plate 274). The rusticated basement and the window frames of the ground floor recall the Palazzo del Te at Mantua; bizarre details such as the busts over the mezzanine windows, the inscriptions on the basement, and the metopes under the balustrade may have been inspired by ideas of the patron, a famous humanist who wished to turn his house into the seat of an academy. The portal and the top storey have been copied almost literally from an illustration in Serlio's treatise. The ornamental tops of the mezzanine windows are to be found in later designs by Vignola, and are a characteristic feature of his work.[15]

With its rusticated window-surrounds and the rusticated blocks through which the columns of the portal rise, the façade of Vignola's first Roman building, the Palazzina of Julius III's villa (Plates 273 and 275), recalls the Palazzo Bocchi. The articulation of the centre of the façade is an innovation; its three bays are composed in the guise of a triumphal arch and executed in freestone, so that this part of the front stands out in higher relief than the flat brick walls at the sides.

The villa is situated outside the city walls, and it is this situation which explains both the reminiscences of fortified buildings and the triumphal arch motif of the façade. The portal – the only entrance – leads into a walled papal enclosure (Figure 87) and is thus similar to the Vatican. There is nothing of the kind in Roman architecture about 1550, though there are details reminiscent of Giulio Romano and of Serlio's treatise. The façade as a whole is a novel and thoroughly considered solution of the commission in hand.

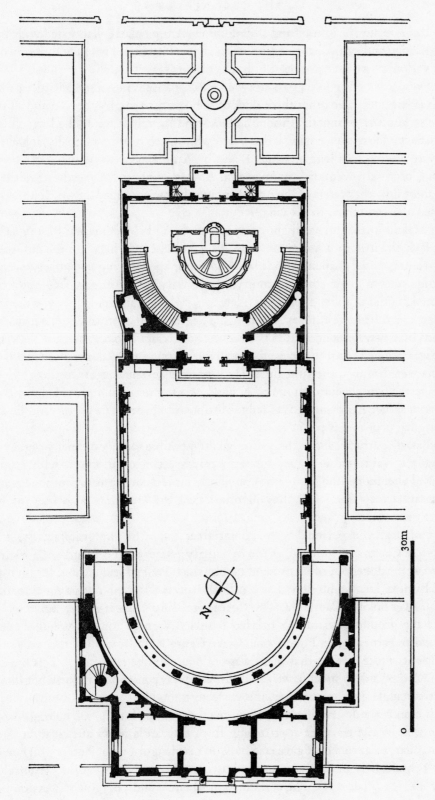

Figure 87. Giacomo Barozzi da Vignola: Rome, Villa di Papa Giulio, begun 1551, plan

As Vasari relates, he himself and Bartolommeo Ammannati collaborated with Vignola on the design and construction of the villa. The architectural history and the attribution of its various parts have not been fully elucidated.[16]

The vestibule of Vignola's two-storeyed Palazzina leads into a semicircular courtyard loggia (Plate 276). The other three sides of the court are single-storeyed and obviously in the style of Ammannati. Antique statues stand in the niches of the long sides. The façade facing the entrance wing is decorated with stucco reliefs; originally, it had a small doorway leading to a loggia, which is also by Ammannati and which looks down on a lower, profusely decorated nymphaeum. At that point, at the very heart of the complex, there flow the waters of the Aqua Vergine, the ancient aqueduct which Julius III had restored and conducted to his villa.[17]

Pope Giulio's villa can hardly be compared to the Villa Madama and Pius IV's Casino, since it is situated in a valley and not on a hillside. Yet here too the differences in level are an essential element in the plan. The visitor approaching from the two-storeyed Palazzina enters a single-storeyed courtyard. It is only from Ammannati's loggia that he first catches sight of the nymphaeum (Plate 277), which is situated far below the level of the first court. Its lowest storey, the Fontana Segreta of the Aqua Vergine, can only be reached by stairways concealed in the walls. The account books show that this arrangement was planned from the start; the earthworks round the Palazzina and the Fontana Segreta were begun at the same time. The semicircular stairway leading down from the loggia to the nymphaeum, on the other hand, was not originally provided for, as many *pentimenti* show. Ammannati was only called in after work had begun, and he altered the original plan at this point.

As Vasari's narrative hints, the patron was responsible for a good many of the details. Certainly it was not always easy for the working architects to fall in with Julius III's proposed alterations: the Pontiff was obviously far less concerned about the breaks and the unsatisfactory transitions they involved than the architects who had to alter or restrict their plans.

Vignola's artistic personality found far freer range of expression in the Palazzo Farnese at Caprarola. Situated in the hereditary estates of the Farnese, Caprarola belonged to the dukedom of Castro and Nepi, which Paul III had created for his son Pier Luigi Farnese. During his period as Cardinal, Paul had started a pentagonal fortress on the hill overlooking Caprarola. The Rocca, probably a single-storey building, determined the ground plan of the palazzo built by Vignola for the younger Cardinal Alessandro Farnese, the Pope's grandson (Figure 88). It was of this palazzo that Montaigne wrote in 1581 that there was nothing else like it in Italy. 'This building is surrounded by a deep moat hewn out of the tufa; it is pentagonal in form but looks like a pure rectangle. Inside, however, it is perfectly round.'[18]

This is an exact description of the unusual form of the building. The multi-storeyed façade seen by the traveller approaching from Caprarola looks at first sight like that of a 'regular' palazzo, i.e. of a palazzo built on a rectangular plan (Plate 278). The circular court ('inside it is perfectly round'), however, gives the polygon a 'regular' form in the interior (Plate 279). The combination of circle and polygon appears more than

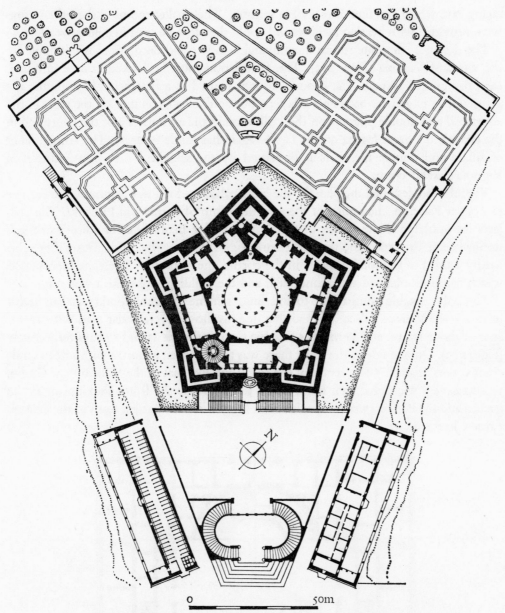

Figure 88. Giacomo Barozzi da Vignola: Caprarola, Palazzo Farnese, begun 1559, plan

once in the plan: in one corner of the pentagon is the famous round staircase (Plate 280), in the corresponding angle the round chapel. The difficulties presented by this unusual plan have all been mastered with elegance and restraint. But what most aroused the admiration of contemporaries was the skilful disposition and arrangement of the rooms, not the lavishness of the frescoes on the ground floor and the piano nobile. Thus, for instance, visitors driving in through the basement storey can alight and walk directly to the round staircase; a circular driveway under the court brings the carriage back to the entrance. On the piano nobile, the five central bays of the façade form an open loggia

271

facing east, which was therefore cool in summer. The smaller rooms in the other wings were provided with heating facilities and could therefore be used in colder weather.

The design of the state rooms, incomparable in size and decoration, is undoubtedly the work of Vignola (Plate 281). The articulation must be looked at as a uniform, carefully graded system. The ground floor is treated as a basement throughout; the piano nobile in general has single pilasters, but double half-columns on the piers in the courtyard and double pilasters on the walls around the ambulatory of the court and in the chapel; the great loggia on the façade again has single pilasters. The arrangement of single and double members is governed by the scheme b – a – b, a leitmotif in Vignola's architecture.

Vignola also designed the plan for the huge palazzo which was begun by the Farnese in 1558 at Piacenza, the capital of the new dukedom of Parma and Piacenza. The projects far outstripped the means of the dynasty; after many interruptions, work was stopped soon after 1600 and the court removed to Parma. The finished part represents hardly a third of the total project; in the cortile, the impressive freestone incrustation which had been planned was abandoned, and the building looks like a vast ruin.

The only possible comparison to this huge scheme in contemporary Italian architecture is the Vatican Palace. The existing designs show a rectangular plan with frontages of about 111 m. and 88 m. (335 and 190 feet), and with 23 and 17 bays respectively (Figure 89). On one side of the court there was to have been a theatre with fifteen semi-circular tiers of seats.[19] The centre of the city front, like that of the Villa di Papa Giulio, was to have a triumphal arch motif and a tower, while the fronts looking on to the garden and the Po were provided with open loggias like the garden front of the Palazzo Farnese in Rome.

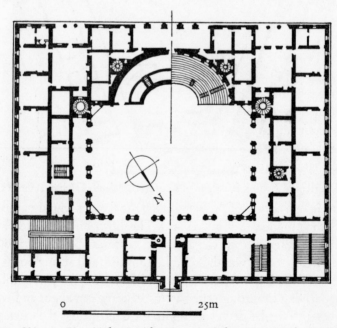

0 25m

Figure 89. Giacomo Barozzi da Vignola: Piacenza, Palazzo Farnese, begun 1558, plan

The scheme recalls that of the Vatican in so far as it combines elements of the palazzo, fortress, and villa. A moat was planned in front of the city façade with a drawbridge leading up to the main portal. On the garden front, on the other hand, with its loggias, there was to be no trace of fortification. The Villa Madama was the model for the theatre in the court; the articulation of the court arcades repeats the motif of the Upper Belvedere Court.

The palazzo at Piacenza was commissioned by Margaret of Parma, the natural daughter of Charles V and the wife of Duke Ottavio Farnese. At almost the same time, in 1561, Margaret's step-brother, Philip II, conceived the idea of the Escorial. Both buildings stand witness to the ambitions of the house of Habsburg. Francesco Paciotto, the fortifications architect, who had competed with Vignola for the commission, later made projects for the Escorial. It is therefore not by chance that the Escorial has a number of typological and formal elements in common with the great scheme for Piacenza.[20]

On one of his journeys to Parma and Piacenza, Vignola probably designed the Portico dei Banchi in the city of Bologna, where he had worked earlier (Plate 282). The portico, one of the great achievements of urban architecture in sixteenth-century Italy, is almost as important for the general view of the main piazza of Bologna as Sansovino's Libreria for the Piazzetta in Venice. The narrow side of the piazza opposite the Palazzo del Comune consisted of a number of buildings varying in height and width, with arcades and shops on the ground floors. Vignola faced these *banchi* with a uniform portico-façade harmonizing with the rest of the piazza. The round-arched arcades of the ground-floor loggias and the low mezzanine are framed in Corinthian pilasters. The only articulation of the two upper storeys consists of pilaster strips; the windows have the ornamental tops characteristic of Vignola.[21]

Ecclesiastical Architecture

After the Sack of Rome, religious building in the city, with the exception of the construction of St Peter's, had come to a standstill. Except for some minor confraternity churches, only one religious building of any size was erected in the second quarter of the century, and that was the hospital church of S. Spirito in Sassia,[22] the work of Antonio da Sangallo the Younger, built between 1537 and 1545. S. Spirito is the first Roman example of the flat-roofed single-aisled church with chapels which had been developed in Florence in the late Quattrocento. Sangallo's church had an important influence on the future, since the tendency to broaden the nave as far as possible resulted in fundamentally new spatial forms in the third quarter of the century.

The Roman mother-church of the Jesuit Order, Il Gesù, begun by Vignola in 1568, shows the full development of the type (Figure 90). The tunnel-vaulted nave, nearly 18 m. (60 feet) in width, has four chapels on each side, and the end walls of the transept are aligned with the outer walls of the chapels. The domed crossing is followed by a bay of the same width as the nave and the broad apse.[23]

On entering, the visitor has the impression of a wide and high hall bounded on both sides by huge double pilasters (Plate 284). The tunnel-vault rises above a cornice which

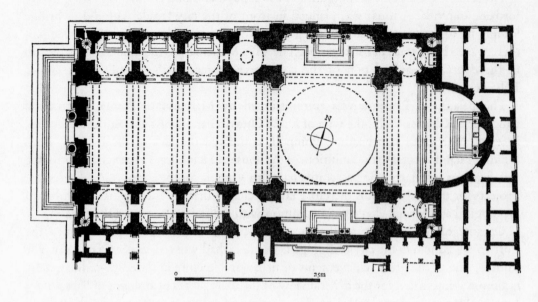

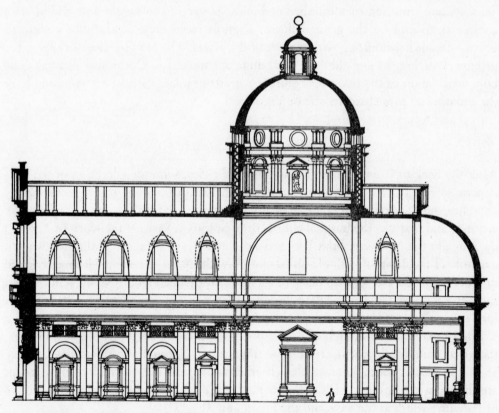

Figure 90. Giacomo Barozzi da Vignola: Rome, Gesù, begun 1568, plan and section

runs continuously from the façade to the piers of the crossing. Between the coupled pilasters, low, round-arched openings lead into the chapels. While the nave is brightly lit from the façade windows and the lunettes of the tunnel-vault, the chapels are comparatively dim. Above them is the gallery, the 'coretti', which are cut off from the nave by gratings.

The comparison between the Gesù and Alberti's S. Andrea at Mantua, which is so often drawn in literature, only holds good up to a point. In S. Andrea, the transverse tunnel-vaults of the chapels act as abutments to the main vault, while in the Gesù the side-thrust of the main tunnel-vault is conducted outwards to buttresses resting on walls between the chapels. Unlike the chapels in S. Andrea, which rise to the height of the crowning cornice, the low, saucer-domed chapels in the Gesù are of no importance for the spatial effect of the nave or for the statics of the vault.

In a church of the importance of the Gesù, a dome over the crossing was indispensable; as far as might be, the diameter of the dome had to be equal to the width of the nave. The plan shows that Vignola fulfilled these requirements by continuing the row of chapels into the piers of the crossing; the four low, narrow chapels in the corners between the transept, nave, and chancel are, as it were, hollowed out of the piers. The result is a simple, clear configuration of various spatial elements; the dome seems to rest on the surrounding walls, and not on three-dimensional piers. At the same time, these small chapels form a convenient passage between the nave and the transept.

The foundation stone of the building was laid on 26 June 1568, after years spent in discussing the situation, size, and shape of the church. Certain details in the history of the plan have never been cleared up. Nanni di Baccio Bigi had submitted a design for the church as early as 1550. In 1554 Michelangelo also was called in. In addition, financial difficulties retarded the beginning of construction. Work started only when Cardinal Alessandro Farnese agreed to make larger contributions in 1568. The Cardinal was enthusiastically in favour of Vignola's plan, which the Order accepted with reluctance. Building was directed by the Jesuit Father Giovanni Tristano, an architectural expert who had already worked on several churches of the Order. It must have come as a surprise when in 1571 the Cardinal decided to have the façade executed after a design by Giacomo della Porta (Plate 286). Several plans submitted by Vignola (Plate 285) must have failed to satisfy him.

When Vignola died in the summer of 1573, the nave, with the two piers of the crossing belonging to it, had risen as far as the crowning cornice. The great tunnel-vault and the façade were finished in 1577. After the purchase of several more plots of land, it was possible to carry on with the building, and the church was consecrated in 1584. Vignola's ground plan certainly remained in force till the church was completed. The vaulting of the nave and the façade, on the other hand, are Porta's work. Porta also directed building operations after 1573; his formal idiom can be recognized particularly in the choir and the dome.

After consultation with the Order, in 1568 the Cardinal wrote to Vignola: 'The church is to have a single nave, not a nave and aisles, and there are to be chapels on both sides'; further, 'the church is to be entirely vaulted over'. The rest he left to Vignola's

judgement. What the Cardinal was actually aiming at was a wide, open space not cluttered up with additions, thereby partaking of a tendency which became general after the middle of the sixteenth century. The same trend can be seen in contemporary churches in Milan, Florence, and Venice. In France and Germany it resulted a little later in the removal of Gothic rood screens and altars from cathedrals. It is only partly true that the Gesù and the Jesuit churches of the seventeenth century were determined by rules laid down by the Council of Trent; it was probably rather the new ideal of a church with a spacious interior clearly bounded but imposing no definite perspectives, which developed about the middle of the sixteenth century, that influenced the ideas of the Council.[24]

In engravings of the early seventeenth century the great tunnel-vault over the nave of the Gesù is stuccoed in plain white and quite unadorned (Plate 283). The grey travertine of the twin pilasters was faced with marble in the nineteenth century. In the middle of the seventeenth century the vault was decorated with the polychrome stucco and frescoes which have made of the Gesù a model of decorative art of the Baroque. On the other hand, the stuccoes and altars of the side chapels, which are in any case hardly visible from the nave, were made at the time of building. Thus, in its original form, the interior corresponded exactly to the ideas and instructions of the Council of Trent. In its monochrome it recalls the Sforza Chapel or Michelangelo's designs for S. Giovanni dei Fiorentini.

While Vignola, in the Gesù, contributed largely to forming the type of the Baroque longitudinal church, he also enriched the conception of the centrally planned church in a way which was to become of prime importance for the architects of the seventeenth and eighteenth centuries: he was the first to create an ecclesiastical building on an oval plan.[25] Even in his first Roman building, the small memorial chapel of S. Andrea in

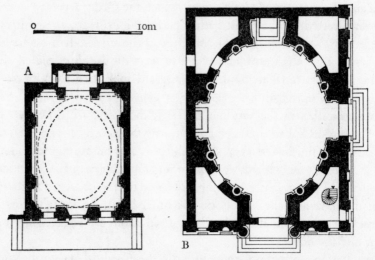

Figure 91. (A) Giacomo Barozzi da Vignola: Rome, S. Andrea in Via Flaminia, 1550–c. 1553, plan of ground floor; (B) Giacomo and Giacinto Barozzi da Vignola: Rome, S. Anna dei Palafrenieri, begun 1565, reconstruction of original plan

Via Flaminia (1550-c. 1553) (Plates 287 and 288 and Figure 91A), which is part of the group of the Villa di Papa Giulio, the rectangular interior is vaulted over by an oval dome. A more thoroughgoing design is the plan, probably dating from 1559, for a chapel for the conclave in the Belvedere Court of the Vatican, which is planned as an oval interior enclosed in a rectangle.[26] In the last ten years of his life Vignola put into practice the *concetto* of a purely oval space in the church of the confraternity of S. Anna dei Palafrenieri (Figures 49 and 91B).[27] Like the chapel of the conclave project, S. Anna is a 'double shell' building, which combines two stereometric figures: an interior oval enclosed in a square sheel of masonry.[28]

As the sixteenth- and seventeenth-century plans of Rome show, S. Anna stood free to the view on three sides. A dome was certainly anticipated in the original project. In the early sixteenth century in Rome these prerequisites would have resulted in a 'regular' centrally planned building, possibly of the same type as S. Eligio degli Orefici, also a confraternity church. The curious form of S. Anna can be explained neither by the function nor by the situation of the building, but only by assuming it to be a specific *concetto* of the architect. Unlike those of Bramante, Vignola's plans do not emerge from the concept of a stereometric structure, conceived as a uniform figure, in which interior and exterior are mutually related; on the contrary the interior is unrelated to the exterior, the space to its shell, and even the articulation to the structure. Similar trends clearly appear in Peruzzi's drawings, but Vignola was the first to turn the *concetto* into reality. In this context there come to mind the varying connections of the circle and polygon at Caprarola.

The interior oval of S. Anna is articulated by eight columns set in the wall (Plate 290). The intercolumnar spaces, where the altars and niches are situated, are wider than those in the diagonals with the low entrances into the subsidiary chapels.[29] Thus in the same way as in the round court of Caprarola, a rhythm of alternating narrow and wide inter-columniations articulates the wall. The main front of S. Anna (Plate 289) and the side façade on the via Angelica, a street laid out shortly before the church, have the flat pilasters which are Vignola's trade-mark. The two fronts – they are, after all, the sides of a rectangle – have, in spite of the difference of length, five bays each. The disposition of these bays differs as much as that in the interior. Thus in this centrally planned building, not only is the interior unrelated to the exterior, but the system of the main façade is also unrelated to that of the side façade. In Bramante's plans for St Peter's, in Leonardo da Vinci's designs for centrally planned buildings, or even in S. Maria presso S. Biagio at Montepulciano, on the other hand, 'all parts are equally grouped round one point',[30] and in such a way that 'every individual form seems logically related to all the other elements . . . by its situation in the total plan'.[31]

Vignola's 'invention' had successors in Rome and northern Italy in the sixteenth century. The importance of the oval plan in the work of Bernini and Borromini and in Austrian and German architecture of the seventeenth and eighteenth centuries cannot be taken into consideration here.

THE PERIOD FROM 1575 TO 1600

In the last quarter of the sixteenth century, building activity in Rome rose almost to fever-pitch. The two popes Gregory XIII (1572–85) and Sixtus V (1585–90) were both men of energy and initiative and had at heart the continuation and completion of St Peter's (cf. above, pp. 254–7), of the Gesù, and of the Capitoline palazzi; new wings were added to the Vatican, and in the Belvedere Court Sixtus V built the new library between the lower and upper terraces, which destroyed Bramante's great architectural perspective. With the same ruthlessness, Sixtus V demolished the ancient Lateran Palace and replaced it by a new and dull building. Many of the present main vistas of the city are due to this Pope and the new streets he cut through it (Figure 92) – the via Sistina still bears his name. He set up the obelisks in the Piazza del Popolo and in front of S. Maria

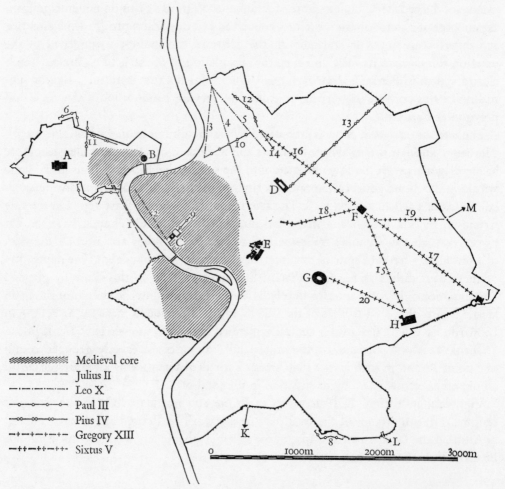

Figure 92. Plan of Rome with streets planned in the sixteenth century (Gerhard Krämer)

278

Maggiore and the new Lateran Palace, and had the obelisk in front of St Peter's removed to its present site. The erection of the obelisks as a *point de vue* at the ends of the new streets and in front of great churches was not purposeless. Their *interpretatio christiana* was part of a programme for the 'restauratio' of Rome in which the political and religious trends of the Counter-Reformation were mingled with a close study of sources and monuments characteristic of the period. Thus a large number of old churches was repaired or renovated; 'confessiones' – imagined to be a feature *more antico*, i.e. as open crypts – were constructed in front of the high altars to house the relics of patron saints;[32] and Sixtus V crowned the columns of Trajan and Marcus Aurelius with figures of St Peter and St Paul.

Giacomo della Porta

In the Roman architecture of the last quarter of the century, the first name that comes to mind is that of Giacomo della Porta (1533?–1602). As 'architetto del popolo romano' he became surveyor of the works on the Capitol after Michelangelo's death. During Vignola's lifetime, Cardinal Alessandro Farnese commissioned Porta to design the façade of the Gesù (Plate 286); he executed the transept, dome, and choir of the church, which was completed in 1584 (Plate 284). In 1573, after Vignola's death, he was appointed architect-in-chief of St Peter's, where he built the mortuary chapel for Gregory XIII and the corresponding one for Clement VIII. Both chapels had been planned in 1569 at the latest, to judge from Dupérac's engravings, to have minor domes, the conception of which probably goes back to Vignola. Finally, after the demolition of the so-called Rossellino–Bramante choir, Porta built the west arm of the crossing[33] and vaulted the main dome in 1588–90.[34] He also succeeded Vignola in the final work on the Palazzo Farnese.

1. Via Lungara
2. Via Giulia
3. Via Ripetta
4. Via del Corso (Via Flaminia)
5. Via Babuino (Via Paolina)
6. Fortifications around Belvedere
7. Fortification Porta S. Spirito-Porta Cavalleggeri
8. Fortification near Porta Ardeatina
9. Piazza Farnese and Via dei Baullari
10. Via Condotti
11. Borgo Angelico
12. Passeggiata di Villa Medici
13. Via Venti Settembre (Strada Pia)
14. Via Gregoriana
15. Via Merulana
16. Via Sistina
17. Via Santa Croce di Gerusalemme
18. Via Panisperna
19. Street linking S. Maria Maggiore and Porta S. Lorenzo
20. Street linking S. Giovanni in Laterano and the Colosseum

A. St Peter's
B. Castel S. Angelo
C. Palazzo Farnese
D. Quirinal Palace
E. Campidoglio and S. Maria in Aracoeli
F. S. Maria Maggiore
G. Colosseum
H. S. Giovanni in Laterano and Lateran Palace
J. S. Croce in Gerusalemme
K. Porta S. Paolo and road to S. Paolo fuori le Mura
L. Porta S. Sebastiano and road to S. Sebastiano fuori le Mura
M. Porta S. Lorenzo and road to S. Lorenzo fuori le Mura

In all these buildings Porta appears as a thoroughly reliable if not very inspired architect, with a brilliant command of the problems of construction and a sympathy for the buildings already begun. He is 'the chief disciple of Michelangelo in the later sixteenth century. On his own, Porta rarely exhibits the grandiose power and magnificence of Michelangelo'.[35] His buildings are marked by a sober monumentality: the detail is less subtle than Vignola's. Porta's model is not to be sought in antiquity; his capitals, portals, and window surrounds are a standardized simplification of Michelangelo's formal idiom at St Peter's and the Capitol.

The comparison between Porta's Gesù façade and Vignola's, which was not executed, but has been preserved in an engraving, is one of the standard tasks in the teaching of architectural history (Plates 285 and 286).[36] Porta's language is by far the blunter. By reducing the number of niches and statues and duplicating all members next to the main portal, he deprived the single members of their individuality. Stepped up both in relief and height, Porta's scheme leads to a climax in the centre bay, where one finds the portal, the emblem of the Jesuits, the double pediment, the large upper window, the shield with the Farnese arms, and finally the Holy Cross.

Vignola had tried to preserve as much as possible the equilibrium of an ancient temple front. Compared with Porta's ponderous double pilasters, Vignola's rhythmic system of niches, portals, and pilasters is far more complex, the interplay of verticals and horizontals subtler, the treatment of the surface richer. Many characteristic elements of Porta's final design already occur in Vignola's various projects for the façade. It was left to the younger architect to accomplish the synthesis of his predecessor's ideas. It is tempting to assume that Vignola's classical training prevented him from reaching this synthesis. By doubling the pediment over the main portal Porta certainly abandoned what may be called the utopia of the ancient temple front applied to the Christian church. The central portal and the window above it receive such a powerful emphasis from their size and framework that the central bay of the façade looks like one vertical unit.

In a similar way, Della Porta stresses the vertical members in the small church of S. Maria ai Monti (Plate 291), which he designed himself, and which was begun in 1580. Its plan is a simplified variant of that of the Gesù: three chapels on each side of the nave, a transept aligned with the chapels, a semicircular apse (Figure 93). It is just because of this similarity that the differences stand out. The entrances to the chapels are framed in single and not in double pilasters as in the Gesù, and these pilasters correspond to projections in the entablature. Owing to these interruptions in the horizontals, the nave is not, as in the Gesù, a uniform hall, but a space with vertical divisions. Moreover, the ratio between the inner length and inner height of the interior is different (Gesù about 8 : 3, S. Maria ai Monti about 2 : 1).

In 1591 the Theatine Order began the building of its own Roman mother church, S. Andrea della Valle, near the Gesù. It took nearly thirty years to complete, but its main elements must have been established from the beginning. Quite early the church was regarded as a rival to the Gesù, and it is in fact related to it in size and type. Father Fabrizio Grimaldi (1543–1613), a native of southern Italy, collaborated with Della Porta

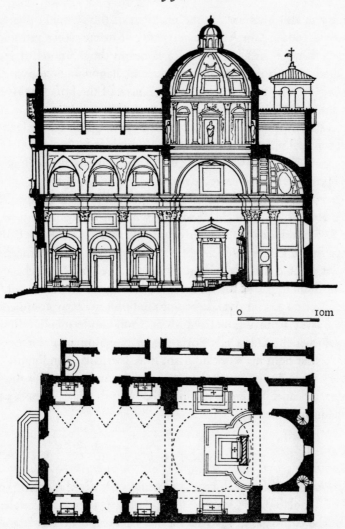

0 10m

Figure 93. Giacomo della Porta: Rome, S. Maria ai Monti, begun 1580, section and plan

in the design; the contribution of Della Porta is proved convincingly not only by the sources but by style.[37] For all its relationship to the Gesù, the interior shows the same tendency to vertical emphasis as S. Maria ai Monti. The pillars resemble those of the Campidoglio façades; the pilasters, again not coupled, have half-pilasters recessed a little on both sides (Plate 292), and these bundled pilasters, which are expressed in a projection in the main architrave, are carried through the vault as transverse arches. The entrances to the chapels rise almost to the height of the architrave, so that their *outer* wall – again in striking contrast to the Gesù – is seen as the actual spatial boundary. The steeper proportions of the dome and choir underline the stressed verticality of the nave. The bearing function of the pillars is emphasized by the grouped pilasters and can be interpreted dynamically; the spacious hall of the Gesù, bounded by a balanced system of double pilasters and an unbroken entablature, can be interpreted statically.

Della Porta was also interested in the problem of the centrally planned church. An unrealized project for the church of the university of Rome shows a rotunda with a comparatively steep dome.[38] In 1582, Della Porta began the memorial church of S. Maria Scala Coeli, next to S. Paolo alle Tre Fontane, an octagon vaulted by a flattened dome, with alternating broader and narrower sides. Three of the broader sides swell out into semicircular apses; the fourth contains the entrance.[39]

More impressive than these centrally planned buildings, in which Della Porta returns to traditional types of plan, is the façade of the church of S. Atanasio dei Greci, founded by Gregory XIII. The two-storeyed front of the nave is flanked by three-storeyed towers. This is the first double-towered façade in Rome, though the idea already appears in the early designs for St Peter's and later in Vignola's projects for the Gesù. The upper parts of the façade of SS. Trinità dei Monti, which is of the same type and was built shortly after S. Atanasio, may also have originated in a design by Della Porta.[40]

Della Porta simplified Vignola's subtle compositions; his system of articulation is more easily intelligible, his decoration 'modern', i.e. rather Michelangelesque than antique, and his buildings lack the speculative element which comes out for example in Vignola's predilection for the oval. It was not only his masterly command of his métier but his turning away from Vignola and his profound understanding for the late works of Michelangelo which made Della Porta the leading Roman architect of the seventies and eighties. At first sight his work does not look particularly individual; his peculiarly 'Roman' style – Della Porta was the only prominent architect of his time to be born in Rome – becomes clear if his œuvre is compared with those of Vignola's followers who worked beside him in the city.

Other Architects

Francesco Capriani da Volterra (c. 1530–1594) and Ottavio Mascarino (1536–1606) may be regarded as Vignola's pupils. In 1565–6 Capriani was active at Guastalla, the residence of a branch of the Gonzaga, in 1570–80 on the Villa d'Este at Tivoli, and subsequently for the Gaetani in Rome.[41] In Volterra's most important Roman work, the hospital church of S. Giacomo degli Incurabili on the Corso,[42] the oval plan appears for the first time in an ecclesiastical building on a large scale (long axis of the oval c. 25·5 m. or 83 feet 8 in., short axis c. 18·7 m., or 61 feet 4 in.) (Figure 94). The side-thrust of the dome covered by a timber roof is borne by volutes. There is no outer shell. In the interior (Plates 293 and 294), the main cornice, as in the Gesù, is broken at both ends of the long axis, i.e. at the entrance and at the choir, by tall arches which reach up into the zone of the vaulting. Thus the long axis is given a marked predominance. The entrances to side chapels are stepped after the fashion of a triumphal arch.

The building differs in many important respects from Volterra's project of 1590, which has been preserved in Stockholm (Plate 295). The double pilasters which, in the drawing, articulated all the piers in the oval interior, are only present in the finished building as a frame for the entrance and the choir; the openings leading to the side chapels are flanked by single pilasters. In this way greater stress is given to the longitudinal axis, the

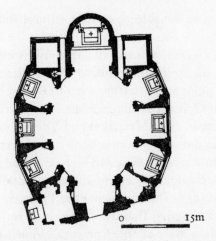

Figure 94. Francesco Capriani da Volterra: Rome,
S. Giacomo degli Incurabili, begun 1592, plan

piers lose some of their plastic force and structural expression, and the rhythm of the wall comes from the grouping of the pilasters. A similar change can be seen in the exterior. Instead of the multiple, somewhat skimpy articulation of the façades of the courtyard in the design there are now unadorned, unarticulated walls; the exterior is merely a shell for the interior. Obviously these changes reflect Volterra's final design; they appear, together with an unexecuted project for the façade, in a drawing of 1595–6 (Plate 296), and they are an open rejection of the 'classical' ideal of identical treatment of the interior and exterior of the building. That ideal is still apparent in Volterra's earlier designs which adopt a large number of details from the famous Bramante project for St Peter's, which had become known through Serlio. The choice of an oval plan for the church is certainly incomprehensible without Vignola's pioneer work, but Volterra first aimed at uniting the new spatial form with piers which were already out of date in the late sixteenth century. He then resolved this incongruity, and, in doing so, created the model for the oval churches of the seventeenth and eighteenth centuries, which were based on the completed building of S. Giacomo.

With the exception of the Palazzo Borghese, which will be considered later, Roman palazzo façades conform to the type of the Palazzo Farnese; the architect's hand can be traced mainly in the details of the portals and window surrounds. A characteristic example may be seen in Volterra's dated design of 1581 for Cardinal Enrico Gaetani's palazzo (Plates 297 and 298), which is distinguished from many other similar buildings by the shape of the balcony over the main entrance.[43] The detailed text to the plan shows the disposition of the various rooms: on the ground floor, on either side of the courtyard, storerooms, the kitchen, the huge chimney, and the hearth; on the façade 'salotti' and 'camere' (living rooms and bedrooms); on the piano nobile the 'sala grande' and the 'galleria' for state receptions. The great hall was to measure 15·5 by 8·7 m. (51 by 29 feet), the gallery, at the time an indispensable part of the palazzo, 14 m. by 6 m. (46 by 20 feet). According to the text accompanying this plan, two nephews of

the Cardinal were to live in the palazzo too; in all probability the second floor was intended for them.

Like his countryman Vignola, a friend of his youth, Ottaviano Mascarino (1536–1606) of Bologna began his career as a painter.[44] Soon after the elevation of Gregory XIII, himself a native of Bologna, Mascarino went to Rome; from 1577 to 1585 he was active on the Vatican and Quirinal buildings as the Pope's architect. According to a remark made by Della Porta in 1593, Mascarino and Volterra were regarded as 'the best architects . . . he makes no distinction between the two of them, and both could be put in the same box and taken out by chance, and there are none better in Rome'.[45]

The Vatican Palace was considerably enlarged during the pontificate of Gregory XIII. On the side of the Cortile di S. Damaso facing the Piazza S. Pietro, the second wing, begun under Pius IV, and adjoining Bramante's loggias at right angles, was completed; the forms of the older wing were adopted practically unaltered (Figure 49). Further, under Gregory XIII the west range of the Belvedere Court was completed after nearly eighty years of building, and a fourth storey added, which Bramante had not planned; it is known to visitors to the Vatican Museum as the Galleria delle Carte Geografiche. For the most part, these enterprises were carried out under Mascarino's supervision. He realized Bramante's ideas in the Belvedere Court just as Della Porta had realized Michelangelo's ideas for the Campidoglio and the dome of St Peter's; the architectural details have been 'modernized' and the rooms arranged in accordance with their new functions, but the basic conception of Bramante's original designs 'never ceased to be the guiding principle . . . it is to the credit rather than to the detriment of Bramante's conception that it excited future generations not only to complete a project that might have remained inchoate, but to find in it the opportunity to express the changing climate of taste and requirements of function'.[46]

In the Quirinal, the summer residence of the popes since Gregory XIII, Mascarino erected the two-storeyed loggia which remains as the north range of the present courtyard (Plate 299). Originally flanked by two flat projections, it was the garden front of a free-standing villa of the Farnesina type: when the complex was enlarged, it was deprived of that function. Towards the end of Gregory XIII's reign it was provided with the towering Belvedere which still crowns the whole Quirinal group. The individual forms of the loggia and the Belvedere are closely connected with those of the façade of Caprarola; even Mascarino's famous oval staircase (Plate 300) is unimaginable without Vignola's circular staircase at Caprarola (Plate 280).[47] Mascarino also adopted Vignola's ideas in several designs for oval churches.[48] It is therefore surprising that two generally reliable seventeenth-century authors should attribute to him one of the most original buildings of his time, the nave of S. Salvatore in Lauro, a nave with four flat chapels on either side, and with a tunnel-vault supported by double columns. The motif of columns standing free in front of the wall probably derives from Michelangelo's church in the Baths of Diocletian. The double columns invest the comparatively small space with a monumentality unequalled in Mascarino's other work.[49]

Another successor of Vignola was Martino Lunghi the Elder, a Lombard (before 1540?–1591). His name first appears in 1568 in the building records of the Dominican

church of S. Croce, founded by Pius V in his birthplace, Bosco Marengo, near Alessandria, and begun in 1566.[50] The plan and elevation of S. Croce have many details in common with Vignola's Roman churches – indeed Vignola, who worked on the Vatican Palace and St Peter's under Pius V, may have collaborated in the designs. It is likely that Lunghi, who had probably been working in Genoa, was first summoned to Bosco Marengo to supervise building operations. The motif of the tripartite lunette window which dominates the façade already appears in Antonio da Sangallo's designs for St Peter's, and is frequent in Vignola's late work.[51] From 1569 Lunghi was active in Rome; in the early years of Gregory XIII's reign he conducted the work on the Vatican and Quirinal, which was taken over in 1577 by Ottaviano Mascarino.

In 1578, the year after its medieval predecessor had been struck by lightning, Lunghi was commissioned to rebuild the tower of the Palazzo del Senatore on the Campidoglio (Figure 82). The most important building on which he worked, however, is the Palazzo Borghese, though it is very difficult to identify his part in it. The main façade (Plate 301) was erected soon after 1560, i.e. about the same time as Caprarola; the client, also a native of Bologna, was a protégé of Cardinal Alessandro Farnese. There are analogies in Vignola's work to the details which diverge from the Roman idiom. The façade is five-storeyed, like that of the Palazzo Farnese at Piacenza (see above, pp. 272–3). The portal, flanked by free-standing columns, tallies with a plate in the *Cinque Ordini* which shows a project by Vignola for the portal of the Cancelleria. The central window is emphasized by a blind arch, flanking pilasters, and pediment. Thus the central axis in both storeys is articulated on its own, as in the Villa di Papa Giulio. It has been suggested that the design for the façade should be attributed to Vignola, and that its weaknesses may be explained by the fact that he did not supervise the execution.[52]

The fame of the Palazzo Borghese is due less to its façade than to its courtyard with the double columns (Plate 302). This motif, which is to be found quite frequently in contemporary Genoese and Lombard architecture, is without precedent in Rome and had few successors there. The account books give no clear indication of whether the double columns were already part of the courtyard side of the façade range, which was begun about 1560, or were only introduced by Lunghi, who took charge of the second stage of building in 1586. The latter seems more probable to me, the more so as the documents of Bosco Marengo show that Lunghi was in touch with Genoa. In any case, Lunghi continued the motif along both side ranges – to that extent, at least, one of the finest courtyards in Rome is his work. The high aesthetic quality of the courtyard is certainly difficult to place in Lunghi's verified work, for instance the façade of S. Girolamo degli Schiavoni.[53]

The one Roman architect of the late sixteenth century who was famous in his lifetime is Domenico Fontana (1543–1607). That fame was admittedly based above all on the removal and re-erection of the obelisk in the Piazza di S. Pietro, an engineering achievement which was admired by experts and the general public alike.[54] But Fontana kept up an uncommonly widespread activity in architecture too. It contributed to his good fortune that Cardinal Felice Peretti, in whose service he was, became, as Sixtus V, the most zealous and energetic patron of architecture of the period, and entrusted his

architectural projects to Fontana. Thus Fontana played a most important part in the three papal palaces, the Vatican, the Quirinal, and the Lateran, the latter a new building constructed to his design (Plate 303). He laid out new streets; together with his brother Giovanni, he conducted to Rome the first new aqueduct it had had since antiquity, and, with the Moses Fountain of the Acqua Felice, gave the city its first monumental water-display. The new Vatican Library in the Belvedere Court (Figure 49 and Plate 304) and the Pope's mausoleum, the Cappella Sistina adjoining S. Maria Maggiore, are his work too.

When Sixtus V died in 1590 not all his plans had been realized,[55] yet what remains of the five years of his pontificate is astounding enough as an achievement both of organization and finance.[56] Even as a cardinal, Sixtus had obviously come to realize Fontana's talent for organization in the building of his Villa Montalto-Peretti.[57] That talent even covered stylistic 'organization'. The time-limits set by the Pope were so narrow that they could be kept to only if the formal vocabulary was standardized and reduced to a small number of types. This is the explanation of the uniform, even monotonous character of this thoroughly derivative and entirely unoriginal architecture, which adopted its types from established models and its articulations from Vignola's Cinque Ordini. Fontana's lack of imagination was admirably suited to the impatience of the Pope, who cared only for efficiency and never took time to consider the slow maturing of an artistic idea.

And yet it would be a mistake to judge the achievement of the client and his architect merely as multa non multum. When the Pope had the small Presepe Chapel in S. Maria Maggiore (since ancient times identified with the crib of Bethlehem) removed to the centre of his mortuary chapel, and the shrine of the Host erected above it, with himself kneeling before the sacrament, he invested the building with a historical and theological significance which cannot be judged by purely architectural standards of criticism. The same may be said of the obelisk brought to Rome by Augustus and erected by Sixtus in front of the choir of S. Maria Maggiore. The inscription records the birth of Christ in the reign of Augustus, the Flight into Egypt, the Pax Augusta, and the crib brought from Bethlehem to Rome, the centre of the ancient and the Christian worlds; thus the cross on the obelisk symbolizes the triumph of Christianity over paganism as well as the manifold relationships between these monuments.[58]

Soon after the Pope's death Fontana went to Naples, where he remained in the viceroy's service till his death. But his Neapolitan designs, for instance the Palazzo Reale, lack the austerity and sober gravity which were peculiar to Sixtus V and his buildings. Fontana's nephew, Carlo Maderno, who took over his work in Rome, had a greater affinity to Della Porta than to his uncle.[59]

NORTHERN ITALY: GENOA, MILAN, AND PIEDMONT

Galeazzo Alessi in Genoa

LIKE Palladio and Vignola, Galeazzo Alessi (1512–72), a native of Perugia, is one of the great architects of the period. His buildings are of a typological and stylistic importance for Genoa and Milan equal to Palladio's palazzi and villas for the Veneto. However, unlike his great contemporaries, Alessi wrote no treatise; this may be one of the reasons why we have no satisfactory account of his *œuvre* and his career.[1]

Alessi's first buildings in Genoa show him in full command of the repertoire of contemporary Roman architecture. S. Maria di Carignano, a centrally planned church situated on a hill commanding a panorama of the city, cannot be imagined without Sangallo's and Michelangelo's projects for St Peter's. The plan of the Villa Cambiaso (1548), with its three-bay loggia flanked by projecting wings, follows a type which originated in all probability with Peruzzi. Alessi's familiarity with Sanmicheli's palazzi at Verona is demonstrated by the superb articulation of the façade (Plate 305): Doric half-columns on the ground floor, fluted Ionic pilasters on the upper storey, the doubling of the pilasters giving the order a forcefulness which is reminiscent of Raphael.[2] The disposition of the interior is no less masterly. The great salone is situated above the entrance loggia and the adjoining vestibule, its vaulting reaching up to the roof, so that the room is also lighted by the upper mezzanine windows. Adjoining the rear of the salone is the loggia of the upper storey, its vaulting supported by two pairs of columns (Plate 306). The walls of the loggia show the same combination of monumental austerity and rich ornament as the façade: the soffits of the arches are covered with ornament, termini fill the spandrels between the arches, and the crowning cornice is outstandingly lavish.

The church of S. Maria di Carignano, planned in 1549, stands on a hill which belonged to the Sauli, and a number of anecdotes show that this church which they founded is to be regarded primarily as a monument raised to their own family.[3] Thus there were no historical and liturgical conditions, as there were in St Peter's, to prevent the realization of an ideal centrally planned church. The founders' wishes coincided perfectly with the architect's ideas. In a letter to his patron, Alessi calls the church 'my first-born creation, and of all my daughters the dearest'.

The square plan (Figure 95), as in Michelangelo's project for St Peter's, encompasses the Greek cross of the main arms and the four chapels in the angles; from outside, the apse, encased in a rectangle of masonry, appears as a projection. The main dome over the crossing is surrounded by four minor domes and two campanili instead of the originally planned four (Plate 309).[4] The tops of the towers reach up as high as the crown of the great dome, while the four minor domes hardly rise above the church roof. The crossing piers are unusually massive (Plate 308); the diameter of the dome is only a little wider

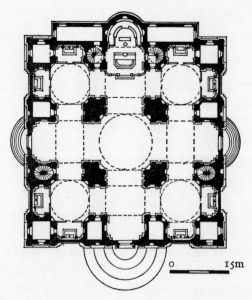

Figure 95. Galeazzo Alessi: Genoa, S. Maria di Carignano, designed 1549, plan

than the arms of the crossing. Here Alessi drew his conclusions from experiences in the building of St Peter's,[5] so that inside the dome looks somewhat cramped; in spite of its height it does not appear to be the centre of the building, but merely a strong vertical accent above the junction of the four arms of the cross. Outside, the arms of the cross are provided with façades; their giant pilasters carry pediments with large lunette windows.

Alessi's strictly classical project was not entirely carried through, even in the execution of the façades, and the lavish sculptural ornament of the seventeenth century finally modified the effect of the original design. All the same, S. Maria di Carignano, along with the churches in Todi and Montepulciano, may be regarded as the finest centrally planned building of the sixteenth century. Like Alessi's other Genoese works, its fame spread far beyond the bounds of Italy, thanks to its inclusion in Rubens's volume of engravings published in 1622 under the title *Palazzi di Genova*.

Although Alessi's activity in Genoa lasted less than ten years,[6] his style had a lasting influence on Genoese architecture. This *stile alessiano* can be identified most clearly in the palazzi in the Strada Nuova, now the via Garibaldi, which according to Vasari was planned by Alessi. This street is the Genoese equivalent to contemporary town-planning enterprises in Venice, Rome, and Bologna.

The Genoese patriciate had lived, from time immemorial, in the crowded districts round the harbour, but the houses, for the most part fortified and cramped, could no longer satisfy the new demand for decorum and comfort. Spanish ceremonial demanded *grandezza* even in the architectural background of life. In 1550 the Doge issued a decree ordering the layout of a new street *in ornamentum civitatis* in a comparatively vacant area at the edge of the old town. A committee of seven patricians supervised the necessary expropriations, demolitions, and ground-levellings. In 1558 the first building sites were sold, the profits going to the renovation of the cathedral and the construction of the

Molo. Between 1558 and 1570 eleven of the fifteen palazzi in the street, which was 225 m. (250 yards) long and 7·5 m. (25 feet) broad, were finished. Originally the street ended at a garden wall. It was therefore not planned as a thoroughfare.[7] All the frontages are aligned along the street (Plate 307); alleys 3.5 m. (12 feet) wide separated each palazzo from its neighbour. Obviously the height as well as the width of the façades was prescribed, and the portals of opposite palazzi had to face each other. However the owners were free to arrange the interiors as they wished – all the palazzi have two main storeys with mezzanines – and there are variations in the placing of the staircases, in the height of the storeys, and in the courtyards; moreover the rise in the land to the rear led to numerous differences in the arrangement of vestibules, courtyard arcades, terraces, and staircases.

For several buildings, the architectural history and the architect are unknown.[8] The street was laid out by Bernardino da Cantone (mentioned between 1537 and 1576), who was employed by the city administration and had also worked under Alessi on S. Maria di Carignano.[9] Other architects mentioned in the sources are the brothers Giovanni and Domenico Ponsello, who had also worked on the church, Giovanni Battista Castello, il Bergamasco, and the brothers Giovanni and Rocco Lurago.[10] Castello's works (c. 1510–1569) are notable for their excellent stucco-work on the façades and vaults.[11] The Palazzo Doria Tursi has always been admired for its imaginative handling of the rise in level behind the façade: a straight flight of steps leads from the vestibule into the long, colonnaded courtyard, and from the back of the courtyard another flight leads to a landing, from which branching flights lead to the loggias of the piano nobile. This plan was later repeated in the famous courtyard of Genoa University.[12]

The function and the special quality of the Strada Nuova emerge best when it is compared with the palazzo façades on the Canal Grande in Venice. In both cases the feudal nobility had created its own adequate expression in architecture. This process, which took several centuries in Venice, was completed by the Genoese nobility in a single resolute act. It seems to me that the whole project was also based on a perfectly conscious artistic conception. In spite of many differences, the two rows of ten façades erected in the first stage of building look like a single composition; for all the many variants, a rational plan stands out clearly, as Vasari, the first to appreciate the Strada Nuova, realized. His attribution of the layout as a whole to Alessi seems thoroughly credible, and it has been restated recently by the leading authority on the subject.[13]

The biggest palazzo designed by Alessi for a Genoese patron stands in the centre of Milan (Figure 96). The client, Tommaso Marino, had acquired a fortune in Milan by banking and tax-farming; in an inscription on a building he calls himself Duke of Terranuova, a title which he had acquired for the huge sum of 300,000 scudi.[14] The size and luxury of this town mansion of a *nouveau riche* are unprecedented among the patriciate of the period: the area it covers approximately equals that of Sixtus V's Lateran Palace in Rome; the three-storey façades (Plate 310) are respectively of seventeen and eleven bays, of a width of 62 m. and 54 m. and a height of 23 m. (203 and 177 feet, 75 feet); the salone, situated between two courtyards, is about 22 m. long and 11 m. wide (72 by 36 feet).[15] The façade has the same 'classical' system of articulation as the

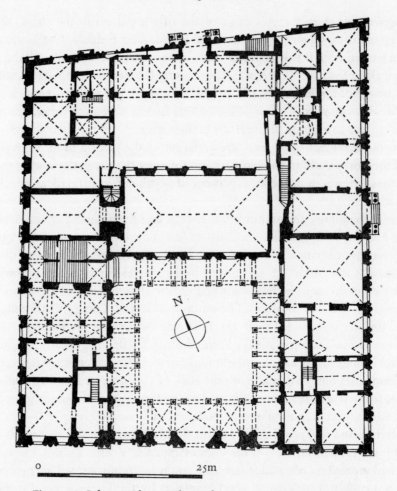

Figure 96. Galeazzo Alessi: Milan, Palazzo Marini, begun 1558, plan

Villa Cambiaso in Genoa, yet in the present case the subordinate elements take on a curious life of their own, so that ornament drowns structure. The window aedicules on the ground floor are squeezed in as an Ionic minor order between the Doric half-columns of the main order. The architrave of the aedicules consists of boldly projecting stones, and the shafts of the columns stick in their blocks. On the piano nobile the pilasters of the window surrounds taper downwards, and the gaps in the broken pediments open on to grotesque human or animal heads which, in their turn, act as brackets for the surrounds of the mezzanine windows. On the top storey the pilasters of the main order taper too, and the flutings, laid on as strips, converge downwards. Further, in place of an orthodox capital there is a ⬜-shaped block at the top of the pilaster, bearing a gigantic head framed by brackets.

Every pair of the twenty-four columns of the courtyard supports an architrave which forms the impost of the round-arched arcade, so that the heavy piers of the upper storey stand on the intercolumnar spaces of the ground floor (Plate 311). The contrast between the profuse ornament of the Ionic piers and the plainness of the

Doric columns is intentional. For the theorist, the Ionic order is feminine, the Doric masculine; accordingly, there are lions' heads on the brackets over the Doric columns, but caryatids in the Ionic upper storey.

The stylistic sources of this 'painterly' architecture are to be found in the work of the Raphael circle, for instance the stuccoed façade of the Palazzo dall'Aquila, the Vatican logge, or again in Giulio Romano's works in Rome and Mantua. In Rome, the painterly trend as it appears in the middle of the century, especially in the work of Pirro Ligorio,[16] yielded to the more austere style of Michelangelo and Vignola. In Lombardy, on the other hand, with its innate love of the lavish decoration of flat surfaces, it flourished. This Lombard delight in ornament may also explain why the anthropomorphization of architectural members (cf. Alessi's termini in the courtyard of the Palazzo Marino) did not remain confined to the decoration of villas and public fountains, as it did in Rome.

Alessi's name appears in the documents of nearly all the important buildings which were in progress in Milan about 1560. His prestige was, in all probability, based on the effect of the Palazzo Marino. Further, Alessi was able to enter into the heritage of the two most important architects active in Milan before his arrival.

Cristoforo Lombardino and Domenico Giunti in Milan

On the death of the last Sforza in 1536, the dukedom of Milan passed into the hands of the Spanish branch of the house of Habsburg. After the political situation had settled down, it became possible to continue building work which had been suspended during the long wars.

In the thirties and forties the most outstanding architect was Cristoforo Lombardi or Lombardino (first mentioned in 1510; d. 1555), who had been active since 1510 as a sculptor, but from 1526 till his death was architect-in-chief of the cathedral.[17] As the building of the cathedral lagged during his term of office, Lombardino had time to take on other commissions, including the preparation of designs for the façade of the Certosa di Pavia and the supervision of their execution.[18] In 1545 he collaborated with Giulio Romano on projects for the façade of S. Petronio at Bologna.[19] In Milan there is verified evidence of his work on the Palazzo Stampa di Soncino[20] and the church of S. Caterina alla Chiusa,[21] now demolished. His work is notable for a surprising classical 'purism', which shows that Lombardino had been in Rome about 1515; it is the same phase of style as can be seen in Giuliano da Sangallo's designs for the façades of S. Lorenzo in Florence and that by Cola dall'Amatrice for S. Bernardino at L'Aquila (cf. above, pp. 186-7). The most impressive Milanese example of this style is the great dome over the centrally planned church of S. Maria della Passione,[22] begun by Battagio in 1489 (Plate 312). The exterior has the high tiburio – in the present case octagonal and two-storeyed – embracing the vaulting which had been traditional in Lombardy since the Middle Ages. The sides of the octagon have Lombardino's characteristic articulation by twin half-columns, round-arched and rectangular niches, and aedicules, and there are traces which show that the remaining surfaces were ornamented by painting. The tiburio, traditional in form but modern in articulation, surrounds an eight-sided domical vault, which is

steeper than is usual in Lombardy. The articulation of the interior of the dome is also an innovation. The angles between the chapels are set with half-columns whose entablature projects. They continue into the drum as wall-strips, and into the vault of the dome as ribs. Thus, unlike older Lombard usage, there is a marked stress on the vertical aspects of the dome. Its curve recalls Sangallo's almost contemporary project for St Peter's, but Lombardino is more consistent than Sangallo, since he omits the coffering of the dome. The decorative scheme of the Pantheon dome is not suited to a domical vault.[23]

From 1533 to 1555 Lombardino worked on S. Maria presso S. Celso, superintending the enlargement of the church by aisles and an ambulatory.[24] At that time the form of the façade, itself enlarged by these additions, must have been discussed too. A sketch in the Victoria and Albert Museum shows a project of the kind which stylistically and chronologically finds its place in Lombardino's œuvre (Plate 313).[25] The façade is treated as a two-storeyed flat portico. For the unusual use of the Corinthian order for the ground floor the project had to conform to the existing Corinthian atrium. The consistent purism with which the scheme of the antique temple front is here transferred to a Christian church can only be paralleled in this period in the work of Palladio.

In 1547 the Viceroy of Milan, Ferrante Gonzaga, acquired the Villa Simonetta, which was situated outside the town gates. Ferrante was conducting a lively correspondence with the humanist Paolo Giovio, who himself possessed a famous villa on Lake Como. After a visit to the Villa Simonetta, Giovio wrote to its owner 'there is a wealth of flowing water there. There are fish-ponds, aviaries, and all kinds of menageries such as Varro and Columella report in ancient times. . . . We have given this lovely place the name nymphaeum, because it is the name given by an ancient Roman to his own estate, which was surrounded with flowering gardens and much water. . . . Master Domenico da Prato will assuredly find a thousand delicious concetti to adorn the place . . . above all he must see that the entrance side looks dignified and stately.'[26]

The architect mentioned here was Domenico Giunti of Prato (1506–60), whom Ferrante Gonzaga had already employed in Sicily and had brought to Milan in 1546.[27] The Simonetta is the only well-known secular building by Giunti (Plate 316). He considerably enlarged the layout of 1547 by building side wings which created a U-shaped forecourt for the old façade. To the ground floor of the courtyard and the narrow sides of the new wings he added a columned loggia; on the top was a terrace which opened a view on to the adjoining fish-ponds, gardens, and service ranges. The original rear became the new façade (Plate 317); it was invested with the 'dignità e pomposa vista' required by Giovio by means of a new three-storeyed portico. The ground floor has round-arched arcades on pillars with Doric half-columns, the piano nobile Tuscan columns and an architrave, the second storey Corinthian columns carrying a timber ceiling.[28]

The owner's delight in country life, the literary culture of his circle, and the skill of a classically trained architect combined to create a work which was no less near to antique models in function and form than the Villa Madama or Pius IV's Casino. Stylistically Giunti's portico façade[29] is closely related to Lombardino's almost contemporary design

for S. Maria presso S. Celso (Plate 313). The Roman analogy to this Milanese classicism is Pirro Ligorio's archaeological style.

Ferrante Gonzaga and his architect played an important part in the general layout of the city. When the fortifications were renovated, the suburbs which had developed outside the medieval walls were incorporated in the city itself. In the centre, the piazza in front of the cathedral was enlarged by the demolition of the old church of S. Tecla. Since the Franciscan monastery of S. Angelo had been sacrificed to the new bastions, the viceroy founded a new building within the walls, which was designed by Giunti and begun in 1552. Work proceeded so rapidly that the new church of S. Angelo could be consecrated as early as 1555.[30] In this case Giunti recast on very original lines the type of the aisleless friary church which was familiar to him from his native Tuscany (Plate 318). The nave is spanned by a tunnel-vault. The partition walls between the chapels are set with fluted Ionic pilasters, and the transept is cut off from the nave by a comparatively low triumphal arch and broad pilasters. An important element in the spatial effect is the illumination by large round windows in the penetrations of the vaulting and the tall clerestory above the cornice. In spite of the long row of chapels, one has an impression of a wide, spacious hall. The transept too has a tunnel-vault, but its axis runs at right angles to that of the nave, so that it becomes an almost independent spatial element, the actual content of which is the high altar – a disposition which is perfectly adapted to the functions of a Minorite church. The transept and choir serve the liturgy, the nave the sermon. As in most Franciscan churches, the exterior is quite plain. The importance of the building lies in the plain, functional, yet novel disposition of the interior, which is not only admirably suited to its purpose, but also modern, since it anticipates certain peculiarities of the Gesù.

In a similar fashion, a traditional theme is reformulated in S. Paolo alle Monache (Plate 320).[31] S. Paolo belongs to the Lombard type of aisleless convent churches in which the congregation is separated from the choir by a high, transverse wall.[32] The attribution of the church to Giunti, suggested by Baroni, is supported by the 'classical', i.e. windowless, wide tunnel-vault, the uninterrupted cornice, and the giant Corinthian half-columns between the shallow chapels. The monumental simplicity of the interior recalls S. Andrea at Mantua.

Alessi's Later Works in Milan

Cristoforo Lombardino died in 1555 and Domenico Giunti, who in 1556 had accompanied his patron, Ferrante Gonzaga, to Mantua, in 1560. These dates coincide with Galeazzo Alessi's arrival in Milan. Although Alessi had kept his house in Perugia, and had been in Genoa, Brescia, and Rome in the course of these years, Milan remained the real headquarters of his activity from 1557 to 1569.[33] His one competitor, Vincenzo Seregni (1509–94), who had been in the cathedral office of works, made a name only in commissions for civic works; in important ecclesiastical buildings he was overshadowed by Alessi.[34] Thus, for instance, in 1565 Alessi was appointed surveyor of the works of S. Maria presso S. Celso, an appointment in which Seregni had succeeded Lombardino

in 1555. Alessi designed the façade of the church, which was completed long after his departure from Milan by Martino Bassi (Plates 314 and 315).[35] A comparison between the design and the execution shows that Bassi retained the fundamental features of Alessi's conception, but reduced the decoration and its relief. In the two attic zones, harsh and rather primitive forms replace Alessi's subtle details. Unfortunately the flanking obelisks, which were an important feature in the design, were greatly reduced in height.

The voluminous, 'didactic' programme of statues and reliefs on the façade recalls Giuliano da Sangallo's and Michelangelo's designs for S. Lorenzo in Florence. S. Maria presso S. Celso is the one great Italian church façade of the Cinquecento on which a programme of the kind was actually executed. As in the façade of the Certosa di Pavia, executed a century earlier, the Lombard delight in the decorative enlivening of the wall surface was greater than the need to equate the church façade with an antique temple front, which had practically been the orthodox rule for Italian architects since Alberti. The classical orders, the columns, architrave, and pediment, are little more than a foil for the sculpture.

The system of columns which Alessi's predecessor in office had designed about 1550 for the same façade excluded any possibility of decoration. It is hardly possible to imagine a greater contrast than that between the 'classical' project of a Lombard and the peculiarly 'Lombard' façade of Alessi, the Central Italian. The committee were obviously satisfied with Alessi's work, for they also commissioned designs from him for the interior furnishings of the church.[36]

Alessi's role in the great Olivetan church of S. Vittore al Corpo, Milan, begun in 1560 and completed after 1580 by Martino Bassi, has not yet been clarified. His name appears in the documents, yet how Alessi collaborated with Seregni, who had been working on the monastery buildings since 1553, remains an open question.[37] The aisled basilican nave and the monks' choir behind the altar (Plate 319) repeat the scheme of other churches of the order, like the apses of the transepts. The centralized arrangement of the transept and choir recall the centrally planned Lombard churches of the late Quattrocento, and the comparatively cramped crossing Alessi's church in Genoa. The diameter of the dome is less than the width of the nave; as in S. Angelo, the piers of the dome advance into the nave and create a clear distinction between nave and crossing.

It is obvious that liturgical considerations played their part here, as in S. Angelo, in the disposition of the transept and choir. In medieval churches, the monks' choir reached as far as the first bays of the nave, and it was separated from the transept and the congregation in the nave by walls and high stalls. The high altar in the choir was barely visible from the nave, and a special altar for the lay congregation stood in front of the monks' choir.[38] In S. Angelo and S. Vittore, on the other hand, the monks sit in the choir behind the high altar, which is separated from the congregation only by a low balustrade and is therefore in full view from the nave. The differences in level in the pavement explain this arrangement. The chancel area is separated from the congregation by two steps; in S. Angelo these steps are situated between the front piers of the crossing, in S. Vittore between the rear piers.

In the projects for ecclesiastical buildings of the late fifteenth and early sixteenth centuries liturgical considerations played no great part. The central plan, the form preferred by the period, was in any case not suited to liturgy; the longitudinal buildings followed the traditional scheme. On the other hand, the placing of the choir stalls behind the altar in the two Milanese churches indicates a close collaboration between the architect and the clergy; the consequences for the liturgy must have been considered in great detail. The innovations correspond to the reforming aims of the Council of Trent.[39]

These tendencies find their clearest expression in Alessi's church of SS. Paolo e Barnaba, built between 1561 and 1567 (Figure 97).[40] The building was commissioned by the Milanese branch of the new religious order of the Barnabites, a foundation of the Counter-Reformation authorized by Pope Paul IV in 1556. The sources confirm that Alessi's project was only accepted after several sittings of the chapter, and there is hardly any doubt that one of the points at issue was the shape of the choir.

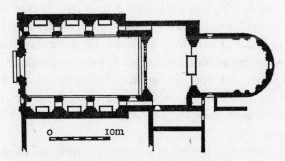

Figure 97. Galeazzo Alessi: Milan, SS. Paolo e Barnaba, 1561–7, plan

In S. Barnaba too the high altar stands between the rear piers of the crossing and in front of the monks' choir (Plate 321). These piers, however, advance so far into the interior that they must be regarded less as supports of the crossing vault than as vertical members of the triumphal arch which frames the altar, and at the same time marks the boundary between the crossing and the choir. The front crossing piers project far less, and for that reason the arch they support, which separates the tunnel-vault of the nave from the crossing vault, is higher and wider than the triumphal arch. The spectator standing in the nave sees the front arch as a frame to the triumphal arch, and that, in its turn, as a frame to the high altar. A similar calculation lies behind the gradations of the vault and the pavement. The peculiar trough-shaped vault over the crossing, i.e. over the liturgical area in front of the high altar, is higher than the vault of the nave, but it draws the eye upward far less than a dome would.[41]

In S. Barnaba, the crossing piers, the arch under the vault, and the vault itself owe their shape far more to their part in the total spatial effect than in S. Vittorio and S. Angelo. The 'liturgical area' with the high altar is the real content of this spatial picture.[42] Finally, the unusually delicate stucco decoration, carefully matched with the architectural members, is important in this spatial effect.

Other works by Alessi in Milan are the façade of the church of S. Raffaelle and an organ loft in the cathedral. Further, he prepared designs for the Sacro Monte of Varallo, the earliest of the three 'Sacred Hills' in Lombardy. Here the Stations of the Cross form a monumental processional way to the top of the hill.[43]

*

Alessi is mentioned for the last time in Milan in 1568. He spent the last years of his life in Perugia, where he held the honorary office of Prior in 1571. It may have contributed to his leaving Milan that Archbishop Carlo Borromeo passed the great architectural commissions to Pellegrino Pellegrini, who was summoned to Milan in 1564, and was fifteen years younger than Alessi.

In the same year, 1564, the Council of Trent published its enactments on reform. Cardinal Carlo Borromeo, born in 1538, had, in his function as Secretary of State to his uncle, Pius IV, taken a leading part in the concluding stage of the Council. He showed an unflagging energy in putting into action reforms in his archbishopric, which he took over after the death of the Pope in 1565. It is mainly due to Borromeo's activity that ideas put forward at the Council of Trent had an earlier and more lasting influence on ecclesiastical building in Lombardy than in Rome. Borromeo visited practically all the parishes and religious communities in his vast diocese in person.[44] What he saw and heard on these long journeys was not without influence on his *Instructiones* for the building and furnishing of churches, published in 1577, the most important Counter-Reformatory expression in literary form of a theme which, since Alberti, had been left entirely to the architects.[45]

The style of the *Instructiones* is typical of Borromeo – terse and clear, relating throughout to practical aims and comprehensible even to a country priest. Although the liturgy always takes precedence over aesthetics, the architect's work is never dismissed as negligible. Thus at the beginning of the book it is stated that the suitable site for the church is 'to be determined by the judgement of the bishop with the assent of the architect appointed by him'. In principle the churches are to be cruciform, 'as we see in the great Roman basilicas'. In exceptional cases departures from this rule by the architect may be approved by the bishop. In the chapters on the 'cappella maggiore' with the high altar and the clergy choir, there is a description of the arrangement that has already been noted in S. Angelo, S. Vittore, and S. Barnaba. In this connection, therefore, the *Instructiones* codify a type already established in Milan and familiar to the Archbishop. Borromeo may also have had in mind the Milanese churches of S. Ambrogio and S. Maria presso S. Celso when he explicitly recommended an atrium in front of the church.[46]

Pellegrino Pellegrini

In many respects, Carlo Borromeo's connection with his architect Pellegrino Pellegrini (1527–96) resembles Domenico Fontana's with Sixtus V.[47] In 1564, before his own return, the Cardinal announced from Rome the arrival of Pellegrini in Milan.[48] He stood resol-

utely by his protégé until his own death, and gave him the commissions for all the major buildings he founded. In 1567 he had Seregni dismissed against the will of the Fabrica del Duomo and Pellegrini appointed chief architect of the cathedral.

Like Fontana, Pellegrini combined an expert knowledge of architecture with great organizing capacity. In his buildings, he simplified Alessi's formal vocabulary. His own style is less elegant and more sober, but what really distinguishes him from Fontana is his wealth of ideas. His range of modes of expression can be seen in the Canons' Courts in the archiepiscopal palace in Milan (Plate 322) and the Collegio Borromeo in Pavia (Plate 323), which he designed in the first year of his work for Borromeo. Jacob Burckhardt describes the pillared arcades of the Canonica as 'a tall, rusticated double hall, in which glum rustication is at last taken seriously. Either the architect or S. Carlo himself wished the courtyard to have an air of gloomy majesty; only one lower and one upper storey, though both of tremendous height'.[49] At Pavia, on the other hand, the courtyard arcades have architraves on paired columns; the motif of the Palazzo Marino has been adopted here, though its profuse sculptural ornament has been suppressed. For that reason, Pellegrini's arcades, unlike Alessi's, look light and almost weightless. The façade of the Collegio is less attractive. On the ground floor low rectangular windows alternate with higher round-arched niches, but on the upper storeys only the central bay is stressed by a high round arch crowned by a pediment. A third system appears in the double-bay flat projections flanking the façade, with windows lighting the two stair-cases. In a smaller building, this accumulation of motifs might have been regarded, in the idiom of the time, as 'capriccioso', but in a façade of seventeen bays it produces an effect of restlessness or lack of discipline.

In 1569, a year after the beginning of work on the Gesù in Rome, Carlo Borromeo laid the foundation stone for the Jesuit church of S. Fedele, Pellegrini's most important ecclesiastical building in Milan. Pellegrini owed this commission to the Cardinal too; the Vicar General of the Order in Rome wished to entrust the project to Father Tristano.[50]

The plan of S. Fedele (Figure 98) is as unusual as its elevation. The nave, 16 m. (50 feet) wide, consists of only two square bays (Plate 324). Its vaults are supported on semi-

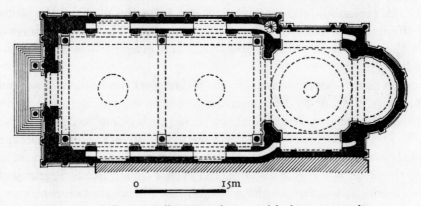

0 15m

Figure 98. Pellegrino Pellegrini: Milan, S. Fedele, begun 1569, plan

circular wall-arches and transverse arches which, in their turn, rest on six giant free-standing columns.[51] The structural elements and the enclosing walls have nothing in common except the continuous Corinthian architrave which projects far beyond the columns: 'The construction is of such a kind that the entire nave can be imagined without the enclosing walls.'[52] The wall sections between the columns are articulated in the b–a–b motif of a triumphal arch.

The eastern parts of the church were built to a different plan in the seventeenth and eighteenth centuries, but Pellegrini's project has been preserved in drawings.[53] They show a transept whose end walls are aligned with the nave, a dome over the square crossing, and a semicircular apse. Instead of the high Lombard tiburio which was actually executed, a lower Roman dome with a drum, a spherical outer shell, and a lantern was planned.

The interior of S. Fedele surpasses the Roman Gesù in brightness and clarity. In both churches the aim of the architect was a wide space, without anything to hinder a free view of the high altar. But while Vignola places the walls bearing the vault *behind* the walls enclosing the nave, Pellegrini takes the opposite course by placing the structural elements in the interior, i.e. in front of the walls. In the Gesù the side altars stand in deep chapels screened from the nave by arches; in S. Fedele they stand in shallow niches which open towards the nave in tall arches, and therefore appear as an articulation of the wall and not as subsidiary spaces.[54]

It is very interesting to note that the articulation of the walls of the Gesù may be regarded as a recasting of Bramante's pilaster system in St Peter's, while S. Fedele is a direct reversion to the antique. Pellegrini was in Rome in 1564.[55] At that time the building of S. Maria degli Angeli in the Baths of Diocletian was progressing rapidly. Carlo Borromeo was certainly familiar with his uncle's favourite enterprise, and for Pellegrini it was important as the work of Michelangelo. Thus it follows without difficulty that, three years after Pellegrini's stay in Rome, he took up, in his plans for S. Fedele, the motif of the free-standing columns bearing the imposts of the vaulting. In S. Maria degli Angeli the lower edge of the architrave is 14 m. (46 feet) above the pavement, in S. Fedele 13·40 m. (45 feet); thus the springers of the vault are roughly of the same height in both churches. The Caesarean dimensions of the thermae columns could not, of course, be repeated in the Jesuit church, and Pellegrini mastered the problem by placing his columns on pedestals 3·30 m. (11 feet) in height. The vaults are saucer-shaped, which makes them lighter than a groin-vault and gives the separate bays a certain independence.

Pellegrini's church obviously satisfied all the liturgical and aesthetic requirements of his clients. It is clear from the documents that the Milanese Jesuits approved the design of the church just as much as the Cardinal, who made the building possible by subventions and enabled his own architect to undertake the work. When the *Instructiones* appeared, S. Fedele was still under construction. They are so generalized that they in no way inhibited the architect's artistic freedom, and even a church like S. Fedele, built on a system so immediately influenced by antiquity, could be adapted to them.

In Jesuit church building, however, S. Fedele had no successors. The settlements were

obliged to submit the projects for their churches to the Vicar General in Rome, and all the prominent members of the order were trained in Rome. It was therefore no more than a matter of course that the Roman mother church should become the architectural model for the churches of the order.

Pellegrini's round church of S. Sebastiano in Milan, founded by the city after the great plague of 1576, is a striking example of how little the *Instructiones* inhibited the architect's artistic freedom (Figure 99).[56] In this case the tradition for centrally planned churches which went back to the Middle Ages carried the day over the ideological scruples of the *Instructiones*, according to which 'the round form, frequently used by the ancients for the temples of their gods, has rarely been used by Christians'. Once again Pellegrini reverted directly to the antique model; the circular plan as well as the construction and decoration of the dome are inspired by the Pantheon and not by Bramante's Tempietto.[57]

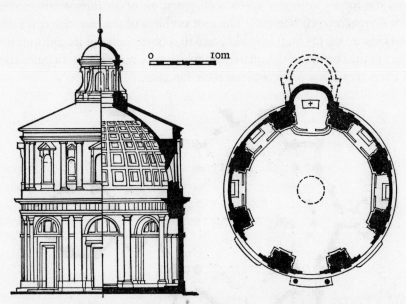

Figure 99. Pellegrino Pellegrini: Milan, S. Sebastiano, begun 1577, half-elevation and half-section of original project, and plan (the choir altered later)

During his long term of office as architect-in-chief of the cathedral of Milan, i.e. Carlo Borromeo's own church, Pellegrini built the high barriers between the choir and the ambulatory, and the crypt under the choir known as the *scurolo*. His share in the many designs for the façade in the later sixteenth century has still to be investigated; he was certainly the first to advocate vigorously a façade in the 'new' style. The four portals of the aisles, begun while he was in office, are preserved in the neo-Gothic façade.[58]

The Rebuilding of S. Lorenzo in Milan: Martino Bassi

The greatest enterprise in ecclesiastical architecture in Milan in the sixteenth century was the restoration of an Early Christian rotunda. On 5 June 1573, as we read in the

chronicle, 'the church of S. Lorenzo, one of the oldest and most beautiful churches in Milan, collapsed. . . . The whole city wept because the finest building it possessed was lying in ruins and might never be restored'.[59] The fear was groundless, especially thanks to the efforts made by Carlo Borromeo to assemble the means for rebuilding, measuring the ruins and preparing plans for restoration.

The superintendence of the works was entrusted to Martino Bassi (1542–91), who has already been mentioned as Alessi's successor at S. Maria presso S. Celso.[60] Bassi, who became chief architect of the cathedral in 1587 when Pellegrini was called to Spain, did not live to see the completion of S. Lorenzo; when he died, the vaulting of the dome was in progress.

Carlo Borromeo had given orders that there should be no alteration in the plan of the old church; the sixteenth-century building stands on its ancient foundations (Figure 100). Thus S. Lorenzo presents a unique phenomenon – the late antique quatrefoil plan determines the highly complex spatial configuration of an interior defined by walls built in the Cinquecento (Plate 326). The root problem of the restoration was the dome, which was over 20 m. (65 feet) in width, and the construction of its eight supports. The four towers in the corners of the quatrefoil, which take up the side-thrust of the domes, survived the collapse and have retained their function.

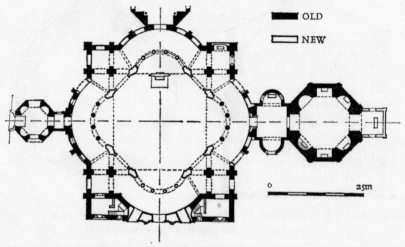

OLD

NEW

0 25m

Figure 100. Martino Bassi: Milan, S. Lorenzo, rebuilt after 1573, plan

Bassi's plan for a domical vault was repeatedly modified and only adopted after long discussion. In contrast to other projects, Bassi first wished to abandon the drum; he was ultimately persuaded to insert openings in the foot of the dome which, from the outside, look like windows in a drum. This drum is actually a Lombard tiburio surrounding the vault, and from the outside the dome rising from it looks too low. The interior (Plate 325) gains by the massive Doric piers of the dome and the projecting main cornice, which give it a gloomy monumentality. The old building must have looked as transparent and weightless as S. Vitale at Ravenna.

Some of the projects entered for the rebuilding have been preserved.[61] Their wealth

of ideas almost rivals that of the ideas for St Peter's. Bassi's first scheme was a low spherical vault after the fashion of the Pantheon (with an open oculus). One project (Plate 327), perhaps by Pellegrini, has a notably steep dome not unlike that of Florence Cathedral in outline, but on a circular plan; for the corner towers, two storeys were to be added to the old stumps. The actual rebuilding of S. Lorenzo is a belated echo of Bramante's plan for St Peter's, which in its turn had been reminiscent of the late antique central plan of S. Lorenzo.[62]

Ascanio Vitozzi in Piedmont

In 1584, Duke Carlo Emanuele I of Savoy appointed Ascanio Vitozzi (c. 1539–1615), a native of Orvieto, as his architect and engineer. Vitozzi had taken part in several campaigns and was experienced in fortifications; nothing is known of his training as an architect. His activity in Turin was comprehensive, but there are few records of it.[63] His chief work, the pilgrimage church at Vicoforte di Mondovì, begun in 1596, the largest centrally planned building of the late Cinquecento in Italy, was only completed in the eighteenth century.

Detailed evidence of the history of the planning of the church and the forms which Vitozzi had in mind for the Madonna di Vico exists in the sources and preliminary sketches. The Duke, the client for the church, wished to make it the funerary church of the house of Savoy, though it is difficult to disentangle religious from dynastic motives. The process of the design is characteristic of Carlo Emanuele; in addition to the plans prepared at Turin, he had others sent from Genoa, Rome, and Milan. The whole collection looks like a pattern-book of church plans current about 1600; in addition to the rotunda, the octagon, and the square, basilican plans were proposed with and without chapels attached to the aisles, as well as a single-aisled church with chapels.[64] All the projects include a large dome; it is, however, interesting that the idea of placing the altar with the miraculous image under the dome first appears at a late stage of planning.

In Vitozzi's project, which the Duke ultimately decided to execute, the miraculous image is placed in the centre of an oval space 36 m. long and 24 m. wide (120 by 80 feet) (Plate 329 and Figure 101). On the diagonal axes four large chapels adjoin the oval, on the transverse axis the vestibules, on the longitudinal axis the choir at one end, the entrance at the other. The lavish decoration of the exterior was necessary since the building was a pilgrimage and votive church: there are giant orders on the three entrance sides, four towers flanking the ends of the oval, and carefully articulated tripartite lunette windows in the diagonals between the side portals and the towers.[65]

In spite of a certain eclecticism in some details, Vitozzi's plan was a thoroughly original solution of the problem in hand.[66] With the miraculous image in the centre of the oval, the visual and liturgical function of the high altar is preserved in the choir. The tripartite lunette windows provide a wealth of light for the chapels destined for the tombs of the Duke's family and separated from the main space by the arrangement of the columns and screen walls. The lavish articulation of the portals of the transverse axis

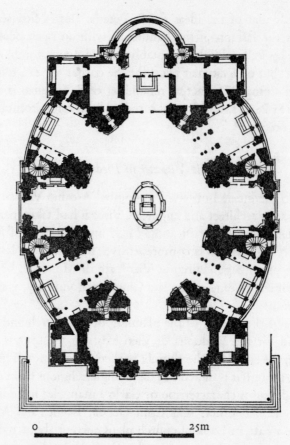

Figure 101. Ascanio Vitozzi: Vicoforte di Mondovì, S. Maria, begun 1596, plan

turns three sides of the church into twin-towered façades; since the choir apse is also flanked by towers, the three-dimensional body of the church allows the plan, an oval interlocked with a cross, to stand out clearly. At the same time the ideal, already stated by Alberti, of the free-standing, wholly visible centrally planned church is realized; with its towers and gigantic dome the church dominates the hilly country surrounding it (Plate 328).

The historical roots of Vitozzi's design lie in Rome. There is nothing comparable to it in Piedmontese architecture of the Cinquecento. But the Madonna di Vico is distinguished from its Roman models by the peculiarly unconventional and independent interpretation of the adopted form. From that point of view Vitozzi may be regarded as the pioneer of the great Piedmontese Baroque architecture.

PALLADIO

SINCE the eighteenth century, the name of Andrea Palladio (1508–80) has stood for architectural perfection. There are Palladian buildings in Russia and in the United States. Travellers visit the little town of Vicenza for the sole purpose of seeing Palladio's works.

Yet the fact that no Renaissance architect has had so much research lavished on him in the last generation cannot be entirely explained by his quality and his fame. The general interest in the Cinquecento has been, if anything, on the decline, and our knowledge of Pellegrini or Alessi has on the whole remained stationary, while recent publications on Palladio would stock a small library.[1] The reasons for the present interest in Palladio lie in particular qualities of his work. It is curiously abstract; it can be visualized independently of its environment, and therefore lends itself to imitation. Many of his works conform to the present trend to smooth surfaces, right angles, and plain cubic forms. Equally, many of his buildings have remained practically unaltered, so that it requires no historical imagination to see them in their original form. Finally, Palladio founded his own enduring fame by a book of illustrations and comments on his own work.[2]

The Quattro Libri di Architettura

In the history of architecture, Palladio's treatise occupies a key position. It combines the humanistic literary tradition of the editions and commentaries of Vitruvius with the illustrated pattern-books written by architects for practical use.

In his *Dieci Libri di Architettura*, Alberti uses the language and title of his classical model; he writes for humanists and cultivated clients, but not for working architects. Unlike rhetoric, dialectics, and grammar, architecture was not one of the seven liberal arts. A new Vitruvius, Alberti appeals to the reader as a writer, not as an architect; the classical form of the book is at least as important as its contents. Serlio's and Vignola's treatises, on the other hand, are addressed to the practical architect. The concise Italian texts merely serve as explanations to the illustrations; they lay no claim to literary merit and assume no particular scholarship in the reader.

Palladio was familiar with the monuments of antiquity and the literary tradition established by Vitruvius, since he had himself written a little book, *Antichità di Roma* (1554), and had illustrated Daniele Barbaro's commentary on Vitruvius (1556). Yet there was nothing of the learned humanist in the author of the *Quattro Libri*. Born in Padua, the son of a miller, he had been trained as a stonemason in Padua and Vicenza. In 1534 he married a carpenter's daughter. Even as late as 1542 he appears in the records as *lapicida*. Even as *architector*, the name first given him in 1540, and then from 1545 on, he was not a representative of the liberal arts.

Thus when Palladio writes, at the beginning of his book, that in the study of architecture, which he had practised from his youth, Vitruvius had been his 'maestro e guida', 'il solo antico scrittore di quest'arte', that is no mere literary flourish, nor is it possible to miss the echo of Dante. Just as Dante was inspired by Virgil, the author of the *Quattro Libri*, speaking as a writer and an architect, finds his inspiration in Vitruvius. In going on to say that the book is meant to help the reader 'to avoid errors, barbarous (i.e. Gothic) devices, excessive costs, and premature dilapidation of buildings' Palladio is speaking to the client as well as to the architect.

The title-page summarizes the contents of the book: 'After a short treatise on the five orders and indications of the most important requirements in building, the present volume proceeds to deal with private buildings, streets, bridges, squares, sport halls, and temples'. The 'short treatise' refers to Book I, which is on more or less the same lines as the corresponding chapters in Serlio and Vignola. Book II contains 'designs for many houses, urban and rural, by Palladio, with illustrations of Greek and Roman houses'. Thus Palladio's own buildings take their place beside the buildings of antiquity; in fact they bear the stamp of antiquity as illustrations of ancient private houses built according to Vitruvius's text.

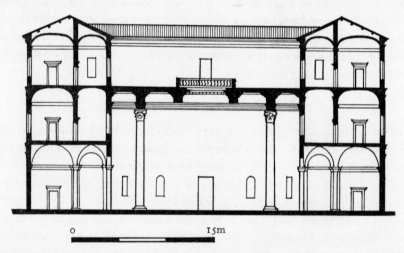

Figure 102. Andrea Palladio: Venice, convent of S. Maria della Carità, Atrio Corinthio, from the *Quattro Libri*, 1570

A typical example – the convent of S. Maria della Carità in Venice, designed by Palladio – is illustrated with the caption 'Atrio Corinthio' (Figure 102). Palladio adds the remark that he had tried to reproduce the house of antiquity, and, in doing so, had given it a Corinthian atrium.[3] The vestry beside the atrium 'serves as a tablinum, the name given at that time to the room in which they preserved the portraits of their ancestors'. Considering the previous reconstruction of the antique house with a tetrastyle atrium, and the one which follows with a roofed atrium, the convent building must be regarded as an archaeological reconstruction.

The only authority Palladio had for these reconstructions was Vitruvius's text, which

is, in his own words, 'most difficult and obscure and to be used with great caution'. Nor did the ruins of Imperial Rome, which he had seen, have much to offer him for the Greek and early Roman premises described by Vitruvius. Thus what the illustrations actually show are modern architectural compositions. Their style belongs to the Cinquecento; what Palladio had learnt from Vitruvius and existing monuments – whether rightly or wrongly – was fused in them with the forms and types of the sixteenth century to create a new unity.

It is in Book III, 'Edifici pubblici', that the elements of this synthesis are most clearly demonstrated. After a technical and historical introduction, the section on bridges describes Caesar's bridge over the Rhine and other examples, ancient and modern. It concludes with a stone bridge 'di mia invenzione', a superb rendering of Palladio's project for the Rialto in Venice (Plate 340). The type of the basilica is illustrated by the Basilica Portia in Rome and Palladio's Basilica at Vicenza. The comment in the text states that both buildings serve the same purpose, namely jurisdiction and the conduct of public affairs, however widely they may differ in form. In the ancient basilicas, the colonnades were in the interior, in the modern form they are on the exterior.

Book IV, 'Ancient Temples in Rome and other Places in Italy and Elsewhere', contains, with one exception, no contemporary buildings or reconstructions. There were sufficient monuments extant to illustrate the types of ancient sacred architecture. Bramante's Tempietto at S. Pietro in Montorio, the only 'modern' building to find a place in Book IV, represents the Doric peripteral rotunda. The selection of ancient monuments is essentially the same as Serlio's, though the woodcuts in Palladio's treatise are made with far greater care. They are only based in part on Palladio's own measurements; he often makes use of older drawings.[4] Architects of the twentieth century may feel some surprise when they read in the preface to this book that 'Anyone can see by studying ancient temples the forms and decoration that should be used for churches' (i.e. Christian churches), but in that sentence Palladio prophesied the development of church building down to the nineteenth century. It must, of course, be realized that that development was influenced by the churches he built himself – which are not illustrated in the treatise – and still more by the treatise itself.

Vicenza, and the workmen in the shop in which Andrea di Pietro of Padua spent his apprenticeship as a sculptor's assistant, had little to contribute to the formation of Palladio's personality as an artist. But not far from Vicenza the great buildings were rising which were to make the Veneto the most outstanding architectural centre of Italy. Falconetto was active at Padua, Giulio Romano at Mantua, Sanmicheli at Verona, Sansovino at Venice. When Palladio declares, in the first lines of his book, that he had dedicated his life to the study of architecture from his youth, those were the masters that were foremost in his mind. It was to them that he owed the formation of his critical judgement and his style. The Basilica of Vicenza, Palladio's first monumental work, shows that his style was fully developed by the end of the forties. Ideas and influences can be traced from all four masters, but they give no impression of alien elements: they have simply flowed into Palladio's formal idiom.

In 1538 at latest, the stonemason, then thirty years of age, made the acquaintance of

Gian Giorgio Trissino (d. 1550), a humanist who belonged to one of the patrician families of Vicenza, and an amateur architect himself.[5] A travelled man of the world, Trissino recognized the gifts of the young workman. He introduced him to the study of antiquity and patronized him with all the means in his power. In 1541, Palladio – the classical name is an invention of Trissino's – accompanied his patron to Rome. After his return, and in all probability on Trissino's recommendation, he became the foremost architect of the Vicentine nobility.[6] He returned to Rome several times later. He had also studied at first hand the ancient monuments of northern Italy and the south of France. The fact that in 1556 he became one of the founding members of the learned Accademia Olimpica is proof of the respect in which he was held in Vicenza. In 1561 commissions began to come in from Venice, and in 1570 he settled there with his family. It was in Venice too that his *Quattro Libri* was published in 1570, and in Venice again in 1575 that an Italian translation of Caesar's Commentaries appeared with his illustrations. He kept in touch with Vicenza; in the last year of his life he designed the theatre of the Accademia Olimpica. A month before his death he still received fees for his work on the Basilica.

Churches

'We, who worship no false gods, will choose the most perfect and beautiful form for our churches. Since the circle excels all other forms in being simple, homogeneous, everywhere the same, solid and capacious, our temples shall be circular. The circle mirrors God's unity, infinity, his homogeneity and justice' ('Unità, infinita Essenza, Uniformità e Giustizia').

This famous passage appears in Book IV of Palladio's treatise, five years before Carlo Borromeo's *Instructiones*, in which the central plan was expressly rejected as pagan and little suited to a Christian ecclesiastical building. Alberti had already praised the central plan as the most beautiful form of church building. To the architects it remained the ideal of beauty as long as aesthetics dominated the field.[7] But however often round churches may appear in sketchbooks and paintings, actual centrally planned buildings are very rare. These exceptions include Bramante's Tempietto, S. Maria di Campagna near Verona, and S. Sebastiano in Milan – all votive churches. The clergy preferred the traditional forms. Many new buildings were erected on old plans, since the centrally planned church is in any case ill-suited to the Christian liturgy.[8]

After the middle of the sixteenth century, the practical liturgical requirements of the clergy overcame the aesthetic ideas of the architects. When Palladio writes, after the passage quoted above, that longitudinal churches had their advantages, it sounds like a farewell to the central plan: 'The entrance lies at the foot of the Cross; it faces the high altar and the choir. At the ends of the arms of the Cross are two more altars or entrances. In the longitudinal church, the worshipper can see before his eyes the tree on which our Saviour hung. This is the form in which I built the church of S. Giorgio Maggiore in Venice.'

S. Giorgio Maggiore, the Benedictine monastery church begun in 1566, is a basilica with a dome over the crossing, transepts terminating in half-domes, and a long chancel

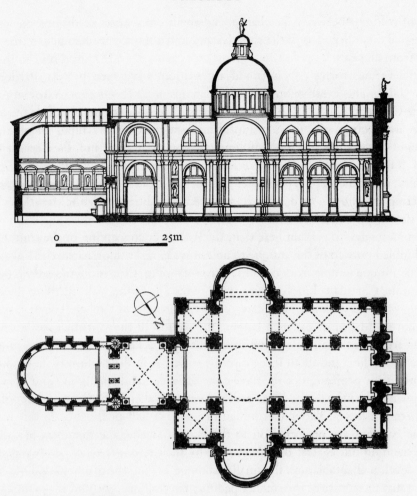

0 25m

Figure 103. Andrea Palladio: Venice, S. Giorgio Maggiore, begun 1566, section and plan

(Figure 103). It was Palladio's first great ecclesiastical building. The plan is of a type common since medieval times, but the visitor entering the church finds himself in an unprecedented, highly surprising kind of space, traditionally described as bright, clear, plain, solemn (Plate 330). The vaults and walls are stuccoed in pure white, against which the half-columns, pilasters, and arches stand out in grey.[9] The three-bay nave has a tunnel-vault with lunettes, the aisles have groin-vaults. The piers are solid enough to make a clear separation between the aisles, but they do not look massive. They are a skilfully composed organism of vertical members: giant half-columns on high pedestals towards the nave, lower paired pilasters under the springers of the arcade arches, half-columns between pilasters in the aisles. Pilasters adjoin the giant columns of the crossing. Beyond the crossing, the aisled system of the nave is carried one bay forward; the chancel then continues the nave, but it is longer and wider than the bays of the nave and differs from them by its groin-vault supported by fluted free-standing columns. A characteristic invention of Palladio, which was destined to have a great future, is the

group of columns between the chancel and the monks' choir; only here the columns, which in all the other parts of the church stand in front of or are engaged in the wall, are visible from all sides.

All the various forms of vaults and articulations have their precise parallels in the *Quattro Libri*. The creative intention which inspired S. Giorgio Maggiore was an 'antique Christian church'. To Palladio that was natural, not paradoxical; the forms of antique architecture, the most beautiful and stately ever invented, become the expression of the noblest and most sublime creation of architecture, the Christian House of God. If the interior of S. Giorgio envelops the visitor of today with its atmosphere of solemnity, it is difficult to say whether that feeling arises from an immediate impression on entering the church, or because he is already conditioned by the countless churches which descended from Palladio.

It is unnecessary to explain here that, for Palladio's conception of the church façade, the columned portico of the antique temple was the right thing in the right place.[10] But while the antique temple front consists of free-standing, three-dimensional elements, the façade of the Christian church, which is the outer side of the wall enclosing the interior, takes on, of its very nature, the character of the ground of a relief. The nave and aisles in S. Giorgio Maggiore differ in height; the section of the Christian basilica is totally different from that of an antique temple. Palladio was faced with this problem in three Venetian churches, and in all three cases he solved it in the same way: by reducing to a minimum the projection of the nave over the aisles, and setting in front of it a composite giant order; the slopes of the pediment run parallel to the slope of the roof. At the sides there is a lower, flatter Corinthian order with half-pediments. In this way, two 'antique' systems are projected on to the church façade, the members of the central system standing out against the flatter sides by their stronger relief. Both systems have a fully developed entablature, the smaller running behind the giant order. One can even imagine that the centre of the smaller pediment is concealed behind the giant order.

The effort to create the church façade *all'antica* can be traced from Alberti through Bramante's and Raphael's designs for St Peter's down to Vignola and Cristoforo Lombardino. But not even Palladio could nullify the inherent incompatibility. By doubling the system, and by the apparent concealment of the smaller pediment, he displays the problem, he does not solve it, though his treatment, if complex, is dignified and consistent in itself. That is obvious from the many imitations which continued into the nineteenth century.

When the façade of S. Giorgio Maggiore was completed, after 1600, certain alterations had obviously been carried out in the details. The façade of S. Francesco alla Vigna (Plate 332), which was built under Palladio's supervision about the same time as the interior of S. Giorgio, is superior to that of S. Giorgio both in composition and in detail. The side and central parts stand on a common base. The flanking half-pediments are supported by half-columns instead of pilasters, which are employed only at the corners. Thus the smaller system is characterized as a temple *in antis*.

In the Redentore, the latest façade of this type, the larger order is also treated as that of a temple *in antis* (Plate 333).[11] In this case the main pediment corresponds to the crown

of the vault. Above it rise a tall attic and the roof of the nave, and the buttresses above the half-pediments. The architrave of the lesser order corresponds to the main cornice in the interior. Here, therefore, the façade reflects the structural system of the interior; the roofs are visible above it. In that way the façade, in a quite unprecedented fashion, becomes an integral part of the building. Seen from a distance, the façade, dome, towers, and roofs unite in an admirably balanced composition. On the other hand, the strata of the surface can only be grasped by the observer standing directly in front of the church.

The Redentore was founded by the republic of Venice. During the plague of 1576, the Doge vowed that a church should be built in honour of the Redeemer. After the Senate had voted for a longitudinal and against a central plan, and had approved the design Palladio submitted in accordance with this decision, the foundation stone was laid in the spring of 1577.[12] Since the end of the plague in the summer of 1577, a procession of thanksgiving has taken place every year, crossing over to the Giudecca on a temporary

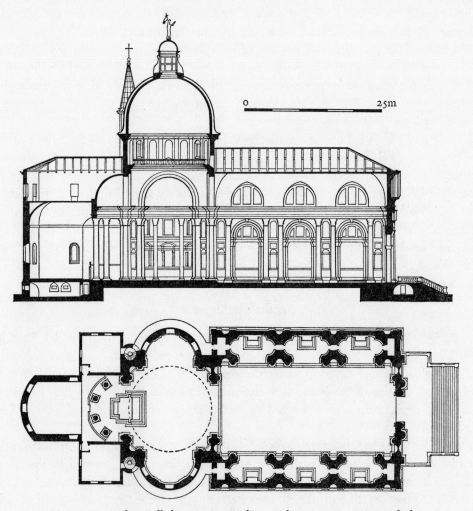

Figure 104. Andrea Palladio: Venice, Redentore, begun 1577, section and plan

bridge of barges. The participants in the procession, therefore, see the strangely com-posed church façade facing them at the end of a *via sacra*. The dome in the centre of the picture rises over the altar on which the Doge lays the thankoffering.

The function of the church is also expressed in the configuration of the plan (Figure 104). On entering, the visitor finds himself in a moderately high, oblong room sur-rounded by half-columns (Plate 331). Opposite the entrance a great arch opens on to the high altar and the area under the dome. Looked at from the crossing, the parts of the wall that support the arch are seen to be the piers of the dome. The result is that the domed space looks wider than the nave, while actually both are equal in width. As in S. Giorgio, the presbytery and the chancel are separated by a screen of columns, but in the Redentore they are arranged in a semicircle, and their architrave supports the half-dome of an apse.

The liturgical heart of the church, the crossing, is dominated by the circle of the drum and dome and by the semicircles of the crossing arches and apses, the nave by the uninterrupted horizontal of the cornice and the verticals of the columns. In the plan and elevation of the side chapels, the semicircle is again the dominant note.

The plan of the Redentore recalls that of Pellegrini's almost contemporary church of S. Fedele at Milan. Pellegrini inserts the antique motif of a vault resting on free-standing columns as if it were some quotation from an old work in a thoroughly contemporary wall-composition. In Palladio's church, ancient and modern can no more be separated than column and wall or space and structure.

The plague which led to the foundation of the Redentore was also the origin of the votive church of S. Sebastiano at Milan. The transactions of the Venetian Senate give the reasons why the Redentore was to be built 'in forma quadrangolare' and not on a central plan: the function of divine service was clearly regarded as more important than the 'ideal' central plan which was practically the rule for votive churches. A curious light is cast on the Senate's decision of 1577 by the fact that fifty years later the city, again menaced by the plague, returned to the central plan in the church of S. Maria della Salute.

Secular Architecture

The Basilica Palladiana at Vicenza is the medieval senate house, round which Palladio built a two-storeyed loggia (Plate 334 and Figure 105).[13] On the ground floor, the number of arches was determined by the disposition of the old building; further, in deciding on the size of the intercolumniation, three broad passages, varying in width, which ran straight through the building under the great hall, had to be taken into consideration.

Every pier of the loggia is faced by a half-column whose entablature projects from the entablature along the wall. Smaller, free-standing columns are inserted in this main order, their architraves serving as imposts to the round-arched arcading. A similar form of this 'Palladian' motif had already appeared ten years earlier in Serlio's Book IV and in the upper storey of Sansovino's Libreria. In the Basilica, the motif has a practical

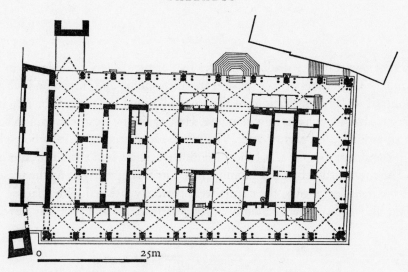

Figure 105. Andrea Palladio: Vicenza, Basilica, begun *c.* 1550, plan

purpose. By detaching minor columnar elements from the pier, Palladio was able to integrate the old bays, which were unequal in width, into a system of seemingly equal arcades. At the same time, each of the members of the pillar is given its own structural function, but that function, unlike Sansovino's system, which unfolds in a plane, can only be understood if the spectator moves round it. There is yet another difference between the Basilica and the Libreria: in the former the sculptural decoration is confined to the key-stones of the arches and the statutes on the attic. The effect of the Libreria is born of the rich Ionic order of the upper storey, that of the Basilica derives from the 'masculine' Doric of the ground floor.

In 1571, more than twenty years after the beginning of work on the Basilica, Palladio was commissioned for the Loggia del Capitanato (Plate 335), which stands opposite it, and was the residence of the Venetian 'City Captain' of Vicenza. Building stopped after three bays had been erected. It is uncertain whether Palladio's project had envisaged five or seven bays.[14]

The composite giant order of the Loggia is a superb example of Palladio's late style. In comparison with the clear, unusually careful detail of the Basilica, the forms look coarse and violent. The volume of the pillars is extremely reduced, the window surrounds of the upper storey break into the entablature, uncouth triglyphs support the architraves of the balconies, and the wall is smothered with stucco ornament. Among these restless, intentionally unclassical forms stand the four tall half-columns crowned with their part of the entablature. They look like the remains of an antique building which has had arcades and an upper storey forced into it. The column, the most important and dignified element of ancient architecture, is invested with the greatest dignity and monumentality when it dominates several storeys of a modern utilitarian building. It is in that way that the giant order of Palladio's Loggia should be understood.

Palazzi

In Book II of his treatise, Palladio illustrates five of the palazzi he designed in Vicenza (Figure 106).[15] The façades of these palazzi are still standing and correspond substantially to the illustrations, but illustrations of the parts adjoining the rear of the façade ranges bear no resemblance to what is now standing. Here again the treatise proves to be a combination of architectural theory and 'Vitruvian' reconstructions. Palladio's plans and elevations transform the palazzi of the Vicentine patriciate into antique domestic architecture. The courtyard becomes a monumental Vitruvian peristyle. As the present condition of the buildings shows, the clients were perfectly satisfied with a façade. Further suggestions of Palladio's were certainly beyond their means and probably beyond their wishes.

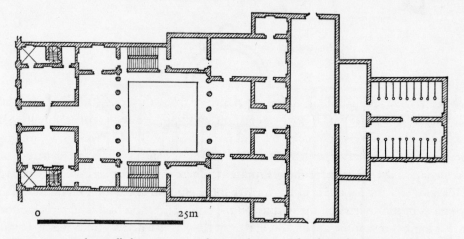

Figure 106. Andrea Palladio: Vicenza, Palazzo Valmarana, plan from the *Quattro Libri*, 1570

For the patrician of the terraferma, the courtyard was not the same thing as it was for his contemporaries in Rome and Florence. Besides, the medieval tangle of streets and the density of the built-up areas in Vicenza did not allow for large building sites. The street front, the entrance hall, and the rooms on the piano nobile were the true status symbols of the clients.

In the division of the house into two storeys of roughly equal height, and in the fenestration, Palladio's façades are of the same type as those of Sanmicheli in Verona, even though, for Palladio as for Sanmicheli, every building presented a new problem. The rusticated front of the early Palazzo Thiene (Plate 336) contains Roman echoes and reminiscences of Giulio Romano's Mantuan style. The classical façade of the Palazzo Chiericati, designed about the same time, with its colonnaded front, was determined by its situation on the 'Isola', an open tract of land on the edge of the town. In designing it Palladio had in mind the two-storeyed portico which surrounded the Roman forum. The façades of the Palazzi Iseppo Porto and Barbaran seem closely related to each other, yet there was an interval of twenty years between their building. Palladio's work cannot

be easily classified and dated by a consistent stylistic development; instead, for each new building he drew on a repertory of fully developed types which already existed in his mind. All the same, the giant pilasters of the façade of the Palazzo Valmarana (Plate 337) already show the trend to exaggerated dimensions which is characteristic of his late work and can be seen in the Loggia del Capitanato.[16]

Villas

Among the illustrations in Book II there are reproductions of more than twenty villas which Palladio designed for the Venetian and Vicentine nobility (Figure 107). While in his palazzi Palladio adopted and developed the type of the upper-class town mansion, it was he who created the villa type of the terraferma.[17] The social and economic developments which inaugurated the type have only become clear through very recent

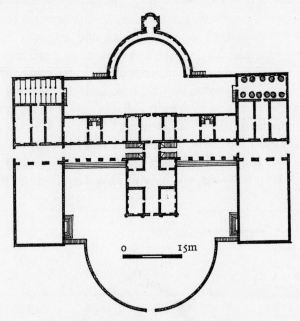

Figure 107. Andrea Palladio: Maser, Villa Barbaro,
plan from the *Quattro Libri*, 1570

research. The Turkish advance in the eastern Mediterranean and the discovery of America were the death-knell of Venetian overseas trade. The republic therefore began to take an interest in the agricultural development of its own lands in the terraferma. The great swamps of the river valleys were systematically reclaimed, and country estates became an attractive source of income to the nobility.[18]

Unlike the Roman and Florentine country seats, Palladio's villas are surrounded by fields and vineyards which belonged to the owner of the villa and were agriculturally productive. Thus the estate includes, beside the villa whose owner enjoyed country life in warm weather, houses for farmworkers, barns, wine cellars, grain stores, and

stables. The modest properties on the terraferma could not compete with the terraced gardens, the mazes, the fountains and the grottoes of Rome. But the distinction and simplicity of Palladio's work gave them an incomparable charm which can be felt even today.

The master's house, usually two-storeyed, but occasionally of only one storey, five to seven bays wide, stands as a rule on a slight rise in the land. It is generally distinguished by a pediment over a columned or pillared hall (Plate 338).[19] But at its sides, or wherever the terrain permitted, there were low open wings leading to the outbuildings. As Palladio explains, in this arrangement care had to be taken to prevent the master from being disturbed by the outdoor work, or interfering in it himself.

In the placing of loggias and pediments every Palladian villa presents some new variant. The pediment may rise above the roof or be set in front of it. There are two-storeyed loggias or giant orders in front of two storeys. The service wings may be parallel or at right angles to the axis of the house, or may curve away in front of it. The plans of the whole group are always symmetrical, like those of the rooms of the house; in the centre there is a salone.[20] The length, width, and height of the separate rooms, their geometry, are determined by a system of rational proportions which is a characteristic of Palladio's architecture and comes out most clearly in the villas; it stems from Vitruvius and Alberti. 'The geometrical keynote is, subconsciously rather than consciously, perceptible to everyone who visits Palladio's villas and it is this that gives his buildings their convincing quality' (Wittkower).

Palladio purposely gave the name 'suburbana' to his most famous villa, La Rotonda (Plate 339), which was planned as a country seat for the dignitary of the Church for whom it was built. It is, however, not only the absence of service buildings that dis-

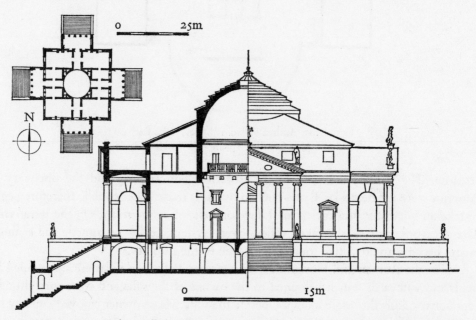

Figure 108. Andrea Palladio: Vicenza, La Rotonda, c. 1566–70, plan and section

tinguishes the Rotonda from the other villas – it is also the only work by Palladio that corresponds exactly to the illustration in the *Quattro Libri*.[21] Here, and here only, was the architect able to realize to the full his vision of 'well-building', as Sir Henry Wotton called it. That applies to the situation of the Rotonda on a height 'with gentle approaches' as well as to its form. The plan (Figure 108), composed of the simplest and therefore the most beautiful geometrical figures, the square, circle, and rectangle, is symmetrical on both axes. The same porticoes with the same pediments appear on all four sides, and even the number of steps leading to the loggias is equal. Thus the Rotonda presents the same view from all four sides; in the high round salone in the centre we begin to understand what Palladio means when he ascribes to the circle the divine qualities of *unità* and *uniformità*. If the vault over this room is shaped like a dome, a feature till then confined to churches, that is perfectly consistent.

With all its simplicity, this architecture is highly abstract and in the literal sense of the word 'absolute', i.e. bound by no this-worldly conditions. When Goethe visited the Rotonda, he called it 'habitable, but not homely'. The identity of aesthetic and theological categories which was a peculiarity of the Renaissance conception of architecture could only be achieved if the patron was prepared, as he was in the case of the Rotonda, to accept the aims and ideals of the architect. That is why the Rotonda has become the exemplar of ideal architecture.

VENICE AND PADUA IN THE LATE SIXTEENTH CENTURY

IN the last years of his life, after Sansovino's death in 1570, Palladio became the most prominent architect in Venice, and was commissioned for public buildings by the senate. After the fires of 1574 and 1577 he submitted reports for the restoration of the Doge's Palace, though the actual work was carried out by Antonio da Ponte, the 'proto' (architect-in-chief) of the Signoria.[1] Da Ponte was active at the same time on the building of the state prison adjoining the Doge's Palace on the Riva degli Schiavoni.[2] The unadorned façade, appropriate to the purpose of the building, is a variant of Sansovino's style. For the Rialto Bridge (1588–91), Da Ponte's masterpiece, he adopted designs by Palladio (Plates 340 and 341). The stone bridge replaced a wooden draw-bridge. Its width and height had to be calculated for the shipping on the Canal Grande, and the building of shops on the bridge, the open arch over its centre, and the side pavements were also prescribed. The bridge as executed is plainer than Palladio's more ambitious design, but Da Ponte did full justice to the complex requirements and structural difficulties of the commission. The bridge soon became a landmark of Venice.[3]

Beside the art of the great 'foreigner' Sanmicheli, and of Sansovino and Palladio, Venice had its own native building tradition in the sixteenth century which continued,

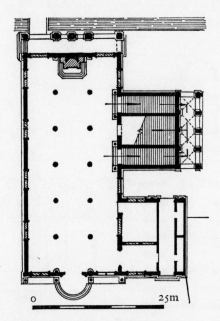

Figure 109. Bon Bergamasco, Scarpagnino, and Giangiacomo da Grigi: Venice, Scuola di S. Rocco, c. 1515ff., 1527ff., and 1549ff., plan

practically unaltered, the architecture of the late Quattrocento. The outstanding masters of this trend, Antonio Abbondio of Lombardy, named Il Scarpagnino (*c.* 1481?–1549), and Giangiacomo da Grigi (first mentioned in 1550, d. 1572), collaborated on the Scuola Grande di S. Rocco (Figure 109), which was finished after a protracted building period about 1560. It may be regarded as a characteristic example of this local style.[4] The complex adjoining the church contains, in addition to the offices and assembly rooms of the Scuola, the great halls made famous by Tintoretto's paintings. In contrast to Sansovino's and Palladio's 'classical' façades, that of the Scuola is an example of display architecture set in front of a building (Plate 342). The free-standing columns of the two storeys stand on far-projecting pedestals, and the crowning cornice has no relation to the gable behind it. The old Venetian delight in costly stone is expressed in the polychrome incrustation. The staircase leading to the upper hall of the Scuola is an important document in the history of the staircase (Plate 343). Two parallel flights with tunnel-vaults lead, half-way up, to a landing; from there a single, broader and domed central flight turns at 180 degrees to reach the upper storey. For all its simplicity, the arrangement is entirely monumental, and the staircase has an importance similar to those in the ricetto of the Laurenziana and at Caprarola.

In Paduan architecture of the middle of the sixteenth century, local tradition also has more force than the new classical art of Sansovino and Palladio. The church of the abbey of S. Giustina and the cathedral, which were built at this time, are among the largest ecclesiastical buildings in Italy.[5] S. Giustina, S. Sepolcro at Piacenza, S. Salvatore in Venice, and a number of other monasteries were united in the Cassinese Congregation. The Byzantino-Venetian plan of the cross-domed church, which first appeared in S. Salvatore and was then adopted by the other two churches, is enriched in S. Giustina by a far-projecting transept with apses (Figure 110). The three gigantic bays of the nave

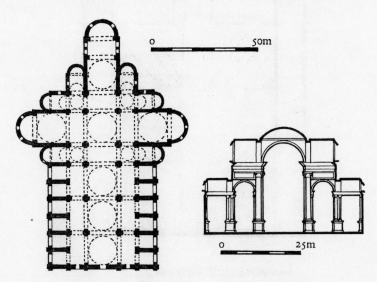

Figure 110. Andrea Moroni and Andrea della Valle:
Padua, S. Giustina, begun 1532, plan and section

(Plate 344) are vaulted with low, windowless domes, but the four domes over the crossing, the choir, and the transepts are brightly illuminated by drums and lanterns. Thus there is an effective contrast between the radiant brightness of the eastern parts and the muted light in the nave.

The rebuilding of the cathedral, for which projects had been commissioned from Sansovino and Michelangelo, was ultimately carried out after a design by Andrea della Valle of Padua (d. in Venice, 1577). The plan is a variation on the type of S. Giustina, but in the cathedral the longitudinal axis is stressed with greater force, while the number of domes is reduced. The abandonment of the rhythmic sequence of the vaults certainly impairs the spatial effect.

Scamozzi

In 1583, Vincenzo Scamozzi (1552–1616), born at Vicenza, was given the commission for the Nuove Procurazie adjoining Sansovino's Libreria on the south side of the Piazza. Scamozzi adopted the system of the Libreria practically without alteration. By the addition of a third storey, the long façade was given its due relationship to the width of the Piazza.[6]

Further, after Palladio's death, Scamozzi finished the Teatro Olimpico at Vicenza (Figure 111); it was opened in 1585 with a performance of *Oedipus Tyrannus*. The auditorium, with its crowning colonnade and its spendid proscenium (*frons scenae*), is certainly inspired by Palladio's design. Scamozzi supplemented the stage wall by the street vistas visible behind the three doorways.[7]

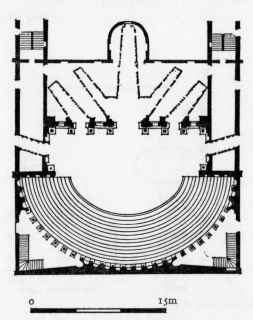

o 15m

Figure 111. Andrea Palladio and Vincenzo Scamozzi:
Vicenza, Teatro Olimpico, opened 1585, plan

318

The Teatro Olimpico was fitted into an older building. A few years later, Scamozzi built for Duke Vespasiano Gonzaga at Sabbioneta the first real theatre in modern architecture (Plate 345). The form of the auditorium is taken from Palladio's Olimpico. The seating in the theatre at Sabbioneta strictly followed court protocol. The duke and his family sat in the loggia crowning the auditorium, his entourage filled the semi-circular steps, while ordinary spectators stood in the pit. Scamozzi abandoned the stage wall of the proscenium, and treated the stage, as Serlio had already done, as one street vista. Palladio's conception of the reconstruction of the antique *frons scenae* was abandoned. It was taken up later by Inigo Jones.[8]

CHAPTER 27

TUSCANY 1550–1600

Ammannati

THE Florentine sculptor Bartolomeo Ammannati (1511–92), who worked under Sansovino on the sculpture of the Libreria in Venice, shows Sansovino's influence in his very first work of architecture, an arch which he constructed in the palazzo of the Paduan doctor of medicine Marco Benavides, between the courtyard and the garden adjoining it (Plate 346).[1] With its vigorous Doric order the arch is an excellent example of a reversion to classical antiquity which was particularly in favour among the humanists of Padua University.[2]

After a short period of work in Urbino, Ammannati went in 1550 to Rome, where he received several important commissions from Julius III on the recommendation of his friend Vasari. His share in the work on the Villa di Papa Giulio has already been mentioned. Certain details which the Villa Giulia has in common with the Villa Imperiale at Pesaro built for the Duke of Urbino may have originated with Ammannati, who became familiar with the Villa Imperiale during his work at Urbino.[3] The garden front of the present Palazzo di Firenze in Rome, which Ammannati renovated and enlarged for Julius III's brother, still recalls the Benavides arch in the consistent application of the classical orders; the shallower relief of the courtyard front (Plate 347) shows his preoccupation with Vignola's style.

Ammannati's architectural masterpiece is the courtyard of the Palazzo Pitti in Florence, begun in 1560 (Plate 349). The Quattrocento building which had passed into the possession of Duke Cosimo I in 1549 consisted only of the façade range; the courtyard had not risen above its beginnings.[4] But a stately courtyard was indispensable for a princely residence in the Cinquecento: further, the rise in the terrain behind the building and its situation on the outskirts of the city gave the opportunity for an ideal composition of palazzo, cortile, and garden. The old building was enlarged by two rear wings, and a large horseshoe-shaped theatre was built in the garden, its level corresponding to that of the piano nobile. The ground floor and pavement of the courtyard are therefore invisible from the theatre; a one-storeyed retaining wall separates the courtyard from the garden. In planning the layout, it had to be taken into consideration that, looking from the garden, the courtyard should be the show façade of the palazzo.

The three-storeyed cortile is one of the most important Cinquecento examples of the use of rustication (Plate 348). Serlio's advice to restrict rustication to fortifications and buildings of a similar character was by no means followed universally, as can be seen in buildings by Giulio Romano, Alessi, and Pellegrini. While the rustication of Sansovino's Zecca façade in Venice is perfectly adapted to the function of the building, in the cortile of the cathedral Canonica or the Palazzo Marino in Milan it is merely the architect's personal mode of expression.

Ammannati, who had collaborated in the building, knew the façade of the Villa di Papa Giulio, which offers one of the few examples of rustication in Roman urban architecture. But whereas Vignola's portal follows Serlio's rule, namely that only the Tuscan order is appropriate to rustication, the rustication of the Pitti cortile stretches up to the Ionic and Corinthian orders of the upper storeys. Various kinds of considerations must have led to the divergence from the canon. The *robustezza* of the rustication was well suited to the princely character of the building. The courtyard was the proscenium for the performances in the garden theatre, in which nature and art were combined in the same way as rustication with architecture. And finally the Quattrocento entrance side was already rusticated.

The only later building of Ammannati's which can compare with the Pitti courtyard in monumentality and power of expression is the Ponte S. Trinità in Florence (Plate 354).[5] The curve of the three arches of the bridge and the roadway across it is formed of elliptical segments; the elasticity of the flat arches connecting the two river banks is like a taut bow. From ancient times, bridge arches had been constructed as semicircles, or segments of circles, and in the Middle Ages occasionally as pointed arches, but the elliptical curve is present in a design by Vignola as early as 1547 for a small bridge near Bologna.[6] Ammannati may also have seen Michelangelo's vault in the piano nobile of the Palazzo Farnese, the curvature of which resembles the three-centred arch, i.e. the ellipse. We know that Vasari discussed the projects for the Ponte S. Trinità with Michelangelo, and brought back drawings and notes to Florence. It is therefore not impossible that Michelangelo devised the arch of the bridge. Ammannati was solely responsible for its execution, however,[7] and the mouldings and heraldic cartouches show his inimitable, dignified, slow-paced calligraphy.

Vasari

Giorgio Vasari (1511–74), as architect of Duke Cosimo I, had a similar function and status to Pellegrini in Milan and Domenico Fontana in Rome. Diplomatic skill, astounding industry, indefatigable energy, and facility in production made him the ideal court artist. It is due above all to his talent for organization that Florence once more became the capital of European art in the late sixteenth century.

At a time when he was arranging the Palazzo Vecchio as a residence for the Duke, Vasari designed the Uffizi, the greatest Florentine building enterprise of the time; in his own words, 'the loggia of the huge building that stretches to the Arno, of all the buildings that I have erected, was the most difficult and the most dangerous, because it had to be constructed over the river and, as it were, in the air'.[8]

The Uffizi, built before the great enterprises of Sixtus V, like the roughly contemporary Escorial is an early example of the architecture of absolute monarchy (Figure 112). It was erected by order of Cosimo I for thirteen administrative agencies, so that they would abandon their time-honoured offices, which were scattered all over the town, and move into the new building. The documents contain urgent reports on the resistance of the guilds to the move and of the owners of the many houses,

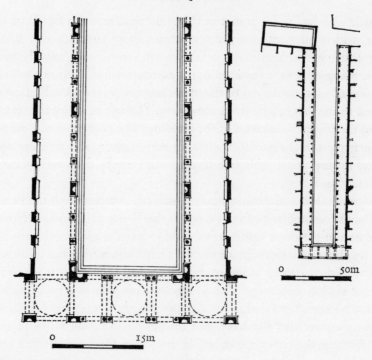

Figure 112. Giorgio Vasari: Florence, Uffizi, 1560–soon after 1580, plan and detail

shops, and workshops demolished or expropriated to make room for the new building.

Work was begun on the foundations in 1560; in 1564 the range adjoining the Palazzo Vecchio was being used and the narrow side looking on the Arno was nearly complete. After Vasari's death the building was continued by Alfonso Parigi and Bernardo Buontalenti, and finished soon after 1580. According to contemporary documents the total cost amounted to 400,000 scudi.[9] The twelve masons and twenty-four workmen were supervised by a deputy overseer, who acted in Vasari's place. For some parts of the building full-scale wooden models were made according to Vasari's directions. As provveditore, Vasari had a salary of 150 scudi and other benefits.

The chronicle mentioned above reports that the old buildings had been pulled down 'in order to construct the street and the new quarters' for the administration. The loggia corridors on the ground floor of the Uffizi were built for pedestrian traffic and for the clients of the authorities waiting in front of the portals (Plate 350). The street (Plate 351), about 140 m. (150 yards) in length and 18 m. (60 feet) in width, lined with uniform four-storeyed façades, which leads from the Piazza Signoria to the Arno, is the urbanistic analogy to the Strada Nuova in Genoa; the client in this case was the ruler of the dukedom of Tuscany, while in Genoa it was the patrician oligarchy of the republic. Consequently, the Florentine buildings are uniform and the Genoese façades vary.

Vasari subdivided the long façade into units of three bays. On the ground floor, coupled Doric columns alternate with thicker pillars. In the main storey, flat wall-strips frame each set of three windows. The middle window has a segmental pediment, the side windows triangular ones, so that the central axis of each group of three has a strong

central accent. A delicate relief, indispensable to the general effect of the long fronts, is given by the shallow projections of the cornice above the pillars and pilaster strips. Complicated details were impossible in a façade of this length and height. The relief had to be easy to read; more powerful projections with rhythmic backward and forward movements would have produced an effect of restlessness.[10]

The vaulting of the ground-floor loggia is lighted by openings in the mezzanine over the Doric order. Similar windows are to be seen in the coffered tunnel-vault of Bramante's choir in S. Maria del Popolo and in the cortile loggia of Peruzzi's Palazzo Massimo. At this point Vasari could quote 'classical' models. On the other hand, there is a novel variation of the traditional coffering in the tunnel-vault.[11]

The choice of the Doric order for the ground floor of the Uffizi was, as Vasari writes, the Duke's. For the construction of the architrave, a new kind of iron clamp was used, which Vasari describes in detail.[12]

While he was supervising the work on the Uffizi, Vasari also had a hand in the rebuilding of the medieval Palazzo Comunale of Pisa, which was remodelled in 1561 by Cosimo I to become the residence of the Cavalieri di S. Stefano, an order which he had founded.[13] In his native town of Arezzo Vasari designed in 1566 the abbey church of SS. Fiora e Lucilla, and in 1573 the Logge Vasariane.[14]

Vasari's modernization of the interior of the great Florentine friars' churches of S. Maria Novella (1565–72) and S. Croce (1566–84) is important for sixteenth-century architecture in Europe. It is closely connected with the ideas of the Council of Trent, and parallel to the contemporary work of Carlo Borromeo in Milan. Both 'purified' churches express the new ideal conception of the open, clarified space which was also expressed in the Gesù in Rome. According to Vasari, he acted by order of Cosimo I, who wished, as a Catholic ruler, to follow the path of the great Solomon 'and to have the churches renovated, improved, and beautified'. So he had to remove the high medieval screens and the monks' choirs from the nave and to place the choir stalls behind the new high altar. In S. Croce a tall gilt ciborium was placed on the high altar; further, in both churches the old altars in the aisles were replaced by uniform, large aedicules with new altar paintings.[15] According to contemporary writers, all other monastic churches were cleared in the same fashion, and looked 'rinate e rimbellite'.[16]

Buontalenti

Vasari's work at the Uffizi was completed by Bernardo Buontalenti (1531–1608), who, in 1586, superintended the building of the theatre in the upper storey – the first permanent theatre in Florence (though later demolished) – and designed the famous *tribuna*, the octagonal domed hall in which the finest pieces of the Medicean art collection were exhibited.[17] Buontalenti owes his reputation above all to his technical skill. He built fortresses, harbours, and canals, and was a fireworks specialist. His greatly admired architectural masterpiece, the Medici villa at Pratolino, near Florence, begun in 1569 (Plate 352), was almost entirely destroyed in the early nineteenth century; according to Montaigne, who visited Pratolino in 1580, its fountains and gardens rivalled those of the

Villa d'Este at Tivoli, though they had 'quelque peu plus de mignardise'.[18] Of the Medici Villa at Signa, also designed by Buontalenti, only the palazzo remains; its plain and undecorated forms recall Florentine villas of the Quattrocento. His large addition to the Palazzo Vecchio continues the type of earlier Florentine façades with its coarse rustication and plain windows.

Where Buontalenti shows an inexhaustible wealth of invention is in his architectural ornament. His native talent was for decorative detail, and form as a whole and articulation remain traditional. A famous example is the Porta delle Suppliche, a side entrance to the Uffizi (Plate 353). The portal is Michelangelesque in type, but Buontalenti varies the motif of the broken pediment by reversing the half-pediments, i.e. by making them sweep up from the centre to the sides. On the portal of the Casino Mediceo, the tympanum is inhabited by a bat-like animal whose wings spread out like a shell. The wavy bands of the archivolts look as though they had been moulded in clay. The same is true of the swags which hold the coat of arms in place as the keystone of the arch.[19]

The system of the façade of S. Trinità in Florence, completed in 1594, in which Buontalenti reverts to the Albertian scheme of S. Maria Novella, looks outdated beside the contemporary façade of S. Susanna in Rome, but the 'pediments, door-frames, cartouches, capitals, and volutes have been given forms never seen before'.[20] Rome has nothing to compare with Buontalenti's high altar in S. Trinità and the staircase leading from the transept to the altar (Plate 355). The banisters taper downwards instead of upwards, and the steps, rolled like volutes, are too narrow for use and are merely there for the visual effect; the actual way up to the altar is at the side, behind the balustrade.[21]

The weak successors of Cosimo I had neither the energy nor the means to continue his great enterprises, so that several of Buontalenti's schemes were abandoned at their beginnings or never carried out. Among these projects are the Cappella dei Principi, the mausoleum of the ducal house, behind the choir of S. Lorenzo, not completed till the eighteenth century, the façade of the cathedral, the reconstruction of the choir of S. Spirito, and Buontalenti's stairway and fountain in front of the Palazzo Pitti.[22]

The many models for the façade of the cathedral made after designs by Buontalenti and his competitors are preserved in the Museo dell'Opera.[23] Compared with the contemporary development in Rome, they have the oddly old-fashioned look of Florentine architecture about 1600, when interest was concentrated more on detail than on the organization of the form as a whole. That also holds good of Buontalenti's contemporary Dosio (1533–c. 1609) and his pupil Ludovico Cardi, called Cigoli (1559–1613), and the architectural work of the sculptor Giovanni da Bologna (1524–1608). The Michelangelesque motif of columns recessed into the wall had no progeny in Rome; in Florence it survives in Dosio's Cappella Niccolini in S. Croce, and in Giovanni da Bologna's Cappella del Soccorso in SS. Annunziata.[24]

Bizzarrie

The bizarre grotto behind the Palazzo Pitti conveys some idea of the vanished gardens laid out by Buontalenti at Pratolino; it is one of the most important examples of the

fusion of nature with art which is an outstanding characteristic of the Cinquecento. The façade (Plate 356), begun by Vasari – the ground floor is a repetition of the Uffizi motif of double Doric columns flanked by pillars – is attached to the passage between the Uffizi and the Pitti. Buontalenti's upper storey can hardly be regarded as architecture; the pumice-stone which hangs from the pediments like stalactites and the mosaic wall make the front look like a freak of nature. Over the architrave of the columns a lunette opens on to the dark interior of the grotto (Plate 357) in which were 'the four rough-hewn figures by the divine hand of Michelangelo, which look as if they had been specially made for this purpose. They support the vaulting. Buontalenti also created many figures, human and animal, and had them painted by his pupil Poccetti'.[25] From the first grotto a passage of artificial rocks leads into a smaller one, which ends in a third grotto with a mosaic wall fountain, from which water drips over rock crystal. In the midst of this cave stands the fountain with Giambologna's nude figure of Venus Anadyomene. It is only when the eye has grown accustomed to the dim light that it becomes aware of the countless shells on the pedestals of the statues and on the walls, the satyrs which look up from the edge of the fountain, the water jets which shoot up round the statue, the seemingly natural forms untouched by human hand on walls and vaults. The grotto represents the birth cave of the Anadyomene. What has been created here, with frescoes, stucco-work, unhewn stone, and flowing water, is the counterpart of the courtly ceremonial in the neighbouring palazzo, a union of nature and art which seems to come from an older, more primitive world.[26]

The strange and intentional contrast between nature not yet shaped and architecture shaped according to the rules of the art can be traced throughout the century. It is first seen in the rusticated base of Bramante's Palazzo Caprini, and in Giulio's Sala dei Giganti and his unfinished, half-hewn columns in the Palazzo del Te at Mantua. Quite similar columns can be seen in the courtyard of Palladio's Palazzo Thiene at Vicenza, and the same building contains a fireplace shaped like the mouth of a huge leafy head, and another like the mouth of Polyphemus. About 1550 the sculptor employed on the building, Bartolomeo Ridolfi, did three similar fireplaces in Sanmicheli's Villa Fumane near Verona.[27] On the ground floor of the studio which Federico Zuccari built for himself in Florence in 1579, 'rough, unhewn' blocks project from the smoothly worked surface, three showing in relief the tools of the painter, sculptor, and architect, and on the upper storey two perfectly 'correct' windows flank a panel, now empty, which was intended for a fresco. As Zuccari explains in his treatise: 'These three professions [are] a single science . . . ; this excellent profession [of architecture] in conjunction with two others appears really as one single and complete science. . . .' With his 'scienza' the artist forms out of the raw material of nature the 'perfect' creation of art.[28]

The quickset mazes and the Rometta of the Villa d'Este at Tivoli, or Buontalenti's grottoes adjoining the Pitti, must be regarded in this sense as pictorial architecture. At Pratolino there was an 'artificial mountain, at the top of which is a white horse, leaping, with two wings, and immediately below . . . there sit the nine muses with Apollo carved in stone'.[29] Thus Pegasus reared on an artificial Parnassus.

The most famous example of bizarre 'pictorial architecture' is the so-called Sacro

Bosco of Bomarzo.[30] In this case, what is represented is the opposite of order and rule. There are no straight paths in the gardens – in contrast to the clarity of the scheme in the Villa d'Este, it is intentionally disordered. In the small house which stands on the hillside there are no right angles; all the walls, floors, and ceilings are off the straight. The tortoises hewn in tufa in the garden are as big as the elephants by the side of them, so that even the dimensions are 'irrational'. Not far from a miniature tempietto (Plate 358) is the monstrous opening of a huge cave, a Gate of Hell (Plate 359), much larger than the portal of the tempietto. The visitor, confronted time and again by extravagance, is encouraged by an inscription to wonder whether so many marvels have been made to deceive him, or to impress him as creations of art.[31] This is a conscious allusion to the ambiguity of all art – it may be truth, and it may be deceit, turning the world upside down, an architectural parallel to the contemporary paintings of Pieter Brueghel.

The client at Bomarzo, Virginio Orsini, who resided in the castle above the garden, was in close contact with the Roman humanists of his day. His letters show that he made a considerable contribution to the design and conception of the complex. The gardens of Bomarzo should not be regarded merely as the capricious idea of an eccentric, for beside the formal canon of Palladio or Vignola, the architecture of the sixteenth century also tolerated the possibility of an uncanonical 'bizzarria', though admittedly the bizarre forms are placed only where they can be justified.

Thus Federigo Zuccari, in the last decade of the century, repeated on the front of his Roman residence, in a somewhat milder form, the 'bizzarrie' of the Florentine façade. The real showpiece, however, is the portal in the wall which originally separated the little garden from the street – a huge, grotesque maw flanked by two similar ones for the windows (Plate 360). It is significant that the portal led into the garden, for in such a situation, as in the garden beside the Pitti, fantastic natural forms and forces 'not yet tamed' were acceptable. It is not by chance that Zuccari's gate of the Inferno in a drawing for the *Divina Commedia* is very similar.[32] From ancient times the architect was regarded as the image of God; as God created the order of the world, the architect creates the order of his building. In the world created by God, Hell is the opposite of 'right being'; in the world of the architect, the 'bizzarrie' are the opposite of rule and order.

NOTES TO PART ONE

NOTE: For full quotations of the works here abbreviated as Stegmann–Geymüller and as Venturi, *Storia*, see Bibliography, section V. 1. 1 (p. 406) and section III (p.400).

For the art and architecture of Italy in the period preceding that dealt with in the present volume, see John White, *Art and Architecture in Italy: 1250–1400* (Pelican History of Art) (Harmondsworth, 1966); for sculpture in the period dealt with in Part One: Charles Seymour Jr, *Sculpture in Italy: 1400–1500* (Pelican History of Art) (Harmondsworth, 1966).

CHAPTER I

p. 3
1. Leone Battista Alberti (ed. L. Mallé), *Della Pittura* (Florence, 1950), 54 (prologue): 'Who is so dull or jealous that he would not admire Filippo the Architect in the face of this gigantic structure, rising above the vaults of Heaven, wide enough to receive in its shade all the people of Tuscany. Built without the aid of any trusswork or mass of timber, an achievement that certainly seemed unbelievable ... in these times as well it might have been unknown and beyond the knowledge of the antique [i.e. architects].'

2. G. C. Argan, *Brunelleschi* (Verona, 1955), 11. See also Marsuppini's epitaph (Note 55, below).

3. For the building history of Florence Cathedral with all documents and complete bibliography, see W. and E. Paatz, *Die Kirchen von Florenz*, III (Frankfurt, 1952), 320 ff., in particular 331–4. The documents *in extenso* in C. Guasti, *La Cupola di S. Maria del Fiore* (Florence, 1857).

p. 4
4. Cf. R. Salvini in *Atti 1° Congresso Nazionale Architettura, 1937* (Florence, 1938), where he points out the very restricted value of the picture of the Duomo in the Spanish Chapel.

A reminiscence of the model of 1367 can also be felt in the dome of the St Philip Reliquary in the Opera del Duomo (Foto Sopr. 23220), *c.* 1400.

5. For the various preparatory models leading up to the final project, cf. Paatz, *op. cit.*, 457, and R. Krautheimer, *Ghiberti* (Princeton, 1956), 254 ff.

6. P. Sanpaolesi, *La Cupola di S. Maria del Fiore* (Rome, 1941); Frank D. Prager, 'Brunelleschi's Inventions and the Revival of Roman Masonry Work', *Osiris*, IX (Bruges, 1950), 457 ff. H. Siebenhüner's important studies have unfortunately remained unpublished; a few references in *Zeitschrift für Kunstgeschichte*, VIII (1939), 90, and *Mitteilungen des Kunsthistorischen Instituts Florenz*, V (1940), 435. See also Note 16.

7. Prager, *op. cit.*, 507.

p. 5
8. Siebenhüner, *op. cit.*

9. Prager, *op. cit.*, 458.

10. The best summary of the established biographical data is still C. von Fabriczy, *F. Brunelleschi* (Stuttgart, 1892), 609, and in *Jahrbuch der Preussischen Kunstsammlungen* (1907), supplement.

11. Filippo's father was also a member of the commission of experts appointed to judge the model of 1367 mentioned above. Cf. Prager, *op. cit.*, 460; P. Sanpaolesi, *Brunelleschi e Donatello nella Sagrestia Vecchia di S. Lorenzo* (Pisa, 1948), 43.

12. The goldsmiths, who were affiliated to the Arte della Seta, were the noblest of the Guilds of the Greater Arts. The documents, published in Fabriczy, *op. cit.* (1907), show that Brunelleschi was enrolled twice in the matricula of the goldsmiths: in 1398 and again in 1404. The meaning of this duplicate entry has not yet been elucidated. Brunelleschi did not figure as an independent master in the contracts with the cathedral authorities of Pistoia in 1399, but only as an assistant on the silver altar (cf. Sanpaolesi, 'Aggiunte al Brunelleschi', *Bollettino d'Arte* (1953), 225); but he must all the same have passed master in order to enter for the competition for the door of the Florence baptistery in 1401, and probably did so about 1400.

13. For Brunelleschi's scientific attainments, as far as they can be gathered from the sources, Fabriczy, *op. cit.*, 5 ff.; P. Sanpaolesi, 'Ipotesi sulle conoscenze matematiche, statiche e meccaniche del Brunelleschi', *Belle Arti* (Pisa, 1951), 1 ff.

14. Cf. E. Panofsky, *Artist, Scientist, Genius. Notes on the Renaissance Dämmerung* (New York, The Metropolitan Museum of Art, 1953), 83 ff.

15. See above, Note 6.

p. 6
16. The mechanical constructions and inventions are very clearly analysed by Sanpaolesi, *op. cit.* (Note 6), 16 ff. The employment of the endless screw is particularly important (p. 21). See also L. Reti, *Tracce dei progetti perduti di Filippo Brunelleschi nel Codice Atlantico di Leonardo da Vinci* (IV Lettura Vinciana) (Florence, 1965), and F. D. Prager and G. Scaglia, *Filippo Brunelleschi. Studies*

of his Technology and Inventions (Cambridge, Mass., 1970).

p. 6 17. Sanpaolesi, *op. cit.* (Note 13).

18. For Brunelleschi's perspective constructions, the latest study is A. Parronchi, 'Le due tavole prospettiche del Brunelleschi, Paragone 107', *Arte* (1953), 3 ff. and 109, *ibid.* (1959), 3. Further, H. Siebenhüner, *Kunstchronik*, VII (1954), 129 ff.; Sanpaolesi, *op. cit.* (Note 13), 3 ff.; *idem*, *op. cit.* (Note 11), 41 ff.; John White, *Warburg Journal*, IX (1946), 103 ff.; E. Panofsky, *The Codex Huygens and Leonardo da Vinci's Art Theory* (Studies of the Warburg Institute, XIII) (London, 1940), 93 ff.; R. Wittkower, *Warburg Journal*, XVI (1953), 275.

19. Cf. Argan, *op. cit.*, 18–19.

20. Building history in detail and bibliography in Paatz, *op. cit.*, II, 442 ff. For documents, see Fabriczy, *op. cit.*, 555 ff. For the best analysis of formal elements, see Stegmann–Geymüller, I, 6–8. For the capitals, H. Saalman, 'Brunelleschi, Capital Studies', *Art Bulletin*, XL (1958), 120 ff., and M. Gosebruch, 'Florentinische Kapitelle von Brunelleschi bis zum Tempio Malatestiano und der Eigenstil der Frührenaissance', *Römisches Jahrbuch für Kunstgeschichte*, VIII (1958), 63 ff. Brunelleschi resigned as architect in chief in 1424. See G. Marozzi, 'Ricerche sull'aspetto originale dello Spedale degli Innocenti', *Commentari*, XV (1964), 166 ff.; A. Mendes and G. Dallai, 'Nuove indagini sullo Spedale degli Innocenti', *ibid.*, XVII (1966), 83 ff.

21. For the Ospedale S. Matteo (now the Accademia delle Belle Arti), cf. Barbacci in *Bollettino d'Arte* (1938), 65, and *Le Arti*, IV (1942), 225, where there is also an account of the Ospedale S. Antonio at Lastra a Signa, which was, like the foundling hospital, endowed by the Arte della Seta.

p. 7 22. The most accurate summary of Romanesque formal motifs which Brunelleschi could draw on is still that by Paolo Fontana in *Archivio Storico dell'Arte*, VI (1893), 256. Cf. also H. Folnesics, *F. Brunelleschi* (Vienna, 1915), 11 ff., and the review of it by P. Frankl in *Repertorium etc.* (1919), 225. See also recently H. Burns, 'Quattrocento Architecture and the Antique. Some Problems', in R. R. Bolgar (ed.), *Classical Influence on European Culture* (London, 1971); H. Klotz, *Frühwerke Brunelleschi's und die mittelalterliche Tradition* (Berlin, 1970). For the eight-volute capital, cf. L. Heydenreich, *Jahrbuch der Preussischen Kunstsammlungen* (1931), 18 and Saalman, Gosebruch, and others.

23. For the module of the Ospedale cf. Stegmann–Geymüller, I, 8.

24. The grand layout of the Ospedale S. Maria Nuova (cf. Paatz, *op. cit.*, IV, 1 ff.) has not yet been properly studied as a standard example for the development of modern hospital building (G. Pampaloni and U. Procacci, *Lo Spedale di S. Maria Nuova* (Florence, 1961), only deal with Buontalenti's loggia). The uninterrupted modernization of the buildings which went on till very recently is covering up the last vestiges of the original. I am indebted to Dr Carlo Donzelli, Director of the hospital, for a reproduction of the whole complex as it appeared in the eighteenth century (Figure 3). The cross-shaped plan of the great wards dates from the first third of the fourteenth century and seems to have been the prototype of its kind. The hospital of S. Spirito in Sassia, Rome, was enlarged in the fifteenth century after the pattern of S. Maria Nuova. See below (p. 62).

25. For the building history and literature, cf. Paatz, *op. cit.*, II, 464 ff.; Saalman, *op. cit.*, 123 ff. Excellent illustrations in P. Sanpaolesi's remarkable study cited in Note 11. Donatello's intervention in the layout of the Sagrestia Vecchia will be discussed later (p. 25). The side chapels in the nave were not provided for in the original plan, but were part of an extension carried out in 1442, in my opinion suggested by the plan of S. Spirito; Fabriczy, *op. cit.*, 158 and 163 ff. A valuable recent account of the building history of S. Lorenzo is in V. Herzner, 'Die Kanzeln Donatellos in S. Lorenzo', *Münchner Jahrbuch der bildenden Kunst*, XXIII (1972), 101, esp. 118 f.

26. Brunelleschi had only two models for the p. construction of the pendentive in Tuscany: S. Paolo a Ripa d'Arno in Pisa, and the Pieve of Arezzo. The pure pendentive does not seem to have been developed in antique architecture, but only in Byzantium. It is frequent in the Veneto, and the surprising resemblance between the baptistery of Padua and the spatial composition of the Sagrestia Vecchia – the latter is simply a remodelling of the Paduan building on the basis of the *ratio* of the new style – suggests very forcibly that Brunelleschi had known this, or some other similar medieval Byzantine building. Analogous Gothic types of spatial compositions in Florence, such as the baptistery of S. Croce or the Spanish Chapel in S. Maria Novella, could not have given him any constructive ideas. See also below, Note 29.

27. For Brunelleschi's development of the technical combination of pendentive and dome, cf. Heydenreich, *op. cit.* (Note 22), 7; Sanpaolesi, *op. cit.* (Note 11), 22, and also in *Atti del 1° Congresso*

Nazionale di Architettura, 1936 (Florence, 1938), 37 ff.

28. Cf. Heydenreich, *op. cit.*, 14.

29. Modern as it is, the design of S. Lorenzo makes full allowance for all the requirements of the cult and liturgy; none has been left out of account. The Sagrestia Vecchia, as the mausoleum of the Medici, is even furnished with 'iconographical features', which stress its antique type (cf. the latest study by G. Bandmann, 'Über Pastophorien . . . im mittelalterlichen Kirchenbau', in *Essays in Honour of Hans Kauffmann* (Berlin, 1956), 56 ff.). In this connection there may be an explanation of the curious form of the lantern: the onion shape and spiral flutings are nothing more nor less than a reproduction of the Holy Sepulchre in Jerusalem. This is the only case in which Brunelleschi made use of the iconographic type of sepulchral chapel, while Alberti did so in his idealized imitation of the Holy Sepulchre for the Rucellai in S. Pancrazio (see below, p. 34).

30. Building history and bibliography in Paatz, *op. cit.*, v, 117 ff. See also Saalman, *op. cit.* (Note 20), 129 ff.

31. Cf. Antonio Manetti (ed. E. Toesca), *Vita di Filippo di Ser Brunelleschi* (Florence, 1927), 79–80; cf. also the new edition by H. Saalman, *The Life of Brunelleschi by Antonio di Tuccio Manetti* (University Park, Pennsylvania State University Press, and London, 1970), 120 ff. This would have been the first monumental piazza in modern architecture with a consciously calculated, and certainly magnificent, perspective effect. The idea had its influence on the later, scenographically planned piazzas of the Early Renaissance (Pienza, Vatican Borgo, and Alberti's and Filarete's treatises).

32. A very important remark by Paatz, *op. cit.*, 118 and 175, note 70.

33. Manetti, *op. cit.*, 80; ed. Saalman, *op. cit.*, 126–7.

p. 12 34. The size of the bays is calculated exactly, with allowance made for the diameters of the columns and the thickness of the wall, which was not yet the case in S. Lorenzo. Cf. Heydenreich, *op. cit.*, 11–12.

35. A statement like the following – 'that Brunelleschi wanted his buildings to be looked at as if they were projected on to an intersection' (Wittkower, in an otherwise excellent study, *op. cit.* (Note 18), 289) – seems a little excessive. That a space constructed by Brunelleschi on a true scale of proportions throughout should at the same time have an adequate pictorial effect is a natural, and

certainly intentional product of the use of linear perspective. Yet to my mind it is going too far to assume that the architect wished his work to be viewed as a picture. Jacob Burckhardt has given the perfect formulation of the interplay of pictorial effects in Early Renaissance architecture in one brief phrase: 'In his early work *Della pittura*, Alberti even derives architecture from an existing art of painting; according to him, the master-builder first learns his posts and lintels from the artist – the most cogent argument for the pictorial conception of architecture in the Early Renaissance' (*History of the Renaissance in Italy*, I, v, para. 30). See also L. H. Heydenreich, 'Strukturprinzipien in der Florentiner Frührenaissance-Architektur: Prospectiva Aedificandi', *Papers of the XXth International Congress of the History of Art* (Princeton, 1962), II, 108 ff.

S. Spirito is the one and only church in which Brunelleschi had to abandon basic forms of traditional church planning in the logical development of this scheme of composition; the quadripartite division of the front wall required four porches at the west end. In the controversy about the composition of the west front of the church which was not fought out till 1481, the conflict came to a head; if the three-bay front sanctified by custom and symbolic value was to be retained, the logic of Brunelleschi's composition would have to be destroyed. This very illuminating proceeding will be discussed later (see p. 135 and Chapter 13, Note 26). If the conventional form of the three porches won the day in spite of the vehement opposition of the more qualified personalities, it proves how deeply the Florentines were committed to a 'convenienza' of the religious building sanctified by tradition. It was only in isolated examples that a conception of form triumphed over functionalism in Florence, and where it did, some external and therefore historically important factor was always at work. The most striking example is the chancel of SS. Annunziata, which will be briefly discussed later.

36. Plans and sections in Stegmann–Geymüller, I, 20 ff. Building history and bibliography in Paatz, *op. cit.*, I, 515 and 537. The most recent studies and the startling deductions drawn from them by a group of Sanpaolesi's pupils (G. Laschi, P. Roselli, P. A. Rossi) are published in *Commentari*, XII (1961), 24 ff. (published in 1962).

37. A glance at the ground plan of the friary (Paatz, *op. cit.*, 515; our Figure 6) will show that the outline of the Pazzi Chapel was almost entirely

determined by the older parts of S. Croce still standing. Cf. also *Commentari, op. cit.,* 33.

p. 13 38. For an ideal reconstruction sketch see Folnesics, *op. cit.,* 68–9. The parapet balustrade on the portico is a nineteenth-century addition, which, most happily, remained unfinished. Old views of the Pazzi Chapel in M. L. Thompson, *Marsyas,* VI (1954), 70 ff.

39. Construction sketch of the cupola in *Commentari, op. cit.,* 33. For the development of Brunelleschi's domes, see Note 56.

p. 14 40. Valuable discoveries concerning the works on the Pazzi Chapel in Saalman, *op. cit.,* 127, and in *Commentari, op. cit.,* 25 ff.

41. Cf. Sanpaolesi, *op. cit.* (Note 12), and Argan, *op. cit.,* 33.

42. I think it very likely that Giuliano da Maiano, whose collaboration in the Pazzi Chapel is established by documentary evidence, took a leading part in the building of the portico. Cf. *Commentari, op. cit.,* 26.

43. Building history in Paatz, *op. cit.,* III, 107 ff. The unfinished building was wretchedly restored in 1937. Our Figure 7 is drawn from an engraving of 1821, which represents a so-called model of Brunelleschi then still existing (cf. *Osservatore Fiorentino,* 1821); further Marchini in *Atti 1° Congresso Nazionale di Architettura, 1936* (Florence, 1938), 147, and Siebenhüner, *op. cit.* (1939; Note 6), 89.

44. Cf. Heydenreich, *op. cit.* (Note 22), *passim.* Sanpaolesi's and Argan's arguments – the former in *op. cit.* (Note 6), the latter in *Warburg Journal* (1946) – have proved that Brunelleschi's studies of antiquity began early in his life, and that there was therefore a first stay in Rome. This gives greater significance to the second phase of Brunelleschi's assimilation of Roman building, which opened up classical building construction to him and therefore led to the conscious employment of a completely novel manner of building, one capable of generating new styles.

p. 15 45. Manetti, *op. cit.,* 61–2. The central plan became the ideal – if ever – only towards the end of the century. But a centrally planned building was never erected in the Quattrocento unless it was justified by the purpose of the religious building concerned; they were always oratories or pilgrimage churches or memorial chapels. We shall return to this important point later.

p. 16 46. This is also proved by the unusually large number of drawings of the plan of S. Maria degli Angeli, which go from Leonardo and Giuliano da Sangallo into the Seicento and even later.

47. Cf. Paaatz, *op. cit.,* III, 333; P. Sanpaolesi, 'L Lanterna di S. Maria di Fiore', *Bollettino d'Arte* (1956), 210 f., where the authenticity of the model of the lantern in the Opera del Duomo is discussed and confirmed.

48. The next example of their variation is Alberti's volutes on the façade of S. Maria Novella.

49. The tabernacle shape – in the last resort probably borrowed from goldsmiths' work (cf. the knob of the bishop's crozier in Donatello's St Louis) – which Brunelleschi gave to the lantern requires more ornate decoration than the type of aedicule with columns current up to that time. The structure as a whole is certainly an idea of Brunelleschi's. His successors, especially Michelozzo, found scope for their imagination and invention in the execution of the details.

50. Cf. Paatz, *op. cit.,* III, 334; Saalman, *op. cit.,* 133 ff.

51. Cf. Heydenreich, *op. cit.* (Note 22), 14.

52. We must resign discussion here in any detail of the palazzi ascribed to Brunelleschi – Casa Lapi, Palazzo Busini, Palazzo Bardi (cf. Fabriczy, *op. cit.,* 52 and 286 ff.). For Brunelleschi's work in fortification and secular building cf. the outline given by Argan, *op. cit.* (Note 2), 143 ff. The Palazzo Pitti will be discussed by itself below.

53. Cf. Giorgio Vasari (ed. G. Milanesi), *Vite . . .* (Florence, 1878 ff.), II, 371; Fabriczy, *op. cit.,* 300. Manetti does not mention the Palazzo Medici.

54. Cf. Argan, *op. cit.* (Note 2), 148; M. Salzini, p. 17 'Il Palazzo della Parte Guelfa', *Rinascimento,* II (1951), 3; A. Chiapelli, in *Nuova Antologia* (March 1923), 3 ff.

55. The boundless admiration of his contemporaries is expressed in the beautiful words of Carlo Marsuppini in Brunelleschi's epitaph (1456) in the cathedral of Florence: Quantum Philippus Architectus Arte Daedalaea valuerit cum huius celeberrimi templi mira testudo tum plures machinae divino ingenio abeo adinventae documento esse possunt. Quapropter ob eximias sui animi dotes singularesque virtutes XV° Kl Maias Anno M°CCCC° XLVI° eius B. M. corpus in hac humo supposita grata patria sepelleri jussit.

56. Brunelleschi's domes on pendentives show a steady improvement in their constructional technique, especially in the relation between the spatial effect in the interior and the monumentality of the exterior. The employment of the heightened outer shell – first used in the Pazzi Chapel – and the insertion of the drum between the spandrel zone and the springing of the dome – first used in the dome

over the crossing in S. Spirito – are Brunelleschi's 'inventions' and remained the rule for every later dome. (The dome over the crossing in S. Lorenzo was disfigured by Brunelleschi's successor because he had no intelligible model before him.) Whether the Cappella Barbadori in S. Felicità can actually be attributed to Brunelleschi, as a kind of rehearsal in dome construction, must be left open, in spite of the growing tendency to ascribe it to him (Fontana, Sanpaolesi, Saalman, Argan, and others). In my opinion the mediocre quality of the formal elements would point the other way. The counter-arguments have been convincingly set forth by U. Schlegel, 'La Cappella Barbadori', *Rivista d'Arte*, XXXII (1957), 77 ff.; cf. also Heydenreich, *op. cit.* (Note 35), 121 f. The most recent apologist of the Barbadori Chapel, H. Klotz (*op. cit.* (Note 22), 27 f. and 130 ff.), does not adduce factual proof for his attribution.

CHAPTER 2

18 1. See Bibliography under Architects: Michelozzo.

2. For Michelozzo's work in sculpture and his association with Ghiberti and Donatello, cf. O. Morisani, *Michelozzo architetto* (Turin, 1951), 85 ff.; R. Krautheimer, *Lorenzo Ghiberti* (Princeton, 1956), *passim*; J. Pope-Hennessy, *Italian Renaissance Sculpture* (London, 1958); Charles Seymour Jr, *Sculpture in Italy: 1400–1500* (Pelican History of Art) (Harmondsworth, 1966), 288 ff.

3. There is no really adequate study of Michelozzo as a sculptor. Summary but excellent analysis of his style by R. Longhi, *Vita artistica*, II (1927), 16 f. See also L. H. Heydenreich, 'Gedanken über Michelozzo', *Festschrift für W. Pinder* (Leipzig, 1938), 285. H. W. Janson's M.A. thesis (Harvard, 1937) was unfortunately never published. Pope-Hennessy, *op. cit.*, 288 ff.; Seymour, *op. cit.*, *passim*.

4. Orcagna's influence on Michelozzo's work, including his sculpture, was in my opinion considerable.

5. H. Siebenhüner and L. H. Heydenreich, 'Die Klosterkirche S. Francesco al Bosco in Mugello', *Mitteilungen des Kunsthistorischen Instituts Florenz*, V (1937–40), 183 and 387 ff.; Morisani, *op. cit.*, 35 and 88.

. 19 6. Paatz, *op. cit.* (Chapter 1, Note 3), III, 8 ff.; G. Marchini, 'Il S. Marco di Michelozzo', *Palladio*, VI (1942), 102; *idem*, 'Aggiunte a Michelozzo', *Rinascità*, VII (1944), 37.

7. Vasari, *op. cit.* (Chapter 1, Note 53), II, 441.

. 20 8. For the sacristy, or more precisely Chapel of

the Novitiate, in S. Croce, cf. Paatz, *op. cit.*, 508.

9. L. H. Heydenreich, 'Die Tribuna der SS. Annunziata, Florence', *Mitteilungen des Kunsthistorischen Instituts Florenz*, III (1931), 258; W. Lotz, *ibid.*, V (1937), 402; Morisani, *op. cit.*, 59 and 91; Paatz, *op. cit.*, I, 62 ff.; S. Lang, 'The Programme of the SS. Annunziata', *Journal of the Warburg and Courtauld Institutes*, XVII (1954), 288 ff.

10. The view put forth by Lotz that there was no articulation by pilasters in the interior applies only to the chancel. The pilasters in the transept can be clearly distinguished in the drawing in the Florentine State Archives (reproduced by Lotz); they correspond to the articulation of the walls of the nave. That is what makes SS. Annunziata the prototype of the pilastered aisleless church with side chapels, which was further developed in S. Francesco al Monte, in the Annunziata at Arezzo, and above all in Rome. Alberti's extension of this type will be discussed separately below.

11. The following examples of Michelozzo's p. 21 capitals will illustrate the quality of his decorative imagination: S. Francesco al Bosco, 1427; Brancacci tomb, Naples, *c.* 1430; altar canopy of S. Miniato, 1448; Palazzo Medici, 1445–50; S. Marco, Florence, *c.* 1438; lantern of Florence Cathedral, *c.* 1450; vestibule of SS. Annunziata, 1450.

12. For the SS. Annunziata ciborium, cf. Paatz, *op. cit.*, 97; for the tabernacles at Impruneta, Venturi, *Storia*, VIII, 309. We know of only two more early examples of the fluted column: in the courtyard of the small Palazzo Gerini in Via Ginori, probably built by Michelozzo (*c.* 1460), and Alberti's porch of S. Pancrazio (see below).

13. Vasari, *op. cit.*, II, 442 ff., names, in addition to the villas and churches listed below (see Notes 16 and 17), the rebuilding of S. Girolamo, Fiesole, and a design for the pilgrims' hospital at Jerusalem, endowed by Cosimo. No trace of it has survived. Vasari also mentions the shrine in S. Miniato (Plate 9), which, according to him, Michelozzo built to a commission from Piero de' Medici (cf. comments in C. von Fabriczy, 'Michelozzo di Bartolomeo', *Jahrbuch der Preussischen Kunstsammlungen*, XXV (1904), supplement, 34 ff.).

14. For the library of S. Giorgio Maggiore, Venice, cf. Morisani, *op. cit.*, 43 and 89; F. R. Horne, 'Michelozzo Michelozzi', *Journal of the Royal Institute of British Architects*, XIX, III (1912), 208. W. Timofievitsch, 'Ein neuer Beitrag zur Baugeschichte von S. Giorgio Maggiore', *Bollettino del centro ... Andrea Palladio*, V (1963), 334 ff., publishes a drawing of the early Cinquecento

which shows the site of Michelozzo's library.

p. 21 15. Palazzo Medici, 1444–67. Cf. Morisani, *op. cit.*, 53 and 92; G. and C. Thiem, *Toskanische Fassaden-Dekoration* (Munich, 1964), 61 ff.; W. A. Bulst, 'Die ursprüngliche innere Aufteilung des Palazzo Medici', *Mitteilungen des Kunsthistorischen Instituts Florenz*, XIV (1969/70), 369 ff.; R. Hatfield, 'Some Unknown Descriptions of the Medici Palace in 1459', *The Art Bulletin*, LXII (1970), 232 ff. Later variants: Palazzo Strozzino, ground floor (Morisani, *op. cit.*, 95); courtyard of the Palazzo della Signoria (*ibid.*, 98); Palazzo Gerini-Neroni (W. Limburger, *Gebäude von Florenz* (Leipzig, 1910), no. 279, p. 65); Thiem, *op. cit.*, 57.

p. 23 16. The latest study of the villas in Morisani, *op. cit.*, 53 and 92. See also B. Patzak, *Palast und Villa in Toskana* (Leipzig, 1913), II, 67; C. Frommel, *Die Farnesina* (Berlin, 1961), 85 ff. Approximate dates: Trebbio, 1430; Caffagiuolo and Fiesole (Villa Mozzi), 1450; Careggi, 1457. A. Jahn-Rusconi, *Le Ville Medicee* (Rome, 1938).

17. Chiesa di Trebbio, *c.* 1430; S. Girolamo, Volterra, 1447.

18. Heydenreich, *op. cit.* (Note 3), 274, and Morisani, *op. cit.*, 95.

19. A very accurate idea of the Banco Mediceo, Milan, built after a design by Michelozzo, can be obtained from a drawing in Filarete's Treatise (Figure 34). The surviving portal, now in the Museo del Castello Sforzesco, is the work of Milanese masons. For Michelozzo's concessions to the Upper Italian style, good observations in H. Folnesics, 'Der Anteil Michelozzo's an der Mailänder Renaissance Architektur', *Repertorium für Kunstwissenschaft*, XL (1917), 12. The Portinari Chapel in S. Eustorgio will be discussed in another connection (p. 100). Cf. Morisani, *op. cit.*, 96 f.

20. Michelozzo's share in the restoration work on the Rectors' Palace, Dubrovnik, has been convincingly demonstrated by H. Folnesics, 'Studien zur Entwicklungsgeschichte der Architektur und Plastik des 15. Jahrhunderts in Dalmatien', *Jahrbuch des Kunsthistorischen Instituts der K.K. Zentralkommission für Denkmalpflege*, VIII (1914), 191 ff. Cf. Morisani, *op. cit.*, 97 f.

21. Michelozzo's decorative forms certainly owe a great deal to the ideas he received in his years of association with Donatello (see below). Yet he avoids the capriciousness which is the stamp of Donatello's ornament. When Michelozzo is working on his own he always subordinates ornament to structure. In the Palazzo Medici (courtyard, chapel, coffered ceilings), in the Annunziata

(vestibule), in the altar shrine of S. Miniato, and in the lantern of the Duomo he elaborates his own ornamental forms, richer than Brunelleschi's, more restrained than Donatello's; they are among the best produced in the Early Renaissance. Cf. also Gosebruch, *op. cit.* (Chapter 1, Note 20), 128 ff.

CHAPTER 3

1. For Ghiberti the architect the most recent p. study is R. Krautheimer, *Lorenzo Ghiberti* (Princeton, 1956), 254 ff. His collaboration in the building of the dome of Florence Cathedral was soon terminated by Brunelleschi. Sanpaolesi's attempt to make Ghiberti an equal associate is countered by the clear evidence of the documents (P. Sanpaolesi, *Rivista d'Arte*, XV (1936), 361 ff.; contested by A. Pica, *Emporium*, XCVII (1943), 70 ff., and Krautheimer, *op. cit.*, 255). Ghiberti's activities as a practical architect were limited to minor works; in more important enterprises, for instance in the competition for the lantern on the dome, he was never successful. Ghiberti must have realized his inadequacy, which also explains his attempted apologia at the end of his autobiographical *Commentarii*. The treatise on architecture which he announces there was never written. His feeling for architecture comes out all the more impressively in the ideal architecture of the backgrounds of his reliefs. It should not be underrated.

2. Krautheimer, *op. cit.*, 269 ff. and 315 ff. (Ghiberti and Alberti).

3. Cf. Kenneth Clark, 'Architectural Backgrounds in Fifteenth-Century Italian Painting', *The Arts* (1946–7), I, 13 ff.; II, 33 ff.

4. In 1418–19 Donatello and Nanni di Banco were paid for their work on the construction of the great model of the cathedral dome (C. Guasti, *La Cupola di S. Maria del Fiore* (Florence, 1857), document 43), but Donatello had no share in the idea of its construction. The great importance of his architectural ornament is still best described in W. von Bode, 'Donatello als Architekt und Dekorator', *Jahrbuch der Preussischen Kunstsammlungen* (1901); also H. von Geymüller, *ibid.* (1894), 256, and Stegmann–Geymüller, II, 2. A very valuable recent study is M. Lisner, 'Zur frühen Bildhauerarchitektur Donatellos', *Münchner Jahrbuch*, IX/X (1958–9), 72 ff. Cf. also Gosebruch, *op. cit.* (Chapter 1, Note 20), 110 ff.

5. Documents in C. von Fabriczy, *Jahrbuch der Preussischen Kunstsammlungen* (1905), 242 ff. For

later criticism, which has fallen back on Fabriczy's early dating, cf. Lisner, *op. cit.*

6. Cf. Bode, *op. cit.*, 28 (and p. 11, Tribüne von S. Lorenzo aus der Schule Donatellos).

p. 25 7. In a number of documents Donatello and Michelozzo are called 'compagni', which gives an idea of their fourteen years' association (1425–38). Cf. V. Martinelli, 'Donatello e Michelozzo a Roma, I', *Commentari*, VIII (1957), 167 ff., especially 171–3; Lisner, *op. cit.*

8. Dates and bibliography in C. von Fabriczy, *Jahrbuch der Preussischen Kunstsammlungen* (1904), Beiblatt, 34 ff. Cf. also O. Morisani, *Michelozzo architetto* (Turin, 1951), *passim*. Florence: Baldassare Coscia tomb, 1425–8; Naples: Brancacci tomb, 1426–8; Montepulciano: Aragazzi tomb, 1427–37; Prato: pulpit, 1433–8. See also R. G. Mather, 'New Documents on Michelozzo', *The Art Bulletin*, XXIV (1942), 226–39; O. Morisani, *Fonti per lo studio di Donatello* (Naples, 1946); Martinelli, *op. cit.*; Lisner, *op. cit.*, 85; J. Pope-Hennessy, *Italian Renaissance Sculpture* (London, 1958), *passim*.

9. I would not even venture to ascribe the whole design of the Prato pulpit to one master rather than to the other. In my opinion it developed, with the change of plan, out of a collaboration between the *compagni*. While the bronze capital may be accepted as Donatello's invention, the soft outlines of the pilasters seem to point to Michelozzo. It is difficult to do justice to talent when it is associated with genius.

10. Sanpaolesi, *op. cit.* (Chapter 1, Note 11), convincingly dates the beginning of the Donatello stage of building about 1429; the actual work must have lasted through the thirties (Lisner, *op. cit.*, 81 ff.). Donatello's 'sculptor's architecture' offers a striking contrast to the spatial organization of Brunelleschi. Donatello's heavy columned porticoes changed the apse of the Sagrestia Vecchia in a way that was certainly not foreseen in Brunelleschi's original plan. In my opinion, the idea that these alterations of Donatello's were not approved by Brunelleschi is no more than an old but unreliable anecdote (Manetti, *op. cit.* (Chapter 1, Note 31), 65). The truth must rather be that Donatello's feeling for relief in architecture was not without its influence on Brunelleschi, as can be seen in the stronger modelling of the Pazzi Chapel, which came immediately after it.

11. Cf. Martinelli, *op. cit.* Michelozzo's collaboration in the tabernacle and in its reconstruction as set forth by Martinelli must remain hypothetical.

12. Cf. the famous passages in L. B. Alberti, *De* p. 26 *re aedificatoria*, VII, 3, VIII, 1, and IX, 1.

13. For Alberti's conception of *varietà*, see M. Gosebruch, *Zeitschrift für Kunstgeschichte* (1957), 229 ff.

We should not leave unmentioned among Donatello's architectural works the huge pedestal of the Gattamelata statue in Padua. Conceived as a tomb 'all'antico' and imposing in its grandeur, it is Donatello's most monumental 'building'. There are good illustrations in E. Panofsky, *Tomb Sculpture* (New York, n.d.), plates 392 and 393, and M. Gosebruch, *Das Reiterdenkmal des Gattamelata* (Reclam Werkmonographien, XXIX) (Stuttgart, 1958), plate 1.

CHAPTER 4

1. In addition to the three main treatises, *De* p. 27 *statua* (1434–5), *De pictura* (1435–6), and *De re aedificatoria* (1444–52), mention must be made of *Descriptio urbis Romae* (1432–4), *Elementa picturae* (c. 1435), *Della prospettiva* (lost). There is still useful bibliography of Alberti's writings in F. H. Michel, *La Pensée de L. B. Alberti* (Paris, 1930), 10–46. Subsequent re-publications: *Della pittura* (ed. L. Mallé) (Florence, 1950); *De re aedificatoria*, in the English translation by Leoni, facsimile with foreword and notes by J. Rykwert (London, 1955). For Alberti's theory of art, see J. von Schlosser, *Die Kunstliteratur* (Vienna, 1924; Italian ed., *La Letteratura artistica*, Florence, 1964), and the brilliant study by Kenneth Clark, *Alberti on Painting* (London, 1944). See also G. Hellmann, *Studien zur Terminologie der Kunsthistorischen Schriften L. B. Albertis*, MS. thesis (Cologne, 1955).

2. *Dell'architettura*, lib. IX, c. 11: 'fa di aver prima bene esaminate e considerate in ogni loro minima circostanza le imprese che tu metterai fuori. Il dar fine colle mani d'altri alle tue invenzione e immaginazioni è cosa grande e faticosa.'

3. The most exhaustive and reliable source documentation for the life of Alberti is still G. Mancini, *Vita di L. B. Alberti*, 2nd ed. (Florence, 1911), and C. Ricci, *Il Tempio Malatestiano* (Milan-Rome, 1924). Important later discoveries are the date of Alberti's birth (C. Ceschi, 'La Madre di L.B.A.', *Bollettino d'Arte* (1948), 191), and the reappearance of Alberti's famous letter to Matteo de' Pasti of 18 November 1454 (C. Grayson, *An Autograph Letter from L.B.A. etc.* (New York, The Pierpont Morgan Library, 1957)). See also R. Watkins, 'The Authorship of the Vita anonyma of Leon

Battista Alberti', *Studies in the Renaissance*, IV (1957), 101 ff. An extensive bibliography on Alberti is now available in J. Gadol, *Leon Battista Alberti* (Chicago and London, 1969).

p. 28 4. Cf. E. Garin, in *Enciclopedia dell'arte* (Rome, 1958), I, cols. 211 ff.; *idem*, *L'Umanesimo italiano* (Bari, 1952), 81 ff.; C. Grayson, 'The Humanism of Alberti', *Italian Studies*, XII (1957), 42 and 49.

5. Mancini, *op. cit.*, 88 ff.

6. Cf. Grayson, *op. cit.* (Note 4), 52; Garin, *Enciclopedia dell'arte (op. cit.)*, col. 214.

p. 29 7. Ricci, *op. cit.*, 95; Venturi, *Storia*, VIII (I), 165 f. The campanile of the Duomo may also go back to a design of Alberti.

8. It was not until this time that there appeared – as a pure work of scholarship, to which Alberti, as he says himself, had prompted his 'amici litterati' – the *Descriptio Urbis Romae*, the first modern city topography on a mathematical basis; see O. Lehmann-Brockhaus, *Kunstchronik*, XIII (1960), 346. Text: *Descriptio Urbis Romae* (ed. G. Mancini), in *L. B. Alberti, Opere inedite* (Florence, 1890), 36 ff.; new edition with historical and critical comment by L. Vagnetti and G. Orlandi, in *Edizioni dell'Istituto di Elementi di Architettura e Rilievo dei Monumenti*, *Quaderno I* (Genoa, 1968), 25 ff. Cf. also R. Krautheimer, *Lorenzo Ghiberti* (Princeton, 1956), 316, and T. Magnuson, *Studies in Roman Quattrocento Architecture* (Stockholm, 1958), 7. Alberti's 'invention' consists in the very simple fact that he applied to the medieval system of city views (Ptolemaic projection) the mathematical division of the circle in degrees plus the axial cross, and was in that way able to assign to every monument its fixed geometrical location.

9. Cf. here P. Tomei, *L'Architettura a Roma nel Quattrocento* (Rome, 1942), *passim*, especially 103 ff., Magnuson, *op. cit.*, 19 f., and Mancini, *op. cit.*, chapter XIII.

10. Magnuson, *op. cit.*, 55 ff., especially 85, has given a good description of Alberti's collaboration in the Borgo project, although in his otherwise justified criticism of Dehio (*Repertorium für Kunstwissenschaft*, III (1880), 241 ff.) he attaches too much weight to the continuation of the medieval tradition of town planning. The decisive point is the new conception of the *concetto*, as Magnuson himself admits in the end.

11. Exhaustive analysis of the Manetti text in Magnuson, *op. cit.*, 163 ff., who however does not give a reconstruction; Günter Urban, 'Zum Neubauprojekt von St Peter unter Papst Nikolaus

V.', *Festschrift für Harald Keller* (Darmstadt, 1963), 131 ff.

12. 'La grand'opera da uguagliarsi a qualcuna delle antiche, premieramente la sospese per consiglio di L. B. Alberti' (Mattiae Palmerii, *De temporibus etc.*, 241, quoted from Mancini, *op. cit.*, 303).

13. Mattiae Palmerii, *op. cit.*: 'Alberti . . . eruditissimos a se scriptos de architectura libros Pontifici ostendit'. For the question of date, cf. the conclusive evidence recently published by C. Grayson, 'The Composition of L. B. Alberti's Decem Libri de re aedificatoria', *Münchener Jahrbuch der bildenden Kunst*, XI (1960), 152, and *Kunstchronik*, XIII (1960), 359 ff. According to Grayson, the main parts of the treatise were written between 1443 and 1452: there were probably interpolations later, but only about details. p. 30

14. The standard work is still Ricci, *op. cit.* Later references: G. B. Milan, *Agostino di Duccio architetto e il Tempio Malatestiano* (Rome, 1938); D. Garattoni, *Il Tempio Malatestiano* (Bologna, 1951); C. Brandi, *Il Tempio Malatestiano* (Rome, 1956); M. Salmi, 'Il Tempio Malatestiano', *Atti Accademia Nazionale di S. Luca*, 4th series, vol. I (1951–2) (Rome, 1953), 56 ff.; G. Ravaioli, 'Il Malatestiano', *Studi Malatestiani* (Faenza, 1952), 121 ff.; M. Salmi, 'La Facciata del Tempio Malatestiano', *Commentari*, XI (1960), 244.

15. Cf. Ricci, *op. cit.*, 5 ff.; E. Hutton, *Sigismondo,* p. 31 *Lord of Rimini* (London, 1906); G. Soranza, 'La tragica sorte dello stato di Sigismondo Malatesta', *Studi Malatestiani* (Faenza, 1952), 197 ff. A recent complete and reliable treatment of the subject is offered in the catalogue of *Sigismondo Malatesta e il suo tempo. Mostra storica* (Rimini, 1970).

16. A. Campana, *Origini, formazione e vicende della Malatestiana. Celebrazione del Quinto Centenario della Biblioteca Malatestiana* (Faenza, 1954).

17. Only three laureates of the court of Rimini were in fact buried there – the poets Basinio Basini (d. 1457) and Giusto di Conti (d. 1449) and the military engineer Roberto Valturio (d. 1475) – but Sigismondo had the remains of the Greek philosopher Gemistos Pleto brought from Mistra to Rimini. Cf. Ricci, *op. cit.*, 284 ff.

18. Originally (1447–50) Sigismondo had merely commissioned two memorial chapels for the old building of S. Francesco, the chapels of Sigismondo and Isotta. The plan for the rebuilding of the whole church only came up in 1450. Cf. for the latest evidence Gosebruch, *op. cit.* (Chapter I, Note 20), 154 ff.

19. 'Aedificavit nobile templum a Rimini in

honorem Divi Francisci: verum ita gentilibus implevit, ut non tam Christianorum quam infidelium daemones adorantium templum esse videretur. . . . In eo templo concubinae suae tumulum erexit et artificio et lapide pulcherrimum adjecto titulo gentili more in hunc modum Divae Isottae Sacrum' (*Commentarii*, 51–2, quoted from Ricci, *op. cit.*, 553 and 435).

20. In addition to Matteo de' Pasti's medal, the illuminated pages of the Hesperis Codices, rediscovered by O. Paecht ('Giovanni da Fano's Illustrations for Basinio's Epos Hesperis', *Studi Malatestiani* (Faenza, 1952), 91 ff.), are important since they show the church in the process of building. The recently discovered autograph letter from Alberti to Matteo de' Pasti of 18 November 1454 is of the greatest importance for the reconstruction of the façade; it contains a small sketch showing the shape of the double volutes which were to decorate the sloping ends of the lean-to roofs; see Grayson, *op. cit.* (Note 3), with a facsimile of the letter. Reconstruction sketch on the basis of the letter by N. Salmi, *Commentarii*, XI (1960), 244 ff.

21. Cf. Ricci, *op. cit.*, documents VIII (supplemented by the original published by Grayson), XI, and XIV. Also G. Soergel, *Untersuchungen*, 15–17. One of the Hesperis pages (Paecht, *op. cit.*, figure 1) gives an approximate idea of the construction of the roof before it was covered by the pitched roof.

22. For the stripping of the churches of Ravenna, especially S. Apollinare in Classe, and for the use of the spoils in the Tempio Malatestiano and the echoes of other Ravennate motifs in the building (monument and palace of Theodoric, ornamental forms, pedestals of columns, etc.) cf. the careful investigations of Ricci, *op. cit.*, 210 ff. and 280 ff. It may be assumed that the back walls of the two sarcophagus niches and the pediment niche were to have coloured incrustations of the kind; this would have enhanced the classical-Ravennate polychromy of the façade still more.

23. For the famous letter of 18 November 1454, cf. Soergel, *op. cit.*, 8 ff., and R. Wittkower, *Architectural Principles in the Age of Humanism*, 2nd ed. (London, 1952), 33. The execution of the building was in the hands of Matteo de' Pasti, Matteo Nuti, Alvise Carpentiere, and others, not forgetting Agostino di Duccio. The documents show very clearly the collaboration between these local capomaestri and their respect for Alberti, who was absent, as well as the interest always taken by the patron. For the style of the individual forms

arising from this collaboration, cf. the excellent analyses by Gosebruch, *op. cit.*, 63 ff.

24. Cf. H. Kauffmann, 'Die Renaissance in Fürsten- und Bürgerstädten', *Kunstchronik*, VII (1954), 126.

25. How keenly Florence was opposed to a monument of a similar tendency can be seen in the dispute about the choir of SS. Annunziata (see above, p. 20). The question of papal architecture in Rome is the subject of a separate discussion (see pp. 48 ff.). Outside Rome, Pius II realized at Pienza his own conception, as patron, of the layout of the city which might stand as the antithesis to Rimini.

26. Cf. Roberto's description, studded with obscure hints, of the imagery of S. Francesco, in *De re militari*, XIII, 13; C. Mitchell, 'The Imagery of the Tempio Malatestiano', *Studi Romagnoli*, II (1951), 77 ff.

27. For bibliography see W. Paatz, *Die Kirchen von Florenz*, III (Frankfurt, 1952), under S. Maria Novella. For the façade, Wittkower, *op. cit.*, 29 ff., and Hellmann, *op. cit.*, 53 ff. A careful analysis and reconstruction of the façade was made by W. Kiesow, *Zeitschrift für Kunstgeschichte*, XXV (1962), 1 ff.

28. Cf. L. H. Heydenreich, *Jahrbuch der Preussischen Kunstsammlungen*, LII (1931), 21 ff.

29. L. H. Heydenreich, 'Die Tribuna der SS. Annunziata', *Mitteilungen des Kunsthistorischen Instituts Florenz*, III (1930), 270.

30. Stegmann–Geymüller, III; Mancini, *op. cit.*, 422. The unfinished façade must be imagined as wider by one bay. For the palace, especially the disposition of the interior, no work has been done since Stegmann–Geymüller. It would be worth special study. The portals correspond precisely to the 'Ionic door' described by Alberti, lib. VII, cap. 12.

31. L. H. Heydenreich, 'Die Cappella Rucellai', *De Artibus Opuscula, Essays in Honor of Erwin Panofsky* (New York, 1961), 219; M. Dezzi Bardeschi, 'Nuove ricerche sul S. Sepolcro nella Cappella Rucellai a Firenze', *Marmo*, II (1963), 134 ff.; D. Neri, *Il Santo Sepolcro della Cappella Rucellai* (Florence, 1934); Paatz, *op. cit.*, IV, 568. For the history of the church down to our own times, D. F. Tarani, *La Badia di S. Pancrazio in Firenze* (Pescia, 1923).

32. The state of the church before rebuilding (1807) can be seen in the illustrations in Seroux d'Agincourt, *Histoire d'art par les monuments* (Milan, 1825), I, 159–60, and II (plates), plate LII, nos. 17–20; Heydenreich, *op. cit.* (Note 31), figure 1.

33. See Heydenreich, *op. cit.* (Note 31).

34. In exactly similar fashion, Brunelleschi had crowned the Sagrestia Vecchia of S. Lorenzo with an onion-dome lantern in order to mark it as a sepulchral chapel. Cf. above, Note 29 to Chapter 1.

p. 34 35. The room at the back now communicating with the sepulchral chapel through an arched opening was originally separated from Alberti's chapel by a wall. The arch greatly impairs the spatial effect.

36. Bibliography: G. Braghirolli, 'L. B. Alberti a Mantua', *Archivio Storico Italiano*, N.S. IX (1869), 1 (documents); P. Oriolo, *Arte e inscrizione . . . S. Andrea in Mantova* (Mantua, 1892); C. Cottafavi, *Ricerche e documenti . . . Palazzo Ducale di Mantova* (Mantua, 1939), 31 ff. (important rectification and completion of the older documentary material). Good summary by E. Marano in *Mantova, Le Arti*, II (1961), 63 (Luca Fancelli) and 117 (L. B. Alberti).

37. For S. Sebastiano: S. Davari, *Rassegna d'Arte*, I (1901), 93 (documents); Vasco Restori, *Mantova e dintorni* (Mantua, 1937), 323 ff.; V. Matteucci, *Le Chiese di Mantova* (Mantua, 1905), 167. Ludovico's dream is related by F. Amadei, *Chronica universale di Mantova* (1745), reprinted in *Mantova*, II (1961), 119.

p. 35 38. For the aspect of the building at the end of the eighteenth century, important illustrations in Seroux d'Agincourt, *op. cit.*, II, plate LII, nos. 9–12. It is uncertain when the staircase loggia was built. Seroux d'Agincourt, *op. cit.*, writes that the church was entered through the lower church, which gave access to the upper part. Thus there was a direct access (by way of a staircase in the tower?). The loggetta greatly disfigures the façade, and it is difficult to believe that Alberti planned it in this form.

39. Wittkower's attempt (*op. cit.*, 41 ff.) to reconstruct a 'first plan' by Alberti in the form of a six-pilaster façade with a monumental flight of steps completely concealing the present basement storey seems to me a little too bold, for it completely eliminates the outstanding characteristic of the building – its two-storeyed design – and destroys the central feature of the composition of the façade: the strange but entirely consistent series of openings, both horizontal and vertical (central axis). The instruction 'minuire quelli pilastri', which for that matter was Alberti's own wish, can hardly be taken to mean the 'removal' of a whole pair of pilasters, but only as a narrowing or shortening of the order. In any case, the document provides all the evidence needed to prove that the present four-pilaster elevation is in accordance with Alberti's plan.

40. 'Per essere fatto quello edificio sul garbo antiquo, non molto dissimile da quello viso fantastico di messer Baptista degli Alberti, io per ancho non intendeva se l'haveva a reussire chiesa o moschea o synagoga.' Quoted from Davari, *op. cit.*, 93 ff.

41. Documents: Braghirolli, *op. cit.*; *idem* in *Archivio Storico Lombardo*, III (1876) (Luca Fancelli); E. Ritscher, *Die Kirche S. Andrea in Mantua* (Berlin, 1899), in folio (also the work by Cottafavi quoted in Chapter 8, Note 5); P. Pelati, *La Basilica di S. Andrea* (Mantua, 1952); *Mantova, Le Arti*, II (1961), 127 ff. There are two brilliant recent studies of S. Andrea: R. Krautheimer, 'Alberti's Templum Etruscum', *Münchener Jahrbuch der bildenden Kunst*, XII (1961), 65 (cf. also *Kunstchronik*, XIII (1960), 364 ff.), and E. Hubala, 'L. B. Alberti's Langhaus von S. Andrea', *Festschrift Kurt Badt* (Berlin, 1961), 83 ff.

42. Alberti's nave was shortened when the cross- p. ing was erected; the original connection with the domed space is hypothetical. The adjustment of the rotunda to the outlines of the nave seems to be in accordance with the general trend of the time (S. Maria delle Grazie, Pistoia; S. Bernardino, Urbino; Osservanza, Siena).

43. Ten Books, lib. VII, cap. 10 (ed. Ticozzi, 1833, p. 243): 'Nè penso che in questo luogo sia da lasciare indietro che ne le volte le mosse de gli archi hanno ad avere oltre al mezzo diametro, tanto di diretto al manco, quanto tolgono gli aggetti de le cornichi a coloro che stando nel mezzo del tempio alzano gli occi all'insuso.'

44. See Hubala's excellent analysis of this structural system, *op. cit.*, 102 ff. The spatial effect of the Badia Fiesolana (H. Willich, *Baukunst der Renaissance in Italien*, I (Potsdam, 1914), 37) is also based on the concealment of the sources of light; perhaps another hint of Alberti's collaboration in the building (cf. below, p. 42).

45. Cf. here also Hubala, *op. cit.*, 116 ff.

46. Cf. Wittkower, *op. cit.* (Note 23), 47; Hubala and Heydenreich, in *Kunstchronik* (1960), 357; *Mantova, Le Arti*, II (1961), 131.

47. Cf. Grayson and Heydenreich, *Kunstchronik* (1960), 358.

48. Cf. Mancini, *op. cit.* (Note 3), 490. In 1597 p. 3 an order from the duke expressly laid down the adherence to Alberti's model.

49. Mancini, *op. cit.*, 490.

50. Hellmann, *op. cit.*; Soergel, *op. cit.*; Wittkower, *op. cit.*; Krautheimer, *op. cit.*; Hubala, *op. cit.*; Gadol, *op. cit.*

CHAPTER 5

39 1. For the notion of *varietà* cf. Martin Gosebruch, in *Kunstchronik*, IX (1956), 30, and *Zeitschrift für Kunstgeschichte*, XX (1957), 229 ff.

2. Studies of Antonio di Manetti Ciaccheri: Thieme Becker (under Ciaccheri), VI (1912), 556; L. H. Heydenreich, in *Jahrbuch der Preussischen Kunstsammlungen*, LII (1931), 26; idem, in *Mitteilungen des Kunsthistorischen Instituts Florenz*, III (1930), 270 ff.; W. and E. Paatz, *Die Kirchen von Florenz*, I (Frankfurt, 1940), *passim*; Venturi, *Storia*, VIII (1), 369; H. Saalman, 'Brunelleschi, Capital Studies', *Art Bulletin*, XL (1958), 126.

3. See above, p. 20.

4. For Pagno di Lapo Portigiani, cf. Thieme Becker, XXVI (1932), 144; C. von Fabriczy, in *Jahrbuch der Preussischen Kunstsammlungen*, XXIV (1903), supplement, 119–39 (main study with documents and bibliography); Venturi, *Storia*, VIII (1), 326 ff.; I. B. Supino, *L'Arte nelle chiese di Bologna, secoli XV–XVI* (Bologna, 1938), *passim*, especially 248 ff. and 313 ff. (Cappella Volta in S. Domenico and Cappella Bentivoglio in S. Giacomo).

5. For Maso di Bartolomeo, called Masaccio, cf. Thieme Becker (under Maso), XXIV (1930), 210; C. Yriarte, *Livre de souvenirs de Maso di Bartolomeo* (Paris, 1894); Venturi, *Storia*, VIII (1), 329 ff.; P. Rotondi, *Il Palazzo ducale di Urbino* (Urbino, 1952), *passim*.

6. For the Badia Fiesolana, cf. P. Vicenzo Viti, *La Badia Fiesolana* (Florence, 1926), principal study with documents. There are two brilliant essays which emphasize the part that Cosimo de' Medici as the donor played in the planning of the cloister: E. H. Gombrich, 'The Early Medici as Patrons of Art' (1960), reprinted in *Norm and Form* (London, 1966), 35 ff., and U. Procacci, 'Cosimo de' Medici e la costruzione della Badia Fiesolana', *Commentari*, XIX (1968), 80 ff. But the *spiritus rector* of the whole enterprise, and especially the church, was Timoteo Maffei. See also Stegmann–Geymüller, I, 49 ff.; Venturi, *Storia*, VIII (1), 226; H. Willich, *Baukunst der Renaissance in Italien*, I (Potsdam, 1914), 37; P. Sanpaolesi, in *Enciclopedia dell'arte italiana* (under Brunelleschi), II (1959), col. 823. Cf. also C. von Fabriczy, *F. Brunelleschi* (Stuttgart, 1892), 266 ff. (documents).

7. The attribution to Brunelleschi goes back to p. 40 Vasari (Milanesi, II, 307 ff.). Cosimo de' Medici certainly made a very large donation to the Badia in 1441–2, and the building of the monks' living quarters was taken in hand (the so-called Appartamento Medici). But when Cosimo died in 1464, the parts begun in 1456, i.e., only ten years after Brunelleschi's death – cloisters, refectory, dormitory – were still under construction. The church was not begun till March 1461; it was finished in the rough in 1464.

8. L. H. Heydenreich, *op. cit.* (Chapter 4, Note 31), 326. The 'directional' lighting from hidden sources might also be interpreted as an Albertian feature. The principle of directional lighting attains its full development in S. Andrea in Mantua (see above).

9. For the typology of the Florentine Quattrocento palazzi cf. L. H. Heydenreich, 'Der Palazzo Guadagni', *Festschrift für Eberhard Hanfstaengel* (Munich, 1961), 43 ff. For the Palazzo Strozzino attributed to Michelozzo (ground floor) and Giuliano da Maiano (upper floor), cf. W. Limburger, *Die Gebäude von Florenz* (Leipzig, 1910), 166. Also Venturi, *Storia*, VIII (1), 383 ff.

10. There is now an exhaustive study on sgraffito ornament: G. and C. Thiem, *Toskanische Fassadendekoration in Sgraffito und Fresco* (Munich, 1964).

11. This palazzo, which was admirably restored in 1962, would be worth a monograph (cf. however the valuable preliminary study by A. Moscato, *Il Palazzo Pazzi a Firenze* (Florence, 1963), with complete documentation and bibliography). The interesting design of the elevation and the masterly execution of the ornament suggest the presence of some remarkable superintendent: the fluted brackets with applied leaves at the corners are closely related to those in the great hall of the Palazzo Pitti; both represent the 1460–70 phase of style. Giuliano da Maiano took legal proceedings to recover the large sum of 1,800 lire for work he claimed to have done on the Palazzo Pazzi and the Pazzi Chapel (Moscato, *op. cit.*, 70 ff.). He must have taken an important part in the building of the palace; the dolphin capitals in the courtyard are quite in his style. See below, p. 46.

12. The chief work on the subject, K. Busse in *Jahrbuch der Preussischen Kunstsammlungen*, LI (1930), 110 ff., has in my opinion been far too much neglected, although it gives a definite basis for the dating (beginning of building, 1458). In spite of this documentation, the design has in very recent

times (G. C. Argan, *Brunelleschi* (Verona, 1955), 150 ff., P. Sanpaolesi, in *Enciclopedia dell'Arte*, II, col. 822) been attributed to Brunelleschi on the ground – very weak to my mind – that Brunelleschi's model for the Palazzo Medici had found a late echo here. Yet Brunelleschi smashed his model in a fit of anger – that must have been in 1444 at latest, which is fourteen years before the Palazzo Pitti was begun. Willich, *op. cit.*, 89, refers to Alberti, while Busse gives Vasari's mention of Luca Fancelli.

p. 40　13. Similar balustrades in a version of Ionic occur in the galleries of the dome of Florence Cathedral and in the lantern of the Sagrestia Vecchia of S. Lorenzo. But the fluting of these colonnettes in the Palazzo Pitti is unique – a special form which deserves attention and again points to a somewhat later phase of style.

p. 41　14. This important reference comes from P. Sanpaolesi, although he connects these forms with Brunelleschi, while for my part I see in them all the characteristics of about 1460. Cf. Sanpaolesi, *op. cit.* (Chapter 1, Note 11), 95 f.

15. Busse, *op. cit.*, 113; Vasari (Milanesi, II, 373; cf. also the note in the Gottschewski–Gronau edition, vol. III, 133); *Mantova, Le Arti*, II (1961), 98.

p. 42　16. For rusticated blocks and rustication in general, see below, pp. 116, 128, and 136 f.

17. For Bernardo and Antonio Rossellino, see Vasari (Milanesi, III, 93 ff.); C. von Fabriczy, *Jahrbuch der Preussischen Kunstsammlungen*, XXI (1900), 33 ff. and 99 ff. (Chronologischer Prospekt); Stegmann–Geymüller, III; Thieme Becker, XXIX (1935), 42 ff.; Venturi, *Storia*, VIII (1), 491 ff.; also Note 27 below. For Agostino di Duccio, see Note 28 below.

18. Cf. V. Martinelli, *Commentari*, VIII (1957), 167 ff., and IX (1958), 3 ff.

19. The – to my mind very 'Roman' – motif of the half-columns engaged in the wall is unusual for this period and very important as an ornamental form. The late drawing of the ground plan (seventeenth century) gives no clues to the dating; can the chapel be of still older origin?

20. P. Sanpaolesi, in *Rivista d'Arte*, XXIV (1942), 143 ff., and M. Tyskiewicz, *ibid.*, XXVII (1951–2), 203. A copy, exact to the last detail, of the Chiostro degli Aranci is to be found in the cloister of S. Francesco at Prato (1439), which was executed by Rossellino's assistant Domenico di Pino. See Sanpaolesi, *op. cit.*, 162.

p. 43　21. Cf. pp. 27 ff. above for Alberti, and the references given there. For Vasari's catalogue of Bernardo's buildings for the Pope cf. Milanesi, III, 98 ff. The layout of the piazza at Fabriano clearly shows features of Rossellino; cf. L. H. Heydenreich, 'Pius II als Bauherr von Pienza', *Zeitschrift für Kunstgeschichte*, VI (1937), 141. See also Note 23.

22. In 1463 Rossellino submitted a very favourable report on the execution of the chapel and the tabernacle in SS. Annunziata, on which Giovanni di Bertino was engaged. Cf. Tyskiewicz, *op. cit.*, 209.

23. Heydenreich, *op. cit.* (Note 21), 105–46 (with relevant literature); R. K. Donin, *Österreichische Baugedanken am Dom von Pienza* (Vienna, 1946); L. Grassi, in *Palladio*, IV (1954), 97 ff.; E. Carli, *Pienza* (Siena, 1966). In addition to the buildings of the main piazza, Pius commissioned twelve houses, among them the Casa dei Canonici behind the Palazzo Vescovile; he further ordered his treasurer, Lollius, his chamberlain, Thomas, and the Cardinals of Artois, Mantua, and Pavia to build palazzi at Pienza.

24. Cf. A. Schiavo, *Monumenti di Pienza* (Milan, p. 4 1942), *passim*; Carli, *op. cit.*, *passim*.

25. Heydenreich, *op. cit.* (1931) (Note 2), 28; Paatz, *op. cit.*, III (1952), 334.

26. The best survey is in Venturi, *Storia*, VIII (1 and 2), *passim*; see also Stegmann–Geymüller, XI, and Julius Baum, *Baukunst und dekorative Plastik der Frührenaissance in Italien* (Stuttgart, 1924).

27. Vasari (Milanesi, III, 94 ff.); Stegmann–Geymüller, III, 3, 2 ff.; Paatz, *op. cit.*, IV (1952), 239 ff. (with complete bibliography); F. Hartt, G. Corti, and C. Kennedy, *The Chapel of the Cardinal of Portugal at San Miniato at Florence* (Philadelphia, 1964). The documents mention Antonio Manetti as executant architect.

28. The scanty notices on Agostino di Duccio's p. 4 architectural activity are to be found in A. Pointner, *Die Werke des florentiner Bildhauer Agostino d'Antonio di Duccio* (Strassburg, 1909), and in Ricci, *op. cit.* (Chapter 4, Note 3), *passim*. Cf. also Venturi, *Storia*, VIII (1), 735 ff.

The range of Agostino's architectural vocabulary is shown by his last work. Twelve years after S. Bernardino he executed the Porta S. Pietro in the same city (1473 ff.). Here he made use of quite another 'style': adapting motifs from the antique Arch of Augustus in Perugia and applying classic pilasters of the Albertian order, he invests this town gate with fitting monumental strength.

29. For Giuliano da Maiano, see Vasari (Milanesi, II, 467 ff.); Thieme Becker, XIV (1921), 211 ff.;

Fabriczy, *op. cit.* (Note 4), 137 ff. (chronological survey); Stegmann–Geymüller, IV; L. Cendali, *Giuliano e Benedetto da Maiano* (S. Casciano, n.d. [1926]); Venturi, *Storia*, VIII (I), 373 ff.; A. Sabatini, 'La Chiesa di S. Chresti a Maioli', *Rivista d'Arte*, XXIV (1942), 180 ff.; L. Borgo, 'Giuliano da Maianos Santa Maria del Sasso', *Burlington Magazine*, CXIV (1972), 448 ff. For Giuliano's share in the execution of the Pazzi Chapel and of the Palazzo Quaratesi-Pazzi, see Note 11 above.

30. Cf. Fabriczy, *op. cit.* (Note 4), 302 ff.

31. Venturi, *Storia*, VIII (I), 390 ff.; C. Grigioni, 'Il Duomo di Faenza', *L'Arte*, XXVI (1923), 161 ff.

32. For Loreto, see p. 139 below under Giuliano da Sangallo.

CHAPTER 6

48 1. For Rome at the beginning of the Quattrocento cf. P. Tomei, *L'Architettura a Roma nel Quattrocento* (Rome, 1942), 5 ff.; T. Magnuson, *Studies in Roman Quattrocento Architecture* (Figura. Studies edited by the Institute of Art History, University of Uppsala, IX) (Stockholm, 1958), 3 ff.

2. Cf. E. Müntz, *Les Arts à la cour des papes pendant le XVe et XVIe siècle*, I–III (Bibliothèque des Écoles françaises d'Athènes et de Rome, IV, IX, XVIII) (Paris, 1878, 1879, 1882).

49 3. Cf. Tomei, *op. cit.*, 13.

50 4. Martin V, a descendant of the Roman Colonna family, became the first patron of the restoration of the church of SS. Apostoli adjacent to the family palace, which he used as his residence from 1424 on. For Martin V's building activity cf. Müntz, *op. cit.*, I, 1 ff.; Tomei, *op. cit.*, 33 ff., 54 f.; Magnuson, *op. cit.*, 222. For the Lateran: S. Ortolani, *S. Giovani in Laterano* (Chiese di Roma illustrate, XIII) (Rome, n.d.). We must unfortunately abandon any attempt at a consideration of the ornament (in painting as well as sculpture) with which Martin V and his successors embellished the buildings they restored.

5. For the *magistri viarum*, cf. E. Re, 'I Maestri di Strada', *Archivio Società Romana Storia Patria*, XLIII (1920), 5–102; C. Scaccia-Scarafoni, 'L'antico statuto dei Magistri stratarum', *ibid.*, L (1927), 239 ff.; Tomei, *op. cit.*, 21; Magnuson, *op. cit.*, 34 ff. With the control of the office of the *magistri viarum* in their hands, the popes also secured authority over the municipal administration; it was the permanent policy of the Curia to restrict its rights.

6. Tomei, *op. cit.*, 34 (text of *breve*); Müntz, *op. cit.*, I, 4.

7. Cf. G. Mancini, *Leone Battista Alberti* (Florence, 1911), 95 ff.; Tomei, *op. cit.*, 7.

8. Cf. Müntz, *op. cit.*, I, 352 (text of the bull); Tomei, *op. cit.*, 10.

9. Tomei, *op. cit.*, 8; Müntz, *op. cit.*, I, 34. For p. 51 Cyriacus of Ancona cf. C. Hülsen, *La Roma antica di Ciriaco d'Ancona* (Rome, 1907).

10. Müntz, *op. cit.*, I, 68, and *Nouvelles Recherches* (1884), 49 ff.; Magnuson, *op. cit.*, 55 f.

11. G. Manetti (ed. L. Muratori), *Vita Nicolai V summi pontificis*, in *Rerum italicarum scriptores*, III, 2 (Milan, 1734), 929; extracts in Müntz, *op. cit.*, I, 339, and Magnuson, *op. cit.*, 351 ff.

12. 'Hic urbem Romam multies ac maximis aedificiis mirum in modum exornavit, cuius opera, si compleri potuissent, nulli veterum imperatorum magnificentiae cessura videbantur, sed iacent adhuc aedificia sicut ruinae murorum ingentes' (Europa, cap. LVIII, 458–9, quoted from Müntz, *op. cit.*, I, 71, note 2).

13. Cf. Magnuson, *op. cit.*, 36 ff.

14. Tomei, *op. cit.*, 9 f.; Mancini, *op. cit.*, 297 ff.; D'Onofrio, *Le Fontane di Roma* (Rome, 1957), 35.

15. Tomei, *op. cit.*, 54; Magnuson, *op. cit.*, 32; E. Siebenhüner, *Das Kapitol* (Munich, 1953), 35.

16. Magnuson, *op. cit.*, 115 ff.; A. P. Fruaz, *Il Torrione di Niccolo V in Vaticano* (Città del Vaticano, 1956).

17. For the architects at work on the Vatican p. 52 buildings of Nicholas V, cf. Müntz, *op. cit.*, I, 79 ff.; F. Ehrle and P. Egger, *Der Vatikanische Palast . . . bis zur Mitte des 15. Jahrhunderts* (Studi e documenti per la storia del Palazzo Apostolico Vaticano, II) (Città del Vaticano, 1953); Magnuson, *op. cit.*, 53 ff. and 211 ff.

18. Manetti (ed. L. Muratori), *op. cit.*, III, 2, cols. 907–60. Cf. the exhaustive investigations by Magnuson, *op. cit.*, 55 ff. (Nicholas and Gianozzo Manetti) and 89 ff. (Nicholas, Alberti, and Rossellino).

19. Müntz, *op. cit.*, III, 1 ff.; Tomei, *op. cit.*, 10 and 15 ff.

20. P. Lauer, *Le Palais du Latéran* (Paris, 1911); p. 53 G. Rohault de Fleury, *Le Latéran au moyen âge* (Paris, 1877).

21. Tomei, *op. cit.*, 103 ff.; Müntz, *op. cit.*, I, 142.

22. F. E. Fasolo, 'San Teodoro al Palatino', *Palladio*, V (1941), 112; Müntz, *op. cit.*, I, 86 and 146.

23. Agostino di Duccio chose the same motif for his double door of S. Bernardino at Perugia (1460); later it appears again on the entrance to the loggia of the house of the Cavalieri di Rodi (c. 1470, illustrated in Tomei, *op. cit.*, figure 54).

24. This chapter was written before G. Urban's comprehensive investigations on the subject in 'Der Kirchenbau des Quattrocento in Rom', *Römisches Jahrbuch für Kunstgeschichte*, IX (1963), 75–287 had been published. Thus I can refer to its extremely reliable results only through additional quotations in the Notes.

p. 53 25. For the aisleless church and the basilica in Tuscany, cf. L. H. Heydenreich, 'Gedanken über Michelozzo di Bartolomeo', *Festschrift für Wilhelm Pinder* (Leipzig, 1938), 264 ff. Michelozzo's S. Francesco al Bosco is the only vaulted church before 1450 in Florence; see above, p. 20, and Urban, *op. cit.* (Note 24), 85 ff.

26. Cf. Huetter and E. Lavagnino, *S. Onofrio al Gianicolo* (Chiese di Roma illustrate, XL) (Rome, n.d.); Tomei, *op. cit.*, 42; Urban, *op. cit.* (Note 24), 79 ff. The polygonal structure of the choir dates only from 1500. In its original form, S. Onofrio was the only aisleless church prior to Alberti, who was particularly interested in it, as can be seen by the fact that he marked the church in his plan of Rome. Cf. O. Lehmann-Brockhaus, 'Albertis Descriptio Urbis Romae', *Kunstchronik*, XIII (1960), 346 ff.

p. 54 27. J. Barthier, *L'Église de la Minerve* (Rome, 1910); R. Spinelli, *S. Maria sopra Minerva* (Chiese di Roma illustrate, XIX) (Rome, n.d.); Tomei, *op. cit.*, 45; Urban, *op. cit.* (Note 24), 119 ff.

28. C. Jovanovits, *Forschungen über den Bau der Peterskirche in Rom* (Vienna, 1877); G. Dehio, 'Die Bauprojekte Nikolaus V's und Leone Battista Albertis', *Repertorium für Kunstwissenschaft*, III (1880), 241 ff.; Magnuson, *op. cit.*, 163 ff.; F. Graf Wolff Metternich, 'Gedanken zur Baugeschichte der Peterskirche in 15. und 16. Jahrhundert', *Festschrift für Otto Hahn zum 75. Geburtstag* (Göttingen, 1955); Urban, *op. cit.* (Note 24), 112 ff.

29. The church was begun during the pontificate of Calixtus III. The first building period lasted till about 1470. Cf. Tomei, *op. cit.*, 109 ff.; J. Fernandez Alonso, *Santiago de los Espagnoles* (Rome, 1958); Urban, *op. cit.* (Note 24), 266.

30. Günter Urban, 'Zum Neubauprojekt von St Peter unter Papst Nikolaus V.', *Festschrift für Harald Keller* (Darmstadt, 1963), 131–73.

31. G. Zippel, 'Paolo II e l'arte', *L'Arte*, XIV (1911), 187 ff.; Müntz, *op. cit.*, I, 277 ff.; Tomei, *op. cit.*, 109 ff.

32. The total height of the Benediction Loggia in all three storeys is 105 feet. The ground floor arcade has a height of 13 m. (42 feet 6 in.), the second storey 10 m. (33 feet), and the third 9 m.

(29 feet 6 in.). (I am indebted for these details to the kindness of F. Graf Wolff Metternich.) The third storey was not added till the reign of Alexander VI.

33. It seems a mistake to me to describe the p. 5 Benediction Loggia and the Loggia di S. Marco as being of the same type (Tomei, *op. cit.*, 112 and 214, 288); on the contrary, they represent two radically different conceptions of style. Cf. Urban, *op. cit.* (Note 24), 125 ff.

34. On the other hand, the question whether the master commissioned in September 1470 to continue work on the loggia, Julianus Francisci de Florentia (Zippel, *op. cit.*, 187), can be identified with Giuliano da Sangallo is of the greatest importance. It was he to whom the work on the Palazzo Venezia was entrusted between 1469 and 1470, assisted by a team of twelve masons and thirty-three workmen (Müntz, *op. cit.*, II, 70). Marchini's researches have shown that the date of Giuliano da Sangallo's birth must be 1443 or 1444 (G. Marchini, *Giuliano da Sangallo* (Florence, 1942), 70). According to his own manuscript entry in the Codex Sangallensis in the Vatican Library, he began his sketchbook in Rome in 1465, when he was twenty-one or twenty-two. Thus he was twenty-five in 1468, and perfectly qualified by his age and training to supervise a working group of builders, as the documents testify. Both commissions, the Benediction Loggia and the Palazzo S. Marco, seem to me to offer perfectly appropriate occupations for a young and gifted architect, and were for Giuliano of the greatest importance in the development of his style. The doubts expressed by Tomei, *op. cit.*, 110, and Magnuson, *op. cit.*, 213 and 327, are based on the false assumption that Giuliano was born in 1452, and take no account of Marchini's research. I return to this point below.

35. Tomei, *op. cit.*, 157 and 208; Magnuson, *op. cit.*, 312 ff.; Urban, *op. cit.* (Note 24), 269.

36. E. Lavagnino, *La Chiesa di S. Maria del Popolo* (Chiese di Roma illustrate, XX) (Rome, n.d.); Tomei, *op. cit.*, 177 ff.; Urban, *op. cit.* (Note 24), 154 ff.

37. Tomei, *op. cit.*, 280 ff. p.

38. Müntz, *op. cit.*, 156; Tomei, *op. cit.*, 123 ff.; De Romanis, *La Chiesa di S. Agostino a Roma* (Rome, 1921); Urban, *op. cit.* (Note 24), 274 ff.

39. We may remember the tedious discussions, often leading to acute controversy, about the façade of the cathedral of Florence and those of S. Lorenzo and S. Spirito. The best survey of the literature on the subject is in W. and E. Paatz, *Die Kirchen von Florenz*, under the individual buildings.

59 40. The most convenient collection of illustrations is in J. Baum, *Baukunst und dekorative Plastik der Frührenaissance in Italien* (Stuttgart, n.d.), plates 25, 26, 30.

 41. Tomei, *op. cit.*, 129 ff. The church was built by Sixtus IV in token of his gratitude for the preservation of Florence from the war which the Pazzi conspiracy might have caused. Cf. Urban, *op. cit.* (Note 24), 176 ff.

60 42. The central plan is characteristic of the Renaissance memorial church. The subject would repay study. Cf. references on pp. 20, 31, and 77. Cf. also W. Lotz, 'Notizen zum kirchlichen Zentralbau der Renaissance', in L. L. Möller and W. Lotz (eds.), *Studien zur Toskanischen Kunst* (Munich, 1964), 157 ff.

 43. B. Pesci and E. Lavagnino, *S. Pietro in Montorio* (Chiese di Roma illustrate, XLII) (Rome, n.d.); Tomei, *op. cit.*, 113 ff.; Urban, *op. cit.* (Note 24), 277 ff.

 44. Cf. below, pp. 141–2.

61 45. Cf. Tomei, *op. cit.*, 281 f.; P. Rotondi, *Il Palazzo Ducale di Urbino* (Urbino, 1950), I, 446; L. Serra, *Rassegna Marchigiana*, XI (1933), 437 ff., and XII (1934), 1 ff.; P. Giordani, 'Baccio Pontelli a Roma', *L'Arte*, XI (1908), 96 ff.; G. de Fiore, *Baccio Pontelli* (Rome, 1963).

62 46. Vasari (ed. Milanesi), *Vite . . .* , II (Florence, 1878), 652 ff.

 47. E. Battisti, 'Il Significato simbolico della Cappella Sistina', *Commentari*, VIII (1957), 96 ff.; Tomei, *op. cit.*, 139 ff.

 48. Tomei, *op. cit.*, 142 ff.; P. De Angelis, *L'Arciconfraternità ospitaliera di Santo Spirito in Saxia* (Rome, 1950); idem, *L'Arcispedale di S. Spirito in Saxia nel passato e nel presente* (Rome, 1952); E. Amadei, 'L'Ospitale di S. Spirito in Sassia', *Capitolium*, XXXIII, x (1958), 16 ff.

 49. Cf. W. and E. Paatz, *Die Kirchen von Florenz*, under S. Maria Nuova.

 50. For the Ospedale Maggiore in Milan and hospital building in the fifteenth century, see p. 97 below.

 51. Total length of wards 126 m. (415 feet), width 12·8 m. (42 feet), height 13·1 m. (43 feet).

 52. Cf. details given by De Angelis, *op. cit.*

64 53. Practically nothing has survived of the papal palaces. After all, the popes resided for the most part outside the Vatican or Lateran: the great residences adjacent to SS. Apostoli (Martin V), S. Maria in Trastevere (Eugenius IV), and S. Maria Maggiore (Martin V and Nicholas V) were all pulled down to make room for later buildings. A large number of cardinals' residences, e.g. those of Guillaume d'Estouteville, Francesco Piccolomini, and Bessarion, have disappeared too (Magnuson, *op. cit.*, 222 ff.).

 54. Magnuson's book is of capital importance for secular architecture in Rome in the Quattrocento. Further, L. Callari, *I Palazzi di Roma* (Rome, 1944); G. Giovannoni, *Saggi sulla architettura del Rinascimento* (Rome, 1946); idem, *Il Quartiere romano del Rinascimento* (Rome, 1946).

 55. E. Paatz, 'Ein antikischer Stadthaustyp im mittelalterlichen Italien', *Römisches Jahrbuch für Kunstgeschichte*, III (1939), 129 ff.; A. Boëthius, *Kejsarnas Rom och medeltidens städer* (Acta Universitatis Gotoburgensis, LIX (1953), Bo. 4) (Göteborg, 1953); Magnuson, *op. cit.*, 47 f.

 56. Now the Palazzo Sforza-Cesarini; Magnuson, *op. cit.*, 230 ff.

 57. Tomei, *op. cit.*, 94; Magnuson, *op. cit.*, 333 (under its present name of the Palazzo dei Cavalieri di S. Sepolcro). Cardinal Stefano Nardini's palazzo (or Palazzo del Governo Vecchio), built about 1475, is of the same type; G. Zippel, 'Il Palazzo del Governo Vecchio', *Capitolium*, VI (1930), 365 ff.

 58. About 1460–70. Cf. Tomei, *op. cit.*, 95.

 59. Magnuson, *op. cit.*, 229.

 60. Tomei, *op. cit.*, 60 ff.; Magnuson, *op. cit.*, 227 ff.; P. Simonelli and G. Breccia Fratadocchi, *Almo Collegio Capranica* (Rome, 1955).

 61. Tomei, *op. cit.*, 94 and 263. p. 66

 62. H. Egger, P. Dengel, and M. Dvořák, *Der Palazzo Venezia in Rom* (Vienna, 1909); F. Hermanin, *Il Palazzo di Venezia* (Rome, 1948); E. Lavagnino, 'L'Architettura del Palazzo Venezia', *Rivista del R. Istituto di Storia dell'Arte e Archeologia*, V (1935–6), 128 ff.; Magnuson, *op. cit.*, 245 ff.; Tomei, *op. cit.*, 63 ff.; G. Zippel, 'Paolo II e l'arte', *L'Arte*, XIII (1910), 241 ff., and XIV (1911), 13 ff.

 63. Tomei, *op. cit.*, 78. p. 67

 64. Vasari's (*op. cit.* (Note 46), II, 470) naming of Giuliano da Maiano as the architect of the Palazzo Venezia may be due to a confusion of his name with that of Giuliano da Sangallo, who, however, can only have been employed on the building as a foreman (cf. Note 34, above, and Marchini, *op. cit.*, 84. In ignorance of Marchini's discoveries Magnuson, *op. cit.*, 293–4, gives a mistaken account of the question).

 65. Magnuson, *op. cit.*, 296, reaches the same conclusion.

 66. H. Egger, *Das päpstliche Kanzleigebäude im*

15. *Jahrhundert* (Mitteilungen des Österreichischen Staatsarchivs, Ergänzungsband, III) (Vienna, 1951); D. Gnoli, 'Il Palazzo della Cancelleria, etc.', *Archivio Storico dell'Arte*, V (1892), 176 ff. and 331 ff.; *idem*, 'Bramante e il Palazzo della Cancelleria', *Studi Romani*, V (1957), 518–38; Tomei, *op. cit.*, 220 ff.

p. 69 67. The pilaster front can be seen in many variations in the wooden inlay work inside the Palazzo Ducale at Urbino, and in the famous architectural perspectives at Urbino, Baltimore, and Berlin (illustrated in Rotondi, *op. cit.* (Note 45), II, 411–18, and R. Papini, *Francesco di Giorgio Martini* (Florence, 1946), II, in particular 75–86).

68. H. Willich, *Baukunst der Frührenaissance in Italien* (Handbuch der Kunstwissenschaft) (Potsdam, 1914), 106–7. The triumphal-arch motif appears for the first time, though in another connection, in the internal structure of S. Andrea at Mantua (Willich, *op. cit.*).

69. Lavagnino, *op. cit.*, and Gnoli, *op. cit.* (Notes 62 and 66). Cf. also Tomei, *op. cit.*, 292–3.

p. 70 70. Palazzo Giraud-Torlonia, cf. Tomei, *op. cit.*, 231 ff.; Palazzo Turci, cf. *ibid.*, 275. Another successor was the Palazzo Santori (now the Palazzo Doria al Corso), the courtyard of which closely resembles that of the Cancelleria. (The arcades have been walled up.) Cf. Gnoli, *op. cit.*, 537.

71. For the Palazzo Santacroce, cf. Tomei, *op. cit.*, 239.

CHAPTER 7

p. 71 1. C. Budenich, *Il Palazzo Ducale di Urbino* (Leipzig, 1905); T. Hofmann, *Bauten des Herzogs Federigo da Montefeltro als erste Werke der Hochrenaissance* (Leipzig, 1905). The standard work is by P. Rotondi, *Il Palazzo Ducale di Urbino*, 2 vols. (Urbino, 1950), with many plans and illustrations and a complete list of literary sources. Further: P. Zambetti, *Il Palazzo Ducale di Urbino* (Rome, 1951); G. Marchini, 'Il Palazzo Ducale di Urbino', *Rinascimento*, IX (1958), 43 ff.; *idem*, 'Aggiunte al Palazzo Ducale di Urbino', *Bollettino d'Arte*, XLV (1960), 73 ff.; L. H. Heydenreich, 'Federico da Montefeltro as a Building Patron', *Studies in Renaissance and Baroque Art presented to Anthony Blunt* (London, 1967), 1 ff.

2. Francesco Filelfo, 'Commnetarii de vita e rebus gestis Frederici comitis urbinatis (ligae) italicae imperatoris', a cura di G. Zannoni, *Atti e Memorie della Deputazione di Storia Patria delle Marche*, V (1901), 263 ff.; Vespasiano da Bisticci

(ed. P. D'Ancona and E. Aeschlimann), *Vita degli uomini singolari* (Milan, 1950); Benedetto Baldi, *Vita e fatti di Federico da Montefeltro, 1603* (Rome, 1724); J. Dennistoun, *Memoirs of the Dukes of Urbino* (London, 1851, 2nd ed., London, 1909); R. de la Sézeranne, *Le Condottiere: Federico da Montefeltro* (Paris, 1927); G. Franceschini, *Figure del Rinascimento urbinate* (Urbino, 1959); Federico da Montefeltro, *Lettere di stato e d'arte, 1470–1480*, a cura di Paolo Alatri (Rome, 1949); *Ordini e offitii alla Corte del Serenissimo signor Duca d'Urbino*, a cura della R. Acc. Raffaello (Urbino, 1932).

3. Federico's revenues were very great. In 1453, when he was barely thirty, he drew a monthly salary of 8,000 ducats as gonfaloniere of the king of Naples in time of war; in peacetime his annual salary was 6,000 ducats. In 1482 he received 165,000 ducats for himself and his troops, 15,000 being secured to him for times of peace. In the same year, the republic of Venice offered him 80,000 ducats for his neutrality, which Federico refused out of loyalty to his allies (and in possession of double revenues!); Dennistoun, *op. cit.*, 259. Cf. also Marchini, *op. cit.* (1958), 56.

4. For the fireplace in the Sala della Iole cf. B. Degenhart, *Bollettino d'Arte* (1950), 208. The figures of Hercules and Iole are based on Boccaccio's Iole in *De claris mulieribus*.

5. For the paintings in the Sala dei Guerrieri, cf. p. 7 Rotondi, *op. cit.* (1958), I, 155.

6. Marchini (*op. cit.* (1960), 73) proves that a courtyard was already being built for this first complex, and that its columns were later used in the ducal palace at Urbania.

7. Mario Salmi, *Piero della Francesca ed il Palazzo Ducale di Urbino* (Florence, 1945).

8. Baldi, *op. cit.*, 45. There is plenty of evidence for the close friendship between Federico and Alberti; Federico's own in his letters to Cristoforo Landino, 1475 (Alatri, *op. cit.*, 102) and to the Duke of Ferrara, 1480 (Franceschini, *op. cit.*, 102); Alberti's in a sentence recorded in the Disputazioni Camaldolesi (G. Mancini, *Vita di L. B. Alberti*, 2nd ed. (Florence, 1911), 470). Alberti dedicated to Federico a copy of the *Familia*, today the Codex Urb. lat. 229, Vatican Library.

9. Marchini, *op. cit.* (1960), 76.

10. Cf. Rotondi, *op. cit.*, I, 29. p. 7

11. B. Castiglione (ed. V. Cian), *Il Cortegiano*, lib. I, cap. 2 (Florence, 1908), 13 ff. A large number of other contemporary appreciations is quoted by Rotondi and by Franceschini, *passim*. Lorenzo de' Medici and Francesco Gonzaga had detailed draw-

ings made for them of the palace (G. Gaye, *Carteggio*, I, 274, in *Giorn. Stor. Litt. Ital.*, XVI (1890), 155).

12. Vespasiano da Bisticci, *op. cit.*, 208: 'Aveva voluto avere notizia di architettura, della quale l'età sua, non dico signori ma di privati, non c'era chi avesse tanta notizia quanto la sua Signoria. Veggansi tutti gli edifici fatti fare da lui, l'ordine grande e le misure d'ogni cosa come l'ha osservate, e maxime il palagio suo, che in questa età non s'è fatto più degno edificio, si bene inteso e dove siano tante degne cose quante in quello. Bene ch'egli avesse architettori appresso della sua Signoria, nientedimeno nell'edificare intendeva parere loro, dipoi dava e le misure a ogni cosa la sua Signoria, e pareva a udirne ragionare, che la principale arte ch'egli avesse fatta mai fusse l'architettura; in modo ne sapeva ragionare e metter in opera per lo suo consiglio!'

. 75 13. *The Commentaries of Pius II*: F. A. Gragg and L. C. Sabel, *Smith College Studies in History*, XXII, XXX, XXXV, XLIII (Northampton, Mass., 1937–57), book IX, 597 ff.

14. Cf. Salmi, *op. cit.*, 42.

15. Belonging to the third period of building (Francesco di Giorgio). Cf. Rotondi, *op. cit.*, 293 ff.

16. Marchini, *op. cit.* (1958).

17. In the Italian palazzo of the first half of the century the interior staircase found no real aesthetic development. In the Palazzo Piccolomini at Pienza, it occupies more space than usual (Pius takes pains to point this out), but it first achieved monumentality in the Palazzo Ducale at Urbino. Leonardo da Vinci made a note of it (MS. L. fol. 19 verso). Baldi (*op. cit.*, 275) and Daniele Barbaro in his Commentary on Vitruvius single it out for praise.

. 76 18. The private apartments of the Duke, the innermost core of the building, contain Federico's own most private world, distributed over three low storeys of the turret front on the smallest ground plan: a bathroom in the lowest storey, on an antique model (with an adjacent room for games); by way of the spiral staircase in the turret, and through the adjoining chapels in the middle storey, the way leads finally to the Studiolo in the piano nobile. It measures 3·5 by 3·5 m. (11 feet 6 in. by 11 feet 6 in.); above the superb tarsia panelling on the walls, seven groups of four figures represented the masters of human knowledge, whom Federico regarded as his tutors. Just as Pliny the Younger, in his Villa Laurentina, had made for

himself a private nook – a *buon ritiro* – in which he could indulge at leisure in his studies, free of all disturbance and relieved of all the vexations of his public life, Federico had himself pictured in his Studiolo as a statesman *procul negotiis*. The whole ducal apartment, the congeries of tiny rooms as a sphere of most private retirement, is so akin to Pliny's *diaeta*, even down to many details which he describes so vividly in one of his letters, that it tempts one to believe that Federico had this Laurentina of Pliny's in mind as his pattern; the various *cubicula*, the seclusion, and the view of the wide landscape from a kind of terrace – all these details in Pliny's description can be matched in Federico's Appartamento. And, like Pliny, Federico could say with pride and delight: 'amoris mei, re vera amores, ipse posui'.

It is a tempting thought to regard Alberti as the originator of this beautiful invention, and his close friendship with Federico finds eloquent testimony in the letters of both. Not only are Pliny's letters in the Duke's library, so that he must have known the description of the Laurentina: Alberti even quotes the letter in the tenth book of his treatise on architecture when he describes the exemplary form of a place of peace and quiet.

19. Laurana may have come from Urana, near Zara. There are no certain data of training and activity till 1465. He possibly collaborated in the design for the triumphal arch of the Castelnuovo in Naples (ascribed to him). First appearance in records in 1465 at the courts of Ludovico Gonzaga at Mantua, Alessandro Sforza at Pesaro, and Federico da Montefeltro at Urbino. The three dukes lent Laurana to each other. At Mantua he is believed to have worked on the rebuilding of Castel S. Giorgio, though the courtyard was only built later under the supervision of Luca Fancelli. No certain evidence of work at Pesaro. Thus the Palazzo Ducale at Urbino is his only certain work. Laurana owed his reputation mainly to his skill in building technique; his style was first formed at Urbino as an important synthesis of the formal idioms of Alberti and Piero; there is also a Venetian element. He worked for Urbino from 1465 till 1472; in 1472 he was back at Pesaro, where he worked on the (now half-ruined) castello. In 1479 he made his will there and died soon after.

Bibliography: Thieme-Becker, XXII (1928), 442 ff. and earlier literature. Also A. Venturi, *L'Arte*, XLI (1938), 370; Rotondi, *op. cit.*, *passim*; Grassi, *Palladio*, IV (1954), 97; Marchini, *op. cit.* (1958), 43; L. Babic, *Actes XIXᵉ Congrès internationale*

histoire de l'art (Paris, 1959), 231. A good summary of the origins of Laurana's style in Salmi, *op. cit.*, 100 f.

20. Franceschini, *op. cit.*, 68 ff. In March 1466, Federico's nephew and viceregent, Ottaviano degli Ubaldini, requested the Duke of Mantua to send Laurana to Milan in order to discuss with Federico, who was there at the time, the model of the palazzo which had already been prepared, since the architects at work at Urbino could not manage by themselves. Thus Laurana must have made the model in 1465 on his first visit to Urbino from Pesaro.

p. 76 21. First published in Gaye, *op. cit.*, 214. The latest reprints in Rotondi, *op. cit.*, I, 109, and Heydenreich, *op. cit.*, 3. In addition to the famous hymn to architecture, the document contains the following important passage: 'et havendo noi cercato per tutto, et in Toscana massime dove è la fontana delli Archittetori, et non avendo trovato huomo che sia veram(en)te intendente, et ben perito in tal misterio, ultimam(en)te havendo per fama prima inteso et poi per esperienza veduto et conosciuto quanto l'egregio huomo Mastro Lutanio ostensore so questa sia dotto, e instrutto in quest'arte.' In actual fact there was no architect of standing in Tuscany in 1465. Michelozzo had left Florence, Bernardo Rossellino was dead, Giuliano da Sangallo had just begun his activity in Rome, Luca Fancelli was in Mantua, and Giuliano da Maiano was still very young.

22. Laurana had first given proof of his capacity for solid building in the field of fortifications; as a Dalmatian trained in Venice he must have been more experienced in the aesthetic problems of vaulting than the Florentines. The three kinds of vault – *a lunette, in botte*, and *in crucie* – are mentioned in Laurana's disputes with his working architects; Rotondi, *op. cit.*, I, 122.

23. For the details of the collaboration of North Italian and Florentine masters, cf. Rotondi, *op. cit.*, *passim*.

24. An important factor in the design of the Sala del Trono is to be seen in the window openings – now walled up – along the interior long wall; originally the light entered here through tall slanting shafts, which helped to give an even lighting of the room – another example of the directional lighting which we have met so far only in Albertian architecture (cf. also Note 42).

25. Cf. Salmi, *op. cit.*; P. Zampetti, in *Enciclopedia cattolica*, VII (1951), 961, under Laurana.

26. In the Laurana period, the enlargement of the palazzo to the form in which we now see it was completed except for the square tower on the west front and the loggia of the Cortile del Pasquino on the south side, that is, the whole north wing from the steps to the Appartamento del Duca, the great courtyard, and the Duchess's apartments with the terrace garden. The building was standing as far as the piano nobile; the decoration and the continuation into the upper storey, like the facing of the façade, dragged on into the next period. For the very difficult (and very often procrastinating) distribution of the decorative work among the various masters see Salmi, *op. cit.*; Rotondi, *op. cit.*; and Marchini, *op. cit.*

27. In their conception, both rooms belong to the Laurana phase. Even the decoration and furnishing of the Cappella del Perdono is, in my opinion, and in view of its Piero–Alberti character, a design of Laurana (certainly not of Francesco di Giorgio). Executed by Ambrogio Barocci. It was called finished in a poem as early as 1480 (Rotondi, *op. cit.*, 361, who suggests that it may be an early work of Bramante).

28. Cf. Note 17. Venice developed a feeling for p. 7 monumental staircases earlier than Florence, though mostly for those outside buildings.

29. The size and structure of the courtyard belong to Laurana's design. The execution was completed by Francesco di Giorgio in the top storey.

30. The equality in height of the doorways and window openings in the piano nobile is, I believe, only to be matched in the Palazzo Pitti. Pilaster frames and flat rustication with fine joints can be seen in Francesco Sforza's Cà del Duca in Venice (*c.* 1460). The basement strips at Urbino were to have borne the reliefs with machines of war and military emblems which are now preserved in the palace museum. Lavish decoration of this kind points, in my opinion, to Lombardo-Venetian art, and therefore to Laurana as author, for he combined here what little had been done in the design of palazzo façades up to that time (Palazzo Pitti, Palazzo Rucellai, Palazzo Piccolomini at Pienza, Cà del Duca in Venice) in a single new and monumental form.

31. In his book *Francesco di Giorgio Martini, architetto*, 3 vols. (Florence, 1946), R. Papini attempts to make Francesco di Giorgio the architect in chief of the Palazzo Ducale. This excess of zeal has provoked justified repudiation (P. Sanpaolesi and M. Salmi, *Belle Arti*, I (Pisa, 1946)), yet as a collection of material his work is extremely

useful. For Francesco di Giorgio's share in the work, cf. Rotondi, *op. cit.*, I, 289 ff., and Marchini's valuable statement, *op. cit.* (1958).

32. Marchini, *op. cit.* Francesco di Giorgio himself gives an exhaustive description of his stable building (120 by 9·80 by 12·70 m., or 394 by 32 by 42 feet!) in his Treatise (ed. C. Promis (Turin, 1841), 171; ed. C. Maltese (Milan, 1967), II, 339–40).

33. For the tarsia-work, cf. Papini, *op. cit.*; further F. Arcangeli, *Tarsie* (Rome, 1942), 7; A. S. Weller, *Francesco di Giorgio* (Chicago, 1943), 182 ff.; A. Chastel, 'Marqueterie et perspective au XV^e siècle', *Revue des Arts* (1953), 141 ff.

34. P. Rotondi, 'Contributi urbinati a Francesco di Giorgio', *Studi artistici urbinati*, I (Urbino, 1949), 85 ff.

35. *Ibid.*, 106 ff.

36. For the mausoleum originally planned in the Corte del Pasquino, cf. Rotondi, *op. cit.* (Note 1), 296 ff. For S. Bernardino (after 1482 and before 1490), cf. P. Rotondi, in *Belle Arti*, I (Pisa, 1947), 191 ff.; M. Salmi, in *Studi artistici urbinati*, I (Urbino, 1949), 38 ff.; C. Maltese, *ibid.*, 77.

37. M. Salmi, in *Atti dell'Accademia Spoletana* (1923–6), 271.

p. 78 38. A similar, later example of the interaction of heterogeneous – eastern and western – traditions of style is the cathedral at Šibenik (Sebenico) (see below).

39. Piero's altarpiece in the Brera in Milan, painted for S. Bernardino at Urbino; Signorelli's 'Descent of the Holy Ghost' in the Palazzo Ducale at Urbino; Raphael's 'School of Athens'.

40. L. Serra, *L'Arte nelle Marche* (Pesaro, 1934), II, 16–17.

41. Venice, Porta dell'Arsenale, palazzo of Francesco Sforza; Rimini, Tempio Malatestiano.

42. I regard the meeting and mutual influence of Alberti and Laurana at Urbino as of capital importance. Both were creators of a new spatial organization and were closely akin to each other in the means they employed – the sense of greatness in form, monumental vaults, directional lighting, etc.

43. See above, pp. 61–2, 69–70. Baccio Pontelli was at Urbino from 1479 to 1482, and after his years in Rome returned in 1492.

44. For S. Francesco at Ancona cf. G. Moretti in *Bollettino d'Arte*, XXIII (1929–30), 60.

45. The loggia of the Palazzo Comunale is ascribed to Giorgio da Sebenico by Marchini (personal information).

46. Marchini, *op. cit.* (1960). For Giorgio da Sebenico, cf. also C. Bima, *Giorgio da Sebenico* (Milan, 1954).

47. P. Remington, 'The Private Study of p. 79 Federico da Montefeltro', *Bulletin of the Metropolitan Museum*, XXXVI (1941), 1 ff.; E. Winternitz, *ibid.*, XXXVII (October 1942). Also Papini, *op. cit.*, 247.

48. Salmi, *op. cit.* (Note 36), 30 ff. For documents, A. Gianandrea, *Il Palazzo del Comune di Jesi* (1877).

49. The best survey in Serra, *op. cit.*, II, *passim*, and Papini, *op. cit.*

50. The 'fantasticare' in fortifications is clearly illustrated in Francesco di Giorgio's treatise.

CHAPTER 8

1. The rule of the Gonzaga was in many respects p. 80 similar to that of the Montefeltro. They had been lords of Mantua since 1328, and were, with the Montefeltro, the only princes in Italy to be freely and gladly recognized. The geographical situation of their domain between the great powers of Venice and Milan necessitated political caution and wisdom. As military leaders they observed the old rule of Rome by serving, as far as possible, the weaker side in order to preserve their independence. The house of Gonzaga ruled for four hundred years, a period only exceeded by the house of Savoy.

The best historical survey is still that of P. Kristeller, *Andrea Mantegna*, English ed. (Berlin, 1901), *passim*, especially 185 ff. A recent, most informative and reliable publication is *Mantova, La Storia* (3 vols.), *Le Lettere* (3 vols.), *Le Arti* (3 vols. in 5) (Mantua, 1957–65). The third part, *Le Arti*, a cura di A. Marani e C. Perina (1961–5), gives an equally splendid history of architecture; also Venturi, *Storia*, VIII (2), 386 ff.

2. For documents see Kristeller, *op. cit.*, 182 ff.

3. Cf. pp. 20 and 34 ff.

4. Cf. Note 20 to the previous chapter. Laurana's works cannot be more definitely distinguished. G. Pacchioni's attempts to attribute to him the courtyard of the Castel S. Giorgio (*Bollettino d'Arte* (1923), 96 ff.) have been refuted by the documents discovered by C. Cottafavi (cf. Note 5).

5. For Fancelli (1430–95) see W. Braghirolli, 'L.F., Scultore, architetto e idraulico del secolo XV', *Archivio Storico Lombardo*, III (1876), 610. Cf. also Clinio Cottafavi, 'Ricerche e documenti sulla costruzione del Palazzo Ducale di Mantova del secolo XIII al secolo XIX', *R. Accademia Virgiliana*

di Mantova (Mantua, 1939), 31 ff. Recently the excellent chapter on Fancelli in E. Marano, *Mantova, Le Arti*, II (Mantua, 1961), 63 ff.

6. G. Pacchioni, *Mantova* (Bergamo, 1930); N. Giannantoni, *Guida del Palazzo Ducale di Mantova* (Rome, 1929); *Mantova, Le Arti (op. cit.)*, I and II, *passim*.

p. 80 7. Cf. Kristeller, *op. cit.*, 175 ff.; documents, 472 ff.

8. Cf. on the subject P. Tigler, *Filarete's Architektur-Theorie* (Berlin, 1962), 18 ff.

9. Feliciano entitled his description of this excursion *Jubilatio*; Kristeller, *op. cit.*, 472.

p. 81 10. Cottafavi, *op. cit.*, 31 ff.

11. For documents see Kristeller, *op. cit.*, 469 (no. 7).

12. There is, unfortunately, no recent study of Luca Fancelli which attempts to combine the many partial results yielded by research. Both his personality and his work deserve more attention; the biographical outline by E. Marano mentioned in Note 5 is well worth study as a first step, especially as it makes use of all the documentary evidence available.

13. Good reproductions of both buildings in Marano, *op. cit.*, plates: Rovere, text, pp. 70 ff. (figures 53–63); Casa via Frattini, figure 81 (see also the house of the same type in via Franchetti 11, figure 82).

14. Cf. Alfredo Barbacci, 'La "Nova Domus" nel Palazzo Ducale e il suo restoro', *Le Arti*, IV (1942), 222. See also Venturi, *Storia*, VIII (I), 588. Excellent illustrations of the restored façade in *Mantova, Le Arti*, II, plates 84–6. A report from a foreman of the works to the Duke (1481) contains this instructive passage: 'Harei tanto a caro. . . . havere inteso la sua [i.e. Fancelli, then absent on account of illness] fantasia . . . i muratori ogni giorno congerisce cum mg° Luca e lui sopra un disegno le dà ad intendere quanto vuole che facciamo.'

p. 82 15. Up to Serlio's design for Anzy-le-Franc. Cf. Barbacci, *op. cit.*

16. Cf. above, Chapter 7, Note 11.

17. J. Ackerman, in *Transactions of the XXth International Congress of the History of Art* (New York, 1962), II, 6 ff.

18. Giuseppe Fiocco, 'Andrea Mantegna e il Brunelleschi', *Atti 1° Congresso Nazionale Storia Architettura* (Florence, 1938), 179 ff.; Marano, *op. cit.* (Note 5), 141 ff., plate 121.

19. Among the illustrations to Francesco di Giorgio's treatise there are several plans of palazzi

in which a round courtyard is inserted in a quadrangular layout.

20. C. Yriarte, *La Maison de Mantegne à Mantoue* (Cosmopolis, 1897), 738; L. Dorez, 'A. Mantegna et la légende *Ab Olympo*', *Acad. Inscr. Belles Lettres, Comptes rendus de séances* (1918), 370 ff.; Earl Rosenthal, 'The House of Andrea Mantegna in Mantua', *Gazette des Beaux-Arts*, VIe période, LX (1962), 327 ff.

21. Fiocco, *op. cit.*

22. *La Basilica rinascimentale di S. Maria in Porto* (Ravenna, 1950), 54 ff.

CHAPTER 9

1. See Bibliography under Venice. p. 83

2. G. Lorenzetti, *Guida di Venezia* (Venice, 1926), and E. R. Trincanato, *Venezia minore* (Milan, 1948), introductory chapters.

3. For canals and *campi*: P. Molmenti and Mantovani, *Calli e canali in Venezia* (Venice, 1893); J. Matznetter, 'Venedigs Stadt- und Hafenanlagen etc.', *Festschrift für Johann Sölch* (1950); K. Donin, 'Österreichische Denkmalspflege in Venedig', *Mitteilungen der Gesellschaft für vergleichende Kunstforschung*, Vienna, VII (1954), 19, with bibliography.

4. Trincanato, *op. cit.*, 114, gives a good description of the pile-grid construction.

5. Terminology in Lorenzetti, *op. cit.*, introduction, 16 ff.

6. Trincanato, *op. cit.*, 42 ff.; E. Hubala, *Die Baukunst der venezianischen Renaissance (1460–1550)*, unpublished Habilitationsschrift (Munich, 1958); *idem*, 'Venedig', in *Reclams Kunstführer: Oberitalien Ost* (Stuttgart, 1965), 607 ff.

7. See Note 9. p. 84

8. Lorenzetti, *op. cit.*, 408, 294, 279; P. Paoletti, *L'Architettura e la scultura del Rinascimento in Venezia* (Venice, 1897), *passim*.

9. E. Dyggve, 'Palatium Ravennatum Sacrum', *Archaelogisk Kunsthistor. Meddelsir*, III, 2 (Copenhagen, 1941); G. Fiocco, 'La Casa veneziana antica', *Rendiconti Accad. Naz. Lincei, Cl. Mor.*, ser. 8, IV (1949), 38 ff.

10. K. M. Swoboda, *Römische und Romanische Paläste* (Vienna, 1919), 77 and 185. Cf. also J. Ackerman, 'Sources of the Renaissance Villa', in *Studies in Western Art* (Acts of the XXth International Congress of the History of Art), II, *The Renaissance and Mannerism*, 6 ff.

11. G. Lorenzetti, 'Un Prototipo veneto- p. 8
bizantino del Palazzo Ducale di Venezia', *Miscellanea Supino* (Florence, 1933), 23 ff.

86 12. Trincanato, *op. cit.*, 150 ff.; Hubala, *op. cit.* (1965), 611.

13. For chimneys, types of balconies, and *cavalcavie*, cf. Lorenzetti, *op. cit.* (Note 2), 17–18, and Trincanato, *op. cit.*, 89–90. For gardens, G. Damerini, *Giardini di Venezia* (Bologna, 1931); reproduction of the garden of the Palazzo Dario in Lorenzetti, *op. cit.*, plate LXXIX. Cf. also Trincanato, *op. cit.*, 95 and 273.

14. Lorenzetti, *op. cit.*, 620; Paoletti, *op. cit.*, I, 29. The Palazzo Giustinian, its neighbour (Paoletti, *op. cit.*, 31), is also of 1450. Cf. recently E. Arslan, *Venezia gotica* (Milan, 1970), *passim.*

15. Cà d'Oro, 1421–40. Architect Matteo Raverti. Cf. Lorenzetti, *op. cit.*, 633; Paoletti, *op. cit.*, I (I), 20; Arslan, *op. cit.*, 189 and *passim.*

16. R. Gallo, 'Il Portico della Carta', *Rivista di Venezia* (1933), 283; Hubala, *op. cit.* (1965), 639–42; Arslan, *op. cit.*, 242 ff.; E. R. Trincanato and G. Mariacher, *Il Palazzo ducale di Venezia* (Florence, 1967).

17. Paoletti, *op. cit.*, I (2), 139 ff.; Lorenzetti, *op. cit.*, 299; Hubala, *op. cit.* (1965), 855.

18. Paoletti, *op. cit.*, I (2), 34 ff.; L. Beltrami, 'La Cà del Duca', *Nozze Albertini–Giacosa, 8.9.90* (Milan, 1890); J. Spencer, 'The Cà del Duca in Venice and Benedetto Ferrini', *Journal of the Society of Architectural Historians*, XXIX (1970), 3 ff.; D. Lewis, *Two Lost Renascences of Venetian Architecture: New Plans by Bon and Sanmicheli for the Site of the 'Ca del Duca'* (unpublished M.A. thesis, Yale University, 1970) (with complete, partly new documentation).

19. For the complicated negotiations between the Duke and the representatives of the Corner family, and the tensions arising over the architects involved, see the thorough investigations of D. Lewis.

87 20. Treatise, Cod. Magl. II.IV. 140, lib. XXI, fol. 123 and 169 verso (ed. Spencer, *op. cit.* (below, Chapter 10, Note 8), text pp. 289 ff., plates (facsimile) 169 verso).

21. Paoletti, *op. cit.*, 190 ff.; Lorenzetti, *op. cit.*, 442; G. Mariacher, *Arte Veneta*, IX (1955), 37; Hubala, *op. cit.* (1965), 877 and 880.

22. Hubala, *op. cit.* (1958), 66 ff., gives an excellent comparative analysis of Florentine and Venetian decorative forms.

23. Paoletti, *op. cit.*, I (2), 119 and 277 f.; Lorenzetti, *op. cit.*, 149; Venturi, *Storia*, VIII (2), 60 ff.; L. Angelini, *Bartolomeo Bono, Guglielmo d'Alzano* (Bergamo, 1961), 15 and 29; Hubala, *op. cit.* (1965), 628 f.

24. Paoletti, *op. cit.*, I (2), 188; Lorenzetti, *op. cit*, 150; L. Angelini, *Mauro Codussi* (Milan, 1945), 54 ff.; Hubala, *op. cit.* (1965), 627.

25. The campanile, it will be remembered, collapsed in 1902 and was re-erected in 1911. See Paoletti, *op. cit.*, I (2), 276; Lorenzetti, *op. cit.*, 152 ff.; A. Levi, *I Campanili di Venezia* (Venice, 1890); G. Gattinoni, *Il Campanile di S. Marco* (Venice, 1910); Angelini, *op. cit.* (Note 23), 13 and 24; Hubala, *op. cit.* (1965), 620.

26. P. Kristeller, *Engravings and Woodcuts by Jacopo de' Barberi* (Berlin, 1896), 33; G. Mazzariol and T. Pignatti, *La Pianta prospettica di Venezia del 1500 disegnata da Jacopo de' Barberi* (Venice, 1963). The plan, cut on six wood-blocks, and measuring 135 by 285 cm. (53 by 112 in.), is drawn with astounding exactness.

27. Paoletti, *op. cit.*, I (2), 60 ff.; Lorenzetti, *op. cit.*, 287; Angelini, *op. cit.* (Note 24), 40; Hubala, *op. cit.* (1965), 882. p. 88

28. Paoletti, *op. cit.*, I (2), 164; Lorenzetti, *op. cit.*, 279; Angelini, *op. cit.* (Note 24), 29; Venturi, *op. cit.*, 550; Hubala, *op. cit.* (1965), 945 ff.

29. Lorenzetti, *op. cit.*, 743; P. Meneghini, O.F.M., *S. Michele in Isola di Venezia* (Venice, 1962).

30. Reprinted in Paoletti, *op. cit.*, and Angelini, *op. cit.* (Note 24).

31. Sometimes erroneously described as rustication; what was used by Alberti in the Palazzo Rucellai was, on the contrary, the smooth stone blocks of the tomb of Cecilia Metella. For the Albertian style of S. Michele, cf. R. Pallucchini, *Storia della civiltà veneziana*, III, *La Civiltà veneziana del Quattrocento* (Florence, 1957), 156.

32. The centrally planned Cappella Emiliani was built in 1527–43 by Guglielmo d'Alzano; Angelini, *op. cit.* (Note 23), 121 ff. p. 89

33. Temanza, *Vite*, I (1778), *op. cit.*, 82; Paoletti, *op. cit.*, I (2), 205; Lorenzetti, *op. cit.*, 316; Mariacher, *op. cit.* (Note 21), 46 f.; Hubala, *op. cit.* (1965), 807 ff.

34. The timber barrel-vault is well described by J. Durm, *Baukunst der Renaissance in Italien* (Stuttgart, 1903), 80. (The timber barrel-vault planned for the Tempio Malatestiano, Rimini, may be imagined in a similar form.)

35. P. Rotondi, *Il Palazzo Ducale di Urbino*, 2 vols. (Urbino, 1950), 279 ff. and 310.

36. Paoletti, *op. cit.*, I (2), 123. The old façade as shown in Barbari's plan of Venice suggests that the original plan was basilican, i.e. akin to S. Giobbe. Chancel chapel by Bartolommeo Bono, 1495: Angelini, *op. cit.* (Note 23), 12 and 21.

37. Lorenzetti, *op. cit.*, 496 and 517; Hubala, *op. cit.* (1965), 905 and 935.

p. 90 38. Paoletti, *op. cit.*, I, 177; Lorenzetti, *op. cit.*, 371; Angelini, *op. cit.* (Note 24), 51; Hubala, *op. cit.* (1965), 899.

p. 90 39. Paoletti, *op. cit.*, I (2), 170 ff.; Lorenzetti, *op. cit.*, 342; Angelini, *op. cit.* (Note 24), 73; Hubala, *op. cit.* (1965), 884.

40. Hubala, *op. cit.* (1958), 160 ff.

41. S. Lio, Cappella Gussoni: Paoletti, *op. cit.*, I (2), 222; Lorenzetti, *op. cit.*, 314; Mariacher, *op. cit.*, 36; Hubala, *op. cit.* (1965), 890. SS. Apostoli, Cappella Corner: Angelini, *op. cit.* (Note 23), 40; Lorenzetti, *op. cit.*, 408; Hubala, *op. cit.* (1965), 859.

p. 91 42. Paoletti, *op. cit.*, I (2), 116 ff.; Lorenzetti, *op. cit.*, 380; Hubala, *op. cit.* (1965), 930. Spavento was also the architect of the sacristy of St Mark's – a simple, well proportioned room with a coved ceiling – and of the small church of S. Teodoro behind St Mark's (Lorenzetti, *op. cit.*, 216).

43. On the scuole, cf. Lorenzetti, *op. cit.*, 22. See also the recent book by B. Pullan, *Rich and Poor in Renaissance Venice* (reviewed by Fletcher, *Burlington Magazine*, CXIII (1971), 747), which gives extremely valuable historical information on the scuole.

p. 92 44. For the Scuola di S. Rocco cf. A. Mazzucato, *La Scuola Grande di San Rocco*, 3rd ed. (Venice, 1955); Angelini, *op. cit.* (Note 23), 16 and 37.

45. A hall with a fine ceiling (1484) still survives from the Scuola della Carità, today part of the Galleria dell'Accademia. Cf. Lorenzetti, *op. cit.*, 633 and plate XLI. Another hall which has survived in its original state is that of the Scuola di S. Giorgio degli Schiavoni, of *c.* 1500, with Carpaccio's paintings: Lorenzetti, *op. cit.*, 360 and plate XLI.

46. Paoletti, *op. cit.*, I (2), 102 ff. and 175; Lorenzetti, 321 ff.; P. Paoletti, *La Scuola Grande di S. Marco* (Venice, 1929); Angelini, *op. cit.* (Note 24), 46.

47. Paoletti, *op. cit.* (Note 8), I (2), 169; Lorenzetti, *op. cit.*, 571 ff.; *idem, La Scuola Grande di S. Giovanni Evangelista* (Venice, 1929); Angelini, *op. cit.* (Note 24), 66; Mariacher, *op. cit.*, 48.

48. Paoletti, *op. cit.*, I (2), 151 ff.; Lorenzetti, *op. cit.*, 237; G. Mariacher, *Arte Veneta*, II (1948), 67; M. Muraro, 'La Scala senza giganti', *De Artibus Opuscula XL. Essays in Honor of E. Panofsky* (New York, 1961), 350.

49. For Antonio Rizzo, see Thieme-Becker, XXVIII (1934), 408 f.; Venturi, *Storia*, VIII (2), 489 ff.; Muraro, *op. cit.*

p. 93 50. Cf. the engraving by Canaletto-Brustolon,

'L'Incoronazione del Doge' (Lorenzetti, *op. cit.*, plate XXIII).

51. Cf. Hubala, *op. cit.* (1958), 26 ff. and 45; *idem, op. cit.* (1965), 640–1.

52. G. Chiminelli, 'Le Scale scoperte nei palazzi veneziani', *L'Ateneo Veneto*, XXXV, vol. I (1912), 210 ff.

53. Other examples: Casa Goldoni, Ponte S. Tomà; Palazzo van Axel-Soranzo-Brozzi, Fondamenta Sanudo, near S. Maria dei Miracoli.

54. Paoletti, *op. cit.*, I (2), 259 and plate I, 9; Trincanato, *op. cit.*, 96. A plain spiral staircase of the period still survives in the Corte del Forno at Cannaregio (*ibid.*, 101 and plates 108–9).

55. Lorenzetti, *op. cit.*, 594; Angelini, *op. cit.* (Note 24), 105.

56. Trincanato, *op. cit.*, 172.

57. Attributed to Pietro Lombardo (*c.* 1480–90). Paoletti, *op. cit.*, I (2), 222; Trincanato, *op. cit.*, 177; Mariacher, *op. cit.* (Note 21), 36.

58. Paoletti, *op. cit.*, I (2), 185; Lorenzetti, *op. cit.*, 590. Lombardi workshop 1487 ff.; H. Willich, *Baukunst der Renaissance in Italien*, I (Berlin-Potsdam, 1914), 138; Hubala, *op. cit.* (1965), 779.

59. Paoletti, *op. cit.*, I (2), 185; Lorenzetti, *op. cit.*, 605; Angelini, *op. cit.* (Note 24), 82; Hubala, *op. cit.* (1965), 769.

60. On the rear façade (rio del Palazzo). p.

61. Paoletti, *op. cit.*, I (2), 187; Lorenzetti, *op. cit.*, 621; Willich, *op. cit.*, 139; Angelini, *op. cit.* (Note 24), 92; Hubala, *op. cit.* (1965), 758.

62. Hubala, *op. cit.* (1965), 744. Good illustrations in J. Baum, *Baukunst und dekorative Plastik der Frührenaissance in Italien* (Stuttgart, 1924).

63. J. Ackerman, 'Sources of the Renaissance Villa', *Transactions of the XX International Congress of the History of Art* (New York, 1961), II, 6 ff.

64. La Brusa, Vicenza; Castello da Porto Colleoni, Thiene. Cf. Ackerman, *op. cit.*

65. See the following chapters, Lombardy, p. 112, and Emilia, p. 114.

66. A. Moschetti, 'Il Monastero di Praglia', *L'Arte*, VII (1904), 324.

67. Durm, *op. cit.* (Note 34), 79; D. Frey, 'Der p. Dom von Sebenico', *Jahrbuch der K.K. Zentralkommission*, VII (1913), 1 ff.; H. Folnesics, *ibid.*, VIII (1914), 27 ff.; Angelini, *op. cit.* (Note 24), 35 ff.; C. Bima, *Giorgio da Sebenico* (Milan, 1954).

68. Venturi, *Storia*, VIII (2), 309; G. Zorzi, *Contributi alla storia dell'arte vicentina nei secoli XV e XVI*, parte 2, *Architetti, ingegneri etc.* (Vicenza, 1925); F. Franco, *La Scuola architettonica di Vicenza*.

Palazzi minori del sec. XV–XVIII (I Monumenti italiani, fasc. III) (Rome, 1934).

69. G. M. Urban da Gheltof, *Gli Artisti del Rinascimento nel vescovado di Padova* (Padua, 1883); A. Moschetti, *Padova* (Bergamo, 1912), 18–20.

70. R. Brenzoni, *Architetti e scultori dei laghi lombardi a Verona* (Como, 1958).

CHAPTER 10

96 1. *Storia di Milano* (Fondazione Treccani), VI, *Il Ducato visconteo, 1392–1450*, and VII, *L'Età sforzesco, 1450–1500* (Milan, 1955 and 1956).

2. J. S. Ackerman, 'Ars sine scientia nihil est', *Art Bulletin*, XXXI (1949), 84 ff.; H. Siebenhüner, *Deutsche Künstler am Mailänder Dom* (Milan, 1944).

3. Cesare Cesariano, *Di Lucio Vitruvio Pollione de architectura libri decem traducti de latino in vulgare* (Como, 1521).

97 4. For the Lombard tiburi of medieval times, see A. Kingsley-Porter, *Lombard Architecture* (New Haven, 1917); *Storia di Milano* (Fondazione Treccani), III (Milan, 1954). For the competition for the tower over the crossing of the Duomo of Milan, cf. L. Beltrami, 'Leonardo da Vinci negli studi per il tiburio della cattedrale di Milano', *Nozze Beltrami-Rosina* (Milan, 1903); L. H. Heydenreich, *Sakralbaustudien Leonardo da Vinci's*, 2nd ed. (Munich, 1970). Bramante's report in *Annali della fabbrica del duomo di Milano*, III (Milan, 1880), 62 ff.; Francesco di Giorgio's *ibid.*, 60 ff. Cf. also *Storia di Milano*, *op. cit.*, VII, 670.

5. J. S. Ackerman, 'The Certosa of Pavia and the Renaissance at Milan', *Marsyas*, III (1947–9), 20 ff.; *Storia di Milano*, *op. cit.*, VI and VII (1955–6), 622.

6. H. Willich, *Baukunst der Renaissance in Italien* (Berlin, 1914), 150.

7. For facet-cut masonry, cf. *Reallexicon zur Deutschen Kunstgeschichte*, III (Stuttgart, 1954), cols. 1424 ff. For the towers of the Castello of Milan, L. Beltrami, *Castello di Milano* (Milan, 1894), 181. They aroused the youthful admiration of Federico da Montefeltro. Another imposing tower in facet-cut masonry is in the Castello Gavone (Marina di Finale, Liguria), of the second third of the fifteenth century, obviously prompted by the Milanese towers. Cf. T. O. de Negri, *Bollettino Ligustico* (1951), fasc. 1; N. Lamboglia and G. A. Silla, *I Monumenti del Finale* (Bordighera, 1951).

8. Antonio Averlino, called Filarete, born in Florence about 1400, died after 1465. Possibly trained by Ghiberti. In 1433 called by Eugenius IV to Rome, where he spent twelve years on the bronze doors for St Peter's. In 1447 he was given the commission for the funerary monument of Cardinal Antonio Chiaves, of Portugal, which was not, however, executed by him since he had to flee from Rome under suspicion of the theft of relics. Between 1448 and 1450 working in Florence, Venice, and Lombardy; appointed court architect at Milan by Francesco Sforza on the recommendation of Piero de' Medici. In 1452 *ingegnere della fabbrica del duomo*. A model of a tiburio by him was, however, rejected and he was dismissed. Worked on Milan Castello (perhaps on the tower front, according to Peter Tigler, including the two facet-cut towers). His chief work was the Ospedale Maggiore, which he superintended till 1465. Between 1460 and 1465 he wrote his treatise on architecture, dedicating one copy to the Duke of Milan, a second to Piero de' Medici. As a friend of Filelfo, the latter recommended him in 1465 to the Greek philosopher Georgios Amoirukios, who wished his help during a stay he planned in Constantinople (T. Klette, *Die griechischen Briefe des Franciscus Philelphus* (Greifswald, 1890), 146). That was the last news of Filarete; we know from the sources that he intended to go to Constantinople, but it is uncertain whether he did. If so, he may have died there. Cf. Tigler, *op. cit.* (below), 5 f.

Literature: W. von Oettingen, *Der Bildhauerarchitekt Antonio Averlino, genannt Filarete* (Leipzig, 1888); M. Lazzaroni and A. Muñoz, *Filarete* (Rome, 1908); M. Salmi, in *Atti I° Congresso nazionale storia architettura* (Florence, 1938), 185 ff.; J. Spencer, 'Filarete and Central Plan Architecture', *Journal of the Society of Architectural Historians*, XVII, 3 (1958), 10 ff.; H. Saalman, 'Filarete's Theory of Architecture', *Art Bulletin*, XLI (1959), 89; P. Tigler, *Die Architekturtheorie des Filarete* (Berlin, 1963).

On the treatise: the first edition (incomplete) by W. von Oettingen, in *Quellenschriften für Kunstgeschichte*, N.F. III (Vienna, 1896), has now been replaced by J. Spencer's edition: *Filarete's Treatise on Architecture* (New Haven and London, 1965), in 2 vols.: I. Introduction and translation; II. Facsimile of the Cod. Magl. II.IV.140 in the Biblioteca Nazionale, Florence. See also J. Spencer, 'La Datazione del trattato del Filarete', *Rivista d'Arte*, XXXI (1956), 93 ff. For the new critical edition by Anna Maria Finoli and Liliana Grassi (Milan, 1972), see Bibliography I.c.

9. P. Pecchiai, *L'Ospedale Maggiore nella storia e nell'arte* (Milan, 1927); G. Castelli, *L'Ospedale*

Maggiore di Milano (Milan, 1939); L. Grassi, *La Cà Grande, Storia e ristauro* (Milan, 1958); G. C. Bascapé, 'Il Progresso dell'assistenza ospedaliera nel sec. XV', *Tecnica Ospedaliera, 1936* (Rome, 1936); E. W. Palm, *Los Hospitales antiguos de la Española* (Ciudad Trujillo, 1950); *Mantova. Le Arti*, II (1961), 67 ff.: *L'Ospedale grande di Mantova*.

p. 97 10. Filarete (ed. Spencer), *Treatise, op. cit.*, text pp. 137 ff., plates 82 verso and 83 verso.

p. 99 11. For the extant MSS. of the treatise cf. Lazzaroni and Muñoz, *op. cit.*, and especially Tigler, *op. cit.*, which is of capital importance for the literary form of the treatise; also E. Garin, in *Storia di Milano, op. cit.*, VII, 565 and 568, and L. Firpo, 'La Città ideale del Filarete', *Studi in memoria di G. Solari* (Turin, 1954), 11 ff.

p. 100 12. Filarete, *Treatise*, lib. I.

13. E. Arslan, *Storia di Milano, op. cit.*, VII, 621; Tigler, *op. cit.*, 3 ff.

14. E. Motta, *Bollettino Storia della Svizzera Italiana*, VIII (1886); Thieme-Becker, XI (1915), 485 ff.; Beltrami, *op. cit.* (Note 7), 194 and *passim*; *idem, op. cit.* (Chapter 9, Note 18); Arslan, *op. cit.*, 630 ff. Recently D. Lewis, in his extensive study on the Cà del Duca (see Chapter 9, Note 18), has published quite a number of hitherto unknown documents on Ferrini's activity in the service of the Dukes of Milan.

15. Cf. F. R. Hiorns, 'Michelozzo Michelozzi', *Journal of the R.I.B.A.*, 3rd series, XIX (1911–12), 213 ff.; C. Baroni, 'Il Problema di Michelozzo a Milano', *Atti IV° Congresso Nazionale Storia Architettura* (Milan, 1939), 122; O. Morisani, *Michelozzo architetto* (Turin, 1951), 71 and 96; Arslan, *op. cit.* (Note 13), 625.

16. Imola, Palazzo Sforza by Giorgio Fiorentino. Venturi, *Storia*, VIII (1), 375. Filarete's drawing of the Banco Mediceo is on folio 192 recto of the Cod. Magl. II.IV.140 (see Note 8).

p. 101 17. The last survey in Arslan, *op. cit.* (Note 13), 619 ff.

18. Thieme-Becker, XXXI (1937), 228 (Giovanni), 229 (Guiniforte), and 230 (Pietro); C. Baroni, *Documenti per la storia dell'architettura a Milano nel rinascimento e nel barocco*, I, *Edifici sacri* (Florence, 1940), 195 ff.; Bascapé, in P. Mezzanotte and G. C. Bascapé, *Milano nell'arte e nella storia* (Milan, 1948), 33; A. M. Romanini, *Storia di Milano, op. cit.*, VII, 601 ff.

19. A. Pica and P. Portalupi, *Le Grazie* (Rome, 1938); Romanini, *op. cit.*, 610.

p. 102 20. Romanini, *op. cit.*, 615; Mezzanotte and Bascapé, *op. cit.*, 105 ff.; E. Bossi and A. Brambilla,

La Chiesa di S. Pietro in Gessate (Milan, 1953).

21. A. Bollan, *S. Maria Incoronata in Milano* (Milan, 1952); Mezzanotte and Bascapé, *op. cit.*, 795.

22. Arslan, *op. cit.*, 632.

23. Examples in F. Malaguzzi-Valeri, *La Corte di Lodovico il Moro*, 3 vols. (Milan, 1912–15), II, *passim*, and *Storia di Milano, op. cit.*, VII, parte V, *passim*.

24. C. Baroni, 'Ein unbekanntes Werk des Architekten Lazzaro Palazzi in Mailand', *Mitteilungen des Kunsthistorischen Instituts Florenz*, V (1937), 40, p. 342; Arslan, *op. cit.*, 637.

25. F. Malaguzzi-Valeri, *G. A. Amadeo* (Bergamo, 1904); Venturi, *Storia*, VIII (2), 591 ff.; Arslan, *op. cit.*, 637.

26. The gradation in the masonry, which appears in the Cà del Duca and in S. Michele in Isola, is prefigured in a number of façade designs in Filarete's treatise. Thus it is quite possible that there was a contact between Codussi and Filarete, who was also working at Bergamo.

27. For the buildings mentioned, cf. Malaguzzi- p. 1 Valeri, *op. cit.* (Note 23), 171 ff.; for the Castello, *ibid.*, 589 ff. See also Venturi, *Storia*, VIII (2), 168 ff.

28. Donato Bramante was born in 1444 at Monte Asdrualdo (now Fermignano) near Urbino. Nothing is known of his youth and training. Yet it may be assumed that he was working on the Ducal Palace as *garzone* and picked up important ideas from the architects there. Bramante first became prominent in 1477, when he was commissioned as a painter to do a frieze in fresco (a group of philosophers), for the façade of the Palazzo del Podestà at Bergamo. He also worked as a painter in Milan. The first record of his work as an architect is in 1482 in the rebuilding of S. Maria presso S. Satiro in Milan. In 1488 he was consulted for the Duomo of Pavia, and in 1490 for the dome over the crossing in Milan Cathedral. In the nineties there came the rebuilding of the cloisters of S. Ambrogio and the choir of S. Maria delle Grazie, the planning of the piazza at Vigevano, and the design of the façade of Abbiategrasso (1497). In 1499, after the fall of Ludovico il Moro, he left Milan and went straight to Rome.

The most important literature is: Malaguzzi-Valeri, *op. cit.* (Note 23), II, *Bramante e Leonardo*; L. Beltrami, *Bramante a Milano* (Milan, 1912); G. C. Argan, 'Il Problema del Bramante', *Rassegna Marchigiana*, XII (1934), 212; C. Lorenzetti, 'Lo Stato attuale degli studi su Bramante', *ibid.*, 304; G. Fiocco, 'Il primo Bramante', *Critica d'Arte*, I (1935–6), 109; C. Baroni, *Bramante* (Bergamo,

1944); O. H. Förster, *Bramante* (Vienna, 1956); Arslan, *op. cit.*, 638 ff.; F. Graf Wolff-Metternich, 'Der Kupferstich Bernardos de Prevedari aus Mailand von 1481. Gedanken zu den Anfängen der Kunst Bramantes', *Römisches Jahrbuch für Kunstgeschichte*, XI (1967/8), 9 ff. Recently A. Bruschi, *Bramante architetto* (Bari, 1969), a most reliable work for documents and building history.

29. P. Rotondi, *Il Palazzo Ducale di Urbino*, 2 vols. (Urbino, 1950), 333 ff.; Bruschi, *op. cit.*, 37 ff. and 730.

30. G. Biscaro, *Archivio Storico Lombardo*, XIV (1910), 105 ff.; Venturi, *Storia*, VIII (2), 691 (with bibliography); Bruschi, *op. cit.*, 171 ff. and 751 ff.

31. G. Chierici, *Atti IV° Congresso Nazionale Storia Architettura* (Milan, 1939), 25 ff.; *idem*, *La Chiesa di S. Satiro* (Milan, 1942).

32. L. H. Heydenreich, *Zeitschrift für Kunstgeschichte* (1937), 129 ff.; Hans Kauffmann, in *Condordia Decenalis*, *op. cit.* (Cologne, 1941), 123 ff.; R. Wittkower, in *Journal of the Warburg and Courtauld Institutes*, XVI (1953), 275; W. Lotz, *Mitteilungen des Kunsthistorischen Instituts Florenz*, VII (1953–6), 202 ff.; Arslan, *op. cit.*, 639; Förster, *op. cit.*, 97 ff.; Bruschi, *op. cit.*, 122 ff.

33. Willich, *op. cit.*, 71; Giovannoni, in *Miscellanea J. B. Supino* (Florence, 1933), 177; F. Gianini-Midesti, *Il Duomo di Pavia* (Pavia, 1932); O. H. Förster, in *Festschrift für Heinrich Wölfflin* (Dresden, 1935), 1 ff.; Arslan, *op. cit.*, 642 ff.; Bruschi, *op. cit.*, 180 and 765 ff.

34. Pica and Portalupi, *op. cit.* (with bibliography); Arslan, *op. cit.*, 650. See also S. Lang, *Warburg Journal*, XXXI (1968), 218 ff.; Bruschi, *op. cit.*, 194 and 783 ff.

35. Baroni, *op. cit.* (Note 18), 43 ff.; Malaguzzi-Valeri, *op. cit.* (Note 23), II, 135; P. Bondioli, *Il Monastero di S. Ambrogio* (Milan, 1935); Förster, *op. cit.* (Note 28), 126 ff.; Arslan, *op. cit.*, 654; Bruschi, *op. cit.*, 812.

36. Biscaro, *op. cit.*, 226; Malaguzzi-Valeri, *op. cit.* (Note 23), II, 135. The tree columns with cut-off branches appear again in a drawing by Leonardo (Cod. Atl. f. 315r).

37. L. H. Heydenreich, *Forschungen und Fortschritte*, X (1934), 305 ff.; F. Graf Wolff Metternich, *Kunstchronik*, XV (1962), 285; Bruschi, *op. cit.*, 546 and 883 ff.

38. Malaguzzi-Valeri, *op. cit.* (Note 23), II, *passim*; Venturi, *Storia*, VIII (2), 650 ff.; Arslan, *op. cit.*, 665.

39. C. Baroni, *S. Maria della Passione* (Milan, 1938).

40. C. Baroni, *L'Architettura lombarda da Bramante al Ricchino* (Milan, 1941), 35 and 83, 112 ff.; Arslan, *op. cit.*, 680.

41. Malaguzzi-Valeri, *op. cit.* (Note 23), III, 235 and 240; Venturi, *Storia*, VIII (2), 639, 645 ff.; Arslan, *op. cit.*, 665 ff.; A. Terzaghi, *Palladio*, N.S. III (1953), 145; G. Agnelli and A. Novasconi, *L'Incoronata di Lodi* (1952).

42. The present state of the building is the result of a modern restoration. (Reproduction of the original building in the rough in Venturi, *op. cit.*, 647.)

43. Cf. Note 38 for relevant literature. Also Willich, *op. cit.*, 156 ff.

44. Malaguzzi-Valeri, *op. cit.* (Note 23), II, 79 ff.; Arslan, *op. cit.*, 659 ff.; Bruschi, *op. cit.*, 227 and 819 ff.

45. Willich, *op. cit.*, 160–1.

46. Beltrami, *op. cit.* (Note 28), 12 ff.; A. Taramelli, 'La Piazza Ducale in Vigevano', *L'Arte*, V (1912), 248 ff.; Malaguzzi-Valeri, *op. cit.* (Note 23), II, 158 ff.; Arslan, *op. cit.*, 657, with bibliography; W. Lotz, 'Sansovino's Bibliothek von S. Marco und die Stadtbaukunst der Renaissance', in *Kunst des Mittelalters in Sachsen. Festschrift Wolf Schubert* (Weimar, 1967), 336 ff.

47. P. Gazzola, *La Cattedrale di Como* (Monumenti italiani) (Rome, 1939); F. Frigerio, *Il Duomo di Como e il Broletto* (Como, 1940).

48. Malaguzzi-Valeri, *op. cit.* (Note 23), II, 38; *Storia di Milano*, VII, 601 and 603; *ibid.*, 667, with reproductions of the Palazzo Magnani, which was pulled down in 1782; G. Rosa and F. Reggiori, *La Casa Silvestri* (Milan, 1962).

49. Venturi, *Storia*, VIII (2), 655; C. Calzecchi, 'Il Palazzo Fodri', *Bollettino d'Arte* (1933), 524 ff.

50. F. Malaguzzi-Valeri, 'L'Architettura a Cremona nel Rinascimento', *Emporium*, XIV (1901), 269; Venturi, *Storia*, VIII (2), 654; E. Signori, *Cremona* (Bergamo, 1928), 79.

51. See above, Bernardo Rossellino, p. 44.

52. See above, p. 78.

53. See below, p. 116.

54. R. Brenzoni, 'La Loggia del Consiglio veronese nel suo quadro documentario', *Atti Istituto Veneto Scienze, Lettere, Arti. Cl. scienze morali*, CXVI (1957–8), 165; *idem*, 'Fra Giocondo e la Loggia del Consiglio nella bibliografica veronese', *Atti Acc. Agricoltura, Scienze e Lettere di Verona*, series VI, vol. IX (1957–8), 14.

55. U. Papa, 'La Loggia di Brescia', *Rivista d'Italia*, II (1898), fasc. 8; C. Boselli, 'Notizia di storia dell'architettura . . . di Brescia', *Commentari*

p. 111

p. 112

dell'Ateneo di Brescia (1950), 109 ff.; E. Arslan, 'Commento breve alla Loggia di Brescia', *ibid.* (1956).

p. 112 56. G. Panazza, *L'Arte medievale nel territorio di Brescia* (Bergamo, 1942).

57. Venturi, *Storia*, VIII (2), 675.

58. *Ibid.*, 681.

CHAPTER II

p. 114 1. A. Gatti, *La Basilica petroniana* (Bologna, 1913); P. Ubertalli, *Il S. Petronio di Bologna* (Milan, 1911); G. Zucchini, *Guida della basilica di S. Petronio* (Bologna, 1953); R. Bernheimer, 'Gothic Survival and Revival in Bologna', *The Art Bulletin*, XXXVI (1954), 263 ff. For Antonio di Vicenzo: G. Giovannoni, 'Considerazioni . . . su S. Petronio di Bologna', *Miscellanea in onore di J. B. Supino* (Florence, 1933), 165 ff.

2. G. Zucchini, *Le Vicende della chiesa di S. Giovanni al Monte* (Bologna, 1914); J. B. Supino, *L'Arte nelle chiese di Bologna* (Bologna, 1938), 333 ff.; U. Beseghi, *Le Chiese di Bologna* (Bologna, 1956), 125.

3. Cf. Supino, *op. cit.*, 355 ff.

4. F. Malaguzzi-Valeri, *Emporium*, X (1899), 282; Supino, *op. cit.*, 399; Venturi, *Storia*, VIII (2), 452 ff.

5. Venturi, *Storia*, VIII (2), 404.

6. A. Rubbiani, *Rassegna d'Arte* (1909), 175; A. Foratti, *Miscellanea in onore di J. B. Supino* (Florence, 1933), 354 ff.; Supino, *op. cit.*, 314 ff.; A. Raule, *S. Giacomo Maggiore* (Bologna, 1955).

7. Supino, *op. cit.*, 299 f.

8. Thieme-Becker, XI (1915), 591 ff.; *Enciclopedia italiana* (Treccani), XV (1932), 237 ff.; Supino, *op. cit.*, 11 ff.; C. Ricci, *Archivio Storico Lombardo*, IV (1911), 92 ff. (documents); Venturi, *Storia*, VIII (2), 373 ff.; L. Beltrami, *Vita di Aristotile da Bologna* (Bologna, 1912); F. Filippini, 'Le Opere architettoniche di Aristotile F. in Bologna e in Russia', *Cronache d'Arte*, II (1925), 105 ff. Aristotile was a friend of Filarete, who often mentions him in his treatise (under the pseudonym of Letistoria).

p. 115 9. Supino, *op. cit.*, 16 ff.

p. 116 10. Venturi, *Storia*, VIII (2), 459; Supino, *op. cit.*, 23; L. Sighinolfi, *Il Palazzo Fava in via Manzoni, Nozze Fava* (Bologna, 1912); F. Malaguzzi-Valeri, *L'Architettura a Bologna nel Rinascimento* (Rocca S. Casciano, 1899), 131 ff.

11. Venturi, *Storia*, VIII (2), 457; Supino, *op. cit.*, 22; A. Rubbiani, *Rassegna d'Arte* (1908), 124.

12. See U. Beseghi, *Palazzi di Bologna* (Bologna, 1957), 213 ff.

13. Especially in the Palazzo dei Diamanti, Ferrara. See p. 119.

14. Supino, *op. cit.*, 20 ff.; Venturi, *Storia*, VIII (2), 467 ff.

15. G. Agnelli, *Ferrara e Pomposa* (Bergamo, 1904); P. Niccolini, *Ferrara* (Ferrara, 1930); N. L. Citadella, *Notizie relative a Ferrara . . .* (Ferrara, 1864), and *Documenti etc.* (1868); G. Padovani, *Architetti ferraresi* (Rovigo, 1955); G. Medri, *Ferrara* (Ferrara, 1957); B. Zevi, *Biagio Rossetti* (Ferrara, 1960), 17 ff., with classified bibliography of Ferrara.

16. Cf. R. Longhi, *Officina ferrarese* (Florence, p. 1956).

17. A. Venturi, *L'Arte*, XVII (1914), and XX (1917); Zevi, *op. cit.*, 21.

18. Padovani, *op. cit.*; Zevi, *op. cit.*, 21 ff. (for Pietro di Benvenuto) and 57 (for the Palazzo Schifanoia).

19. Typical examples of Ferrarese window ornament in terracotta in Zevi, *op. cit.*, 75 ff., plates 77–81.

20. Zevi, *op. cit.*, 22. In 1481 Pietro was entrusted with the repairs to the Fondaco dei Turchi, at that time the Venetian palace of the Este.

21. The first monograph to do justice to the importance of Rossetti is by G. Padovani, *B. Rossetti* (Ferrara, 1931) (supplemented in *Architetti ferraresi, op. cit.*). Zevi's comprehensive study, already mentioned (Note 15), contains a complete list of all documentary references, and is remarkable for its wealth of points of view, especially as regards town planning.

22. Zevi, *op. cit.*, 62 f. and 86 ff. (S. Giorgio) and 69 (Palazzo Pareschi).

23. *Ibid.*, 133 ff. and *passim.*

24. Reproduction in *ibid.*, 190–1. p.

25. Cf. the general plan with monuments marked in *ibid.*, 244–5.

26. P. Gino and M. Zanotti, *La Basilica di S. Francesco in Ferrara* (Genoa, 1958); Zevi, *op. cit.*, 303 ff., plates pp. 355 ff.

27. With the collaboration of Ercole Roberti? Cf. Zevi, *op. cit.*, 306 ff., plates pp. 388 ff.

28. *Ibid.*, 309 ff., plates pp. 404 ff.

29. *Ibid.*, 313 ff., plates pp. 423 ff.

30. *Ibid.*, 317 ff., plates pp. 438 ff.

31. *Ibid.*, 64, 102 ff. p.

32. *Ibid.*, 192 ff.

33. *Ibid.*, 197.

34. *Ibid.*, 194 ff.

35. *Ibid.*, 200 ff. and 320 ff.

36. Venturi, *Storia*, VIII (2), 476; *Enciclopedia* p.

italiana, xxxv (1937), 859 ff. (with older bibliography).

37. G. Ferrari, *Piacenza* (Bergamo, 1931); P. Gazzola, 'Il Rinascimento a Piacenza', *Atti 1° Convegno Nazionale Storia Architettura* (Florence, 1936), 245 ff.

38. P. Gazzola, *Opere di A. Tramello* (Rome, 1935); J. Ganz, *Alessio Tramello* (Frauenfeld, Switzerland, 1968).

39. P. Roi, 'S. Sepolcro a Piacenza', *Bollettino d'Arte*, xvii (1923–4), 356 ff.; P. Verdier, *Mélanges d'Archéologie et d'Histoire*, lxiv (1952), 312; Ganz, *op. cit.*, 37 ff.

40. A. Pettorelli, *La Chiesa di S. Sisto* (Piacenza, 1935); C. Baroni, 'S. Sisto a Piacenza', *Palladio*, ii (1938), 28; Ganz, *op. cit.*, 10 ff.

121 41. Corna P. Andrea, *Storia ed arte di S. Maria di Campagna* (Bergamo, 1908); Ganz, *op. cit.*, 53 ff.

CHAPTER 12

122 1. Venturi, *Storia*, viii (2), 197 and 198.

2. *Ibid.*, 206. Cf. also *Pinerolo, Guida* (Pinerolo, 1934).

3. Cathedral rebuilt in 1405–35; baptistery thirteenth century, renovated in the fifteenth century.

4. E. P. Duc, *Le Prieuré de St Pierre et St Ours* (Aosta, 1899); P. Toesca, *Aosta* (Rome, 1911); M. Aldrovandi, *Aosta* (Turin, 1930), 15 f.

5. Venturi, *Storia*, viii (2), 218.

6. F. Rondalino, *Il Duomo di Torino* (Turin, 1898); A. Midana, *Il Duomo di Torino* (Italia sacra, nos. 7–8) (Milan, 1929); S. Solero, *Il Duomo di Torino* (Pinerolo, 1956); G. Urban, 'Der Dom von Turin und seine Stellung zur römischen Architektur des Quattrocento', *Römisches Jahrbuch für Kunstgeschichte*, ix–x (1962), 245 ff. (appendix).

7. It would be a rewarding study to treat the question of the basilican façade of the fifteenth century as a separate subject. The number of – more or less – complete façades (Rimini: S. Francesco; Florence: S. Maria Novella; Rome: S. Maria del Popolo and S. Agostino; Venice: S. Zaccaria; Modena: S. Pietro; Bolsena: S. Cristina; Ferrara: S. Francesco; Turin: Duomo) is very small in comparison with those that were never finished. In Florence, for instance, S. Lorenzo and S. Spirito were the subjects of repeated competitions, discussions, and disputes which give a great deal of insight into the problems involved in the decisions. It looks as if the great architects of the Quattrocento, in particular, tended to evade the question,

or to delay it until it was too late. Brunelleschi's churches, the Duomo of Faenza, and S. Maria presso S. Satiro in Milan are examples of these 'delaying tactics'. It was not until the eighteenth century that the problem was mastered by a greater freedom and assurance in the use of articulating orders. Cf. the few but excellent remarks by Jacob Burckhardt in his *History of the Renaissance in Italy*, chapter x, paras. 68–71. For the dispute about the façade of S. Spirito, see below, Chapter 13, p. 135 and Note 26.

8. E. Checchi, 'La Chiesa bramantesca di **p. 123** Roccaverano', *Bollettino d'Arte* (1949), 205 ff.; Bruschi, *op. cit.* (Chapter 10, Note 28), 1047 f.

9. Venturi, *Storia*, viii (2), 251 ff.; P. Guglielmo Salvi, 'Il Duomo di Genova', *L'Italia Sacra*, ii (1931–4), 845 ff., especially 896. Cf. also L. A. Cervetto, *I Gaggini da Bissone* (Milan, 1903).

10. Venturi, *Storia*, viii (2), 254 (Palazzo in Vico d'Oria) and 257 (Palazzo in Piazza S. Matteo); R. Piacentini, 'Palazzo Andrea Doria', *Architettura*, x (1930–1), 101 ff.; G. Noémi, 'Palazzo Doria in Piazza S. Matteo', *Bollettino d'Arte*, xxvii (1933–4), 75 ff.

11. 'Palazzo Cambiaso, Restauro', *Bollettino d'Arte*, n.s. iii (1923–4), 285. The only example of an outer courtyard staircase in Florence is Giuliano da Sangallo's flight of stairs in the Palazzo Guadagni (see below, p. 136). Giuliano may have taken the idea of this motif – unknown in Tuscany – from Liguria, since he was working there for Giuliano della Rovere in the nineties.

12. A reflection of this specifically Genoese **p. 124** polychromy can be seen in Giuliano da Sangallo's Palazzo Rovere at Savona (see below, p. 138).

13. Venturi, *Storia*, viii (2), 1 ff.

14. *Ibid.*, 2.

15. *Ibid.*, 5 and 15.

16. *Ibid.*, 53 ff. This section is so far the only comprehensive account of architecture in Sicily, except for a little pamphlet by E. Calandra, *Breve Storia dell'architettura in Sicilia* (Bari, 1948). There are practically no special studies, but cf. E. Maganuco, *Problemi di datazione dell'architettura siciliana* (Catania, 1939); G. B. Comandé, *Influenze spagnuoli nell'arte della Rinascenza* (Palermo, 1947), 8 ff. Cf. also *T.C.I. Attraverso l'Italia: Sicilia* (Milan, 1933); G. Samonà, 'L'Architettura in Sicilia dal secolo XIII a tutto il Rinascimento', *Atti VII° Congresso Nazionale Storia Architettura, Palermo, 1950* (Palermo, 1956), 135 ff.

17. Venturi, *Storia*, viii (2), 62.

18. *Ibid.*, 130 f. See also next Note.

19. *Ibid.*, 129, and R. Pane, *Architettura del Rinascimento in Napoli* (Naples, 1937), 38 and 102. The Spanish works, in particular the Casa de los Picos at Segovia, were only built in the sixteenth century. Cf. B. Bevan, *History of Spanish Architecture* (London, 1938), 137; V. Lampérez y Romea, *Arquitectura civil espagnola*, I (Madrid, 1922), 344. Even the Palazzo Steripinto at Sciacca belongs to the turn of the century: Calandra, *op. cit.*, 63, plate; *T.C.I. Attraverso l'Italia, Sicilia*, 135.

p. 124 20. See below, p. 128, Notes 49–51.

21. S. Di Bartolo, *Monografia sulla cattedrale di Palermo* (Palermo, 1903); Venturi, *Storia*, VIII (2), 92; S. Cardella, *L'Architettura di Matteo Carnalivari* (Palermo, 1936), 8.

22. Venturi, *Storia*, VIII (2), 115 ff.

23. Comandé, *op. cit.*, 7 ff.

24. Sources: G. Filangieri di Satriano, *Documenti per la storia, le arti e le industrie delle provinzie napolitane*, 6 vols. (Naples, 1883–92). Summonte's frequently published letter to M. A. Michiel is available, with a good commentary, in F. Nicolini, *L'Arte napolitana del Rinascimento* (Naples, 1925). Cf. also C. von Fabriczy, 'Toscanische und oberitalienische Künstler im Dienste der Aragonesen in Neapel', *Repertorium für Kunstwissenschaft*, XX (1897), 85. Literature: R. Pane, *Architettura del Rinascimento in Napoli* (Naples, 1943); A. De Rinaldis, 'Forme tipiche dell'architettura napolitana nel prima metà del' 400', *Bollettino d'Arte*, IV (1924), 162 ff.; Venturi, *Storia*, VIII (1), 669 ff., VIII (2), 19 ff., XI (1), *passim*; G. L. Hersey, *Alfonso II and the Artistic Renewal at Naples 1485–1495* (New Haven and London, 1969); C. Thoenes, *Neapel und Umgebung* (Reclam's Kunstführer Italien, VI) (1971) (excellent).

p. 125 25. Jacob Burckhardt, *Kultur der Renaissance in Italien. Collected Works* (ed. E. Kägi), V (1930), 24 ff.

26. The triumphal procession is described in detail, according to the sources, by C. von Fabriczy, 'Der Triumphbogen Alfonso I's etc.', *Jahrbuch der Preussischen Kunstsammlungen*, XX (1899), 4 ff. and 146 f. Cf. also Burckhardt, *op. cit.*, 302.

27. The mass of literature and the opposing views are critically summarized in L. Planiscig, 'Ein Entwurf für den Triumphbogen am Castelnuovo in Neapel', *Jahrbuch der Preussischen Kunstsammlungen*, LIV (1933), 16 ff., and also in the last major publication by R. Filangieri di Candida, *Castelnuovo Reggia angioina e aragonese a Napoli* (Naples, 1934). Cf. also Pane, *op. cit.*, 65 ff.; R. Causa, 'Sagrera, Laurana e l'Arco di Castelnuovo', *Paragone*, V (1954), no. 55, pp. 3 ff. The documents

are collected in C. von Fabriczy, *op. cit.* (Note 26), 146, and *idem*, *op. cit.* (Note 24), 85 ff. (cf. however the critical revision in Planiscig, *op. cit.*).

The design from the Pisanello circle discovered in 1932 (Rotterdam, Boymans Museum, formerly Koenigs Collection, cf. Planiscig, *op. cit.*) has made confusion worse confounded as far as the origin of the Alfonso Arch is concerned. The design, executed entirely in Late Gothic forms, has many striking points of resemblance to the monument as it was completed: the coupled order in the lower storey, the niche in the upper storey which was to contain the equestrian statue, and the crowning series of niches, although with five instead of the four niches of the finished monument. On the other hand, the central iconographic motif of the arch, the attic with its cycle of reliefs, is lacking. But the great medallion over the arch recalls the tondi of Frederick II's gatehouse at Capua. Degenhart (*A. Pisanello* (Vienna, 1941), 49 ff.) gives good grounds for assigning the drawing, which bears the ancient and credible name of Bononus de Ravena, a master who appears in the account-books of the Castello between 1444 and 1448, to the first stage of the preliminary plans. Given the standing of Pisanello in Naples, his advice was certainly sought, and we can assume that he worked on the subject of the reliefs on the arch (Degenhart). Cf. also H. Keller, 'Bildhauerzeichnungen Pisanello's', *Festschrift Kurt Bauch* (Munich, 1957), 139 ff.

The final transformation into the type of the triumphal arch *all'antica* was therefore only carried out in the following years, probably after 1452, when Pietro da Milano and Francesco Laurana arrived on the scene.

28. The arch of Pola is the only extant classical monument of its type with coupled columns, since the so-called Elephant Arch of Domitian was destroyed by Domitian's successors. Cf. E. Noack, 'Triumph und Triumphbogen', *Vorträge der Bibliothek Warburg, 1925–1926* (Leipzig, 1928), 147 ff., plates XVI and XXXIII. See also Pane, *op. cit.*, 75. A little later, the arch of Pola again served as a model, this time for the Porta dell'Arsenale in Venice, built in 1464 (see p. 86 above).

29. A collaboration by Alberti (E. Bernich, *Napoli Nobilissima*, XII (1903–4), 114 ff., 131 ff.) is quite out of the question, as has been proved by G. Mancini (*Vita di L. B. Alberti*, 2nd ed. (Florence, 1911), 434) and Pane (*op. cit.*, 80).

30. The passage in the life of Donatello by the Anonimo Magliabecchiano, XII (1903–4) (G. Semper, *Donatello* (Vienna, 1875), 307) which

states that Donatello had designed an equestrian statue for Alfonso has been completely neglected in recent research, which to my mind is a mistake. (Cf. also G. Milanesi, *Catalogo delle opere di Donatello* (Florence, 1887), 15 and 63; Vasari (ed. Milanesi), *op. cit.*, II, 409.)

31. Pane, *op. cit.*, 88 ff. For the Capua gatehouse (demolished in 1557) cf. C. Shearer, *The Renaissance of Architecture in Southern Italy* (Cambridge, 1937), 118 ff., and C. A. Willemsen, *Kaiser Friedrich's II Triumphbogen zu Capua* (Wiesbaden, 1953), 26 ff.; the latter also contains reproductions of extant fifteenth-century drawings of the gatehouse (plates 98–104); one is by Francesco di Giorgio.

32. The library founded by the house of Aragon was famous; it has been reconstructed with the utmost care and published in a de luxe edition by T. De Marinis, *La Biblioteca napolitana dei re d'Aragona*, 4 folio vols. (Verona, 1947–51). See also Burckhardt, *op. cit.*, 158 f.

33. Cf. Note 24.

34. In February 1482, Lorenzo de' Medici lent Filarete's Trattato from his own library in order that it might be copied for the 'Cardinale di Aragona' (M. Del Piazzo, *Protocolli del Carteggio di Lorenzo il Magnifico* (Florence, 1956), 229; previously, K. Frey, 'Michelagniolo Buonarotti', *Quellen und Forschungen*, I (1907), 59). In all probability this is the present Codex Valencianus in the University Library at Valencia, unfortunately lost – or as we hope mislaid – since the Spanish civil war. It contains the dedication to Piero de' Medici, which is also in the Medici copy, the Codex Magliabecchianus, but bears on the frontispiece the arms of Aragon. Since Cardinal Giovanni of Aragon died in Rome in 1485, the codex must have been taken into the royal library at Naples at the latest in that year. Cf. Marinis, *op. cit.*, II, 72. The dates given by M. Lazzaroni and A. Muñoz, *Filarete* (Rome, 1908), 237, need correction.

126 35. For Giuliano's work and great reputation in Naples cf. the documents in C. von Fabriczy, 'Chronolog. Prospekt der Lebensdaten und Werke', *Jahrbuch der Preussischen Kunstsammlungen*, XXIV (1903), 137 ff.; also *Repertorium*, XX (1897), 85 ff. For the Porta Capuana, Pane, *op. cit.*, 92.

36. Summonte, *op. cit.*, 172. Literature on Poggioreale: A. Colombo, 'Il Palazzo e il giardino di Poggioreale', *Napoli Nobilissima*, I (1892), 117 ff., 136 ff., 166 ff.; idem, *Storia per le provincie napolitane*, X (1885), 186 ff. (with summary of all contemporary documents); Fabriczy, *op. cit.* (Note 35); Pane, *op. cit.*, 15 ff.; C. L. Frommel, *Die Farnesina*

und Peruzzi's architektonisches Frühwerk (Berlin, 1961), 90 ff.

37. Frommel succeeded in giving an enlightening interpretation of Peruzzi's drawings (*op. cit.*, 93). See also the representation of Poggioreale in the engraving of S. de Bloen (*Nuovo Teatro*, 1663), reproduced in *Bollettino del Centro . . . Andrea Palladio*, XI (1969), plate 1.

38. The resemblance between the Nova Domus and Poggioreale has remained unnoticed up to now, yet it seems to me obvious. Further, Fancelli employed the type of the villa with corner pavilions before the Nova Domus in the palazzo-villa of Motteggiana (cf. *Mantova, Le Arti, op. cit.*, II, 78 f. and 92). This experiment of Fancelli's may well have been the reason why Lorenzo de' Medici proposed him as Giuliano da Maiano's successor as architect-in-chief at Poggioreale (cf. Note 40).

39. Cf. above, Chapter 7, Note 11.

40. For Sangallo's grandiose project for the p. 127 King of Naples' palace (Codice Barberino, fol. 9 and 39v, Taccuino Senese, fol. 8v and 17) – which brought him in an honorarium of 100 ducats – cf. Pane, *op. cit.*, 35 ff., and R. Marchini, *Giuliano da Sangallo. Florence* (Florence, 1942), 88. For Luca Fancelli, who was in Naples during the first half of the year, cf. C. von Fabriczy, *Repertorium*, XX (1897), 95, and W. Braghirolli, *Archivio Storico Lombardo*, III (1876), 621.

41. Francesco di Giorgio was at Naples in 1479–80, 1490–1, and in 1495, chiefly engaged on fortifications (Fabriczy, *op. cit.* (Note 40), 100 ff.). But as Summonte expressly names him as a collaborator on Poggioreale, he must at any rate have acted as a consultant there.

42. This seems to be the most suitable place to summarize the little that is known of the elusive personality of the humanist Fra Giovanni Giocondo Veronese (1433–1515), in so far as it is connected with the present work. The literature is scanty: Vasari (ed. Milanesi), *op. cit.*, V, 261, also the Bemporad Edition (Florence, 1915), with an exhaustive introduction by G. Fiocco; G. Fiocco, 'Fra Giocondo', *Atti dell'Accademia d'Arti, Industrie e Commercio di Verona*, ser. IV, vol. XVI (Verona, 1915); P. Lesueur, 'Fra Giocondo en France', *Bulletin de la Société de l'Histoire de l'Art français* (1931), 115 ff.; R. Brenzoni, 'La Loggia del Consiglio di Verona e Fra Giocondo nella bibliografica veronese', *Atti dell'Accademia d'Arti, Scienze e Lettere* (1958); idem, *Fra Giocondo* (Florence, 1960); F. Graf Wolff Metternich, 'Der Entwurf Fra Giocondo's für Sankt Peter', *Festschrift Kurt Bauch*

(Munich, 1957), 155 ff. Fra Giocondo was a Franciscan and a man of great learning, whose printed works – especially the 1511 edition of Vitruvius and the Commentari di Giulio Cesare of 1513 – made him famous among architects. As an epigraphist he made a large collection of classical inscriptions which Mommsen mentions with the greatest respect. In his time he had a great name as an architectural engineer, and was mainly consulted in that capacity in many places – France, Venice, Lombardy, Naples, and finally even in Rome. But his knowledge of engineering also applied to architecture as an art; at Naples he was appointed superintendent of Poggioreale after Maiano's death. In contemporary literature he is denoted as *architectus prestabilis*, *architectus nobilis* and *in architectura omnium facile princeps* (Lesueur, *op. cit.*, 116). Charles VIII and Louis XII took him into their service as an architect, as did the Republic of Venice, and Leo X appointed him to assist young Raphael, in spite of his eighty years, as superintendent of the Opera of St Peter's (1514). All the documents bear witness to the extraordinary respect and esteem which Fra Giocondo enjoyed not only for his great knowledge, but also for the charm of his personality. In the older literature, important works are ascribed to him, e.g. the Loggia del Consiglio at Verona, a large number of drawings, and a considerable share in the new plans for St Peter's after Bramante's death. This *œuvre* could not stand the test of more informed criticism; even his plan of St Peter's is rather a free paraphrase on the theme than a genuine plan (Metternich, *op. cit.*). His time in Naples came at the beginning of his professional career, and was at first largely occupied with the study of classical monuments. He was also paid for 126 illustrations for Francesco di Giorgio's treatise on architecture (cf. De Marinis, *op. cit.* (Note 32), II, 298). Since Francesco's Florentine Codex contains 127 illustrations, it must have been copyist's work supervised by Fra Giocondo. His work as architect-in-chief at Poggioreale cannot be clearly distinguished; nevertheless he was in office for more than two years and was rewarded by lucrative sinecures. In addition to Francesco di Giorgio and Giuliano da Sangallo, who were both in Naples at the same time, though only for short periods, Fra Giocondo must be regarded as the personality which had the most considerable, if not a direct, influence on developments at the turn of the century in Naples. He was in every sense the representative of Tuscan early classicism there,

while his design for St Peter's – submitted between 1505 and 1512, during the Bramante phase of planning – shows him to have been an intermediary of Veneto-Byzantine Renaissance forms which he had obviously made his own during the time he spent in Venice (Metternich, *op. cit.*). In the last resort, Fra Giocondo, in matters of design, was rather a highly respected and knowledgeable partner in discussion – this is the undertone of Raphael's letter to his uncle of 1 July 1514 – than a creative architect. His practical activity was technical, as can be seen in his Seine bridge in Paris or his defensive works in Venice. (All the evidence to be found in the sources is collected in R. Brenzoni's two publications.)

43. *Tutte le opere di architettura di Sebastiano Serlio Bolognese*, lib. III (Venice, 1584), 122. Cf. Pane's fine interpretation of Serlio's plans, *op. cit.*, 16 ff.

44. Pane, *op. cit.*, 26 ff.

45. The passage from Summonte in Pane, *op. cit.*, 8.

46. Ed. Spencer, *op. cit.* (Chapter 10, Note 8), I, 123, II, folio 70 verso.

47. Pane, *op. cit.*, 113 ff.

48. For the Palazzo Penna, A. De Rinaldis, *Bollettino d'Arte*, IV (1924), 168 ff.; Pane, *op. cit.*, 101 f. For the Palazzo Caraffa, Pane, *op. cit.*, 105 ff. For the Palazzo D'Aponte, *ibid.*, 52 f.

49. The Hohenstaufen castles, which remain from Prato to Sicily, show many variants of ashlar in superb technique. A. Haseloff (*Die Bauten der Hohenstaufen in Unteritalien* (Leipzig, 1920), 231 f.) gives a summary of all the variants; in Sicily, the block cut as a truncated prism can be seen in the Castello of Augusta (G. Agnello, *L'Architettura sueva in Sicilia* (Rome, 1935), 181 ff.). Cf. also Shearer, *op. cit.*, *passim*.

50. Pane, *op. cit.*, 37 ff. p. 1:

51. See p. 97 above. The towers of the Castello Sforzesco were most likely designed by Filarete. They aroused the interest of Federico da Montefeltro and were soon famous and imitated (see above, Chapter 10, Note 7). Even Cesariano describes them in detail in his commentary to Vitruvius (ed. Como, 1521, fol. 21ᵛ). For R. Sanseverino cf. R. Spreti, *Enciclopedia Storica Nobiliare Italiana*, VI (Milan, 1932), 234 ff.

The huge conical plinths of the towers of the Castelnuovo, in spiral courses, where diamond-cut blocks are also used, were first built in the sixties to cloak the (older) towers. But in them the ornamental forms employed in the Castello of Milan have taken on bizarre shapes. What comes out here

is a Spanish feeling. For the date: Filangieri, *op. cit.* (Note 27), 234 ff.

52. Palazzo Siculo: Pane, *op. cit.*, 44 (with illustration). A scion of this southern type in the Marches is the Palazzo Diamante at Macerata (*c.* 1500).

53. Pane, *op. cit.*, 57 f.

54. For the chapels in S. Anna di Monteoliveto cf. Pane, *op. cit.*, 185 ff. – where a number of porches of the same stylistic phase are quoted. While all the parts of the Brancacci Chapel in S. Angelo a Nilo – which still belonged to the Angevin period – were prepared by Donatello and Michelozzo in Tuscany and merely 'assembled' in Naples, the chapels of Monteoliveto were actually built in Naples. The only parts made in Florence were the altars by Antonio Rossellino and Benedetto da Maiano. See also recently Thoenes, *op. cit.* (Note 24), 42 ff.

55. Pane, *op. cit.*, 206 ff.; Thoenes, *op. cit.*, 122 ff.

56. Pane, *op. cit.*, 234 ff. The architect was probably Romolo Balsimelli of Settignano (b. 1479), who arrived in Naples somewhere about 1500 (*ibid.*, 232). Cf. Thoenes, *op. cit.*, 68 ff.

57. Pane, *op. cit.*, 247 ff.; Thoenes, *op. cit.*, 263 ff.

58. Pane, *op. cit.*, 254; Thoenes, *op. cit.*, 226.

59. Pane, *op. cit.*, 254 ff.; Thoenes, *op. cit.*, 269.

CHAPTER 13

130 1. Cf. also G. Urban, in *Römisches Jahrbuch für Kunstgeschichte*, IX/X (1961/2), 237. The assimilation of Roman antiquity in architecture at the time of the Early Renaissance took in the study of building construction on equal terms with architectural types. Yet the study of the great monuments (Colosseum, Basilica of Maxentius, Minerva Medica, Pantheon, Thermae) should neither be over- nor underrated; it set the standards for the ideal image of Rome. The countless *small* monuments – tombs, houses, villas – are, however, not much less important for the development of Renaissance architecture; they provided a vast repertory of form which was, at that time, far greater than that of the few remains now extant. The architects of the Quattrocento drew much of their knowledge from this *architettura minore*. The developing change in the attitude to antiquity from the time of Brunelleschi, by way of Alberti, to the generation of Francesco di Giorgio and Giuliano da Sangallo is a fascinating subject which could be treated from the existing monuments and the architectural drawings (views of classical monuments).

2. As I have pointed out above, the art of architectural ornament has not had the treatment it deserves in this short survey. The systematic study of Quattrocento decorative forms began well with Stegmann–Geymüller, X and XI, for Tuscany; A. G. Meyer, *Oberitalienische Frührenaissance* (Berlin, 1897–1900) for Lombardy; P. Paoletti, *L'Architettura e la scultura del Rinascimento in Venezia* (Venice, 1893–7) for Venice; and J. Baum, *Baukunst und dekorative Plastik der Frührenaissance in Italien* (Stuttgart, 1920) – but there it stopped. It stands in urgent need of a fresh start such as P. Rotondi's publications on Urbino, G. Urban's on Rome, and the – unfortunately still unpublished – Venetian studies by E. Hubala. Reference has already been made to partial but valuable studies of the subject (Saalman, Gosebruch, Chastel, Marchini, Sanpaolesi, etc.).

3. See above, pp. 103 ff.

4. Bibliography: Vasari (ed. Milanesi), *op. cit.*, III, 69 ff. Also G. Mancini, *Cinque Vite di Vasari annotate* (Florence, 1917), 42 and 105; S. Brinton, *Francesco di Giorgio Martini*, 2 vols. (London, 1934–5); A. S. Weller, *Francesco di Giorgio* (Chicago, 1943) (with bibliography of older literature and complete list of documents); R. Papini, *Francesco di Giorgio Martini architetto*, 3 vols. (Florence, 1946) (which also contains a detailed treatment of fortifications). The severe criticism called forth by this work has already been referred to in the Urbino section (Chapter 7, Note 31). Later studies: M. Salmi, 'Disegni di Francesco di Giorgio nella Collezione Chigi-Sarazeni', *Quaderni Acc. Chigiana*, XI (Siena, 1947); *Studi artistici urbinati*, I (Urbino 1949) (with contributions on Francesco di Giorgio by M. Salmi, C. Maltese, P. Rotondi, and P. Sanpaolesi); P. Rotondi, *Il Palazzo Ducale di Urbino*, 2 vols. (Urbino, 1950), *passim*; C. Maltese, 'L'Attività di Francesco di Giorgio architetto militare nelle Marche attraverso il suo *Trattato*', *Atti XI° Congresso Storia Architettura, Marche, 1959* (Rome, 1962). For the treatise, cf. Note 12. For Francesco di Giorgio's work in painting also C. Maltese, 'Il Protomanierismo di F.d.G.M.', *Storia dell'Arte*, IV (1969), 440 ff.

5. P. Sanpaolesi, 'Aspetti dell'architettura del p. 131 '400 a Siena e Francesco di Giorgio Martini', *Studi artistici urbinati*, I (Urbino, 1949), 137 ff.

6. For documentation, see Weller, *op. cit.*, 7, and C. Maltese, *Studi artistici urbinati*, I (Urbino, 1949), 60 ff.

p. 131 7. For documentation, see G. Mancini, *Notizie sulla chiesa del Calcinaio* (Cortona, 1867). See also Weller, *op. cit.*, 15 ff., and Papini, *op. cit.*, 71 ff.

8. Cf. the drawings in Francesco's treatise: Cod. Laurenzio Ashb., 361 (Florence), fol. 12v; Cod. Saluzziano 148 (Turin) fol. 84²/v. Reproduced in Maltese, *op. cit.* (Note 6), 65–6.

9. P. Rotondi, *Studi artistici urbinati*, 1 (Urbino, 1949), 87 ff.

p. 132 10. For documents, A. Gianandrea, *Il Palazzo del Comune di Jesi* (Jesi, 1877); M. Salmi, *Studi artistici urbinati*, 1 (Urbino, 1949), 30 ff.

11. M. Salmi and C. Maltese in *Studi artistici urbinati*, 1 (Urbino, 1949), 38 and 77; P. Rotondi, 'Quando fu costruita la chiesa di S. Bernardino in Urbino?', *Belle Arti*, 1 (1947), 191.

12. Francesco di Giorgio Martini (ed. C. Promis), *Trattato di architettura civile e militare*, 3 vols. (Turin, 1841). A new edition, which had become urgently necessary, has been published by C. Maltese (2 vols., Milan, 1962). On the question of the treatise cf. also Mancini, *op. cit.*, 105, Weller, *op. cit.*, 268 ff., and Papini, *op. cit.*, 189 ff.

Several versions of the original of Francesco's treatise have been preserved, which are described, not very clearly, by Promis, *op. cit.*, 1, 87 ff., and, not very adequately, by Weller, *op. cit.*, 268 ff. The new edition by Corrado Maltese provides a clear connection. The most important of the MSS. are the Codex Ashburnham 361, Biblioteca Laurenziana, Florence – an abridged presentation of the text; Codex II. I. 141 (former Biblioteca Magliabecchiana) in the Biblioteca Nazionale, Florence; and Codex 148 of the former Library of the Duke of Genoa, Turin (Plate 135). These three MSS. are lavishly illustrated. There must be added to them a fourth, the Codex S. IV. 6, in the Biblioteca Nazionale, Siena, which is hardly illustrated at all, but is interesting because it is obviously a draft – there are a large number of erasures and corrections.

The Ashburnham Codex contains some marginal notes by Leonardo (cf. J. P. Richter, *The Literary Work of Leonardo da Vinci*, II (Oxford, 1939), 417) which can be dated about 1490. According to C. Maltese this codex was written during the years Francesco spent at Urbino and was the first written version of his studies in architectural theory. Since the dedication of the treatise and several passages in the text refer to Federico da Montefeltro, it must have been begun before Federico's death in 1482. The expanded version of the text, on the other hand, mentions a number of fortifications which Francesco only built in the nineties,

so that work on this part of the treatise must have been continued till 1500; see C. Maltese, 'Francesco di Giorgio come architetto militare nelle Marche', *Atti XI° Congresso di Storia Architettura, Marche 1959* (Rome, 1962). For the discussions concerning the chronology and authenticity of the various manuscripts of the treatise see also A. Parronchi, 'Su un manoscritto attribuito a Francesco di Giorgio Martini' and 'Sulla composizione dei trattati attribuiti a F.d.G.M.', *Atti dell'Accademia Toscana di Scienze e Lettere 'La Colombaria', Firenze*, XXXI (1960), 165 ff., and XXXVI (1971), 165 ff.

The treatise is divided into seven parts. Book I deals with the basic principles of architecture and with building materials; Book II with domestic and palazzo architecture (it contains the description of the great stables at Urbino); Book III with town planning and the orders; Book IV with church building; Book V, which is as long as the first four books put together, with fortifications – it is the heart of the treatise; Book VI with harbour-building; Book VII with war machinery and building tools.

In the Codex Magliabecchiana the treatise is followed by an excerpt from Vitruvius which is the earliest translation from the Latin into the vernacular. If it was made by Francesco, which W. Lotz doubts (*Mitteilung–Kunsthistorisches Institut Florenz*, V (1940), 429), but C. Maltese confirms, the work would imply a highly cultivated background and could have been written nowhere but in the humanistic atmosphere of the court of Urbino.

The codices in Florence and Turin contain, as an appendix to the treatise, a large number of drawings of machines (Florence) and of antique monuments (Turin). Cf. Note 15.

13. Filarete, *Trattato*, lib. II, Cod. Magl. II. IV. 140, fol. 7 verso: 'L'architetto debba nove o sette mesi fantasticare o pensare e rivoltarselo per la memoria in più modi e fare vari disegni nella sua mente'. For Fancelli, see above, p. 81, and Chapter 8, Note 14. Francesco di Giorgio expresses the same idea: '. . . dato che alcuno nella fantasia avesse ordinato alcuno . . . edifizio, volendo quello fare componere e fabbricare, non può senza il disegno esprimere a dichiarare il concetto suo' (*Trattato*, ed. Promis, 328).

14. Many of Peruzzi's ideal designs for basilicas go back, to my mind, to ideas of Francesco di Giorgio. Pietro Cataneo too copies Francesco (E. Berti, 'Un Manoscritto di P. Cataneo . . . e un

codice di Francesco di Giorgio', *Belvedere*, VII, I (1925), 100 ff.).

15. E.g.: staircases, Cod. Magl. II.1.141, fol. 249V–250; Cod. Ashb. 361, fol. 16^2/v, 18V (monumental spiral staircases). Courtyards: Florence, Uffizi, Dis. arch. 320A, 328A; Cod. Ashb. 361, fol. 17^2, 18^2. What has never been thoroughly investigated is the connection between Francesco's free architectural drawings – especially those of the so-called *Taccuino del viaggio* (Florence, Uffizi, Dis. arch. 318–37) – and the illustrations to his treatise; indeed, a systematic survey of his architectural drawings has yet to be made. A first and welcome classification is in Weller, *op. cit.*, 259 ff. The many studies of antique monuments, the sketches of free designs, and the pattern drawings in the MS. of the Trattato provide a wealth of material which is, with Giuliano da Sangallo's and Leonardo's, the most exhaustive documentation of architectural drawing in the Quattrocento. We can judge the value which Francesco himself attached to architectural drawings from his remarks on the *arte antigrafica* (*Trattato*, lib. I and Conclusione (ed. Promis), 125 and 328).

16. Cf. Weller, *op. cit.*, 24 ff. (Milan and Pavia) and 29 ff. (Naples), and Papini, *op. cit.*, *passim*. There is evidence for his visits to Rome in many drawings of ancient monuments.

17. The latest, admirably compact biography is by G. Marchini, *Giuliano da Sangallo* (Florence, 1942) (with bibliography of the older literature and complete list of sources). For further reference the following studies are indispensable: Vasari (ed. Milanesi), *op. cit.*, 267 ff.; Stegmann–Geymüller, V (1908); G. Clausse, *Les Sangallo*, I (Paris, 1900); C. von Fabriczy, 'Giuliano da Sangallo. Chronologischer Prospekt', *Jahrbuch der Preussischen Kunstsammlungen*, XXIII (1902), supplement, I ff.; Venturi, *Storia*, VIII (1), 469 ff.; E. Barfucci, *Lorenzo di Medici* (Florence, 1945), 258 ff. Special studies: C. von Fabriczy, *Die Handzeichnungen des Giuliano da Sangallo* (Stuttgart, 1902); R. Falb, *Il Taccuino Senese di Giuliano Sangallo* (Siena, 1902); C. Huelsen, *Il Libro di Giuliano da Sangallo, Codex Vatic. Barb. Lat. 4424*, 2 folio vols. (Leipzig, 1910). For his wood-carvings and sculpture: D. Frey, 'Ein unbekannter Entwurf für ein Chorgestühl . . .', *Mitteilungen des Kunsthistorischen Instituts Florenz*, III (1939), 197 ff.; M. Lisner, *Holzkruzifixe in Florenz und in der Toskana* (Munich, 1970), 85 ff.; U. Middeldorf, 'Giuliano da Sangallo and A. Sansovino', *The Art Bulletin*, XVI (1934), 107; Marchini, *op. cit.*, 103.

18. Ed. Huelsen, *op. cit.*, fol. 1r. p. 133

19. E. Müntz, *Les Arts à la cour des Papes* (Paris, 1878), II, 16, 38, 43, 70; C. von Fabriczy, 'Chronologischer Prospekt', *op. cit.* (Note 17), 2 f. For a critical estimate of documentary evidence, Marchini, *op. cit.*, 84.

20. Marchini, *op. cit.*, 88 f.; P. Sanpaolesi, 'Il Palazzo di Bartolomeo della Scala', in *Toskanische Studien: Festschrift für Ludwig H. Heydenreich* (Munich, 1963).

21. Full interpretation by A. Parronchi, 'The Language of Humanism and the Language of Sculpture', *Journal of the Warburg and Courtauld Institutes*, XXVII (1964), 108 ff.

22. Stegmann–Geymüller, V, 5; Patzak, *Renais-* p. 135 *sance und Barockvilla*, II (Leipzig, 1912–13), 107; Marchini, *op. cit.*, 16 and 85; C. Frommel, *Die Farnesina, etc.* (Berlin, 1961), 89. P. Sanpaolesi, *Brunelleschi* (Milan, 1962), points out that the coffering in the vestibule and salone are solid units cast in curved shape, and therefore prepared by a kind of pozzolana technique derived from antiquity. He had applied the same technique before in the coffering of the arcades of the courtyard in the Scala palace; these facts give a grain of truth to Vasari's anecdote which relates that Giuliano, in order to demonstrate the quality of his new process, first vaulted a room in his own house with it (Vasari (ed. Milanesi), IV, 271).

23. Stegmann–Geymüller, V, 7; Marchini, *op. cit.*, 20 and 87.

24. Stegmann–Geymüller, 11; Marchini, *op. cit.*, 11 and 84; W. Paatz, *Die Kirchen von Florenz*, IV (Frankfurt, 1952), 90 ff.

25. Clausse, *op. cit.*, I, 120; cf. Marchini, *op. cit.*, 89.

26. The best account of the solution of the façade of S. Spirito is still Fabriczy's (*Brunelleschi* (Stuttgart, 1892), 202), or that of Paatz (*op. cit.*, V, 120). The dispute whether Brunelleschi's plan should be retained, with four entrances on the front, or whether this unconventional scheme should be abandoned for the conventional three entrances, went on for twelve years (1475–87). The architect-in-chief at that time, Salvi d'Andrea, was in favour of three entrances; another group, taking its stand on a statement by the aged Paolo Toscanelli, supported the four-entrance scheme. Giuliano da Sangallo, an adherent of Brunelleschi, was unable to be present at the deciding meeting held in May 1486 as he could not leave Prato. At the meeting, Giuliano da Maiano spoke for the three-entrance scheme; the result of the voting

was 30 for and 17 against. At the second voting there were 38 against the four entrances and only 9 for. Thus Salvi had won the day. Paolo Toscanelli's vote – he had died in 1486 – was easily set aside: 'Maestro Paghojo . . . aveva sentito che le porte avevano a essere 4, ma che modo avessino a stare che nol sapeva . . .'. It was in vain that Sangallo wrote to Lorenzo de' Medici the following day bitterly complaining of the 'boria del maiano' and imploring him to use his influence to prevent an outrage on so beautiful a building. (Sources: Gaye, *op. cit.* (Chapter 7, Note 11), II, 450, and C. Pini and G. Milanesi, *La Scrittura d'artisti italiani* (Florence, 1876), I, no. 89.) On fol. 14ʳ of the Codex Barberinus, Sangallo gives a fully elaborated solution for the four-entrance scheme.

p. 135 27. *Taccuino Senese* (ed. Falb, *op. cit.*, Note 17), fol. 5 (not identified by Falb). Cf. also C. von Fabriczy, *Die Handzeichnungen des Giuliano da Sangallo*, *op. cit.*, 34 and 77. On fol. 21ᵛ (Falb, plate XII) there is a drawing of a similar 'extension' of the plan of S. Lorenzo; all accompanying compartments are squared up, including the side chapels; one dome per bay of the nave and also of the aisles and side chapels.

28. Marchini, *op. cit.*, 33 and 90; Paatz, *op. cit.*, V, 121; Stechow, *op. cit.*, 138; Middeldorf, *op. cit.*, 107 ff.; G. Kauffmann, *Reklams Führer durch Florenz* (Stuttgart, 1962), 295 ff.

p. 136 29. The aisled androne with dividing columns already exists in Giuliano's design for the King of Naples' palace. Giulio Romano's androne in the Palazzo del Te in Mantua is also one of the successors of this motif, which, starting with the Palazzo Venezia (Alberti?) in Rome and the Palazzo Pitti in Florence and passing by way of the Palazzo Ducale at Urbino, became more and more monumental until, like the staircase, it took its place as an outstanding feature of the artistic design of the aristocratic secular building.

30. Marchini is right in seeing in this construction – exterior cube, interior octagon – the reversion to antique monuments, though in a Tuscan version. The purity of the spatial structure is much impaired today by the vestry cupboards which have been put in. The coupled pilasters (with seven flutings) and the blind aedicule windows in the upper storey are novel forms arising from a combination of Brunelleschian and Albertian rules. The capitals are among the most beautiful in Florence (Plate 13H). The double-shell cupola harmonizes the spatial proportions of the interior with the exterior and is an important link in the develop-

ment of the motif, which can be seen in such rich variations in Florentine ecclesiastical buildings.

31. Marchini, *op. cit.*, 38 and 91, with a reconstruction sketch of the loggia originally planned under the roof – an innovation later employed in the Palazzo Guadagni and its successors.

32. For the fine handling of the rustication, in particular the concealed joints, cf. J. Durm, *Die Baukunst der Renaissance* (Stuttgart, 1903), 30 ff. (plates pp. 34 and 40); further the systematic classification of types of rustication by J. Auer, *Die Quaderbossierung der italienischen Renaissance* (Vienna, 1887).

33. Marchini, *op. cit.*, 41–2. The motif is quite unusual in Florence; possibly Giuliano picked up ideas for it from Liguria (cf. above, p. 123).

34. There is no documentary evidence for the Casa Horne. On stylistic grounds the building is ascribed to Giuliano and Cronaca. The superb capitals in the cortile closely resemble those in the sacristy of S. Spirito (cf. Stechow, *op. cit.*, 138). Also C. Gamba, *Il Dedalo* (1920), 162; G. Marchini, 'Il Cronaca', *Rivista d'Arte*, XXIII (1941), 123 ff.; L. H. Heydenreich, 'Über den Palazzo Guadagni in Florenz', *Festschrift Eberhard Hanfstaengel* (Munich, 1961), 43 ff.

35. Marchini, *op. cit.*, 90; G. Pampaloni, *Palazzo Strozzi* (Rome, 1963).

36. For the wisdom of Filippo Strozzi's tactics p. 13 as a building patron towards Lorenzo de' Medici, cf. the contemporary account in Gaye, *op. cit.*, I, 354 ff. Cf. also Barfucci, *op. cit.*, 267; J. Burckhardt, *Gesamtausgabe*, VI, *Die Kunst der Renaissance in Italien* (Berlin and Leipzig, 1932), 15.

37. Cf. above, pp. 40–2.

38. While the earlier design for Poggio a Caiano certainly shows the use of Roman models for constructive details, while preserving as a whole the type of the Tuscan country seat, the spreading layouts of the King of Naples' palace and the Palazzo Medici in Florence revert to the conception of the classical Roman villa-palace, since all kinds of functional and ornamental structures are combined in a composition designed to form a view. What both designs have in common is the axial plan, which has its charm in the sequence of all kinds of structures: open and closed spaces in oblong, square, semicircular, or circular forms. This is a 'fantasy' which far surpasses that of the Nova Domus at Mantua and Poggioreale. As a *concetto*, it is a prefiguration of Bramante's Belvedere. In this connection it is important, to my mind, to recall another building erected in the

same year which is actually a kind of restoration of an antique country seat – the Villa Colonna at Palestrina. Many writers, from Patzak to Ackerman, have pointed out that the *antique* villa, with its exedra and terraces, was the model for Bramante's Belvedere cortile. Yet so far as I know nobody has mentioned the fact that after the fifties the Palazzo Baronale at Palestrina was re-erected by Stefano Colonna, and still more by his son Francesco on the ruins of the antique villa. The building history is entirely obscure; all we have to go on are the meagre data given by O. Marrucchi, *Guida archaeologica dall'antica Preneste* (Rome, 1932) (first edition, 1885). The porch of the palazzo bears the beautiful inscription: Vastabant toties quod ferrum, flamma vetustas/ Francesci instaurat cura Columnigeri 1493. The most casual survey of the present state of the building shows that the palazzo erected above the exedra belongs to that date; a few capitals in the interior even make it likely that the roofing of the semicircular portico had already been taken in hand under Stefano. The well in the open space below the semicircular flight of stairs was also constructed at that time. Many structural members (windows, entrance doors) in the straight wings at the sides bear the marks of the same period; the additions and alterations made by the Barberini in the seventeenth century can be clearly distinguished. Thus the Palazzo Colonna at Palestrina takes on great importance as a Quattrocento palazzo-villa erected on ancient foundations. Neither Tomei nor Magnuson mentions it. See L. H. Heydenreich, 'Der Palazzo baronale der Colonna in Palestrina', *Festschrift Walter Friedlaender* (Berlin, 1965), 85 ff.

39. Marchini, *op. cit.*, 46 and 93, with reconstruction sketch, p. 47.

p. 139

40. *Ibid.*, 92 (Grottaferrata and S. Pietro in Vincoli) and 49 and 94 (Loreto). See also L. Serra, 'La Basilica di Loreto', *Rassegna Marchigiana* (1933), 405. In the construction of the cupola Giuliano's hands were tied by the existing drum built by his old adversary Giuliano da Maiano. Yet he seems to have endeavoured to tone down Giuliano da Maiano's octagonal form – which resembled the dome of Florence Cathedral – and to conceal the ribs of the shell. Cracks soon developed. Francesco di Giorgio and Bramante were called in to make a report; it was not finally repaired till 1536 by Antonio da Sangallo the Younger.

41. The triumphal arch of the altar of the Gondi Chapel (1504–9) shows the influence of Bramante, but the marble seats on the side walls are a relapse

into the minor form. R. Marchini, *Palladio*, III (1939), 205, accepts a collaboration by Benedetto da Rovezzano.

42. In the documents he appears for a short time as *administrator* and *coadjutor operis* (see below, p. 164).

43. Giuliano's architectural drawings, collected *p. 140* and identified with the utmost accuracy by C. von Fabriczy and C. Huelsen (corrected by Marchini, *op. cit.*, 101 ff.), still await stylistic analysis and evaluation of their place in the history of style. Cf. W. Lotz, 'Das Raumbild etc.', *Mitteilungen des Kunsthistorischen Instituts Florenz*, VII (1953–6), 153 ff., especially 211 ff.; also B. Degenhart, 'Dante, Leonardo und Sangallo', *Römisches Jahrbuch für Kunstgeschichte*, VII (1955), 101 ff., especially 178 ff.

44. Antonio da Sangallo the Elder (1455–1534). The literature on Antonio the Elder is more than meagre: Thieme-Becker, XXIX (1935), 403; Vasari (ed. Milanesi), IV, 267 ff.; Stegmann–Geymüller, V; Clausse, *op. cit.*, I, 289 ff., also the notice by C. von Fabriczy, *Repertorium für Kunstwissenschaft*, XXXVII (1904), 73; Venturi, *Storia*, VIII (I), 472 ff. For work in sculpture see C. von Fabriczy, *Jahrbuch der Preussischen Kunstsammlungen*, XXX (1909), supplement, *passim*.

45. The ceiling of S. Maria Maggiore was executed on the commission of Alexander VI. As Giuliano was not in Rome between 1493 and 1498, Antonio may have done the work (E. Müntz, *Les Arts à la cour des Papes*, IV (Paris, 1898), 163 and 206; Vasari, IV, 278).

46. Clausse, *op. cit.*, 299; L. H. Heydenreich, Thieme-Becker, *op. cit.*, 203.

47. See below, pp. 184–6.

48. Stegmann–Geymüller, IV; C. von Fabriczy, *p. 141* 'Chronologischer Prospekt', *Jahrbuch der Preussischen Kunstsammlungen*, XXVII (1907), supplement, 45; Venturi, *Storia*, VIII (I), 418; G. Marchini, 'Il Cronaca', *Rivista d'Arte*, XXIII (1941), 99.

49. L. Grassi, 'Disegni inediti di Simone del *p. 142* Pollaiuolo', *Palladio* (1943), 43; Lotz, *op. cit.* (Note 43), 199.

50. Stegmann–Geymüller, IV (3), 8; Marchini, *op. cit.* (Note 48), 125; L. H. Heydenreich, 'Der Palazzo Guadagni in Florenz', *Festschrift für E. Hanfstaengel* (Munich, 1961), 43 ff.

51. To quote only the most recent literature: *p 143* Richter, *op. cit.* (Note 12), II, 19 ff.; Venturi, *Storia*, XI (I), 1 ff.; C. Baroni, 'Leonardo architetto', *Leonardo da Vinci* (Novara, 1939), 248; L. H. Heydenreich, 'Leonardo da Vinci, Architect

of Francis I', *Burlington Magazine*, XCIV (1952), 277; A. Sartoris, *Léonard architecte* (Paris, 1952); G. U. Arata, *Leonardo architetto e urbanista* (Milan, 1953); L. H. Heydenreich, *Leonardo da Vinci* (Basel, 1953), 86 ff.; C. Maltese, 'Il Pensiero architettonico di Leonardo da Vinci', *Leonardo da Vinci, Saggi e Ricerche* (Rome, 1953), 333 ff.; L. H. Heydenreich, *Leonardo architetto* (Florence, 1963); *idem, Die Sakral-baustudien L.d.V.* (Munich, 1970); C. Pedretti, *A Chronology of Leonardo da Vinci's Architectural Studies after 1500* (Geneva, 1962); P. Murray, 'Leonardo and Bramante', *Architectural Review*, CXXXIV (1963), 346.

p. 143 52. F. Babinger, 'Vier Bauvorschläge Leonardo da Vinci's an Sultan Bajazid II (1502–1503)', *Nachrichten der Akademie der Wissenschaft Göttingen* (1952), 1 ff.

53. C. Pedretti, 'Il "Neron da Sancto Andrea"', *Raccolta Vinciana*, XVIII (1960), 65, and XIX (1962), 273.

54. Some scholars believe that the chapel annex to S. Maria della Fontana was based on designs by Leonardo (A. Annoni, 'Considerazioni su Leonardo da Vinci architetto', *Emporium*, XLIX (1919), 171, and F. Reggiori, 'Il Santuario di S. Maria della Fontana di Milano', *Arte Lombarda*, II (1956), 37 ff.). For further designs by Leonardo for various buildings see Pedretti, *op. cit.* (Note 51), and S. Lang, 'Leonardo's Architectural Designs and the Sforza Mausoleum', *Journal of the Warburg and Courtauld Institutes*, XXXI (1968), 218 ff.

p. 144 55. L. H. Heydenreich, 'Considerazioni intorno a ricenti ricerche su Leonardo da Vinci', *La Rinascità*, V (1942), 161 ff.

56. L. H. Heydenreich, 'Les Dessins scientifiques de Leonardo da Vinci', *Les Arts plastiques* (1953), 11 ff.

57. There is a resemblance between certain p. 14 designs for churches by Leonardo, Francesco di Giorgio, and Baldassare Peruzzi which I cannot attribute entirely to chance. Considering the close connections between Francesco di Giorgio and Leonardo on the one hand, and Francesco di Giorgio and Baldassare Peruzzi on the other, it seems quite plausible to admit a kinship of ideas. Serlio states that his treatise was based largely on Peruzzi's ideas.

58. Cf. Maltese, *op. cit.*, 346. While Giuliano da Sangallo studied and sketched countless antique monuments, not a single drawing of the kind by Leonardo has come down to us. Even the very word *antico* appears very rarely in the many thousand sheets of his drawings, and while he sketched a reconstruction of the ancient mole at Civitavecchia, his archaeological interest was confined to its technical structure. He had little time to spare for the *antichità* of the harbour works.

59. Cf. L. H. Heydenreich, 'Zur Genesis des St. Peter-Plans von Bramante', *Forschungen und Fortschritte*, X (1934), 365 ff.; *idem, Leonardo da Vinci architetto* (Vinci, 1963); F. Graf Wolff Metternich, 'San Lorenzo in Mailand, Sankt Peter in Rom', *Kunstchronik*, XV (1962), 285.

60. Maltese, *op. cit.*, 345; L. H. Heydenreich, *Leonardo architetto* (Vinci, 1963); *idem*, 'Leonardo and Bramante', in C. D. O'Malley (ed.), *Leonardo's Legacy. An International Symposium* (Berkeley and Los Angeles, 1969), 124 ff.

NOTES TO PART TWO

NOTE: For full quotations of the works here abbreviated as Vasari Mil. and as Venturi, *Storia*, see Bibliography section I. B (p. 398) and section III (p. 400).

For the art and architecture of Italy in the period following that dealt with in the present volume, see Rudolf Wittkower, *Art and Architecture in Italy: 1600–1750* (Pelican History of Art) (Harmondsworth, 1958; 3rd ed., Harmondsworth, 1973, in paperback, Harmondsworth, 1973); for painting in the period dealt with in Part Two: S. J. Freedberg, *Painting in Italy: 1500–1600* (Pelican History of Art) (Harmondsworth, 1971).

CHAPTER 14

149 1. For Serlio's life and work see A. Blunt, *Art and Architecture in France: 1500–1700* (Pelican History of Art; the edition here quoted is the first, Harmondsworth, 1953; the second edition was published by Penguin Books in hardback in 1970 and in paperback in 1973), 44 ff., and M. Rosci, *Il Trattato di architettura di Sebastiano Serlio* (Milan, n.d.), 13 ff.

2. See the authoritative survey of Bramante's *œuvre* by A. Bruschi, *Bramante architetto* (Bari, 1969).

3. Cesare Cesariano's edition of Vitruvius (Pavia, 1521), fol. 70 verso. The edition of Vitruvius published in 1536 at Perugia by Bernardo Caporali is practically a reprint of the Cesariano text; it adds to the passage quoted that the author, i.e. Caporali, had taken part in a symposium with Perugino, Signorelli, and Pinturicchio held at Bramante's house, where Vitruvius's description of the ancient peripteral temple was discussed.

150 4. Cf. Bramante's alteration of S. Satiro, Milan, and the church of S. Maria delle Grazie di Fornò at Forlì, built in 1450, an imitation on a smaller scale of S. Stefano Rotondo, Rome. See also E. Rosenthal, 'The Antecedents of Bramante's Tempietto', *Journal of the Society of Architectural Historians*, XXIII (1964), 55 ff. According to the inscription on a marble tablet in the crypt, the Tempietto ('Sacellum') was 'erected by King Ferdinand and Queen Isabella of Spain in 1502'. R. Bonelli (*Da Bramante a Michelangelo* (Venice, 1960), 19 and 45), G. de Angelis d'Ossat (*Palladio*, XVI (1966), 83 ff.), and Bruschi (*op. cit.*, 481 and 989) suggested a date *c.* 1510; but see Rosenthal, *op. cit.*, 55, note 2. It should also be noted that Queen Isabella died in 1504.

5. Book III. See also W. Lotz, 'Notizen zum kirchlichen Zentralbau der Renaissance', in *Studien zur Toskanischen Kunst, Festschrift für L. H. Heydenreich* (Munich, 1964), 162 f.

6. The two ancient rotundas appeared already in Giuliano da Sangallo's Codex Barberini, and also later in Serlio and Palladio. As in the ancient buildings, the height of the columns in Bramante's Tempietto tallies fairly exactly with the width of the cella. The use of the Doric instead of the Corinthian order may be connected with Serlio's theory that the 'robuster' Doric order was appropriate to the 'masculine' St Peter's (Book IV). p. 151

7. For confirmation, see G. Giovannoni's *Saggi sulla architettura del Rinascimento*, 2nd ed. (Milan, 1935), 152.

8. The seated figure of the Apostle in the altar niche is modern; the relief and mensa, on the other hand, are part of the original furnishings. Early in the seventeenth century the crypt under the Tempietto was renovated and at the same time alterations were made to the altar, porch, dome, and lantern.

9. C. Ricci, 'Il Chiostro della Pace', *Documenti Bramanteschi, Nuova Antologia* (1915), 361 ff.; Bruschi, *op. cit.*, 872 ff. The cloister was commissioned by Cardinal Oliviero Carafa; his name appears in the architrave of the Ionic order. p. 152

10. In J. S. Ackerman's authoritative monograph, *The Cortile del Belvedere* (Vatican City, 1954), all the documents and the views of the Belvedere Court are contained and set forth in order. The present description and analysis of its architecture are based on this monograph. See also Bruschi, *op. cit.*, 291 ff. and 865 ff.; H. H. Brummer, *The Statue Court in the Vatican Belvedere* (Stockholm, 1970). p. 153

11. For the date of the medal see R. Weiss, 'The Medals of Pope Julius II (1503–1513)', *Journal of the Warburg and Courtauld Institutes*, XXVIII (1956), 180 f.

12. In his *Commentari*, Pius II speaks with enthusiasm of the view from the garden loggia of the Palazzo Piccolomini at Pienza; the terraces and staircases of the Belvedere Court also recall a p. 155

project of 1489 by Giuliano da Sangallo for the palace of the King of Naples (Figure 45) (G. Marchini, *Giuliano da Sangallo* (Florence, 1942), 88, and Bruschi, *op. cit.*, 308 and figure 209), which Bramante may have known.

p. 156 13. The arrangement can be compared to that of Roman triumphal arches.

14. Under construction at the time of Bramante's death, the logge were completed by Raphael; for the chronology see Bruschi, *op. cit.*, 931 ff. The glazing in of the façades has greatly impaired the original architectural effect.

p. 157 15. L. von Pastor, *The History of the Popes from the Close of the Middle Ages*, 3rd English ed., 36 vols. (London, 1950), VI, 636 ff. and 461 ff., is the best summary of the data of the rebuilding of St Peter's under Julius II. For the medal and the parchment plan see also P. Murray, 'Menicantonio, du Cerceau, and the Towers of St Peter's', in *Studies in Renaissance and Baroque Art presented to Anthony Blunt* (London 1967), 7 ff.

p. 158 16. In contrast to the usual orientation, the façade of St Peter's is to the east, the choir to the west. For the relation of Rossellino's choir to the new structure cf. F. Wolff Metternich, 'Bramantes Chor der Peterskirche zu Rom', *Römische Quartalschrift*, LVIII (1963), 271 ff.

p. 159 17. Book III.

p. 161 18. The measurements given by Serlio in Book III for the designs by Bramante, Raphael, and Peruzzi, which all tally with each other, are as follows:

Interior diameter of the dome	188 palms
Total height of the lantern	36 palms
Total height of the dome	224 palms
Height of the crossing arches	220 palms
Span of the crossing arches	104 palms

Serlio measures the span from pilaster to pilaster; this gives 110 palms from wall to wall, i.e. the width of the nave of old St Peter's. The difference of 4 palms (about 3 feet) seems small in these great dimensions. For the measurements and the slight inaccuracies of Serlio's figures see F. Wolff Metternich, 'Über die Massgrundlagen des Kuppelentwurfes Bramantes für die Peterskirche in Rom', in *Essays in the History of Architecture presented to Rudolf Wittkower* (London, 1967), 40 ff. As Count Metternich has shown, the parchment plan provided for a dome the radius of which was to equal the width of the *apse* of old St Peter's (80 palms), whereas the radius of the final scheme

equals the width of the *nave* of the Constantinian church.

19. Cf. below, pp. 198–9.

20. Charles de Tolnay, *The Tomb of Julius II* (Princeton, N.J., 1954), 19 and 164, and H. von Einem, in *Festschrift für Hans Jantzen* (Berlin, 1951), 152 ff., have assumed that Michelangelo's design of 1505 for the tomb had in view the site over the confessio, and was therefore intended as the tomb both of the Apostle and the Pope. Yet neither Vasari nor Condivi seems to offer any adequate support for this theory, especially as none of the reconstructions of the Michelangelo design carried out so far contains a proper emplacement for the altar, which was indispensable as the liturgical focus of the building (cf. F. Wolff Metternich in *Der Mensch und die Künste, Festschrift für Heinrich Lützeler* (Düsseldorf, 1962), 443 ff.). We know that Julius II vigorously opposed Bramante's attempts to change the site of the confessio; the determination to preserve the original confessio also comes out in the splendid structure of the *tigurio* designed by Bramante to encase the high altar during the building of the new church; for the back wall consisted of the apse of Constantine's basilica. For the measurements and plan of the *tigurio* see J. Christern and K. Thiersch, *Römische Quartalschrift*, LXIV (1969), 16 ff. and figure 4.

21. F. Tassi (ed.), *Ricordi, prose e poesie di Benvenuto Cellini* (Florence, 1829), III, 367. p. ▶

22. For the identification of the building see p. ▶ Giovannoni, *op. cit.*, 97, note 2, and Bruschi, *op. cit.*, 1040 ff. The façade was drawn by Palladio. The engraving in the present volume is reproduced from the comprehensive ancient and contemporary views brought out by the French publisher Antonio Lafreri in Rome about the middle of the sixteenth century. For a catalogue of these engravings cf. C. Huelsen, 'Das Speculum Romanae Magnificentiae des Antonio Lafreri', *Festschrift für Leo S. Olschki: Collectanea Variae Doctrinae* (Munich, 1921), 121 ff.

23. Serlio characterizes rustication as 'parte opera di natura e parte opera di artificio' (Book IV, 'dell'ornamento rustico').

24. For documents see the summary in Bruschi, *op. cit.*, 960 ff. According to the legend, the Casa Santa was the place of the Virgin's birth carried from Nazareth to Loreto by angels. The incrustation was completed by Andrea Sansovino under Leo X after a model by Bramante. See also Bruschi, *op. cit.*, 652 ff., for Bramante's design of the large oblong square bounded by the façades of the

church of the Santa Casa and the papal palace.

25. Book IV, 'dell'ordine corinthio': 'A temple of this order shall be dedicated to the Virgin as the Mother of Christ.' The encasement of the high altar and the tomb of the Apostle in St Peter's, begun by Bramante about the same time, had, like the Tempietto, the Doric order. See above, Note 6.

164 26. In Spain, c. 1530, in Charles V's palace at Granada. In France, echoes of the Vatican logge can be seen in the north-west front of Blois (cf. Blunt, op. cit., 10 and plate 8b). In Germany the knowledge of Bramante's designs about 1510–15 can be proved from the work of three artists: a master of the Altdorfer circle at Regensburg (cf. P. Halm, Münchner Jahrbuch der bildenden Künste, 3rd series, II (1951), 20); in Hermann Vischer, the son of Peter Vischer, who made drawings of Bramante's buildings in 1514–15 (cf. W. Lotz, Miscellanea Bibliothecae Hertzianae (Munich, 1961), 157 ff.); and finally in the Fugger Chapel in St Anna at Augsburg (cf. W. Lotz, Mitteilungen des Kunsthistorischen Instituts in Florenz, VII (1956), 208).

27. Pastor, op. cit., 360; also above, Chapter 12, Note 42.

28. Leo X's papal writ of 1 August 1514: V. Golzio, Raffaello nei documenti, nelle testimonianze dei contemporanei e nella letteratura del suo secolo (Città del Vaticano, 1936), 33. Raphael had been at work on the building since 1 April 1514. Fra Giocondo's appointment was confirmed on 1 August 1514: as the elder, he received four hundred ducats, Raphael three hundred, but both bore the title of 'magister operis', while Giuliano da Sangallo was employed as superintendent and assistant. He had the same salary as Raphael, three hundred ducats a year. Documents for the appointments of Fra Giocondo and Sangallo in Pastor, op. cit.

29. A satirical dialogue printed in 1517 describes how St Peter keeps Bramante waiting at the gates of Heaven until the new church is finished. Bramante attempts to throw the blame for the destruction of old St Peter's on Julius II and to make excuses for himself. Cf. Andrea Guarna da Salerno, ed. G. and E. Battisti, Scimmia (Rome, 1970), 105–21.

165 30. For these questions cf. D. Frey, Bramante-Studien. Bramante's St Peter-Entwurf und seine Apokryphen (Vienna, 1915), and the plates in T. Hofmann, Entstehungsgeschichte des St Peter in Rom (Zittau, 1928). The more recent account of Bra-

mante's share in the planning and building history found in O. H. Förster, Bramante (Vienna-Munich, 1956), 209 ff., differs somewhat from the following.

31. Variants:

(a) Giuliano da Sangallo, Uffizi 9 (cf. Marchini, op. cit., plate XXIb).

(b) Giuliano da Sangallo, Uffizi 7 (cf. Marchini, op. cit., plate XXIIa).

Antonio da Sangallo, Uffizi 252 (cf. Hofmann, op. cit., 110).

Peruzzi, Uffizi 2 (Plate 167).

(c) Giuliano da Sangallo, Codex Barberini (cf. Marchini, op. cit., plate XXIIb).

Mellon sketchbook, fol. 72 verso (Plate 170; for the sketchbook see H. Nachod, 'A Recently Discovered Architectural Sketchbook', Rare Books, VIII (1955); cf. also below, Chapter 15, Note 13).

(d) Raphael according to Serlio.

Peruzzi, Uffizi 14 (cf. H. von Geymüller, Les Projets primitifs pour la basilique de Saint-Pierre de Rome (Paris, 1875), plate 20, 6).

Peruzzi according to Serlio (Figure 52B).

Mellon sketchbook, fol. 73 recto (cf. Nachod, op. cit., figure 7, and Förster, op. cit., figure 111).

32. Variants:

(a) Giuliano da Sangallo, Uffizi 8 recto.

(b) Peruzzi according to Serlio (Figure 52 B).

(c) Mellon sketchbook, fol. 70 verso–71 recto (cf. Nachod, op. cit., figure 2, and Förster, op. cit., figure 112).

33. Variants:

(a) Antonio da Sangallo, Vienna (Frey, op. cit., figure 30).

(b) Codex Coner, fol. 17 (cf. T. Ashby, 'Sixteenth-Century Drawings of Roman Buildings attributed to Andreas Coner', Papers of the British School at Rome, II (1904), 1 ff.).

(c) Giuliano da Sangallo, Uffizi 9 (see above).

(d) Giuliano da Sangallo, Uffizi 7, variant to the right (see above).

(e) Giuliano da Sangallo, Codex Barberini, variant to the left (see above).

Peruzzi, Uffizi 14, variant to the left (Plate 168).

(f) Giuliano da Sangallo, Codex Barberini, right-hand variant.

Raphael according to Serlio.

Mellon sketchbook, fol. 72 verso (see above).

(g) Mellon sketchbook, fol. 73 recto (see above).

(h) Peruzzi, Uffizi 14 (Plate 168).

Peruzzi, Uffizi 16 (Geymüller, *op. cit.*, plate 20, 5).

Peruzzi, Uffizi 15 (Frey, *op. cit.*, figure 12).

Antonio da Sangallo, Uffizi 255.

Antonio da Sangallo (copy), Munich, Staatsbibliothek, cod. icon. 195 (related solution).

CHAPTER 15

p. 167 1. V. Golzio, *Raffaello nei documenti etc.* (Vatican City, 1936), 33 f.

2. Bramante's life and work show how small was the part played in the practice of architecture by technical training.

3. Erected as the memorial chapel of Agostino Chigi, banker to Julius II and Leo X, and of his brother Sigismondo. The mosaics in the dome bear the date 1516. Part of the decoration was incomplete when the patron died in 1520; according to a contract dating from that year the work was continued after the existing designs. The marble slabs and the pyramid-shaped monuments were partly renovated by Bernini. For documents on the history of the building see Golzio, *op. cit.*, 101 and 126; J. Shearman, 'The Chigi Chapel in S. Maria del Popolo', *Journal of the Warburg and Courtauld Institutes*, XXIV (1961), 129 ff., and M. Hirst, *ibid.*, 183 ff.

4. In the constellation pictured in the dome, Raphael continued a tradition which went back to the choir of the Pazzi Chapel. Cf. J. Seznec, *The Survival of the Ancient Gods* (New York, 1953), 79 ff.

p. 169 5. Golzio, *op. cit.*, 222 and 47, note 1; H. von Geymüller, *Raffaello Sanzio studiato come architetto* (Milan, 1884), 57, with the date 1520, not confirmed elsewhere. Vasari called the palazzo 'cosa bellissima'. The façade was stuccoed by Giovanni da Udine (see Vasari Mil., VI, 555, as 'cosa singolare'). Cf. the floor plan of the palace in Munich, Staatsbibliothek, cod. icon. 195.

p. 171 6. First attribution to Raphael on an engraving by Alessandro Specchi, 1696. According to Vasari, the author was Raphael's pupil Lorenzetto. The Specchi engraving gives the date as 1515, which may go back to some lost inscription on the building. Reconstruction of the original façade in Geymüller, *op. cit.*, 54; it was twice enlarged and

now has seventeen instead of the original seven bays.

7. Baldassare Castiglione was in possession of a letter by Raphael which contained a description of the layout (cf. Golzio, *op. cit.*, 147 ff.). A copy of this letter was recently discovered and published by P. Foster; cf. 'Raphael on the Villa Madama: the Text of a Lost Letter', *Römisches Jahrbuch für Kunstgeschichte*, XI (1967–8), 307 ff.: 'the form, style and architectural terminology in Raphael's description confirm the hypothesis . . . that the architect of the Villa Madama may have had in mind the creation of a building similar to Pliny's Laurentine Villa'.

After Raphael's death Giulio Romano and Giovanni da Udine continued work on the decoration of the loggia (cf. A. Venturi, *Archivio Storico dell'Arte*, II (1889), 157 ff.). The actual work was probably discontinued soon after 1520. For a detailed description of the villa see Serlio, Book III; for views of the building before the modern restoration see T. Hofmann, *Raffael in seiner Bedeutung als Architekt*, 2nd ed., I (Zittau, 1908), plates IV–XII, XLVII–XLVIII; for further literature see C. L. Frommel, 'La Villa Madama e la tipologia della villa romana nel Rinascimento', *Bollettino del Centro Internazionale di Studi di Architettura Andrea Palladio*, XI (1969), 47 ff. and 63, note 12.

The 'Ninfeo' at Genazzano, probably the remains of a never-completed villa designed for Cardinal Pompeo Colonna, has many traits in common with the Villa Madama; cf. C. L. Frommel, 'Bramantes Ninfeo in Genazzano', *Römisches Jahrbuch für Kunstgeschichte*, XII (1969), 137 ff. Frommel's attribution to Bramante appears convincing in view of the analogies between the Ninfeo and the parchment plan for St Peter's. Cf. also Bruschi, *Bramante architetto* (Bari, 1969), 1048 ff.

8. Golzio, *op. cit.*, 79 ff., provided definitive p. 1 arguments that this letter, although couched in Castiglione's words, was written by Raphael rather than Bramante. The mere fact that Bramante, according to two reliable witnesses, could not write is a strong point against him. Cf. above, p. 149. The text of the letter in Golzio; English translation by V. Wanscher, *Raffaello Santi da Urbino* (London, 1926), 154 ff. German translation by J. Vogel, *Bramante und Raffael* (Leipzig, 1910). Cf. also V. Cian, *Archivio Storico Lombardo*, N.S. VII (1942), 70 ff., and *Baldassar Castiglione* (Vatican City, 1951).

9. For the organization of the office, see J. S.

Ackerman, *Journal of the Society of Architectural Historians*, XIII (1954), fasc. 3, p. 5, and Lotz, *Mitteilungen des Kunsthistorischen Instituts Florenz*, VII (1956), 195 and 208 ff.

74 10. Cf. above, Note 8.

11. In a letter from Lionardo Sellaio to Michelangelo of 22 November 1516, we read 'Raphael applied for an assistant [at St Peter's] and Antonio da Sangallo was assigned to him' (Golzio, *op. cit.*, 51).

12. Book III. Cf. also Golzio, *op. cit.*, 34.

13. For the sketchbook, now in the collection of Mr Paul Mellon, cf. H. Nachod, 'A Recently Discovered Architectural Sketchbook', *Rare Books, Notes on the History of Old Books and Manuscripts*, VIII, no. 1 (New York, 1955), 1 ff. Nachod's attribution to Domenico de Chiarellis, a member of the office under Bramante and Raphael, is conjectural. The plan of Raphael's project in the sketchbook differs from Serlio's reproduction, since the Rossellino apse is retained and provided with an ambulatory; two colossal towers are added to the front. Serlio's version is an ideal plan, while that in the sketchbook takes account of the progress of the building in 1514.

75 14. Serlio gives the breadth of the nave in Raphael's plan as 92 palms, in Peruzzi's as 104 palms. The difference can be explained by the fact that Raphael intended the nave to be narrower than the crossing arch; this is confirmed by Antonio da Sangallo's memorandum (cf. below, p. 177). The plan in the Mellon sketchbook, which is probably more reliable than Serlio's woodcut in this respect, shows the niches in the piers walled up on the side of the nave; hence the piers were to be reinforced on that side.

15. The reintroduction of the minor domes explains the piercing of the walls of the Rossellino choir; its apse was to be retained, but its exterior view was to be adjusted to the arms of the cross by the one-storeyed ambulatory placed before it. Cf. Plates 162 and 171.

16. Florence, Uffizi 54 and 79; Munich, Staatsbibliothek, cod. icon. 195, fol. 3b.

177 17. Text in Geymüller, *op. cit.*, 293 ff., Vasari Mil., v, 477 f., and G. Giovannoni, *Antonio da Sangallo il giovane* (Rome, n.d.), 132 f.

18. The plan facing Raphael's design in the Mellon sketchbook may show Sangallo's counter-project. The nave is wider and is vaulted in the same way as the rooms of Roman baths; it would therefore have been much better lighted by lunettes than by Raphael's tunnel-vault. Four large chapels have been added to the aisle, and the west

apse now has the same ambulatory as the arms of the cross. All these differences correspond exactly to the suggested improvement contained in the memorandum.

CHAPTER 16

1. For the town-planning history of Rome, see p. 178 Pastor, *op. cit.* (Chapter 14, Note 15), VI, chapter VIII, and VIII, chapter IV; P. Paschini, *Roma nel Rinascimento* (Storia di Roma, XII) (Bologna, 1940), *passim*; P. Pecchiai, *Roma nel Cinquecento* (Storia di Roma, XIII) (Bologna, 1948), *passim*; P. Romano, *Roma nelle sue strade e nelle sue piazze* (Rome, 1947–9); G. Giovannoni, 'Topografia e urbanistica di Roma', in *Storia di Roma*, XXII (Bologna, 1958). Cf. also the appendix 'Zur Urbanistik der Hochrenaissance: Via Giulia und Via Lungara' in C. L. Frommel, *Die Farnesina und Peruzzis architektonisches Frühwerk* (Berlin, 1961), 163 ff.

2. Vasari Mil., v, 451. For the history and restoration of the palace see R. U. Montini and R. Averani, *Palazzo Baldassini e l'arte di Giovanni da Udine* (Quaderni di Storia dell'Arte, v) (Rome, 1957); D. Redig de Campos, 'Notizia su Palazzo Baldassini', *Bollettino Centro Studi per la Storia d'Architettura*, x (1956), 3 ff.

3. For the plan see P. Letarouilly, *Édifices de Rome* p. 179 *moderne* (Liège–Brussels, 1849–66), III, 267. The courtyard was altered several times, but not radically transformed. For similar courtyards in the Palazzi Giraud-Torlonia and Cicciaporci, cf. Venturi, *Storia*, XI, figures 192–7 and 241–2.

4. Sangallo's drawing of the plan of the Palazzo di Giustizia is reproduced in Venturi, *Storia*, XI, figure 97. For the Palazzo di Giustizia see also A. Bruschi, *Bramante architetto* (Bari, 1969), 593 ff.

5. For the contract see D. Gnoli, *Annuario* p. 180 *dell'Associazione Artistica tra i Cultori di Architettura*, *1910–11* (Rome, 1912), 70 f. The rent was 150 ducats per annum. An anonymous drawing in the Metropolitan Museum of *c.* 1560 gives the elevation of two bays of the façade (no. 49.22.82).

6. The legend of an engraving of *c.* 1550 by Lafreri names Bramante as the architect and adds: 'often taken as a design by Raphael' (cf. also Vasari Mil., v, 534). For the authorship see also J. Shearman in *Bollettino Centro Internaz. Studi Arch. Andrea Palladio*, VIII (1967), 357, 359. The present façade in the via de' Banchi has seven bays, that in Lafreri's engraving only five. The palazzo was enlarged in 1866, when the present side and rear façades were added; the cortile was altered too (cf.

Il Buonarroti, I (1866), 75 and 135). Letarouilly, *Édifices*, I, 106, shows the present plan. The Florentine architect Pietro di Giacomo Rosselli was witness to the signing of the contract. In 1516 Rosselli designed the house of Prospero de' Mocchi in the via dei Coronari; the two buildings, however, differ so widely that they can hardly be ascribed to the same architect. Cf. P. Tomei, *L'Architettura a Roma nel Quattrocento* (Rome, 1942), 239.

p. 181 7. As Lafreri's engraving shows, the small square openings over the windows figured in the original building; they belong to the mezzanine rooms above the piano nobile.

8. For the predominance of the centralized plan cf. also W. Lotz, 'Notizen zum kirchlichen Zentralbau der Renaissance', in *Studien zur toskanischen Kunst, Festschrift für L. H. Heydenreich* (Munich, 1964), 157 ff., and S. Sinding-Larsen, 'Some Functional and Iconographical Aspects of the Centralized Church in the Italian Renaissance', in *Acta ad Archaeologiam et Artium Historiam pertinentia*, II (1965), 203 ff., with a list of centralized churches, 243 ff.

9. Vasari Mil., I, 122; G. Mollat, 'Jean de Thororières, architecte de St Louis', *Annales de St Louis des Français*, VI (1902), 279. According to I. Lesellier, *Mélanges*, III (1931), 239, the architect was Jean de Chenevières. That S. Salvatore was not the French national church, but an independent building, can be deduced from Francesco Albertini, *De mirabilibus Romae* (1510), ed. Schmarsow (Heilbronn, 1886), 9. A number of fragments of the decoration of S. Salvatore were later used in S. Luigi dei Francesi.

10. This church, which Albertini (*op. cit.*, 8) expressly names as a foundation of Julius II's, was later vaulted by Antonio da Sangallo the Younger; a choir chapel was added about 1550. About 1575 Giacomo del Duca erected a second dome over Sangallo's vault. Cf. M. Zocca, *Atti del I Congresso Nazionale di Storia dell'Architettura* (Florence, 1937), 100, and S. Benedetti, *S. Maria di Loreto* (Chiese di Roma illustrate, C) (Rome, 1968), 19 ff. For Sangallo's part in the building, which was probably restricted to the vaulting, cf. also J. S. Ackerman, *The Cortile del Belvedere* (Vatican City, 1954), 49, note 2.

11. Cf. J. S. Ackerman, *Journal of the Society of Architectural Historians*, XIII (1954), no. 3, p. 11, note 16. Above the entrance to the church is a group of the Virgin and Child executed for the church by Andrea Sansovino; it is dated 1520.

12. A plan of the same shape is to be found in the anterooms of the Baths of Diocletian, which were repeatedly drawn just at this time.

13. The façade of the Anima, erected under Julius II, is attributed to Andrea Sansovino by A. Venturi in *Storia*, XI (I), 148 f., while G. Marchini, *Giuliano da Sangallo* (Florence, 1942), 20, attributes it to Giuliano da Sangallo.

14. The building of the church was approved by Julius II in 1509, the dome was closed in 1536. The façade was completely renovated at the beginning of the seventeenth century, and the interior was twice restored in the twentieth century. The original state of the building can be reconstructed from sixteenth-century drawings; on one of them, Raphael is named as the architect, on another, Peruzzi. Cf. H. von Geymüller, *Raffaello Sanzio studiato come architetto* (Milan, 1884), 22, and C. L. Frommel, 'S. Eligio und die Kuppel der Cappella Medici', in *Stil und Überlieferung, Akten des 21. Internationalen Kongresses für Kunstgeschichte, Bonn, 1964* (Berlin, 1967), II, 41; 'Geymüller's attribution to Raphael remains the most probable of all hypotheses' (Frommel, *op. cit.*, note 27).

15. Plan and elevation in P. Laspeyres, *S. Maria* p. 1 *della Consolazione zu Todi* (Berlin, 1869). The contracts and documents published in the *Giornale di Erudizione Artistica*, I (1872), 3 ff., and III (1874), 321 ff. A visitation report of 1574 mentions a model designed by Bramante; according to the same authority, the vaults planned (at that time) were to bear 'a certain resemblance to new St Peter's'. This can only refer to Michelangelo's centralized plan, which had been in hand since 1549. Whether the model which was at Todi in 1574 was really based on Bramante must remain a matter of conjecture. Cf. also Bruschi, *op. cit.* (Note 4), 922 ff., and the exhaustive documentation provided by J. Zänker, *Die Wallfahrtskirche Santa Maria della Consolazione in Todi* (thesis, Bonn, 1971).

16. The travertine facing of the north apse was not carried out till early in the twentieth century. Cf. G. Giovannoni, *Bollettino d'Arte*, VII (1913), 32.

17. The faithful reproduction of the Ospedale p. 1 recalls the efforts of Antonio's brother Giuliano da Sangallo to preserve Brunelleschi's plan for the portal of S. Spirito; both brothers must have felt it incumbent on them to preserve Brunelleschi's heritage; cf. W. Lotz, 'Italienische Plätze des 16. Jahrhunderts', *Jahrbuch 1968 der Max-Planck-Gesellschaft*, 50 ff.

18. For the building history cf. A. Schiavo, *Bollettino Centro Storia d'Arte*, fasc. 6 (Spoleto, 1952), 33, and particularly 47 ff.

19. Cf. the plan of Raphael's project in the Mellon sketchbook; in the present volume, Plate 170.

20. See H. von Geymüller, *Der Palazzo Pandolfini in Florenz und Raffaels Stellung zur Hochrenaissance in Toscana* (Munich, 1908). The client was Giannozzo Pandolfini, Bishop of Troia. Raphael was in Florence in 1515 and 1519 (cf. V. Golzio, *Raffaello* (Vatican City, 1936), 36); the plans for the palazzo may have been made during one of these periods. The account of the building history given by Vasari, who saw the palace under construction, is perfectly credible. After the Sack of Rome, work had slackened; after the death of Gianfrancesco da Sangallo in 1530, the palazzo was finished by his brother Aristotile 'to the point at which it can be seen now', which implies that Raphael's plan was not completed (Vasari Mil., IV, 364, and VI, 435). In the present building, only the ground floor can correspond to the original plan. The intention was certainly to give the piano nobile nine bays, but only the four now existing were carried out. The cortile which Raphael doubtless planned must have been abandoned, the finished part shut off by a wall at right angles to the wall of the façade, while the crowning cornice was continued along this wall. Since the name of Pope Clement VII appears in the inscription in the frieze above the wall, this part of the building could have been completed at the earliest in 1524, but probably not before 1530, under Aristotile as chief architect. The right-hand part of the façade never rose above the ground floor; a garden was laid out behind it. Cf. also G. Marchini, in *Raffaello. L'opera. Le fonti. La fortuna*, II (Novara, 1968), 480 ff.

21. The details of the window pediments tally almost exactly with those of the nearly contemporary Palazzo Branconio dall'Aquila, the balconies in front of the windows with those of the Palazzo Caprini. Instead of the upright oblong frame between the windows of the piano nobile, round niches with statues must have been planned, as in the Palazzo dall'Aquila. The present frames date from a later stage of building, when the niches were removed. Baccio d'Agnolo adopted the niche motif in his Palazzo Bartolini Salimbeni, Florence, as early as 1520.

22. For Giuliano da Sangallo's designs, cf. Charles de Tolnay, *Gazette des Beaux-Arts*, LXXVI (1934), 24 ff.; Marchini, *op. cit.* (Note 13), 69 ff. and 100; B. Degenhart, *Römisches Jahrbuch der Kunst*, VII (1955), *passim*; Richard Pommer's un-

published M.A. thesis, 1957 (MS. in the Institute of Fine Arts, New York University); W. Lotz, *Journal of the Society of Architectural Historians*, XXII (1963), 5 ff.; and P. Sanpaolesi, *Rivista Ist. Naz. d'Archeologia e Storia dell'Arte*, N.S. XIII–XIV (1964–5), 283 ff. Raphael's designs for the same façade are lost; cf. Golzio, *op. cit.* (Note 20), 36.

23. L. Serra, *Aquila monumentale* (Aquila, 1912), 38. The façade was begun in 1525, the second storey bears the date 1540. According to earlier sources, the façade bore the inscription 'Cola Amatricius Architector Instruxit 1527'.

24. R. Pane, *Architettura del Rinascimento a Napoli* (Naples, 1937), 269. In a contract of 1516 Giovanni Thoma da Como was instructed to execute certain details in the church of S. Maria delle Grazie in Naples, after the model of the marble arches of the Caracciolo Chapel; thus the ground floor, at any rate, of the latter must have been standing in 1516. Yet the contract does not imply, as Pane assumes, that both buildings are to be ascribed to the same master. In a letter from Pietro Summonte to Marcantonio Michiel, dated 20 March 1524, we read that 'the chapel begun by Galeazzo Caracciolo is now to be continued by his son'. In 1557 the decoration of the chapel was not yet finished; cf. *Napoli Nobilissima*, N.S. III (1922), 127 f. The architecture of the chapel has been attributed to Giovanni Tommaso Malvito by C. Thoenes in *Neapel und Umgebung* (Stuttgart, 1971), 132.

CHAPTER 17

1. In the preface to his Book II, 'della Prospettiva'. p. 188

2. Very few dates of Peruzzi's early life have been preserved. In 1501 he was assistant to Pinturicchio in the painting of the chapel of S. Giovanni in Siena Cathedral. The first works by him in Rome established by documentary evidence date from 1509 to 1510. Vasari gives the date 1503 for his removal to Rome; there is no other evidence for it. See also C. L. Frommel, *Baldassare Peruzzi als Maler und Zeichner* (Vienna–Munich, 1967–8), 10 f.

3. Vasari's attribution of the Farnesina to Peruzzi is now generally accepted. H. von Geymüller's attempt to associate the architecture of the villa with Raphael must be regarded as a failure.

In Aegidius Gallus's *De Viridario Augustino Chisii*, published in Rome in 1511, there is a detailed description of the frescoes on the ground floor of the Farnesina. At that time the building

must have been far advanced, if not complete. Other sources and literature in E. Gerlini, *La Villa Farnesina in Roma* (Rome, 1949), 40 ff., and C. L. Frommel, *Die Farnesina und Peruzzis architektonisches Frühwerk* (Berlin, 1961), 199 ff. In the Villa Le Volte (now Mieli), near Siena, built by Sigismondo Chigi, Agostino's brother, there is an inscription with the date 1505. The composition anticipates certain features of the Farnesina, i.e. the horseshoe plan, the ground-floor loggia between the projecting wings, and the asymmetrical plan. It therefore seems plausible to ascribe it to Peruzzi; see Frommel, *op. cit.*, 106 ff. and 123 ff.

p. 188 4. For the meaning of the frescoes, cf. F. Saxl, *La Fede astrologica di Agostino Chigi* (Rome, 1934), A. von Salis, *Antike und Renaissance* (Erlenbach–Zürich, 1947), 190 ff., and Frommel, *op. cit.* (Note 2), 46 ff.

p. 189 5. Cf. also W. Lotz, *Mitteilungen des Kunsthistorischen Instituts Florenz*, VII (1956), 206.

p. 190 6. See F. Cruciani, *Il Teatro del Campidoglio e le feste romane del 1513* (Milan, 1968), with the texts of the contemporary descriptions and a reconstruction of the theatre by A. Bruschi. A plan of the *theatrum* is to be found in the so-called Codex Coner, a contemporary sketchbook, fol. 23 (see T. Ashby, *Papers of the British School at Rome*, II (1904) and VI (1913); cf. also J. S. Ackerman, *Art Bulletin*, XXXVIII (1956), 55 ff., and I. Lavin, 'The Campidoglio and Sixteenth-Century Stage Design', in *Essays in Honor of Walter Friedlaender* (New York, 1965), 114 ff.). The construction of the Capitoline theatre of 1513 was directed by Pietro Rosselli (see above, Chapter 16, Note 6).

7. That is how Vasari (IV, 595) describes a temporary decorative structure designed by Peruzzi for the occasion of Giuliano de' Medici's nomination as Gonfaloniere della Santa Chiesa. Yet the data he gives tally exactly with the plan of the theatre of 1513; possibly Vasari confused the two ceremonies.

8. Cf. R. Krautheimer, 'The Tragic and Comic Scene of the Renaissance', *Gazette des Beaux-Arts*, 6th series, XXXIII (1948), 327 ff., and R. Klein and H. Zerner, 'Vitruve et le théâtre de la Renaissance italienne', in *Le Lieu théâtral à la Renaissance* (Colloques Internationaux du Centre National de la Recherche Scientifique, 22–27 mars 1963) (Paris, 1964), 49–60.

p. 191 9. On 1 December 1534, Pope Paul III raised Peruzzi's salary for his work on St Peter's from 150 to 300 ducats per month (L. von Pastor, *Storia*

dei Papi, V (Rome, 1959), document 6 in the appendix).

10. Cf. G. Zucchini, *Disegni antichi e moderni per* p. la facciata di S. Petronio* (Bologna, 1933), *passim*, and R. Bernheimer, 'Gothic Survival and Revival in Bologna', *Art Bulletin*, XXXVI (1954), 275.

11. See W. Lotz, 'Die ovalen Kirchenräume des Cinquecento', *Römisches Jahrbuch für Kunstgeschichte*, VII (1955), 26 ff.

12. Cf. H. Wurm, *Der Palazzo Massimo alle Colonne* (Berlin, 1965), and the review by H. Biermann, *Zeitschrift für Kunstgeschichte*, XXX (1967), 251 ff. The palazzo is still in the possession of the family.

13. F. Tassi (ed.), *Ricordi, prose e poesie di Ben-* p. *venuto Cellini* (Florence, 1829), III, 369.

14. G. Giovannoni, *Antonio da Sangallo il giovane*, 2 vols. (Rome, n.d., *c.* 1959). The book, published posthumously, is indispensable for Sangallo's biography, buildings, and drawings; the bibliography and the notes are inadequate. Cf. also J. S. Ackerman, *Journal of the Society of Architectural Historians*, XIII, no. 3 (1954), 3 ff.

15. Cf. above, p. 177.

16. Cf. Giovannoni, *op. cit.*, I, 84.

17. Cf. *Plan und Bauwerk*, catalogue of exhibition p. (Munich, 1952), 15 ff.; H. Siebenhüner, in *Kunstgeschichtliche Studien für Hans Kauffmann* (Berlin, 1956), 172 ff.; E. Rufini, *S. Giovanni dei Fiorentini* (Chiese di Roma illustrate, XXXIX) (Rome, 1957); Giovannoni, *op. cit.*, 214–33 and figures 164, 167–75; J. S. Ackerman, *The Architecture of Michelangelo* (London, 1961), II, 117 ff.; W. Buchowiecki, *Handbuch der Kirchen Roms*, II (Vienna, 1970), 88 ff.

18. Giovannoni, *op. cit.*, I, 79 ff., 347 ff. p.

19. Pastor, *op. cit.*, V, appendix, documents 20 p. and 27a.

20. *Ibid.*, 758, note 4.

21. 'La Fabrica di S. Pietro non ha un soldo'; Venturi, *Storia*, XI (1), 520.

22. Pastor, *op. cit.*, 758.

23. *Ibid.*, 759.

24. *Ibid.*, 760. For the following cf. also Giovannoni, *op. cit.*, I, 143 ff.

25. The raising of the pavement, which Gey- p. müller had already inferred from the drawings and K. Frey from the account books, was confirmed in the building itself during the recent excavations. 'The lower part [of the dividing wall] came to light; its height up to the pavement of the present basilica was 2·60 m. The pavement itself is 60 cm. thick; hence the difference of level between the pavements of the old and new edifices is 3·20 m.';

B. M. Apollonj Ghetti, A. Ferrua, E. Josi, E. Kirschbaum, *Esplorazioni sotto la confessione di S. Pietro in Vaticano* (Città del Vaticano, 1951), I, plate CIX and figure 165. Cf. also G. Giovannoni, *Spigolature nell'archivio di S. Pietro in Vaticano* (Rome, 1941), 12, and *Antonio da Sangallo il giovane* (Rome, n.d.), I, 147.

26. A preliminary design by Sangallo (Uffizi A 66) provides for a dome without drum or pendentives. Its outline and structure would have approximated more closely to the dome of Florence Cathedral than to the model as executed. On a design for a centrally planned church (Uffizi 168), Sangallo formulated very clearly the difference between the 'Florentine' and the new 'Roman' construction of the dome: 'This may be vaulted in two ways. The first, or cheaper, is this: the curve of the dome is begun at the same level as the impost of the great arches, and the dome is built as a domical vault. The second way is to make a cornice at the top of the arches constructed to a perfect circle and above this to go on straight so that you may cut in apertures of any kind you want or windows or even roundels. And above the said apertures make another round cornice from which you may begin to spring the dome; but first keep it straight [i.e. "continue vertically"] for a distance of 2½ times the projection of the cornice.' (Cf. Ackerman, *loc. cit.* (Note 14), II, and Giovannoni, *Sangallo*, I, 228 f.)

27. During the last years of Sangallo's term the tunnel-vaults adjoining the eastern and southern crossing arches were executed; the southern vault, with its centering still in place, appears in the middle of Vasari's fresco, the east vault is encased by the high walls, also built by Sangallo, which are visible between the nave of the old basilica and the crossing area. Cf. also Ackerman's survey of Sangallo's work for St Peter's (*The Architecture of Michelangelo* (London, 1961), II, 87). Summing up Sangallo's achievement, Vasari wrote in 1550 that 'from now on there will be neither cracks [*sc.*, in the piers] nor will it threaten to become a ruin, as it did under Bramante' (*Le Vite* (Florence, 1550), ed. C. Ricci, III (Milan–Rome, 1927), 324).

28. Cf. H. Siebenhüner, 'Der Palazzo Farnese', *Wallraf-Richartz-Jahrbuch*, XIV (1952), 144 ff.; Ackerman, *op. cit.*, I, 75 ff., and II, 67 ff.; and Giovannoni, *op. cit.*, I, 150 ff.

29. Sources in F. Navenne, *Rome. Le Palais Farnèse et les Farnèse* (Paris, 1914), and U. Gnoli, *Mélanges d'Archéologie et d'Histoire*, LIV (1937), 203 ff.

30. Vasari Mil., V, 469. Vasari, who had been p. 202 commissioned by Cardinal Alessandro Farnese to paint in the neighbouring Cancelleria in 1545, must have known all there was to know about the palazzo.

31. See also Ackerman, *op. cit.*, II, 67 ff. The Munich sketchbook (Staatsbibliothek, cod. icon. 195, fol. 8) was attributed to Philibert de l'Orme by A. Blunt (cf. *Philibert de l'Orme* (London, 1958), 15 ff.). De l'Orme was in Rome during the years 1536 to 1538. But as C. L. Frommel has kindly pointed out to me, the drawing must stem from an earlier date and can be attributed to Jean de Chenevières (cf. above, Chapter 16, Note 9). Professor Frommel is preparing an exhaustive study of Roman palazzi, 1500–1550.

The drawing in Munich shows only four of the five piers of the façade wing of the court, and one of the adjoining left wing. Thus the sketch tallies fairly well with Vasari's description of the building before the elevation of Paul III: 'he had built a good part of his palazzo, having made a portion of the first window row [i.e., the second storey] on the front façade, the public room behind it [i.e., the three-aisled vestibule] and started one wing of the court' (Vasari Mil., V, 469).

32. In March 1540, Vittoria Farnese was injured by a fall on the temporary wooden staircase which was then in place (cf. Navenne, *op. cit.*, 257).

33. Cf. Gnoli, *op. cit.*, 209 f.

34. See Vasari Mil., V, 487.

35. See the letter of Prospero Mocchi to Pier Luigi Farnese in A. Gotti, *Vita di Michelangelo Buonarroti* (Florence, 1875), I, 294 f., and Ackerman, *op. cit.*, II, 72.

36. Vasari, *Vite* (Florence, 1550; ed. C. Ricci, Milan–Rome, 1927), I, 325.

37. This is borne out by a contract of 1546 for extensive carving in travertine (5,000 scudi for material alone) with appended drawings for measuring the Doric arches and capitals; cf. Ackerman, *op. cit.*, II, 70.

38. The Ionic arcades in the front and rear wings p. 203 of the piano nobile, originally open, have been walled up in the nineteenth century (E. Lavagnino, *La Chiesa di S. Spirito in Sassia* (Turin, 1962), 51; P. Letarouilly, *Édifices de Rome moderne* (Liège, 1849 ff.), text II, 279; plates II, 130 speaks of 'a regrettable alteration of a rather recent date'). A drawing by Annibale Carracci in Frankfurt (Städel'sches Kunstinstitut, Inv. No. 4064) shows the original aspect of the loggia of the façade wing. In the wings to the right and left, where

mezzanines were accommodated, the arcades were blind from the beginning; the window frames were probably designed by Vignola.

p. 203 39. In point of scale, only the Cancelleria could bear any comparison with the scale of the new building. The second Cardinal Alessandro Farnese, the grandson of Paul III, was in residence there at the time.

p. 204 40. J. S. Ackerman kindly drew my attention to a mason's account of 13 April 1557 in the State Archive in Naples (Carte Farnesiane, busta 2036); the document is signed by Vignola as 'architetto del Ill.mo et R.mo Santo Angelo' (i.e., Cardinal Ranuccio Farnese, who was living in the palazzo at the time).

41. *Documenti inediti per servire alla storia dei musei d'Italia* (Florence and Rome, 1878), I, 72 ('Inventario delle statue . . . che sono nella camera grande del cardinale, detta la galleria . . .').

p. 205 42. Tassi (ed.), *op. cit.* (Note 13), III, 367.

43. Cf. the catalogue of Sangallo's drawings in Giovannoni, *op. cit.*, 407–56.

CHAPTER 18

p. 206 1. Cesariano's design of 1513 replaced an older model delivered in 1505 by Cristoforo Solari; cf. C. Baroni, *Documenti per la storia dell'architettura a Milano nel Rinascimento e Barocco*, I (Florence, 1940), docs. 248 and 250. The high altar of S. Maria presso S. Celso contains a famous miraculous image; the atrium, therefore, like that of SS. Annunziata in Florence, was intended for the sale of devotional articles and as a meeting place for the congregation before and after processions.

2. Cf. C. Baroni, *L'Architettura lombarda da Bramante al Richini* (Milan, 1941), 118 and figures 89 and 92.

3. *Ibid.*, 118; for Cesariano's biography and his commentary to Vitruvius see the introduction by C. H. Krinsky to *Vitruvius De Architectura* (Munich, 1969), the reprint of the Como edition of 1521.

p. 207 4. Sources and dates in L. Testi, *Santa Maria della Steccata in Parma* (no place or date [1922]). The foundation stone was laid in 1521, the dome roofed in 1535, and the installation of the sacred image and the consecration took place in 1539. Cf. also B. Adorni, 'Antonio da Sangallo il giovane e la cupola della Steccata', in *Quaderni dell'Istituto di Storia dell'Architettura*, xv, nos. 85–90 (1968), 95 ff.

5. The four apses were originally identical. In the eighteenth century the wall behind the sanctuary was pierced and a square choir added. The frescoed

half-dome of the sixteenth century was preserved.

6. Vasari Mil., VI, 487: 'built, it is said, after Bramante's design and instructions'.

7. The nave of S. Giovanni has a groin-vault; the transepts terminate in apses.

8. The statues, volutes, and balustrades of the p. 2 roof zone date from the seventeenth and eighteenth centuries. After the original designs, the apses were to be crowned with dwarf galleries ('corridoi'), another medieval feature; Testi, *op. cit.*, 15 f. and 25 f. The design also provided for two minor apses in place of the present twin windows; these 'piccole capelle tonde' had already been executed, at any rate on the east side, by 1525 (cf. Testi, *op. cit.*, 24 f.). The absidioles would have made the exterior view still more restless and intensified the resemblance to choir schemes of the High Middle Ages. They were demolished in 1525–6.

9. A bequest of a thousand ducats for these frescoes dates from 1524; cf. Testi, *op. cit.*, 117.

10. Contract in Testi, *op. cit.*, 265; Parmigianino began his work in the church with the gilding. For the 8,896 pieces of gold leaf supplied to him from June 1534 to April 1539, cf. Testi, *op. cit.*, 122.

11. For his expert's report, cf. Testi, *op. cit.*, 263 f., and Adorni, *op. cit.*, 96 f.

12. The first superintendent was Marcantonio Zucchi, who was succeeded by Alessandro Chierici; the ornamental parts, such as the capitals and mouldings, were mainly the work of Giovanfrancesco d'Agrate, the sculptor.

13. The date of Tramello's birth is unknown. p. 20 He is mentioned in building documents from 1501 to 1528; he died in January 1529. In 1522 he was commissioned for a model of the Madonna di Campagna; the masonry seems to have been completed as early as 1528. In 1531 Pordenone was commissioned for the frescoes in the dome. Cf. P. Gazzola, 'Opere di Alessio Tramello architetto piacentino', *I Monumenti italiani*, fasc. v (Rome, 1935), *passim*, and J. Ganz, *Alessio Tramello* (Frauenfeld, 1968), 53 ff.; for Tramello's biography cf. *Bollettino Storico Piacentino*, LXI (1966), 58 ff.; cf. also J. Schulz, 'Pordenone's Cupolas', *Studies in Renaissance and Baroque Art presented to Anthony Blunt* (London, 1967), 44 ff.

14. The present chancel and sacristy date from the late eighteenth century.

15. According to Vasari (Mil., v, 319), Fal- p. 21 conetto spent twelve years in Rome; but see also G. Gerola in Thieme-Becker, XI (1915), 223 f., and R. Brenzoni in *Atti dell'Istituto Veneto di Scienze, Lettere ed Arti*, CXII (1953–4), 269 ff.; the artist's

documented activity in the Veneto is incompatible with a prolonged sojourn in Rome.

16. See G. Fiocco, 'La Casa di Alvise Cornaro', *Bollettino del Museo Civico di Padova*, LVII (1968), 1 ff., and G. Schweikhart, 'Studien zum Werk des Giovanni Maria Falconetto', *ibid.*, 17 ff.

17. According to a contemporary source, the account by Marcantonio Michiel, these decorations were executed 'after drawings by Raphael' (Th. Frimmel, 'Der Anonimo Morelliano', *Wiener Quellenschriften zur Kunstgeschichte* (1888), 10 f.). The decorations have been attributed to Tiziano Minio and dated 1533–8 by W. Wolters (*Pantheon*, XXI (1963), 21 ff. and 222 ff.; see also Schweikhart, *op. cit.*). The impact made by the Cornaro buildings can be gauged from contemporary descriptions; in addition to Michiel, the Casino and Odeon are also mentioned in the foreword to Book IV of the 1543 edition of Serlio, and by Vasari (Mil., V, 322), who says that Cornaro himself designed the Odeon. Cornaro survived Falconetto by thirty-one years; he died in his palazzo in 1566 at the age of ninety-one. In his later years he wrote a treatise on architecture; cf. G. Fiocco, *Alvise Cornaro, il suo tempo e le sue opere* (Vicenza, 1965), 155–67. Schweikhart (*op. cit.*, 35 ff.) has pointed out that the stylistic difference between the loggia and the Odeon justifies Vasari's attribution of the Odeon to Cornaro.

213 18. Alvise Cornaro was administrator of the bishopric of Padua from 1529 to 1538. A report dated 1543 mentions the as yet unfinished villa with admiration; the execution is less refined than that of Falconetto's other buildings. Schweikhart (*op. cit.*, 35 f.) has suggested that Vasari's attribution of the villa to Cornaro (Mil., V, 324) is trustworthy. The rear façade, in all important details identical with the main front, bears the date 1579 on its steps. During the enlargement the interior was completely altered.

19. Cf. the Serlio quotation, Chapter 14, Note 23.

20. G. Zorzi (*Palladio*, N.S. V (1955), 31) has attributed to Falconetto a number of drawings of ancient buildings contained in volumes of drawings now in the Royal Institute of British Architects which were part of Palladio's estate. Another part of Falconetto's estate seems to have been preserved in MS. 978 in the Biblioteca Comunale at Verona; it contains the drawings for the illustrations in Torello Sarayna's book, *Le Antichità di Verona* (Verona, 1540). The woodcuts in Sarayna's book are by Caroto, who obviously supplemented and

completed Falconetto's illustrations (cf. Vasari Mil., V, 323).

CHAPTER 19

1. E. Langenskiöld's book *Michele Sanmicheli, p. 214 The Architect of Verona* (Uppsala, 1938) has to some extent been superseded by the entries in the catalogue of the exhibition 'Michele Sanmicheli', ed. P. Gazzola (Venice, 1960), below referred to as *Catalogue*. See also the 'bibliografia ragionata' by N. Carboneri in *Michele Sanmicheli, 1484–1559, Studi raccolti dall'Accademia di Agricoltura, Scienze e Lettere di Verona* (Verona, 1960), 195–296.

2. L. Fumi, *Il Duomo di Orvieto e i suoi ristauri* (Rome, 1891), 101.

3. Cf. L. Beltrami, *Relazione sullo stato delle rocche di Romagna, stesa nel 1526 per di ordine Clemente VII per Antonio di Sangallo e Michele Sanmicheli* (Nozze Greppe-Belgioioso) (Milan, 1902).

4. A. Bertoldi, *Michele Sanmicheli al servizio della repubblica veneta* (Venice, 1874).

5. Date on the outer side, 1533, on the city side, p. 215 1535 and 1540; in the inscription Sanmicheli is named as architect. In the nineteenth century the parts of the city wall adjoining the gate on both sides were dismantled and the moat was filled up. Its original state can be seen in Figure 67; cf. also the model illustrated in *Catalogue*, plate 91. The model was made for the exhibition.

6. The date on the outer side is 1557; the city side was completed only after Sanmicheli's death (cf. Vasari Mil., VI, 352). At Verona, Vasari saw a model with a pediment on the outer side 'intended as a parapet for the men serving the guns to be placed on this gate'. Hence the version executed is the result of a change of plan; cf. also *Catalogue*, 192 and plate 156.

7. Cf. R. Brenzoni, *Rivista d'Arte*, XIX (1937), p. 217 57 ff.

8. Langenskiöld, *op. cit.*, 12, prefers the thirties as the date for the Palazzo Pompei; but cf. W. Lotz, *Zeitschrift für Kunstgeschichte*, IX (1940), 221 ff. See also *Catalogue*, 108 ff.

9. L. di Canossa, *Studi e ricerche intorno al Palazzo Canossa* (Verona, 1908), 2 ff., and *Catalogue*, 119 f. The palazzo is still in the possession of the family.

10. The traditional date of *c.* 1530 seems to me right; cf. Langenskiöld, *op. cit.*, 61, *Catalogue*, 122 f., and A. Blunt, *Burlington Magazine*, CIII (1961), 152.

11. The plan of the courtyard is asymmetrical and seems to indicate that the architect's design has

only partly been executed. On the other hand it has been pointed out by Blunt (*ibid.*) that the architrave and frieze of the entablature are continued around the corner at the left end of the façade; hence no prolongation of the façade can have been projected, at least not at the time when the corner block of the entablature was put in place.

p. 217 12. The prototype for the spirally fluted columns of the Palazzo Bevilacqua was obviously the neighbouring late Roman Porta dei Borsari, where the same form appears. Sanmicheli had probably already seen the motif of the alternating fluting, which also occurs on late Roman sarcophagi, in the Temple of Clitumnus near Spoleto. In the Renaissance, this early medieval structure was believed to be Roman; cf. illustration and description in Palladio, *Quattro Libri*, Book III, chapter XXV.

Le Antichità di Verona by Torello Sarayna (Verona, 1540) contains an illustration of the ancient Porta dei Leoni, Verona, that shows columns with alternating spiral flutings in the top storey. Serlio, Book III, fol. 114, correctly gives flat pilasters in his illustration of the same *gate*. The woodcuts for Sarayna's book were made by Giovanni Caroto after drawings which have been preserved in MS. 978, Biblioteca Comunale, Verona. In the particular drawing in question, the columns of the Porta dei Leoni are not fluted. Caroto therefore 'invented' the spiral fluting in his woodcut. His model may have been the Palazzo Bevilacqua.

13. It only seems paradoxical that the b-bays are framed by one straight and one spiral column. As subordinate parts of the scheme, these bays did not need a symmetrical frame. What is really illogical is the present arrangement of the pediments over the side bays, for no satisfying reading can be devised for them even in a reconstruction of the façade in its original width. The simplest explanation, probably, is that when the building was brought to a provisional end, portions already finished were simply put in the wrong place.

p. 218 14. The crowning balustrade with the statues was not added till the Baroque.

15. The rear wings of the courtyard leading towards the river belong to the late seventeenth century. When they were added, the main staircase was added too. At that time the original timber roof of the salone was replaced by flat vaulting. Tiepolo's fresco on this ceiling was destroyed during the last war.

p. 220 16. For the date of the Palazzo Cornaro-Mocenigo a S. Polo, see *Catalogue*, 168 f.; the façade looks like a preliminary study for that of the later Palazzo Grimani. In the rusticated ground floor there are three portals; the two outer ones lead to the rooms in the corner of the palazzo. In the interior, which was very much altered in later renovations, Cinquecento forms are only retained in the vestibule and salone. For the top storey, see next Note.

17. The Palazzo Grimani a S. Luca, today the Corte d'Appello, was begun in 1556 at the earliest, for it was in that year that the client, Girolamo Grimani, acquired the site. Work was still proceeding on the piano nobile in 1561. After Sanmicheli's death, Giovanni Giacomo de' Grigi became superintendent of the works. The balustrade in front of the piano nobile and the top storey are by him. G. Boschieri ('Il Palazzo Grimani', *Rivista della Città di Venezia* (December, 1931), 461 ff., cf. also Vasari Mil., VI, 359) has proved that the plan for the piano nobile was altered in 1561; the height of the original plan was reduced. Boschieri, and after him Langenskiöld (*op. cit.*, 89), interprets this reduction as a proof that no third floor was originally planned. Yet the evidence does not seem quite conclusive. It is quite possible that Sanmicheli had a kind of attic in mind; Langenskiöld's reconstruction of the ground floor and first floor (*op. cit.*, figure 33) looks too broad and low. Girolamo Grimani bequeathed the palazzo to his two sons in 1570; one storey to each. This later arrangement may have been the reason for the alterations made in 1561. A high piano nobile with a low attic would have been an advantage to one of the heirs and a drawback to the other. In the Palazzo Cornaro a S. Polo, Langenskiöld (*op. cit.*, 78 ff. and figure 28) also assumes that the top storey was added later, and refers to Bramante's and Raphael's Roman façades. But conditions in Venice were radically different: building land was dearer; most Quattrocento palazzi have three main storeys. Serlio writes (Book IV, fol. 153 verso): 'The practice of building in Venice has not its like anywhere else in Italy. The town has a very large population and building sites are therefore limited; . . . there is no room whatever for large courtyards and gardens.' He then goes on (fol. 155 and 156) to illustrate two Venetian palazzo façades, both of which have, above the piano nobile, a storey which is not much lower; in both cases the three middle bays are arranged on the triumphal arch pattern. Whether Serlio was influenced by Sanmicheli or vice versa is a question that still awaits investigation. Cf. also

M. Rosci, *Il Trattato di architettura di Sebastiano Serlio* (Milan, n.d.), 31, and *Catalogue*, 168 f. and 172 f.

222 18. Cf. the combination of an aisled vestibule and simple round-arched portal in the Palazzi del Te, Farnese, and Pitti, and of a single vestibule and triple-bay portal in Vignola's Casino for Pope Julius's villa.

19. A contract of 1516, which binds Sanmicheli to carve a complex tombstone for the pavement in front of the high altar of S. Domenico, mentions two round openings with grilles in the floor. Obviously the crypt-like chapel was to receive its light through these grilles (cf. M. Kahnemann Mangione, 'La Tomba Petrucci di M. Sanmicheli in S. Domenico in Orvieto', *Arte Veneta*, xv (1961), 59 ff.). Although the underground chapel is not mentioned in the contract it seems safe to assume that Sanmicheli designed the whole *ensemble*. The tomb, still incomplete in 1520, no longer exists. The pavement around the tomb, the landings of the stairs, and the floor of the chapel were tiled with costly majolica; it probably came from the same workshop as the tiles from the Palazzo Petrucci in Siena, which are now in the Metropolitan Museum of Art.

20. Probably begun in 1527, the chapel is mentioned as under construction in 1529 (cf. R. Brenzoni, *Atti Ist. Ven. Sc. Lett. Arti*, cxv (1957), 125 ff.). In 1538 Margarita Raimondi received permission to replace Paolo Sanmicheli, a cousin of Michele's, then working at the building, by 'another suitable stonemason, who shall complete the chapel' (see G. dal Re, *Madonna Verona*, viii (1914), 52 ff.). According to Vasari (Mil., vi, 353, 'There is no more beautiful building of the kind in Italy') the chapel was still unfinished when Sanmicheli died. In the nineteenth century it was entirely renovated. Cf. also *Catalogue*, 111.

21. Foundation stone laid in 1559, i.e. the year of Sanmicheli's death. Vasari saw at Verona a model of the church made after Sanmicheli's design. The miraculous image was removed to the church in 1561; in 1562 Pope Pius IV granted indulgences. The dome was not completed till 1667. Cf. the anonymous *Descrizione del tempio della Madonna di Campagna* (Verona, 1823), 3 ff., and *Catalogue*, 181 f.

225 22. Verona is on the west side, the choir on the east side of the church. Thus the visitor coming from the town sees only the big cylinder with the dome.

23. For the static and aesthetic problems presented by a vault of the kind, see G. Giovannoni, *Saggi sull'architettura del Rinascimento* (Milan, 1935), 153 ff. In the Madonna di Campagna, the ratio between the height of the domical vault from the springing of the dome to the crown and its width is 3 : 4. In a spherical dome the ratio is 1 : 2.

24. In this connection the sixteenth-century description of the late Roman rotunda adjacent to St Peter's may be of interest: 'The chapel [of S. Petronilla] is an octagon and rotunda [*sic*]. In the rotunda eight altars are inserted in the thickness of the walls, one on each side' (M. Cerrati, *Tiberii Alpharani De Basilicae Vaticanae* (Rome, 1914), 133). The circular mausoleum had a single-shell dome of concrete; the altars stood in rectangular niches. Can Sanmicheli have seen a precedent in Roman prototypes of the kind when he submitted his plan? But there was a more obvious example of the combination of circle and polygon dating from the late Quattrocento: S. Maria della Croce near Crema (Plate 108). Crema was a Venetian possession and Sanmicheli had worked on the fortifications of Orzinuovi near by. The important pilgrimage church is, for all its formal differences, the only Renaissance building that can compare with the Madonna di Campagna. The Lombard mantling of the domical vault with a dwarf gallery and a conical helm must, however, have looked out of date in 1550. For Sanmicheli's work at Crema and Orzinuovi, see Verga, *I Monumenti architettonici di Crema e dei dintorni* (Crema, 1939), *passim*, and *Catalogue*, *passim*.

25. For the execution, see Vasari Mil., vi, 355. p. 226 It should be recalled that the dome of S. Giorgio in Braida and the round chapel in the courtyard of the Lazzaretto at Verona, now a ruin, have always been attributed to Sanmicheli. In the chapel, the altar, visible from all sides of the courtyard, stood in the centre of two concentric colonnades. The interior ring bore the tall drum with the dome, and the peristyle was covered by a lean-to roof, in the same way as in the Madonna di Campagna. Vasari does not mention the chapel in his detailed description of the Lazzaretto (Mil., vi, 359); cf. also *Catalogue*, 175, for S. Giorgio and 144 for the Lazzaretto.

26. Compare, for instance, the very different effect of the Tuscan order in the piano nobile of the Palazzo Pompei and in the Porta Palio. In the latter, the coupling of the columns, and the contrast between them and the relatively low archways, produces an effect of power and monumentality. The totally different relationship in the

façade of the palazzo with its equilibrium of vertical and horizontal elements gives an impression of harmony and tranquillity.

CHAPTER 20

p. 227 1. The date of his birth is uncertain; cf. J. Vogel, *Monatshefte für Kunstwissenschaft*, XIII (1920), 52 ff., and F. Hartt, *Giulio Romano* (New Haven, 1958), 3. In the literature the date 1492 is often mentioned; it comes from Vasari, but there is no documentary evidence of it.

2. Vasari's description of Giulio's art is characteristic: 'proud, assured, capricious, varied, fertile, and universal' (Mil., v, 524).

3. Vasari Mil., v, 549. For Giulio's work in Mantua and the Gonzaga court see also E. Marani and C. Perina in *Mantova: Le Arti*, II (Mantua, 1961), 197 ff.

4. Erected *c.* 1518–20 as the *villa suburbana* of the *datario* Baldassare Turini (Vasari Mil., v, 534). Renovated after the Second World War, it became the Finnish Academy; see Hartt, *op. cit.*, 62 f., A. Prandi, *Villa Lante al Gianicolo* (Rome, 1954), and J. Shearman, 'Giulio Romano: Tradizione, Licenza, Artificio', in *Bollettino del Centro Internazionale di Storia dell'Architettura Andrea Palladio*, IX (1967), 354 ff.

5. Built *c.* 1520 for Paolo Stazi; later the property of the Cenci, now Palazzo di Brazza; cf. E. Gombrich, 'Zum Werke Giulio Romanos', *Jahrbuch der Kunsthistorischen Sammlungen in Wien*, VIII (1934), 79 ff., and IX (1935), 121 ff., Hartt, *op. cit.*, 64, and Shearman, *op. cit.*

6. Cf. on the other hand the portal of the Palazzo Pandolfini (Plate 189).

p. 228 7. The decree appointing Giulio *Superiore delle Strade* prescribes his duties: 'to supervise the level of the streets; to see to it that all basements are lighted by windows, to prevent the erection of chimneys flush with the street, to see that no impediment to traffic is placed in the roadways'. Translation by Hartt, *op. cit.*, 74 f.

8. Vasari Mil., v, 548.

9. Detailed history in Hartt, *op. cit.*, 91 ff.; see also G. Paccagnini, *Il Palazzo Te* (Milan, 1957), and Shearman, *op. cit.*, 360 ff. and 434 ff. The important drawings discovered by Egon Verheyen show the building before its alteration in the eighteenth century; cf. 'Jacopo Strada's Mantuan Drawings of 1567–1568', *Art Bulletin*, XLIX (1967), 62 ff. As K. W. Forster and R. J. Tuttle (*Journal of the Society of Architectural Historians*, XXX (1971), 267 ff.)

and E. Verheyen (*Mitteilungen des Kunsthistorischen Institutes in Florenz*, XVI (1972), 73 ff.) have shown, Giulio's original design was considerably changed during the execution. See also Forster and Tuttle, 280 ff., for a detailed account of the thorough restoration of the building and its decoration in the late eighteenth century. At that time, 'all the façades [were] entirely covered with a heavy mixture of cement . . . most of the rustication is presently two or three times as thick as it was originally'. Moreover, all extant pavements in the palazzo date from this restoration.

10. Vasari Mil., v, 537. As Shearman (*op. cit.*, 434 ff.) has shown, the walls of an older building, mentioned by Vasari as 'muraglia vecchia' (Mil., 436), were incorporated in the northern wing. This explains a number of irregularities in the façade and the courtyard side of this wing.

11. In the old views of the town, small copses can be seen in front of the two main façades. Obviously the situation of the building on an island, the bridge leading to the island, and the vegetation permitted only certain views, whether near or distant. Today the palazzo stands in a wide suburban piazza, where it looks flat and insignificant. Moreover the original colouring of the façades has perished. The material was brick throughout, stuccoed like Bramante's ground floor of the Palazzo Caprini.

12. The motif of the aisled atrium, which was to p. 2 become important later in the work of Sanmicheli and Palladio, occurs also in the Palazzo Farnese in Rome; Antonio da Sangallo, like Giulio, knew it from his work on the Villa Madama. For the derivation of the form from Vitruvius and the first edition of the treatise, cf. P. G. Hamberg, *Palladio*, N.S. VIII (1958), 16 ff.

13. This treatment of the surface must be p. 2 regarded as ironical, if only because the stucco is here *applied* to the wall, while in the ashlar which the stucco imitates the surface is *chipped off.*

14. The pediment over the loggia of the garden p. 2 façade is an addition of the eighteenth century. Originally there was a low colonnade over the ground floor on either side of the loggia; the crowning attic ran on over the loggia (see Verheyen, *op. cit.*, figure 7).

For the gardens, now gone, and the still existing little Casino della Grotta, see Hartt, *op. cit.*, 153 ff.

15. The building history of the Estivale was not elucidated until the renovation of the whole building in the thirties. Cf. W. Lotz, *Zeitschrift für*

Kunstgeschichte, X (1941), 227 ff., and Hartt, *op. cit.*, 187 ff. See *ibid.*, 161 ff., and G. Paccagnini, *Il Palazzo Ducale di Mantova* (Turin, 1969), for Giulio's other work in the Palazzo Ducale.

16. For the reconstruction of the façade, now partly concealed by later additions, see Hartt, *op. cit.*, figure 409. Originally the columns of the piano nobile were coupled at the corners.

17. The motif of the twisted columns appears here for the first time in a large-scale building; it goes back to the famous 'Solomonic' columns of the high altar of old St Peter's, and can also be seen – though with composite capitals – in Raphael's tapestry of the 'Healing of the Paralytic', which Giulio probably worked on too. Further, Cardinal Ercole Gonzaga, a brother of Duke Federigo, acquired about 1540 the so-called Mantuan series of Raphael's tapestries, which were hung in the cathedral. Later they were removed to the Palazzo Ducale. Giulio's cartoon of the 'Triumph of Scipio', made in the thirties (Hartt, *op. cit.*, figure 482), is another example of his conception of the column as a form in movement: the victorious Scipio banquets in the midst of Ionic columns which are spiral-fluted, though not twisted.

18. See the detailed discussion of both buildings in Hartt, *op. cit.*, 241 ff. The rebuilding of the cathedral was not completed till 1600. After Giulio's death, his pupil G. B. Bertani worked on it. The renovation of S. Benedetto, on the other hand, was practically finished when Giulio died. In 1547 new stalls were placed in the church, and the new organ was paid for in 1552; cf. A. Bertolotti, *I Comuni e le parrocchie della provincia di Mantova* (Mantua, 1893), 182, and Marani and Perina, *op. cit.*, II, 211 ff.

232 19. Giulio acquired the building site in 1538. Work was obviously complete by 1544. Thoroughgoing alterations took place in 1800; how far they went is a matter of controversy. F. Hartt obviously assumed that the asymmetrical façade of today originally had three bays on each side of the portal; thus the fourth bay on the left-hand side of today would go back to 1800. The earlier literature, on the other hand, assumed that the façade was originally of five bays and that the entrance was shifted in 1800. Cf. the detailed discussion of the sources in Hartt, *op. cit.*, 236 ff. The traditional assumption of a façade of five bays has again been strongly supported by Marani and Perina, *op. cit.*, II, 214 and note 140. Of the 'coloured stucco which luxuriates over the entire front' (Vasari Mil., V, 549) nothing remains. For the second famous

artist's house at Mantua, Mantegna's, cf. Part One, p. 82.

20. Cf. E. Herget, 'Wirkungen und Einflüsse des p. 233 Palazzo del Te nördlich der Alpen', in *Festschrift für Harald Keller* (Darmstadt, 1963), 281 ff.

21. The east wing on the lake shore was finished in 1556; the north wing was still in construction in 1572; the Galleria della Mostra, the west wing, was not built till *c.* 1600. For the building history, cf. C. Cottafavi, *Ricerche e documenti sulla costruzione del Palazzo Ducale di Mantova* (Mantua, 1939), 5 ff. For Bertani, see Marani and Perina, *op. cit.*, III (Mantua, 1965), 3–70; for his work in the Palazzo Ducale cf. also Paccagnini, *op. cit.*, *passim*.

CHAPTER 21

1. Vasari Mil., XII, 494 ff. Milanesi's text is based p. 235 on a *Vita di Jacopo Sansovino* published soon after the artist's death (no place, no date), and not the shorter text of the Vasari edition of 1568 (cf. *Vita di Jacopo Tatti detto il Sansovino*, ed. G. Lorenzetti (Florence, 1913), 79 f.). For Sansovino's decorations for the state entry of Leo X, cf. Lorenzetti, *op. cit.*, 95 f., and W. Lotz, *Journal of the Society of Architectural Historians*, XXII (1963), 3 f.

2. Lorenzetti, *op. cit.*, 96 f.; for Michelangelo's projects see Chapter 22.

3. See above, Chapter 17, and Lotz, *op. cit.*, 7.

4. H. R. Weihrauch, *Studien zum bildnerischen Werke des Jacopo Sansovino* (Strasbourg, 1935), 42, and M. Tafuri, *Jacopo Sansovino e l'architettura del '500 a Venezia* (Padua, 1969), 9.

5. Vitruvius, *De architectura*, V, 1, speaks of the Roman fora: 'Distribuantur circaque in porticibus argentariae tabernae...'. Alberti, *De re aedificatoria*, VIII, 6, writes in practically the same terms. Cf. W. Lotz, 'Sansovinos Bibliothek von S. Marco und die Stadtbaukunst des Renaissance', in *Kunst des Mittelalters in Sachsen, Festschrift Wolf Schubert* (Weimar, 1967), 336 ff., idem, 'Italienische Plätze des 16. Jahrhunderts', in *Jahrbuch der Max-Planck-Gesellschaft* (1968), 41 ff., and Tafuri, *op. cit.*, 44 ff.

6. G. Lorenzetti, 'La Libreria Sansoviniana di p. 236 Venezia', *Accademie e Biblioteche d'Italia*, II (1929), 73 ff.; also in his *Vita di Jacopo Tatti* (cf. Note 1), 110 ff. See also Tafuri, *op. cit.*, 54 f. and note 76 for the chronology of the building.

7. G. Gaye, *Processo e atti ... per il crollo della Libreria* (Venice, 1855), and L. Pittoni, *Jacopo Sansovino scultore* (Venice, 1909), 168 ff.

8. Cf. Lotz, *op. cit.* (Note 1), 9; see also above, p. 202.

p. 236 9. The motif of the small columns placed within the large order, which reappears not much later in Palladio's Basilica at Vicenza, again comes from Raphael; it occurs, for instance, in the Benediction Loggia in the background of the fresco of the 'Fire in the Borgo' in Raphael's Stanze. Cf. also W. Lotz, 'Palladio e Sansovino', in *Bollettino del Centro Internazionale di Studi sull'Architettura Andrea Palladio*, IX (1967), 13 ff.

p. 237 10. *Quattro Libri*, preface to Book I.

11. *Die Kunst der Renaissance in Italien*, § 53.

12. In planning the new Procurazie, Scamozzi adopted the scheme of the Libreria, but increased the number of storeys to three. Scamozzi also wished to add another storey to the Libreria itself, but the plan would have involved a drastic change in the harmonious proportions of Sansovino's building and was turned down by the Procuratori di Supra. Cf. F. Barbieri, *Vincenzo Scamozzi* (Vicenza, 1952), *passim*, and Tafuri, *op. cit.*, 54.

The medieval Ospizio Orseolo, which was torn down and replaced by the Procurazie Nuove, appears still in the print of 1577 with the celebrations of the victory at Lepanto; cf. plate XIII in *Studies in Renaissance and Baroque Art presented to Anthony Blunt* (London and New York, 1967).

13. Cf. G. Lorenzetti, 'La Loggetta al campanile di S. Marco', *L'Arte*, XIII (1910), 108 ff. An older loggia on the same site was destroyed by lightning in 1537. In a letter from Pietro Aretino to Sansovino, dated 20 November 1537, there is mention of a model of the loggia. The building was roofed in 1539. According to a document of 1602 (cf. Lorenzetti, *op. cit.*, 119) the intention was to build loggias on all four sides of the campanile. In the seventeenth century, the attic was widened by one bay on both sides; at the same time the openings on the narrow sides were closed. For the sculpture of the Loggetta, cf. Weihrauch, *op. cit.*, 54 ff., for its function see Tafuri, *op. cit.*, 65 ff.

14. For the building history of the Zecca, cf. R. Gallo, 'Contributi su Jacopo Sansovino', *Saggi e Memorie di Storia dell'Arte* (Fondazione Cini), I (1957), and Tafuri, *op. cit.*, 72. The older building was demolished in 1535–6. In 1536, Sansovino submitted three models. Work was in progress by 1537. In 1542, workshops were rented out on the ground floor of the new building, but in 1558 it was decided to hand over these rooms to the Zecca. The second storey was completed in 1548. The entrance to the Zecca is from the Piazzetta; the ground floor towards the Molo had botteghe

which were walled up in 1580, obviously in order to obtain more space for the Zecca itself.

15. The reason given for the addition of a top p. 23 storey, decided on in June 1558 and begun three months later, was that the piano nobile was too hot in summer. No architect is named, but in view of the circumstances it can only have been Sansovino. Cf. Gallo, *op. cit.*, and Tafuri, *op. cit.*, 72.

16. In Book IV (1537), we read in the chapter 'dell'ornamento rustico' that the Doric order could be combined with rustication and the result would be 'parte opera di natura e parte opera di artefice'. The Doric columns with rusticated bands and rusticated voussoirs echoed the work of nature, the capitals and the plain parts of the column shafts the work of man: 'la quale mistura, per mio aviso, è molto grata all'occhio, e rappresenta in se gran fortezza'.

17. For the Palazzo Corner, cf. Gallo, *op. cit.*, 86, Lorenzetti, *op. cit.* (Note 1), 115, and Tafuri, *op. cit.*, 28 ff.

18. For S. Geminiano, cf. Gallo, *op. cit.*, 97, and p. 23 Tafuri, *op. cit.*, 145 and 157; for the Scuola Grande della Misericordia, cf. Lorenzetti, *op. cit.* (Note 1), 116, and Tafuri, *op. cit.*, 12 ff.

19. For the Villa Garzoni at Ponte Casale, probably built in the forties, cf. L. Puppi, in 'Prospettive', *Rassegna di Architettura, etc.*, no. 24 (1962), 51 ff., Lotz (cf. Note 1), 10, B. Rupprecht, 'Die Villa Garzoni des Jacopo Sansovino', *Mitteilungen des Kunsthistorischen Instituts Florenz*, XI (1963), 2 ff., L. Puppi, *Bollettino* (*op. cit.*, Note 9), 95 ff., and Tafuri, *op. cit.*, 99.

CHAPTER 22

1. The present account of Michelangelo's work p. 24 in architecture is substantially based on J. S. Ackerman's outstanding study, *The Architecture of Michelangelo*, 2 vols., 2nd ed. (London, 1964). Ackerman has collected and clarified the literature, in particular the work of Charles de Tolnay. A *catalogue raisonné* of Michelangelo's buildings with an extensive pictorial documentation, excellent pictures of the buildings, and reproductions of all Michelangelo's architectural drawings may be found in *Michelangelo architetto*, ed. P. Portoghesi and B. Zevi (Turin, n.d. [1964]). With regard to these publications references to literature have been largely omitted in the following Notes.

The two versions of Vasari's *Vita di Michelangelo* have been edited and exhaustively commented by P. Barocchi: vol. I Testo, vols. II–IV Commento

(Milan–Naples, 1962). The edition also provides extensive excerpts from the pertinent literature.

41 2. For the text of the contract, see G. Milanesi, *Le Lettere di Michelangelo Buonarroti* (Florence, 1875), 671.

42 3. According to the memoirs of G. B. Figiovanni, Prior of S. Lorenzo, the New Sacristy was begun on 4 November 1519; cf. A. Parronchi, in *Atti del Convegno di Studi Michelangioleschi, Firenze-Roma 1964* (Rome, 1966), 322 ff. See also C. F. Frommel, 'S. Eligio und die Kuppel der Cappella Medici', *Stil und Überlieferung, Akten des 21. Internationalen Kongress f. Kunstgeschichte, Bonn, 1964*, II (Berlin, (1967), 41 ff.

245 4. The conditions laid down by the Pope made it impossible for Michelangelo to return to the nave-and-aisles type of Quattrocento libraries (cf., for instance, S. Marco, Florence, or the Biblioteca Malatestiana at Cesena). There may, however, be an echo of this older type in Michelangelo's original project of a nave-and-aisles arrangement of the desks in the reading room.

249 5. Cf. Ackerman, *op. cit.*, I, 54 ff., and II, 49 ff., and G. de Angelis d'Ossat and C. Pietrangeli, *Il Campidoglio di Michelangelo* (Milan, 1965), a book published à propos the Michelangelo celebrations of 1964.

252 6. The rustication of the basement as executed is far flatter than Michelangelo intended it to be. As Dupérac's engraving shows (Plate 250), the two upper storeys were to be of the same height and have the same fenestration. As executed, the top floor is lower, and its square windows give it the look of a mezzanine to the piano nobile. This impairs the effect of the giant order very considerably. Cf. also the drawing in Christ Church, Oxford, published by T. Buddensieg, *Zeitschrift für Kunstgeschichte*, XXX (1969), 177 and figures 6–7.

7. The canopy over the landing of the stairway, which appears in Dupérac's engraving, was not executed. It would have given greater stress to the portal, and also have emphasized, with its smaller order, the effect of the giant pilasters.

8. Cf. W. Lotz, 'Italienische Plätze des 16. Jahrhunderts', *Jahrbuch der Max-Planck-Gesellschaft* (1968), 54 ff.

The effect of the oval as here described cannot be fully appreciated today on the Campidoglio itself. The present pavement of the piazza, executed in 1940 and intended to reproduce the pattern shown by Dupérac, does not fully correspond to that of the engravings. The single oval ring executed in 1940 was opened to the spandrels of the piazza in order to provide level cross-connections across the corners between the access streets and the oval itself. On the other hand, Dupérac's engraving shows that the three oval rings originally planned were to be uninterrupted. The illusion of the identity of the spandrels would thus have seemed far more pronounced than it is today.

9. The layout of the piazza at Pienza, which has **p. 253** often been mentioned in this connection (cf. above, Part One, p. 43), belongs to the prehistory of the plan, but it was not the model for the Campidoglio. At Pienza the piazza is also trapezoidal in shape, but the buildings surrounding it vary in height, articulation, and size. Further, there is no statue in the centre of the piazza. The view over the landscape by means of the diverging façades at the sides, as described by Pius II, has no analogy on the Capitol, since the fronts of the palazzi run towards the Palazzo del Senatore (cf. plan, Figure 82). The view of the forum in Dupérac's engraving is an invention of the engraver's.

10. In a document dated 27 August 1547, Michelangelo is expressly described as the architect 'fabricae palatii . . . Ducis Parma et Placentiae'; cf. A. Schiavo, *La Vita e le opere architettoniche di Michelangelo* (Rome, 1953), 276. Whether the unusual size and height of the salone in the piano nobile were already designed by Sangallo remains an open question. Unlike the older rooms on the right-hand side of the façade, the salone is two storeys in height; this may have been decided in 1541, when Sangallo altered the original plan.

11. A comparison of Michelangelo's top storey **p. 254** with the much 'lighter' one of the Cancelleria shows the important part played in the general effect by the weighty pediments and the high relief of the pilasters. The notion that the top storey of the court was not designed by Michelangelo but by Giacomo della Porta (R. Bonelli, *Da Bramante a Michelangelo* (Venice, 1960), 85) is refuted by the caption of the 1560 engraving of the court, in which only Sangallo and Michelangelo are named as its architects and in which the storey appears in its present form. Bonelli restated his opinion, but without the attribution to Porta, in *Michelangelo architetto* (see Note 1), 618; it is *ex silentio* accepted by G. de Angelis d'Ossat in *Michelangelo: Artista, Pensatore, Scrittore*, ed. M. Salmi (Novara, 1965), 369.

12. Speaking of a chapel, Rabelais wrote in 1548 that it was 'désolée, minée et descouverte comme est à Rome le temple de Saint-Pierre' (*Pantagruel*, Quart Livre, chapter XLV).

p. 254 13. In the interior, the cool monochrome of grey travertine and white stucco is impaired by the brightly coloured marble facing of the seventeenth century. It must also be mentioned in this connection that the lighting planned by Michelangelo was altered in della Porta's execution of the dome: 'Michelangelo's purpose was to bring a diffused light into the dome from invisible sources to create a mysterious effect' (Ackerman, *op. cit.*, II, 110).

14. To the east, the section of Constantine's nave which had been separated by the provisional wall was preserved till the seventeenth century.

p. 255 15. As H. A. Millon and C. H. Smyth (*Burlington Magazine*, CXI (1969), 484 ff.) have shown, the 'present attic order was introduced by his successors' after Michelangelo's death. Michelangelo's design of the attic is preserved in an engraving published in 1564 by Vincenzo Luchino. The attic over the southern arm of the cross, executed as shown in the engraving, was at a later time changed to conform to the altered design which was first executed over the northern arm.

For the façade shown in Dupérac's engravings see C. Thoenes, 'Bemerkungen zur St Peter-Fassade Michelangelos', in *Festschrift Kauffmann, Munuscula Discipulorum* (Berlin, 1968), 331 ff.

16. 'Anyone who, like Sangallo, departed from Bramante's plans departed from truth; any unbiased observer can see that in his model' (letter from Michelangelo, dated 1555 by Milanesi, *op. cit.* (Note 2), 535, but in all probability written in 1546/7, i.e. shortly after Michelangelo's appointment; see E. H. Ramsden, *The Letters of Michelangelo* (London, 1963), II, 69 and 237 f.).

p. 256 17. For the development and dating of Michelangelo's project for the dome and the execution of the double-shell dome by Giacomo della Porta, the most important authority is R. Wittkower, *La Cupola di S. Pietro di Michelangelo* (Florence, 1964); also Ackerman, *op. cit.*, I, 97 ff., and II, 107 ff. H. R. Alker (*Michelangelo und seine Kuppel von St Peter in Rom* (Karlsruhe, 1968), 17 ff.) has tried to prove that the outer shell of the model was altered after 1561 by Michelangelo himself; hence the executed dome would correspond to Michelangelo's final design. Attractive though this theory is, Alker's arguments are not conclusive. His measured drawings of the model and its competent analysis should specifically be mentioned.

p. 257 18. This opinion, which was put forward by John Coolidge, is supported by an exterior view of St Peter's, probably made earlier than Dupérac's

engravings 'secondo il disegno del Buonaroti', which shows the church without minor domes. The four small domes beside the apses of the transepts shown in the view are not, as Ackerman supposed, minor domes, but overhead lights for the spiral staircases in the 'counter-piers'. Cf. J. Coolidge, 'Vignola and the Little Domes of St Peter's', *Marsyas*, II (1942), 63 ff. (particularly 78 and figure 12: reconstruction of the exterior view without minor domes); Ackerman, *op. cit.*, II, 113; R. Wittkower (ed.), *Disegni de le ruine di Roma e come anticamente erono* (Milan, [1963]), 27, reviewed by C. Thoenes, *Kunstchronik*, XVIII (1965), 18 f.

19. Ackerman favours this view, *op. cit.*, II, 114.

20. See above, pp. 195–6.

21. Cf. H. Siebenhüner, 'S. Giovanni dei Fiorentini in Rom', in *Kunstgeschichtliche Studien für Hans Kauffmann* (Berlin, 1956), 172 ff.

22. For the description and reproduction of Michelangelo's projects, cf. Ackerman, *op. cit.*, II, 121.

23. Peruzzi had already conceived a centralized p. 2 plan with oval chapels in the diagonal axes and alternately narrow and wide openings towards the area under the dome in a project for S. Giovanni dei Fiorentini (Uffizi A510); cf. W. Lotz, *Römisches Jahrbuch für Kunstgeschichte*, VII (1955), 21. It is uncertain whether Michelangelo knew these projects.

24. It is notable that all the reproductions of the model show a single-shell dome. A vault of this shape with a span of over 25 m. (80 feet) could only have been cast in concrete. It may be that Michelangelo's drawings gave no clear indications for the dome; it has already been pointed out that even in St Peter's he left the definitive plan of the shape and contour of the dome and lantern undecided till the end.

25. Cf. Ackerman, *op. cit.*, I, 109 f., and II, 122 ff.; begun to a commission from Cardinal Guido Ascanio Sforza (d. 1564); according to Vasari, Tiberio Calcagni (d. 1565) was entrusted with the execution of Michelangelo's designs. The chapel, which Vasari described as unfinished in 1568, was consecrated in 1573. There seems to be no reason to doubt that the execution (probably by Giacomo della Porta) was in line with Michelangelo's intentions. The earliest known views of the building are in Francesco Pagliarino's *Zibaldone* (between 1578 and 1581; Milan, Castello Sforzesco, Cod. Trivulzio 179, unpublished); a drawing in the *Zibaldone* shows the elevation of the façade of the chapel towards the side aisle of the church, which was demolished in the eighteenth century (Plate

265). A memorandum of 1577 concerning the Capitoline buildings mentions the price of travertine which had been used for the 'facciata' and the columns of the chapel; cf. P. Pecchiai, *Il Campidoglio nel Cinquecento* (Rome, 1950), 253.

26. Cf. S. Maria del Popolo, Chigi Chapel, inner width 7·04 m. (23 feet), summit of dome 14·08 m. (43 feet); S. Lorenzo, New Sacristy, inner width 12 m. (39 feet), summit of dome 25 m. (80 feet).

259 27. The unprecedented use of travertine for columns in the interior is characteristic of Michelangelo's predilection for monochrome. The tombs of the two Sforza cardinals, erected about 1580, and the modern decoration impair the intended effect.

28. The lighting we see today does not correspond to the original. Two windows were broken out at the side of the altar; when the adjacent Borghese Chapel was built the corresponding lunette window of the Sforza Chapel was walled up.

260 29. For reproduction and description of preliminary drawings see E. MacDougall, 'Michelangelo and the Porta Pia', *Journal of the Society of Architectural Historians*, XIX (1960), 97 ff.

30. Since the gate, which once stood flush with the Aurelian Walls and towered above them, was isolated in modern times, the original function as a passageway has become unrecognizable. The unimpressive old outer side of the gate, known to us in drawings, was destroyed in the nineteenth century.

261 31. The foundation stone of the church was laid in 1561. The first mass was not said till 1565, and the building was not finished till about 1590, under Sixtus V.

32. The large volutes round the windows, which can be seen in Plate 266, belong to the seventeenth century.

CHAPTER 23

263 1. Cf. M. G. Lewine, 'Roman Architectural Practice during Michelangelo's Maturity', in *Stil und Überlieferung in der Kunst des Abendlandes* (Akten des 21. Internationalen Kongresses für Kunstgeschichte, Bonn, 1964) (Berlin, 1967), II, 20 ff.; also H. Hibbard, 'Maderno, Michelangelo and Cinquecento Tradition', *ibid.*, 33 ff.

264 2. Cf. D. Coffin, *The Villa d'Este at Tivoli* (Princeton, N.J., 1960), and C. Lamb, *Die Villa d'Este in Tivoli* (Munich, 1966), 85 ff.

3. Cf. Lamb, *op. cit.*, 92, and E. Mandowsky and

C. Mitchell, *Pirro Ligorio's Roman Antiquities* (Studies of the Warburg Institute, XXVIII) (London, 1963).

4. For details, see J. S. Ackerman, *The Cortile del Belvedere* (Vatican City, 1954), 73 ff. The ground plan of Michelangelo's stairway is preserved in a drawing in the Metropolitan Museum; see C. de Tolnay, *Stil und Überlieferung* (Note 1), II, 67.

5. For Ligorio's designs for the west corridor, cf. Ackerman, *op. cit.*, 87 ff., and the drawing attributed to Sallustio Peruzzi in the Phyllis Lambert Collection, New York (Plate 154); cf. W. Lotz, *Kunstchronik*, XI (1958), 96 ff. The west wing was completed only about 1580.

6. Stucco coating of a façade appears for the first time in Bramante's Palazzo Caprini; cf. above, p. 163.

7. See W. Friedlaender, *Das Kasino Pius des Vierten* (Leipzig, 1912), and C. Elling, *Villa Pia in Vaticano* (Copenhagen, 1947).

8. For Pliny's letter on the Laurentina, cf. D. p. 265 Coffin, 'The Plans of the Villa Madama', *Art Bulletin*, IL (1967), 119: '. . . Pliny compares the shape of the central court of his Villa to the letter D. . . . However, the passage . . . is a result of later philological criticism. Most of the Italian late fifteenth century and early sixteenth century editions of the *Letters* . . . use the letter O to describe the form of the court in Pliny's Villa.' In early-sixteenth-century printing, however, the letter O – like the court of the Villa Madama, which Coffin connects with it – is circular in shape; but later in the century O took the shape of an oval. Thus I should like to regard the oval court of the Casino as a 'literal' copy of the Laurentina court. Ligorio may also have thought of the oval shape of the circus arena or, as Elling (*op. cit.*, 31 ff.) has suggested, of the ancient naumachia.

9. The beginning of actual building work was p. 266 preceded by large purchases of land and ground-levellings. Cf. the documents in Coffin, *op. cit.*, 8 ff.

10. A letter from Annibale Caro dated 13 July p. 267 1538 gives a full description of the garden of Giovanni de' Gaddi in Rome, where there were grottoes with antique ornament, pergolas, and elaborate fountains: 'tra il piovere, il gorgogliare, e il versare, e di questa fonte, e dell'altra, oltra al vedere, si fa un sentir molto piacevole, e quasi armonioso, congiunto un altro maggior suono, il quale si sente, e non si scorge donde si venga'; A. Caro, *Lettere Familiari* (ed. A. Greco), I (Florence, 1957), 105 ff.

11. For the original condition of the villa as

shown not only in Dupérac and his explanations, but in contemporary descriptions, cf. Lamb, *op. cit.*, and Coffin, *op. cit.*

p. 268 12. Early in the Cinquecento it was possible to place side by side, in a Doric entablature, metopes of different shapes, as in the Tempietto, or to employ different capitals side by side, as in the court of the Palazzo Medici-Lante in Rome; in the second half of the century the Corinthian capital in the crossing of St Peter's was copied for the Gesù (see Hibbard, *op. cit.*, 39), which has the same form of capital throughout.

13. Pastor, *op. cit.*, V, 730; cf. also details in M. Walcher Casotti, *Il Vignola* (Trieste, 1960), I, 259 ff. For Vignola's sojourn in France see also S. Pressouyre, 'Les Fontes de Primatice à Fontainebleau', *Bulletin Monumental*, CXXVII (1969), 225 ff.

14. For the subject of Gothic in the Renaissance, see R. Bernheimer, 'Gothic Survival and Revival in Bologna', *Art Bulletin*, XXXVI (1954), 263 ff.; also *ibid.*, 272 ff., and Walcher Casotti, *op. cit.*, I, 57 ff., for Vignola's designs for S. Petronio.

15. Cf. J. K. Schmidt, 'Zu Vignolas Palazzo Bocchi in Bologna', *Mitteilungen des Kunsthistorischen Instituts Florenz*, XIII (1967), 83 ff. The design shown in the engraving was altered in the execution. The ground floor is the only part left standing from the first stage of building. Instead of the pilasters which appear in the engraving, the portal has Tuscan columns which are partly encased in rusticated blocks; the balcony above the portal and the upper storey belong to a later stage of building.

Until now the engraving had only been known in a variant bearing the date of 1555 and the arms of Pius IV (1561–5); the version published by Schmidt shows the arms of Paul III; the Pius IV version gives the executed portal.

p. 270 16. The villa was begun soon after the elevation of Julius III (1550–4), and practically completed at the time of his death. The profuse antique decoration was removed to the Vatican later in the sixteenth century; as we see it today, the building is the result of many restorations. For a review of the copious literature, see now F. L. Moore, 'A Contribution to the Study of the Villa Giulia', *Römisches Jahrbuch für Kunstgeschichte*, XII (1969), 171 ff.; for a fully documented history of the building and its decoration see T. Falk, 'Studien zur Topographie und Geschichte der Villa Giulia in Rom', *ibid.*, XIII (1971), 101 ff.

17. A portrait medal of the Pope, with Vignola's Palazzina and the nymphaeum on the reverse side,

bears the inscription FONS VIRGINIS VILLAE JULIAE; see Moore, *op. cit.*, figures 3 and 4. For Ammannati's share see also below, p. 320.

18. Michel de Montaigne, *Voyage en Italie par la Suisse et l'Allemagne en 1580 et 1581*; for Caprarola, see Lotz, *Vignola-Studien*, 35 ff., Walcher Casotti, *op. cit.*, I, 71 and 156 ff. (cf. review by C. Thoenes, *Kunstchronik*, XV (1962), 151 ff.), and L. W. Partridge, 'Vignola and the Villa Farnese at Caprarola', *Art Bulletin*, LII (1970), 81 ff. As the documents discovered by Partridge prove, Vignola also designed the street which leads through the town of Caprarola to the palazzo and the semicircular ramps that lead from the street to the palazzo. Before building was begun, the Cardinal ordered full reports and several designs from Vignola and Francesco Paciotto, who was engaged on the Farnese fortifications in Parma and Piacenza. It is clear from these sources that the round cortile was an idea of Vignola; Paciotto had proposed a decagonal court. The work began in 1559 under Vignola's supervision, and when he died in 1573 the Cardinal abandoned the idea of appointing another architect in his place, since the building was practically finished (cf. Fulvio Orsini's letter of 6 September 1573, in A. Ronchini, *Atti e Memorie della Deputazione di Storia Patria per la Provincia di Emilia*, N.S. IV, part II (1880), 54 f.).

19. Cf. Walcher Casotti, *op. cit.*, I, 78 ff. and p. 27 162 ff. At Piacenza, Vignola had to take Francesco Paciotto's designs into account too: cf. G. Kubler, 'Francesco Paciotto, Architect', in *Essays in Memory of Karl Lehmann* (New York, 1964), 176 ff. (Spanish translation: 'Francesco Paciotto, arquitecto', in *Goya, Revista de Arte*, nos. 56–7 (1963), 86 ff.). Paciotto proposed to build the theatre in the court in wood; Vignola's proposal to build it in stone as a permanent structure was, however, accepted. This part of the building never got beyond its beginnings. For the early history of the building and Vignola's plans, see now P. Dreyer, 'Beiträge zur Planungsgeschichte des Palazzo Farnese in Piacenza', *Jahrbuch der Berliner Museen*, VIII (1966), 160 ff.; cf. also A. Terzaghi, 'Disegni originali del Vignola per il Palazzo Farnese di Piacenza', in *Il Palazzo Farnese e la chiesa di S. Agostino in Piacenza* (Piacenza, 1960). As Dreyer points out, Vignola first planned a fortified villa reaching to the Po. The drawings made by Vignola's son Giacinto to his father's instructions are at Windsor and in the State Archives at Parma.

20. Consult, however, Kubler, *op. cit.*, 188. p. 27

21. In Vignola's design, the two windows over

the street openings were to be provided with balconies; these, however, were subsequently omitted, along with the clock towers over the same bays. The rather monotonous façade of today would have gained emphasis and the contour would have been effectively enriched. The attribution to Vignola is made as early as Egnatio Danti's biography of Vignola of 1583 ('built under Pius IV'). Bolognese guide-books of the seventeenth century give the date 1562, which may have appeared on the façade at an earlier time. For Vignola's drawing of the original project in Berlin, cf. Walcher Casotti, *op. cit.*, 61 f. and 147 f., and W. Lotz, 'Italienische Plätze des 16. Jahrhunderts', *Jahrbuch 1968 der Max-Planck-Gesellschaft*, 57 ff.

22. M. J. Lewine gives a list of the churches built in Rome between 1527 and 1575, *op. cit.* (Note 1), II, 20. For S. Spirito in Sassia, *ibid.*, 22, and E. Lavagnino, *La Chiesa di Santo Spirito in Sassia* (Turin, 1962).

23. The measurements of the plan could not be simpler. Exactly half of its total length of 320 palms (71·36 m., or 234 feet 1 in.) is occupied by the nave; the transept also is 160 palms in length, the chapels 40 palms. For the early architectural history of the Gesù cf. J. S. Ackerman and W. Lotz, 'Vignoliana', in *Essays in Memory of Karl Lehmann* (New York, 1964), 14 ff. and its attached bibliography. The profuse Baroque decoration, and in particular Bacciccia's great fresco in the vault, have radically altered the general effect of the interior.

76 24. Nanni di Baccio Bigi's Gesù project of 1550 shows a remarkably wide nave with a timber ceiling, six chapels on each side, and a comparatively narrow transept. This project, which was obviously regarded as the model as early as March 1568, was intended for another site (cf. P. Pirri, 'La Topografia del Gesù di Roma, etc.', *Archivum Historicum Societatis Jesu*, X (1941), 177 ff.). The present site was not definitely decided on till just before the foundation stone was laid.

25. Though designs for oval churches existed as early as Peruzzi; cf. p. 192. Vignola may have become familiar with Peruzzi's ideas through Serlio. On this point, cf. W. Lotz, 'Die ovalen Sakralbauten des Cinquecento', *Römisches Jahrbuch für Kunstgeschichte*, VII (1955), 35 ff.; also Ackerman, 'Vignoliana' (*op. cit.*, Note 23), 12.

77 26. For this and the following point, cf. Lotz, *op. cit.*, 40 ff. Vignola's design for S. Maria del Piano at Capranica, showing an oblong interior with exedrae on the short sides, precedes the plan for the conclave chapel with its 'pure' oval. The

plan of S. Maria del Piano was published and dated (before 1559) by K. Schwager, *Zeitschrift für Kunstgeschichte*, XXXI (1968), 249 f.

27. M. Lewine, 'Vignola's Church of Sant'Anna dei Palafrenieri, Rome', *Art Bulletin*, XLVII (1965), 199 ff. (containing new references to sources and important observations on the building and the reconstruction of its original state; cf. Figure 91B). Excerpts from the building accounts were published by A. Cicinelli, *S. Anna dei Palafrenieri in Vaticano* (Chiese di Roma illustrate, CX) (Rome, 1970), 31 ff.: cornerstone 1565; façade under construction 1566; the columns framing the portal 1567; window grilles 1571–2; interior columns and main cornice 1576; provisional wooden roof and consecration 1583. The clerk of the works was – as in all Vignola's late works – his son Giacinto. The façade and vaulting were completed in the eighteenth century. The interior was disfigured by the restorations of 1842 and 1902–3.

28. For the original function of the 'irregular spaces' in the corners, cf. Lewine, *op. cit.* (Note 27), 211.

29. In addition to the main portal, there was a side entrance to the church in the right-hand side wall. Opposite the main entrance, the altar of St Anne stood in a niche, and there was a second altar on the long side opposite the side entrance. This arrangement was greatly altered by the rebuilding of the seventeenth century, and the enlargement of the high altar recess about 1900. For the reconstruction, see Lewine, *op. cit.*

30. R. Wittkower, *Art Bulletin*, XIX (1937), 263.

31. D. Frey, *Bramante's St Peter-Entwurf und seine Apokryphen* (Vienna, 1915), 75.

32. Cf. E. Hubala, 'Roma Sotterranea, An- p. 279 dachtsstätten in Rom und ihre Bedeutung für die barocke Baukunst', *Das Münster*, XVIII (1965), 157 ff., and R. Krautheimer, 'A Christian Triumph in 1597', in *Essays in the History of Art presented to Rudolf Wittkower* (London, [1967]), 174 ff.

For the following, see also the fine survey and analysis of Roman architecture during the last decades of the Cinquecento in H. Hibbard, *Carlo Maderno and Roman Architecture 1580–1630* (London, 1971), 22–34.

33. Completed in 1585; cf. J. S. Ackerman, *The Architecture of Michelangelo* (London, 1964), II, 96.

34. See p. 256.

35. Cf. H. Hibbard, 'The Early History of p. 280 Sant'Andrea della Valle', *Art Bulletin*, LXIII (1961), 305. For Porta's training and his first buildings see J. von Henneberg, 'An Early Work by Giacomo

della Porta: The Oratorio del SS. Crocefisso di S. Marcello in Rome', *Art Bulletin*, LII (1970), 157 ff.

p. 280　36. Cf. Wölfflin, *Renaissance und Barock*, 2nd ed. (Munich, 1907), 77 f.; H. Willich, *Vignola* (Strasbourg, 1910), 140 f.; T. H. Fokker, 'The First Baroque Church in Rome', *Art Bulletin*, XV (1933), 241 f.; G. Giovannoni, *Saggi sull'architettura del Rinascimento*, 2nd ed. (Milan, 1935), 208 ff.; Walcher Casotti, *op. cit.* (Note 13), 207 f.; Lotz, 'Vignoliana' (*op. cit.*, Note 23), 20 ff.

p. 281　37. Hibbard, *op. cit.* (Note 35), 289 ff.; *idem*, *op. cit.* (Note 32), 25 f.

p. 282　38. According to J. Wasserman, 'Giacomo della Porta's Church for the Sapienza', *Art Bulletin*, XLVI (1964), 502, probably of 1594-7. Wasserman also deals with Porta's share in the court of the Sapienza.

39. Donated by Cardinal Alessandro Farnese; reproduction in P. Letarouilly, *Édifices de Rome moderne* (Liège–Brussels, 1849–66), III, plate 339. To a contract from Cardinal Pietro Aldobrandini, Della Porta also designed for the abbey of S. Paolo alle Tre Fontane a chapel on the site of the martyrdom of St Paul.

40. For the authorship, typology, and dating of the façades of S. Atanasio and the Trinità dei Monti, cf. Giovannoni, *Saggi* (*op. cit.*), 219 ff. The old attribution of S. Atanasio to Della Porta (cf. Hibbard, *op. cit.* (Note 35), 307) is questionable; M. Zocca put forward Francesco da Volterra (*Bollettino d'Arte*, XV (1935-6), 528). According to information kindly given me personally by Dr Herwarth Röttgen, Francesco da Volterra is also mentioned in the building accounts of the church. We may expect this question to be cleared up in Klaus Schwager's monograph on Della Porta. Della Porta's palazzi, among others the Palazzi Maffei-Marescotti, Crescenzi-Serlupi, and Chigi in the Piazza Colonna, till now have been examined only by W. Arslan (cf. 'Forme architettoniche civili di Giacomo della Porta', *Bollettino d'Arte*, VI (1927), 508-27; see also Hibbard, *op. cit.* (Note 32), 31, and, for the Palazzo Chigi, 215). For Della Porta's work on the Villa Aldobrandini at Frascati (under construction from 1601), cf. Schwager, 'Kardinal Pietro Aldobrandinis Villa di Belvedere in Frascati', *Römisches Jahrbuch für Kunstgeschichte*, IX/X (1961/2), 291-382, and C. D'Onofrio, *La Villa Aldobrandini di Frascati* (Rome, 1963).

41. Volterra was already in Rome as 'architetto' before his time in northern Italy; his son Orazio was baptized in St Peter's on 22 May 1559 (from unpublished notes by F. Noack in the Biblioteca Hertziana). In 1583, the Mantuan agent in Rome

recommended Volterra for a post as court architect at Mantua; cf. A. Bertolotti, 'Artisti in relazione coi Gonzaga . . .', *Atti e Memorie Dep. di S. Patria Mod. e Parmensi*, serie III, vol. III (1885), 17. Della Porta is mentioned in the same letter as 'primo architetto di questa citta' (i.e. Rome); a document of 1593 says of Porta 'he is generally held to be the first and principal architect of Rome' (cf. H. Hibbard, *Burlington Magazine*, CIX (1967), 713, with the information that Volterra died before 20 March 1595); see also Hibbard, *op. cit.* (Note 32), 29 and *passim*.

42. Volterra was at work on the hospital buildings as early as 1582. His designs for the church, which was begun in 1592, are dated 1590. The church was vaulted and the façade completed by Carlo Maderno, who took over the building in 1595 and may have made minor adjustments in Volterra's plans. Consecration took place in 1602. Cf. W. Lotz, *Römisches Jahrbuch für Kunstgeschichte*, VII (1955), 58 ff., as corrected by Hibbard, *op. cit.* (Note 32), 27 ff. and 118 ff.; see also R. Wittkower, *Art and Architecture in Italy, 1600-1750* (Pelican History of Art), 3rd ed. (Harmondsworth, 1973), 69.

43. Façade: Uffizi Disegni di Architettura 6722; p. 2 plan of ground floor 6733, of the piano nobile 6732. The project for a new building near the Albergo dell'Orso in the present Via di Tor di Nona was not carried out. The site had been the property of the Gaetani since the early sixteenth century; cf. G. Gaietani, *Domus Caietana*, II (Rome, 1933), 327.

Volterra also collaborated on other enterprises of the eighties and early nineties; no systematic paper on his *œuvre* has as yet been written.

44. A short biography of Mascarino in J. p. 2 Wasserman, *Ottaviano Mascarino and his Drawings in the Accademia Nazionale di S. Luca* (Rome, 1966), 1 ff. (cf. K. Schwager's review in *Zeitschrift für Kunstgeschichte*, XXIX (1968), 246 ff.). Mascarino's father, Giulio, collaborated with Vignola on a bridge in the neighbourhood of Bologna (Wasserman, *op. cit.*, 2). Vignola's son Giacinto calls Mascarino in a letter dated 4 January 1580, 'compatriota e di amicitia derivata fin dai patri nostri' (foreword to Egnatio Danti's edition of Vignola's *Due Regole di Prospettiva* (Rome, 1583)).

45. Cf. the source of 1593 mentioned in Note 41.

46. Ackerman, *op. cit.* (Note 4), 108, with a detailed enumeration of Mascarino's work in the Vatican; cf. also Wasserman, *op. cit.*, 149 ff.; also *idem*, 'The Palazzo Sisto V in the Vatican', *Journal*

of the Society of Architectural Historians, XXI (1962), 26 ff.

47. For Mascarino's activities in the Quirinal, see J. Wasserman, 'The Quirinal Palace in Rome', *Art Bulletin*, XLV (1963), 205 ff., Hibbard, *op. cit.* (Note 32), 194 ff. and figure 11, and Schwager, *op. cit.* (Note 44), 253 f.; on the oval staircase see also H. Hibbard, *The Architecture of the Palazzo Borghese* (Rome, 1962), 59, note 52. Another oval staircase by Mascarino in the Belvedere Court is mentioned in Egnatio Danti's Commentary to Vignola's *Due Regole* (cf. Note 44). In his comparison of the oval Quirinal staircase with Bramante's circular staircase in the Belvedere Court, Danti remarks that the oval plan offers 'più difficoltà' than the circular one, in which 'tutte le linee vanno al punto e centro del mezzo, che nella ovale vanno a diversi punti' (*op. cit.*, 144); the criterion of 'difficoltà' is characteristic of the period. (For other oval staircases in Mascarino's designs for palazzi and villas cf. Wasserman, *op. cit.* (Note 44), *passim*.)

48. Wasserman, *ibid.*, plates 31 and 164; also Lotz, *op. cit.* (Note 25), 69 ff.

49. The first attribution to Mascarino is in P. Totti's guidebook, *Ritratto di Roma moderna* (Rome, 1638), 252; further in G. B. Baglione, *Le Vite dei pittori, scultori ed architetti* (Rome, 1642), 99; cf. Wasserman, *op. cit.* (Note 44), 191. Building began in 1591, the previous building having been destroyed by fire. The crossing, dome, and choir of the present church were not completed till about 1700. The plan published by Wasserman, figure 189, distinguishes the older from the newer parts. There is an arrangement of columns similar to that of S. Salvatore in a plan of 1585 for Sixtus V's Chapel in S. Maria Maggiore; the plan was owned, but not drafted, by Mascarino (K. Schwager, *Miscellanea Bibliothecae Hertzianae* (1961), plate 248).

50. The first summary of what is known of Lunghi is that by H. Hibbard, see Appendix I, 'Biography of Martino Lunghi il Vecchio', in *The Architecture of the Palazzo Borghese* (Rome, 1962), 83–93. For Bosco Marengo see also Ackerman and Lotz, 'Vignoliana', in *op. cit.* (Note 23), 23. The design of the church, in which Pius V had his tomb erected, must have been made in Rome under the eyes of the Pope; according to a contemporary document, 'its portals, balustrades, and windows were constructed in the finest marble' and transported from Rome to Bosco Marengo by sea. The design is also attributed to

the Dominican Egnatio Danti and the Genoese architect Rocco Lurago; see M. Ferrero Viale, *La Chiesa di S. Croce a Bosco Marengo* (Turin, [1959]), 11.

51. Apart from the examples mentioned in Giovannoni, *Saggi* (*op. cit.*), 222, cf. also Vignola's design for S. Maria in Traspontina (Ackerman and Lotz, 'Vignoliana' (*op. cit.*), figures 1–2) and S. Andrea in Via Flaminia. Palladio uses the tripartite lunette in the façade of S. Francesco della Vigna (1562), Alessi in S. Vittore Grande in Milan. For Alessi's tripartite lunettes cf. also Nancy A. Houghton Brown, *Arte Lombarda*, X (1965), 96, note 137.

52. From the seventeenth century onwards the façade and courtyard of the Palazzo Borghese have been regarded as the work of Lunghi of about 1590. H. Hibbard (cf. Note 50) has proved that the palazzo was begun by Tommaso del Giglio, a prelate in the retinue of Cardinal Alessandro Farnese. The fleur-de-lis crest of the Giglios appears in the frieze over the main portal. Hibbard was the first to connect the early building phase with Vignola, the Farnese architect *par excellence*. When Cardinal Deza acquired the palazzo in 1586, the front range was nearly finished; the only part still lacking was the roof. After the staircase had been built by the new owner, the building was ready for occupation. Work was continued in the courtyard, though it is difficult to distinguish between the older and newer parts. In 1605 the palazzo passed into the hands of the Borghese, under whom the courtyard, first planned for 5 by 5 arcades, was given its present dimensions (5 by 7 arcades) and the two-storey loggia at the rear. Deza's architect was Lunghi, who was succeeded, under the Borghese, by Flaminio Ponzio. Cf. also the reviews of Hibbard's book in *Zeitschrift für Kunstgeschichte*, XXVI (1963), 163 ff. (by C. Thoenes), *Art Bulletin*, XLV (1963), 181 ff. (by J. S. Ackerman), and *Journal of the Society of Architectural Historians*, XXIII (1964), 216 ff. (by J. Wasserman).

53. With some justification, R. Wittkower mentions the façade as a characteristic specimen of 'academic petrification' in late-sixteenth-century Roman architecture in Italy (*op. cit.* (Note 42), 7; cf. *ibid.*, 12, and Hibbard, *op. cit.* (Note 50), for the development of the palazzo after its acquisition by the Borghese).

54. Fontana described and illustrated the removal of the obelisk in his book *Della Trasportatione dell'Obelisco Vaticano*, published in 1590, which also describes the buildings erected for Sixtus V. A

second volume was published at Naples in 1603 under the title: *Libro Secondo in cui si ragiona di alcune fabriche fatte in Roma ed in Napoli, dal Cavalier Domenico Fontana.*

p. 286 55. Thus, for instance, a wool factory was to be built in the Colosseum; in his note to the illustration of the project, Fontana remarks (in *Libro Secondo*; cf. Note 54) that Sixtus V's idea was 'to provide work for all the poor in Rome and to save them from begging in the streets'. On the ground floor 'every workman would have a workshop, and in the storey above it a free apartment of two rooms and an open loggia'.

56. During the four years and eight months of his reign Sixtus V spent more than one million ducats for building; see J. Delumeau, *Vie économique et sociale de Rome dans la seconde moitié du XVI siècle*, II (Paris, 1959), 765; see *ibid.*, I (Paris, 1957), 331 f., for the Acqua Felice and the fountains, 504 for the Colosseum project mentioned in the preceding Note. Cf. also the chapter 'Sisto V urbanista' in C. D'Onofrio, *Gli Obelischi di Roma*, 2nd ed. (Rome, 1967).

A traveller who revisited Rome after ten years' absence wrote: 'Everything here looks new – buildings, streets, squares, fountains, aqueducts, obelisks, and a thousand wonderful things – all the work of Sixtus V. We owe to his vigorous and noble mind a Rome which has been re-born from its own ashes' (quoted by A. Muñoz, 'Domenico Fontana architetto', *Quaderni Italo-Svizzeri*, III (Rome and Bellinzona, 1944), 39).

57. For this villa on the Esquiline, between S. Maria Maggiore and the modern railway terminus, which was destroyed in the late nineteenth century, see G. Matthiae, 'La Villa Montalto alle Terme', *Capitolium*, XIV (1939), 139 ff., and D'Onofrio, *op. cit.*, 142 ff.

58. For the memorial chapel of Sixtus V see Schwager, *op. cit.* (Note 49); see also Muñoz, *op. cit.*; G. Matthiae, 'L'Arte di Domenico Fontana', *Capitolium*, XXII (1947), 1 ff.; Wittkower, *op. cit.* (Note 42), 6 f.

59. For Maderno, see Wittkower, *op. cit.*, 7 and 69 ff., and Hibbard, *op. cit.* (Note 32).

CHAPTER 24

p. 287 1. Of fundamental importance is M. Labò's article in the *Dizionario biografico degli Italiani* (Rome, 1960), II, 238 ff. Cf. also Emmina de Negri's survey of the literature in her *Galeazzo Alessi architetto a Genova* (Genoa, 1957), 111 ff.

Little is known of Alessi's training; according to earlier sources he spent the years 1536 to 1542 in the households of various cardinals in Rome, and 1543 to 1548 in Perugia, where, according to Vasari (Mil., VII, 552; see also Labò, *op. cit.*, 238), he worked on the fortress of Paul III which was designed by Antonio da Sangallo and later demolished. A fairly certain early work of his is the secularized little church of S. Maria del Popolo in Perugia; its façade has the motif of a round arch on architraved columns which Alessi often employed later (illustration in Venturi, *Storia*, XI (3), figure 530). Alessi is first mentioned in Genoa in 1548.

2. The client for the villa was Luca Giustiniani. In an agreement dated 1548, the stonemasons pledge themselves to work 'iuxta voluntatem et modum' of Alessi; cf. G. Kühn, 'Galeazzo Alessi und die genuesische Architektur im 16. Jahrhundert', *Jahrbuch für Kunstwissenschaft* (1929), 151, de Negri, *op. cit.*, 60, and E. Poleggi, *Strada Nuova, una lottizzazione del Cinquecento a Genova* (Genoa, 1968), 443 ff. See also the pictorial corpus *Catalogo delle ville genovesi*, published by the Comune di Genova (1967), 41 and 415 ff.

3. From 1549 to 1570 there is documentary evidence of Alessi as architect of the church. Building began in 1552. With the exception of the dome, which was not vaulted till 1603, the interior was complete when Alessi died; the last time he was in Genoa was in 1568. The documents published by S. Varni, *Spigolature artistiche nell' archivio della basilica di Carignano* (Genoa, 1877), have been lost. For literature see Notes 1–2.

4. The height of the great dome up to the apex of the lantern corresponds to the side of the square of the ground plan.

5. The minor domes are relatively wide, in spite p. 2 of their low height; the ratio of their diameter to that of the main dome is 3:4. Cf. on the other hand St Peter's (as executed) 1:4, Sangallo's model of 1539 1:3.

6. Contemporary sources certify Alessi's authorship of the Porta del Molo (with an inscription of 1553) and the octagonal drum and dome of the cathedral (under construction in 1556); further attributed to him is the Palazzo Cambiaso (originally Agostino Pallavicino; Rubens, figure 68, now Banco di Napoli), built under the direction of Bernardino da Cantone (cf. Poleggi, *op. cit.*, 96). Alessi's authorship of the Villas Pallavicini delle Peschiere (first mentioned in 1560) and Scassi (under construction in 1566) has been questioned

on serious grounds. Cf. on this point M. Labò, 'Studi di architettura genovese: Palazzo Carrega', in *Arte*, XXV (1922), 70 ff.; *idem*, 'I Palazzi di Genova di P. P. Rubens', *Genova* (April 1939); de Negri, *op. cit.*, *passim*; *eadem*, in *Genova: Strada Nuova* (cf. Note 7), 138.

289 7. As early as 1568, Vasari said of the Strada Nuova that there was not in the whole of Italy a street 'more magnificent and grand, nor fuller of rich palazzi' (Vasari Mil., VII, 553). According to the travel notes of Heinrich Schickhardt, the Württemberg architect, who visited Genoa in 1599, 'The greater part of this town consists of excellently grand, very large and high houses and splendid palazzi . . . especially in the new streets'. In Rubens's book of engravings, published in 1622, the beginnings of which probably go back to his stay in Genoa (1607–8), all the palazzi built in the street are reproduced. For the history of the street and the individual buildings, see *Genova: Strada Nuova*, published by the Istituto di Elementi di Architettura e Rilievo dei Monumenti (Genoa, 1967), and Poleggi, *op. cit.* For the decree of 1550 see Poleggi, 403, for the sociological aspects of the street and its financial background *ibid.*, 25 ff. The wealth of the nobility derived primarily from foreign trade and extensive banking business. For this point cf. F. Chabod in *Storia di Milano*, IX (Milan, 1961), 404 ff.

8. For the chronology and documentation see Poleggi, *op. cit.*, 71–365.

9. Cf. Bernardino's letter of 1558 to the *Padri del Comune* (Poleggi, *op. cit.*, 415) in which he describes the work he has done since 1550 for the planning and tracing of the street and asks for adequate payment. His request was granted; in the pertinent document he is called *magister caput operis situum viarum* (Poleggi, *op. cit.*, 416). For Bernardino, see also Labò, *op. cit.* (Note 1), 239.

10. For these masters see the documentation in Poleggi, *op. cit.*, 443 ff.

11. Castello appears to have been active as a painter in the circle of Perino del Vaga in Rome; he died in Madrid as court painter to Philip II. For his architectural works in Genoa and his frescoes and stucco-work, cf. M. Labò, *G. B. Castello* (Biblioteca d'arte illustrata, I, 25) (Rome, 1925), 8 ff. See also Venturi, *Storia*, XI (3), 674 ff.

12. Cf. the reproduction of both buildings in R. Reinhardt, *Palast-Architektur von Oberitalien und Toscana* (Genoa and Berlin, n.d.). The Palazzo Doria Tursi, built for Nicolò Grimaldi, was acquired by the Doria in 1593 for 50,000 ducats

(Poleggi, *op. cit.*, 273, with attribution to Giovanni Ponsello).

13. Cf. Labò, *op. cit.* (Note 1), 239; see also P. Torriti, *Tesori di Strada Nuova* (Genoa, 1970), 16 ff., for a rejection of Poleggi's (cf. Note 9) attribution of the street to Bernardino da Cantone.

14. 1553 is the date of Marino's first purchase of building sites. Drawings by Alessi for piers, capitals, and mouldings are mentioned in 1557 in a contract with a stonemason. Building began in 1558, and further land was purchased in 1558 and 1560. The first project provided for piers instead of the present columns on the ground floor of the courtyard. The design was changed in 1558. In December 1559 thirteen stonemasons were granted leave by the cathedral Office of Works to work on the Palazzo Marino (*Annali della Fabrica del Duomo di Milano*, IV, 35) – probably this involved the three storeys of the courtyard mentioned in 1560. Building was abandoned by Marino about 1565 for lack of funds, and after his death in 1572 the incomplete palazzo was confiscated in order to cover the debts of his estate (cf. C. Casati, 'Intorno a Tomaso de Marini', *Archivio Storico Lombardo*, XIII (1886), 622 ff.). The staircase and the façade on the Piazza della Scala are by Luca Beltrami, 1888–92. In 1943 the façades were seriously damaged by bombs, and the salone vault collapsed. Restoration was completed in 1954. See R. Gerla, *La Grande Sala detta d'Alessi in Palazzo Marino* (Milan, 1954).

The plan and elevation of the Archivio Civico, accepted in the literature as Alessi's work (cf. P. Mezzanotte, *Raccolta Bianconi, Catalogo Ragionato*, I (Milan, 1942), 79 ff. and plates XXXVI–XXXIX), in Baroni's opinion represent an initial stage of the planning, before the trapezoidal plan of the original site was 'regularized' by the new purchases (see C. Baroni, *Documenti per la storia dell'architettura a Milano nel Rinascimento e nel Barocco*, II (Rome, 1968), 398; cf. *ibid.*, 399 ff. for the building history). The same is true of the sketches of the elevation by L. Beltrami, *Archivio Storico dell'Arte*, I (1888), 146 ff.

15. The unusual planning of two courtyards is probably due to the necessity of incorporating older parts of the building. The work on three courtyard storeys, mentioned in 1558, can only refer to the Corte Nobile: plots of land acquired in the same year were probably situated in the service courtyard; cf. Baroni, *op. cit.*, 399 f. G. L. Bascapè (*I Palazzi della vecchia Milano* (Milan, 1945), 240) mentions 'older stretches of wall' which 'do not coincide with the plan [i.e. Alessi's]'.

In the detailed description of the building in V. Scamozzi, *L'Idea dell'architettura universale* (Venice, 1615), part I, book III, chapter 6, he writes that there was a garden in the second court.

p. 291 16. Besides Pirro Ligorio's buildings, the Palazzo Spada also belonged to the Roman examples; see J. Wasserman, *Art Bulletin*, XLIII (1961), 58 ff.

As H. Hibbard has shown, the painterly trend has to be understood as a re-evocation of the *ornata maniera* of antiquity; cf. *Stil und Überlieferung in der Kunst des Abendlandes* (Akten des 21. Internationalen Kongresses für Kunstgeschichte, Bonn 1964) (Berlin, 1967), II, 35 ff.

17. Cf. especially C. Baroni, *L'Architettura lombarda* (Milan, 1941), 120 f.

18. See G. Borlini, 'The Façade of the Certosa in Pavia', *Art Bulletin*, XLV (1963), 323 ff.

19. On 21 January 1546 the two masters were paid 100 scudi each for their drawings (A. Gatti, *La Fabbrica di S. Petronio* (Bologna, 1889), 114). The projects are illustrated in G. Zucchini, *Disegni antichi e moderni per la facciata di S. Petronio a Bologna* (Bologna, 1933), plates VI–XI.

20. First attributed to Lombardino by H. Hoffmann, 'Die Entwicklung der Architektur Mailands', *Wiener Jahrbuch für Kunstgeschichte*, IX (1934), 63 ff. In 1534 the cathedral Office of Works reduced Lombardino's salary 'quia servivit comiti Maximiliano Stampae mensibus 4'. The street fronts of the Palazzo Stampa were altered later, but the loggias of the Cinquecento court have been preserved. Their upper storey is probably the first Milanese example of arcades on architraved double columns, which means that the motif was introduced into Milan by Lombardino. The triple-tiered top to the tower also bears the mark of Lombardino's style. The curious apex, a double eagle on two tall columns, is in honour of the Emperor Charles V, whose device *Plus Ultra* appears on the columns. Massimiliano Stampa played a leading part in the occupation of Milan by Spain. Reproduction of court and tower in Mezzanotte and Bascapè, *Milano nell'arte e nella storia* (Milan, 1948), 45 and 294.

21. Vasari Mil., VI, 497; see also P. Mezzanotte, 'S. Caterina alla Chiusa di Milano e Cristoforo Lombardi', *Palladio*, VII (1943), 23 ff., with illustration of the façade before its destruction; also Borlini (cf. Note 18), figure 15.

22. The convincing attribution of the dome (diameter *c.* 23 m., or 75 feet, height to apex *c.* 46 m., or 150 feet) to Lombardino was first made by C. Baroni, *S. Maria della Passione* (Milan, 1938);

idem, op. cit. (Note 14), 55 ff. Vasari (Mil., VII, 544) mentions the dome as the work of Cristoforo Solari il Gobbo (d. 1527), who is often confused with Cristoforo Lombardino, though his verified works make no sense with it. The same confusion occurs in F. Malaguzzi Valeri, 'I Solari, etc.', *Italienische Forschungen*, I (Berlin, 1906), 156 ff., and in Venturi, *Storia*, XI (1), 709 f. In S. Latuada's *Guida di Milano* (Milan, 1737), I, 229, there is a note, unverified elsewhere but thoroughly probable, that the dome was erected about 1530. The attribution to Martino Bassi (b. 1542 or 1546) put forward by E. Tea cannot be supported by the style of the dome (*Atti del IV Convegno Nazionale di Storia dell'Architettura* (Milan, n.d.), 199 ff.). After 1570, an aisled nave with deep chapels was placed in front of the centrally planned church, which considerably impaired the original effect of the dome. Cf. the projects for the nave in the *Raccolta Bianconi* (see Note 14), V, fol. 15a and 15b, and the contract signed by Martino Bassi in Baroni, *op. cit.* (Note 14), 68.

23. At the end of the sixteenth century the dome p. 2 was decorated with painted coffers. The original state can be seen in the drawing in the *Raccolta Bianconi*, mentioned in the preceding Note.

24. For the vestibule built in front of the church cf. p. 206. The architectural history of the nave and the dating of its magnificent tunnel-vault have not yet been elucidated. Cf. Baroni, *Documenti per la storia dell'architettura a Milano nel Rinascimento e Barocco*, I (Florence, 1940), 219 and documents 305–13; also W. Arslan in *Storia di Milano*, VIII (1957), 546 ff.; *ibid.*, 545, views of the church about 1565 with the aisles and choir finished, but façade not yet complete.

25. Cf. W. Lotz, 'Architecture in the later 16th Century', *College Art Journal*, XVII (1958), 131.

26. Cf. Baroni, *op. cit.* (Note 14), 481, for a full documentation including Giovio's letter of 15 September 1547 and the deed of sale of 27 April 1547, with a description of the existing layout. For plans and elevation see also U. Tarchi, *La Villa detta la Simonetta nel suburbio di Milano* (Monumenti Italiani, serie II, fasc. II) (Rome, 1953).

27. Cf. Vasari Mil., VI, 27 (as Domenico Giuntalocchi or Giuntalodi); C. Guasti's commentary (*ibid.*, 31 ff.) was also published separately. Giunti's Milanese *œuvre* has been collected by C. Baroni, *Archivio Storico Lombardo*, N.S. III (1938), 326 ff.; *Palladio*, II (1938), 142; and *op. cit.* (Note 17), 121 f.; cf. also Mezzanotte and Bascapé, *op. cit.*, 47 f. and 770 ff.

28. The service wings and the gardens of the villa, which now stands in an industrial suburb, were destroyed in 1900. The main block, which suffered severely during the war, was restored not long ago.

29. The inscription submitted by Giovio for the façade is interesting: 'Ferdinandus Gonzaga . . . quum ex bellicis atque civilibus curis meritam non ignobilis ocii requiem quaereret nympheum suburbani secessus honestae voluptati dedicavit.'

293 30. Cf. Baroni, *Archivio Storico Lombardo*, N.S. III (1938), 353 ff., and *Palladio*, II (1938), 142. A drawing of the façade (hardly by Giunti) in Milan, Archivio Civico, *Raccolta Bianconi* (cf. Note 14), VII, fol. 17A.

31. Foundation stone laid in 1549, consecrated in 1551. First attribution to Giunti by Baroni, *op. cit.* (Note 17), 122. The client, Contessa Torelli della Guastalla, was a friend of Ferrante Gonzaga.

Alessi, to whom the church was formerly attributed, is not mentioned in the documents in Milan till 1557 (cf. N. Houghton-Brown, *Arte Lombarda*, X (1965), 97, note 191, and Mezzanotte and Bascapé, *op. cit.* (Note 20), 528 f.). The attribution to Cristoforo Lombardino and Vincenzo Seregni, suggested by H. Hoffmann, *Wiener Jahrbuch für Kunstgeschichte*, IX (1934), 63 ff., is untenable for stylistic reasons. Baroni's attribution to Giunti seems convincing in view of the close connection between the client and Ferrante Gonzaga; cf. *op. cit.* (Note 14), 149.

32. For the type, see Liliana Gatti, 'Iconologia delle chiese monastiche femminili dall'alto medioevo ai sec. XVI–XVII', in *Arte Lombarda*, IX (1964), 131.

33. Cf. G. Rocco, 'Galeazzo Alessi a Milano', *IV. Convegno Nazionale di Storia dell'Architettura* (Milan, n.d.), 185.

34. Seregni's early work is difficult to trace; his later work is entirely under Alessi's influence (cf. Baroni, *op. cit.* (Note 17), 123 f.). For the Palazzo del Collegio dei Giureconsulti (1558–68) cf. Baroni, *op. cit.* (Note 14), 318 ff., and P. Mezzanotte in *Storia di Milano*, X (1957), 574 f. For the Palazzo Medici in Via Brera, begun in 1565, now demolished, cf. P. Mezzanotte, 'La Casa dei Medici di Nosiggia e il Palazzo di Pio IV in Milano', in *Rassegna d'Arte*, I (1914), 142 ff.

294 35. For the architectural history cf. Baroni, *op. cit.* (Note 24), 255 ff.; Alessi's project: G. Rocco, 'La Facciata di S. Maria presso S. Celso a Milano', in *Palladio*, IV (1940), 123 ff.; cf. also Baroni, *op. cit.* (Note 17), 126, and Mezzanotte in *Storia di*

Milano, X (1957), 576. For the façade sculpture: E. Kris in *Mitteilungen des Kunsthistorischen Instituts Florenz*, III (1930), 201 ff. Only the lowest storey was carried out under Alessi's supervision. It corresponds to the design in all its details.

36. In May 1568 Alessi delivered drawings for the façade, choir, organ loft, and tabernacle: Baroni, *op. cit.* (Note 24), document 334; cf. also M. L. Gatti Perer, 'Martino Bassi, Il Sacro Monte di Varallo e S. Maria presso S. Celso', *Arte Lombarda*, IX, 2 (1964), 21 ff.

37. For the architectural history see Baroni, *op. cit.* (Note 14), 210 ff.; Mezzanotte and Bascapé, *op. cit.* (Note 20), 712 ff. The foundation stone of the present church was laid in 1560. The remains of the older church, which stood beside the present one, with the orientation reversed, were demolished in 1576, when its relics were transferred to the new building. The late antique mausoleum which was part of the old group was at first intended to be incorporated in the new building, but was eventually demolished. The planning of the new church can be followed in Seregni's (?) drawings in the *Raccolta Bianconi*:

(1) v, fol. 1: the mausoleum as the narthex to the three-bay nave; wide octagonal dome; apses to the choir and transepts.

(2a) v, fol. 4: doubling of the mausoleum; between the twin buildings a narrow vestibule to the nave; octagonal dome and choir similar to those in (1); the transepts reduced in size. Inscribed: 'Di Vincenzo Seregni ingegnere per Santo Vittore'.

(2b) v, fol. 2: copy of the above with text: 'Copia del disegno fatto per me Vincentio' (sc. Seregni).

(3) v, fol. 6: mausoleum removed, nave, transept, and chancel of same type as finished building, but with ambulatory and deep narthex instead of the sixth bay of the nave; groin-vault instead of tunnel-vault. That the church represented in the sheet is S. Vittore is proved by the staircase in the right-hand transept.

(4a) v, fol. 7 a and b: plan and elevation of present building; in front of the façade single-storeyed portico (not executed).

(4b) Similar ground plan, but without portico, in the archives of S. Barnaba, Milan; cf. Baroni, *op. cit.* (Note 17), figure 123. Whether (4) represents the final plan or a sketch requires further investigation, like other attributions of drawings to Seregni.

38. In Italy, most medieval monks' choirs were removed in the late sixteenth century. That of S.

Maria Gloriosa dei Frari in Venice is one of the few to have been preserved.

p. 295 39. J. S. Ackerman has drawn attention to the importance of the Milanese churches in the liturgical reforms of the sixteenth century (lecture held at the Society of Architectural Historians, New York, unpublished). This question has never been adequately investigated. For the placing of the altar and the liturgical requirements see also S. Sinding-Larsen, 'Some Functional and Liturgical Aspects of the Centralized Church in the Italian Renaissance', in *Acta ad Archaeologiam et Artium Historiam pertinentia*, II (1965), 203 ff.

40. Sources for the building history in Baroni, *op. cit.* (Note 24), 89 ff.; cf. also N. A. Houghton Brown, 'The Church of S. Barnaba in Milan', *Arte Lombarda*, IX (1964), II, 62 ff., and X (1965), 65 ff. The planning of the new building was put in hand in 1558.

41. Two preparatory drawings in the *Raccolta Bianconi* show a dome over the crossing (cf. Houghton Brown, *op. cit.*, figures 10-11). The rectangular plan of the crossing would have required an oval dome, and it was probably to avoid the awkward oval vault that the trough-shaped vault was chosen.

42. The present high altar and its balustrade date from the late nineteenth century. The drawings in the *Raccolta Bianconi* (cf. Note 41) show the original arrangement. The façade of S. Barnaba has been altered out of recognition by rebuilding and restoration; on this cf. Houghton Brown, *op. cit.*

p. 296 43. For S. Raffaelle, see G. Rocco, 'La Chiesa di S. Raffaelle a Milano', in *Rassegna d'Architettura*, XII (1940), 230 ff., and Houghton Brown, *op. cit.*, figure 33; for the work in the cathedral, G. Rocco, *Pellegrino Pellegrini e le sue opere nel duomo di Milano* (Milan, 1939), 66 ff., and Mezzanotte and Bascapé, *op. cit.* (Note 20), 184; for Varallo, A. Cavalleri-Murat in *Atti e Memorie del terzo Congresso Piemontese di Antichità ed Arte, Varallo Sesia, 1960* (Turin, 1966), 82 ff., Gatti Perer, *op. cit.* (Note 36), 21 ff., and R. Wittkower, 'Montagnes sacrées', *L'Œil* (November 1959).

44. The accounts of these visits, only partially published (cf. e.g. Angelo Giuseppe Roncalli, *Gli Atti della Visita Apostolica di S. Carlo Borromeo a Bergamo nel 1575*, 4 vols. (Milan, 1936)), have so far escaped the notice of art historians.

45. *Instructionum fabricae et supellectilis ecclesiasticae libri duo* (Milan, 1577). The actual author of the book, which has a preface by the Cardinal, was his closest collaborator, Monsignore Lodovico

Moneta. The latest Italian edition is that of C. Castiglioni and C. Marcora, under the title *S. Carlo Borromeo: Arte Sacra* (Milan, 1952). Also in P. Barocchi, *Trattati d'arte del Cinquecento* (Bari, 1962), III, 9 ff. For the nature and influence of the *Instructiones*, see A. Blunt, *Artistic Theory in Italy 1450-1600*, 2nd ed. (Oxford, 1962), 127 ff.

46. James Ackerman has already drawn attention to these questions; cf. Note 39.

47. Pellegrini, who occasionally used his father's Christian name Tibaldi, first worked as a painter in Rome. The frescoes in Vignola's church of S. Andrea in Via Flaminia were among his earliest works. For his career and his buildings see the literature listed by A. Peroni, 'Architetti manieristi nell'Italia settentrionale: Pellegrino Tibaldi Galeazzo Alessi', in *Bollettino del Centro Internazionale di Studi di Architettura Andrea Palladio*, IX (1967), 272 ff.

48. Pellegrini had already been active in Bologna and Ancona and on the papal fortifications in the Marches; the papal legate in the Marches at that time was Carlo Borromeo.

49. *Der Cicerone*, reprint of the first edition of p. 2 1853. (Leipzig, n.d.), 328. For the building history of the Canonica see Baroni, *op. cit.* (Note 14), 245 ff. and documents 747-82; for the Collegio Borromeo in Pavia, see Peroni, *op. cit.* (Note 47), and *idem*, in *I quattro secoli del Collegio Borromeo di Pavia* (Milan, 1961), 111 ff.

50. Sources in Baroni, *op. cit.* (Note 17), 113 ff. Interesting correspondence between the Superior of the Order and the *rettore* of the convent in Milan concerning the building in P. Pirri, *Giovanni Tristano e i primordi della architettura gesuitica* (Rome, 1955), 170 ff. In December 1567 a design by Pellegrini was sent to Rome and approved, with some slight alterations. This design provided for vaulting; the Superior had recommended a flat roof for the sake of better acoustics. At the consecration of the new building in 1579 only the nave was finished. Building resumed in the seventeenth century – the vault of the dome was begun in 1642 and closed in 1684. The apse was altered in 1723, and the façade was not finished till the nineteenth century.

The quality of the church was recognized as early as the sixteenth century. In the *Trattato dell'arte della pittura* by Lomazzo (Milan, 1585), 438, we read: 'tempio per bellezza, & vaghezza d'architettura, & d'inventione singularissima fra le fabriche moderne, uscito dal divino ingegno di Pellegrino Pellegrini'.

298 51. The columns are 10 m. (30 feet) in height, their bases 3·30 m. (11 feet).

52. W. Hiersche, *Pellegrino de' Pellegrini als Architekt* (Parchim, 1913), 51.

53. Cf. Baroni, *op. cit.* (Note 17), figure 157.

54. The chapels, 5 m. wide and only 2 m. deep (16 feet by 6 feet), are recessed in the outer walls.

55. On 8 April 1564 Carlo Borromeo wrote from Rome that Pellegrini had left Rome for Milan a few days before; cf. G. Rocco, *Pellegrino Pellegrini, l'architetto di S. Carlo, e le sue opere nel duomo di Milano* (Milan, 1939), 203.

299 56. Building began in 1577 and the main cornice was finished in 1595. The dome is by Fabio Mangone, 1617, and the present high altar is of 1759. Cf. Baroni, *op. cit.* (Note 17), 129; (Note 34), 157 ff.; Mezzanotte and Bascapé, *op. cit.* (Note 20), 297.

57. The dome of S. Sebastiano was, according to the original project, to rise as a hemisphere above the outer walls, as in the Pantheon. The present dome, buttressed above the ground floor by volutes, is smaller in diameter; cf. Baroni, *op. cit.* (Note 17), figure 158a and b, and P. Mezzanotte, in *Storia di Milano*, x, 592. For the centrally planned churches of the late sixteenth century cf. Sinding-Larsen, *op. cit.* (Note 39), 208 ff.

58. For details on this point, cf. Rocco, *op. cit.* (Note 55), and Mezzanotte and Bascapé, *op. cit.* (Note 20), 184 ff.

300 59. Report of the Ferrarese Ambassador; cf. A. Calderini, *La Zona monumentale di S. Lorenzo in Milano* (Milan, 1934), 38 ff., and Baroni, *op. cit.* (Note 24), 152, with the sources for the rebuilding. On the late antique building see R. Krautheimer, *Early Christian and Byzantine Architecture* (Pelican History of Art) (Harmondsworth, 1965).

60. For Bassi, see H. Hoffmann, *Wiener Jahrbuch für Kunstgeschichte*, IX (1934), 82 ff.; P. Mezzanotte, *Storia di Milano*, x (1957), 601 ff.; and M. L. Gatti Perer, *Arte Lombarda*, IX (1964), 2, 57 ff. (with F. B. Ferrari's 'Vita di Martino Bassi architetto milanese' of 1771).

61. A systematic investigation into these drawings is much to be desired; cf. Hoffmann, *op. cit.*, 80 ff.; C. Baroni, 'Due nuovi disegni per la ricostruzione del S. Lorenzo a Milano', *Palladio*, v (1941), 57 ff.; *idem*, *op. cit.* (Note 24), 145 f.; Calderari–Chierici–Cecchelli, *La Basilica di S. Lorenzo Maggiore in Milano* (Milan, [1951]), plates LXVI ff.; Mezzanotte and Bascapé, *op. cit.* (Note 20), 561 ff.

301 62. Cf. F. Graf Wolff Metternich, 'St Maria im Kapitol, St Peter in Rom und S. Lorenzo in Mailand', in *Vom Bauen, Bilden und Bewahren* (Festschrift Willy Weyres) (Cologne, 1964), 165 ff.

63. Cf. N. Carboneri, *Ascanio Vitozzi* (Rome, 1966); *ibid.*, 31 ff. and 143 ff. on the churches of S. Maria dei Cappuccini and SS. Trinità in Turin; 131 ff. on Vitozzi's part in the rebuilding of the Castello of Turin; 137 ff. on his design for the Piazza di Castello and the Strada Nuova, which marked the beginning of the Baroque enlargement of Turin. For the latter and Vitozzi's fortifications see also A. Scotti, *Ascanio Vitozzi ingegnere ducale a Torino* (Florence, 1969).

64. Carboneri, *op. cit.*, plates 48–102. For the derivation of these projects from Peruzzi, Serlio, Labacco, etc., see *ibid.*, 67 ff.

65. Work stopped about 1615; at that time the building had reached approximately the cornice of the ground floor. The dome was vaulted according to a changed plan of 1729–33 by Francesco Gallo; the top storeys of the campanili are nineteenth- and twentieth-century. Gallo had also modified the piers and arches below the dome. The project by Vitozzi is known from engravings. On this cf. W. Lotz, *Römisches Jahrbuch für Kunstgeschichte*, VII (1955), 85 ff.; Carboneri, *op. cit.*, 95 ff.; *idem*, *L'Architetto Francesco Gallo* (Turin, 1954), 60 and 142 ff.

66. S. Maria di Carignano, Genoa, and the designs for S. Lorenzo, Milan, being centrally planned buildings with domes and four towers, may have been the patterns used. Vitozzi's oval plan presupposes a knowledge of S. Giacomo al Corso in Rome (cf. Carboneri, *op. cit.* (Note 63), 104 ff.). For the Cistercian monastic buildings next to the church at Mondovì the Duke in 1596 received a drawing from the Cistercians of S. Pudenziana in Rome (Carboneri, *op. cit.*, 111). It is quite possible that Francesco da Volterra, the architect of S. Giacomo al Corso, who during these very years was working at S. Pudenziana (cf. Lotz, *op. cit.* (Note 65), 74 f.), was consulted in the planning of the church at Mondovì. Vitozzi was twice, in 1589 and 1598, briefly in Rome; cf. Scotti, *op. cit.*, 123 and 130.

CHAPTER 25

1. For convenience, the bibliography for Palladio p. 303 is given here. Only the most important works can be enumerated.

General Works

The first fully illustrated publication of Palladio's

œuvre is O. Bertotti-Scamozzi, *Le Fabbriche e i disegni di Andrea Palladio* (Vicenza, 1776 and 1786). – A. Magrini's *Memorie su Andrea Palladio* (Padua, 1845) is still important for reference. – G. G. Zorzi, *I Disegni delle antichità di Andrea Palladio* (Venice, 1959); idem, *Le Opere pubbliche e i palazzi privati di Andrea Palladio* ([Venice], 1964); idem, *Le Chiese e i ponti di Andrea Palladio* ([Venice], 1966); idem, *Le Ville e i teatri di Andrea Palladio* ([Venice, 1968]). Indispensable documentary and illustrative sources. In years of research, the author has collected a wealth of facts from archives on Palladio's life and work. The present Notes give no detailed references to Zorzi's work. Necessary references can easily be found in the list of contents of the various volumes. – R. Pane, *Andrea Palladio*, 2nd ed. (Turin, [1961]). The first modern monograph. – J. S. Ackerman, *Palladio* (Harmondsworth, 1966). An excellent, concise introduction to Palladio's work as a whole. It also contains a survey of the literature. – N. Ivanoff, *Palladio* (Milan, 1967).

Theory and Doctrine of Proportions
R. Wittkower, *Architectural Principles in the Age of Humanism*, 3rd ed. (London, 1962). Fundamental for Palladio's principles of proportion. – E. Forssman, *Dorisch, Jonisch, Korinthisch. Studien über den Gebrauch der Säulenordnungen in der Architektur des 16.–18. Jahrhunderts* (Stockholm Studies in History of Art, v) (Stockholm, 1961). – Idem, *Palladios Lehrgebäude* (Stockholm Studies in History of Art, IX) (Stockholm, [1965]). An excellent review of the relations between the *Quattro Libri* and the buildings.

Villas
G. Mazzotti a.o., *Le Ville venete* (Treviso, 1954). – Idem, *Palladian and Other Venetian Villas* (London, 1958). – M. Muraro, *Civiltà delle ville venete* (private publication by the author, 1964). – J. S. Ackerman, *Palladio's Villas* (Institute of Fine Arts, New York University, The Annual W. W. S. Cook Lecture) (Locust Valley, N.Y., 1967). Summary catalogue of villas; sociological and economic aspects.

Single Buildings
C. Semenzato, *La Rotonda* (Vicenza, 1968); F. Barbieri, *La Basilica Palladiana* (Vicenza, 1968); W. Timofiewitsch, *La Chiesa del Redentore* (Vicenza, 1969); A. Vendetti, *La Loggia del Capitanato* (Vicenza, 1969); G. Bordignon Favero, *La Villa Emo di Fanzolo* (Vicenza, 1970); E. Bassi,

Il Convento della Carità (Vicenza, 1971); L. Puppi, *La Villa Badoer di Fratta Polesine* (Vicenza, 1972): the first seven volumes of the *Corpus Palladianum* published by the Centro Internazionale di Studi di Architettura 'Andrea Palladio', Vicenza.

Guides
Reclam's Kunstführer, Italien, II, *Oberitalien Ost* (Stuttgart, 1965). Exhaustive description and critical appreciation of all Palladio's buildings. – F. Barbieri, R. Cevese, L. Magagnato, *Guida da Vicenza*, 2nd ed. (Vicenza, 1956).

Bibliography
W. Timofiewitsch, 'Die Palladio-Forschung in den Jahren von 1940 bis 1960', *Zeitschrift für Kunstgeschichte*, XXIII (1960), 174 ff. – G. Ferrari, 'Schede di bibliografia palladiana dal 1955', *Bollettino del Centro Internazionale di Studi di Architettura 'Andrea Palladio'*, III (1961), 163 ff. – Later volumes of the *Bollettino* contain accounts of research and bibliographical references.

2. *I Quattro Libri di Architettura di Andrea Palladio* p. 3₤ (Venice, 1570). Countless later editions and translations. Reprint of the 1st edition, Milan, 1945.

3. Vitruvius's terminology can hardly be applied p. 3₤ to the plans of modern secular buildings. For the efforts of the theorists, from Alberti on, to identify *entrata* (i.e. the vestibule) and *cortile* with the Vitruvian *atrium* and *peristylium*, see Forssmann, *Palladios Lehrgebäude* (op. cit.), 63 ff.

4. Part of Palladio's great collection of archi- p. 3₤ tectural drawings has been preserved. Those acquired by the Earl of Burlington (now in the Royal Institute of British Architects) were part of Palladio's estate; in addition to original designs and drawings, they include sheets by Raphael and Falconetto and copies from the Codex Coner. There is as yet no catalogue of the collection. Most of the sheets are reproduced in Zorzi's four volumes. For the drawings of ancient monuments cf. also H. Spielmann, *Andrea Palladio und die Antike* (Munich and Berlin, 1966).

5. At that time Trissino was enlarging his villa p. 3₤ at Cricoli, just outside Vicenza. The attribution of this villa to Palladio is not supported in the recent literature. Cf. Pane, *Andrea Palladio* (op. cit.), 99 ff., and Zorzi, *Le Ville e i teatri* (op. cit.), 221 ff.

6. For the relationship between Trissino and Palladio, see Wittkower, *Architectural Principles* (op. cit.), 57 ff. For Palladio's connections with the nobility of Vicenza, see Barbieri, *Basilica Palladiana* (op. cit.), 55 ff.

7. The admiration of the Pantheon and its influence on ecclesiastical architecture go hand in hand with the development and authority of that ideal of beauty. For that matter, the process was repeated in eighteenth-century classicism.

8. Cf. S. Sinding-Larsen, 'Some Functional and Iconographical Aspects of the Centralized Church in the Italian Renaissance', in *Acta ad Archaeologiam et Artium Historiam pertinentes* (Institutum Romanum Norvegiae), II (1965), 203 ff.; also Ackerman, *Palladio* (*op. cit.*), 126 ff.

307 9. 'Of all colours, white is best suited to temples: the purity of the colour, like the purity of life, is pleasing to God' (*Quattro Libri*, IV, 2).

308 10. Cf. the chapter 'The Genesis of an Idea; Palladio's Church Façades', in Wittkower, *Architectural Principles* (*op. cit.*), 89 ff.; also H. Lund, 'The Façade of S. Giorgio Maggiore', *Architectural Review*, CXXXIII (1963), 283 ff.

11. Cf. S. Sinding-Larsen, 'Palladio's Redentore, a Compromise in Composition', *Art Bulletin*, XLVII (1965), 419 ff., and Timofiewitsch, *La Chiesa del Redentore* (*op. cit.*).

309 12. For sources see Sinding-Larsen, *op. cit.*, and Timofiewitsch, *op. cit.*

310 13. For sources and building history see Barbieri, *Basilica Palladiana* (*op. cit.*).

311 14. Cf. Vendetti, *La Loggia del Capitanato* (*op. cit.*).

312 15. The *Quattro Libri* also contain illustrations of Palladio's Palazzo Antonini at Udine and two designs of his for Verona. The authorship of the Palazzo Civena at Vicenza (c. 1540–5), confirmed by a number of original drawings, is now generally accepted. The building, 'the least assertive of Palladio's works', is not mentioned in the *Quattro Libri*; probably Palladio came to feel it too traditional.

313 16. The group of late façades with giant orders includes the unfinished Palazzo Porto Breganze, which is generally called the Cà del Diavolo, and has always been attributed to Palladio. First mention of the building in Vincenzo Scamozzi, *Idea della architettura universale* (Venice, 1615). There are no sources for its architectural history.

17. For the type and origin of the Venetian villa, cf. L. H. Heydenreich, 'La Villa: genesi e sviluppo fino al Palladio' (with bibliography), in *Bollettino del Centro Internazionale di Studi di Architettura Andrea Palladio*, XI (1969), 11 ff.; C. L. Frommel, *ibid.*, 47 ff.; among the other contributions to this volume, dealing with Palladio's villas, should be mentioned A. Ventura, 'Aspetti storico-economici della villa veneta', *ibid.*, 65 ff.

18. Literary references in Ackerman, *Palladio's Villas* (*op. cit.*), 25, note 19; see also Ventura, *op. cit.*

19. Cf. Ackerman, *ibid.*, 13 ff. p. 314

20. For the geometry of the plan and the proportionality of the rooms, cf. especially Wittkower, *Architectural Principles* (*op. cit.*), 70 f., 107 f., and 126 ff.

21. Sources and building history in Semenzato, p. 315 *La Rotonda* (*op. cit.*), 37 ff. C. A. Isermeyer has shown that the traditional date about 1550 is untenable. The villa was built shortly before the publication of the *Quattro Libri* ('Die Villa Rotonda von Palladio', *Zeitschrift für Kunstgeschichte*, XXX (1967), 207 ff.). The villa is first mentioned in a codicil dated 1571 to the client's will of 1569. It is not mentioned in the text of the will; cf. Semenzato, *op. cit.*, 37. For the drawing of the dome in the *Quattro Libri*, which does not tally with the one actually executed, cf. *op. cit.*, 40, note 13.

CHAPTER 26

1. As early as 1555, Palladio had applied for the p. 316 commission for the Scala d'Oro, the princely staircase of the Doge's Palace, which was eventually executed by Sansovino. For his work in the Doge's Palace cf. G. Zorzi, *Le Opere pubbliche e i palazzi privati di A.P.* (Venice, 1964), 136–67 (also earlier literature).

2. Sources for the Prigioni in G. B. Lorenzi, *Monumenti per servire alla storia del Palazzo Ducale di Venezia* (Venice, 1869), documents 674–8, 741–6 (for the years 1563–73).

3. Documents for the history of planning and building in G. Zorzi, *Le Chiese e i ponti di Andrea Palladio* (Venice, 1967), 227 ff.

4. Begun c. 1515 by Bon Bergamasco, continued p. 317 in 1527 by Scarpagnino, and after the latter's death in 1549 by Giangiacomo da Grigi. The staircase was erected after 1544, the façade, designed by Scarpagnino, from 1536. See P. Paoletti, *L'Architettura e la scultura del Rinascimento a Venezia* (Venice, 1893), 123 ff. and 289 ff.; for da Grigi see also G. Lorenzetti, 'Il Palazzo cinquecentesco veneziano dei Coccina-Tiepolo e il suo autore', *Rivista d'Arte*, XIV (1932), 75 ff.

The Scuola di S. Rocco was one of the five Scuole Grandi, professional associations of laymen, 'meeting on the premises of a particular monastery', who 'placed themselves under the protection of a chosen saint, and undertook to perform certain services for their own poor, sick and dead'; see B. Pullan, *Rich and Poor in Renaissance Venice. The Social*

Institutions of a Catholic State (Oxford, 1971), 33 ff.

p. 317 5. As early as 1522 Alessandro Leopardi had promised a model for S. Giustina which he never delivered. The foundations were laid out by the stonemason Matteo della Valle. After his death in 1532 work was continued by Andrea Moroni and after his death by Andrea della Valle (mentioned 1531–77). The building was vaulted towards the end of the Cinquecento and consecrated in 1606. Cf. G. Bresciani Alvarez in *La Basilica di S. Giustina* (Castelfranco Veneto, 1970), 121 ff.

The cathedral was begun in 1552 by Andrea della Valle and completed only in the eighteenth century; see G. Bresciani Alvarez in *Atti e Memorie Accademia Patavina di Scienze, Lettere ed Arti*, LXXVII (1964–5), part III, 605 ff.

For a project by Michelangelo cf. C. de Tolnay, 'A Forgotten Architectural Project by Michelangelo: the Choir of the Cathedral of Padua', in *Festschrift für Herbert von Einem* (Berlin, 1965), 247 ff.

A notarial document of 1552, overlooked by Tolnay, says: 'Quoniam Magister Andreas [della Valle] composuit formulam sive modellum ipsius templi aedificandi, et sic inventio modi illud fabricandi est sua . . .' (E. Rigoni, *L'Architetto Andrea Moroni* (Padua, 1939), 77). Michelangelo's project – which has not been preserved – was therefore not taken into consideration.

p. 318 6. Cf. R. Pallucchini, 'Vincenzo Scamozzi e l'architettura veneta', *L'Arte*, XXXIX (1936), 3 ff.; F. Barbieri, *Vincenzo Scamozzi* (Vicenza and Belluno, n.d. [1952]); *idem*, *Vincenzo Scamozzi: Taccuino di viaggio da Parigi a Venezia* (Venice and Rome, n.d. [1959]), with interesting drawings of Gothic cathedrals in France. For the Procuratie Nuove see also W. Timofiewitsch, *Arte Veneta*, XVIII (1964), 147 ff. For Scamozzi's villas: C. Semenzato, 'La Rocca pisana dello Scamozzi', *Arte Veneta*, XVI (1962), 98 ff.; for his designs for Salzburg Cathedral: W. Timofiewitsch in *Festschrift Karl Oettinger* (Erlanger Forschungen, XX) (Erlangen, 1967), 411 ff.

7. History of building and sources: G. Zorzi, *Le Ville e i teatri di Andrea Palladio* (Venice, 1968), 282 ff. For Scamozzi's part in the work, L. Magagnato, 'The Genesis of the Teatro Olimpico', *Journal of the Warburg and Courtauld Institutes*, XIV (1951), 200 ff.; *idem*, *Teatri italiani del Cinquecento* (Venice, 1954), 50 ff., and *Arte Lombarda*, XI (1966), part I, 26 ff.

p. 319 8. Cf. Magagnato, *Teatri italiani* (*op. cit.*), 76 ff. The fortified city of Sabbioneta, the capital of his small dukedom, was planned and built by Vespasiano Gonzaga from *c.* 1550 on. For the layout of the streets cf. K. Forster, 'From "Rocca" to "Civitas": Urban Planning at Sabbioneta', *L'Arte*, N.S. II (1969), no. 5, 5 ff. According to Scamozzi's *L'Idea dell'architettura universale* (Venice, 1615), he began the theatre in 1588; it was completed in 1590; see A. Racheli, *Memorie storiche di Sabbioneta* (Casalmaggiore, 1849), 690 ff.

CHAPTER 27

1. Cf. S. Bettini, 'Note sui soggiorni veneti di p. 32 Bartolommeo Ammannati', *Le Arti*, III (1940), 20 ff.; E. Vodoz, 'Studien zum architektonischen Werk des B.A.', *Mitteilungen des Kunsthistorischen Instituts Florenz*, VI (1941), 1 ff.; and M. Fossi, *B.A. Architetto* (Cava dei Terreni, n.d. [1968]).

2. For analogous works in sculpture and painting, cf. for instance T. Buddensieg, 'Die Ziege Amalthea von Riccio und Falconetto', *Jahrbuch der Berliner Museen*, V (1963), 121 ff.

3. Ammannati described the Roman villa in a long letter to his Paduan patron Marco Benavides; see the text of the letter in T. Falk, 'Studien zur Topographie und Geschichte der Villa Giulia', *Römisches Jahrbuch für Kunstgeschichte*, XIII (1971), 171 ff.

For the Villa Imperiale at Pesaro cf. A. Pinelli and O. Rossi, *Genga architetto* (Rome, n. d. [1971]), 137 ff. For Ammannati's share in the Villa di Papa Giulio see also Vodoz, *op. cit.*, 5 ff., C. H. Smyth, 'The Sunken Courts of the Villa Giulia and the Villa Imperiale', in *Essays in Memory of Karl Lehmann* (New York, 1964), 304 ff., and especially Falk, *op. cit.*, 103 ff.

4. Work had been going on on the gardens and fountains from 1550 to 1560; cf. *Diario fiorentino di Agostino Lapini*, ed. G. O. Corazzini (Florence, 1900), 107 and 127; Vodoz, *op. cit.*, 40 ff.; F. Morandini, 'Palazzo Pitti, la sua costruzione e i successivi ingrandimenti', *Commentari*, XVI (1965), 35 ff.; and Fossi, *op. cit.*, 45 ff.; see also the catalogue of the *Mostra documentaria ed iconografica di Palazzo Pitti e giardino di Boboli* (Florence, 1960).

5. The Trecento bridge was destroyed by floods p. 32 in 1557; Ammannati's bridge, begun in 1558, and completed in 1570, was blown up during the retreat of the German army in 1944. It was completely restored after the war. Cf. Fossi, *op. cit.*, 70 ff., and *Michelangelo architetto*, ed. P. Portoghesi and B. Zevi (Turin, n.d. [1964]).

6. Cf. M. Walcher Casotti, *Il Vignola* (Milan, 1960), I, 46, and II, figure 77.

7. Cf. F. Kriegbaum, 'Michelangelo e il ponte S. Trinità', *Rivista d'Arte*, XXIII (1941), 137 ff., and in detail Fossi, *op. cit.*, 70 ff. It should be remembered that Ammannati was sent a clay model by Michelangelo in 1558 for the work on the staircase in the ricetto of the Laurenziana (see p. 246). He was obviously in close touch with Michelangelo at that time. For Ammannati's other palazzi in Florence and Lucca, and for his churches, cf. Vodoz, *op. cit.*, and Fossi, *op. cit.*

8. Vasari Mil., VII, 703. For the architectural history cf. U. Dorini, 'Come sorse la fabbrica degli Uffizi', *Rivista Storica degli Archivi Toscani*, V (1933), 1 ff., and R. Abbondanza, *Mostra documentaria della fabbrica degli Uffizi* (Florence, 1958).

The significance of the Uffizi for Cosimo I's building projects has been discussed by G. Kauffmann, 'Das Forum von Florenz', in *Studies in Renaissance and Baroque Art presented to Anthony Blunt* (London, 1967), 37 ff.

322 9. *Diario fiorentino di Agostino Lapini* (*op. cit.*, Note 4), 207. In comparison, the cost of the Gesù in Rome from 1568 to 1581 was 71,000 scudi.

323 10. By closing the loggia of the upper storey the effect aimed at by Vasari was forfeited. The loggia of the Palazzo Guadagni, with its projecting rafter roof in the Florentine style, shows how the original state of the Uffizi must be visualized.

11. The decoration of Vasari's dome of the Chiesa dell'Umiltà in Pistoia is, however, similar. The model was probably Michelangelo's project for S. Giovanni dei Fiorentini; cf. J. S. Ackerman, *The Architecture of Michelangelo*, I, 2nd ed. (London, 1964), figure 71b, and E. Battisti in *Quaderni dello Istituto di Storia dell'Architettura*, VI–VIII (Saggi . . . in onore del Prof. Vincenzo Fasolo) (Rome, 1961), 187, figure 3.

12. Vasari Mil., I, 131 ff.; cf. L. Bartoli, *Galleria degli Uffizi Firenze. Introduzione all'architettura. I danni di guerra e il progetto di sistemazione* (Florence, [1946]), 13 ff. Ammannati's remarks on his project for the Uffizi dated 1560, i.e. the first year of building, which represents an entirely different scheme for the ground floor and upper storey, may be a criticism of the clamping of the architrave: 'come più ragione d'architettura', i.e. correcter according to the rules of architecture. Illustration in E. Vodoz, *Mitteilungen des Kunsthistorischen Instituts, Florenz*, VI (1940/1), 67.

13. Begun in 1562, occupied in 1565; cf. M. Salmi, *Il Palazzo dei Cavalieri e la Scuola Normale Superiore a Pisa* (Bologna, 1932), 20 ff. For the church of the Order, erected by Vasari in 1565–9, cf. *op. cit.*, 37 ff.

14. For SS. Fiora e Lucilla cf. D. Viviani Fiorini, 'La Badia di Arezzo e Giorgio Vasari', *Il Vasari*, XII (1941), 74 ff.; the plan is of the same type as that of the abbey churches of S. Salvatore in Venice and S. Giustina in Padua, which belonged to the same congregation. For the Logge: D. Viviani Fiorini, 'La Costruzione delle Logge Vasariane di Arezzo', *Il Vasari*, XII (1941), 109 ff.

15. Cf. Vasari Mil., VII, 710 (S. Maria Novella) and 711 (S. Croce).

16. *Diario fiorentino di Agostino Lapini* (cf. Note 4), 152; the *Diario* also reports that the destruction of the 'ponti e cori . . . dispiacque a molti vecchi, perchè dividevano la chiesa, ove molte persone divote si ritiravano ad orare, ed erano secondo l'uso degli antichi christiani'; cf. G. Gaye, *Carteggio inedito d'artisti dei secoli XIV, XV, XVI* (Florence, 1839–40), II, 479 f.

17. At the same time the originally open loggia of the top storey was closed (cf. Note 10); see V. Giovannozzi, 'La Vita di B.B. scritta da Gherardo Silvani', *Rivista d'Arte*, XIV (1932), 509, note 3; cf. also D. Heikamp, 'Zur Geschichte der Uffizien-Tribuna, etc.', *Zeitschrift für Kunstgeschichte*, XXVI (1963), 193 ff.; *idem*, 'La Tribuna degli Uffizi, come era nel Cinquecento', *Antichità Viva*, III (1964), no. 3, 11.

18. Cf. Webster Smith, 'Pratolino', *Journal of the* p. 324 *Society of Architectural Historians*, XX (1961), 155 ff., and D. Heikamp, *Antichità Viva*, VIII (1969), no. 2, 14 ff.; for the still-standing colossal figure by Giovanni da Bologna, see W. Körte, 'Deinokrates und die barocke Phantasie', *Die Antike*, XIII (1937), 290 ff. For an important description of 1600 of the layout of water and fountains cf. W. Heyd (ed.), *Handschriften und Handzeichnungen des Heinrich Schickhardt* (Stuttgart, 1902), 188–99. According to Buontalenti's pupil Gherardo Silvani (cf. previous Note), 'this layout awakened universal admiration and it became the model for all the beautiful fountains in other countries'. Among other things, there were moving, echoing figures and hydraulic organs.

19. The development of the individual motifs can be followed in the preliminary drawings; cf. I. M. Botto, *Mostra di disegni di Bernardo Buontalenti* (Gabinetto Disegni e Stampe degli Uffizi, XXVIII) (Florence, 1968), figures 5–6 (Casino Mediceo) and figures 18–21 (Porta delle Suppliche).

20. W. and E. Paatz, *Die Kirchen von Florenz*, V (Frankfurt, 1953), 272.

p. 324 21. The staircase, built in 1574, and the altar were removed in 1890–7 and incorporated in S. Stefano al Ponte. Good description in Paatz, *op. cit.*, 216 f., and also Giovannozzi, *op. cit.*, 510 f., and *Rivista d'Arte*, xv (1933), 315 f. (with illustration of the altar before its removal).

22. Cf. text and illustrations in the catalogue mentioned in Note 19.

23. Cf. Paatz, *op. cit.*, iii (1952), 335 and 126–31; also L. Berti, *Architettura del Cigoli*, catalogue, Mostra del Cigoli (S. Miniato, 1959), 165 ff.

24. Dosio and Cigoli had also worked in Rome, and Dosio in Naples. For Dosio: L. Wachler, 'G.D., ein Architekt des späten Cinquecento', *Römisches Jahrbuch für Kunstgeschichte*, iv (1940), 143–251; for Cigoli, cf. Berti, *op. cit.*, for Giovanni da Bologna's architectural work, Wachler, *op. cit.*, 244 ff.; cf. also Paatz, *op. cit.*, i (1940), 105 (Cappella del Soccorso), iii (1952), 10 and 18 (Giovanni da Bologna's Cappella Salviati in S. Marco), *ibid.*, 690 (Gaddi Chapel in S. Maria Novella by Dosio), i (1940), 534 (Niccolini Chapel in S. Croce).

p. 325 25. Gherardo Silvani in the biography of Buontalenti quoted in Note 17. Vasari's ground floor dates from 1556–60, Buontalenti's grotto from 1583–93. The four Slaves of Michelangelo were set in place in 1585, Giovanni da Bologna's Venus Fountain in 1592. Cf. V. Giovannozzi, *Rivista d'Arte*, xiv (1932), 510, note 1; also D. Heikamp, 'La Grotta grande del giardino di Boboli', *Antichità Viva*, iv, no. 4 (1965), 27 ff.

26. This union of nature and art is described by the humanist Claudio Tolomei in 1543 as: 'l'ingegnoso artificio nuovamente ritrovato di far le fonti, il qual già si vede usato in più luoghi di Roma. Ove mescolando l'arte con la natura, non si sa discernere s'ella è opera di questa o di quella, anzi o altrui pare un natural artifizio, e ora una artifiziosa natura: in tal modo s'ingegnano in questi tempi rassembrare una fonte, che dell'istessa natura, non a caso, ma con maestrevole arte sia fatta. Alle quali opere arrecan molto d'ornamento, e bellezza queste pietre spugnose, che nascono a Tivoli, le quali essendo formate dall'acqua, ritornan come lor fatture al servizio delle acque; e molto più l'adornano con la lor varietà e vaghezza, ch'esse non avevan ricevute ornamento da loro'; see Heikamp, *op. cit.*, 43.

27. Illustrated in L. Magagnato, *Palazzo Thiene* (Vicenza, 1966), 47 ff., plates 127–34.

28. John Wood of Bath, speaking of this façade, remarks: 'This whimsical front . . . Signiore Zucchari . . . designed to exhibit in it the Samples of his threefold Profession in Theory and Practice; the first being apparent in the Door, the Windows, the Pillasters, and the other Ornaments traced and cut out of the Rock in an unfinished Manner, the second in three Pieces of Sculpture, sketch'd and cut out of the same Rock, and the third in the finished Picture . . .' (*The Origin of Building or the Plagiarism of Heathen detected* (London, 1704); cf. R. Wittkower, *Journal of the Warburg and Courtauld Institutes*, vi (1943), 220 f., and D. Heikamp, 'Federico Zuccari a Firenze', *Paragone Arte*, n.s. xxvii (207) (1967), 9 ff.

29. According to Schickhardt's description (cf. Note 18), 195 f.

30. Believed to have been built between 1550 p. 326 and 1570. For the layout, which has often been described lately, though its interpretation and authorship are not yet clear, cf. the latest account by A. Bruschi, 'Il Problema storico di Bomarzo', *Palladio*, n.s. xiii (1963), 85 ff.

31. 'Tu ch'entri qua pon mente parte a parte
 e dimmi poi se tante meraviglie
 sien fatte per inganno o pur per arte.'

32. For the iconography of the portal and its formal connection with Buontalenti, cf. W. Körte, *Der Palazzo Zuccari in Rom* (Leipzig, 1935), 16 f.; Heikamp, *op. cit.* (Note 28), 14; and E. Guldan, *Zeitschrift für Kunstgeschichte*, xxxii (1969), 229 ff.

BIBLIOGRAPHY

THE bibliography does not aim at completeness. We have omitted encyclopedia articles and guide books.

To a certain extent the footnotes and the bibliography supplement each other: we have excluded from the latter many references given in the footnotes (for which the index should be consulted); conversely, many important studies appear only in the bibliography.

In a few exceptional cases book reviews of special merit are mentioned.

Indispensable for the sources and art theory: J. Schlosser Magnino, *La Letteratura artistica* (Florence, 1956). Extremely useful also is A. Venturi's lavishly illustrated *Storia dell'arte italiana* (cf. section III, p. 400).

For headings I and II of the Bibliography additional items may be found in the bibliographies of the following volumes of *The Pelican History of Art*:

C. Seymour Jr, *Sculpture in Italy: 1400–1500* (Harmondsworth, 1966)

S. J. Freedberg, *Painting in Italy: 1500–1600* (Harmondsworth, 1971)

R. Wittkower, *Art and Architecture in Italy: 1600–1750*, 3rd ed. (Harmondsworth, 1973)

The material is arranged under the following headings:

I. *Sources*
 A. Literary Sources and Archival Documents
 B. Lives of Artists
 C. Treatises

II. *General History. Humanism and the Revival of the Antique. Economic Aspects*

III. *Architecture: General Works*

IV. *Architecture: Specialized Aspects*
 A. Theory and Treatises

B. Materials, Techniques, Engineering
C. Building Types
 1. Churches
 2. Palazzi
 3. Theatres
 4. Villas and Gardens
D. Town Planning and Fortifications
E. Drawings
F. The Problem of Mannerism in Architecture

V. *Provinces and Cities*
 A. General
 B. Emilia and Romagna
 1. Bologna
 2. Parma
 3. Rimini
 C. Liguria
 D. Lombardy
 1. General
 2. Bergamo
 3. Brescia
 4. Mantua
 5. Milan
 6. Pavia
 7. Piacenza
 E. Marche
 1. General
 2. Pesaro
 3. Urbino
 F. Piedmont
 G. Rome and Lazio
 Rome
 1. General
 2. Plans and Drawings
 3. Topography and General Works
 4. St Peter's and the Vatican
 5. The Capitol
 6. Churches
 7. Palaces
 8. Villas

Lazio
 1. Bagnaia
 2. Caprarola
 3. Frascati
 4. Genazzano

H. Southern Italy

I. Tuscany
 1. General
 2. Florence
 3. Pienza
 4. Siena

J. Umbria

K. Veneto
 1. Padua
 2. Venice
 3. Verona
 4. Vicenza

VI. *Architects*

I. SOURCES

A. LITERARY SOURCES AND ARCHIVAL DOCUMENTS

BORROMEO, S. Carlo. *Instructiones Fabricae et Suppellectilis Ecclesiasticae.* Latin ed. in *Acta Ecclesiae Mediolanensis*, II and III, Milan, 1890 and 1892. Latin text with commentary by P. Barocchi in *Trattati d'arte nel Cinquecento*, III, Bari, 1962. Italian ed., as *Arte Sacra*, by C. Castiglioni and C. Marcora, Milan, 1952.

BOTTARI, M. G., and TICOZZI, S. *Raccolta di lettere sulla pittura, scultura ed architettura.* 8 vols. Milan, 1822–5.

FILANGIERI, G. *Documenti per la storia, le arti e le industrie delle provincie napoletane.* 6 vols. Naples, 1883–91.

GAYE, G. *Carteggio inedito d'artisti dei secoli XIV–XVI.* 3 vols. Florence, 1839–40.

KLEIN, R., and ZERNER, H. *Italian Art, 1500–1600. Sources and Documents.* Englewood Cliffs, N.J., 1966.

MANETTI, Giannozzo. *Vita Nicolai V summi pontificis auctore Jannotio Manetto florentino nunc primum prodit ex manuscripto codice florentino.* Milan, 1734. Ed. L. Muratori in *R.I.S.*, III, 2, cols. 907–60.

MONTAIGNE, M. E. DE. *Journal de voyage en Italie par l'Allemagne et la Suisse en 1580 et 1581.* Paris, 1957. Italian ed.: A. D'Ancona, *L'Italia alla fine del XVI secolo. Giornale di viaggio di Michel de Montaigne.* Città di Castello, 1895. English ed.: D. M. Frame (trans.), *The Complete Works of Montaigne . . .*, 861 ff. Stanford, 1958.

Pii Secundi Pontificis Max. Commentarii. Frankfurt, 1584. Trans. F. A. Gragg, ed. L. C. Gabel, *The Commentaries of Pius II*, books I–IX (Smith College Studies in History, XXII, XXV, XXX, XXXV). Northampton, Mass., 1931–51.

VESPASIANO DA BISTICCI (ed. P. D'Ancona and E. Aeschliman). *Vita degli uomini singolari.* Milan, 1950.

B. LIVES OF ARTISTS

BAGLIONE, G. *Le Vite de' pittori, scultori, architetti e intagliatori, dal pontificato di Gregorio XIII del 1572, fino a' tempi di Papa Urbano VIII nel 1642.* Rome, 1642. Facsimile ed. by V. Mariani, Rome, 1935.

SOPRANI, R., and RATTI, C. G. *Vite de' pittori, scultori, ed architetti genovesi.* 2 vols. Genoa, 1768–9; reprinted Bologna, 1969–70.

VASARI, G. *Le Vite de' più eccellenti pittori, scultori e architetti.* Florence, 1550; ed. C. Ricci, Milan–Rome, 1927. Second ed., Florence, 1568. References in the present volume are to the edition of G. Milanesi, 9 vols., Florence, 1878–81, reprinted 1906.

C. TREATISES

ALBERTI, L. B. *L'Architettura* (De re aedificatoria libri X). Latin text, Italian trans., ed. G. Orlandi, 2 vols., Milan, 1966. English trans., ed. James Leoni, London, 1726, 1739, 1755; reprinted London, 1955.

ALGHISI DA CARPI, G. *Delle Fortificazioni.* Venice, 1570.

BARBARO, D. *De Architectura Libri Decem.* Venice, 1556. Italian trans., *I dieci libri dell'Architettura di M. Vitruvio.* Venice, 1567.

BERTANI, G. B. *Gli oscuri e difficili passi dell'opera ionica di Vitruvio.* Mantua, 1558.

CAPORALI, G. B. (ed.). *Architettura, con il suo commento et figure Vetruvio in volgar lingua raportato.* Perugia, 1536.

CATTANEO, P. *Li quattro primi libri d'Architettura.* Venice, 1554; reprinted Ridgewood, N.J., 1964. *Idem*, libri 5–8. Venice, 1567.

CESARIANO, C. *Di L. Vitruvio Pollione, De Architectura libri decem traducti de Latino in Vulgare affigurati.* Como, 1521. Reprinted as *Vitruvius De Architectura.* Munich, 1969.

CORNER, A. (Luigi Cornaro) (ed. G. Fiocco). *Frammenti di un trattato di architettura* (Atti dell' Accademia dei Lincei). Rome, 1952.

FILARETE (Antonio Averlino) (ed. A. M. Finoli and L. Grassi). *Trattato di Architettura*. 2 vols. Milan, 1972. Facsimile and English trans., ed. J. R. Spencer, *Yale Publications in the History of Art*, XVI. 2 vols. New Haven, 1965.

GIOCONDO, Fra (ed.). *M. Vitruvius per Iocundum Solitor Castigatior factus*. Venice, 1511. (First ed. Rome, *c*. 1486.)

LABACCO, A. *Libro appartenente all'architettura*. Rome, 1558.

LOMAZZO, G. P. *Trattato dell'arte della pittura, scultura ed architettura*. Milan, 1584.

MARTINI, Francesco di Giorgio (ed. C. Maltese). *Trattati di architettura, ingegneria e arte militare*. 2 vols. Milan, 1967.

PALLADIO, A. *Le Antichità di Roma*. Venice, 1554.

PALLADIO, A. *Li quattro libri dell'architettura*. Venice, 1570; reprinted Milan, 1952.

RUSCONI, G. A. *Dell'architettura secondo i precetti del Vitruvio*. Venice, 1590.

SERLIO, S. *Regole generali di architettura sopra le cinque maniere degli edifici*. Venice, 1537 and 1551. Books 1–5 and Libro Straordinario. Venice, 1566 and 1584.

SERLIO, S. (ed. M. Rosci). *Il Trattato di architettura di Sebastiano Serlio*. 2 vols. (Ed. of Serlio's Book Six.) Milan, 1967.

TACCOLA, M. (ed. G. Scaglia). *De Machinis. The Engineering Treatise of 1449*. 2 vols. Wiesbaden, 1971.

VIGNOLA, G. Barozzi da. *Regola delli cinque ordini di architettura*. [Rome,] 1562.

BUCK, A. (ed.). *Zu Begriff und Problem der Renaissance* (Essays by D. Cantimori, H. W. Eppelsheimer, F. Simone, E. Mommsen, H. Baron, E. Cassirer, P. O. Kristeller, H. Weisinger, E. Garin, B. L. Ullmann, G. Weise, C. Singer, G. B. Ladner, J. Gadol). Darmstadt, 1969.

CHASTEL, A. *The Age of Humanism. Europe 1430–1530*. New York, 1964.

DELUMEAU, J. *Vie économique et sociale de Rome dans la seconde moitié du XVIe siècle*. 2 vols. Paris, 1957–9.

GARIN, E. *Scienza e vita nel Rinascimento italiano*. Bari, 1965.

JEDIN, H. *Geschichte des Konzils von Trient*. 3 vols. Freiburg, 1957–9.

JEDIN, H. 'Entstehung und Tragweite des Trienter Edikts über die Bilderverehrung', *Theologische Quartalschrift*, CXVI (1935), 143 ff. and 404 ff.

KRISTELLER, P. O. *Studies in Renaissance Thought and Letters* (Storia e Litteratura, LIV). Rome, 1956.

LEVEY, M. *Early Renaissance*. Harmondsworth, 1967.

MÜNTZ, E. *Les Précurseurs de la Renaissance*. Paris, 1882. Italian ed. as *Precursori e propugnatori del Rinascimento*. Florence, 1920.

MÜNTZ, E. *Histoire de l'art pendant la Renaissance*. 3 vols. Paris, 1889–95.

MÜNTZ, E. *Les Arts à la cour des papes Innocent VIII, Alexandre VI, Pie III*. Paris, 1898.

II. GENERAL HISTORY. HUMANISM AND THE REVIVAL OF THE ANTIQUE. ECONOMIC ASPECTS

The following three works are basic:

BLUNT, A. *Artistic Theory in Italy, 1450–1600*. London, 1935.

PASTOR, L. VON. *Geschichte der Päpste seit dem Ausgang des Mittelalters*. Freiburg, 1885–1933. Most recent Italian ed. as *Storia dei Papi*. Rome, 1959. 3rd English ed. as *The History of the Popes from the Close of the Middle Ages*. 36 vols. London, 1950.

VOIGT, G. *Die Wiederbelebung des classischen Altertums oder das erste Jahrhundert des Humanismus*. 3rd ed. Berlin, 1893; reprinted Berlin, 1960.

BARON, H. *The Crisis of Early Italian Renaissance* ... 2 vols. Princeton, 1955; 2nd ed., 1966.

III. ARCHITECTURE: GENERAL WORKS

ACKERMAN, J. S. 'Architectural Practice in the Italian Renaissance', *Journal of the Society of Architectural Historians*, XIII (1954), no. 3, 3 ff.

BAUM, J. *Baukunst und dekorative Plastik der Frührenaissance*. Stuttgart, 1920.

BENEVOLO, L. *Storia dell'architettura del Rinascimento*. 2 vols. Bari, 1968.

BONELLI, R. *Da Bramante a Michelangelo. Profilo dell'architettura del Cinquecento*. Venice, 1960.

BURCKHARDT, J. *Geschichte der Renaissance in Italien*. 1st ed. Stuttgart, 1867. As *Die Kunst der Renaissance in Italien* in *Jacob Burckhardt-Gesamtausgabe*, VI. Stuttgart, 1932.

Dizionario enciclopedico di architettura e urbanistica (diretto da P. Portoghesi). 6 vols. Rome, 1968–9.

DURM, J. *Die Baukunst der Renaissance*. Leipzig, 1914 (and later eds.).

FRANKL, P. *Entwicklungsphasen der neueren Baukunst.* Leipzig, 1914. English ed. as *Principles of Architectural History: The Four Phases of Architectural Style, 1420–1900.* Cambridge, Mass., 1968.

FRANKL, P. *Die Renaissance-Architektur in Italien.* Leipzig, 1912, and later eds.

FUSCO, R. DE. *Il Codice dell'architettura.* 4th ed. Naples, 1968.

GIOVANNONI, G. *Saggi sull'architettura del Rinascimento.* 2nd ed. Milan, 1935.

LOTZ, W. 'Architecture in the Later Sixteenth Century', *College Art Journal*, XVII (1958), 129. ff.

LOWRY, B. *Renaissance Architecture* (The Great Ages of World Architecture, IV). London, 1962.

MURRAY, P. *The Architecture of the Italian Renaissance.* 2nd ed. London, 1969.

PEVSNER, N. *An Outline of European Architecture.* 6th ed. Harmondsworth, 1960.

REDTENBACHER, R. *Die Architektur der italiänischen Renaissance.* Frankfurt, 1886.

RICCI, A. *Storia dell'architettura in Italia.* 3 vols. Modena, 1857.

RICCI, C. *L'Architettura del Cinquecento in Italia.* Turin, 1923.

SALMI, M. 'Rinascimento (Il tardo Rinascimento: Architettura)', *Enciclopedia universale dell'arte*, XI (1964), columns 482–91.

SCOTT, G. *The Architecture of Humanism.* Paperback ed. London, 1961.

SEROUX D'AGINCOURT, G. B. L. G. *Storia dell'arte col mezzo di monumenti della sua decadenza nel IV secolo fino al suo risorgimento.* 7 vols. Milan, 1834–5.

TAFURI, M. *L'Architettura dell'umanesimo.* Bari, 1969.

TAFURI, M. *L'Architettura del Manierismo nel Cinquecento europeo.* Rome, 1966.

VENTURI, A. *Storia dell'arte italiana*, VIII: *Architettura del Quattrocento*, 2 parts, Milan, 1923–4; XI: *Architettura del Cinquecento*, 3 parts, Milan, 1938–40.
 Review by G. Giovannoni, *Palladio*, III (1938), 107 ff.

WILLICH, H., and ZUCKER, P. *Die Baukunst der Renaissance in Italien* (Handbuch der Kunstwissenschaft). Wildpark-Potsdam, 1929.

WITTKOWER, R. *Architectural Principles in the Age of Humanism.* 3rd ed. London, 1962, and New York, 1965. Italian ed. Turin, 1964. German ed. Munich, 1969.

WÖLFFLIN, H. *Renaissance und Barock.* Munich, 1888.

WÖLFFLIN, H. *Die klassische Kunst. Eine Einführung in die italienische Renaissance.* Munich, 1899.

IV. ARCHITECTURE: SPECIALIZED ASPECTS

A. THEORY AND TREATISES

BURNS, H. 'Quattrocento Architecture and the Antique: Some Problems', in R. R. Bolgar (ed.), *Classical Influences on European Culture A.D. 500–1500*, 269 ff. London, 1971.

PRANDI, A. *I Trattati di architettura dal Vitruvio al secolo XVI.* Rome, 1949.

SOERGEL, G. *Untersuchungen über den theoretischen Architekturentwurf von 1450–1550 in Italien.* Cologne, 1957.

STEIN, O. *Die Architekturtheoretiker der italienischen Renaissance.* Karlsruhe, 1914.

B. MATERIALS, TECHNIQUES, ENGINEERING

AUER, J. *Die Quaderbossierung in der italienischen Renaissance.* Vienna, 1887.

HEYDENREICH, L. H. 'Il Bugnato rustico nel Quattro- e nel Cinquecento', *Bollettino del Centro Internazionale di Studi d'Architettura Andrea Palladio*, II (1960), 40 f.

NOEL, P. *Technologie de la pierre de taille.* Paris, 1965.

PARSONS, W. B. *Engineers and Engineering of the Renaissance.* Baltimore, 1939.

PIERI, M. *I Marmi graniti e pietre ornamentali.* Milan, [1950].

PRAGER, F. D., and SCAGLIA, G. *Mariano Taccola and his Book 'De ingeniis'.* Cambridge, 1972.
 With extensive bibliography on engineering in the fifteenth century.

RODOLICO, F. *Le Pietre delle città d'Italia.* Florence, 1953.

ROTH, E. *Die Rustica der italienischen Renaissance und ihre Vorgeschichte.* Vienna, 1917.

THIEM, G. and U. *Toskanische Fassadendekoration in Sgraffito und Fresko 14. bis 17. Jahrhundert.* Munich, 1964.

C. BUILDING TYPES

1. Churches

LARSEN, S. Sinding. 'Some Functional and Iconographical Aspects of the Centralized Church in the Italian Renaissance', *Acta ad archaeologiam et artium historiam pertinentia*, II (1965), 203 ff.

LASPEYRES, P. *Die Kirchen der Renaissance in Mittelitalien.* Berlin and Stuttgart, 1882.

LOTZ, W. 'Notizen zum kirchlichen Zentralbau der Renaissance', *Studien zur toskanischen Kunst* (Festschrift L. H. Heydenreich), 157 ff. Munich, 1964.

LOTZ, W. 'Die ovalen Kirchenräume des Cinquecento', *Römisches Jahrbuch für Kunstgeschichte*, VII (1955), 7 ff.

STRACK, H. *Zentral- und Kuppelkirchen der Renaissance in Italien*. Berlin, 1892.

2. Palazzi

CHIERICI, G. *Il Palazzo italiano dal secolo XI al secolo XIX*. 2nd ed. Milan, 1964.

HAUPT, A., REINHARDT, R., and RASCHDORF, O. *Palastarchitektur von Oberitalien und Toskana vom XIII. bis zum XVII. Jahrhundert*. 6 vols. Berlin, 1903–22.

3. Theatres

MAGAGNATE, L. *Teatri italiani del Cinquecento*. Venice, 1954.

4. Villas and Gardens

DAMI, L. *Il Giardino italiano*. Milan, 1924.

FROMMEL, C. L. 'La Villa Madama e la tipologia della villa romana nel Cinquecento', *Bollettino del Centro Internazionale di Studi di Architettura Andrea Palladio*, XI (1969), 47–64.

HEYDENREICH, L. H. 'La Villa: Genesi e sviluppi fino al Palladio', *Bollettino del Centro Internazionale di Studi di Architettura Andrea Palladio*, XI (1969), 11–21.
With bibliography.

MASSON, G. *Italian Villas and Palaces*. London, 1959.

MURARO, M. *Civiltà delle ville venete* (rotaprint). 1964.

PATZAK, B. *Die Renaissance- und Barockvilla in Italien. Versuch einer Entwicklungsgeschichte*. 2 vols. Leipzig, 1908 and 1913.
For vol. 3 see below V.E.3, Pesaro.

RUPPRECHT, B. 'Villa, Zur Geschichte eines Ideals. Wandlungen des Paradiesischen zum Utopischen', *Probleme der Kunstwissenschaft*, II, 211 ff. Berlin, 1966.

RUSCONI, A. J. *Le Ville medicee*. Rome, 1938.

VENTURA, A. 'Aspetti storico-economici della villa veneta', *Bollettino del Centro Internazionale di Studi di Architettura Andrea Palladio*, XI (1969), 65–77.

D. TOWN PLANNING AND FORTIFICATIONS

ARGAN, G. C. *The Renaissance City*. New York, 1969.
Reviewed by J. S. Ackerman, *Art Bulletin*, LII (1971) 115 f.

BATTISTI, E. 'Osservazioni su due manoscritti intorno all'architettura. Un album di progetti per fortificazioni in Italia nella Biblioteca Nazionale di Madrid', *Bollettino del Centro di Studi per la Storia dell'Architettura*, XIV (1959), 39–40.

BENEVOLO, L. *La Città italiana nel Rinascimento*. Milan, 1969.

BRINCKMANN, A. E. *Stadtbaukunst* (Handbuch der Kunstwissenschaft, IV). Berlin–Babelsberg, 1920.

DE LA CROIX, H. 'The Literature on Fortification in Renaissance Italy', *Technology and Culture*, VI, I (1963), 30–50.

DE LA CROIX, H. 'Military Architecture and the Radial City-Plan in Sixteenth Century Italy', *Art Bulletin*, XLII (1960), 263 ff.

DE LA CROIX, H. 'Palmanova, a Study in Sixteenth-Century Urbanism', *Saggi e Memorie di storia dell'arte*, V (1966), 23–41.

EDEN, W. A. 'Studies in Urban Theory: The "De Re Aedificatoria" of Leone Battista Alberti', *The Town Planning Review*, XIX (1943), 17 ff.

FORSTER, K. W. 'From "Rocca" to "Civitas". Urban Planning at Sabbioneta', *L'Arte*, V (1969), 5 ff.

GARIN, E. 'La Città Ideale', *Scienza e vita civile nel Rinascimento italiano*, 33–56. Bari, 1965.

GUTKIND, E. A. *International History of City Development*. 4 vols. London, 1964–9.

HALE, J. R. 'The Early Development of the Bastion: an Italian Chronology', in J. R. Hale and others (eds.), *Europe in the Late Middle Ages*, 466 ff. London, 1965.

HALE, J. R. 'The End of Florentine Liberty. La Fortezza da Basso', in N. Rubinstein (ed.), *Florentine Studies*, London, 1968, 501 ff.

KLEIN, R. 'L'Urbanisme utopique de Filarete à Valentin Andreae', *L'Utopie à la Renaissance*. Brussels, 1964.

LAVEDAN, P. *Histoire de l'urbanisme*. 2nd ed. 3 vols. Paris, 1959.

LILIUS, H. 'Der Pekkatori in Raahe. Studien über einen eckverschlossenen Platz und seine Gebäudetypen', *Finska Fornminnesföreningens Tidskrift*, LXV (Helsinki, 1967), 182 ff.
With a useful survey of Italian city planning and building.

LOTZ, W. 'Italienische Plätze des 16. Jahrhunderts', *Jahrbuch der Max-Planck-Gesellschaft* (1968), 41–60.

MARCONI, P. 'Una Chiave per l'interpretazione dell'urbanistica rinascimentale: la cittadella come microcosmo', *Quaderni dell'Istituto di Storia dell' Architettura*, XV, fasc. 85–90 (1968), 53–94.

MORINI, M. *Atlante di storia dell'architettura*. Milan, 1963.

ROCCHI, E. *Le Fonti storiche dell'architettura militare*. Rome, 1908.
 Standard work.

Urbanisme et architecture, études écrites et publiées en l'honneur de Pierre Lavedan. Paris, 1954.

ZOCCA, M. 'Le Concezioni urbanistiche di Palladio', X (1960), 69 ff.

ZUCKER, P. *Town and Square*. New York, 1959.

E. DRAWINGS

ASHBY, T. 'Sixteenth Century Drawings of Roman Buildings Attributed to Andreas Coner', *Papers of the British School at Rome*, II (1904) and VI (1913).

BARTOLI, A. *I Monumenti antichi di Roma nei disegni degli Uffizi di Firenze*. 6 vols. Rome and Florence, 1914–22.

FERRI, P. N. *Indici e cataloghi*, III: *Disegni di architettura esistenti nella galleria degli Uffizi in Firenze*. Rome, 1885.

LOTZ, W. 'Das Raumbild in der italienischen Architekturzeichnung der Renaissance', *Mitteilungen des Kunsthistorischen Institutes in Florenz*, VII (1956), 193–226.

NACHOD, H. 'A Recently Discovered Architectural Sketchbook', *Rare Books: Notes on the History of Old Books and Manuscripts*, VIII (1955), 1–11.

WITTKOWER, R. (ed.). *Disegni de le ruine di Roma e come anticamente erano*. Milan, 1963.
 Cf. review by C. Thoenes, *Kunstchronik*, XVIII (1965), 10 ff.

F. THE PROBLEM OF MANNERISM IN ARCHITECTURE

'L'Architettura del Manierismo e il Veneto' (Papers delivered during the Ninth *Corso* of the Centro in 1966), *Bollettino del Centro Internazionale di Studi d'Architettura Andrea Palladio*, IX (1967), 187–416.

BATTISTI, E. 'Storia del concetto di Manierismo in architettura', *Bollettino del Centro Internazionale di Studi di Architettura Andrea Palladio*, IX (1967), 204–10.

BATTISTI, E. 'Proposte per una storia di Manierismo in architettura', *Odeo Olimpico*, VII (1968–70), 19–67.

GOMBRICH, E. 'Zum Werke Giulio Romanos', *Jahrbuch der Kunsthistorischen Sammlungen in Wien*, N.F. VIII (1934), 79 ff., and IX (1935), 121 ff.

HAGER, W. 'Zur Raumstruktur des Manierismus in der italienischen Architektur', *Festschrift Martin Wackernagel*, 112 ff. Cologne, 1958.

HOFFMANN, H. *Hochrenaissance, Manierismus, Frühbarock. Die italienische Kunst des 16. Jahrhunderts*. Zürich–Leipzig, 1938.

LOTZ, W. 'Mannerism in Architecture: Changing Aspects', *The Renaissance and Mannerism. Studies in Western Art* (Acts of the 20th International Congress of the History of Art), II (1963), 239.

MICHALSKI, E. 'Das Problem des Manierismus in der italienischen Architektur', *Zeitschrift für Kunstgeschichte*, II (1933), 88–109.

PEVSNER, N. 'The Architecture of Mannerism', in G. Grayson (ed.), *The Mint, Miscellany of Literature, Art and Criticism*, 116 ff. London, 1946.

TAFURI, M. *L'Architettura del Manierismo nel Cinquecento europeo*. Rome, 1966.

WITTKOWER, R. 'Michelangelo's Biblioteca Laurenziana', *Art Bulletin*, XVI (1934), 123 ff.

ZÜRCHER, R. *Stilprobleme der italienischen Baukunst des Cinquecento*. Basel, 1947.

V. PROVINCES AND CITIES

A. GENERAL

KELLER, H. *Die Kunstlandschaften Italiens*. Munich, 1960.

B. EMILIA AND ROMAGNA

1. Bologna

BERNHEIMER, R. 'Gothic Survival and Revival in Bologna', *Art Bulletin*, XLVI (1954), 263–84.

BESEGHI, U. *Le Chiese di Bologna*. Bologna, 1956.

BESEGHI, U. *Palazzi di Bologna*. Bologna, 1956.

BESEGHI, U. *Castelli e ville bolognesi*. Bologna, 1957.

COULSON, J. E. E. *Bologna, Its History, Antiquities and Art*. London, 1909.

MALAGUZZI-VALERI, F. *L'Architettura a Bologna nel Rinascimento*. Rocca S. Casciano, 1899.

RAULE, A. *Architettura bolognese*. Bologna, 1952.

SIGHINOLFI, L. *L'Architettura bentivolesca in Bologna*. Bologna, 1909.

SUPINO, J. B. *L'Arte nelle chiese di Bologna*. Bologna, 1938.

ZUCCHINI, G. *Edifici di Bologna. Repertorio bibliografico*. Rome, 1931.

2. Parma

CRISTINELLI, G., and GREGHI, F. 'Santa Maria della Steccata a Parma', *L'Architettura*, XIV (1969), 680 ff.

3. Rimini

ARDUINI, F., MENGHI, G. S., PANVINI, F., a.o. (eds.). *Sigismondo Malatesta e il suo tempo*. Exhibition catalogue. Vicenza, 1970.
 Very valuable for its wealth of documentation and illustrations.
RICCI, C. *Il Tempio malatestiano*. Milan and Rome, 1924.

C. LIGURIA

GAUTHIER, M. P. *Les plus beaux édifices de la ville de Gènes et de ses environs*. Paris, 1818.
LABÒ, M. 'Strada Nuova: più che una strada, un quartiere', *Scritti di storia dell'arte in onore di Lionello Venturi*, II, 402 ff. Rome, 1956.
NEGRI, E. DE, FERA, C., GROSSI BIANCHI, L., and POLEGGI, E. *Catalogo delle ville genovesi*. Genoa, 1967.
NEGRI, T. O. DE. *Storia di Genova*. Milan, [1968].
PARMA ARMAN, E. 'Il Palazzo del principe Andrea Doria a Fassolo in Genova', *L'Arte*, X (1970), 12–63.
POLEGGI, E. *Strada Nuova: una lottizzazione del Cinquecento*. Genoa, 1958.

D. LOMBARDY

1. General

Atti II° Convegno Nazionale Storia Architettura. Milan, 1939.
BARONI, C. *Documenti per la storia dell'architettura a Milano nel Rinascimento e nel Barocco*. Vol. I, Florence, 1940; vol. II, Rome, 1968.
BARONI, C. *L'Architettura lombarda dal Bramante al Richini: questioni di metodo*. Milan, 1941.
GRUNER, L. *Terracotta Architecture of North Italy*. London, 1867.
MALAGUZZI-VALERI, F. *La Corte di Ludovico il Moro*. 3 vols. Milan, 1912–23.
MEYER, A. G. *Oberitalienische Frührenaissance*. 2 vols. Berlin, 1897 and 1900.
RICCI, C. *Geschichte der Kunst in Norditalien*. Stuttgart, 1924.
RUNGE, L. *Beiträge zur Backsteinarchitektur Italiens*. Berlin, 1897–8.
Storia di Milano (Fondazione Treccani). 16 vols. Milan, 1953 ff.

2. Bergamo

ANGELINI, L. *Il Volto di Bergamo nei secoli*. Bergamo, 1951.
PINETTI, A. *Bergamo e le sue valli*. Brescia, 1921.

3. Brescia

PERONI, A. 'L'Architettura e la scultura nei secoli XV e XVI', *Storia di Brescia*, II, 620–887. Brescia, 1963.

4. Mantua

Cf. Chapter 8, Notes 1 and 6.
CAMPAGNARI, A., and FERRARI, A. *Corti e dimore del contado del Mantovano*. Florence, 1969.
PACCAGNINI, G. *Il Palazzo ducale di Mantova*. Turin, 1969.
Storia di Mantova: Le Arti, II and III. Mantua, 1963.

5. Milan

BIAGETTI, V. *L'Ospedale Maggiore di Milano*. Milan, 1937.
CALDERINI, A., CHIERICI, G., and CECCHELLI, C. *La Basilica di S. Lorenzo Maggiore a Milano*. Milan–Rome, 1952.
CIPRIANI, R., DELL'ACQUA, G. A., and RUSSOLI, F. *La Cappella Portinari in Sant'Eustorgio a Milano*. Milan, 1963.
DOSSI, L. *Il S. Fedele di Milano*. Milan, 1963.
Il Duomo di Milano. Atti del Congresso Internazionale, Milano 8–12 settembre 1968 (Monografie di Arte Lombarda, Monumenti, III). Milan, 1969.
HOFFMANN, H. 'Die Entwicklung der Architektur Mailands von 1550–1650', *Wiener Jahrbuch für Kunstgeschichte*, IX (1934), 63–100.
MEZZANOTTE, P., and BASCAPÈ, G. *Milano nell'arte e nella storia*. Milan, 1948.
MEZZANOTTE, P. *Raccolta Bianconi: Catalogo ragionato*, I. Milan, 1942.
SPINELLI, S. *La Cà grande [Ospedale Maggiore]*. Milan, 1958.

6. Pavia

PERONI, A. 'Il Collegio Borromeo. Architettura e decorazione', *I quattro secoli del Collegio Borromeo di Pavia*, III–61. Pavia, 1961.

7. Piacenza

FERRARI, G. *Piacenza*. Bergamo, 1931.

GAZZOLA, P. 'Il Rinascimento a Piacenza', *Atti I° Convegno Nazionale Storia Architettura*, 245. Florence, 1936.

E. MARCHE
1. General

TERZAGHI, A. 'Indirizzi del classicismo nell'architettura del tardo Quattrocento nelle Marche', *Atti XI° Congresso Storia Architettura, Roma 1959*, 329. Rome, 1965.

2. Pesaro

MARCHINI, G. 'Il Problema dell'Imperiale', *Commentari*, N.S. XXI (1970), 66 ff.

PATZAK, B. *Die Villa Imperiale in Pesaro*. Leipzig, 1908.

3. Urbino

Cf. Chapter 7, Notes 1 and 2.

TERZAGHI, A. 'Nuovi elementi per il problema di Urbino', *Il Mondo antico del Rinascimento* (Atti V° Convegno Internazionale Studi sul Rinascimento), 279 ff. Florence, 1958.

F. PIEDMONT

CARBONERI, N. 'Architettura', in catalogue *Mostra del Barocco piemontese*. Turin, 1963.

TAMBURINI, L. *Le Chiese di Torino dal Rinascimento al Barocco*. Turin, [1969].

G. ROME AND LAZIO

Rome

Cf. also Chapter 6, Notes 1, 2, 5.

1. General

BRUHNS, L. *Die Kunst der Stadt Rom*. Vienna, 1951.

LEWINE, M. 'Roman Architectural Practice during Michelangelo's Maturity', *Stil und Überlieferung in der Kunst des Abendlandes* (Acts of the 21st International Congress for the History of Art, Bonn, 1964), 20 ff. Berlin, 1967.

MAGNUSON, T. *Studies in Roman Quattrocento Architecture*. Stockholm, 1958.

TOMEI, P. *L'Architettura a Roma nel Quattrocento*. Rome, 1942.

URBAN, G. 'Die Kirchenbaukunst des Quattrocento in Rom', *Römisches Jahrbuch für Kunstgeschichte*, IX–X (1961–2), 73 ff.

2. Plans and Drawings

BARTOLI, A. *I Monumenti antichi di Roma nei disegni degli Uffizi di Firenze*. 6 vols. Rome, 1914–22.

EGGER, H. *Römische Veduten*. Vol. I, Vienna–Leipzig, 1911, 2nd ed., Vienna, 1932; vol. II, Vienna, 1932.

FRUTAZ, A. P. *Le Piante di Roma*. 3 vols. Rome, 1962.

HUELSEN, C. 'Das *Speculum Romanae magnificentiae* des Antonio Lafreri', *Collectanea . . . Leoni S. Olschki . . . sexagenario . . .*, 121 ff. Munich, 1921.

HUELSEN, C., and EGGER, H. *Die römischen Skizzenbücher des Marten van Heemskerk*. 2 vols. Berlin, 1913–16.

MONGERI, G. (ed.). *Le Rovine di Roma al principio del secolo XVI; studi del Bramantino*. 2nd ed. Pisa, 1880.

WITTKOWER, R. (ed.). *Disegni de le ruine di Roma e come anticamente erono*. Milan, n.d.

3. Topography and General Works

GIOVANNONI, G. 'Il Quattrocento. Il Cinquecento', *Topografia e urbanistica di Roma* (Storia di Roma, XXII), 243 ff. Bologna, 1958.

GNOLI, D. *La Roma di Leone X*. Milan, 1938.

HIBBARD, H. 'Di alcune licenze rilasciate dai mastri di strade per opere di edificazione a Roma (1586–89, 1602–34)', *Bollettino d'Arte*, LII (1967), 99 ff.

LETAROUILLY, P. *Les Édifices de Rome moderne*. 3 vols. text, 3 vols. plates. Liège and Brussels, 1849–66.

ONOFRIO, C. D'. *Le Fontane di Roma*. Rome, 1957.

ONOFRIO, C. D'. *Gli Obelischi di Roma*. 2nd ed. Rome, 1967.

ONOFRIO, C. D'. *Il Tevere a Roma*. Rome, 1970.

ORBAAN, J. F. *Sixtine Rome*. London, 1910.

PASCHINI, P. 'Da Ripetta a Piazza del Popolo', *Roma*, III (1925), 211 ff.

PASTOR, L. VON. *Sisto V, creatore della nuova Roma*. Rome, 1922.

PECCHIAI, P. *Roma nel Cinquecento* (Storia di Roma, XIII). Bologna, 1948.

PONNELLE, L., and BORDET, L. *Saint Philip Neri and the Roman Society of His Times*. London, 1932.

PROIA, A., and ROMANO, P. *Roma nel Cinquecento*. 13 vols. Rome, 1933–41.

RE, E. 'Maestri di Strada', *Archivio Società Romana di Storia Patria*, XLIII (1920), 5 ff.

STEVENSON, E. *Topografia e monumenti di Roma nelle pitture a fresco di Sisto V nella Biblioteca Vaticana. Omaggio giubilare a Leone XIII.* Rome, 1887.

VALENTINI, R., and ZUCCHETTI, G. *Codice topografico della città di Roma.* 4 vols. Rome, 1940–53.

4. St Peter's and the Vatican

ACKERMAN, J. S. *The Cortile del Belvedere* (Studi e documenti per la storia del Palazzo Apostolico Vaticano, III). Vatican City, 1954.

FREY, K. 'Zur Baugeschichte des St Peter', *Jahrbuch der Preussischen Kunstsammlungen,* XXXI (1910), XXXIII (1913).

GEYMÜLLER, H. VON. *Die ursprünglichen Entwürfe für St Peter.* 2 vols. Vienna and Paris, 1875.

GIOSEFFI, D. *La Cupola vaticana.* Trieste, 1960.

HOFMANN, T. *Die Entstehungsgeschichte des St Peter in Rom.* Zittau, 1928.

LETAROUILLY, P. *Le Vatican et la basilique de Saint-Pierre de Rome.* 2 vols. Paris, 1883.

ORBAAN, J. A. 'Zur Baugeschichte der Peterskuppel', *Jahrbuch der Preussischen Kunstsammlungen,* XXXVIII (1917), Beiheft.

REDIG DE CAMPOS, D. *I Palazzi vaticani.* Bologna, 1967.

SIEBENHÜNER, H. 'Umrisse zur Geschichte der Ausstattung von St Peter in Rom von Paul III. bis Paul V. (1547–1606)', *Festschrift für Hans Sedlmayr,* 229 ff. Munich, 1962.

THOENES, C. 'Peterskirche', *Lexikon für Kirche und Theologie,* 2nd ed., VIII. Freiburg im Breisgau, 1957.

THOENES, C. 'Studien zur Geschichte des Petersplatzes', *Zeitschrift für Kunstgeschichte,* XXVI (1963), 97 ff.

WITTKOWER, R. *La Cupola di San Pietro di Michelangelo.* Florence, 1964.

WOLFF METTERNICH, F. Graf. 'Bramantes Chor der Peterskirche zu Rom', *Römische Quartalschrift,* LVIII (1963), 271 ff.

WOLFF METTERNICH, F. Graf. 'Le premier projet pour Saint-Pierre de Rome, Bramante et Michel-Ange', *The Renaissance and Mannerism, Studies in Western Art* (Acts of the 20th International Congress of the History of Art), II, 70 ff. Princeton, N.J., 1963.

WOLFF METTERNICH, F. Graf. 'Eine Vorstufe zu Michelangelos Sankt Peter-Fassade', *Festschrift Herbert von Einem,* 162 ff. Berlin, 1965.

WOLFF METTERNICH, F. Graf. 'Massgrundlagen des Kuppelentwurfes Bramantes für die Peterskirche in Rom', *Essays in the History of Architecture presented to Rudolf Wittkower,* 40 ff. London, 1967.

5. The Capitol

LAVIN, I. 'The Campidoglio and Sixteenth-Century Stage Design', *Essays in Honor of Walter Friedlaender,* 114 ff. Locust Valley, N.Y., 1965.

PECCHIAI, P. *Il Campidoglio nel Cinquecento sulla scorta dei documenti.* Rome, 1950.

SIEBENHÜNER, H. *Das Kapitol von Rom. Idee und Gestalt.* Munich, 1954.
 Review by J. S. Ackerman, *Art Bulletin,* XXXVIII (1956), 53 ff.

6. Churches

PECCHIAI, P. *Il Gesù di Roma.* Rome, 1950.

RAY, S. 'La Cappella Chigi in Santa Maria del Popolo a Roma', *L'Architettura,* XIV (1969), 750 ff.

SCHWAGER, K. 'Zur Bautätigkeit Sixtus' V. an S. Maria Maggiore in Rom', *Miscellanea Bibliothecae Hertzianae,* 324. Munich, 1961.

SHEARMAN, J. 'The Chigi Chapel in S. Maria del Popolo', *Journal of the Warburg and Courtauld Institutes,* XXIV (1961), 129 ff.

SIEBENHÜNER, H. 'S. Maria degli Angeli in Rom', *Münchner Jahrbuch der bildenden Kunst,* 3rd series, VI (1955), 179 ff.

URBAN, G. 'Die Cappella Cesi in S. Maria della Pace und die Zeichnungen des Antonio da Sangallo', *Miscellanea Bibliothecae Hertzianae,* 213 ff. Munich, 1961.

7. Palaces

FROMMEL, C. L. *Der römische Palastbau der Hochrenaissance.* 3 vols. Tübingen, in press.

FROMMEL, C. L. *Die Farnesina und Peruzzis architektonisches Frühwerk.* Berlin, 1961.
 Review by J. S. Ackerman, *Art Bulletin,* XLIV (1962), 243 ff.

HIBBARD, H. *The Architecture of the Palazzo Borghese.* Rome, 1962.
 Review by C. Thoenes, *Zeitschrift für Kunstgeschichte,* XXVI (1963), 181 ff.

NAVENNE, F. DE. *Le Palais Farnèse et les Farnèse.* Paris, 1914.

THELEN, H. 'Der Palazzo della Sapienza in Rom', *Miscellanea Bibliothecae Hertzianae,* 302 ff. Munich, 1961.

WASSERMAN, J. 'Giacomo della Porta's Church for the Sapienza in Rome and Other Matters relating to the Palace', *Art Bulletin,* XLVI (1964), 501 ff.

WASSERMAN, J. 'Palazzo Spada', *Art Bulletin*, XLIII (1961), 58 ff.

WURM, H. *Der Palazzo Massimo alle Colonne.* Berlin, 1965.

8. Villas

ANDRES, G. M. 'Cardinal Giovanni Ricci: The Builder of the present Villa Medici from Montepulciano', *Atti del Quinto Convegno Internazionale del Centro di Studi Umanistici*, 283 ff. Florence, 1970.

COFFIN, D. R. 'The Plans of the Villa Madama', *Art Bulletin*, IL (1967), 111 ff.

FALK, T. 'Studien zur Topographie und Geschichte der Villa Giulia in Rom', *Römisches Jahrbuch für Kunstgeschichte*, XIII (1971), 101 ff.

GIESS, H. 'Studien zur Farnese-Villa am Palatin', *Römisches Jahrbuch für Kunstgeschichte*, XIII (1971), 179 ff.

HESS, J. 'Die päpstliche Villa bei Araceli', *Miscellanea Bibliothecae Hertzianae*, 239 ff. Munich, 1961.

HUEMER, F. 'Raphael and the Villa Madama', *Essays in Honor of Water Friedlaender*, 92 ff. Locust Valley, N.Y., 1968.

RAY, S. 'Villa Madama a Roma', *L'Architettura*, XIV (1969), 882 ff.

Lazio

1. Bagnaia

ANGELIS D'OSSAT, E. (ed.). *La Villa Lante di Bagnaia.* Milan, 1961.

BRUSCHI, A. 'Bagnaia', *Quaderni dell'Istituto di Storia dell'Architettura dell'Università di Roma*, XVII (1956).

HESS, J. 'Entwürfe von Giovanni Guerra für Villa Lante in Bagnaia (1598)', *Römisches Jahrbuch für Kunstgeschichte*, XII (1969), 195 ff.

NEGRI-ARNOLDI, F. *Villa Lante in Bagnaia.* Rome, 1963.

2. Caprarola

LABROT, G. *Le Palais Farnèse de Caprarola. Essai de lecture.* Paris, 1970.

3. Frascati

FRANCK, K. L. *Die Barockvillen in Frascati.* Munich and Berlin, 1956.
> Review by H. Hibbard, *Art Bulletin*, XL (1958), 354 ff.

SCHWAGER, K. 'Kardinal Pietro Aldobrandinis Villa di Belvedere in Frascati', *Römisches Jahrbuch für Kunstgeschichte*, XIX (1961–2), 289 ff.

4. Genazzano

FROMMEL, C. L. 'Bramantes "Ninfeo" in Genazzano', *Römisches Jahrbuch für Kunstgeschichte*, XII (1969), 95 ff.

H. SOUTHERN ITALY

CATALANI, L. *Le Chiese di Napoli.* 2 vols. Naples, 1845–53.

CATALANI, L. *I Palazzi di Napoli.* Naples, 1845; reprinted Naples, 1969.

HERSEY, G. L. *Alfonso II and the Artistic Renewal of Naples, 1485–95.* New Haven, 1969.

PANE, R. *Architettura del Rinascimento a Napoli.* Naples, 1937.

THOENES, C. *Neapel und Umgebung.* Stuttgart, 1971.

WEISE, G. 'Chiese napoletane, anteriori al Gesù del Vignola', *Palladio*, N.S. II (1952), 148 ff.

ZANDER, G. 'A proposito di alcune chiese napoletane anteriori al Gesù di Roma', *Palladio*, N.S. III (1953), 41 ff.

I. TUSCANY

1. General

SANPAOLESI, P. 'Architetti pre-michelangeleschi toscani', *Rivista Istituto Nazionale d'Architettura e Storia dell'Arte*, N.S. XIII/XIV (Rome, 1964/5), 269 ff.

STEGMANN, C. VON, and GEYMÜLLER, H. VON. *Die Architektur der Renaissance in Toscana.* 11 vols. Munich, 1885–1908. Abridged English ed., 2 vols., New York, *c.* 1924.

THIEM, G. and C. *Toskanische Fassadendekoration in Sgraffito und Fresco.* Munich, 1964.

2. Florence

BARFUCCI, E. *Lorenzo de Medici.* Florence, 1964.

BULST, A. 'Die ursprüngliche innere Aufteilung des Palazzo Medici in Florenz', *Mitteilungen des Kunsthistorischen Instituts in Florenz*, XIV (1970), 369 ff.

BÜTTNER, F. 'Der Umbau des Palazzo Medici-Riccardi zu Florenz', *Mitteilungen des Kunsthistorischen Instituts in Florenz*, XIV (1970), 393 ff.

CHASTEL, A. *Arts et humanisme à Florence au temps de Laurent le Magnifique.* Paris, 1961.

FRASER JENKINS, A. D. 'Cosimo de Medici's Patronage of Architecture and the Theory of Magnificence', *Journal of the Warburg and Courtauld Institutes*, XXXIII (1970), 162 ff.

GINORI, L. *I Palazzi di Firenze nella storia e nell'arte.* 2 vols. Florence, 1972.

GOLDTHWAITE, R. A. 'The Florentine Palace as Domestic Architecture', *The American Historical Review*, LXXVII (1972), 977 ff.

GOLDTHWAITE, R. A. *Private Wealth in Renaissance Florence. A Study of Four Families.* Princeton, N.J., 1968.

GOMBRICH, E. H. 'The Early Medici as Patrons of Art', *Norm and Form. Studies in the Art of the Renaissance*, 35. London, 1966.

MARTELLI, M. 'I Pensieri architettonici del Magnifico', *Commentari*, XVII (1966), 107 ff.

MORANDINI, F. 'Palazzo Pitti, la sua costruzione e i successivi ingrandimenti', *Commentari*, XVI (1965), 35 ff.

PAATZ, W. and E. *Die Kirchen von Florenz.* 6 vols. Frankfurt, 1952–5.

PAMPALONI, G. *Il Palazzo Strozzi.* Florence, 1960.

PICCINI, A. *Il Restauro dello Spedale di S. Maria degli Innocenti, 1966–70.* Florence, 1971.

ROSCOE, W. *The Life of Lorenzo de Medici.* 2 vols. Philadelphia, 1842.

SCHIAPARELLI, A. *La Casa fiorentina e i suoi arredi nei secoli XIV e XV.* Florence, 1908.

STROZZI, L. (ed. G. Bini and P. Bigazzi). *Vita di Filippo Strozzi.* Florence, 1851.

3. Pienza

CARLI, E. *Pienza.* Siena, 1961.

4. Siena

SECCHI TARUGI, F. 'Aspetti del Manierismo nel architettura senese', *Palladio*, XVI (1966), 103 ff.

J. UMBRIA

TARCHI, U. *L'Arte nel Rinascimento nell'Umbria e nella Sabina.* Milan, 1954.

K. VENETO
1. Padua

See Chapter 9, Note 69.

2. Venice

Cf. Chapter 9, Notes 2 and 3.

CICOGNARA, L., DIEDO, A., and SELVA, G. *Le Fabbriche e i monumenti cospicui di Venezia.* Venice, 1857.

FIOCCO, G. 'L'Ingresso del Rinascimento nel Veneto', *Atti XVIII° Congresso Internazionale Storia dell'Arte* (1955), 56 f.

FONTANA, G. *Venezia monumentale.* Venice, 1865; reprinted 1934.

HUBALA, E. *Die Baukunst der venezianischen Renaissance (1460–1550).* Habilitationsschiift (unpublished). Munich, 1958.
This excellent work raises many stimulating points.

LORENZETTI, G. *Venezia e il suo estuario.* Venice, n.d. English ed., Rome, 1961.

OKEY, T. *The Old Venetian Palaces and Old Venetian Folk.* London, 1907.

PALLUCCHINI, R. *Storia della civiltà veneziana*, III, *La Civiltà veneziana del Quattrocento.* Florence, 1957.

PAOLETTI, P. *L'Architettura e la scultura del Rinascimento a Venezia.* 3 vols. Venice, 1893.

Piazza S. Marco: L'architettura, la storia, le funzioni. Padua, 1970.

RUSKIN, J. *The Stones of Venice.* 1851–8.

SANSOVINO, F. *Venezia, città nobilissima.* Venice, 1581.

SELVATICO, P. *Sull'architettura e sulla scultura in Venezia dal medioevo sino ai nostri giorni.* Venice, 1847.

TEMANZA, T. *Vita dei più celebri architetti e scultori veneziani ... nel secolo XVI.* Venice, 1778.

TRINCANATO, E. R. *Venezia Minore.* Milan, 1949.

3. Verona

See Chapter 9, Note 70.

4. Vicenza

BARBIERI, F., CEVESE, R., and MAGAGNATO, L. *Guida di Vicenza.* Vicenza, 1956.

CEVESE, R. *Ville della provincia di Vicenza.* 2 vols. Milan, 1971–2.

VI. ARCHITECTS

AGOSTINO DI DUCCIO

Milani, G. B. *Agostino di Duccio architetto e il Tempio Malatestiano a Rimini.* Rome, 1938.

Pointner, A. *Die Werke des florentinischen Bildhauers Agostino di Duccio.* Strassburg, 1909.

Venturi, A. *Storia dell'arte italiana*, VIII, 537–50. Milan, 1923–4.

ALBERTI

Cf. Chapter 4, Notes 1–3, 8, 36, and above, I.C TREATISES.

Gadol, J. *Leon Battista Alberti.* Chicago and London, 1969.
With extensive bibliography of recent publications.

Grayson, C. 'The Humanism of Alberti', *Italian Studies*, XII (1957), 37 ff.

Mancini, G. *Vita di L. B. Alberti.* 2nd ed. Florence, 1911.

Mancini, G. *Giorgio Vasari, Cinque vite annotate.* Florence, 1917.

Michel, P. H. *La Pensée de L. B. Alberti.* Paris, 1930.

Ricci, C. *Il Tempio Malatestiano.* Milan–Rome, 1924.

Soergel, G. *Untersuchungen über den theoretischen Architekturentwurf, 1450–1550.* Cologne, 1958.

Venturi, A. *Storia dell'arte italiana*, VIII, 157 ff. Milan, 1923–4.

Wittkower, R. *Architectural Principles in the Age of Humanism, passim.* 3rd ed. London, 1962, and New York, 1965.

ALESSI

Rocco, G. 'Giovanni Alessi a Milano', *Atti del IV Convegno Nazionale di Storia dell'Architettura*, 185 ff. Milan, 1939.

See also below: TIBALDI.

AMADEO

Arslan, W., *Storia di Milano* (Fondazione Treccani), VII, 637 ff. Milan, 1956.

Malaguzzi-Valeri, F. *Giovanni Antonio Amadeo.* Bergamo, 1904.

Venturi, A. *Storia dell'arte italiana*, VIII (2), 591–630. Milan, 1923–4.

AMMANNATI

Belli Barsali, I. 'Ammannati', *Dizionario biografico degli Italiani*, II (1960), 798 ff.

Fossi, M. *Bartolomeo Ammannati architetto* (Atti dell'Accademia Pontiniana). Naples, n.d.

Fossi, M. (ed.). *La Città. Appunti per un trattato. Bartolomeo Ammannati.* Rome, 1970.

Pirri, P. 'L'Architetto Bartolomeo Ammannati e i Gesuiti', *Archivium Hist. Soc. Jesu*, XII (1943), 5 ff.

AVERLINO *see* FILARETE

BON *see* BUON

BRAMANTE

Cf. Chapter 10, Note 28.

Argan, G. C. 'Il Problema del Bramante', *Rassegna Marchigiana*, XII (1934), 212 ff.

Baroni, C. *Bramante.* Bergamo, 1944.

Beltrami, L. *Bramante a Milano.* Milan, 1912.

Bramante tra Umanesimo e Manierismo. Mostra storico-critica, Settembre 1970.
With catalogue of Bramante's œuvre, 213 ff., and bibliography, 219 ff., by A. Bruschi.

Bruschi, A. *Bramante architetto.* Bari, 1969.
With complete bibliography.

Fiocco, G. 'Il primo Bramante', *Critica d'Arte*, I (1935/6), 109.

Förster, O. H. *Bramante.* Vienna, 1956.

Frey, D. *Bramante-Studien*, I: *Bramantes St Peter-Entwurf und seine Apokryphen.* Vienna, 1915.

Malaguzzi-Valeri, F. *La Corte di Lodovico il Moro*, II: *Bramante e Leonardo.* Milan, 1915.

Wolff Metternich, F. Graf. 'Bramante, Skizze eines Lebensbildes', *Römische Quartalschrift*, LXIII (1968), 1 ff.

BRUNELLESCHI

Cf. Chapter 1, Notes 6, 11, 13, 16, 18, 20.

Argan, G. C. *Brunelleschi.* Verona, 1955.

Fabriczy, C. von. *F. Brunelleschi.* Stuttgart, 1892.

Fabriczy, C. von. 'Brunelleschiana', *Jahrbuch der Preussischen Kunstsammlungen*, XXVIII (1907), Beiheft.

Folnesics, H. *F. Brunelleschi.* Vienna, 1915.

Klotz, H. *Die Frühwerke Brunelleschis und die mittelalterliche Tradition.* Berlin, 1970.

Luporini, E. *Brunelleschi.* Milan, 1964.

Manetti, A. (ed. E. Toesca). *Vita di Filippo di Ser Brunellesco.* Florence, 1927. New ed. with English trans. and critical comment by H. Saalman, Pennsylvania State University Press, 1970.

Saalman, H. 'Brunelleschi, Capital Studies', *Art Bulletin*, XL (1958), 115 ff.

Sanpaolesi, P. *Brunelleschi.* Milan, 1962.

BUON (BON), B.

Angelini, L. *Bartolomeo Bon. Guglielmo d'Alzano.* Venice, 1961.

Gallo, R. *Atti Istituto Veneto Scienze Lettere Arti*, CXX (1961/2), 187 ff.

BUONTALENTI

Bemporad, N. 'Gli Uffizi e la scala buontalentiana', *L'Architettura*, XIV (1968), 610–19.

Botto, I. M. (ed.). *Mostra di disegno di Bernardo Buontalenti (1531–1608). Gabinetto Disegni e Stampe degli Uffizi.* Catalogue. Florence, 1968.

Gori-Montanelli, L. 'Giudizio sul Buontalenti architetto', *Quaderni dell'Istituto di Storia dell'Architettura*, XXXI–XLVIII (1961), 207 ff.

BIBLIOGRAPHY

CESARIANO
Krinsky, C. H. Introduction to reprint of Cesariano's edition of Vitruvius, *De architectura*. Munich, 1969.

CIACCHERI *see* MANETTI

CIGOLI (CARDI)
Fasolo, V. 'Un Pittore architetto: il Cigoli', *Quaderni dell'Istituto di Storia dell'Arte*, I (1952), 2 ff., and II (1953), 11 ff.

CODUSSI (CODUCCI)
Angelini, L. *Le Opere in Venezia di Mauro Codussi*. Milan, 1945.
Angelini, L. *Realtà Nuova* (1954), 771 ff.
Carbonari, N. 'Mauro Codussi', *Bollettino Centro . . . Andrea Palladio*, II (1964), 188 ff.

CRONACA
Cf. Chapter 13, Note 34.
Fabriczy, C. von. *Jahrbuch der Preussischen Kunstsammlungen*, XXVII (1906), Beiheft.
Heydenreich, L. H. 'Über den Palazzo Guadagni in Florenz', *Festschrift Eberhard Hanfstaengl*, 43 ff. Munich, 1961.
Stegmann, C. von, and Geymüller, H. von. 'Cronaca', *Die Architektur der Renaissance in Toscana*, IV, 3. Munich, 1890–1906.

DELLA PORTA
Ackerman, J. S. 'Della Porta's Gesù Altar', *Essays in Honor of Walter Friedlaender*, 1 ff. Locust Valley, 1965.
Arslan, W. 'Forme architettoniche civili di Giacomo della Porta', *Bollettino d'Arte*, VI (1926–7), 508.

DONATELLO
See Chapter 3, Notes 4 and 7.

FALCONETTO
Fiocco, G. *Alvise Cornaro, il suo tempo e le sue opere*. Venice, 1965.
Wolters, W. 'Tiziano Minio als Stukkator im Odeo Cornaro zu Padua', *Pantheon*, XXI (1963), 20 ff. and 222 ff.

FANCELLI
Cf. Chapter 8, Note 5.
Marani, E., in *Mantova, Le Arti*, II. Mantua, 1963. Excellent biography.

FIERAVANTI, A.
See Chapter 11, Note 8.

FILARETE
See Chapter 10, Note 8, and above, IC. TREATISES.

FRANCESCO DI GIORGIO MARTINI
See Chapter 7, Notes 31 and 33, and Chapter 13, Notes 4 and 12.

GHIBERTI
See Chapter 3, Note 1.

GIOCONDO, Fra
Cf. Chapter 12, Note 42.
Wolff Metternich, F. Graf. 'Der Entwurf Fra Giocondos für Sankt Peter', *Festschrift Kurt Bauch*, 155 ff. N.p., [1957].

GIORGIO DA SEBENICO (Giorgio Orsini, Giorgio Dalmata)
Cf. Chapter 9, Note 67.
Bima, C. *Giorgio da Sebenico . . .* Milan, 1954.
Marchini, G. 'Per Giorgio da Sebenico', *Commentari*, XIX (1969), 212 ff.

LAURANA, L.
Kimball, F. 'L. Laurana and the High Renaissance', *Art Bulletin* (1927), 129.
Marchini, G. *Bollettino d'Arte*, XLV (1960), 73 ff.
Michelini-Tocci, L. *I due manoscritti urbinati dei principi del Montefeltro con un appendice lauranesca*. Florence, 1959.

LEONARDO DA VINCI
See Chapter 13, Notes 51, 52, 60.

LOMBARDO, P.
Mariacher, G. 'P. Lombardo a Venezia', *Arte Veneta*, IX (1955), 36 ff.
Semenzato, C. 'Pietro e Tullio Lombardo architetti', *Bollettino Centro . . . Andrea Palladio*, VI (1964), 262 ff.

MAIANO, G. DA
Cf. Chapter 5, Note 29.
'Il Duomo di Faenza', *L'Architettura*, XI, 4 (1965), 262 ff.

MANETTI, A.
Cf. Chapter 5, Note 2.
Luporini, E. *Brunelleschi, passim*. Milan, 1964.

MANTEGNA
 See Chapter 8, Note 20.

MARTINI *see* FRANCESCO DI GIORGIO

MASCARINO
 Gloton, J.-J. 'Tradition michelangesque dans
 l'architecture de la Contre-Reforme: le cas
 Mascarino', *Stil und Überlieferung in der Kunst
 des Abendlandes* (Acts of the 21st International
 Congress for the History of Art, Bonn, 1964),
 II, 27. Berlin, 1967.

MEO DA CAPRINO
 Solero, S. *Il Duomo di Torino, passim.* Pinerolo,
 1956.
 Urban, G. *Römisches Jahrbuch für Kunstgeschichte,*
 IX–X (1961–2), *passim.*

MICHELANGELO
 Ackerman, J. S. *The Architecture of Michelangelo.*
 Revised ed. 2 vols. London, 1964–6. Italian
 ed.: *L'Architettura di Michelangelo.* Turin, 1968.
 Alker, H. R. *Michelangelo und seine Kuppel von St
 Peter in Rom.* Karlsruhe, 1968.
 Barocchi, P. (ed.). *G. Vasari: Vita di Michelangelo
 nelle redazioni del 1550 e del 1568.* 5 vols.
 Milan, 1962.
 Frey, D. *Michelangelostudien.* Vienna, 1920.
 Lotz, W. 'Zu Michelangelos Kopien nach dem
 Codex Coner', *Stil und Überlieferung in der
 Kunst des Abendlandes* (Acts of the 21st Inter-
 national Congress for the History of Art,
 Bonn, 1964), II, 12 ff. Berlin, 1967.
 Michelangelo artista-pensatore-scrittore. 2 vols.
 Novara, 1965. English ed. New York, 1965.
 With good bibliography by P. Meller, II, 597 ff.
 Portoghesi, P. 'La Biblioteca Laurenziana e la
 critica michelangiolesca alla tradizione clas-
 sica', *Stil und Überlieferung in der Kunst des
 Abendlandes* (Acts of the 21st International
 Congress for the History of Art, Bonn, 1964),
 II, 3. Berlin, 1967.
 Portoghesi, P., and Zevi, B. (eds.). *Michelangelo
 architetto.* Turin, 1964.
 Schiavo, A. *Michelangelo architetto.* Rome, 1949.
 Schiavo, A. *La Vita e le opere architettoniche di
 Michelangelo.* Rome, 1953.
 Thoenes, C. 'Bemerkungen zur Petersfassade
 Michelangelos', *Munuscula Disciplinorum, Fest-
 schrift Hans Kauffmann,* 331–41. Berlin, 1968.

Tolnay, C. de. *The Medici Chapel.* Princeton,
 1948.
Tolnay, C. de. *Michelangelo.* Florence, 1951.
Tolnay, C. de. 'Michelangelo architetto', *Il
 Cinquecento.* Florence, 1955.
Tolnay, C. de. 'Newly Discovered Drawings
 related to Michelangelo: The Scholz Scrap-
 book', *Stil und Überlieferung in der Kunst des
 Abendlandes* (Acts of the 21st International
 Congress for the History of Art, Bonn, 1964),
 II, 64. Berlin, 1967.

MICHELOZZO DI BARTOLOMEO
 Caplow, H. M. 'Michelozzo a Ragusa', *Journal
 of the Society of Architectural Historians,* XXXI
 (1972), 108 ff.
 Fabriczy, C. von. 'Michelozzo di Bartolomeo',
 Jahrbuch der Preussischen Kunstsammlungen, XXV
 (1904), Beiheft, 34 ff.
 Gori-Montanelli, L. *Brunelleschi e Michelozzo.*
 Florence, 1957.
 Heydenreich, L. H. 'Gedanken über Michel-
 ozzo', *Festschrift Wilhelm Pinder,* 264 ff.
 Leipzig, 1938.
 Mather, R. G. 'New Documents on Michel-
 ozzo', *Art Bulletin,* XXIV (1942), 226 ff.
 Morisani, O. *Michelozzo architetto.* Turin, 1951.
 With rich bibliography.
 Saalman, H. *Zeitschrift für Kunstgeschichte,* XXVIII
 (1965), 1 ff.
 Saalman, H. *Burlington Magazine* (1966), 242.
 Stegmann, G. von, and Geymüller, H. von. *Die
 Architektur der Renaissance in Toscana,* II.
 Munich, 1885–1907.
 Wolff, F. *Michelozzo di Bartolomeo.* Strassburg,
 1900.

NANNI DI BACCIO BIGI
 Lewine, M. 'Nanni, Vignola and S. Martino
 degli Svizzeri', *Journal of the Society of Archi-
 tectural Historians,* XXVIII (1968), 27 ff.
 Wittkower, R. 'Nanni di Baccio Bigio and
 Michelangelo', *Festschrift für Ulrich Middeldorf,*
 248 ff. Berlin, 1968.

OMODEO *see* AMADEO

ORSINI *see* GIORGIO DA SEBENICO

PALLADIO
 See Chapter 25, Note 1.

PELLEGRINI *see* TIBALDI

BIBLIOGRAPHY

PERUZZI

Burns, H. 'A Peruzzi Drawing in Ferrara', *Mitteilungen des Kunsthistorischen Institutes in Florenz*, XII (1966), 245–70.

Egger, H. 'Entwürfe Baldassare Peruzzis für den Einzug Karls V. in Rom', *Jahrbuch der Kunsthistorischen Sammlungen in Wien*, XXIII (1902), 1 ff.

Frommel, C. L. *Die Farnesina und Peruzzis architektonisches Frühwerk*. Berlin, 1961.

Kent, W. W. *The Life and Works of Baldassare Peruzzi*. New York, 1925.

POLLAIUOLO *see* **CRONACA**

PONTELLI

Fiore, G. de. *Baccio Pontelli architetto fiorentino*. Rome, 1963.

RAPHAEL

Brizio, A. M. 'Raffaello', *Enciclopedia universale dell'arte*, XI, 222 ff. Venice–Rome, 1964.

Geymüller, H. von. *Raffaello Sanzio studiato come architetto*. Milan, 1884.

Golzio, V. *Raffaello nei documenti*. Vatican City, 1936.

Hofmann, T. *Raffael in seiner Bedeutung als Architekt*. 4 vols. Zittau, 1904–14.

Marchini, G. 'Le Architetture', in A. M. Brizio (ed.), *Raffaello. L'opera. Le fonti. La fortuna.* 2 vols. Novara, 1968.

Oberhuber, K. 'Eine unbekannte Zeichnung Raffaels [for St Peter's] in den Uffizien', *Mitteilungen des Kunsthistorischen Institutes in Florenz*, XII (1966), 225 ff.

Shearman, J. 'Raphael . . . "fa il Bramante"', *Studies in Renaissance and Baroque Art presented to Anthony Blunt*, 12 ff. London and New York, 1967.

Shearman, J. 'Raphael as Architect', *Journal of the Royal Society of Arts*, CXVI (1968), 388 ff.

RIZZO, A.

Cf. Chapter 9, Note 49.

Muraro, M. 'La Scala senza giganti', *De Artibus Opuscula XL. Essays in Honor of Erwin Panofsky*, 350 ff. New York, 1961.

Paoletti, P. *L'Architettura e la scultura del Rinascimento a Venezia*, 141 ff. Venice, 1893.

ROMANO, G.

See Notes to Chapter 20.

ROSSELLINO, B. and A.

See Chapter 5, Notes 17, 18, 21, 27.

ROSSETTI

Cf. Chapter 11, Note 21.

Zevi, B. *Biagio Rossetti*. Ferrara, 1960.

SANGALLO THE ELDER, A. DA

See Chapter 13, Note 44.

SANGALLO THE YOUNGER, A. DA

Clausse, G. *Les San Gallo: Architectes, peintres, sculpteurs, médailleurs, XVe et XVIe siècles.* 3 vols. Paris, 1900–2.

Frommel, C. L. 'Antonio da Sangallos Cappella Paolina. Ein Beitrag zur Baugeschichte des Vatikanischen Palasts', *Zeitschrift für Kunstgeschichte*, XXVII (1964), 1 ff.

Giovannoni, G. *Antonio da Sangallo il giovane.* 2 vols. Rome, 1959.

Urban, G. 'Die Cappella Cesi in S. Maria della Pace und die Zeichnungen des Antonio da Sangallo', *Miscellanea Bibliothecae Hertzianae*, 213 ff. Munich, 1961.

SANGALLO, G. DA

See Chapter 13, Notes 17, 20.

SANMICHELI

Gazzola, P. (ed.). *Michele Sanmicheli. Catalogo* (of exhibition, Verona, 1960). Venice, 1960.

Langenskioeld, E. *Michele Sanmicheli. The Architect of Verona.* Uppsala, 1938.

Michele Sanmicheli. Studi raccolti dall'Accademia di Agricoltura, Scienze e Lettere di Verona per la celebrazione del quarto centenario della morte. Verona, 1960.

Puppi, L. *Michele Sanmicheli, architetto di Verona.* Padua, 1971.

Ronzani, F., and Luciolli, G. *Le Fabbriche civili, ecclesiastiche e militari di Michele Sanmicheli.* Verona, 1823–30.

SANSOVINO, J.

Lotz, W. 'Sansovinos Bibliothek von S. Marco und die Stadtbaukunst der Renaissance', *Kunst des Mittelalters in Sachsen: Festschrift Wolf Schubert*, 336 ff. Weimar, 1967.

Piazza San Marco: l'architettura, la storia, le funzioni. Padua, 1970.

Puppi, L. 'La Villa Garzoni ora Carraretto a Pontecasale di Jacopo Sansovino', *Bollettino Centro Internazionale Studi Architettura Andrea Palladio*, XI (1969), 95 ff.

BIBLIOGRAPHY

Tafuri, M. *Jacopo Sansovino e l'architettura del '500 a Venezia*. Padua, 1969.
With bibliography.

SCAMOZZI

Barbieri, F. *Vincenzo Scamozzi*. Vicenza and Belluno, 1952.

Barbieri, F. *Vincenzo Scamozzi: Taccuino di viaggio da Parigi a Venezia*. Venice and Rome, 1959.

Barbieri, F. 'Le Ville dello Scamozzi', *Bollettino Centro Internazionale Studi Architettura Andrea Palladio*, XI (1969), 222 ff.

Gallo, R. 'Vincenzo Scamozzi e la chiesa di S. Nicolò da Tolentino a Venezia', *Atti dell' Istituto Veneto di Scienze, Lettere ed Arti*, CXVII (1958/9), 103 ff.

Pallucchini, R. 'Vincenzo Scamozzi e l'architettura veneta', *L'Arte*, XXXIX (1936), 3 ff.

Puppi, L. 'Vincenzo Scamozzi trattatista nell' ambito della problematica del Manierismo', *Bollettino Centro Internazionale Studi Architettura Andrea Palladio*, IX (1967), 310 ff.

Puppi, L. 'Prospettive dell'Olimpico, documenti dell'Ambrosiana e altre cose: argomenti per una replica', *Arte Lombarda*, XI (1966), part I, 26 ff.

Semenzato, C. 'La Rocca pisana', *Arte Veneta*, XVI (1962), 98 ff.

Talamini, T. 'Le Procuratie nuove', *Piazza S. Marco. L'architettura, la storia, le funzioni*, 177 ff. Padua, 1970.

SERLIO

Argan, G. C. 'Sebastiano Serlio', *L'Arte*, N.S. X (1932), 183 ff.

Chastel, A. 'La Demeure royale au XVIe siècle et le nouveau Louvre', *Studies in Renaissance and Baroque Art presented to Anthony Blunt*, 183 ff. London and New York, 1967.

Rosci, M. *Il Trattato di architettura di Sebastiano Serlio*. Milan, 1966.

Timofiewitsch, W. 'Ein Gutachten Sebastiano Serlios für die Scuola di S. Rocco', *Arte Veneta*, XVII (1963), 158 ff.

SOLARI FAMILY

See Chapter 10, Note 18.

TIBALDI

Hiersche, W. *Pellegrino de' Pellegrini als Architekt*. Parchim, 1913.

Peroni, A. 'Architetti manieristi nell'Italia settentrionale: Pellegrino Tibaldi e Galeazzo Alessi', *Bollettino Centro Internazionale Studi Architettura Andrea Palladio*, IX (1967), 272 ff.
With bibliography.

Pignatti, T. 'L'Architettura del Collegio Ghislieri', *Il Collegio Ghislieri 1567–1967*, 299 ff. Milan, 1967.

TRAMELLO

Cf. Chapter 11, Note 38.

Ganz, J. *Alessio Tramello*. Frauenfeld (Switzerland), 1968.

Venturi, A. *Storia dell'arte italiana*, XI (1), 738 ff. Milan, 1938–40.
For good illustrations.

VALERIANO

Enrichetti, M. 'L'Architetto Giuseppe Valeriano', *Archivio storico per le provincie napoletane*, XXXIX (1960), 325 ff.

Pirri, P. *Giuseppe Valeriano S.I., architetto e pittore, 1542–1596*. Rome, 1970.

VASARI

Kallab, W. *Vasari-Studien* (Quellenschriften für Kunstgeschichte und Kunsttechnik, N.F. XIV). Vienna, 1908.

VASARI THE YOUNGER

Vasari, G. (ed. V. Stefanelli). *La Città ideale. Piante di chiese, palazzi e ville*. Rome, 1970.

VIGNOLA

Ackerman, J. S., and Lotz, W. 'Vignoliana', *Essays in Memory of Karl Lehmann*, I ff. Locust Valley, N.Y., 1964.

Partridge, L. W. 'Vignola and the Villa Farnese at Caprarola, part I', *Art Bulletin*, LII (1970), 81 ff.

Walcher Casotti, M. *Il Vignola*. 2 vols. Trieste, 1960.
Reviewed by C. Thoenes, *Kunstchronik*, XV (1962), 151 ff.

VITOZZI

Carboneri, N. *Ascanio Vitozzi. Un architetto tra Manierismo e Barocco*. Rome, 1966.

VOLTERRA

See Chapter 23, Notes 41–3.

THE PLATES

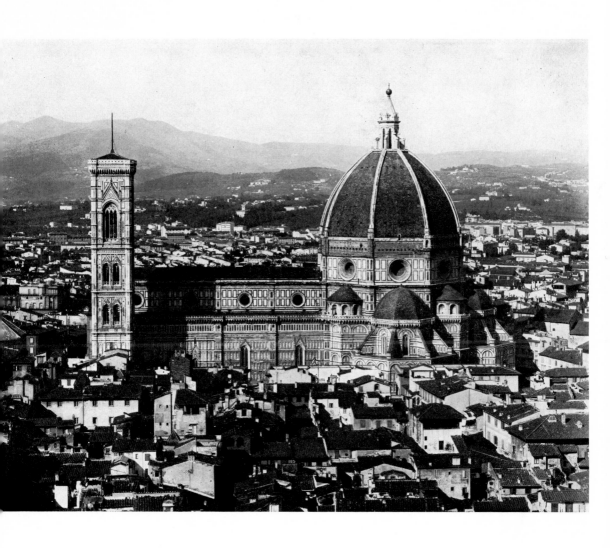

1. Filippo Brunelleschi: Florence Cathedral, dome 1420–36

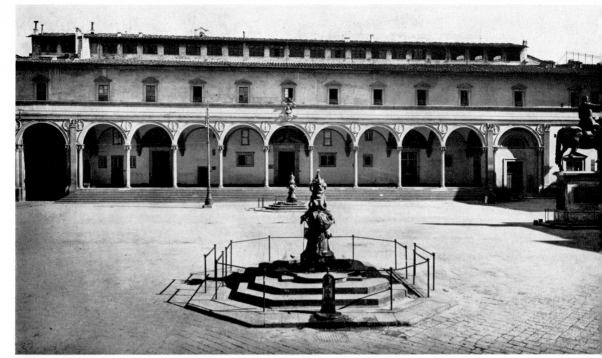

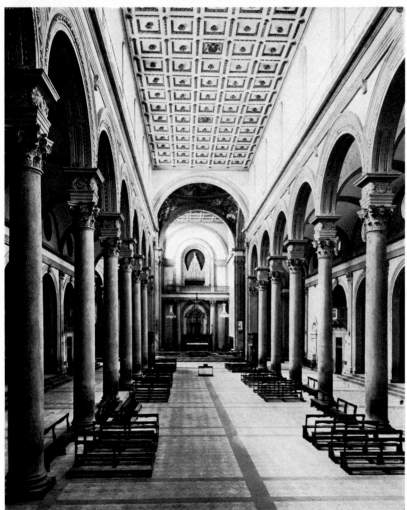

2. Filippo Brunelleschi:
Florence, Foundling
Hospital, begun 1419

3. Filippo Brunelleschi:
Florence, S. Lorenzo, 1421 ff.

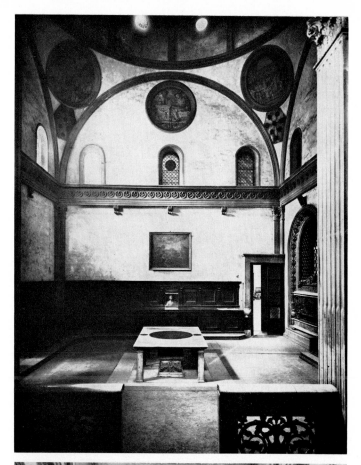

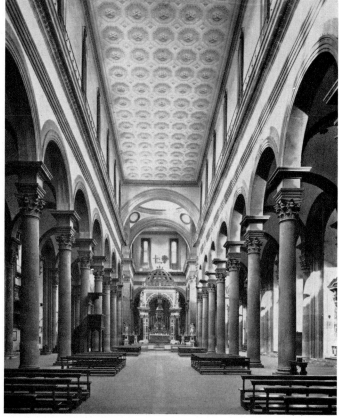

4. Filippo Brunelleschi: Florence,
S. Lorenzo, 1421 ff., Sagrestia Vecchia

5. Filippo Brunelleschi: Florence,
S. Spirito, begun 1436

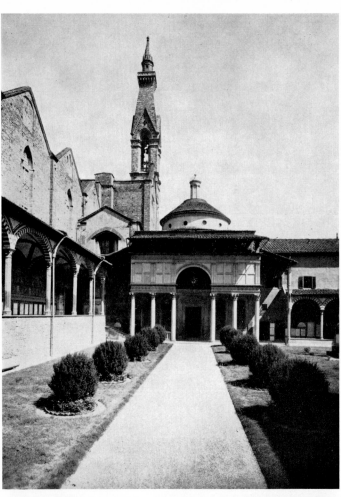

6. Filippo Brunelleschi: Florence, S. Croce, Pazzi Chapel, commissioned 1429

7. Filippo Brunelleschi: Florence, S. Croce, Pazzi Chapel, commissioned 1429

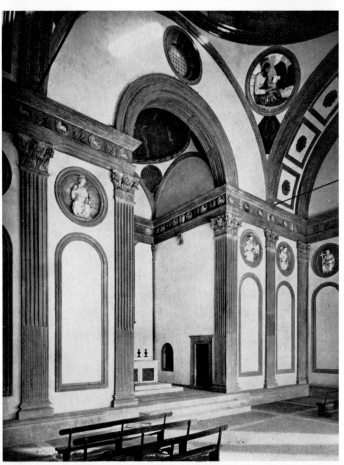

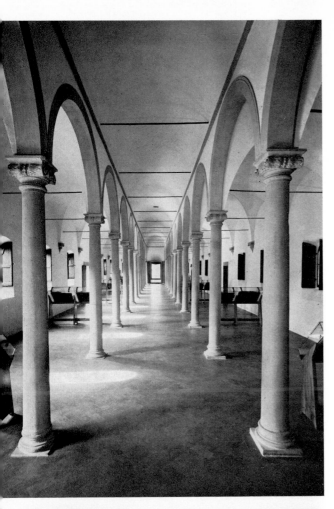

8. Michelozzo di Bartolomeo: Florence, S. Marco, late 1430s, library

9. Michelozzo di Bartolomeo: Florence, S. Miniato, shrine, 1448

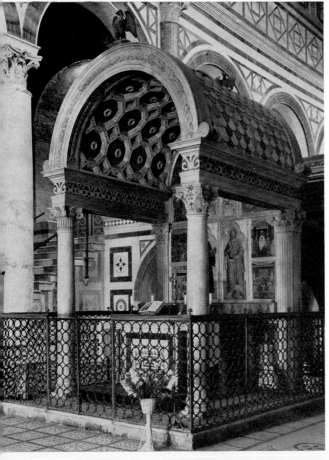

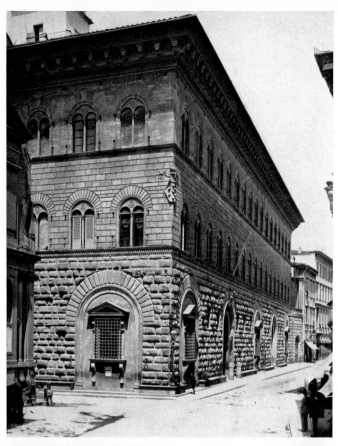

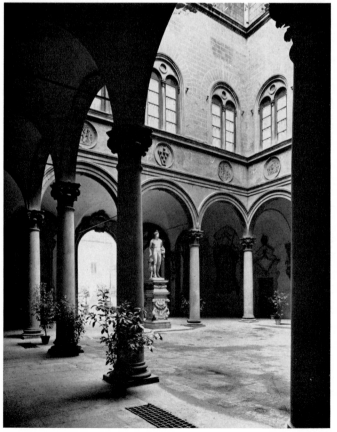

10. Michelozzo di Bartolomeo: Florence, Palazzo Medici, begun 1444

11. Michelozzo di Bartolomeo: Florence, Palazzo Medici, begun 1444, courtyard

12. Michelozzo di Bartolomeo: Pistoia, S. Maria delle Grazie, designed *c.* 1452

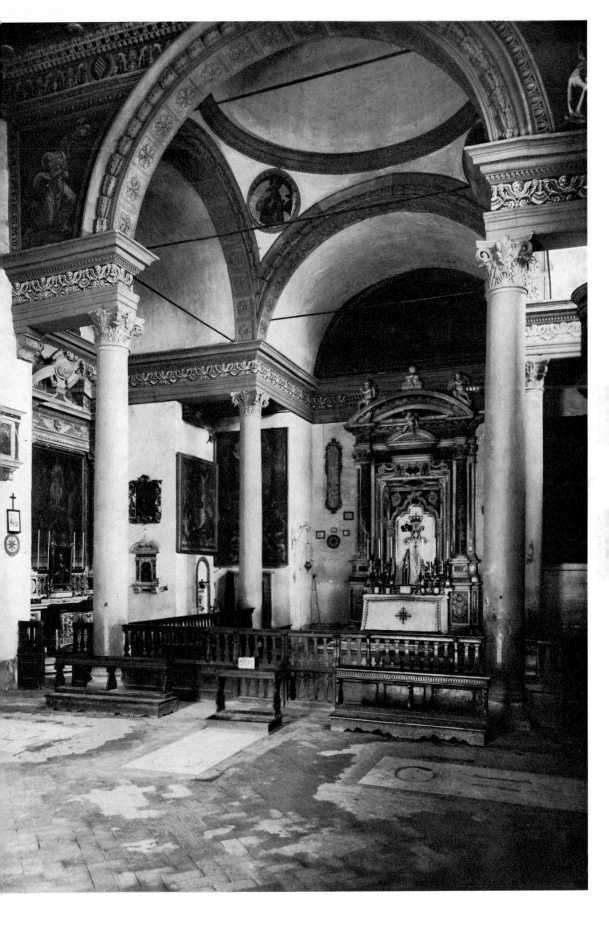

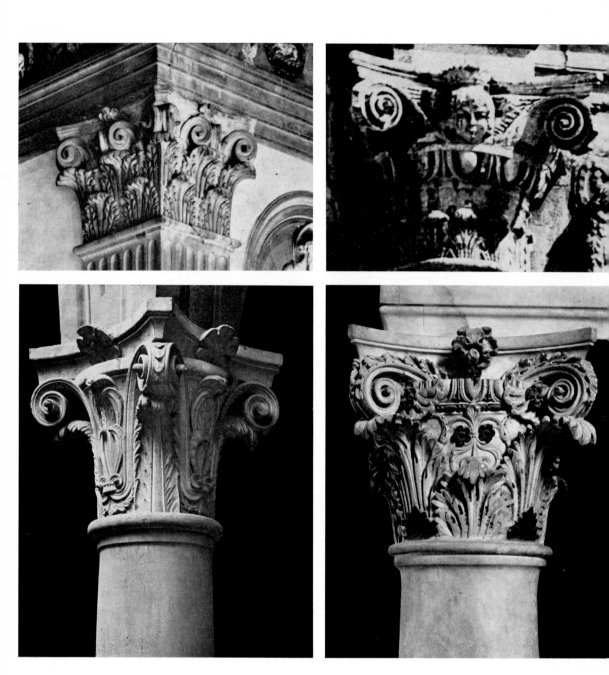

13. Capitals: (A) Filippo Brunelleschi: Florence, S. Croce, Pazzi Chapel, 1440s
(B) L. B. Alberti: Rimini, S. Francesco, begun *c.* 1450, façade
(C) Michelozzo di Bartolomeo: Florence, SS. Annunziata, *c.* 1450, entrance
(D) Michelozzo di Bartolomeo: Florence, S. Miniato, shrine, 1448

(E) Fiesole, Badia Fiesolana, courtyard, *c.* 1460

(F) Giuliano da Maiano(?): Florence, Palazzo Pazzi-Quaratesi, 1460–72, courtyard

(G) Giuliano da Sangallo: Florence, S. Maria Maddalena de' Pazzi, courtyard

(H) Giuliano da Sangallo: Florence, S. Spirito, sacristy

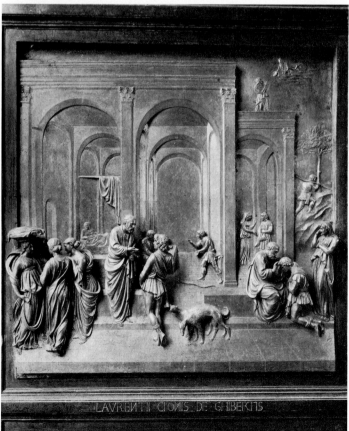

LAVRENTII CIONIS DE GHIBERTIS

14. Lorenzo Ghiberti: Florence, Or
San Michele, St Matthew Tabernacle,
1419–22

15. Lorenzo Ghiberti: Florence,
Baptistery, second door, relief of
Jacob and Esau, c. 1430–5

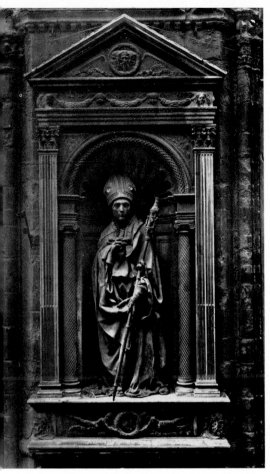

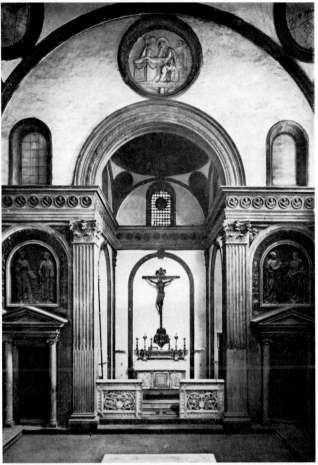

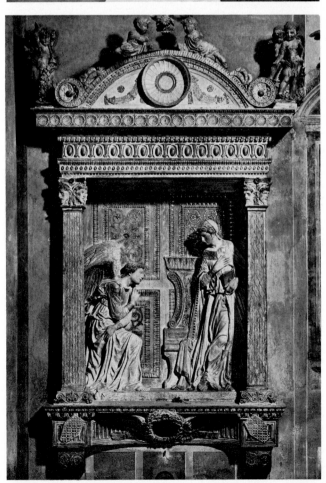

16. Donatello: Florence, Or San Michele, St
Louis Tabernacle (showing the statue in its
original setting), completed 1425

17. Donatello: Florence, S. Lorenzo,
Sagrestia Vecchia, door frames and
sculpture, probably begun *c.* 1429

18. Donatello: Florence, S. Croce, taber-
nacle of the Annunciation, *c.* 1435

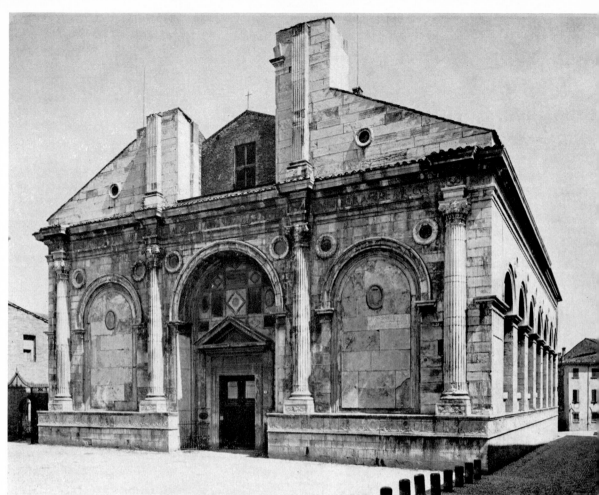

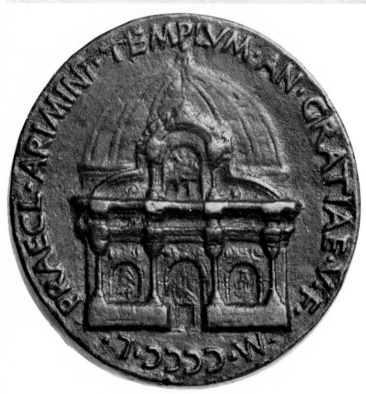

19. L.B. Alberti: Rimini,
S. Francesco, begun *c.* 1450

20. Matteo de' Pasti: Medal
(enlarged) of S. Francesco, Rimini,
1450

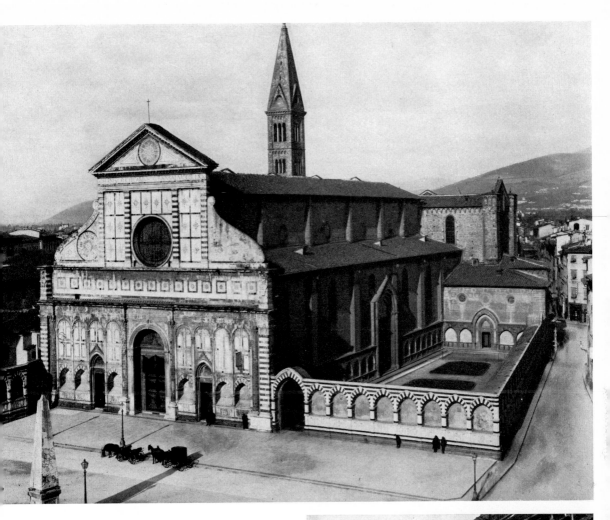

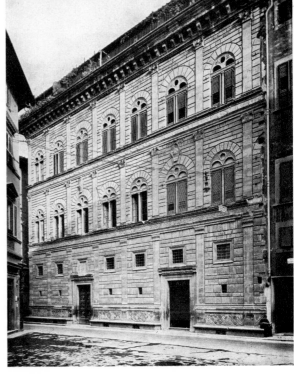

21. L. B. Alberti: Florence, S. Maria Novella, façade, probably begun *c.* 1455–60

22. L. B. Alberti: Florence, Palazzo Rucellai, probably begun *c.* 1455–60

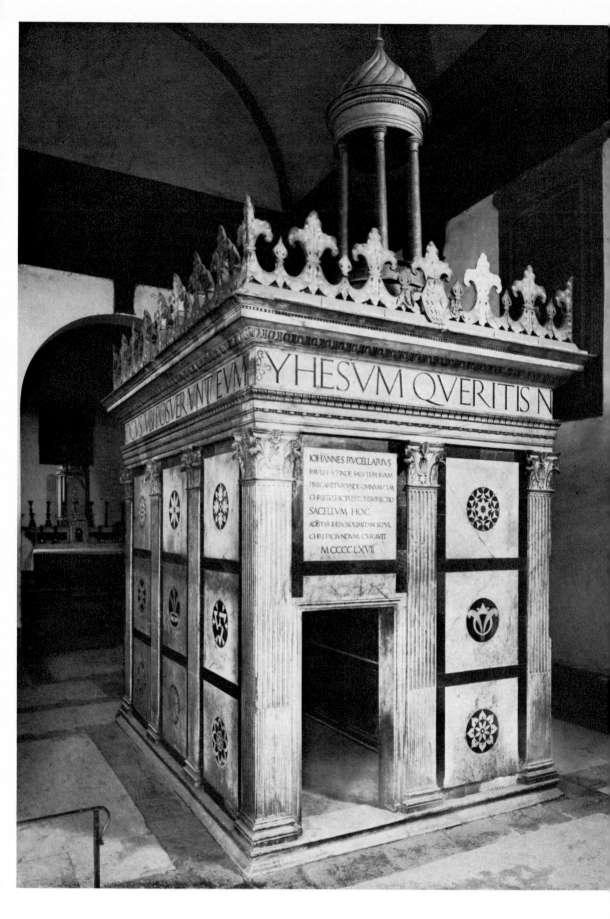

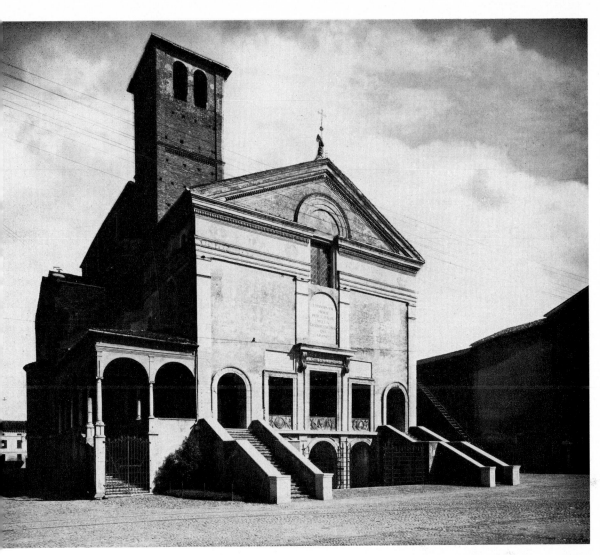

23. L. B. Alberti:
Florence, S. Pancrazio,
Chapel of the Holy
Sepulchre, *c.* 1455–60

24. L. B. Alberti: Mantua,
S. Sebastiano, begun 1460

25. L. B. Alberti: Mantua,
S. Sebastiano, and (*right*)
Florence, S. Pancrazio,
engraving from Seroux
d'Agincourt, early
nineteenth century

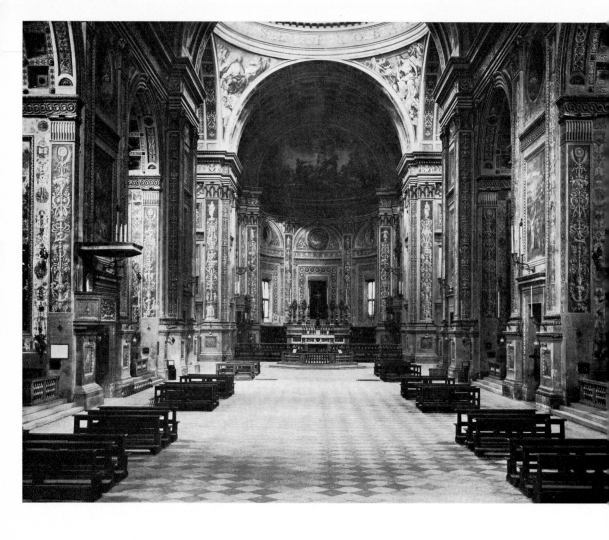

26. L. B. Alberti: Mantua, S. Andrea, begun 1470, interior

27. L. B. Alberti: Mantua, S. Andrea, begun 1470, façade

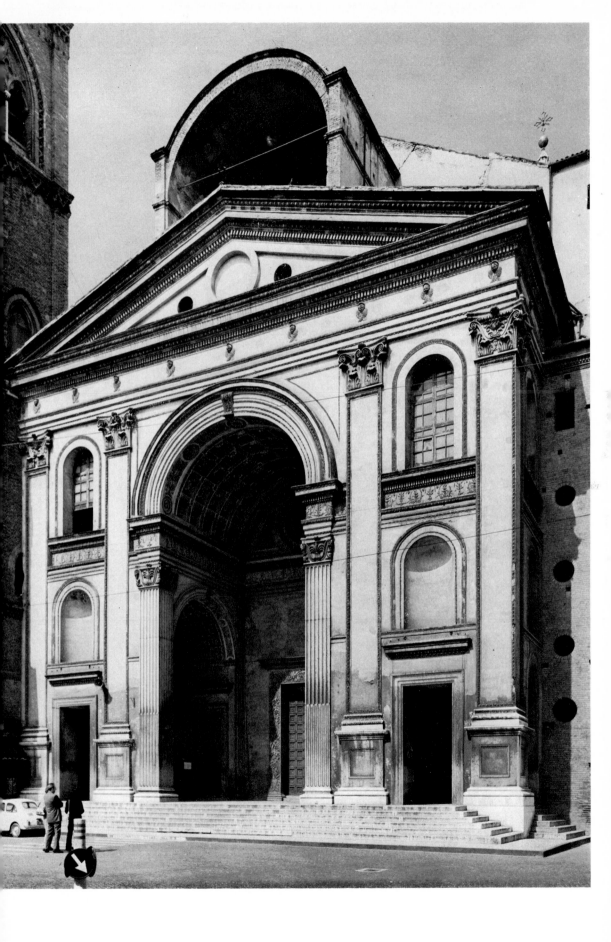

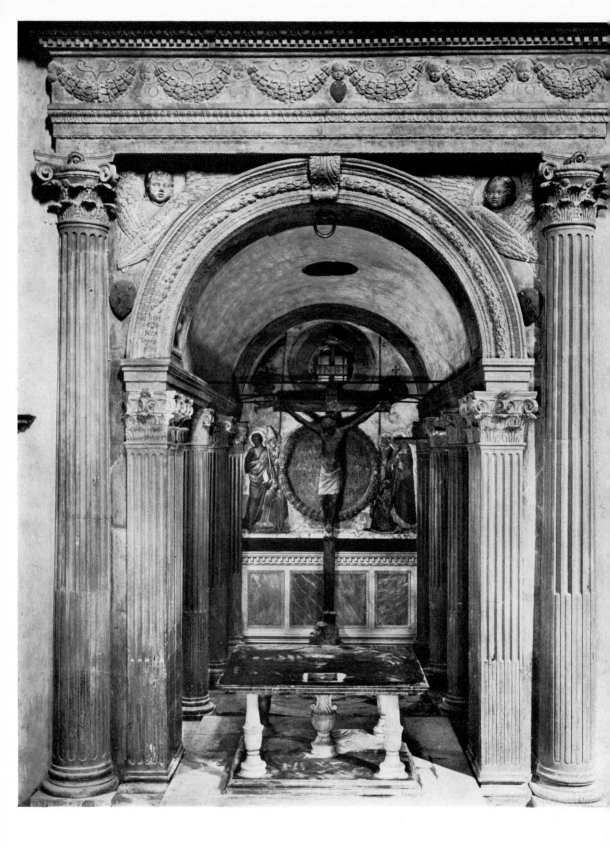

28. Pescia, S. Francesco, Cappella Cardini, 1451

29. Fiesole, Badia Fiesolana, begun 1461

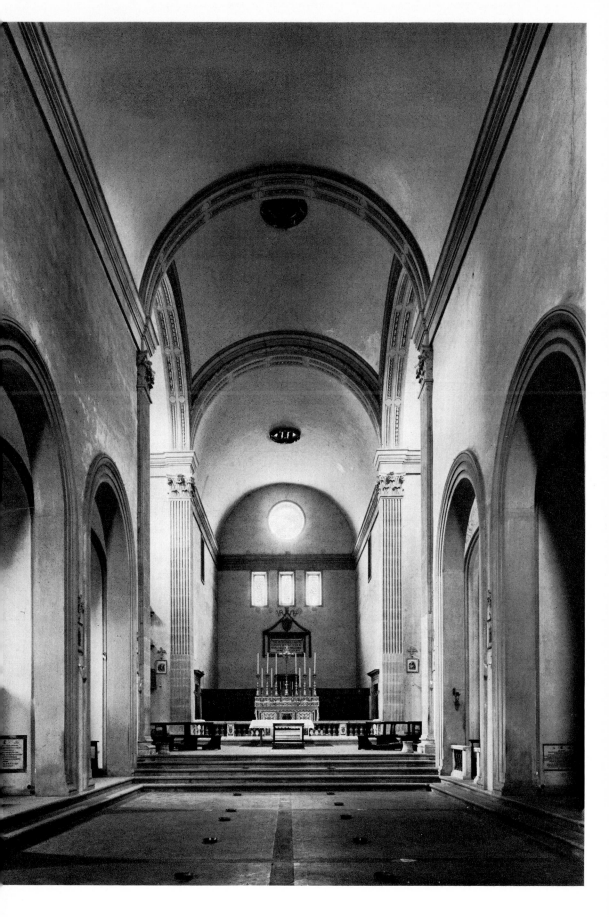

30. Florence, Palazzo Gerini-Neroni, 1460(?)

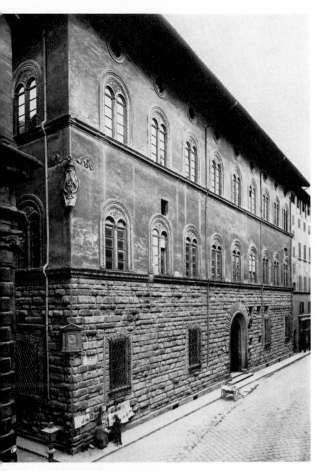

31. Giuliano da Maiano (?): Florence,
Palazzo Pazzi-Quaratesi, 1460–72

32. Florence, Palazzo Pitti, begun 1458

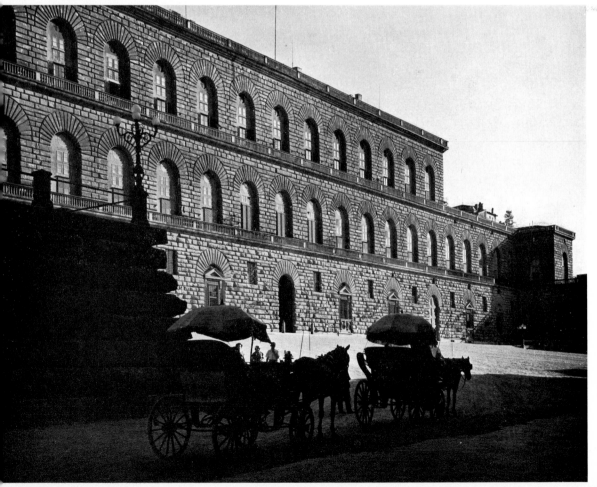

33. Bernardo Rossellino: Arezzo, Misericordia, façade, 1433 (lower parts fourteenth century)

34. Bernardo Rossellino: Florence, Badia, Chiostro degli Aranci, 1436–7

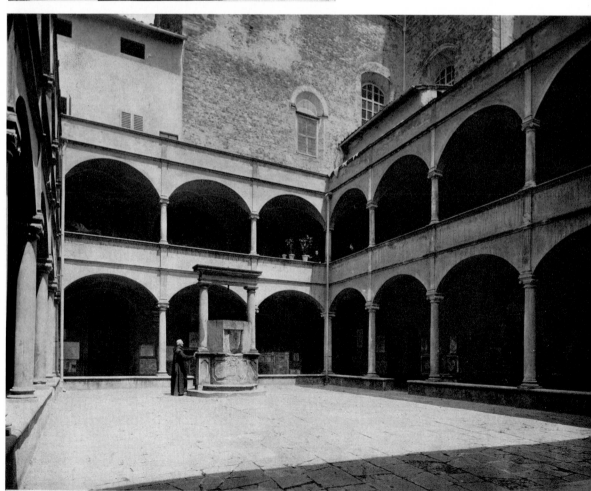

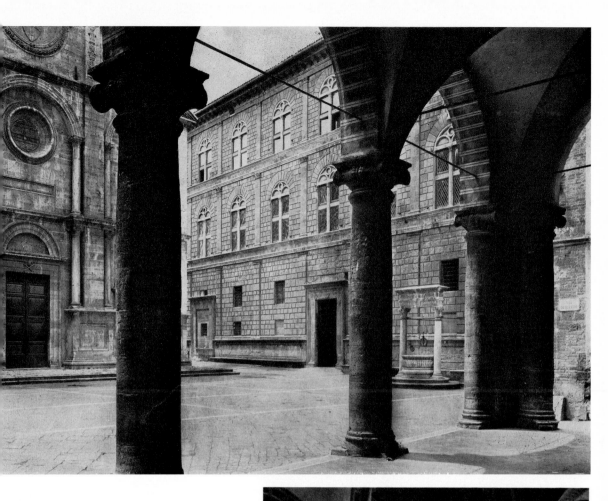

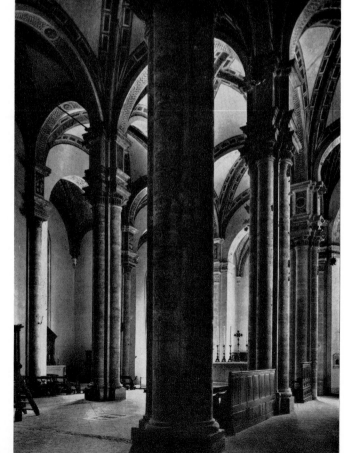

35. Bernardo Rossellino: Pienza, piazza,
1460–2

36. Bernardo Rossellino: Pienza
Cathedral, 1460–2

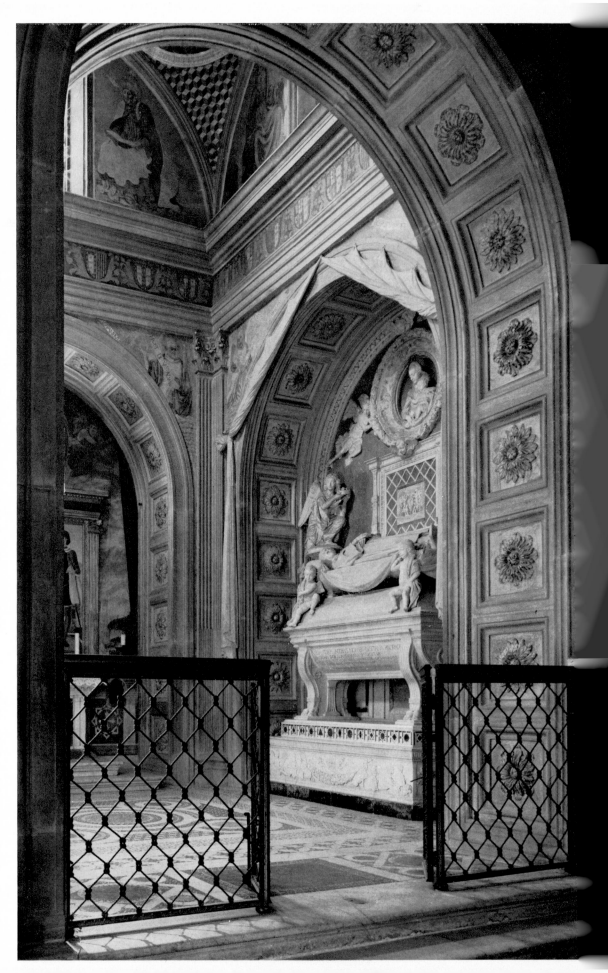

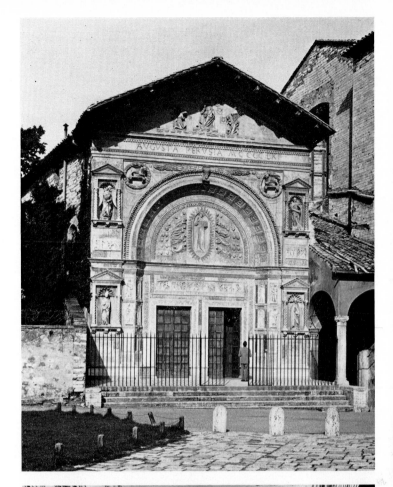

37. Antonio Rossellino and others:
Florence, S. Miniato, Chapel of the
Cardinal of Portugal, 1461–6

38. Agostino di Duccio: Perugia,
S. Bernardino, façade, 1457–61

39. Giuliano da Maiano: Faenza
Cathedral, begun 1474

40. Loreto, Basilica, exterior,
c. 1470–95

41. Giuliano da Maiano: Loreto,
Basilica, interior, after 1470

42. Rome, Vatican, Tower of
Nicholas V, 1447/55

43. Rome, Vatican Palace, Nicholas
V's range, 1447/55

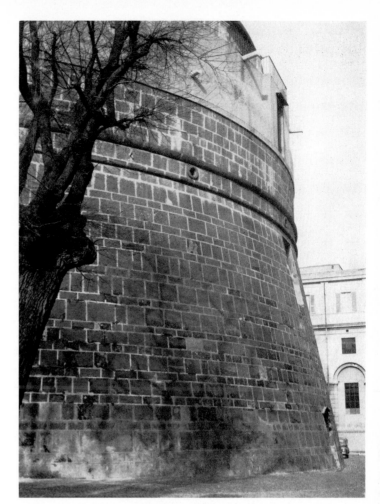

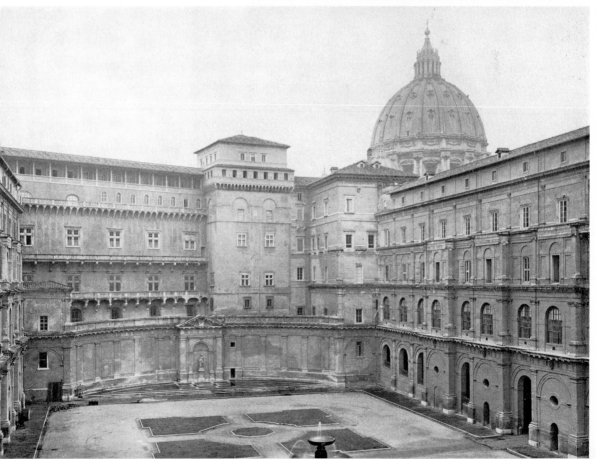

44. Rome, S. Onofrio, between 1434 and 1444

45. Rome, S. Giacomo degli Spagnoli, *c.* 1455–*c.* 1470

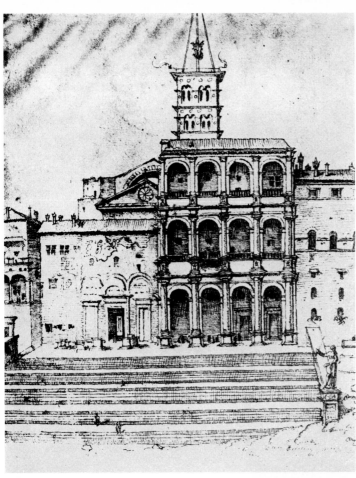

46. Rome, St Peter's, Benediction Loggia, *c.* 1461–95. Drawing by Marten van Heemskerck. *Vienna, Albertina*

47. Rome, S. Marco, façade, *c.* 1460–5

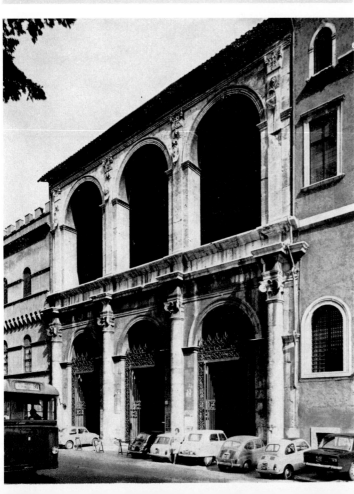

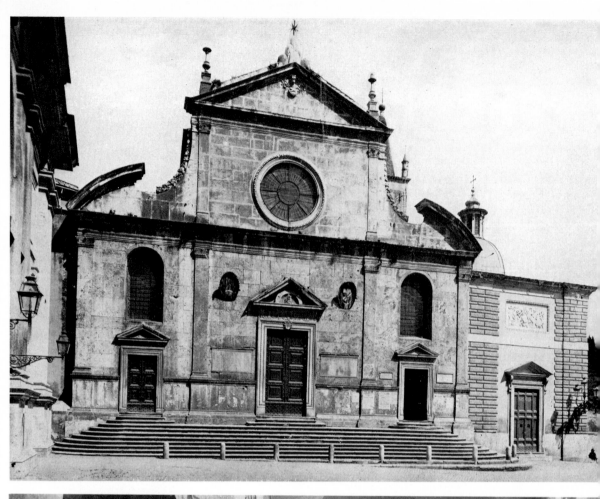

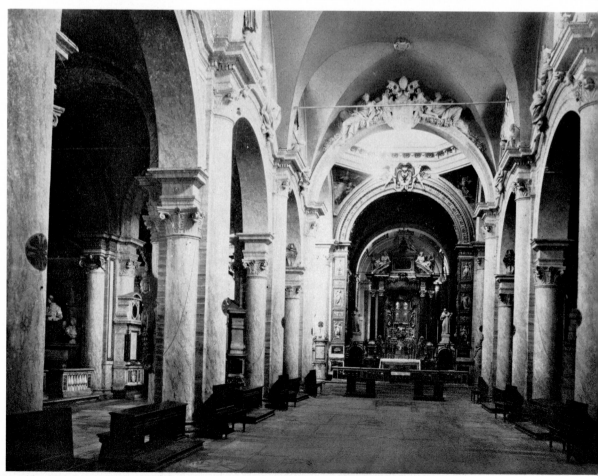

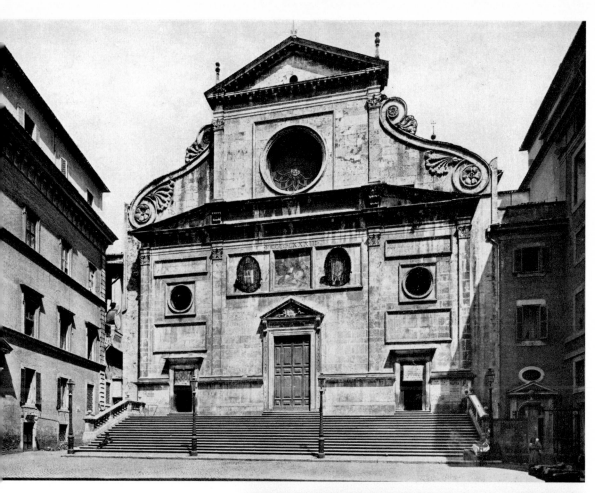

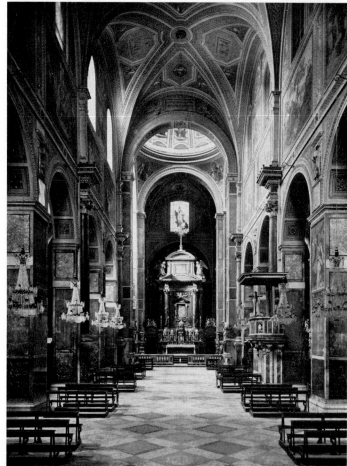

48 and 49. Rome, S. Maria del Popolo,
1472–80

50 and 51. Rome, S. Agostino,
1479–83

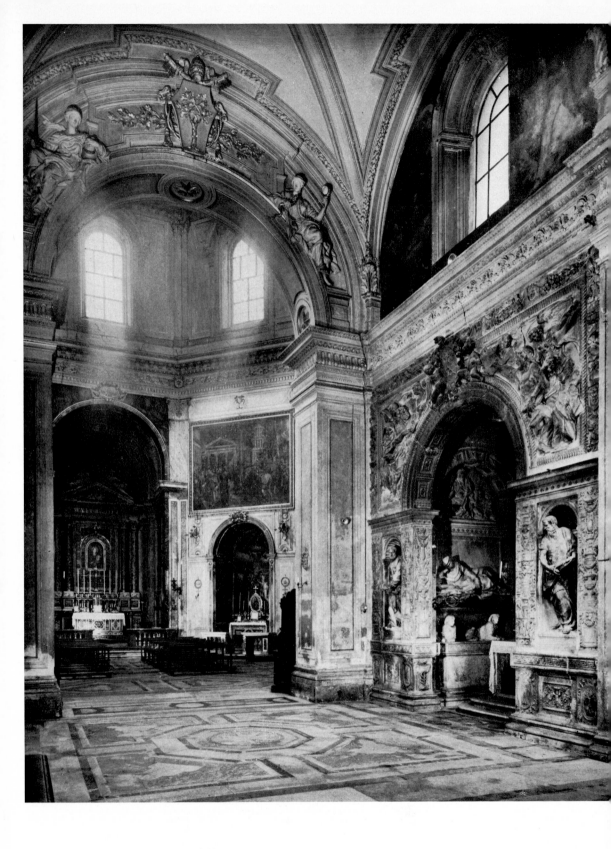

52. Rome, S. Maria della Pace, after 1478–1483

53 and 54. Rome, S. Pietro in Montorio, *c.* 1480–1500

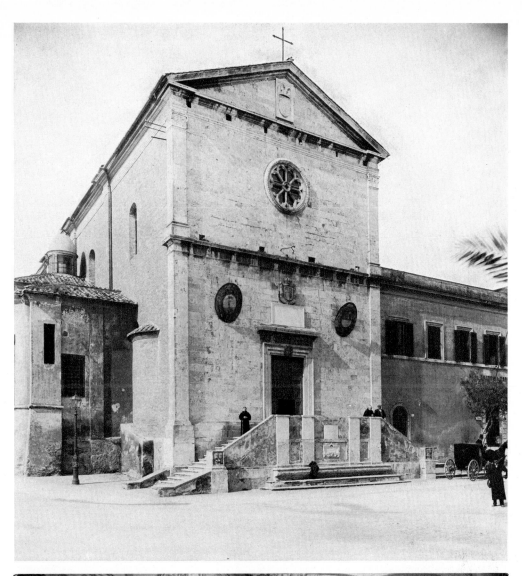

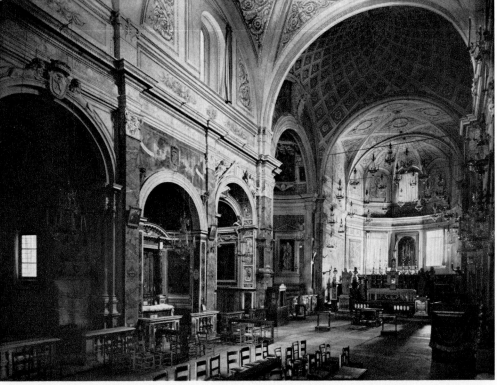

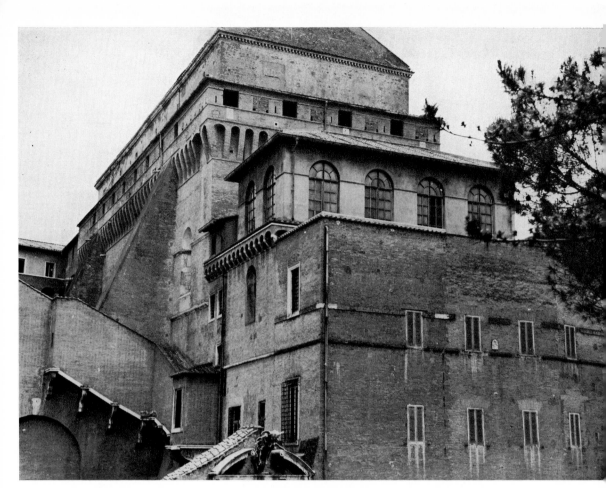

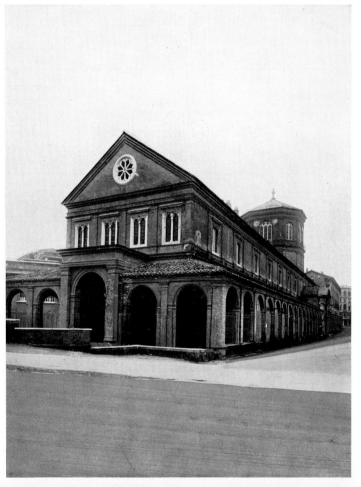

55. Rome, Vatican, Sistine Chapel, 1473–81

56. Rome, Ospedale di S. Spirito, 1474–82

57. Rome, Cancelleria Vecchia, 1458–62, courtyard (restored)

58. Rome, Palazzo Venezia, begun 1455

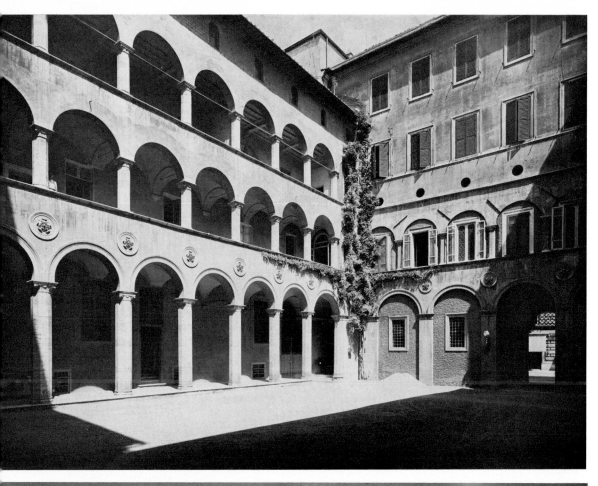

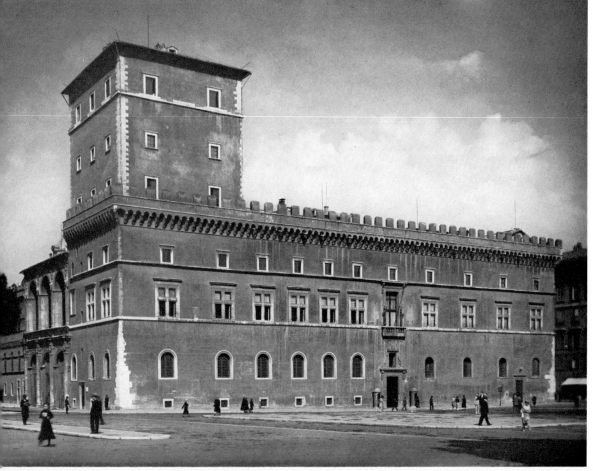

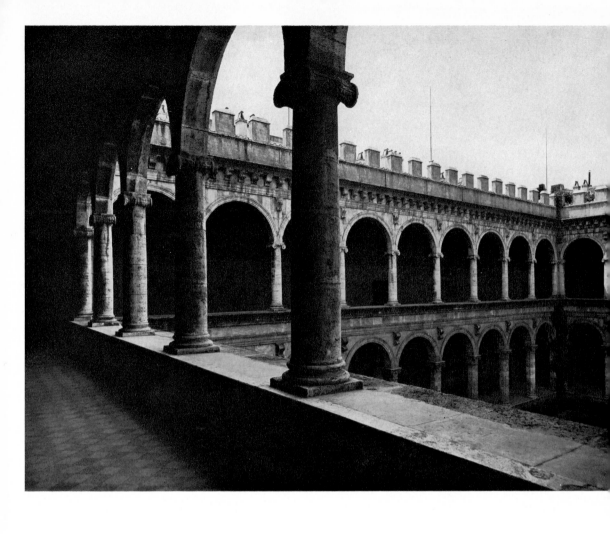

59 and 60. Rome, Palazzo Venezia, begun 1455, Palazzetto (*above*) and great courtyard

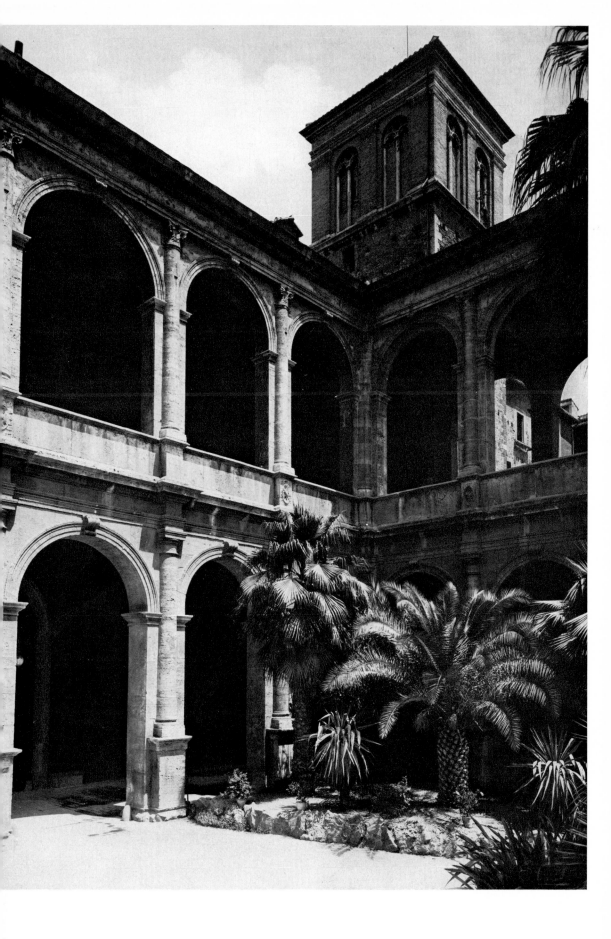

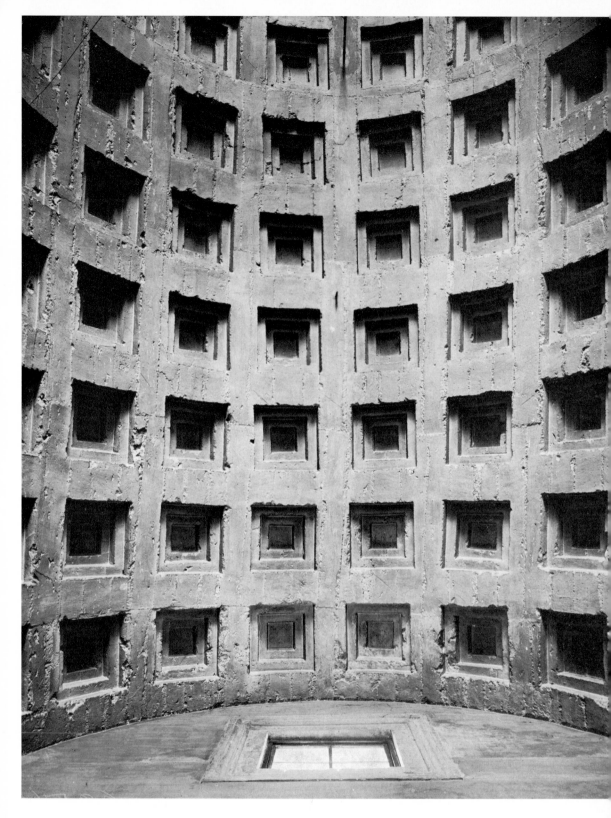

61. Rome, Palazzo Venezia, begun 1455, vault of the great entrance

62. Rome, Cancelleria, begun *c.* 1485

63. Rome, Cancelleria, begun *c.* 1485, courtyard

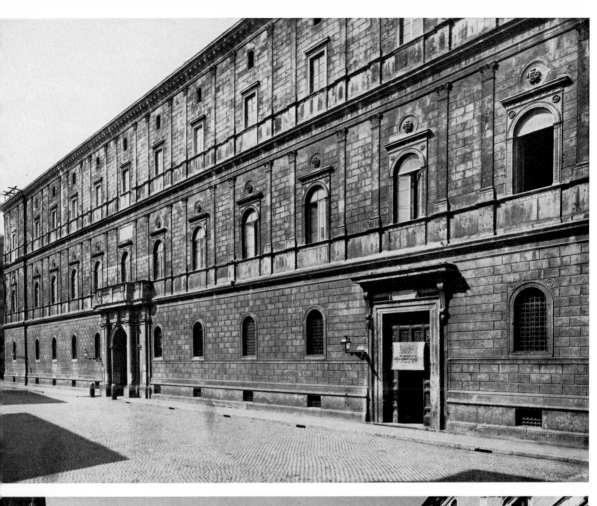

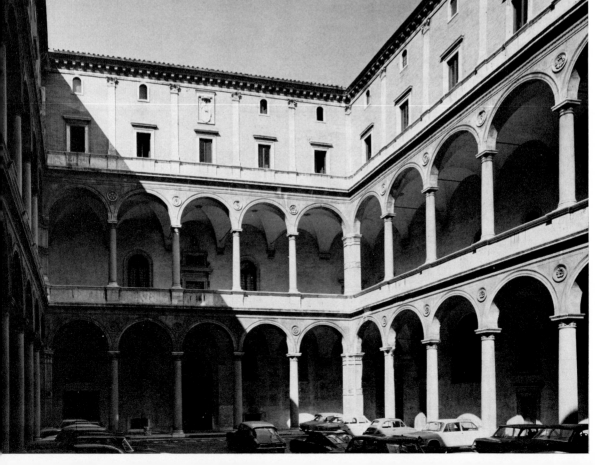

64. Urbino

65 and 66. Luciano Laurana: Urbino, Palazzo Ducale, designed 1464, west façade and courtyard

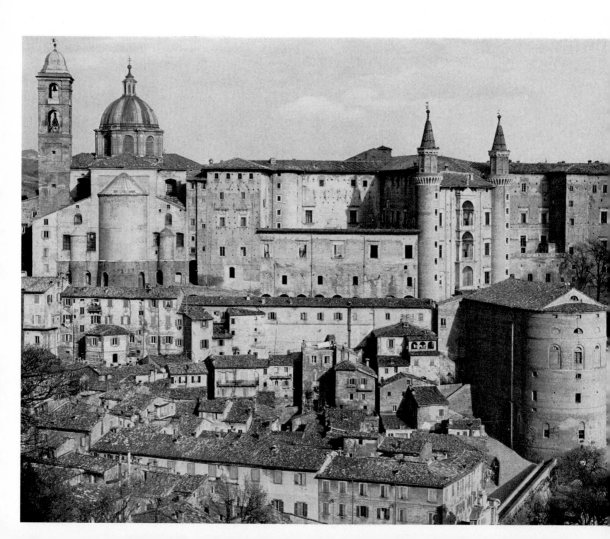

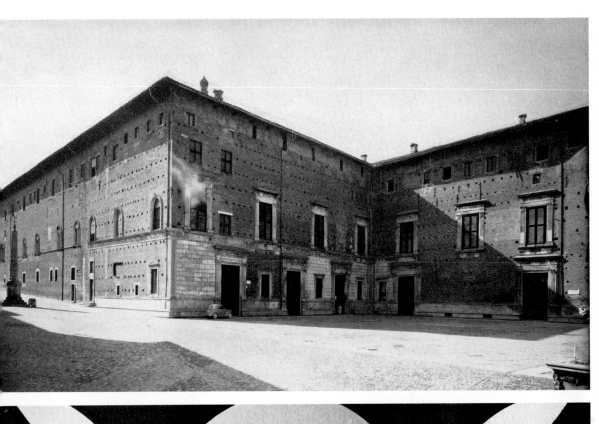
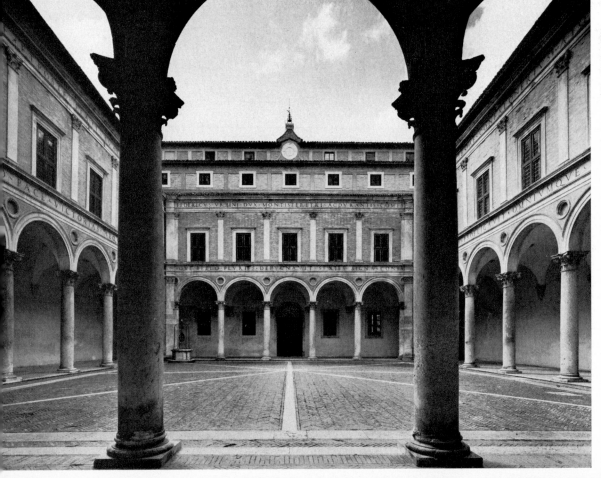

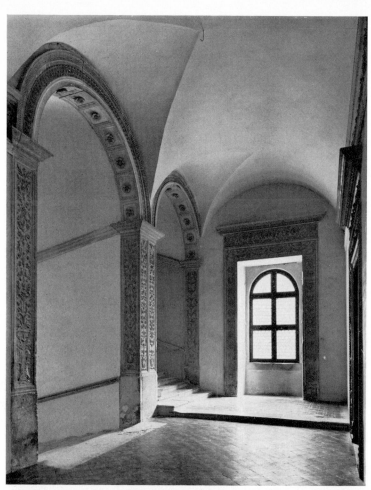

67. Luciano Laurana: Urbino,
Palazzo Ducale, designed 1464,
staircase landing

68. Luciano Laurana: Urbino,
Palazzo Ducale, designed 1464, Sala
del Trono

69. Luciano Laurana: Urbino,
Palazzo Ducale, Cappella del
Perdono, designed after 1464,
finished 1480

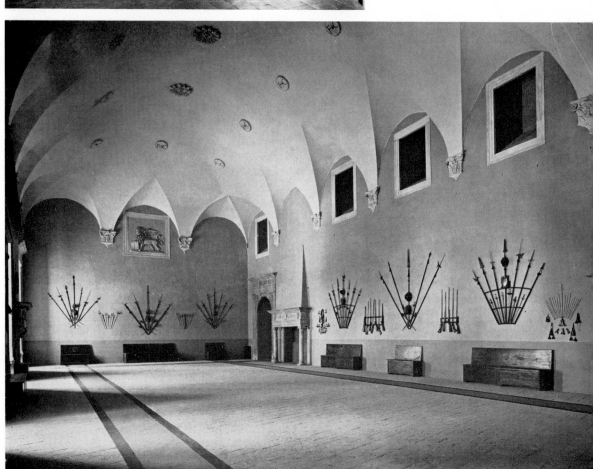

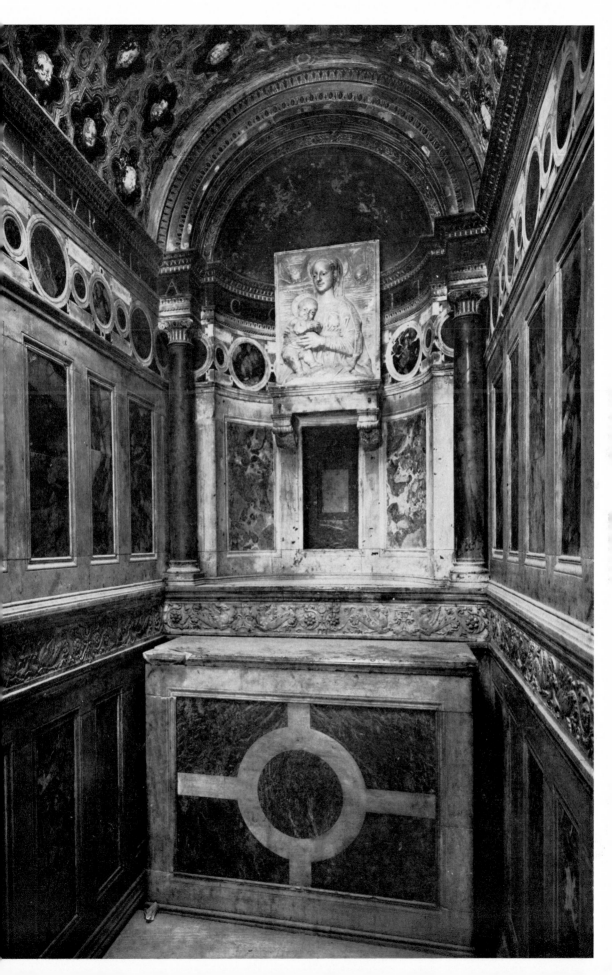

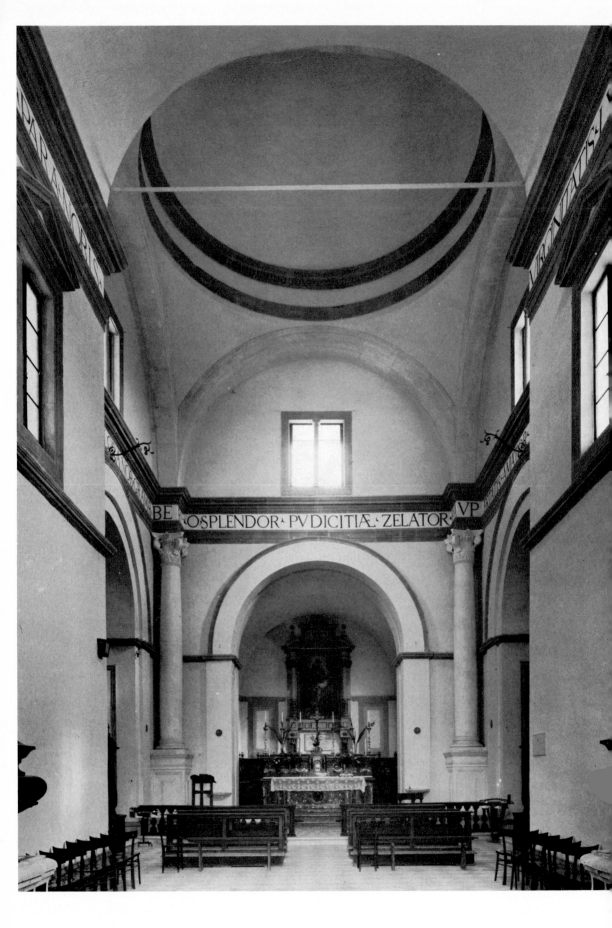

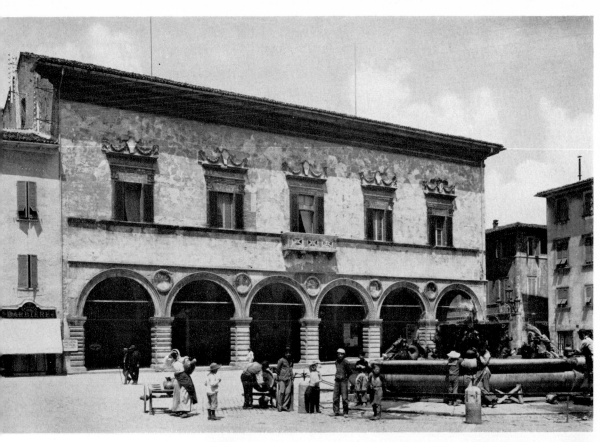

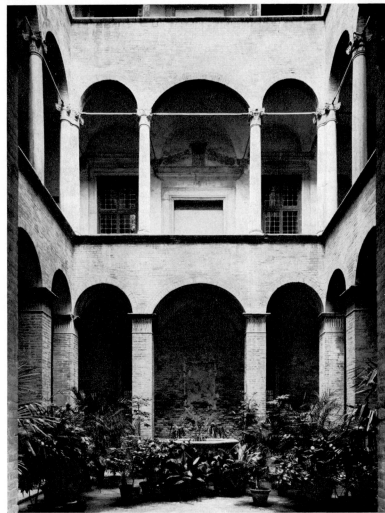

70. Francesco di Giorgio Martini: Urbino, S. Bernardino, between 1482 and 1490

71. Giorgio da Sebenico(?) and others: Pesaro, Palazzo Comunale, ground floor *c.* 1450, first floor *c.* 1470

72. Francesco di Giorgio Martini: Jesi, Palazzo Comunale, courtyard, *c.* 1490–1500

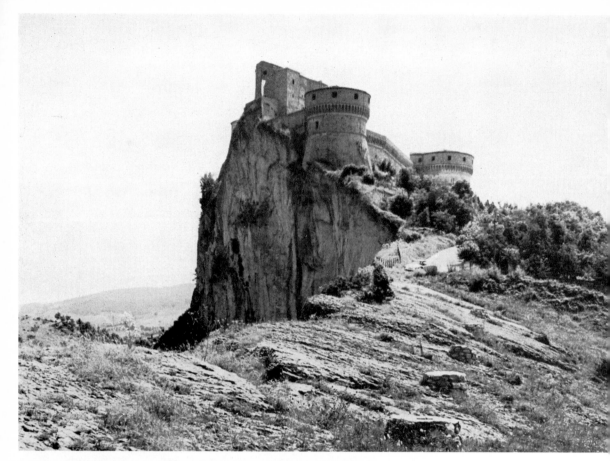

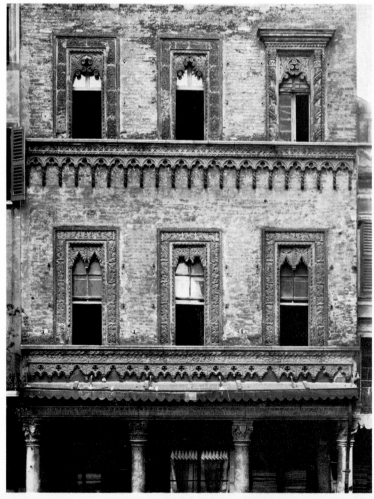

73. Rocca S. Leo, 1479 ff.

74. Mantua, Casa di Giovanni
Boniforte da Concorezzo, 1455

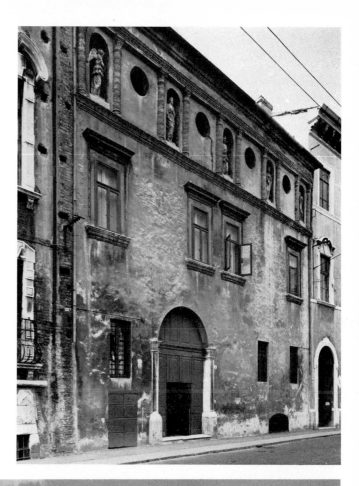

75. Mantua, Casa via Frattini 5,
c. 1460–70

76. Luca Fancelli: Mantua, Palazzo
Ducale, Nova Domus, c. 1480

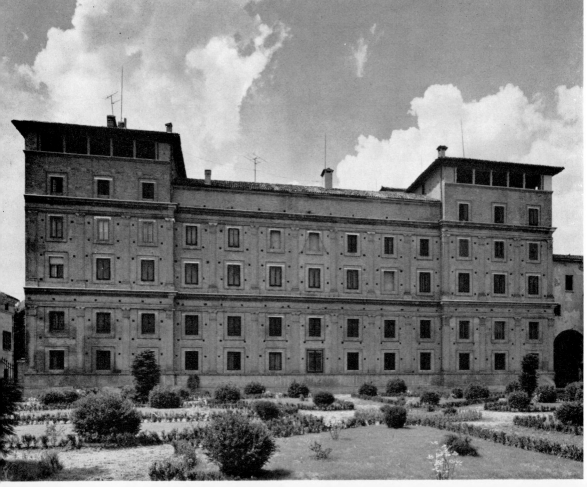

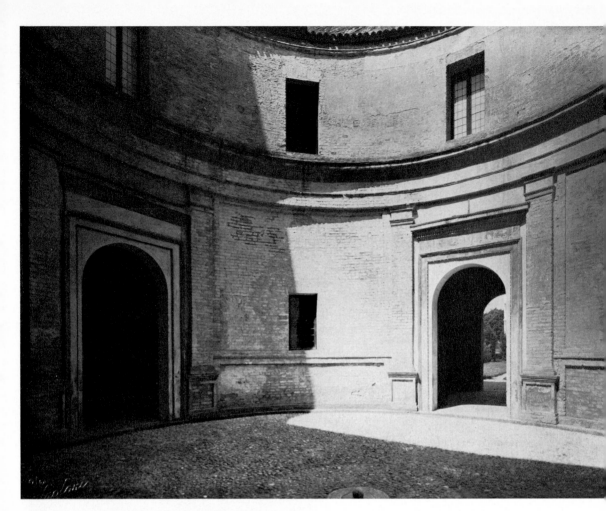

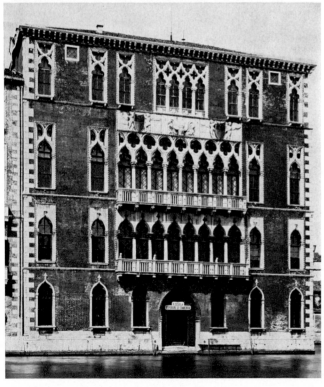

77. Andrea Mantegna: Mantua, Casa di Mantegna, late fifteenth century

78. Venice, Palazzo Foscari, begun *c.* 1450

79. Venice, Cà del Duca (Palazzo Sforza), unfinished, design of Benedetto Ferrini or Antonio Filarete(?), *c.* 1460, detail of basement storey

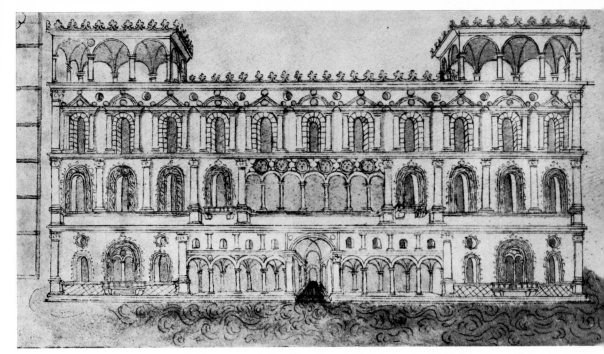

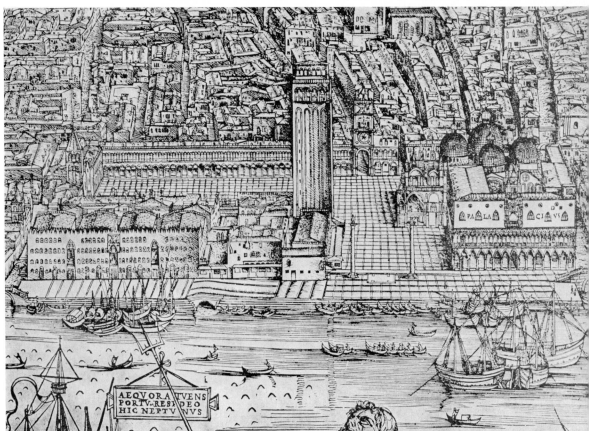

80. Antonio Filarete: Design for a 'Palazzo nel Palude', from the Treatise, c. 1461/2

81. Venice, Piazza and Piazzetta S. Marco, with the Procurazie Vecchie, begun 1496. Detail of woodcut by Jacopo de' Barbari

82. Antonio Gambella and Mauro Codussi: Venice, S. Zaccaria, façade, second half of the fifteenth century

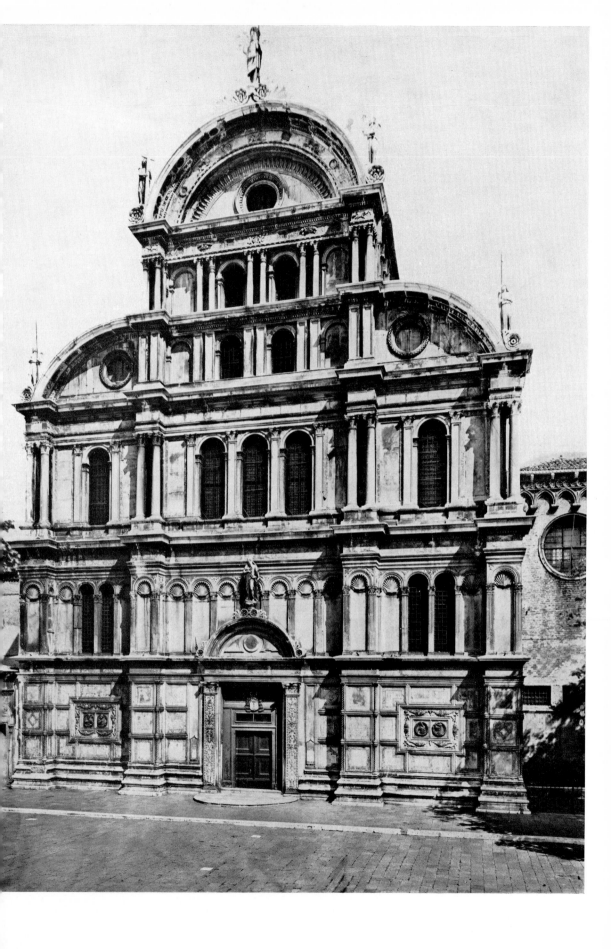

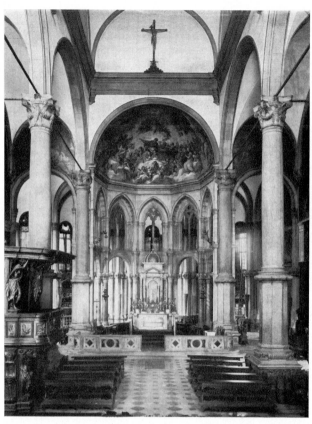

83. Venice, S. Zaccaria, chancel chapel, before 1463–*c*. 1471

84. Mauro Codussi: Venice, S. Michele in Isola, 1470s

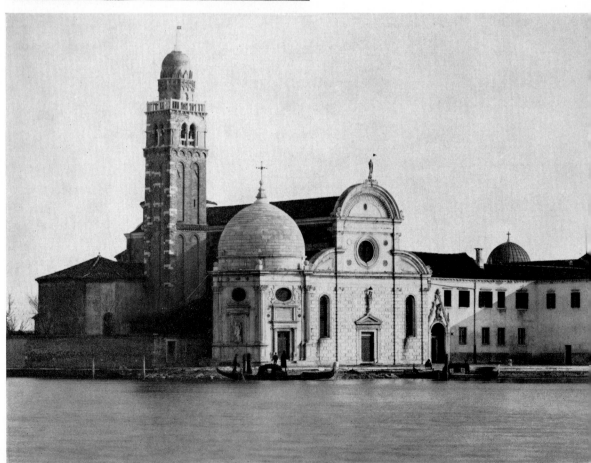

85 and 86. Pietro Lombardo: Venice,
S. Maria dei Miracoli, 1481-9

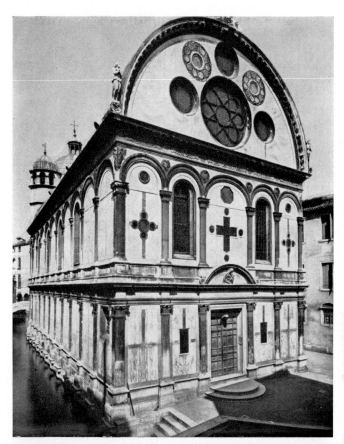

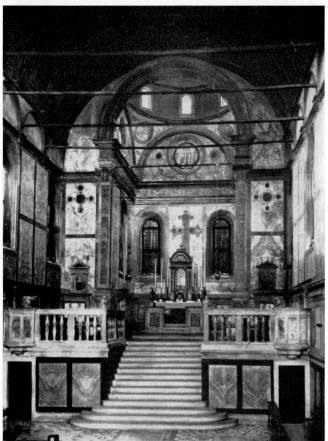

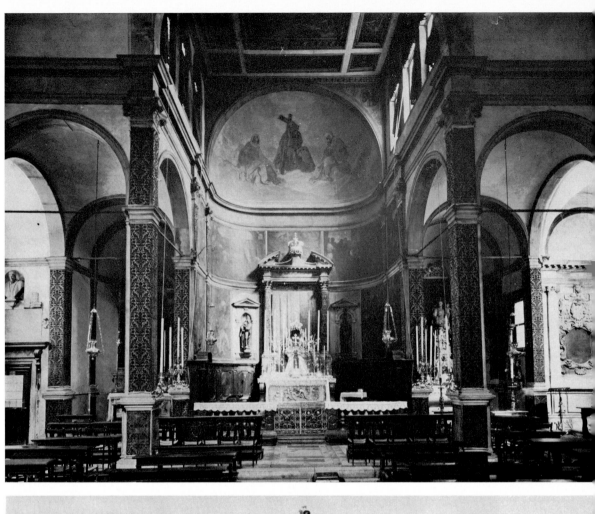

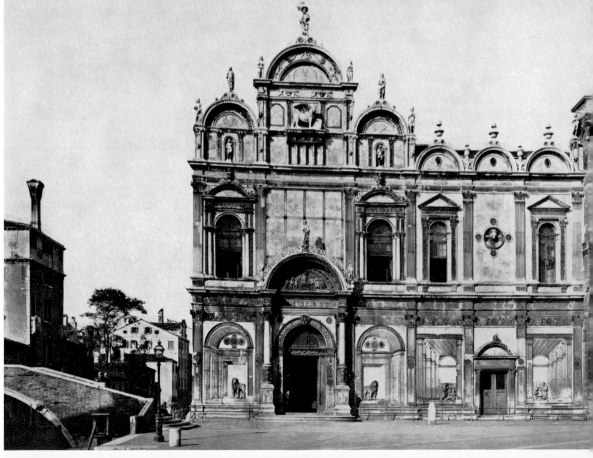

87. Mauro Codussi: Venice, S. Giovanni Crisostomo, begun 1497

88. Giovanni di Antonio Buora, Pietro Lombardo, Mauro Codussi, and others: Venice, Scuola di S. Marco, façade, begun 1487

89. Mauro Codussi: Venice, Scuola di S. Giovanni Evangelista, staircase, 1498

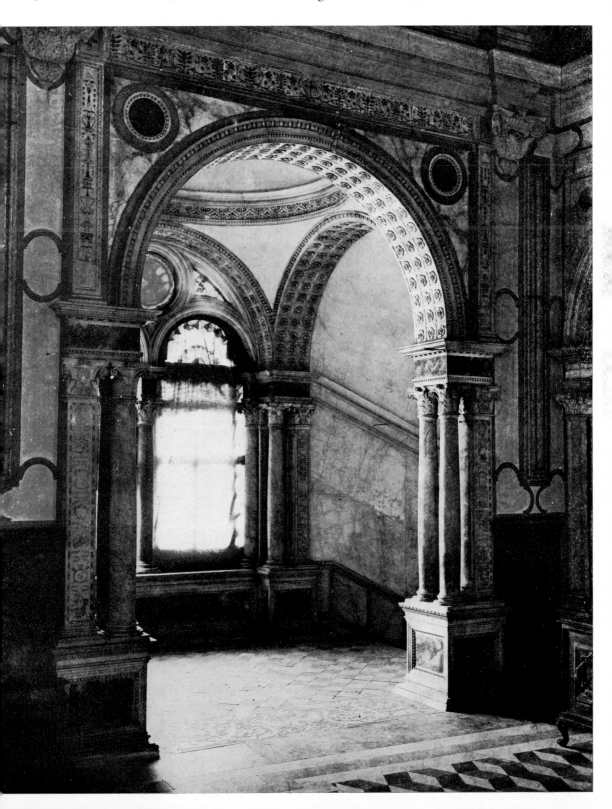

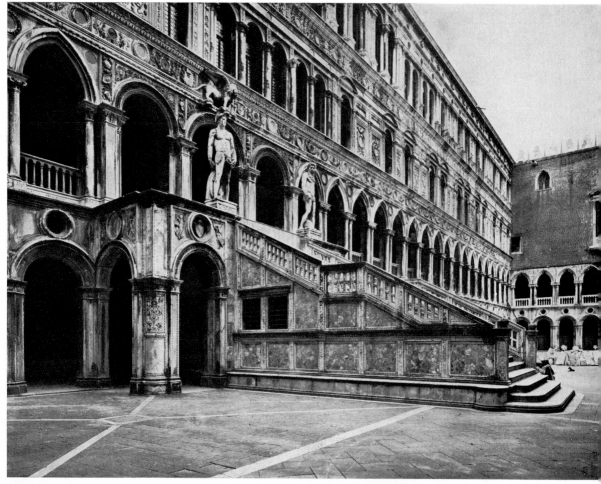

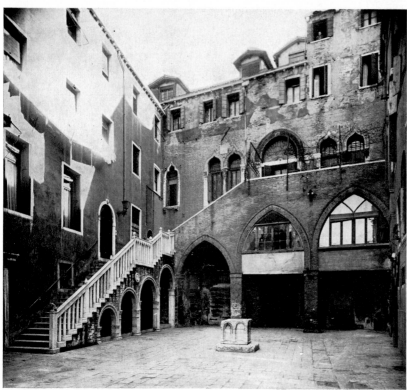

90. Antonio Rizzo and others: Venice, Doge's Palace, Scala dei Giganti, after 1483

91. Venice, *scala aperta*

92. Venice, Palazzo Dario, begun 1487

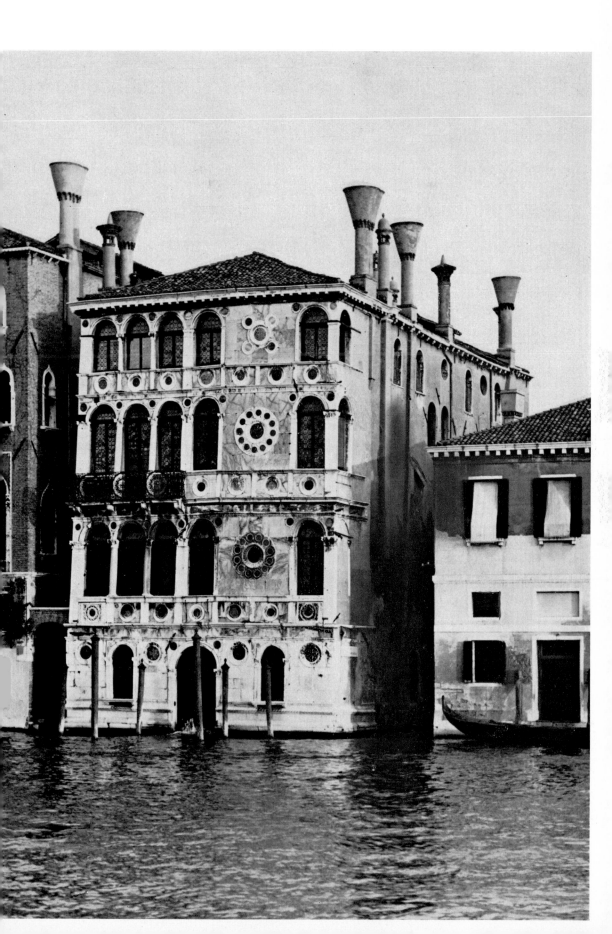

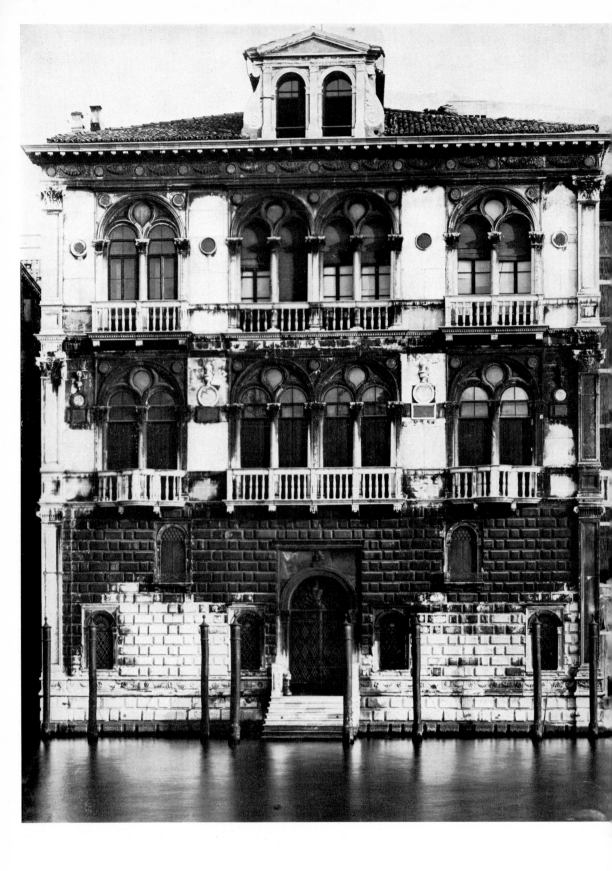

93. Venice, Palazzo Corner–Spinelli, late fifteenth century

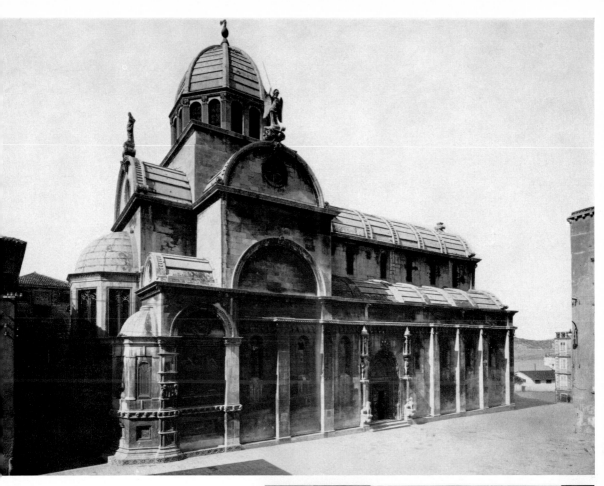

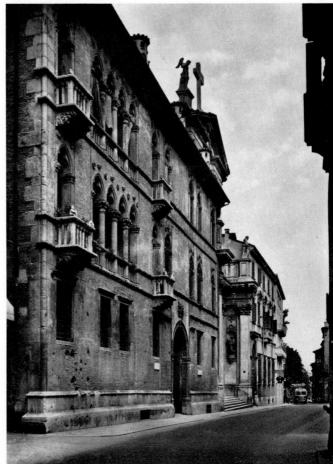

94. Šibenik (Sebenico) Cathedral, mostly after 1477

95. Vicenza, Palazzo da Schio, begun first half of the fifteenth century, finished in the second half

96. G. A. Amadeo and Dolcebuono, with Francesco di Giorgio Martini: Milan Cathedral, tiburio, designed 1487/90

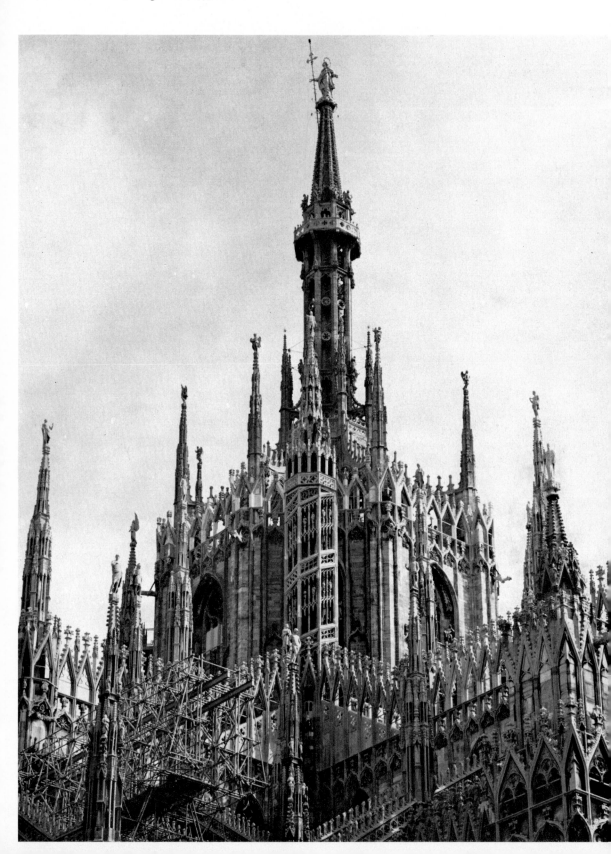

97 and 98. Giovanni and Guiniforte
Solari: Certosa di Pavia, 1429–73 (begun
earlier, finished later)

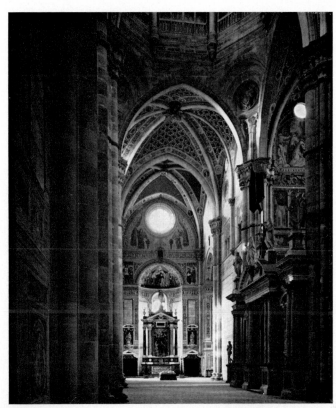

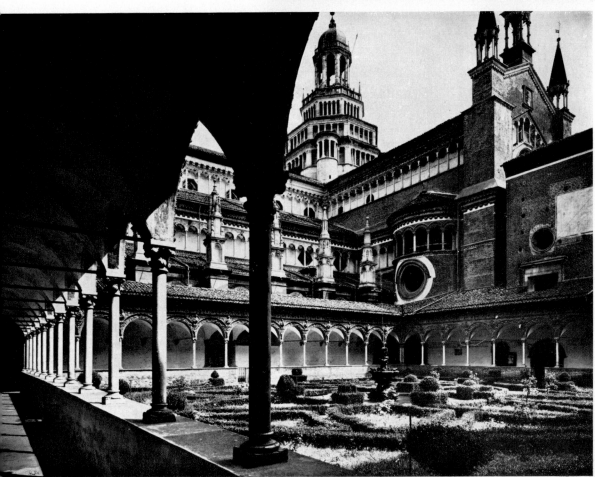

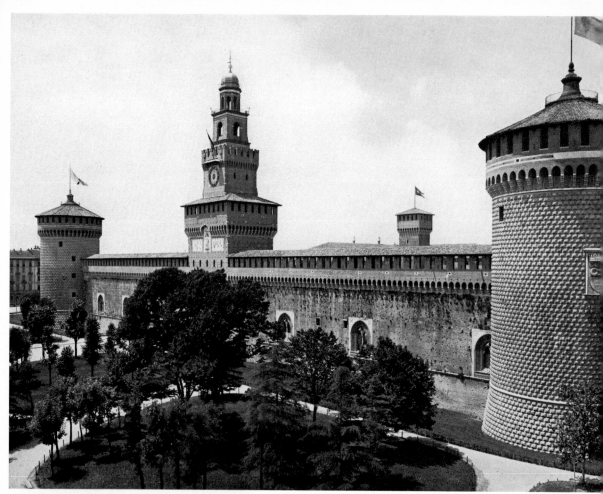

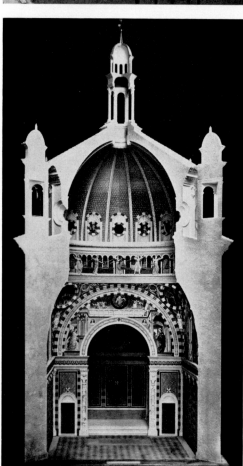

99. Milan, Castello Sforzesco, round towers begun 1455–7

100. Milan, S. Eustorgio, Portinari Chapel (nineteenth-century model), nearly finished in 1468

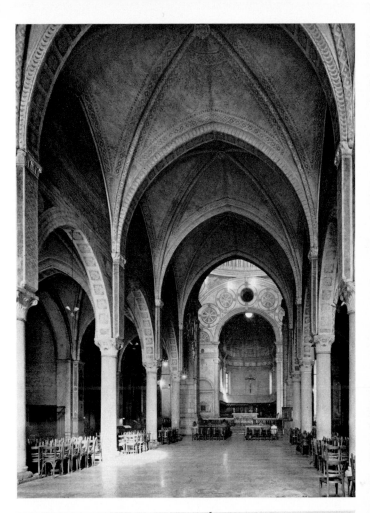

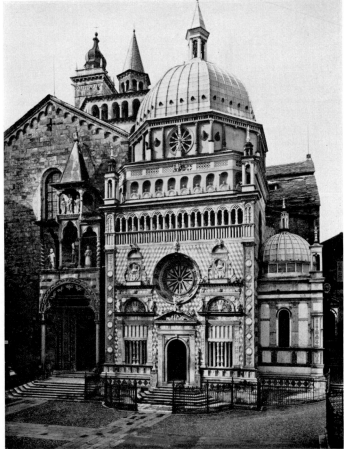

101. Guiniforte Solari: Milan,
S. Maria delle Grazie, begun 1463

102. G. A. Amadeo: Bergamo
Cathedral, Cappella Colleoni,
1470–3

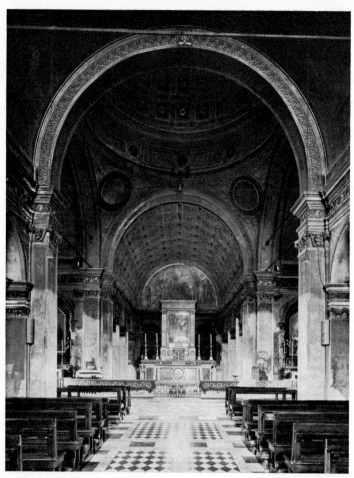

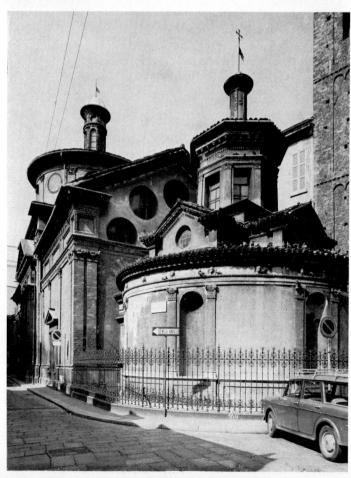

103 and 104. Donato Bramante:
Milan, S. Maria presso S. Satiro,
begun 1478

105. Cristoforo Rocchi: Model for
Pavia Cathedral, before 1490

106. Donato Bramante(?): Pavia
Cathedral, crypt, after 1488

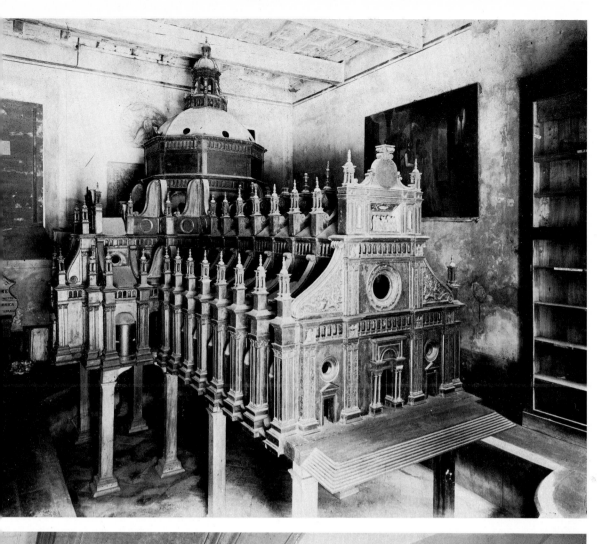

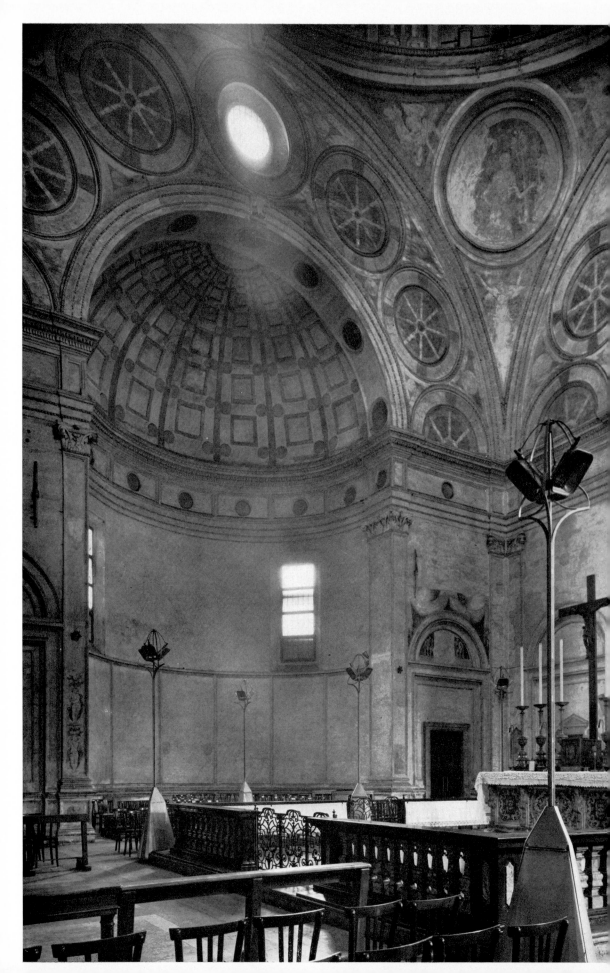

107. Donato Bramante:
Milan, S. Maria delle Grazie,
choir, begun 1493

108. Giovanni Battagio:
Crema, S. Maria della Croce,
begun 1493

109. Elviso Raimondi:
Cremona, Palazzo Raimondi,
1496–9

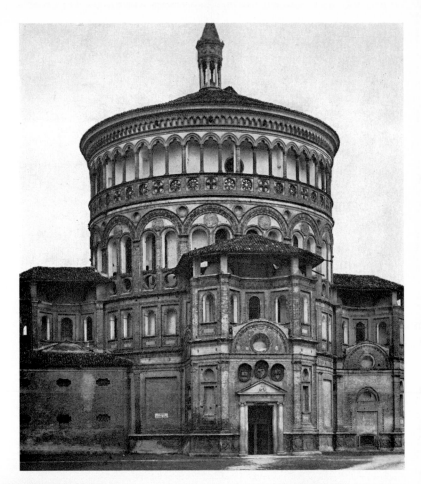

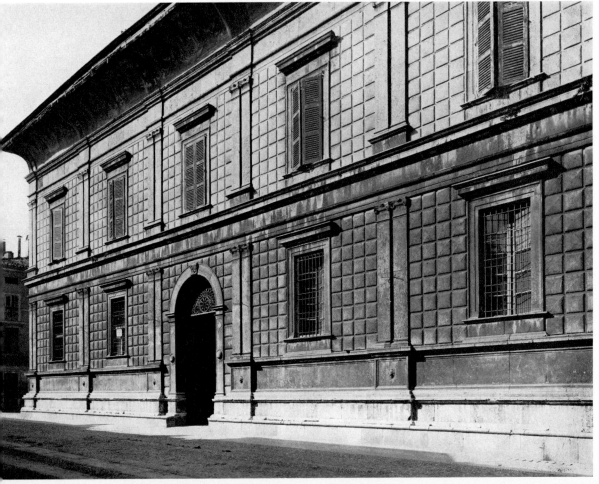

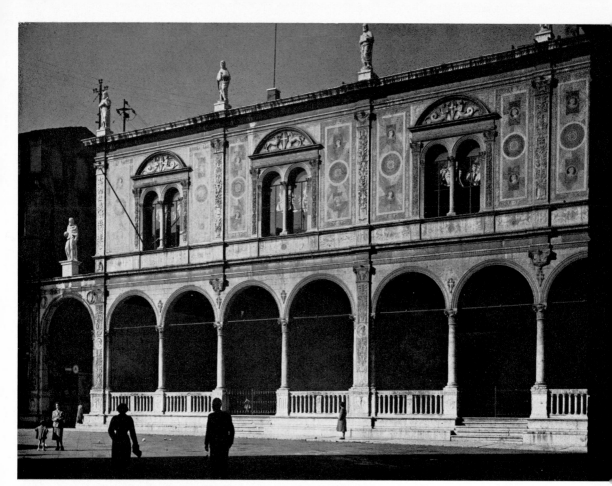

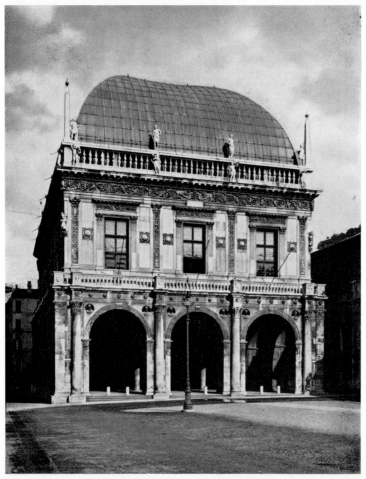

110. Verona, Palazzo del Consiglio, 1474–93

111. Brescia, Palazzo Comunale, Loggia, c. 1490–1510, second storey 1550–60

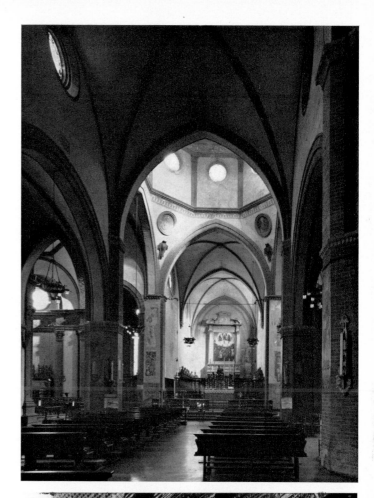

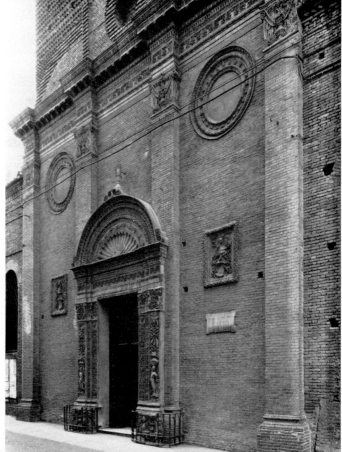

112. Bologna, S. Giovanni al Monte,
begun 1440, dome 1496

113. Bologna, Corpus Domini, 1478–80

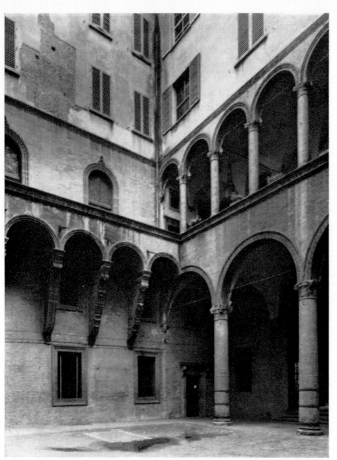

114. Bologna, Palazzo Fava, courtyard, 1483 ff.

115. Biagio Rossetti: Ferrara, S. Francesco, 1494

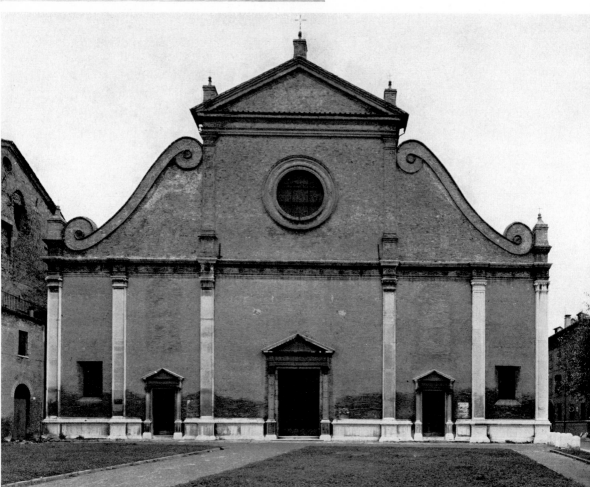

116. Biagio Rossetti: Ferrara,
S. Cristoforo, 1498

117. Biagio Rossetti: Ferrara, Casa
Rossetti, 1490s

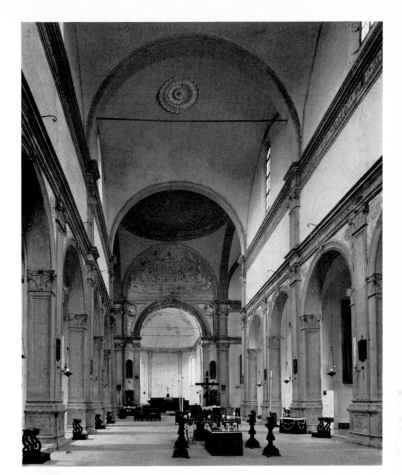

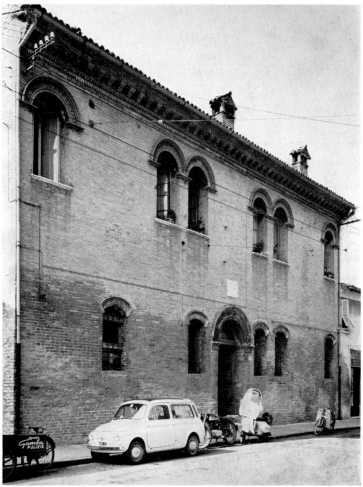

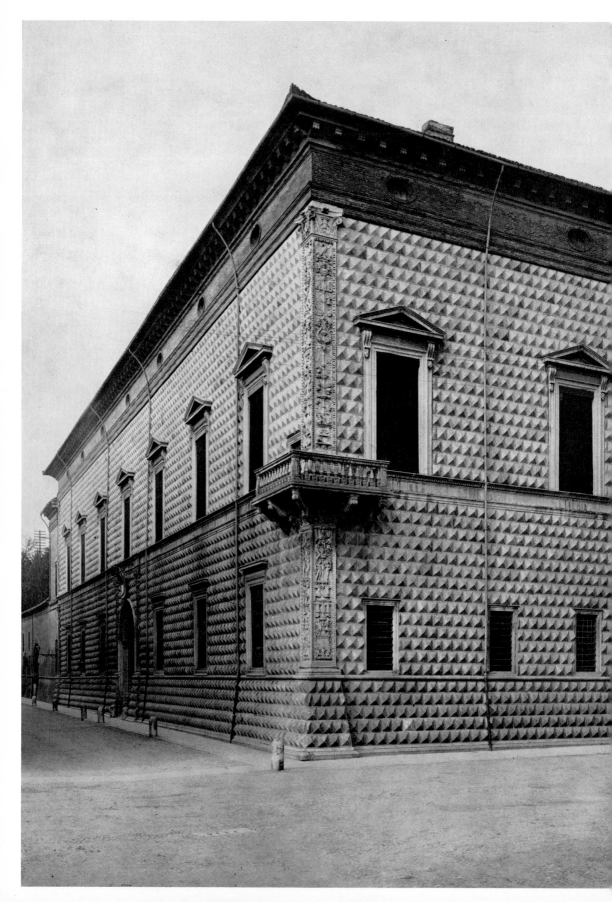

118. Biagio Rossetti: Ferrara, Palazzo dei Diamanti, 1493

119. Alessio Tramello: Piacenza, S. Sisto, begun 1499

120. Chieri Cathedral, 1405–35, baptistery thirteenth century, renovated in the fifteenth century

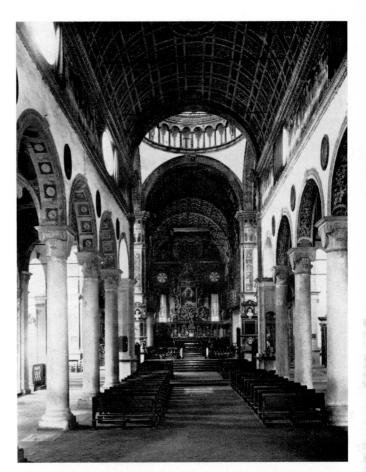

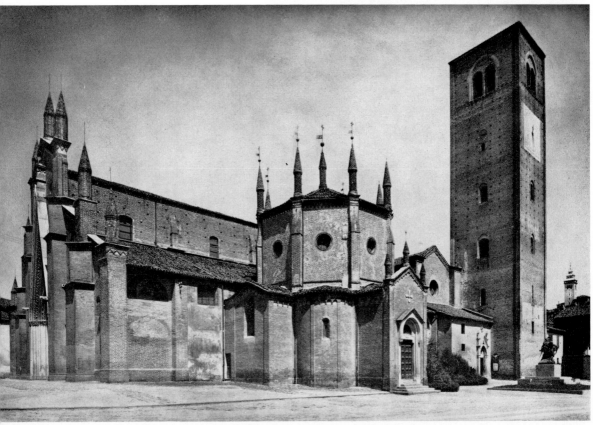

121. Aosta, priory of S. Orso, 1494–1506

122 and 123. Meo da Caprino: Turin Cathedral, 1491–8

124. Genoa, Palazzo Doria in Vico d'Oria, courtyard, second half of the fifteenth century

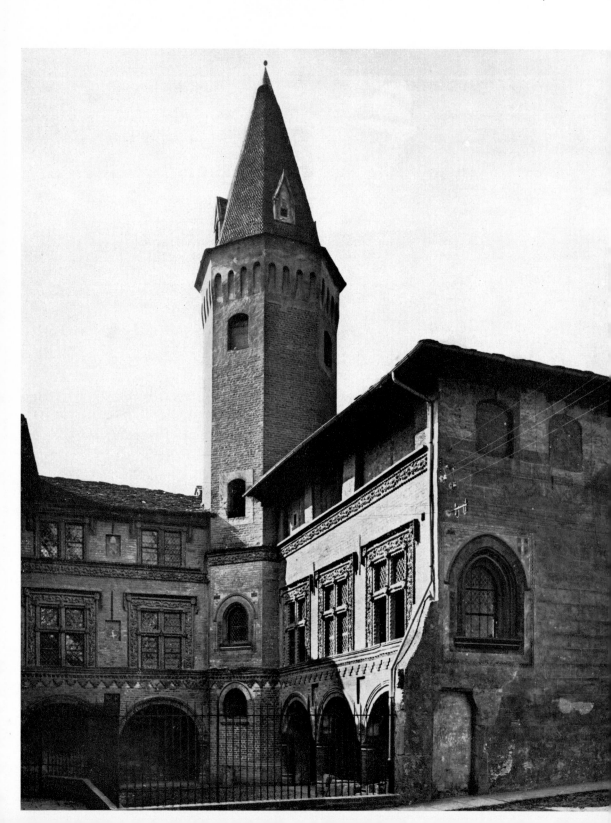

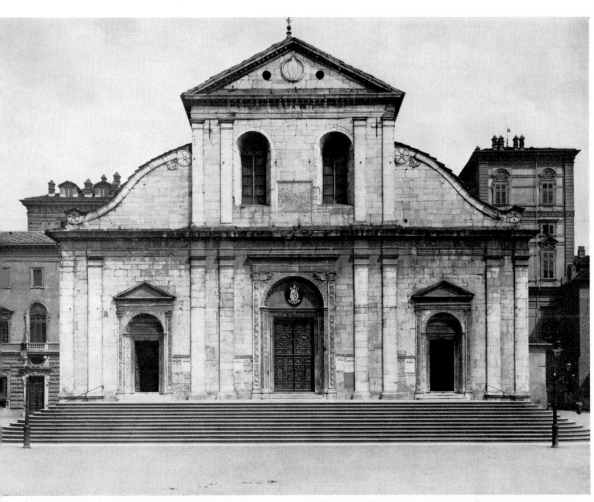

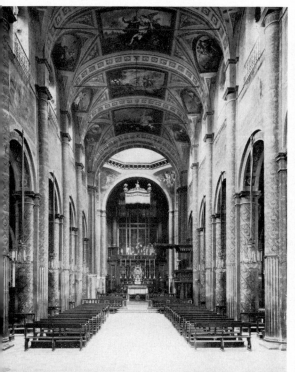

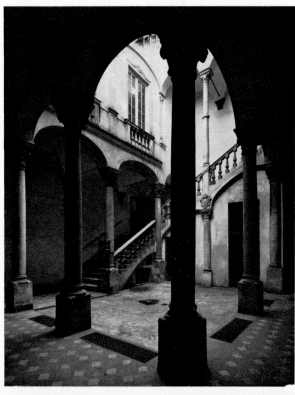

125. Genoa, Palazzo Andrea Doria in Piazza
S. Matteo, *c.* 1486, reconstruction

126. Soleto Cathedral, campanile, first half of the
fifteenth century

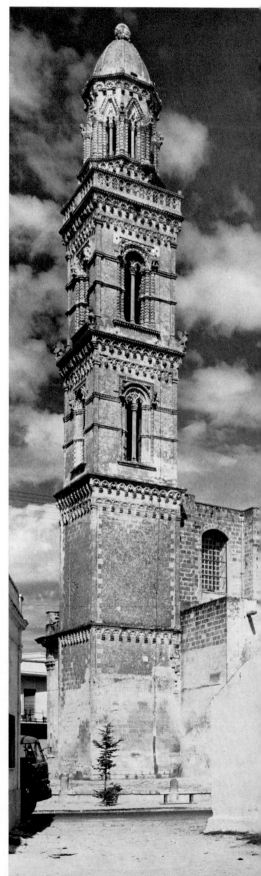

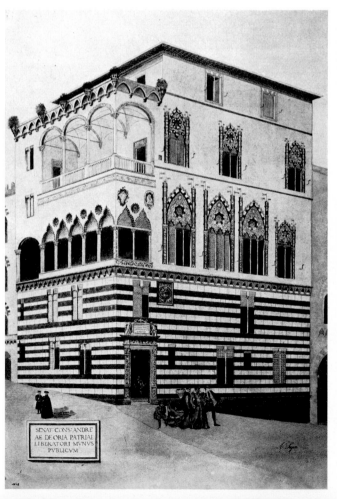

127. Messina, S. Maria della Scala, second half of the fifteenth century

128. Palermo, Palazzo Aiutamicristo, 1490–5

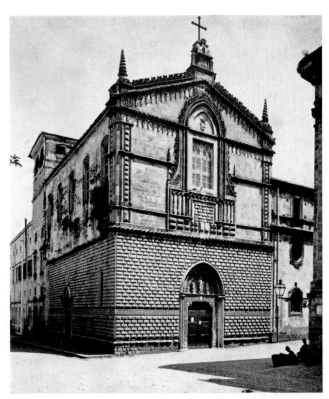

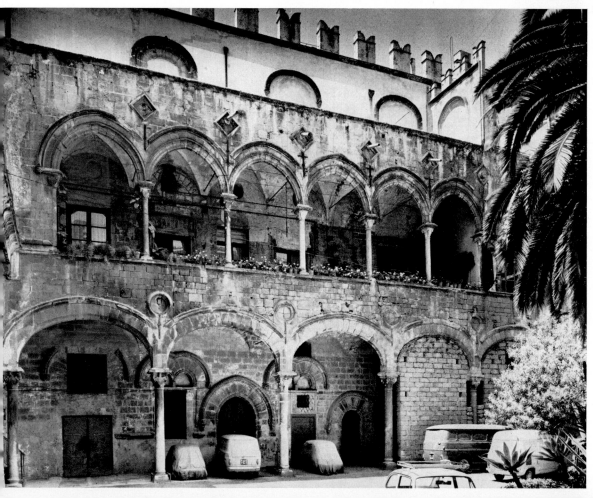

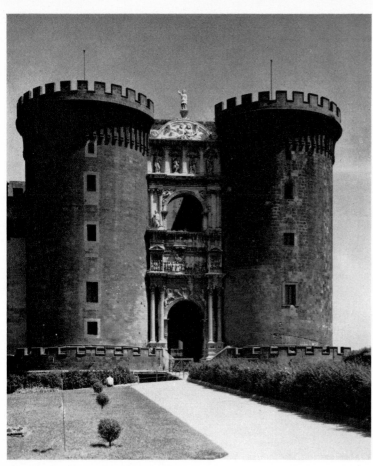

129. Pietro da Milano and Francesco da Laurana(?): Naples, Castelnuovo, Arch of Alfonso begun 1452

130. Giuliano da Maiano: Naples, Porta Capuana, designed in 1485

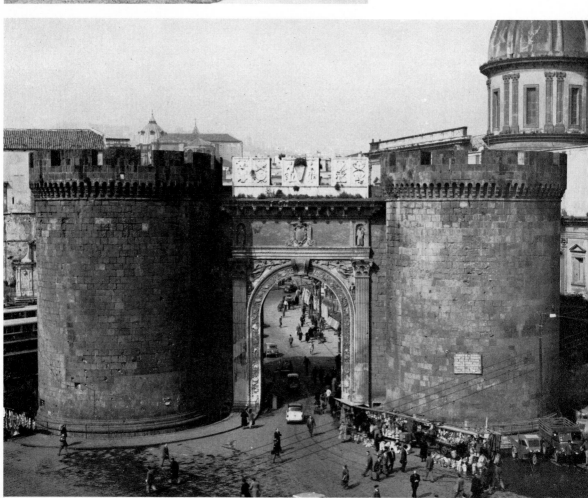

131. Giuliano da Maiano(?): Naples, Palazzo
Cuomo, 1464–90

132. Tomaso Malvita da Como: Naples
Cathedral, Cappella del Soccorso, begun 1497

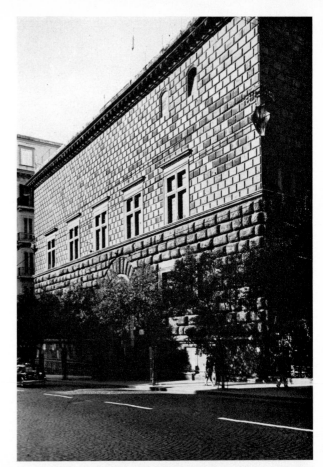

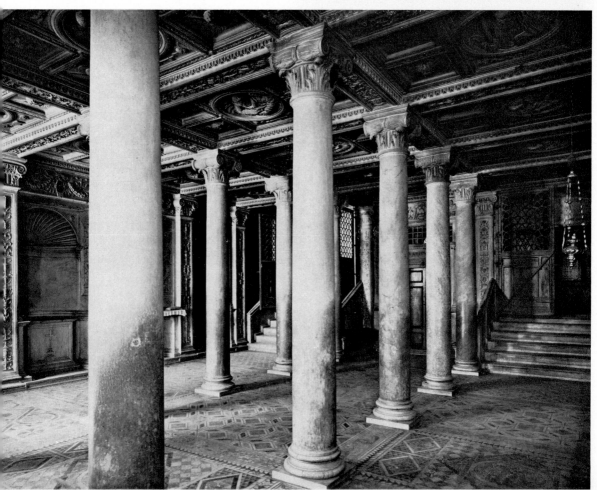

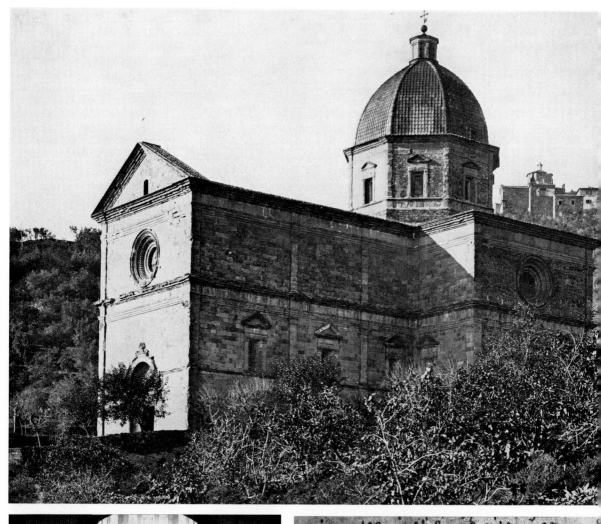

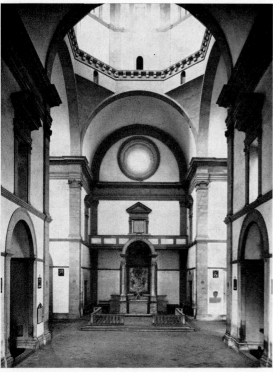

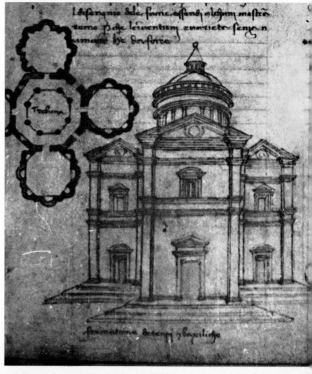

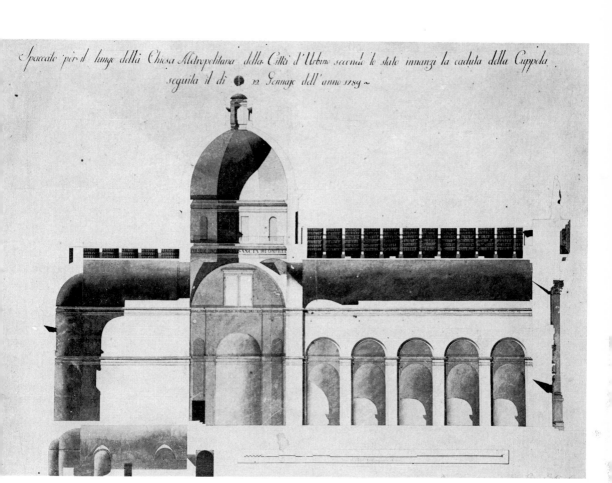

Spaccato per il lungo della Chiesa Metropolitana della Città d'Urbino secondo lo stato innanzi la caduta della Cuppola seguita il dì 12 Gennajo dell'anno 1789~

133 and 134. Francesco di Giorgio Martini: Cortona, Madonna del Calcinaio, begun 1484

135. Francesco di Giorgio Martini: Design for a church from the Treatise

136. Francesco di Giorgio Martini: Urbino Cathedral, begun before 1482, drawing by Valadier

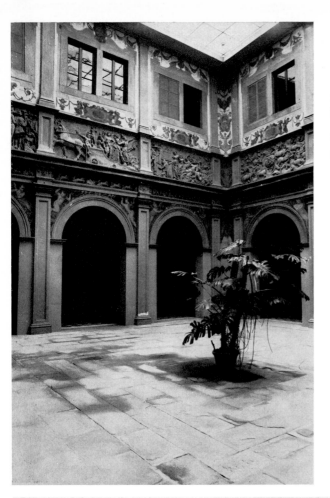

137. Giuliano da Sangallo: Florence, Palazzo Scala, courtyard, 1472/80

138. Giuliano da Sangallo: Poggio a Caiano, designed early 1480s

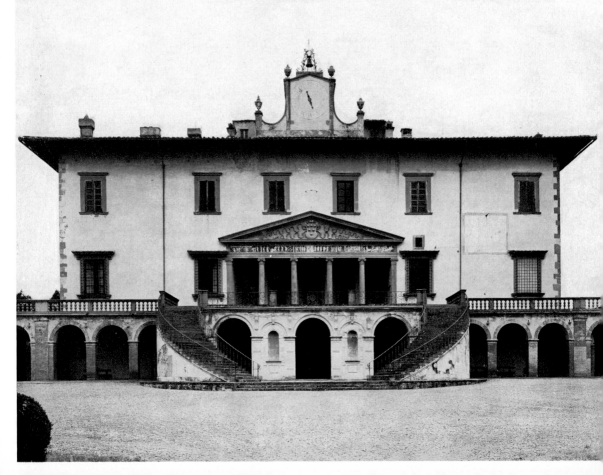

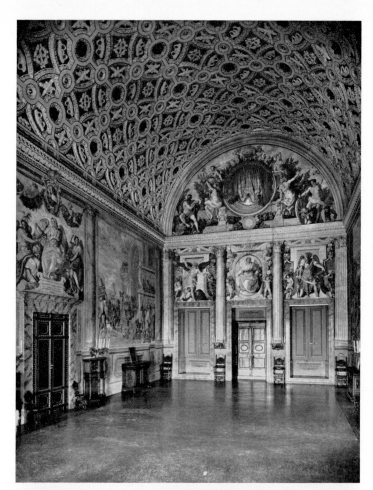

139. Giuliano da Sangallo: Poggio a Caiano, designed early 1480s, salone

140. Giuliano da Sangallo: Prato, Madonna delle Carceri, begun 1484

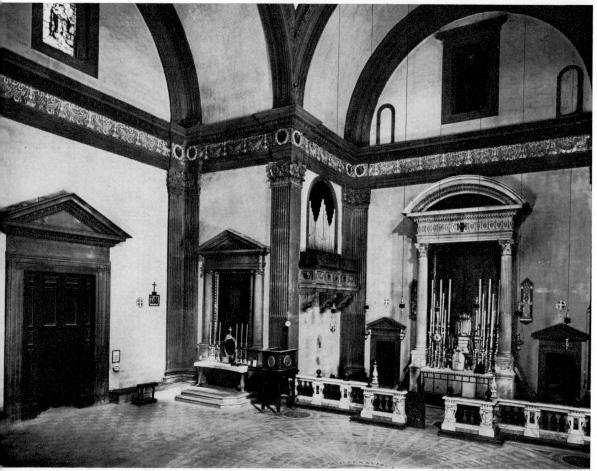

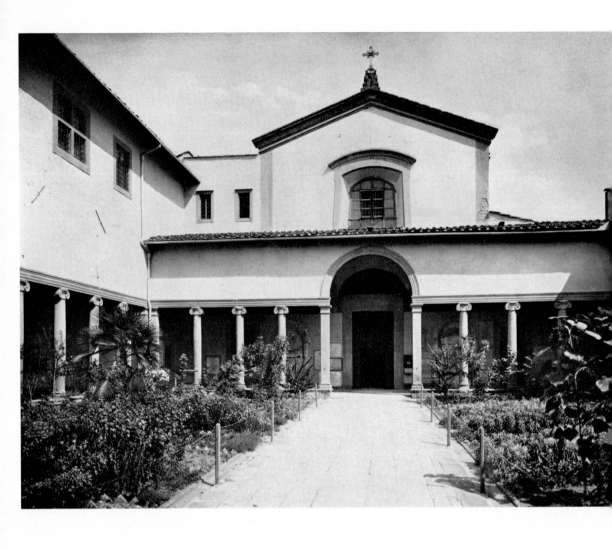

141. Giuliano da Sangallo: Florence, S. Maria Maddalena de' Pazzi, early 1490s

142. Giuliano da Sangallo and Cronaca: Florence, S. Spirito, vestibule of the sacristy, 1492–4

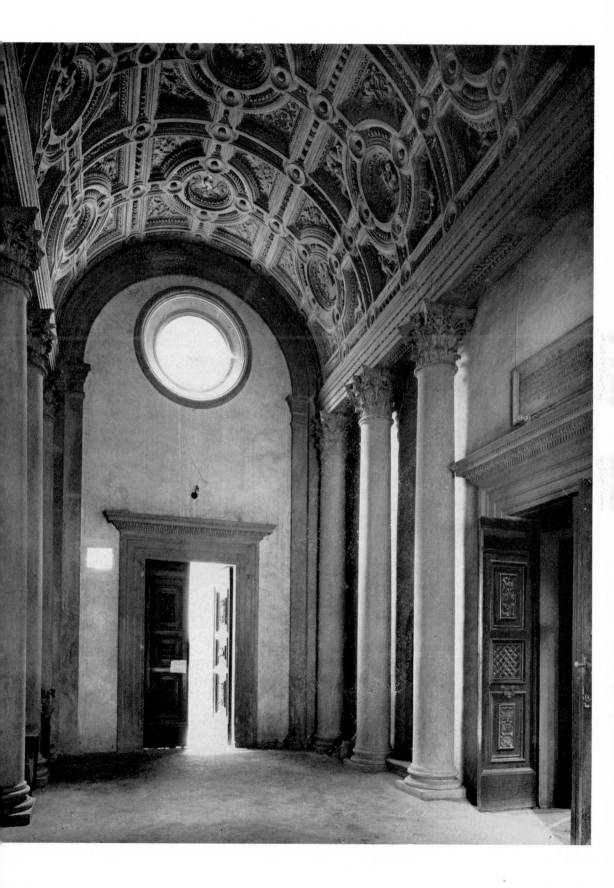

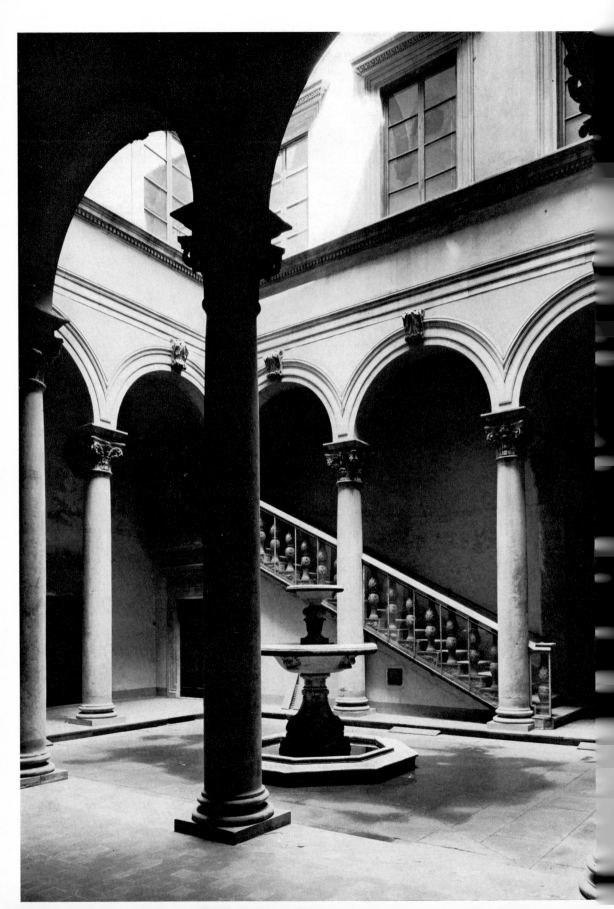

143. Giuliano da Sangallo and Cronaca:
Florence, Palazzo Gondi, begun 1490,
courtyard

144. Giuliano da Sangallo, Cronaca, and
Benedetto da Maiano: Florence, Palazzo
Strozzi, designed 1489–90

145. Cronaca: Florence, S. Francesco
(S. Salvatore) al Monte, late 1480s–1504

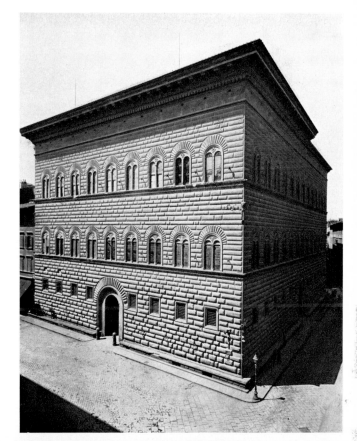

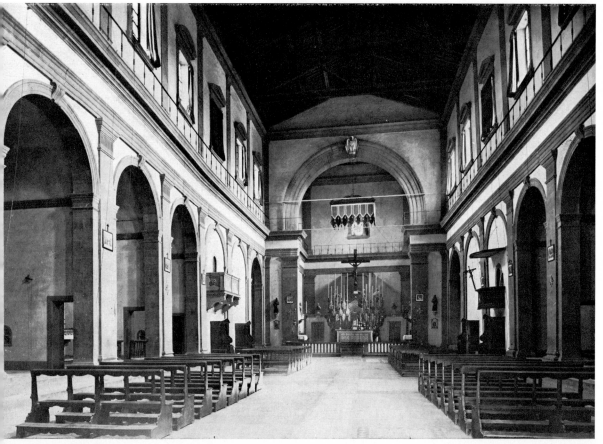

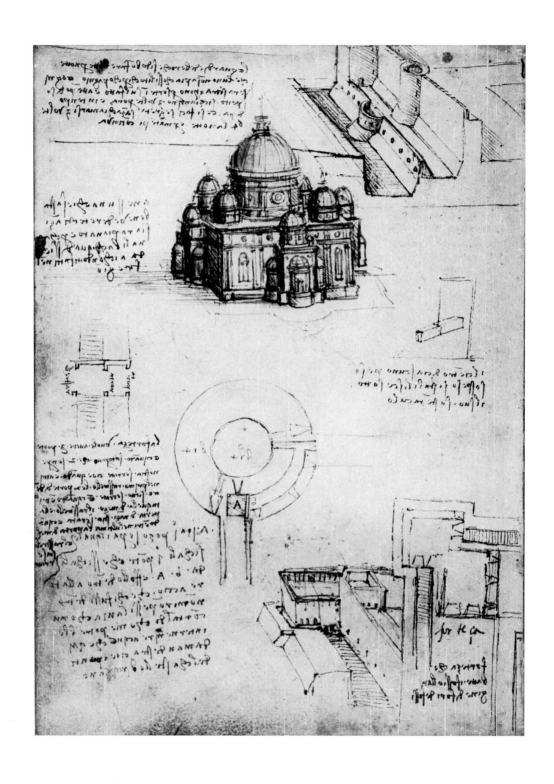

146 and 147. Leonardo da Vinci: Double page (18 verso and 19 recto) from MS. B, *c.* 1490, in the Institut de France, Paris

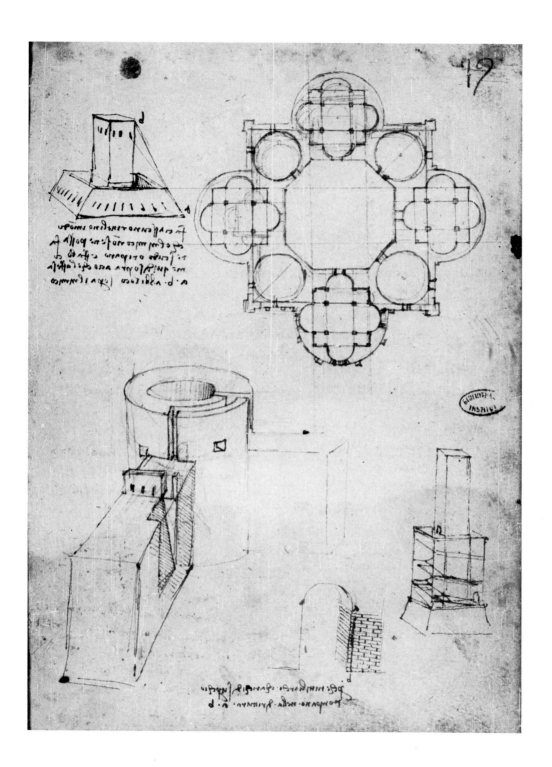

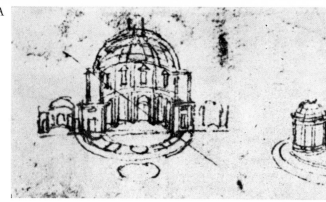

A

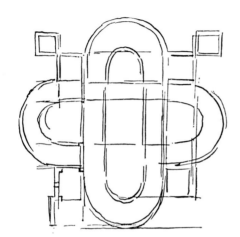

B

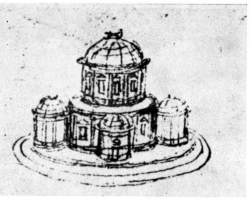

C

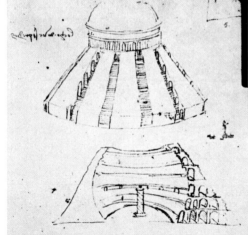

D

148. Leonardo da Vinci: Architectural studies:

(A) Codex Atlanticus (205 verso, a), *c.* 1495–1500, Milan, *Ambrosiana*;

(B) MS. B (57 verso), *c.* 1490–5, *Paris, Bibliothèque Nationale*;

(C) Design for a façade, *c.* 1515, *Venice, Accademia*;

(D) 'Locho dove si predicha', MS. 2037 (5 recto), *c.* 1490–5, *Paris, Bibliothèque Nationale*;

(E) Treatise on the flight of birds (cover), *c.* 1505, *Turin, Biblioteca*;

(F) Studies on the strength of the arch, MS. K (92), *c.* 1505–10, *Paris, Bibliothèque Nationale*

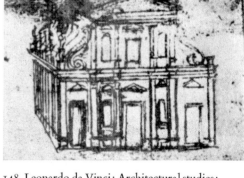

F

E

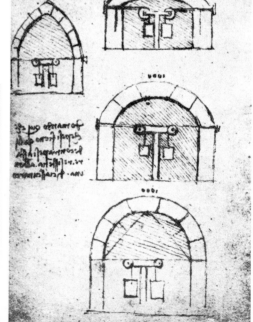

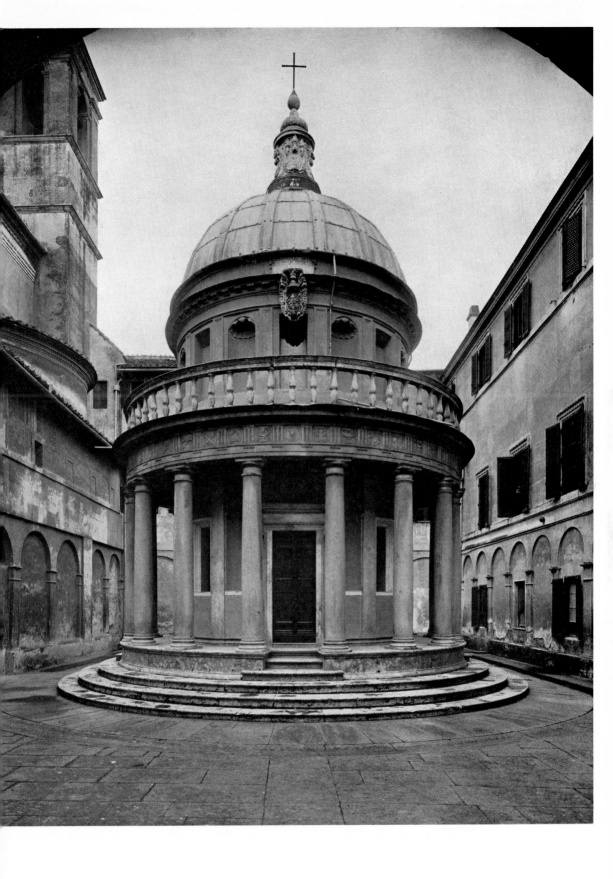

149. Donato Bramante: Rome, S. Pietro in Montorio, Tempietto, 1502

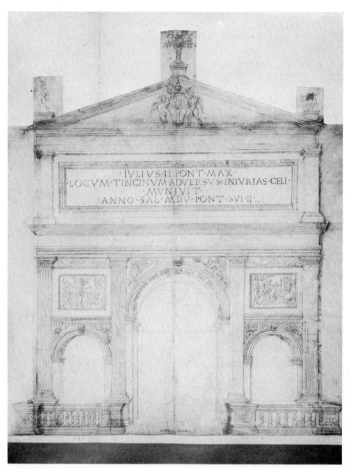

150. Giuliano da Sangallo: Project for the loggia of the Pope's tuba players, 1505. *Florence, Uffizi* (A 203)

151. Donato Bramante: Rome, S. Maria della Pace, cloister, 1500

152. Rome, Vatican, bird's-eye perspective with the Cortile del Belvedere, by Sallustio Peruzzi, *c.* 1570. *Florence, Uffizi* (A 28)

153. Rome, Vatican, Cortile del Belvedere, 1505 ff., air view, looking north

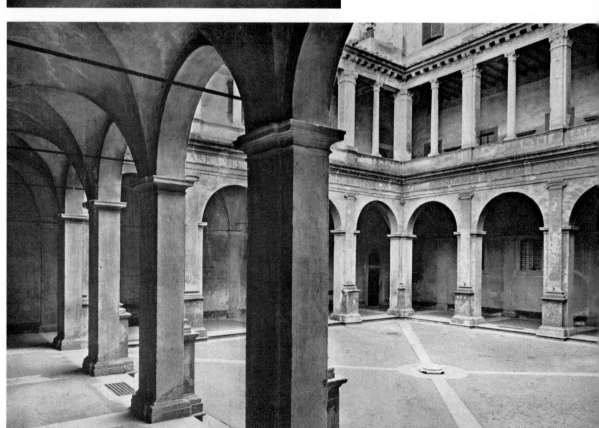

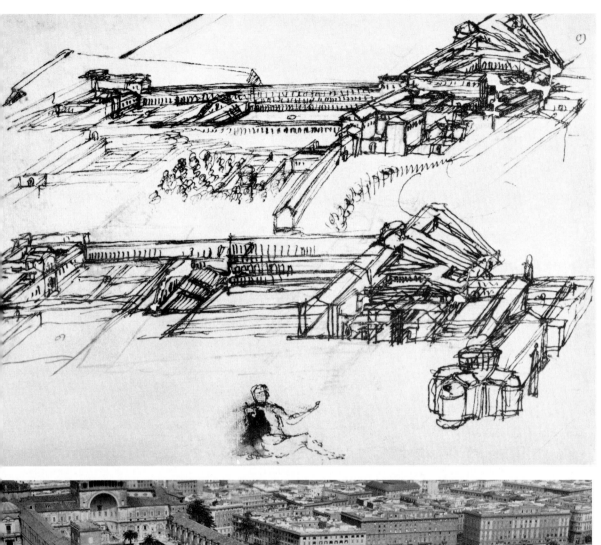
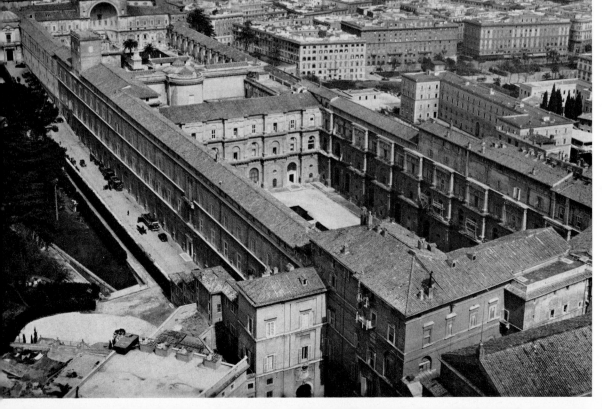

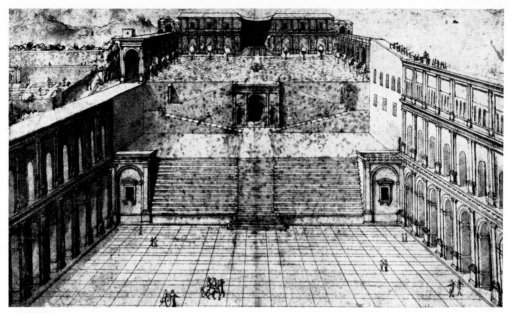

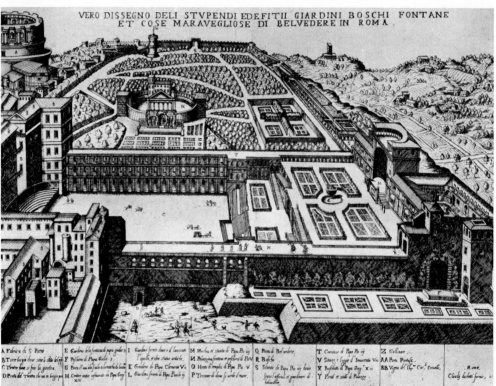

154. Rome, Vatican, Cortile del Belvedere, perspective view from the Stanze, looking north, by Sallustio Peruzzi (?), c. 1560. *New York, Phyllis Lambert Collection*

155. Rome, Vatican, Cortile del Belvedere, bird's-eye perspective, looking west, 1579

156. Donato Bramante: Rome, Vatican, Cortile del Belvedere, three bays of the upper court

157. Donato Bramante: Rome, Vatican, Cortile del Belvedere, perspective view of the upper court (detail), c. 1520, from the Codex Coner. *London, Sir John Soane's Museum*

158. Donato Bramante: Rome, Vatican, Cortile del Belvedere, 1505 ff., entrance leading to the lower court

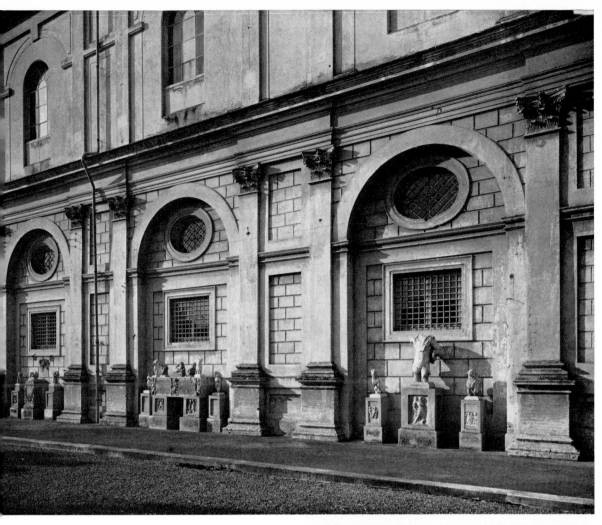

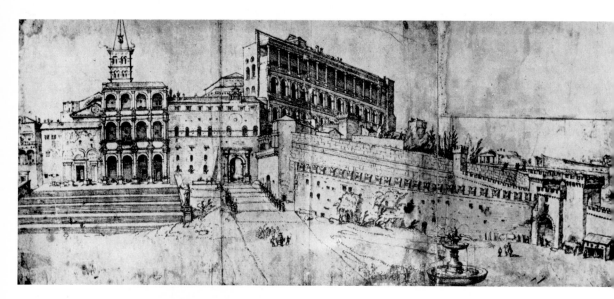

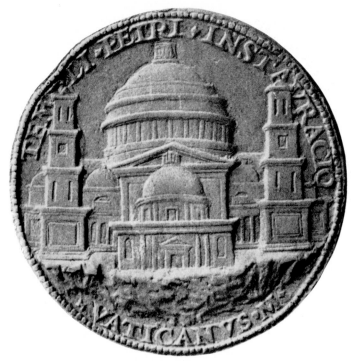

159. Rome, Vatican Palace with the Logge from Piazza S. Pietro, drawing by Marten van Heemskerck. *Vienna, Albertina*

160. Donato Bramante: Project for St Peter's, medal by Caradosso, 1506

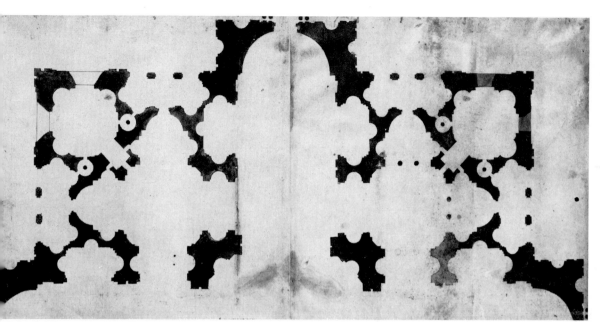

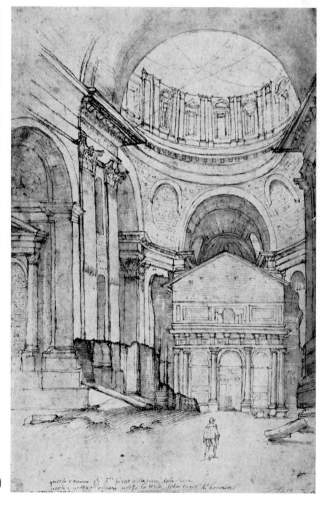

161. Donato Bramante: Project for St Peter's, plan. *Florence, Uffizi* (A 1)

162. Donato Bramante: Rome, St Peter's, plan, *c.* 1514, from the Codex Coner. *London, Sir John Soane's Museum*

163. Rome, St Peter's, interior looking west, with Bramante's piers, vaulted choir, and altar shrine, the drum of the dome designed by Michelangelo, *c.* 1570. *Hamburg, Kunsthalle* (21311)

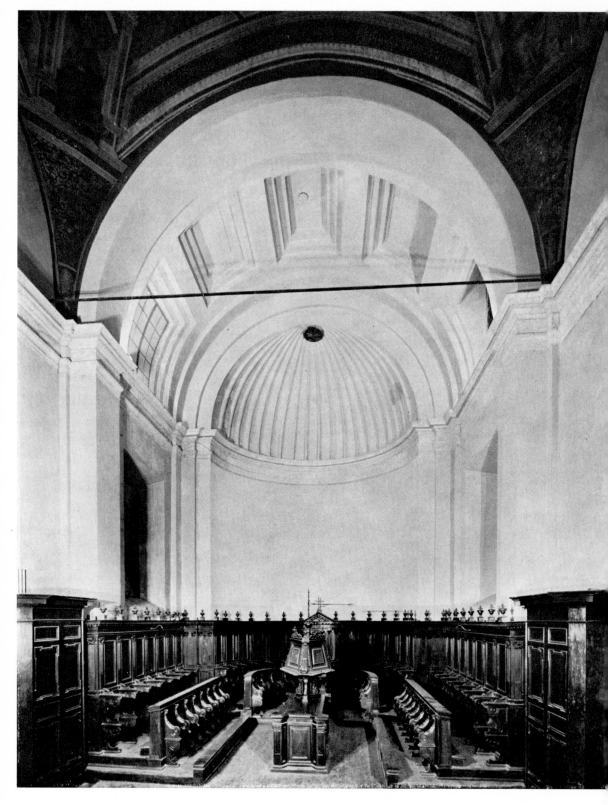

164. Donato Bramante: Rome, S. Maria del Popolo, choir and apse, c. 1508

165. Donato Bramante: Rome, Palazzo Caprini, façade, c. 1510, engraving by Lafreri, 1549

166. Donato Bramante: Loreto, Santa Casa, right flank, begun 1509

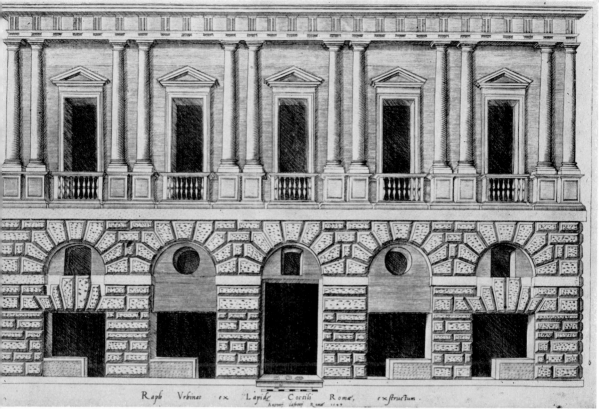

Raph Vrbinas ex Lapide Coerili Roma, exstructum.
Antony Lafreris Rome 1549

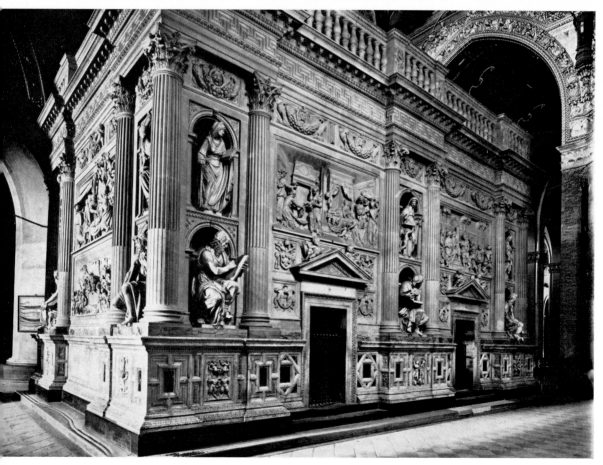

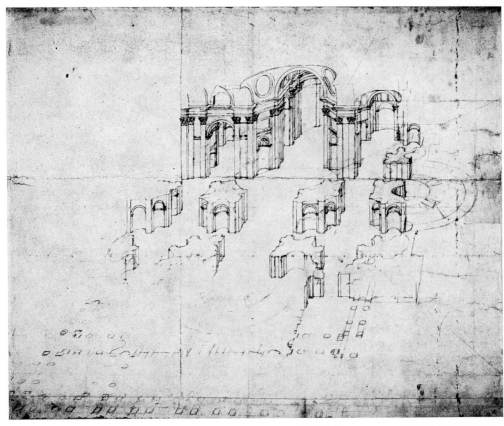

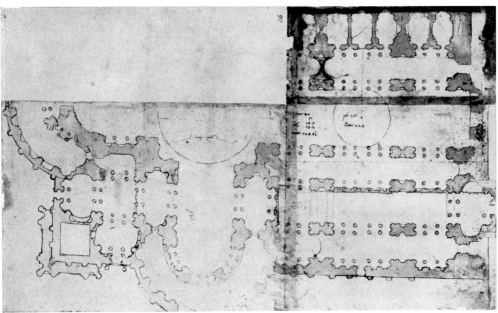

167. Baldassare Peruzzi: Project for St Peter's, bird's-eye perspective. *Florence, Uffizi* (A 2)

168. Baldassare Peruzzi: Project for St Peter's, plan. *Florence, Uffizi* (A 14)

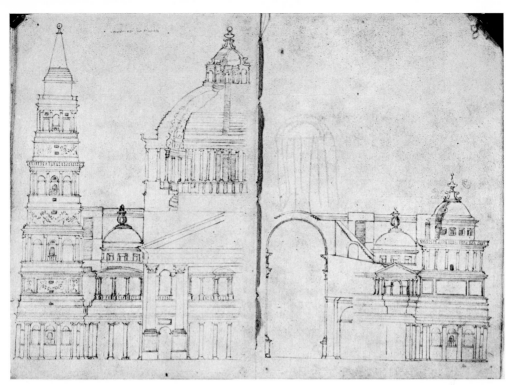

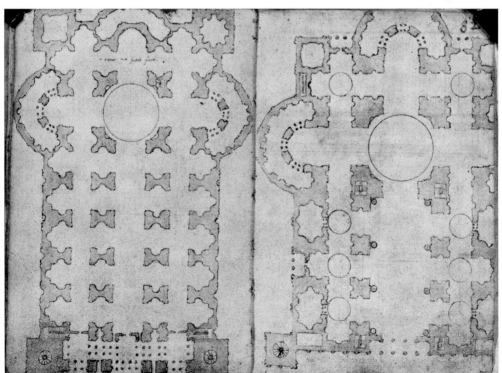

169. Raphael (copy): Project for St Peter's, elevation and section. *Washington, Paul Mellon Collection*

170. (*left*) Raphael (copy): Project for St Peter's, plan, (*right*) Antonio da Sangallo (copy): Project for St Peter's, plan. *Washington, Paul Mellon Collection*

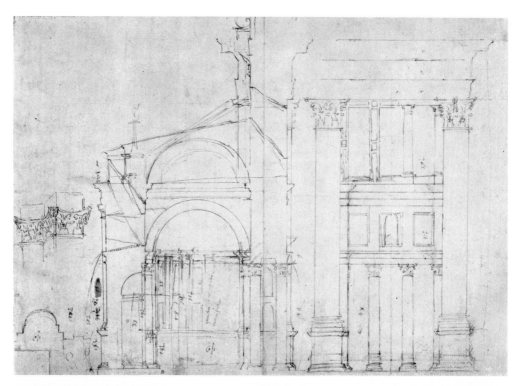

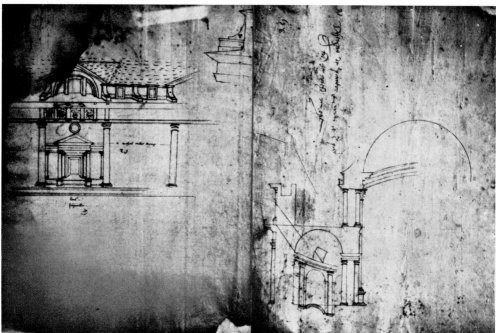

171. Raphael: Project for St Peter's, section of ambulatory and elevation of transept, drawing by Antonio da Sangallo the Younger. *Florence, Uffizi* (A 54)

172. Raphael: Project for St Peter's, exterior of ambulatory, and cross section of transept and ambulatory, French copy after Antonio da Sangallo the Younger. *Munich, Bayerische Staatsbibliothek* (cod. icon. 195)

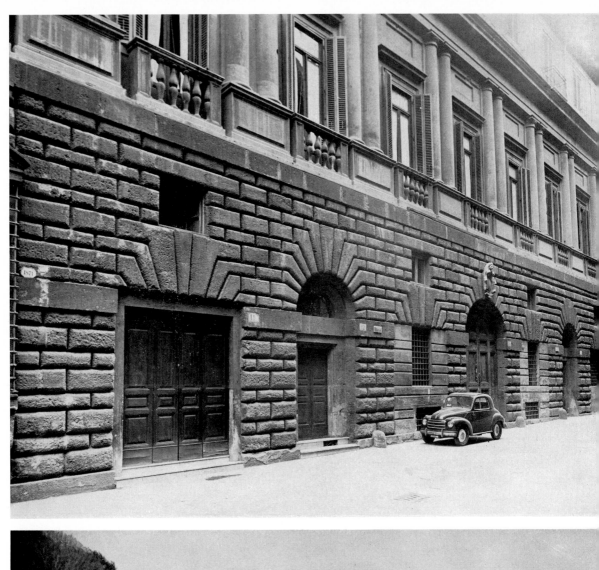

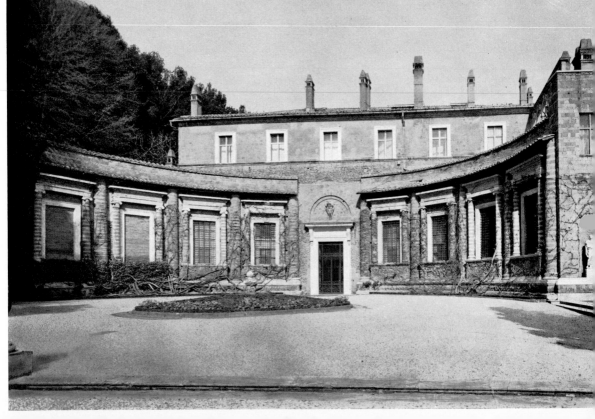

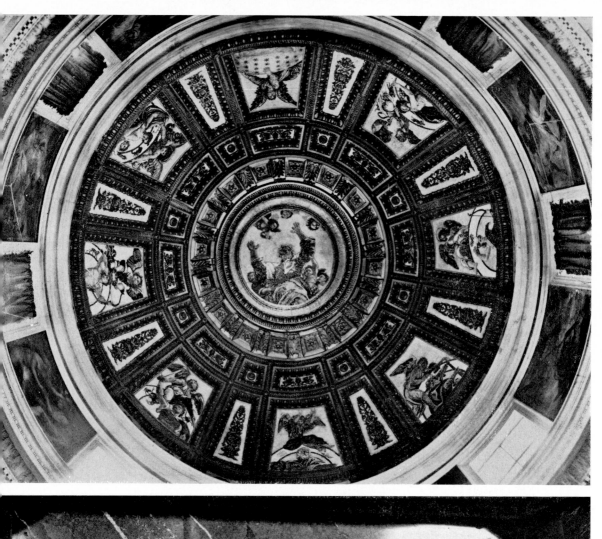

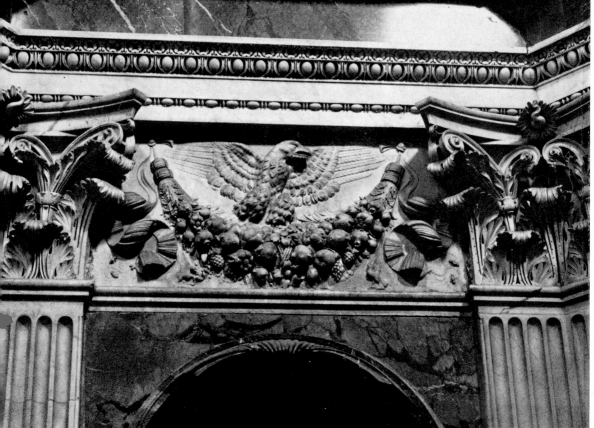

174. Raphael: Rome, Palazzo Branconio dall'Aquila, view of half of façade by Marten van Heemskerck. *Berlin, Staatliche Museen Preussicher Kulturbesitz, Kupferstichkabinett* (vol. 1, 55 verso)

175. Raphael: Rome, S. Maria del Popolo, Chigi Chapel, begun *c.* 1513, looking north

176. Raphael: Rome, S. Maria del Popolo, Chigi Chapel, begun *c.* 1513, cupola

177. Raphael: Rome, S. Maria del Popolo, Chigi Chapel, detail of entablature

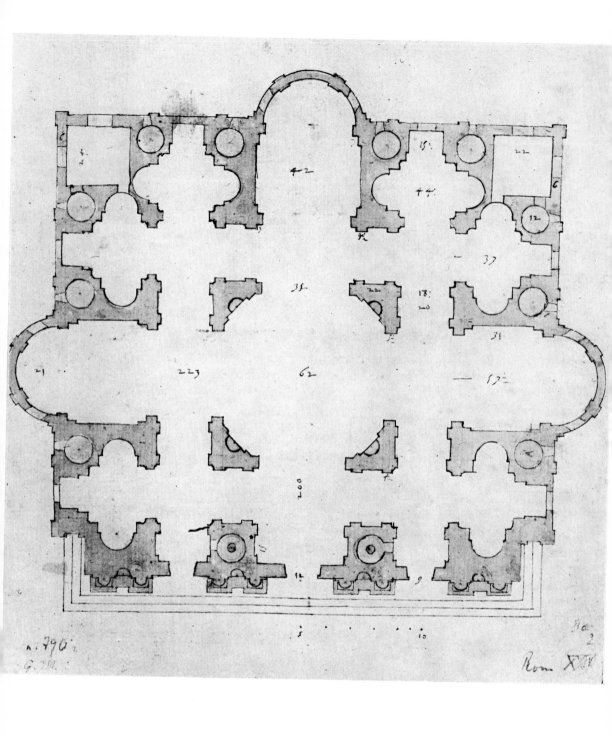

173. Antonio da Sangallo the Younger: Project for St Peter's, plan. *Vienna, Albertina* (790 verso)

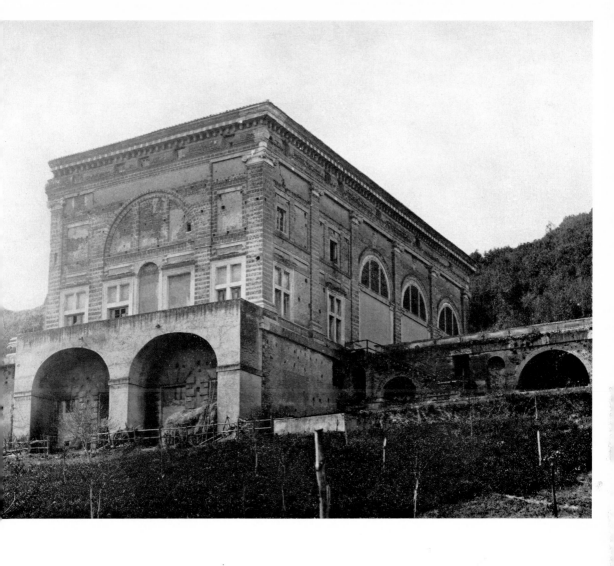

178. Rome, Palazzo Vidoni-Caffarelli, 1515(?). Façade

179. Raphael: Rome, Villa Madama, begun *c.* 1516, round courtyard

180. Raphael: Rome, Villa Madama, begun *c.* 1516, from the north-east (before modern additions)

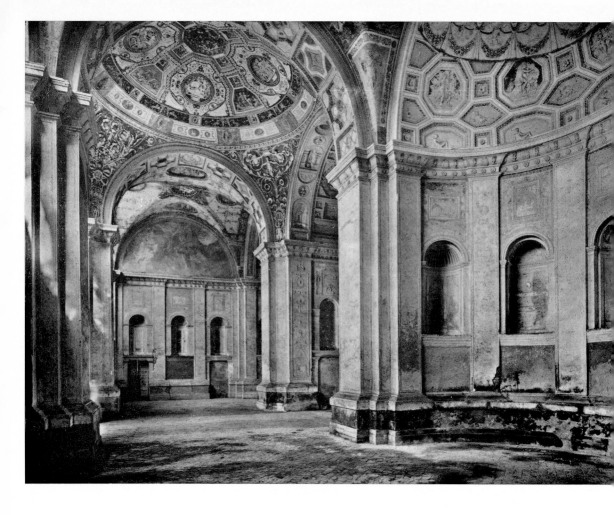

181. Raphael: Rome, Villa Madama, begun *c.* 1516, interior of the loggia, looking east

182. Antonio da Sangallo the Younger: Rome, Palazzo Palma-Baldassini, *c.* 1520, façade, engraving by Falda

183. Rome, Palazzo Alberini-Cicciaporci, under construction in 1515, façade, engraving by Lafreri(?)

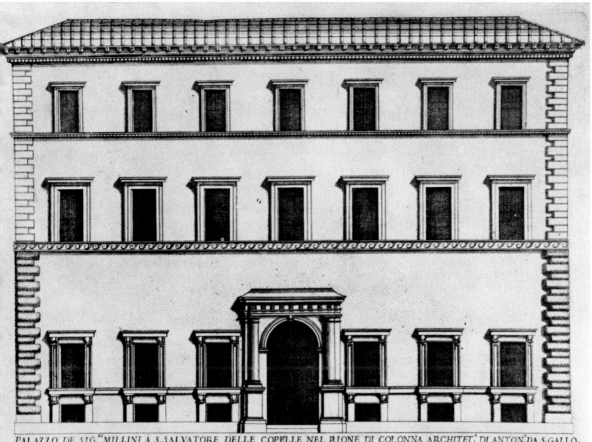

PALAZZO DE SIG.RI MILLINI À S.SALVATORE DELLE COPELLE NEL RIONE DI COLONNA ARCHITET. DI ANTON. DA S.GALLO.

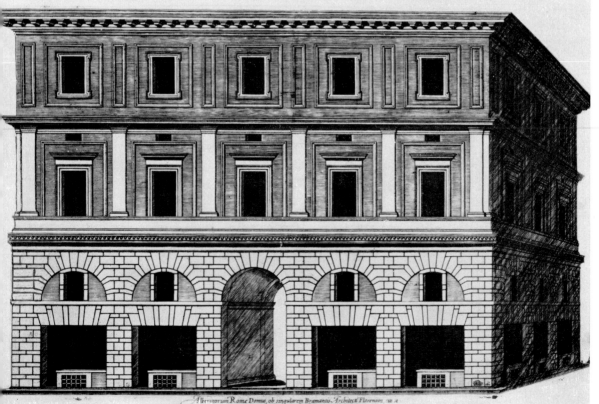

184. Rome, S. Maria di Loreto, begun 1507, looking north

185. Antonio da Sangallo the Elder: Montepulciano, Madonna di S. Biagio, begun 1518

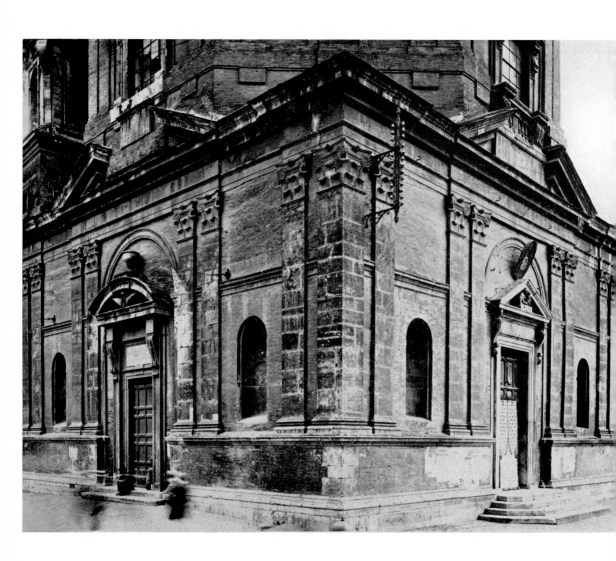

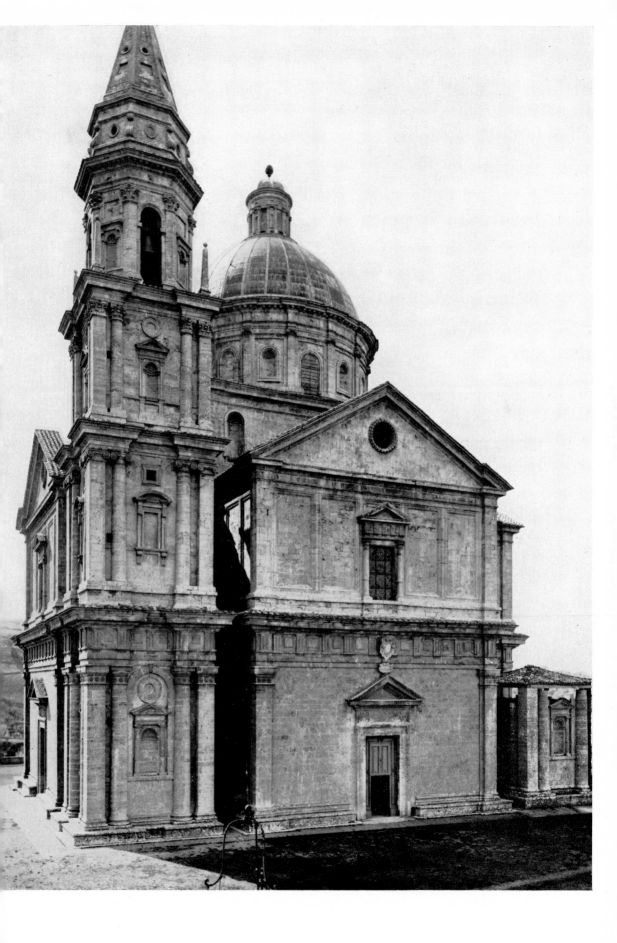

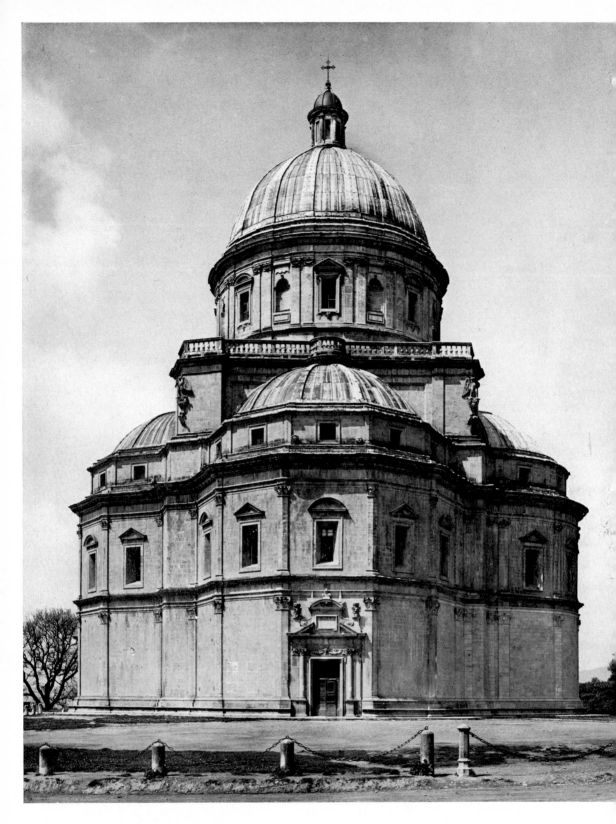

186. Cola da Caprarola and others: Todi, S. Maria della Consolazione, begun 1508

187. Cola da Caprarola and others: Todi, S. Maria della Consolazione, begun 1508

188. Antonio da Sangallo the Elder: Montepulciano, Madonna di S. Biagio, begun 1518

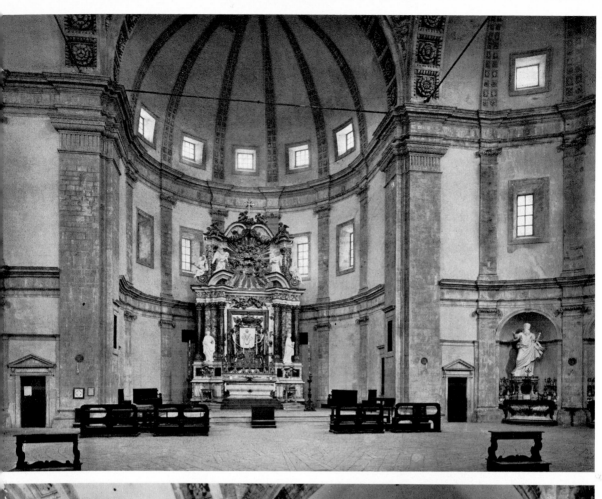

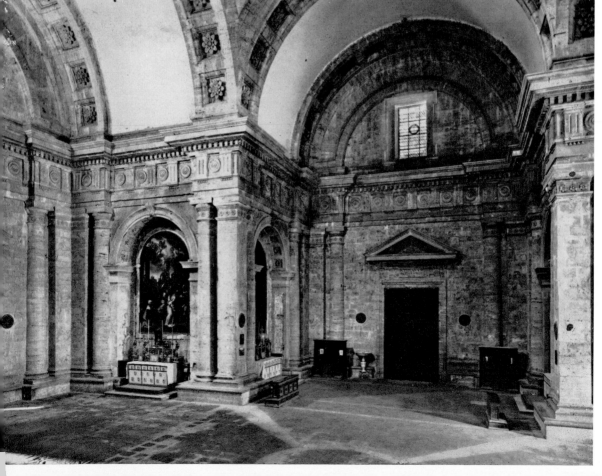

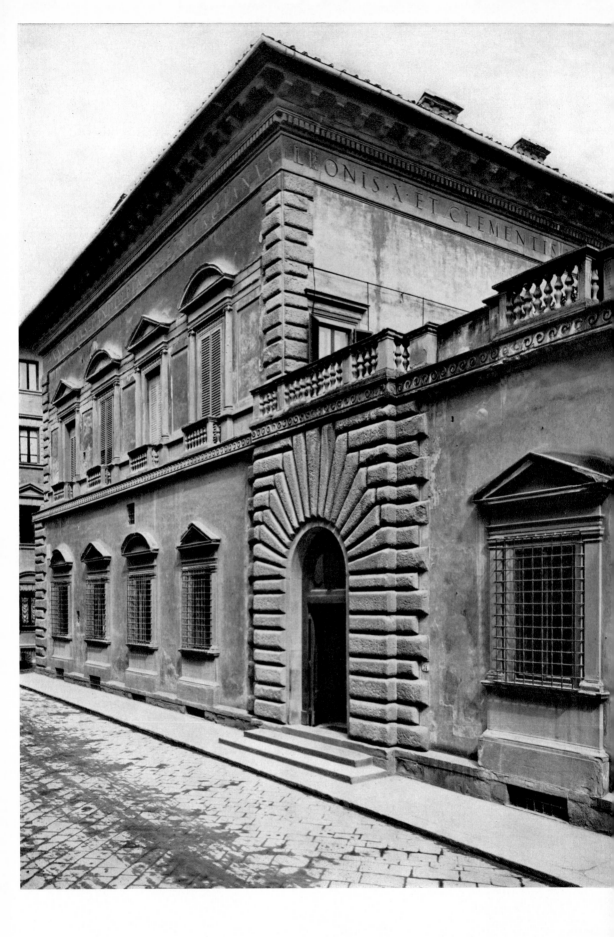

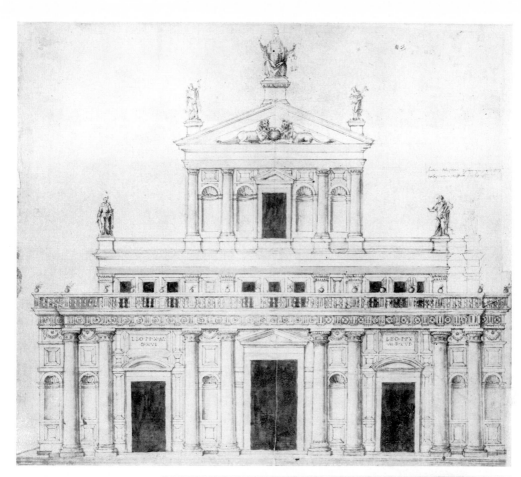

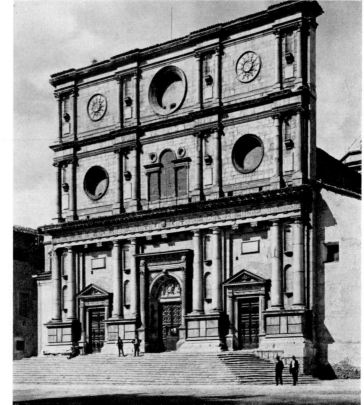

189. Raphael and others:
Florence, Palazzo
Pandolfini, begun *c.* 1518

190. Giuliano da
Sangallo: Project for the
façade of S. Lorenzo,
Florence, 1516. *Florence,
Uffizi* (A 276)

191. Cola dall'Amatrice:
L'Aquila, S. Bernardino,
façade, begun 1525

192. Naples, S. Giovanni a Carbonara, Cappella Caracciolo, begun *c.* 1515
193. Baldassare Peruzzi: Rome, Villa Farnesina, 1509–11, Loggia di Psiche

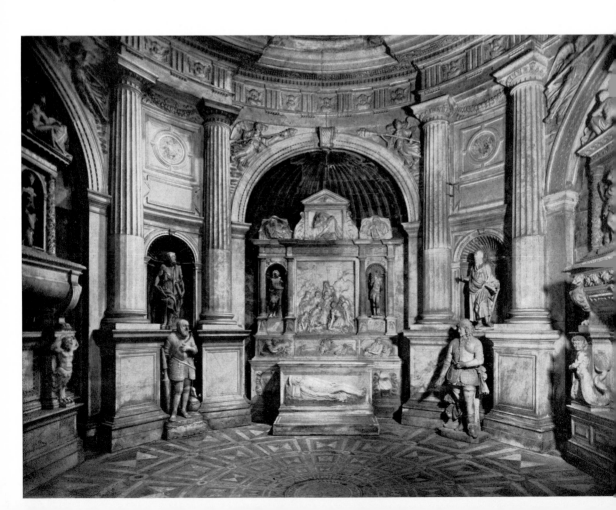

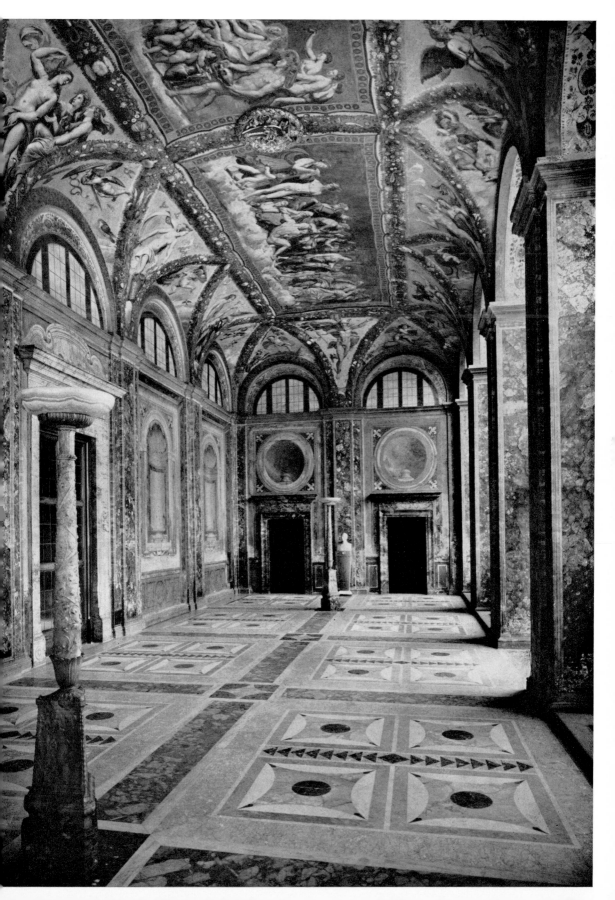

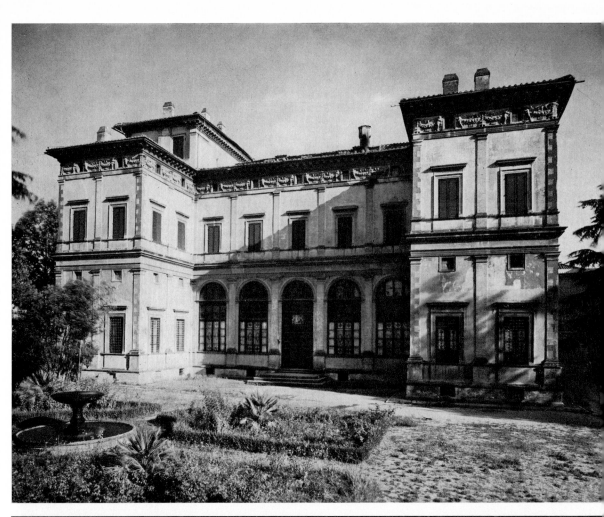

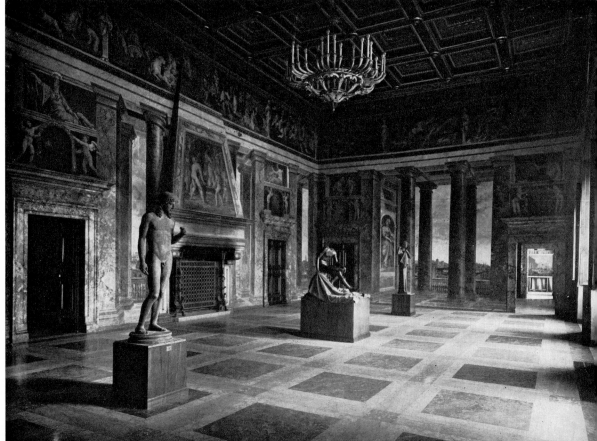

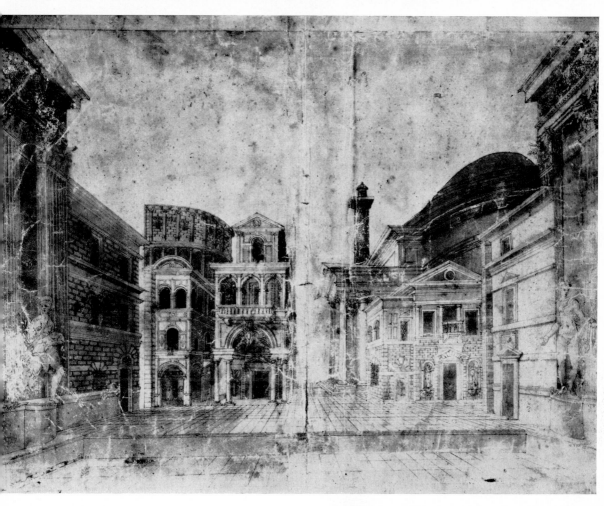

194. Baldassare Peruzzi: Rome, Villa Farnesina,
1509–11

195. Baldassare Peruzzi: Rome, Villa Farnesina,
Sala delle Colonne, *c.* 1512

196. Baldassare Peruzzi: 'Scena tragica'. *Stockholm,
Nationalmuseum*

197. Baldassare Peruzzi: Project for S. Petronio,
Bologna, 1522. *Bologna, Museo di S. Petronio*

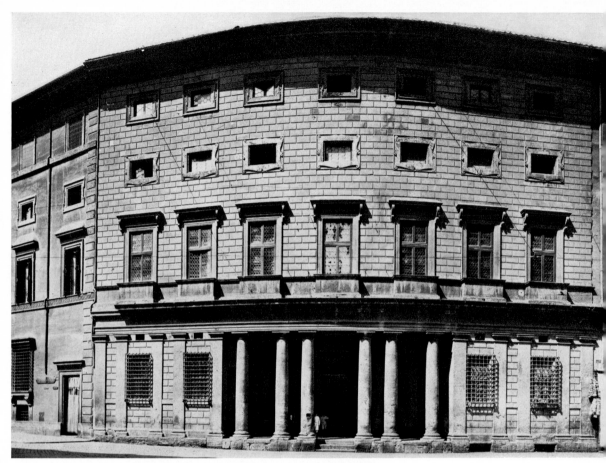

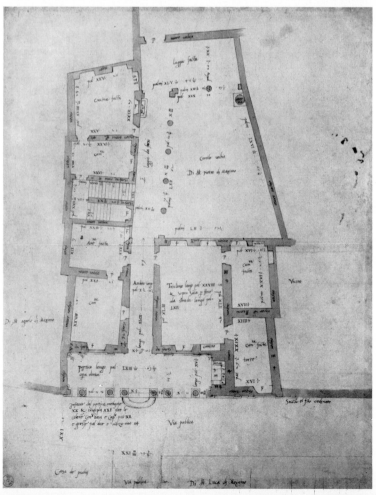

198. Baldassare Peruzzi: Rome,
Palazzo Massimo delle Colonne,
begun 1532, façade and project.
Florence, Uffizi (A 368)

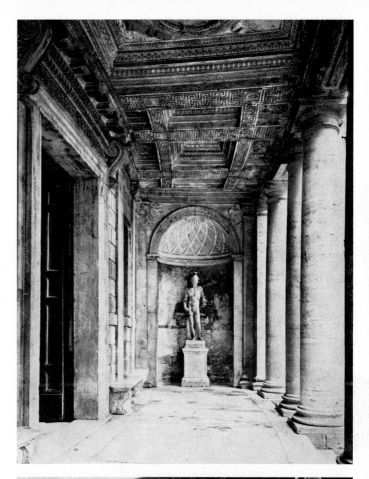

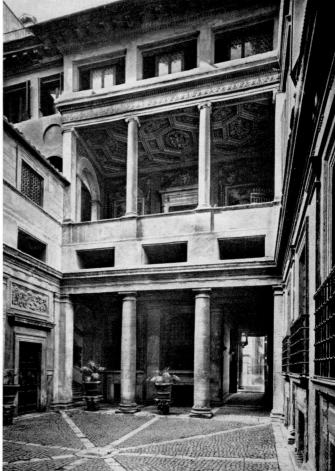

199. Baldassare Peruzzi: Rome, Palazzo
Massimo delle Colonne, begun 1532,
portico

200. Baldassare Peruzzi: Rome, Palazzo
Massimo delle Colonne, begun 1532,
courtyard

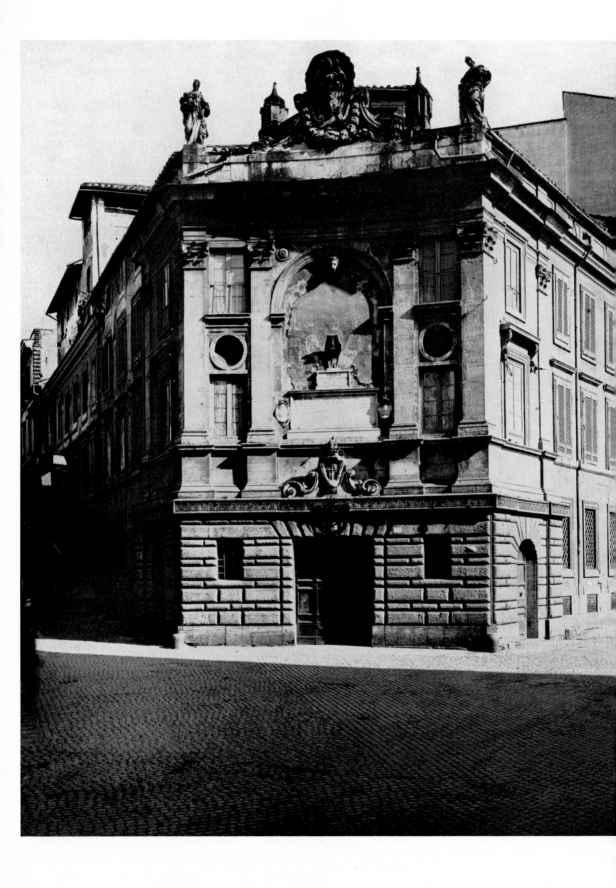

201. Antonio da Sangallo the Younger: Rome, Zecca, façade, *c.* 1530

202. Antonio da Sangallo the Younger: Project for the mint of the dukedom of Castro.
Florence, Uffizi (A 297)

203. Old and New St Peter's, drawing by Marten van Heemskerck, *c.* 1534. *Berlin, Staatliche Museen Preussischer Kulturbesitz, Kupferstichkabinett* (11, 54)

204. Old and New St Peter's, fresco by Giorgio Vasari, 1546. *Rome, Cancelleria*

205. Antonio da Sangallo the Younger: Model for St Peter's, 1539 ff., from the south

206. Antonio da Sangallo the Younger: Model for St Peter's, 1539 ff., cross-section, engraving by Salamanca

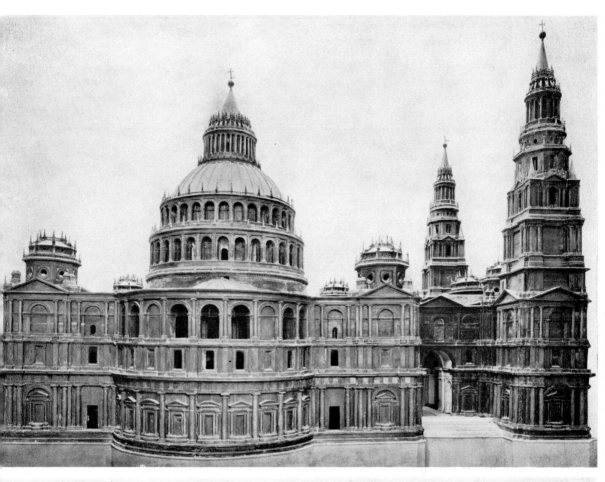

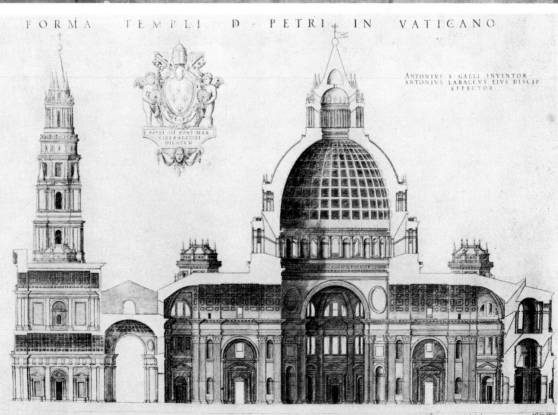

FORMA TEMPLI D · PETRI · IN VATICANO

ANTONIVS · S · GALLI INVENTOR
ANTONIVS LABACCVS EIVS DISCIP·
EFFECTOR·

PAVLI III PONT·MAX·
LIBERALITATI
DICATVM

SVM GRATIA ET PRIVILEGIO

207. Antonio da Sangallo the Younger (French copy): Rome, Palazzo Farnese, plan of ground floor, *c.* 1525–30. *Munich, Staatsbibliothek* (cod. icon. 190)

208. Antonio da Sangallo the Younger: Rome, Palazzo Farnese, plan of ground floor, final project, *c.* 1541. *Florence, Uffizi* (A 248)

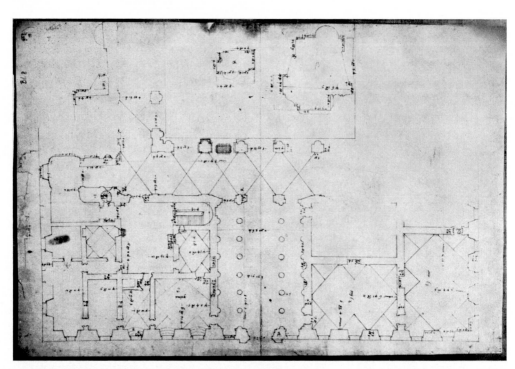

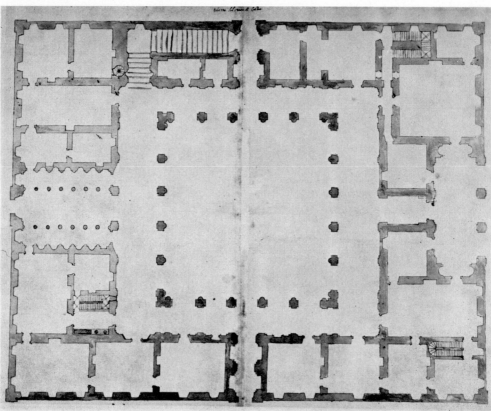

209. Antonio da Sangallo the Younger: Rome, Palazzo Farnese, vestibule, 1517

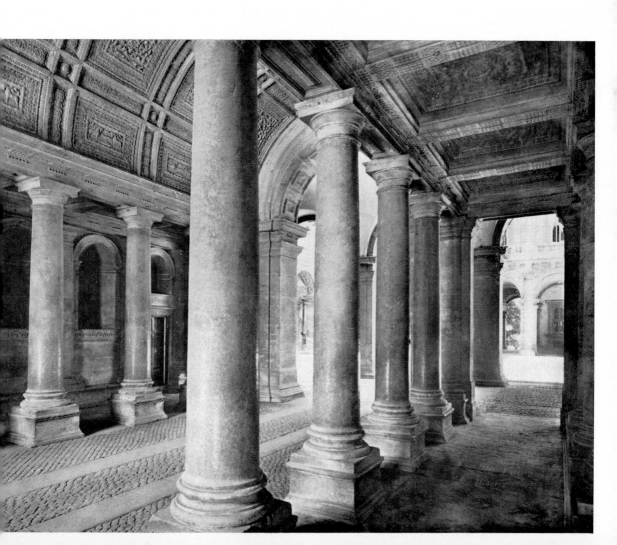

210. Antonio da Sangallo the Younger: Rome, Palazzo Farnese, arcade of the ground floor, 1517

211. Rome, Palazzo Farnese, courtyard, ground floor and first storey by Antonio da Sangallo the Younger, second storey by Michelangelo

212. Rome, Palazzo Farnese, façade by Antonio da Sangallo, designed 1541, finished by Michelangelo, designed 1546

213. Rome, Palazzo Farnese, façade, and Piazza Farnese as designed by Michelangelo, engraving by Nicolas Beatrizet, 1549

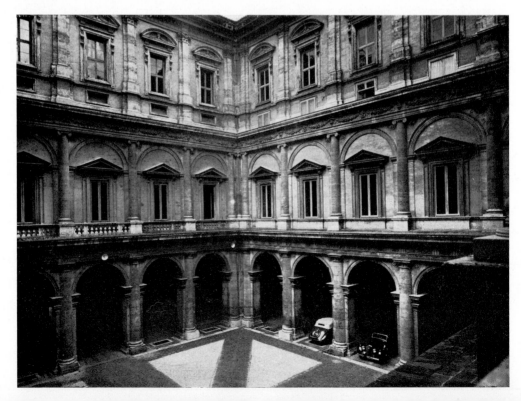

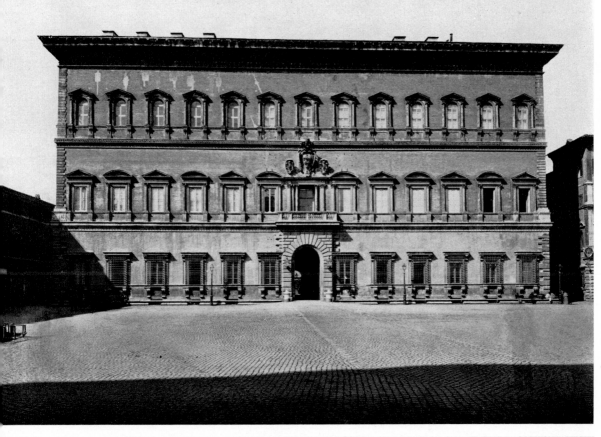

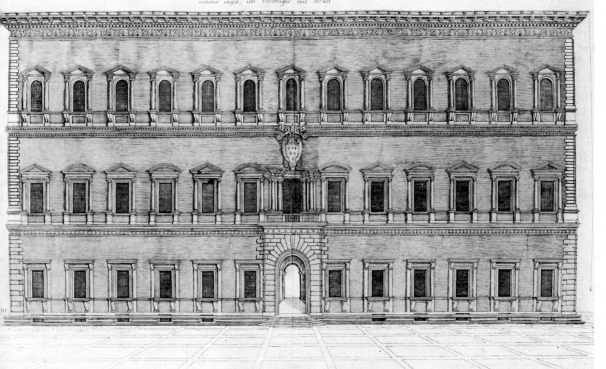

Exterior orthographia frontis Farnesianæ domus: quam Romæ, et magnis impensis, et seruatis architecturæ præceptis Pavlvs Tertivs Pontifex Maximus, à fundamentis memoriæ caussa, sibi Posterisque suis erexit

Mensura Palmorum x 1 Antonij Lafrerij Sequani formis ∞ ∞ XLVIII

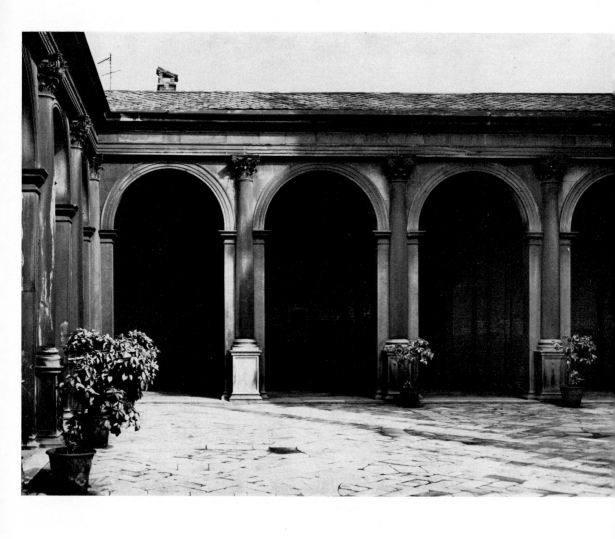

214. Cesare Cesariano: Milan, S. Maria presso S. Celso, atrium, begun 1513

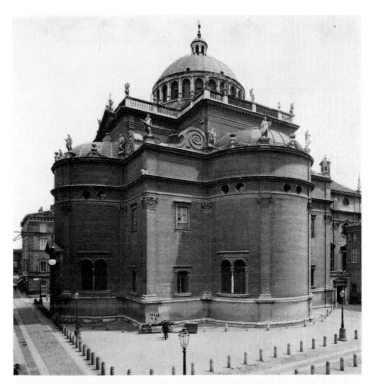

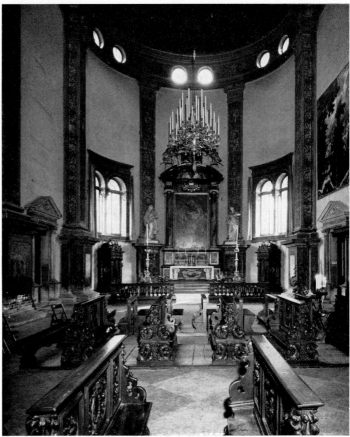

215 and 216. G. F. and Bernardino
Zaccagni: Parma, Madonna della
Steccata, begun 1521

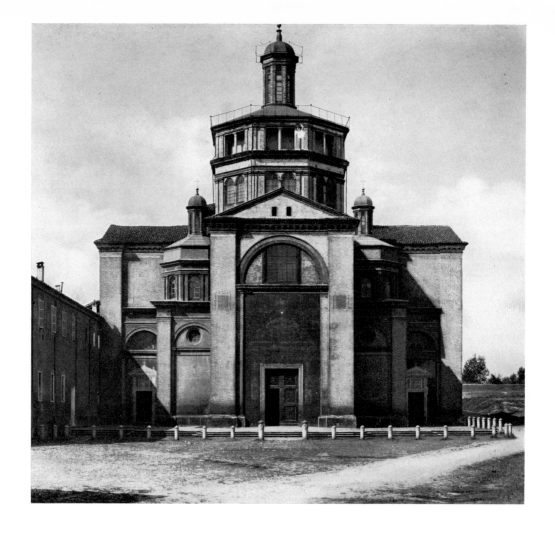

217 and 218. Alessio Tramello: Piacenza, Madonna di Campagna, begun 1522

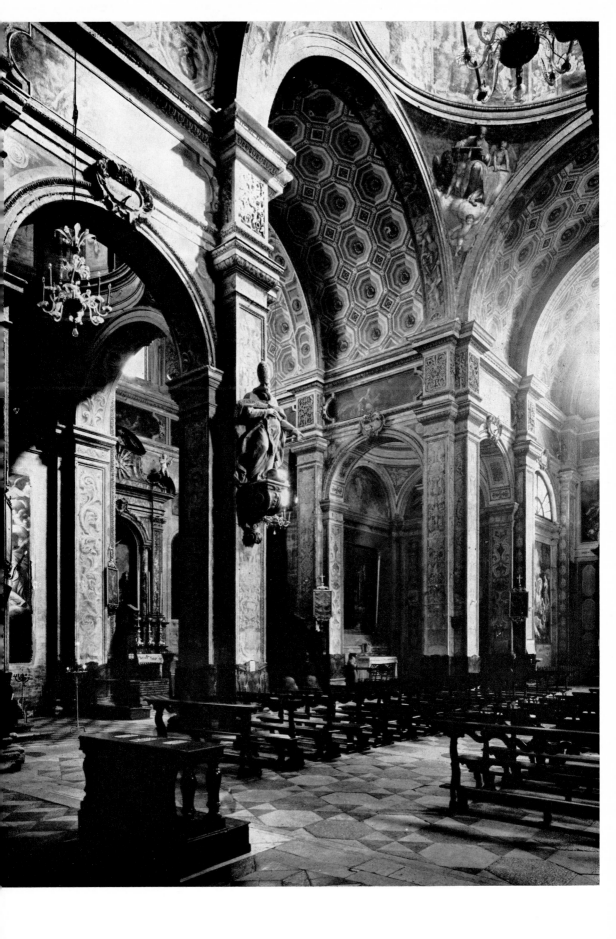

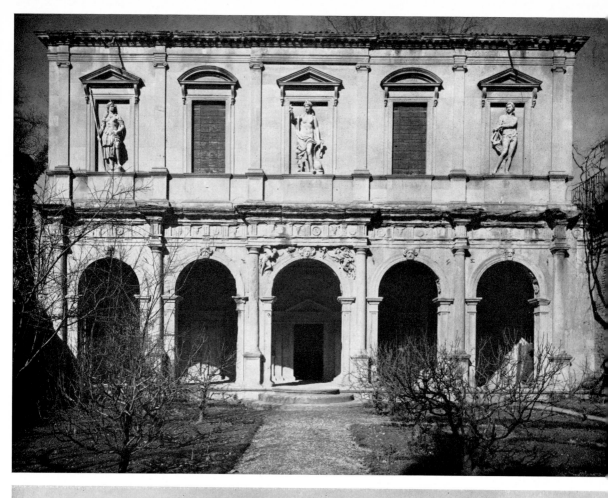

219. Giovanni Maria Falconetto: Padua, Loggia Cornaro, 1524

220. Giovanni Maria Falconetto and others: Luvigliano, Villa dei Vescovi, begun *c.* 1535

221. Giovanni Maria Falconetto: Padua, Porta S. Giovanni, 1528

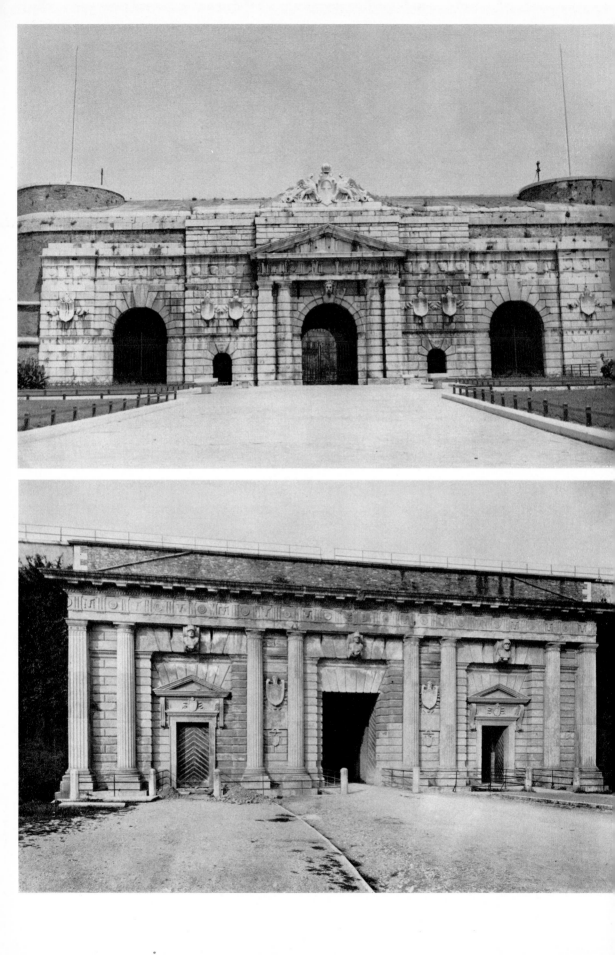

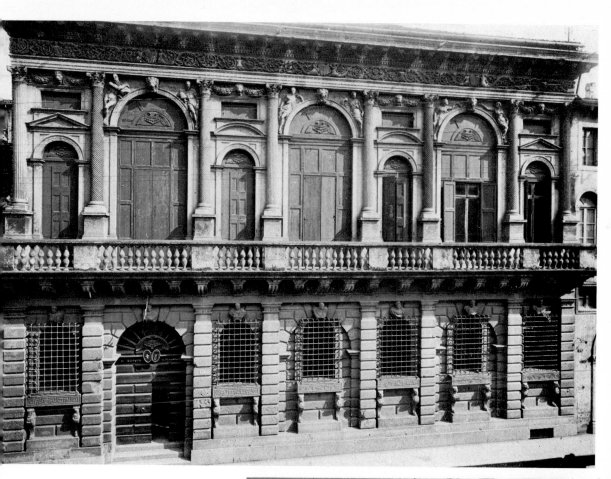

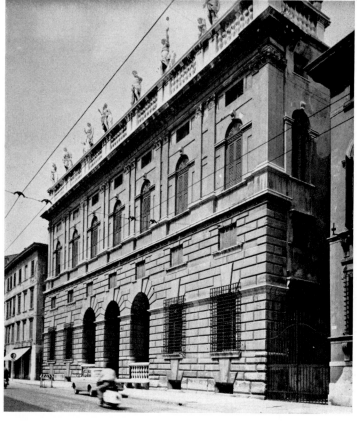

222. Michele Sanmicheli: Verona,
Porta Nuova, 1533–40

223. Michele Sanmicheli: Verona,
Porta Palio, begun *c.* 1555

224. Michele Sanmicheli: Verona,
Palazzo Bevilacqua, *c.* 1530

225. Michele Sanmicheli: Verona,
Palazzo Canossa, begun *c.* 1532

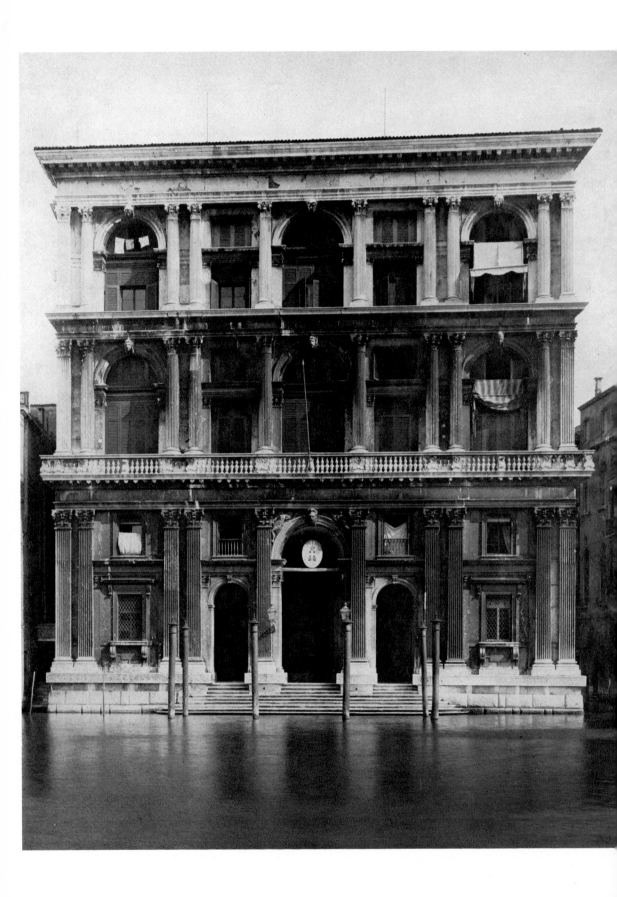

226. Michele Sanmicheli:
Venice, Palazzo Grimani, begun
c. 1556

227 and 228. Michele Sanmicheli:
Verona, Madonna di Campagna,
begun 1559

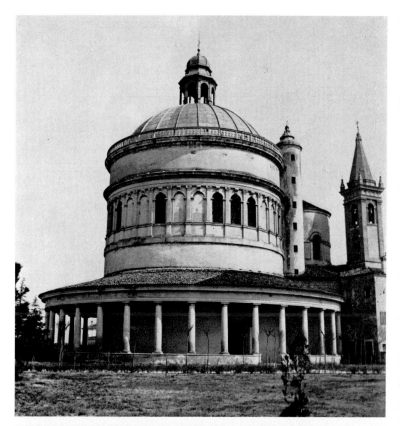

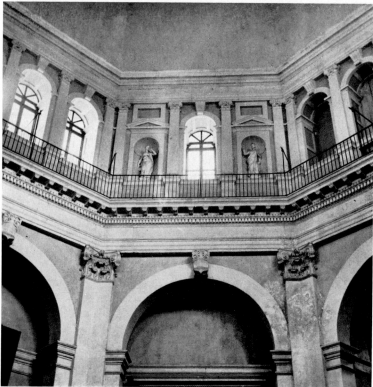

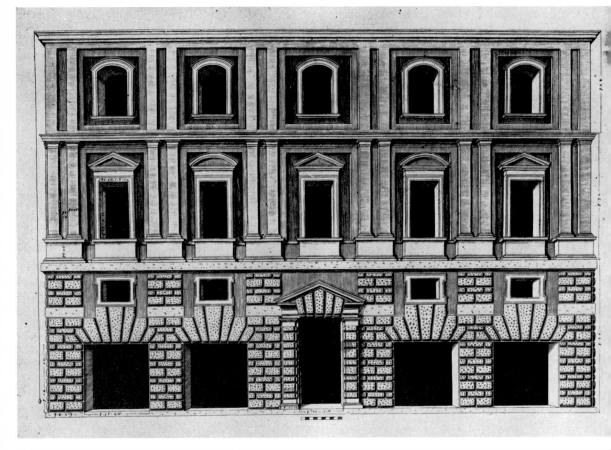

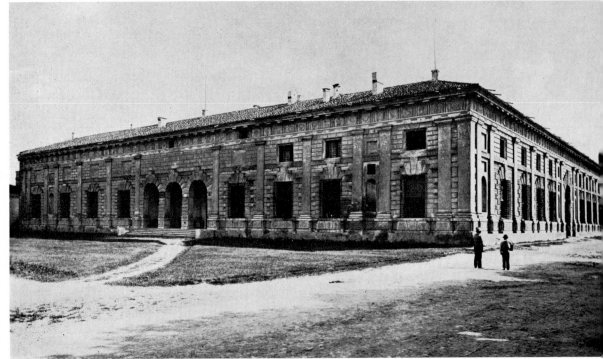

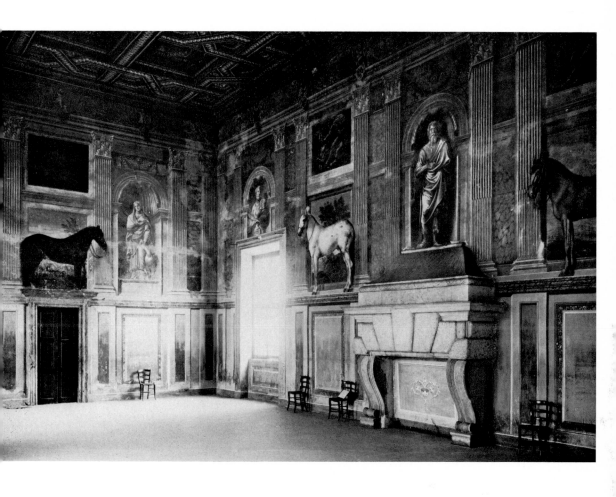

229. Giulio Romano: Rome, Palazzo Maccarani, *c.* 1520, engraving by Lafreri, 1549

230. Giulio Romano: Mantua, Palazzo del Te, begun 1525, façade

231. Giulio Romano: Mantua, Palazzo del Te, begun 1525, Sala dei Cavalli

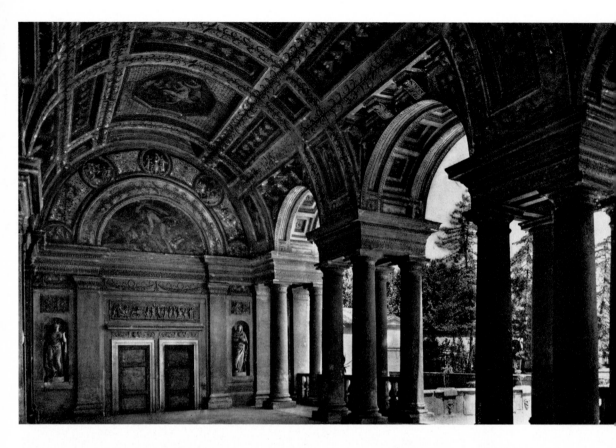

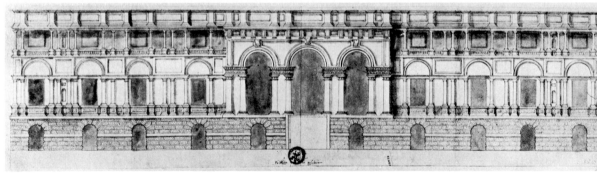

232. Giulio Romano: Mantua, Palazzo del Te, begun 1525, garden loggia

233. Giulio Romano: Mantua, Palazzo del Te, begun 1525, garden façade, drawing, *c.* 1570. *Düsseldorf, Kunstmuseum* (FP 10922)

234. Giulio Romano: Mantua, Palazzo del Te, begun 1525, courtyard

235. Giulio Romano: Mantua, Palazzo Ducale, Cortile della Cavallerizza, façade of the Estivale, *c.* 1539

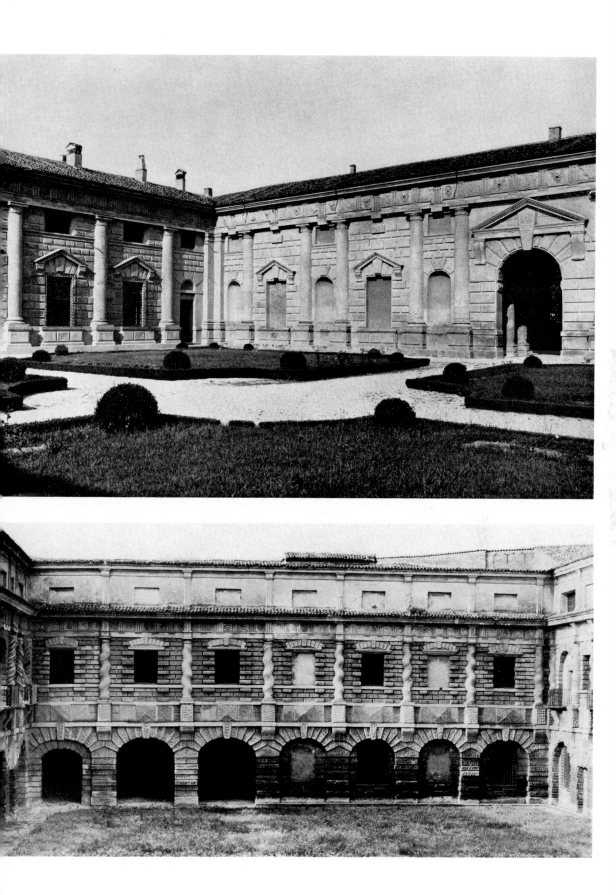

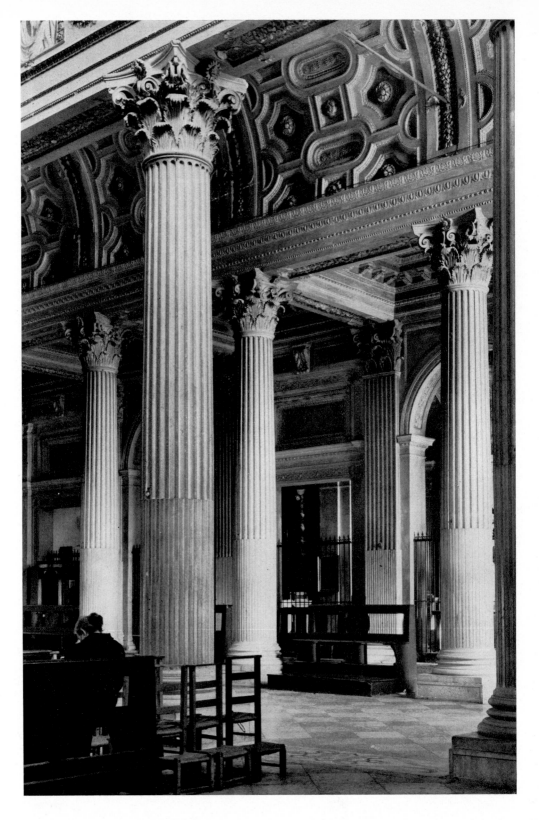

236. Giulio Romano: Mantua Cathedral, after 1540

237. Giulio Romano: S. Benedetto Po (Polirone), abbey church, after 1540

238. Giulio Romano: Mantua, the architect's own house, c. 1540

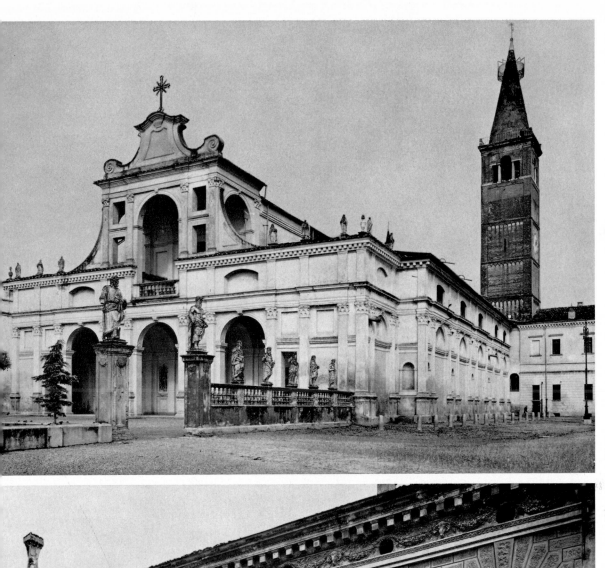

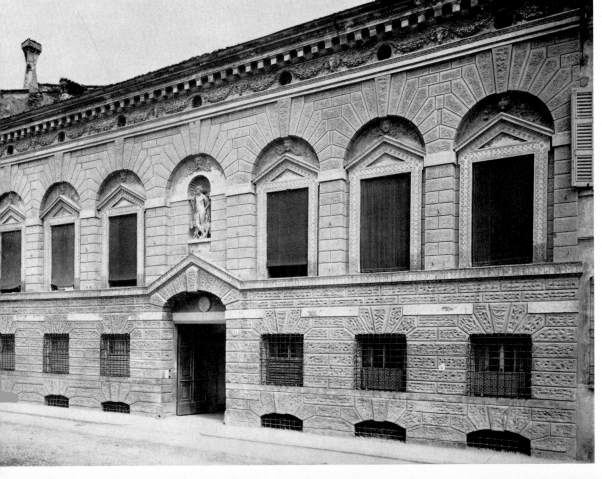

239. Jacopo Sansovino: Venice, Library of St Mark's, begun 1537, detail of façade

240. Jacopo Sansovino: Venice, Library of St Mark's, begun 1537, salone

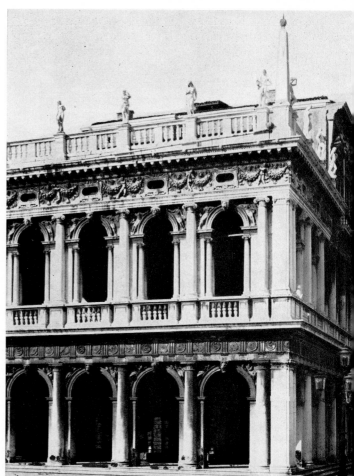

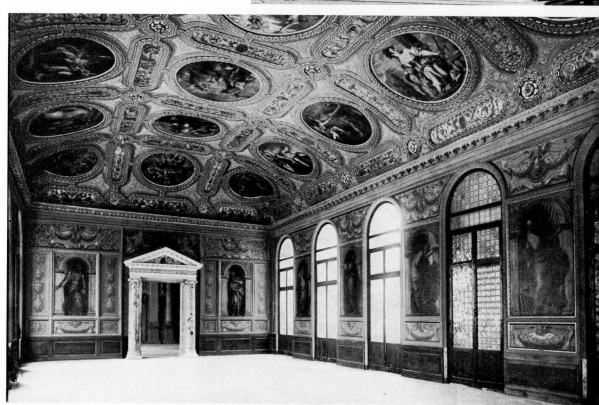

241. Jacopo Sansovino: Venice,
Zecca, begun 1537

242. Jacopo Sansovino: Venice,
Palazzo Corner della Cà Grande,
1530s

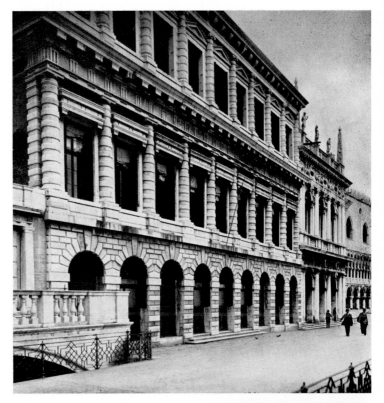

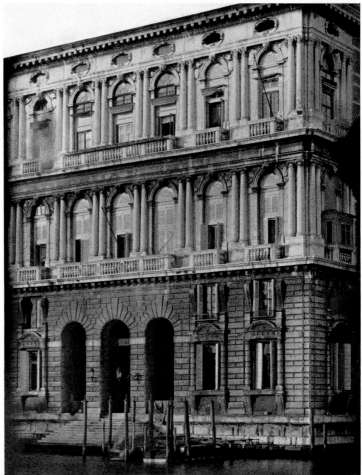

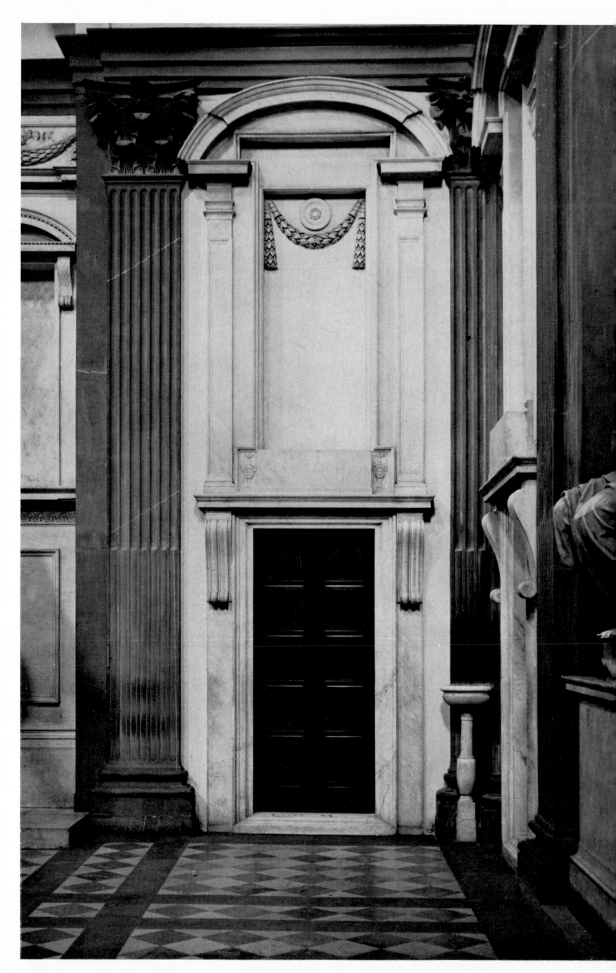

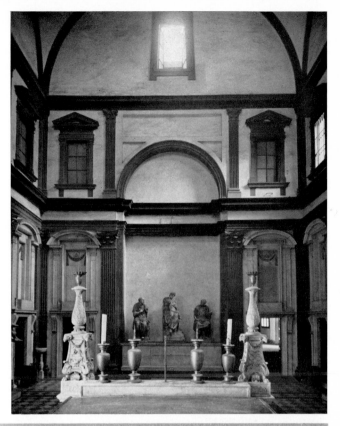

243 and 244. Michelangelo: Florence,
S. Lorenzo, New Sacristy, begun 1519

245. Michelangelo: Model for the façade of
S. Lorenzo, Florence, 1517. *Florence, Casa
Buonarroti*

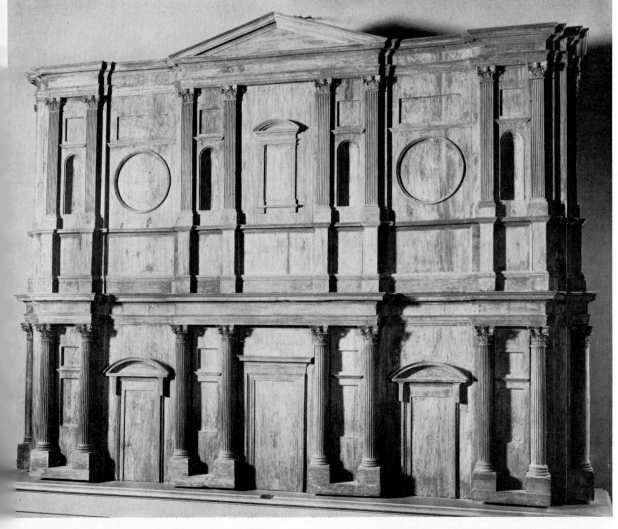

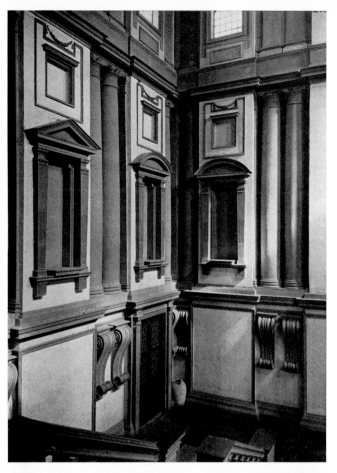

246. Michelangelo: Florence, S. Lorenzo,
Library, begun 1525, ricetto

247. Michelangelo: Florence, S. Lorenzo,
Library, begun 1525, ricetto, staircase

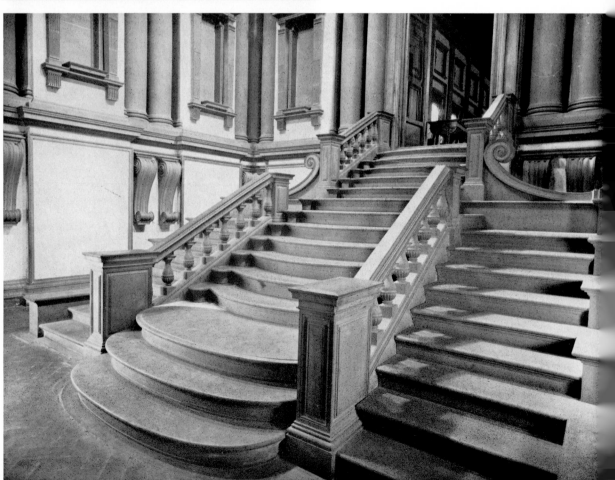

248. Michelangelo: Florence, S. Lorenzo, Library, begun 1525

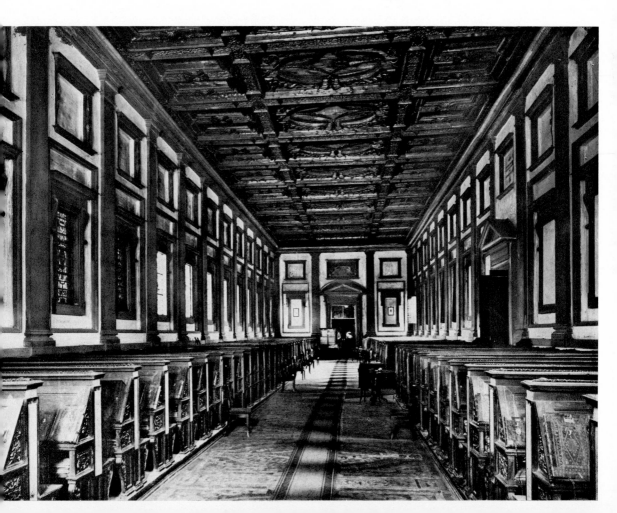

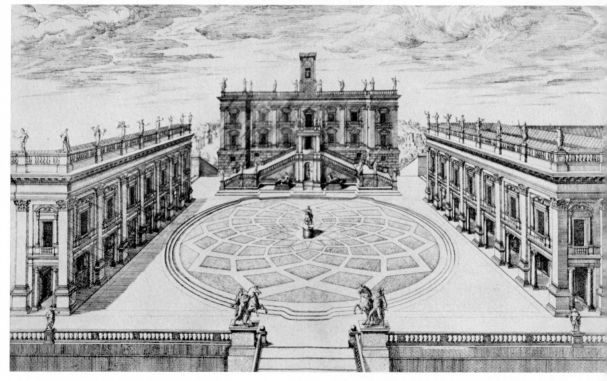

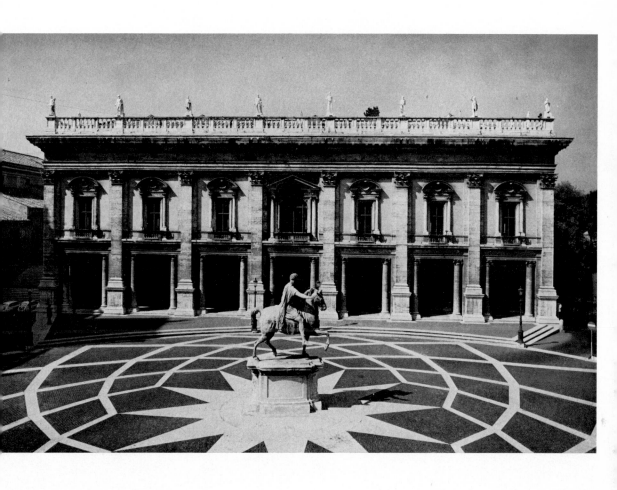

249. Rome, Piazza del Campidoglio, drawing, *c.* 1555. *Paris, Louvre* (École d'Italie, 11028)

250. Michelangelo: Project for the Piazza del Campidoglio, Rome, engraving by Étienne Dupérac, 1569

251. Michelangelo: Rome, Palazzo de' Conservatori, Piazza del Campidoglio, begun 1563

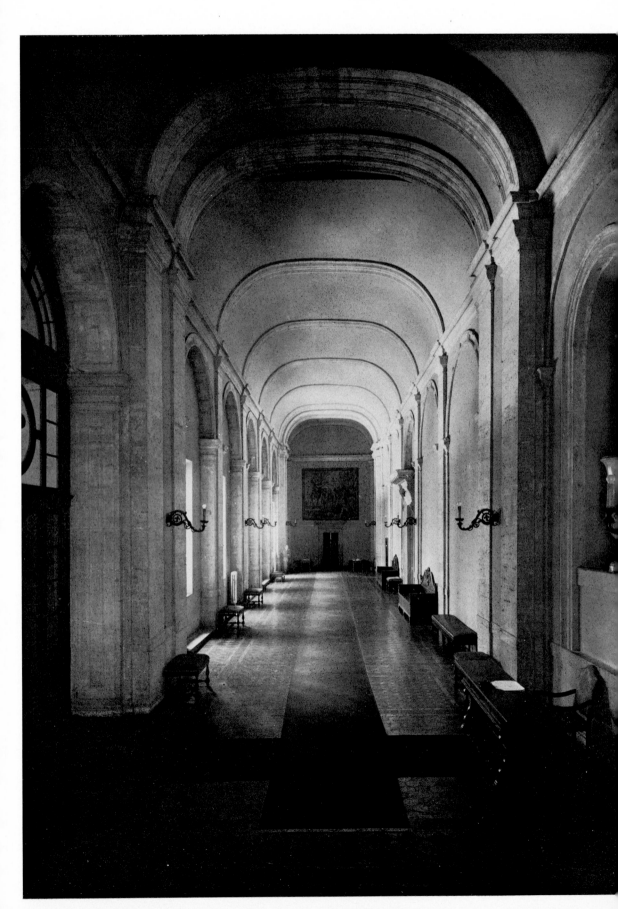

252. Michelangelo: Rome, Palazzo Farnese, vault of loggia in the piano nobile, after 1546

253. Michelangelo: Project for the rear wing of the Palazzo Farnese, Rome, engraving by Antonio Lafreri, 1560

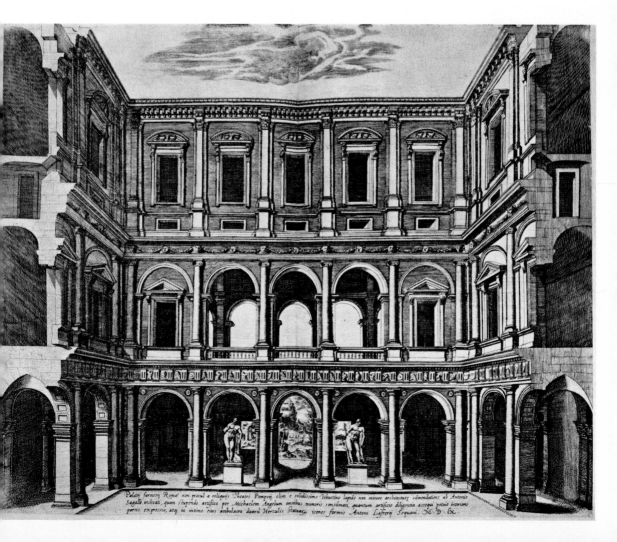

254 and 255. Michelangelo: Rome, St Peter's, from the north, and longitudinal section, engravings by Étienne Dupérac, 1569

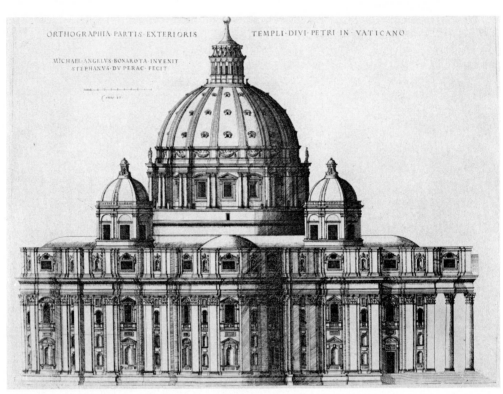

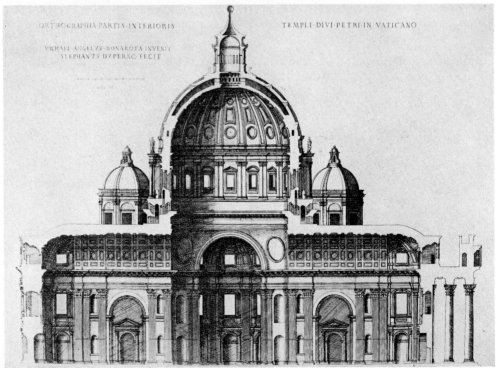

256. Michelangelo: Rome, St Peter's, south apse, designed 1546, finished by 1564, and dome, designed 1558–61, executed 1588–91

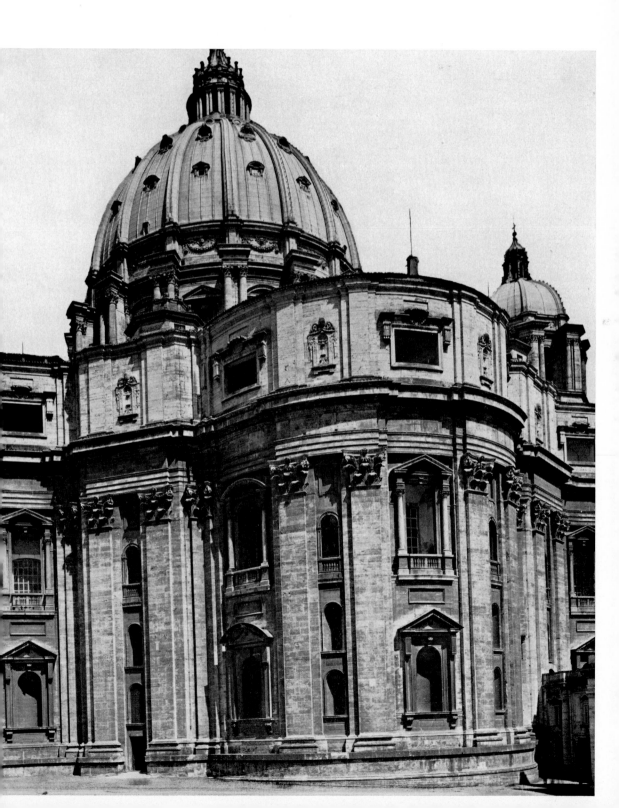

257. Michelangelo: Rome, St Peter's, north transept, designed 1546, nearly finished by 1564

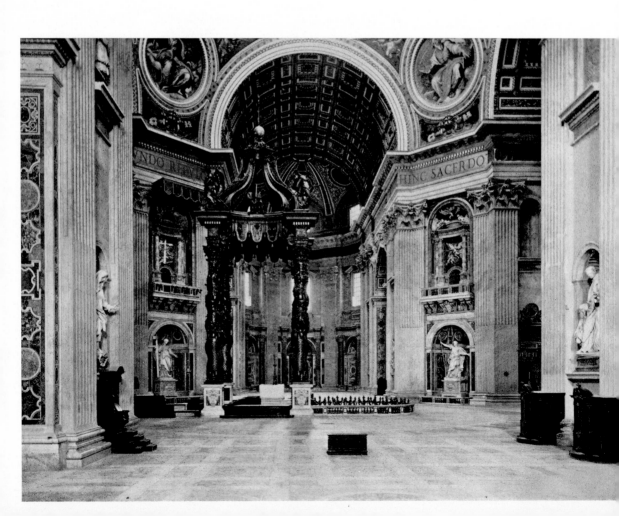

258. Michelangelo: Model for the dome of St Peter's, 1558–61. *Rome, Vatican City*

259. Michelangelo and Giacomo della Porta: Rome, St Peter's, dome, 1588–91

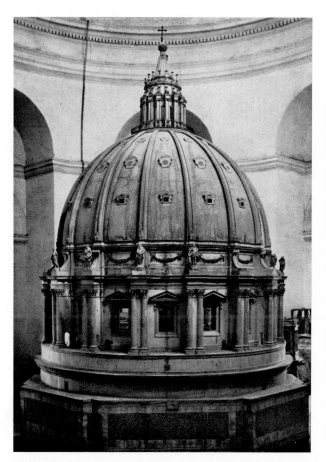

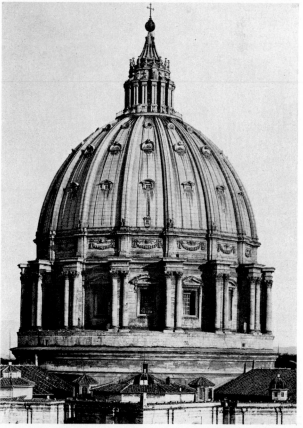

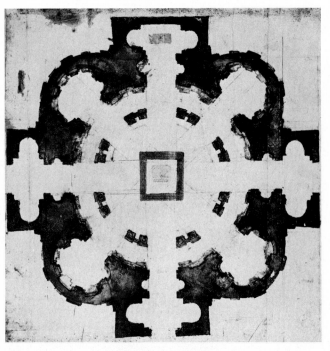

260. Michelangelo: Project for S. Giovanni
dei Fiorentini, Rome, plan. *Florence, Casa
Buonarroti* (124)

261. Michelangelo: Final project for
S. Giovanni dei Fiorentini, Rome, section
and exterior elevation, engraving by
Valérien Regnart

262. Michelangelo: Rome, Porta Pia, begun
1561

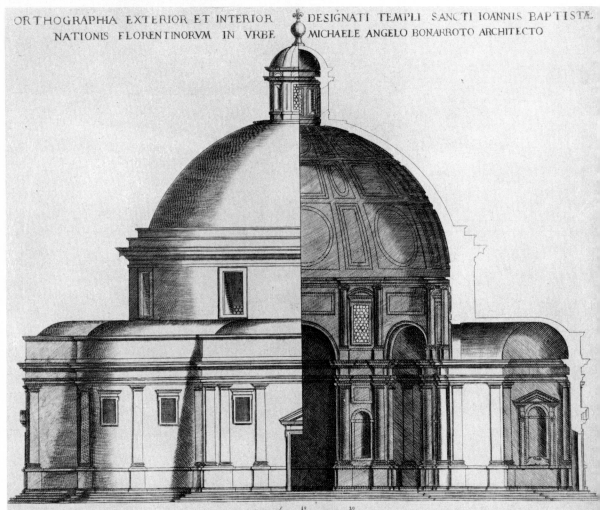

ORTHOGRAPHIA EXTERIOR ET INTERIOR DESIGNATI TEMPLI SANCTI IOANNIS BAPTISTÆ
NATIONIS FLORENTINORVM IN VRBE MICHAELE ANGELO BONARROTO ARCHITECTO

Valerianus Regnartius sculpsit Romæ B.de

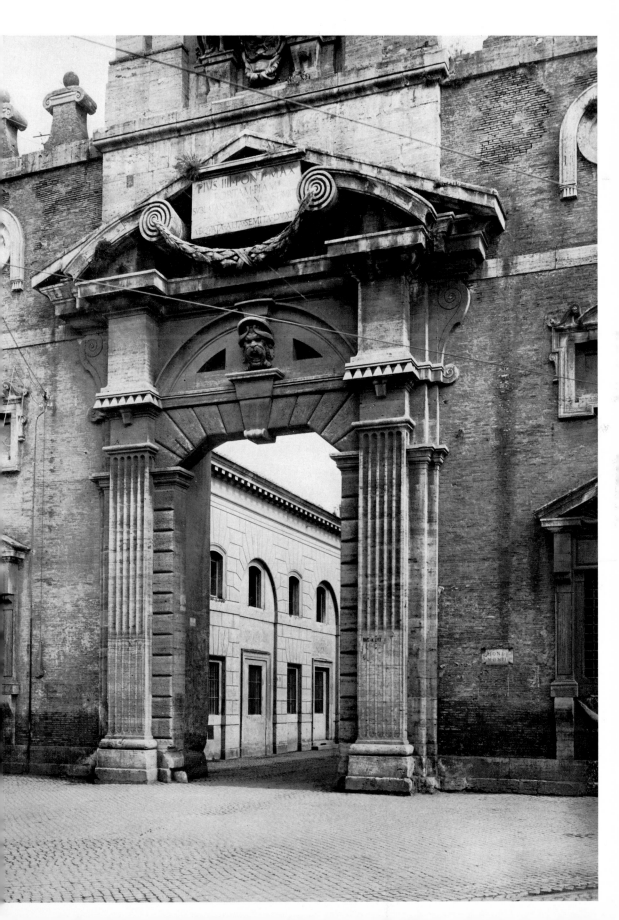

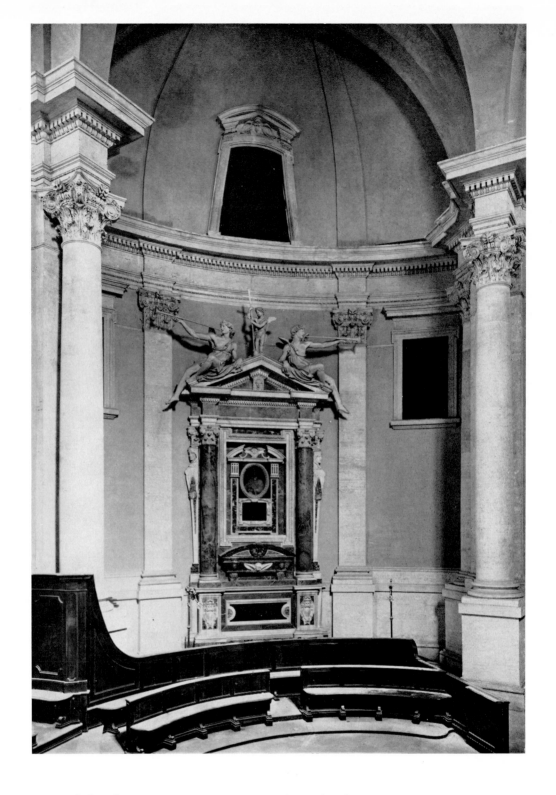

263. Michelangelo: Rome, S. Maria Maggiore, Sforza Chapel, *c.* 1560–1573

264. Michelangelo: Rome, S. Maria Maggiore, Sforza Chapel, *c.* 1560–1573, capitals and entablature

265. Michelangelo: Rome, S. Maria Maggiore, Sforza Chapel, *c.* 1560–1573, elevation of the façade towards the aisle of the church (demolished), drawing by A. Pagliarino, *c.* 1582

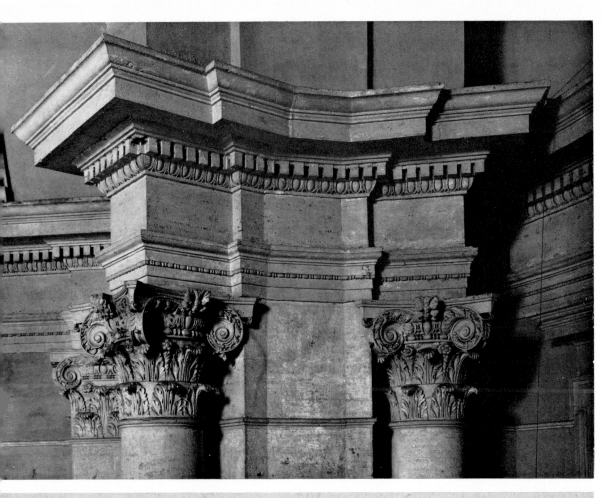

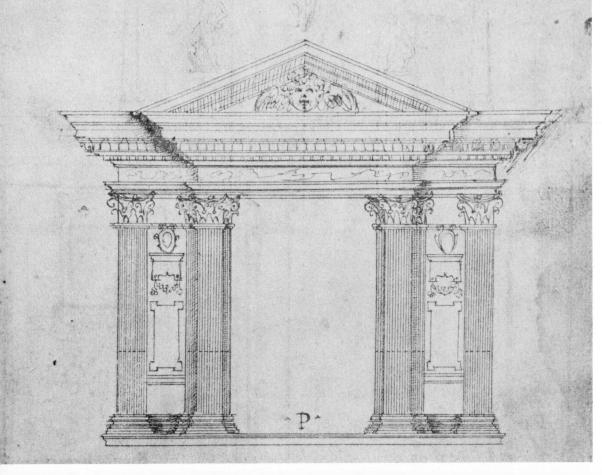

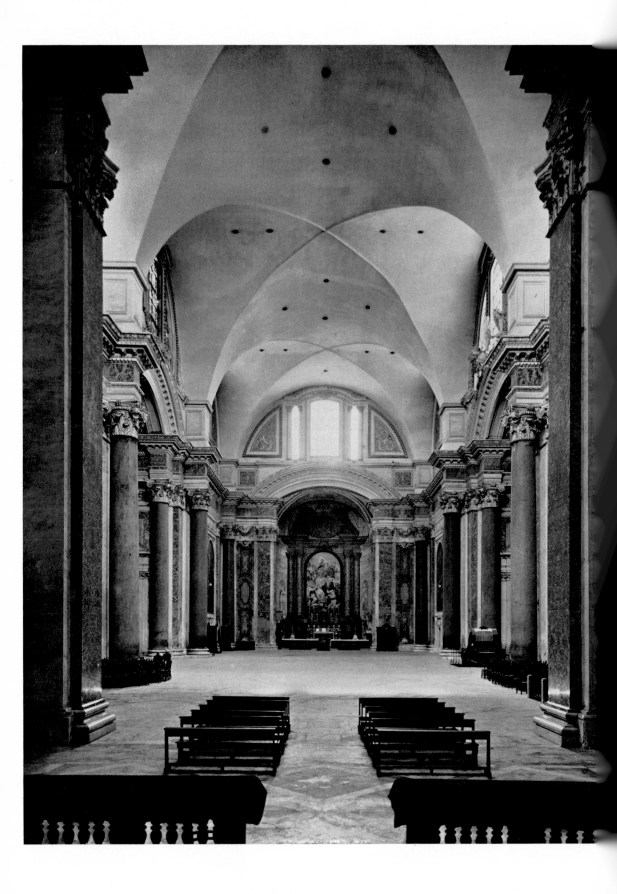

PROSPETTIVA DEL GIARDINO DEL SERENIS.mo GRAN DVCA DI TOSCANA SVL MONTE PINCIO *Architettura di Annibale Lippi.*

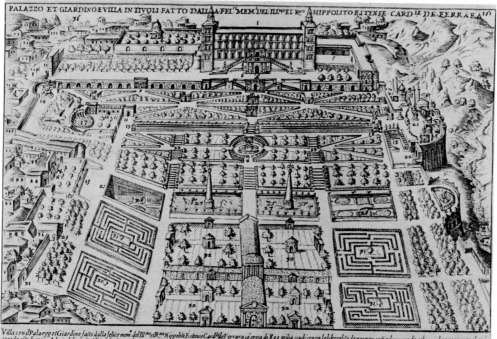

PALAZZO ET GIARDINO E VILLA IN TIVOLI FATTO DALLA FEL.ma MEM. DEL ILL.mo ET R.mo HIPPOLITO ESTENSE CARD.LE DE FERRARA

266. Michelangelo: Rome, S. Maria degli Angeli, remodelling begun 1561

267. Rome, Villa Medici, palace and gardens, looking south, engraving by G. B. Falda

268. Pirro Ligorio: Tivoli, Villa d'Este, c. 1565–1572, engraving by G. Lauro, 1641

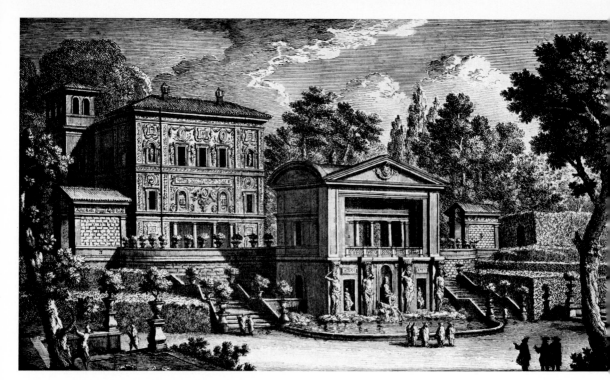

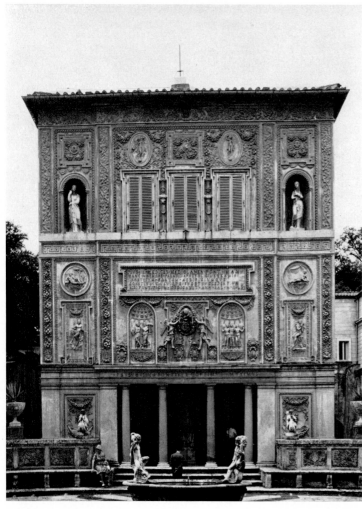

269. Pirro Ligorio: Rome, Casino di Pio IV, begun 1559, looking west, engraving by G. Venturini

270. Pirro Ligorio: Rome, Casino di Pio IV, begun 1559, façade

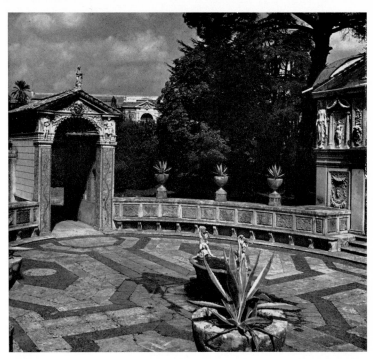

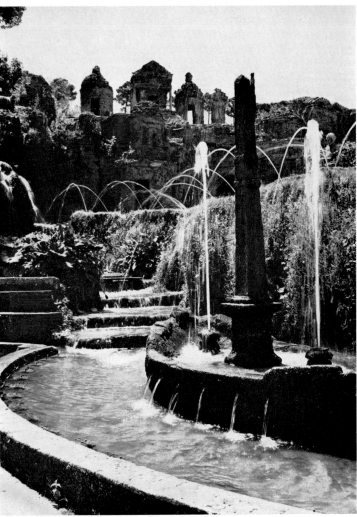

271. Pirro Ligorio: Rome, Casino di Pio IV, begun 1559, courtyard

272. Pirro Ligorio: Tivoli, Villa d'Este, *c.* 1565–1572, fountains of the Rometta

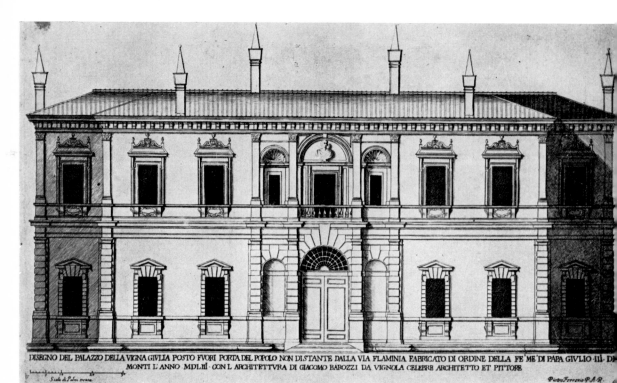

DISEGNO DEL PALAZZO DELLA VIGNA GIVLIA POSTO FVORI PORTA DEL POPOLO NON DISTANTE DALLA VIA FLAMINIA FABRICATO DI ORDINE DELLA FE ME DI PAPA GIVLIO III DI MONTI L'ANNO MDLIII CON L'ARCHITETTVRA DI GIACOMO BAROZZI DA VIGNOLA CELEBRE ARCHITETTO ET PITTORE

273. Giacomo Barozzi da Vignola: Rome, Villa di Papa Giulio, begun 1551, façade, engraving by Ferrerio

274. Giacomo Barozzi da Vignola: Project for the Palazzo Bocchi, Bologna, engraving, 1545

275. Giacomo Barozzi da Vignola: Rome, Villa di Papa Giulio, begun 1551, central bays of façade

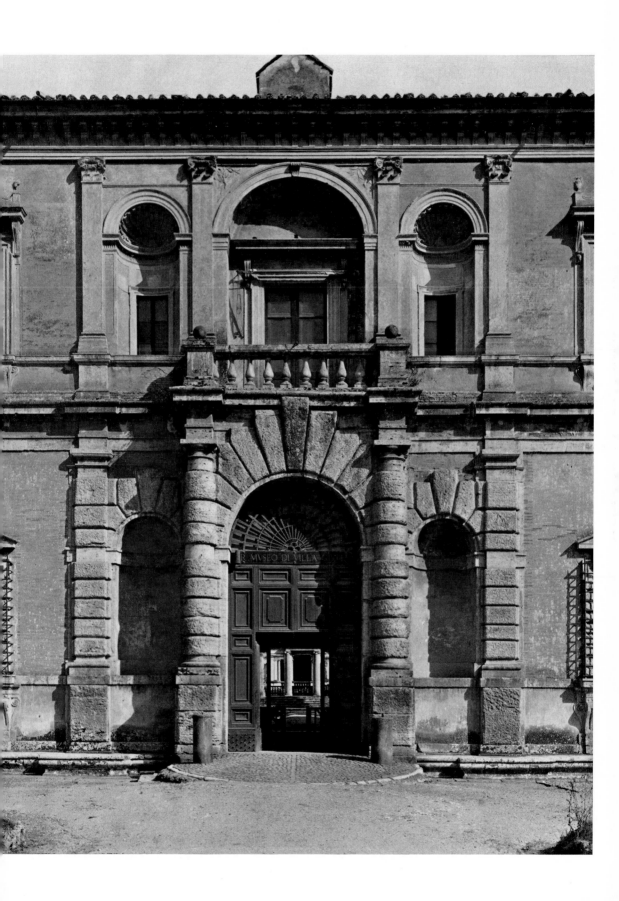

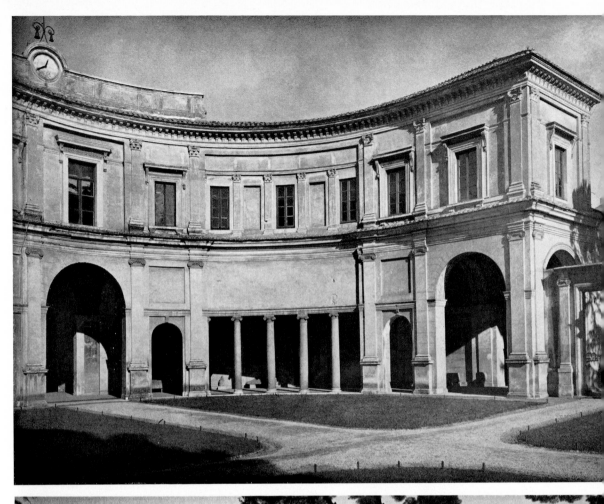
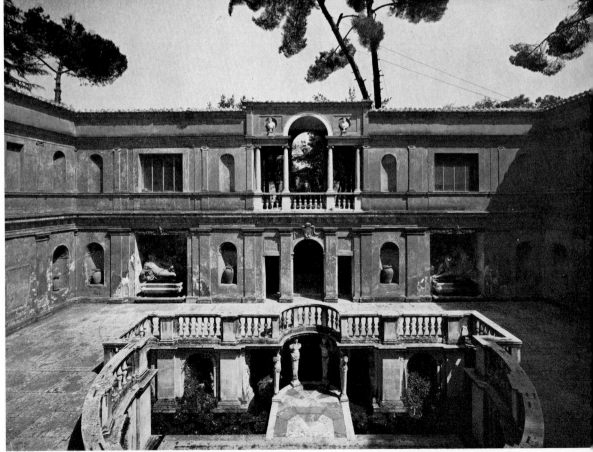

276 and 277. Giacomo Barozzi da Vignola and others: Rome, Villa di Papa Giulio, begun 1551, first courtyard, looking west, and second courtyard with the Fontana Segreta

278. Giacomo Barozzi da Vignola: Caprarola, Palazzo Farnese, begun 1559, façade

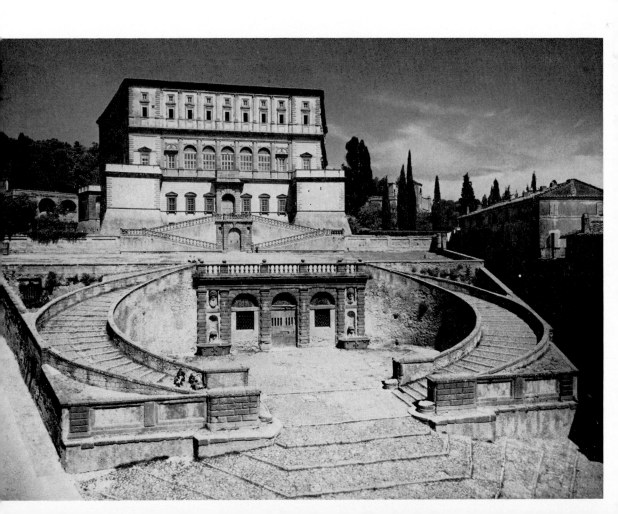

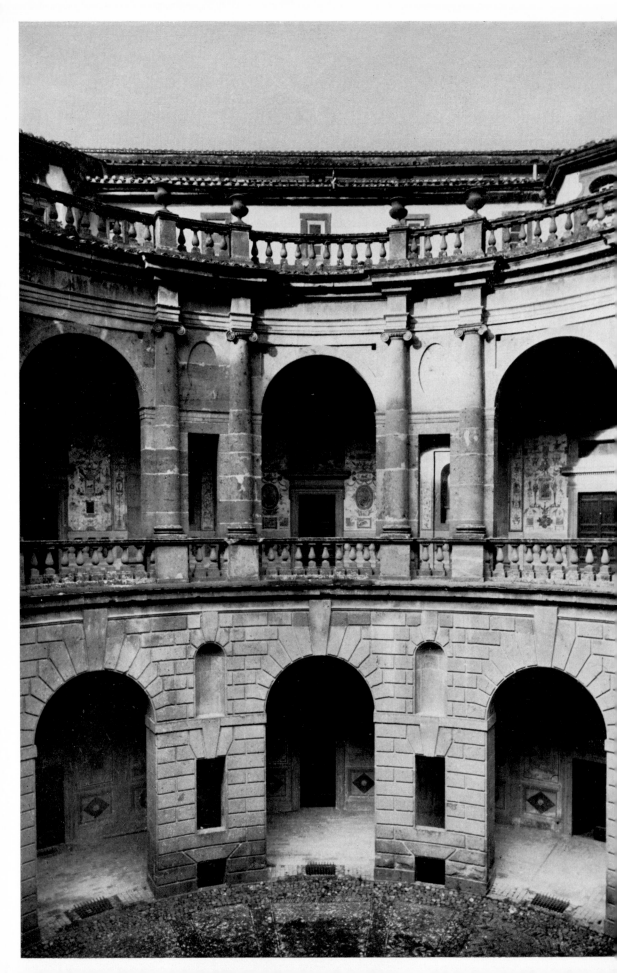

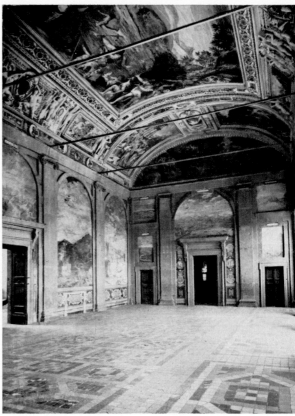

279–81. Giacomo Barozzi da Vignola: Caprarola, Palazzo Farnese, begun 1559, courtyard, staircase, and Sala di Ercole

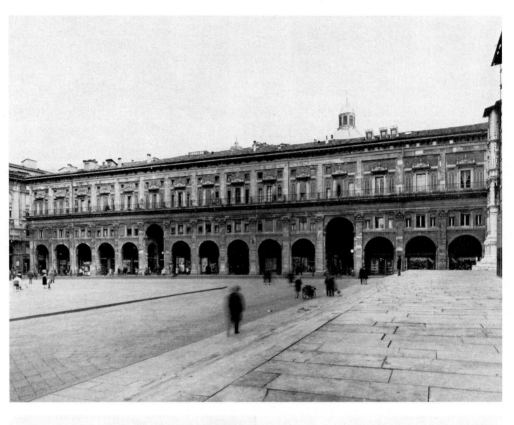

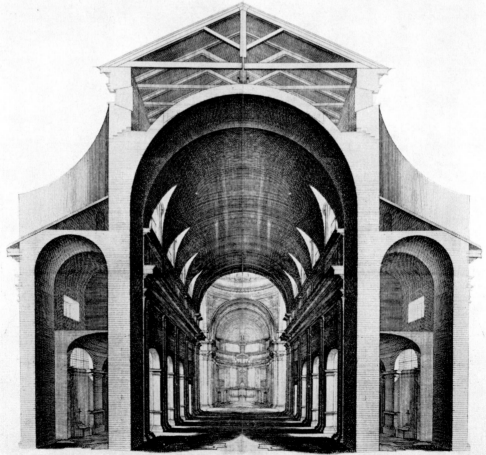

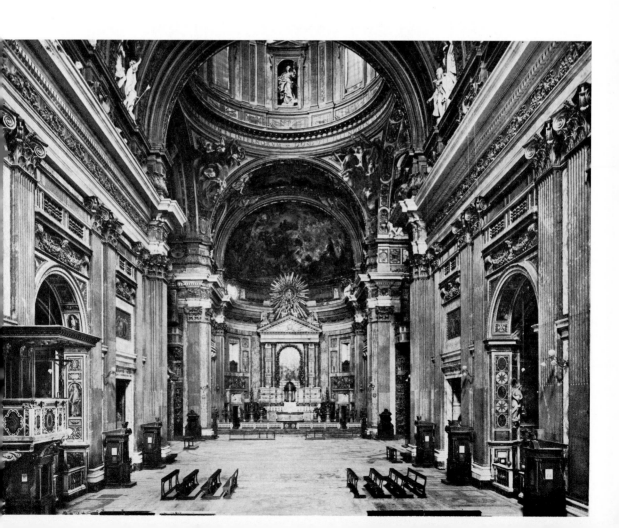

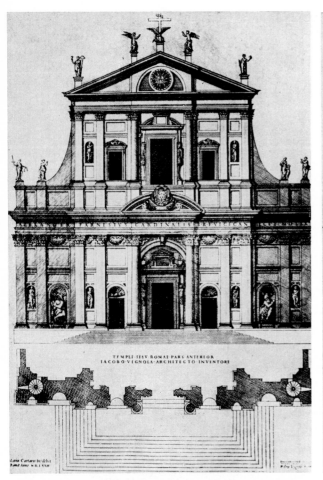

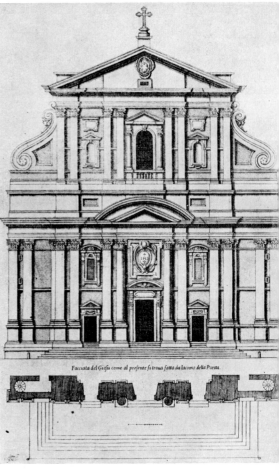

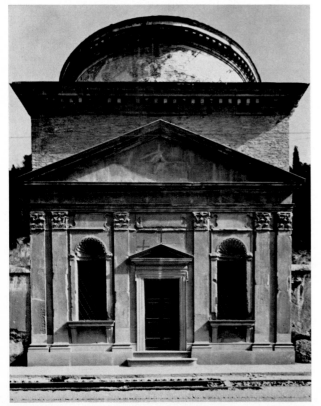

285. Giacomo Barozzi da Vignola: Rome,
Gesù, project for the façade, engraving by
Mario Cartaro, 1573

286. Giacomo della Porta: Rome, Gesù,
façade, begun 1571, engraving by Villamena

287 and 288 (*opposite*). Giacomo Barozzi da
Vignola: Rome, S. Andrea in Via Flaminia,
1550–*c.* 1553

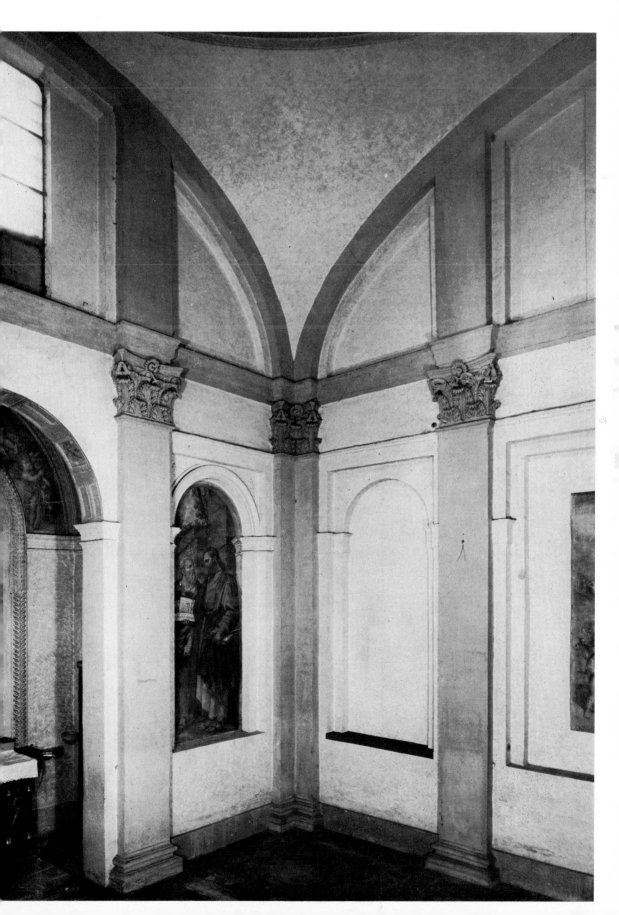

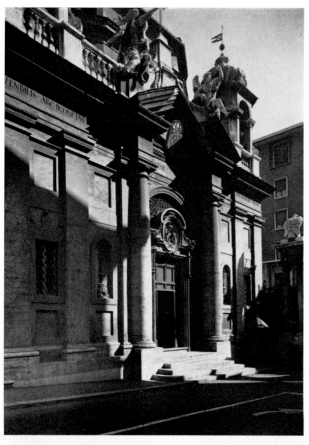

289 and 290. Giacomo and Giacinto Barozzi da Vignola: Rome, S. Anna dei Palafrenieri, begun 1565

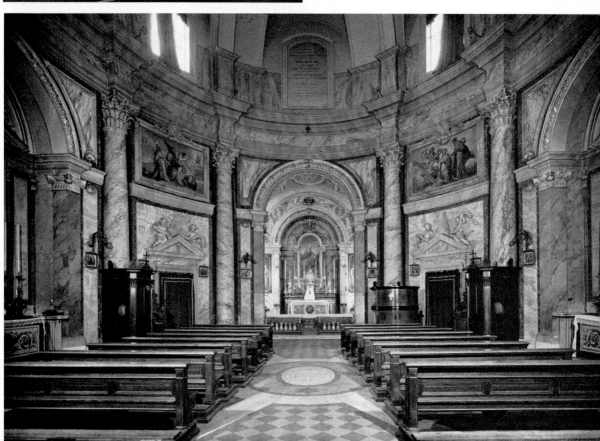

291. Giacomo della Porta: Rome,
S. Maria ai Monti, begun 1580

292. Giacomo della Porta and others:
Rome, S. Andrea della Valle, begun
1591

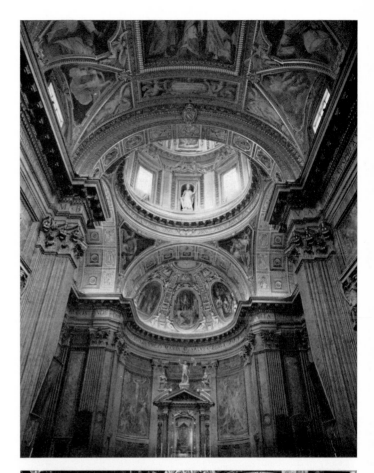

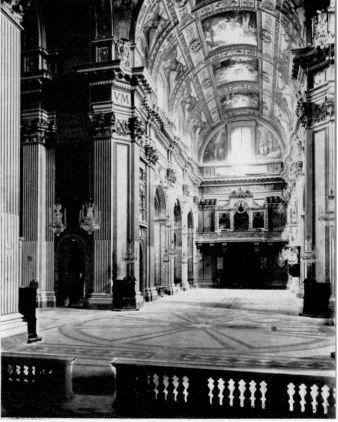

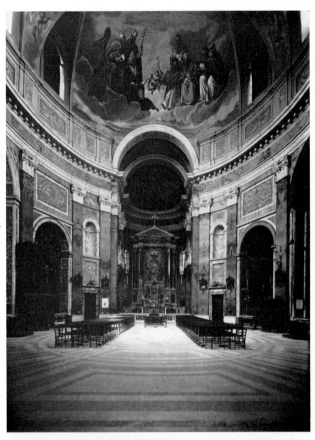

293 and 294. Francesco Capriani da Volterra:
Rome, S. Giacomo degli Incurabili, begun 1592

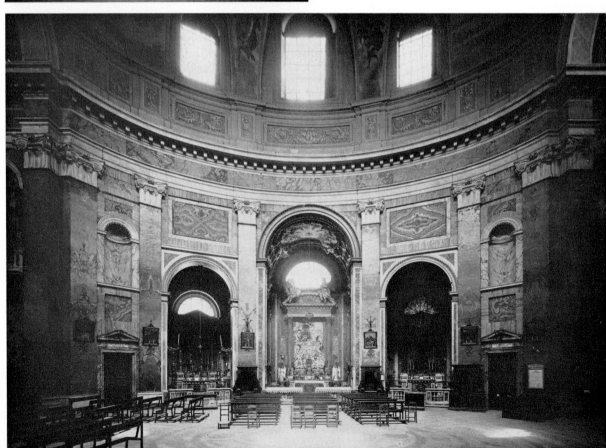

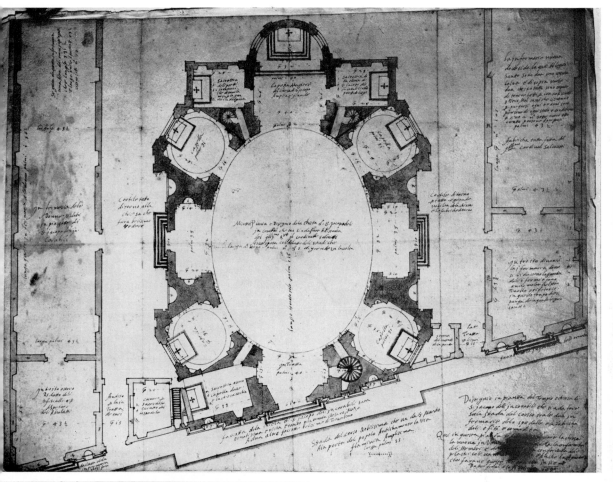

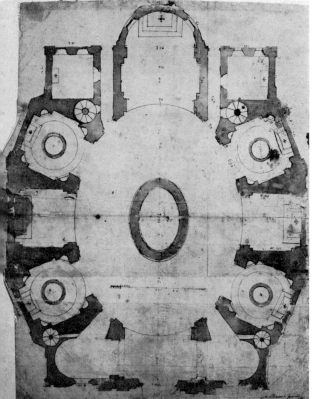

295. Francesco Capriani da Volterra:
Project for the plan of S. Giacomo degli
Incurabili, Rome, 1590. *Stockholm,
Nationalmuseum* (Fullerö Samling 343)

296. Workshop of Francesco Capriani da
Volterra: Project for the plan of
S. Giacomo degli Incurabili, Rome.
Vienna, Albertina (Rom 349)

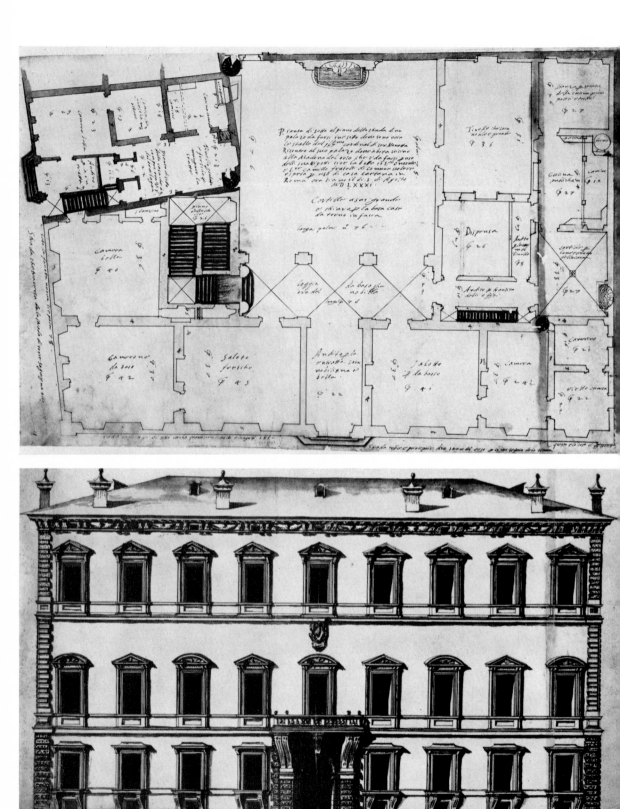

297. Francesco Capriani da Volterra: Project for the Palazzo Gaetani, Rome, 1581, plan of ground floor. *Florence, Uffizi* (A 6733)

298. Francesco Capriani da Volterra: Project for the Palazzo Gaetani, Rome, 1581, façade. *Florence, Uffizi* (A 6722)

299 and 300. Ottaviano Mascarino: Rome, Quirinal Palace, courtyard (*above*) and staircase, 1577–85

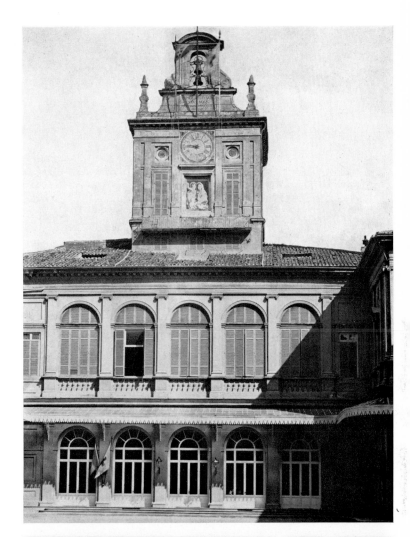

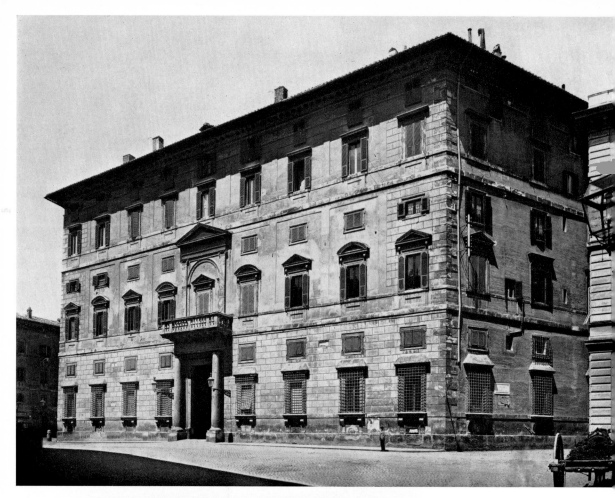

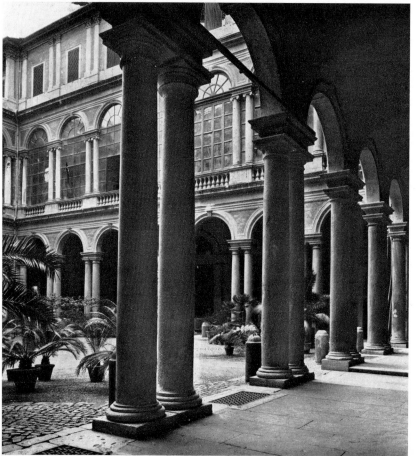

301. Giacomo Barozzi da Vignola and others: Rome, Palazzo Borghese, façade, begun *c.* 1560

302. Martino Lunghi the Elder: Rome, Palazzo Borghese, courtyard, 1586 (begun earlier)

303. Domenico Fontana: Rome, Lateran Palace, begun 1586

304. Domenico Fontana: Rome, Vatican Library, 1587–9

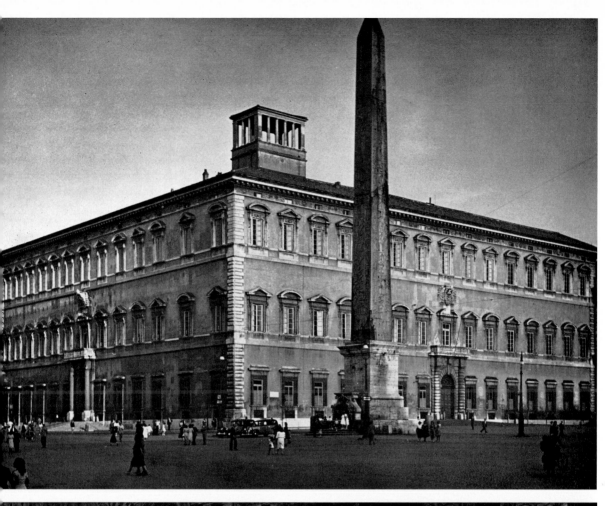

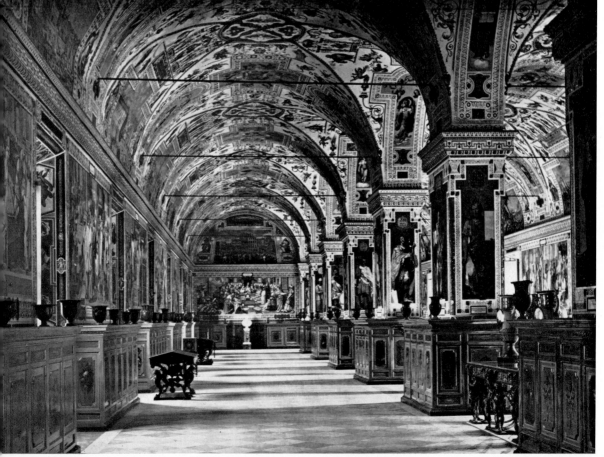

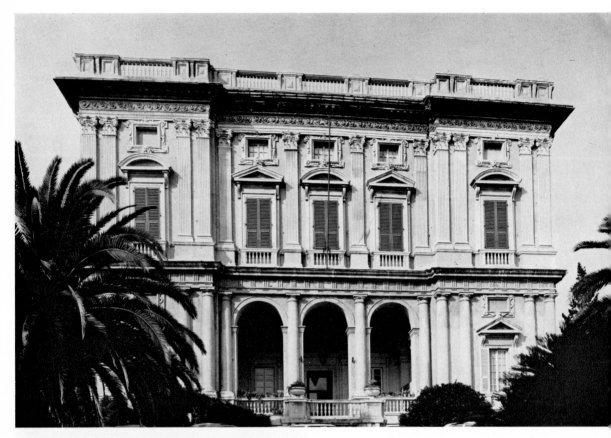

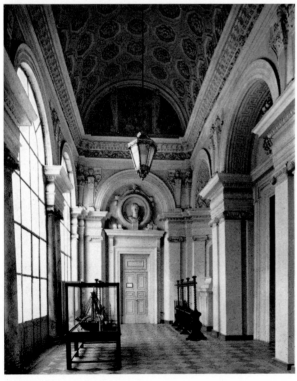

305 and 306. Galeazzo Alessi: Genoa, Villa
Cambiaso, 1548, façade (*above*) and loggia

307. Genoa, Strada Nuova, begun 1558

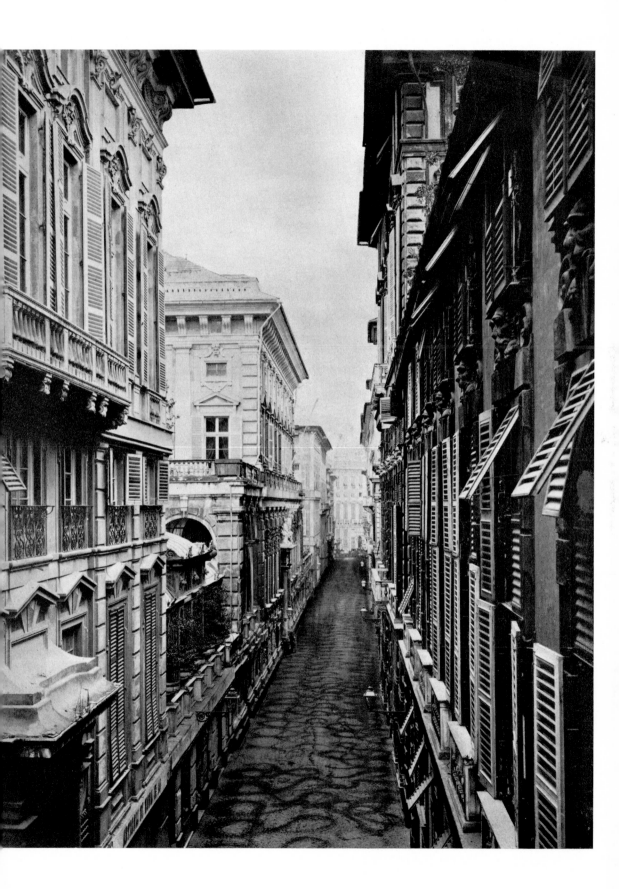

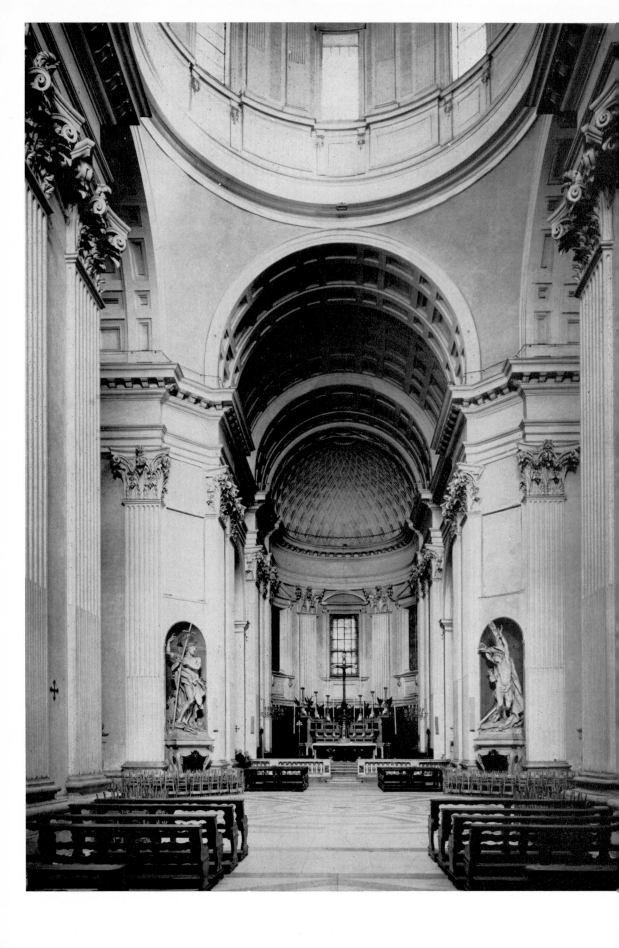

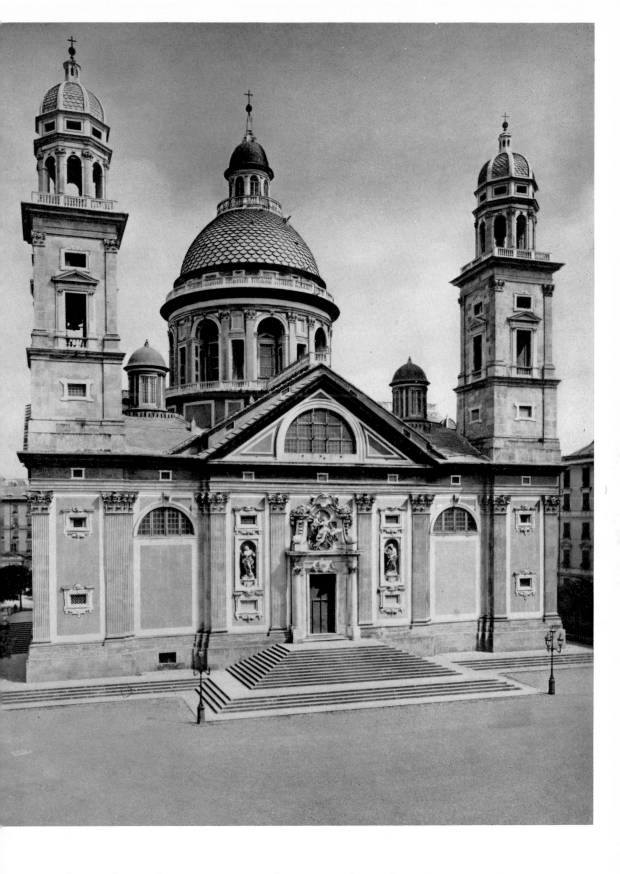

308 and 309. Galeazzo Alessi: Genoa, S. Maria di Carignano, designed 1549

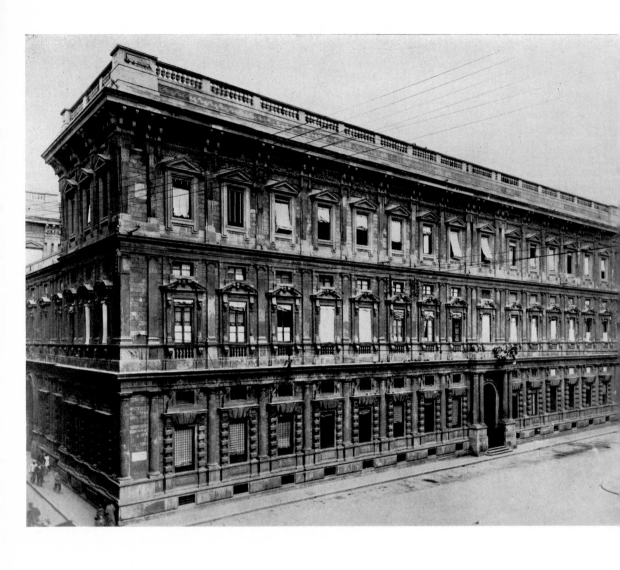

310. Galeazzo Alessi: Milan, Palazzo Marini, begun 1558, façade

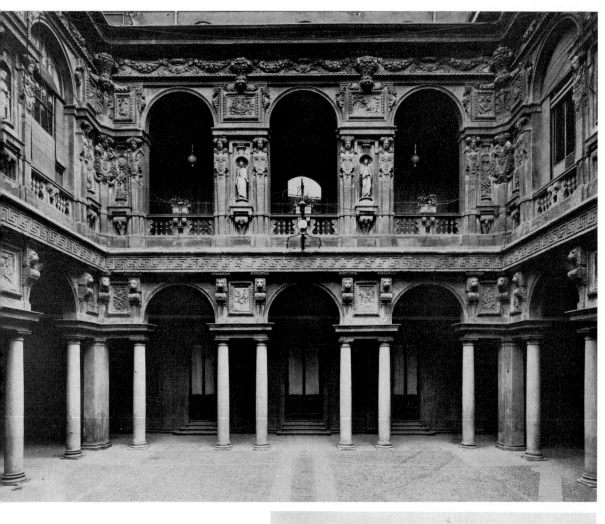

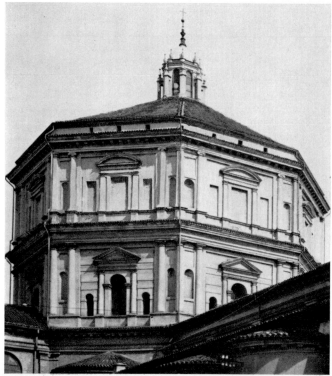

311. Galeazzo Alessi: Milan, Palazzo
Marini, begun 1558, courtyard

312. Cristoforo Lombardino: Milan,
S. Maria della Passione, dome, completed
probably *c.* 1550

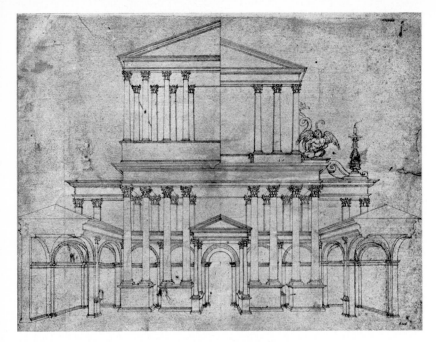

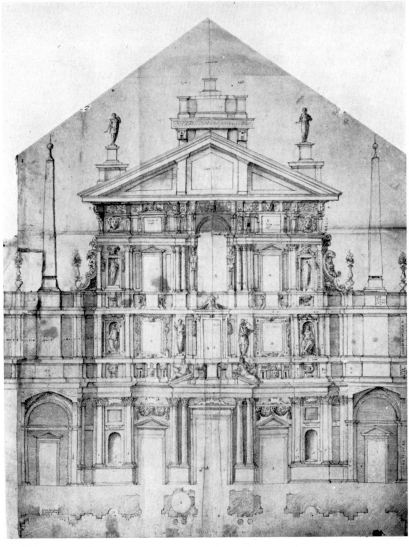

313. Cristoforo Lombardino: Project for the façade of S. Maria presso S. Celso, Milan, *c.* 1550. *London, Victoria and Albert Museum*

314. Galeazzo Alessi: Project for the façade of S. Maria presso S. Celso, Milan, before 1570. *Milan, Biblioteca Ambrosiana*

315. Galeazzo Alessi and others: Milan, S. Maria presso S. Celso, façade

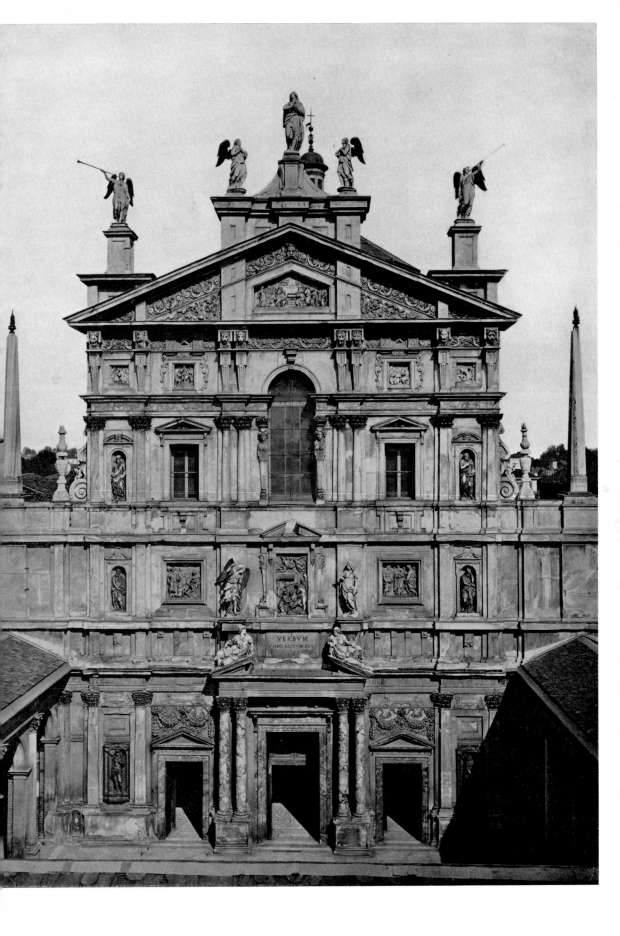

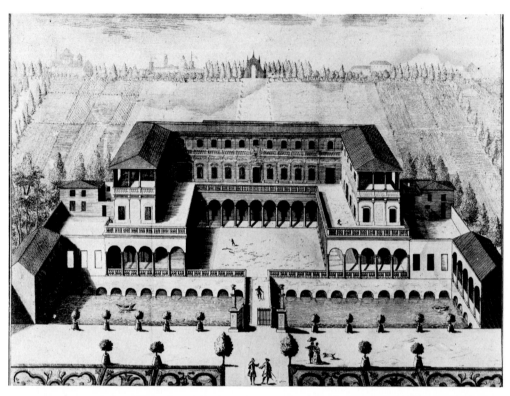

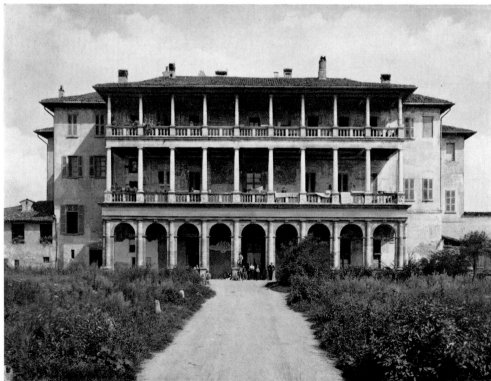

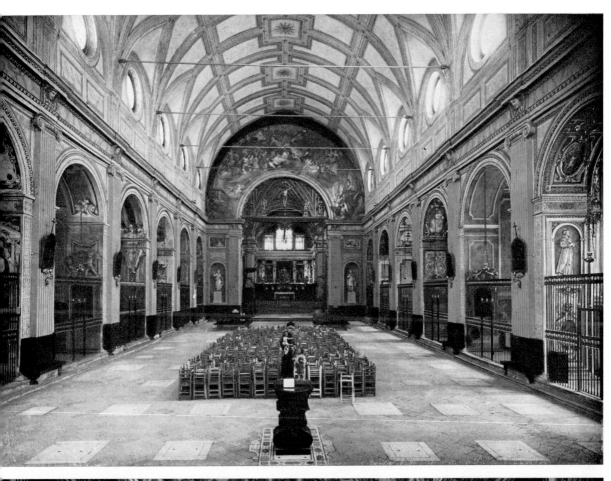

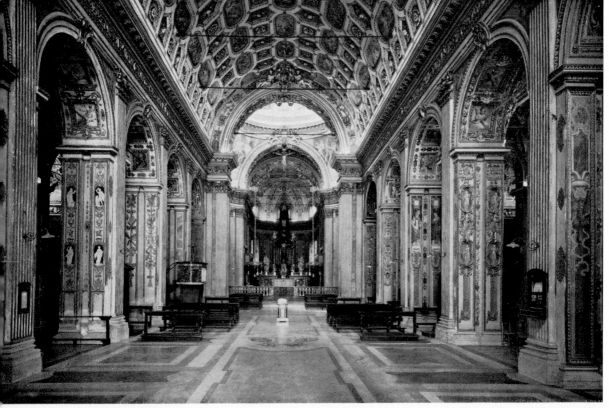

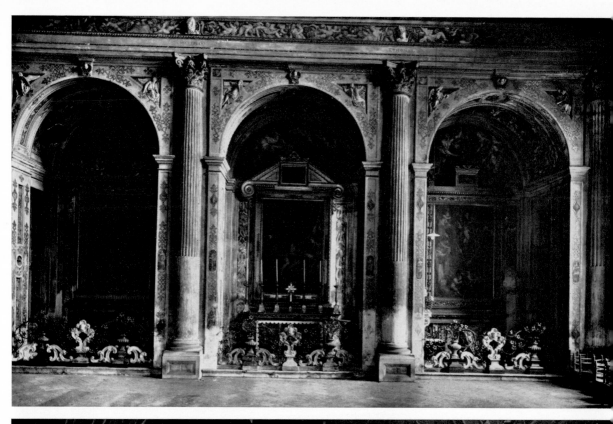

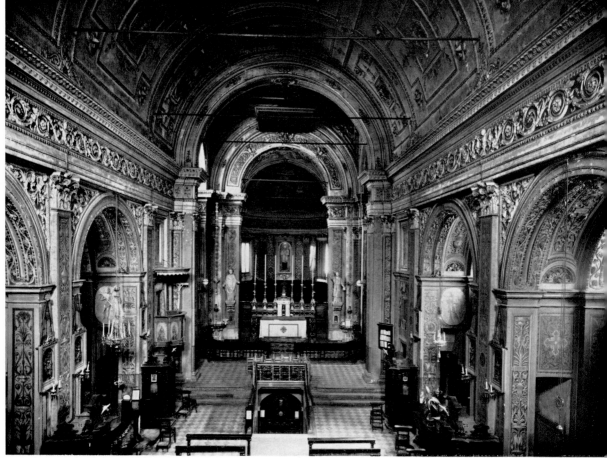

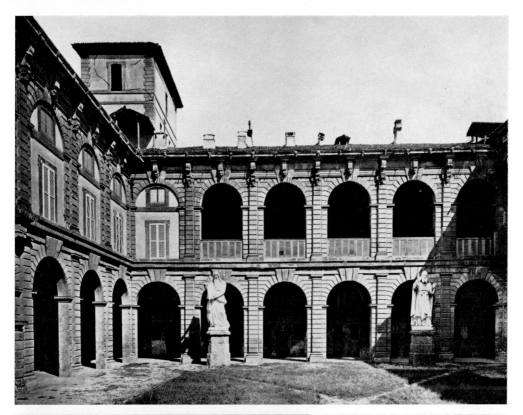

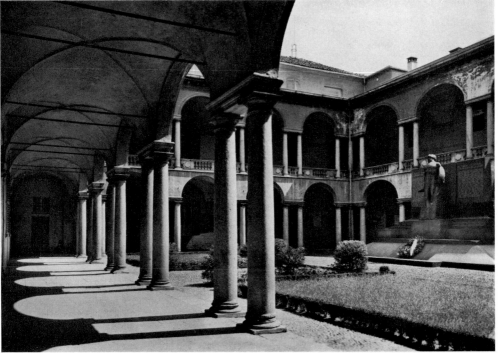

320. Domenico Giunti: Milan, S. Paolo alle Monache, 1549–51

321. Galeazzo Alessi: Milan, SS. Paolo e Barnaba, 1561–7

322. Pellegrino Pellegrini: Milan, Palazzo Arcivescovile, Canonica, designed 1564

323. Pellegrino Pellegrini: Pavia, Collegio Borromeo, courtyard, designed 1564

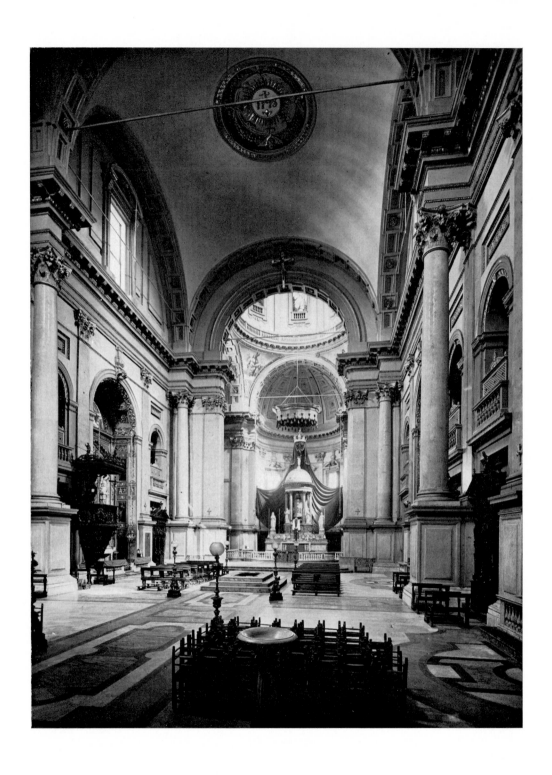

324. Pellegrino Pellegrini: Milan, S. Fedele, begun 1569

325. Martino Bassi: Milan, S. Lorenzo, rebuilt after 1573

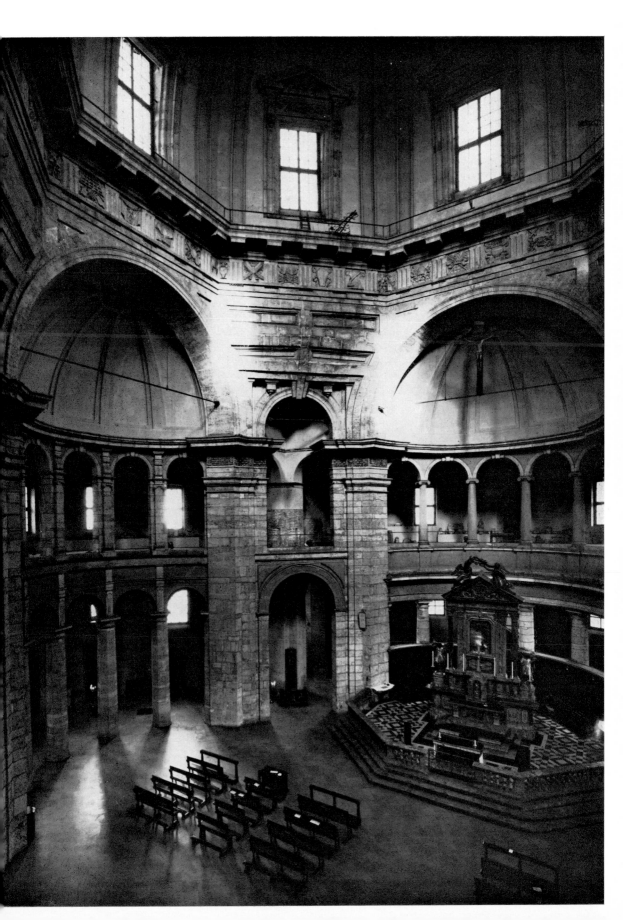

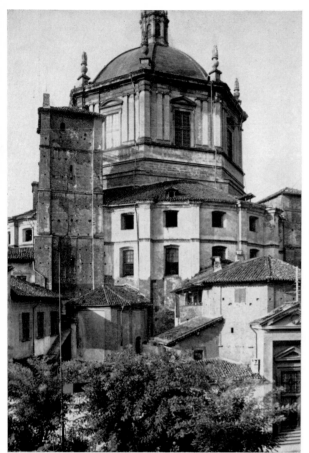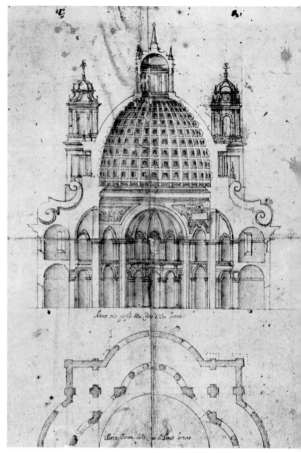

326. Martino Bassi and others: Milan, S. Lorenzo, rebuilt after 1573

327. Pellegrino Pellegrini(?): Project for S. Lorenzo, Milan, cross-section and plan. *Milan, Musei Civici* (Raccolta Bianconi, vol. IV, 24)

328 and 329. Ascanio Vitozzi and others: Vicoforte di Mondovì, S. Maria, begun 1596

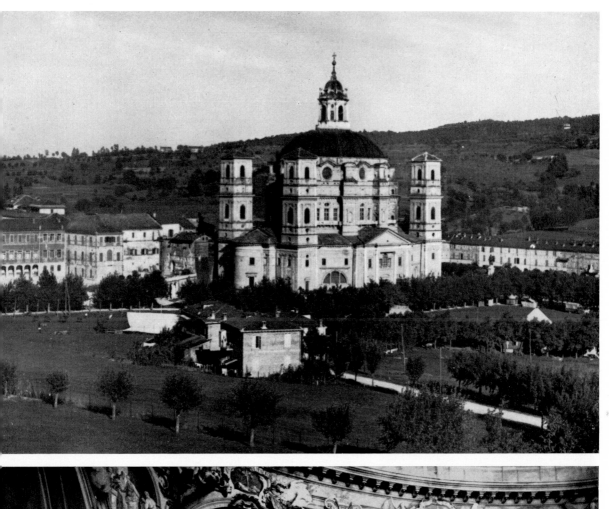

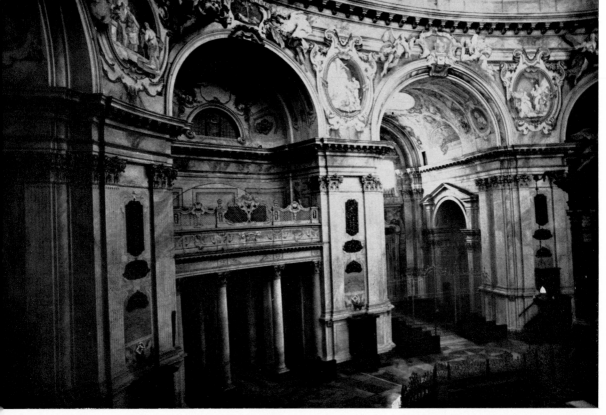

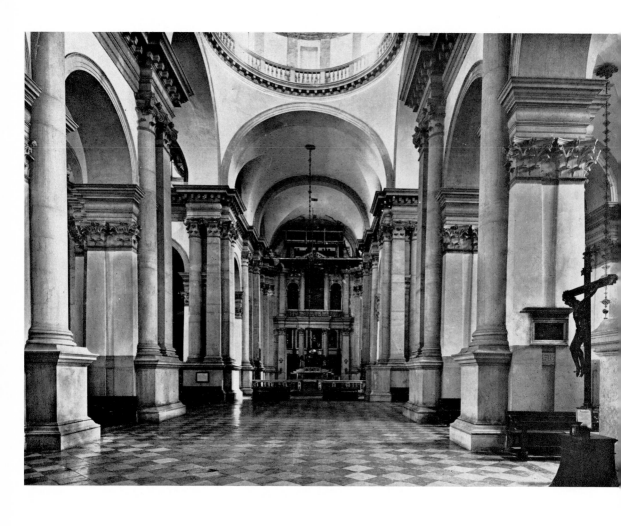

330. Andrea Palladio: Venice, S. Giorgio Maggiore, begun 1566

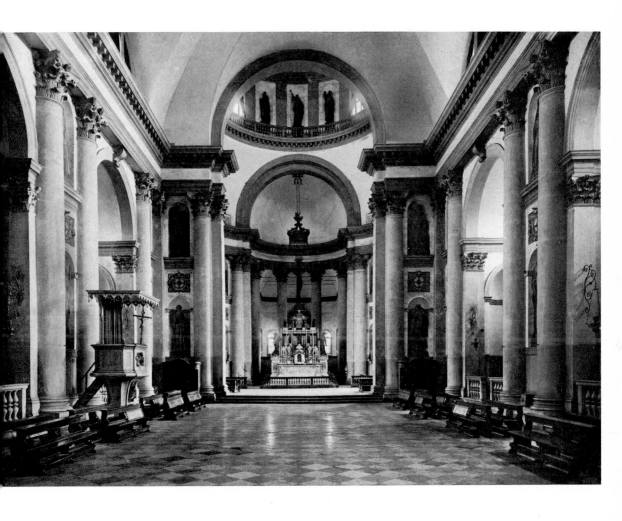

331. Andrea Palladio: Venice, Redentore, begun 1577

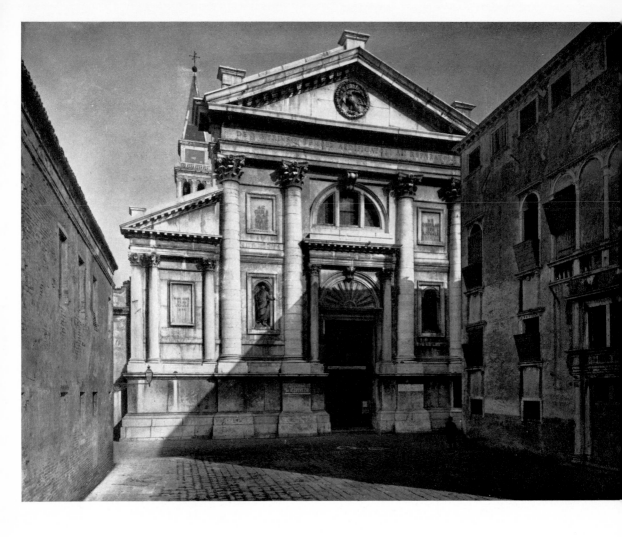

332. Andrea Palladio: Venice, S. Francesco alla Vigna, façade, *c.* 1570

333. Andrea Palladio: Venice, Redentore, begun 1577

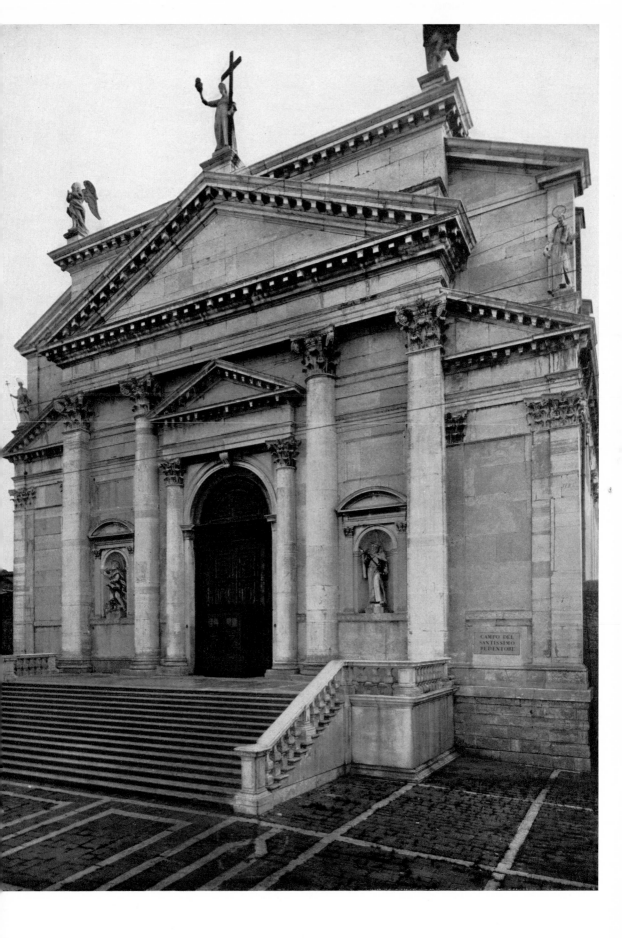

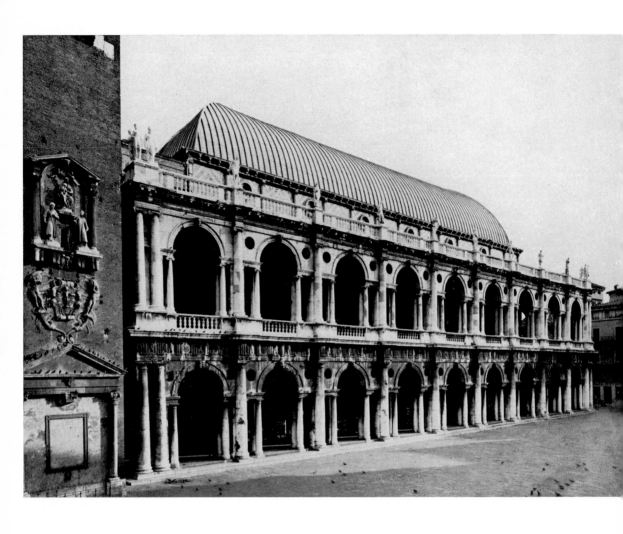

334. Andrea Palladio: Vicenza, Basilica, begun *c.* 1550

335. Andrea Palladio: Vicenza, Loggia del Capitanato, commissioned 1571

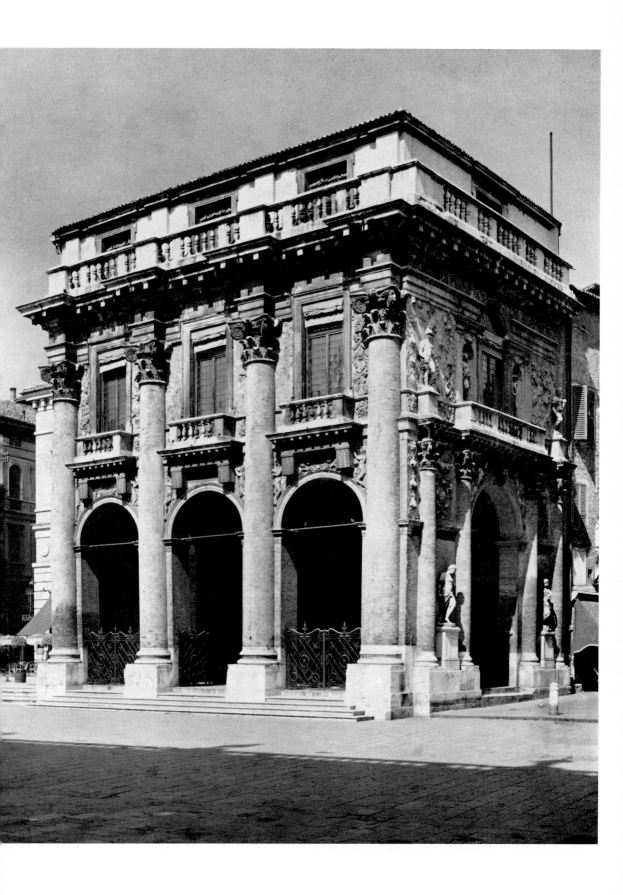

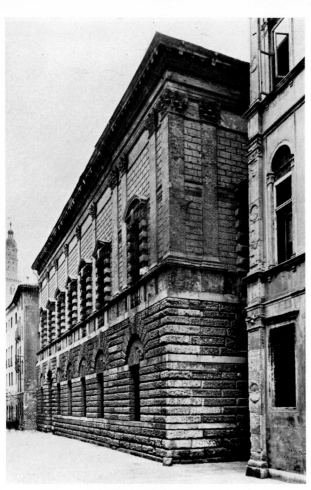

336. Andrea Palladio: Vicenza, Palazzo Thiene, begun 1542(?), façade

337. Andrea Palladio: Vicenza, Palazzo Valmarana, begun c. 1565, façade

338. Andrea Palladio: Pojana Maggiore, Villa, c. 1550–5

339. Andrea Palladio: Vicenza, La Rotonda, c. 1566–70

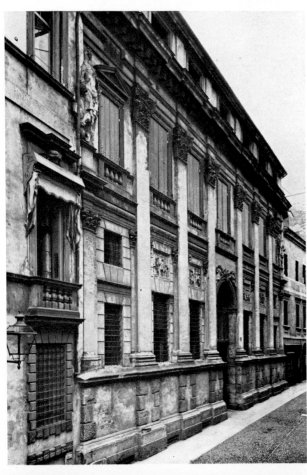

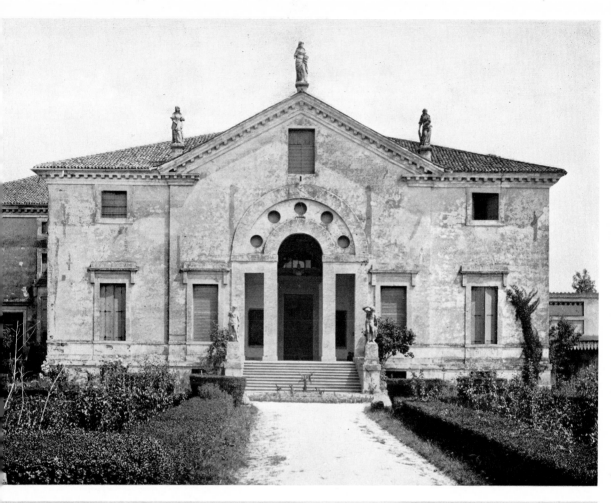

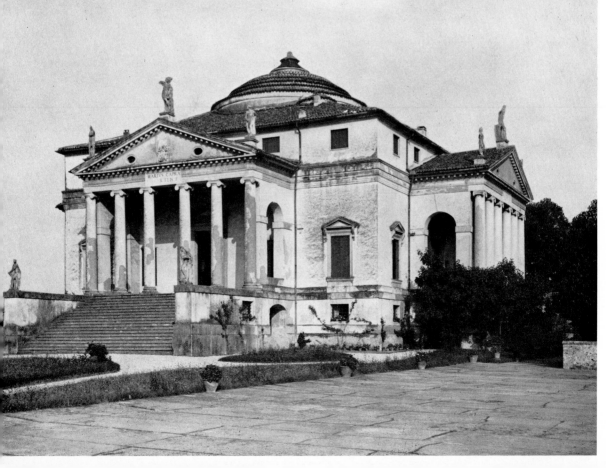

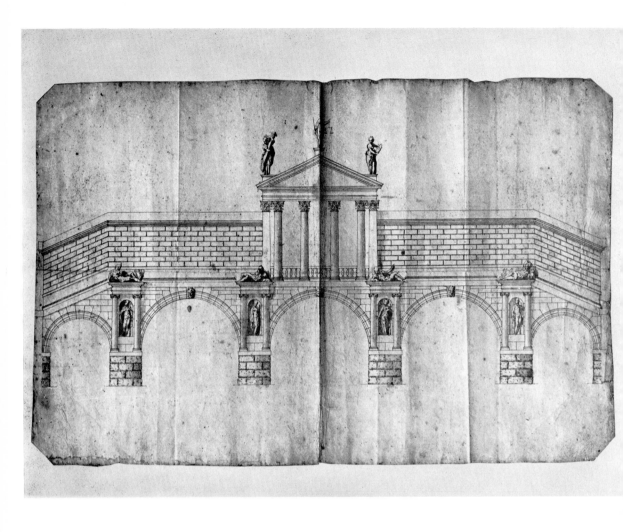

340. Andrea Palladio: Project for the Rialto Bridge, Venice. *Vicenza, Museo Civico*

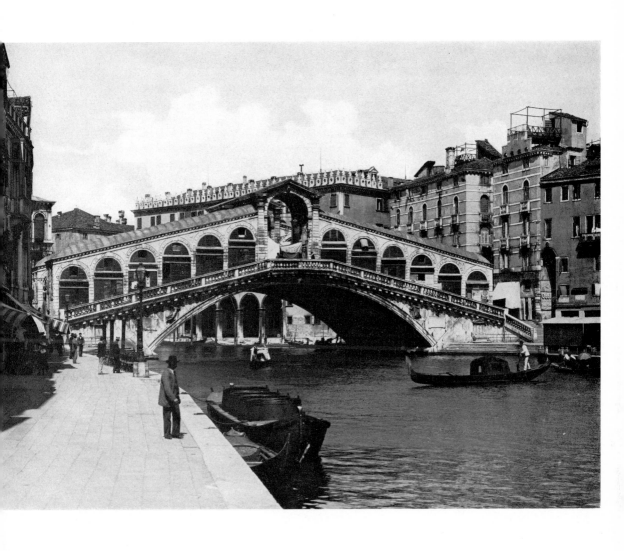

341. Antonio da Ponte: Venice, Rialto Bridge, 1588–91

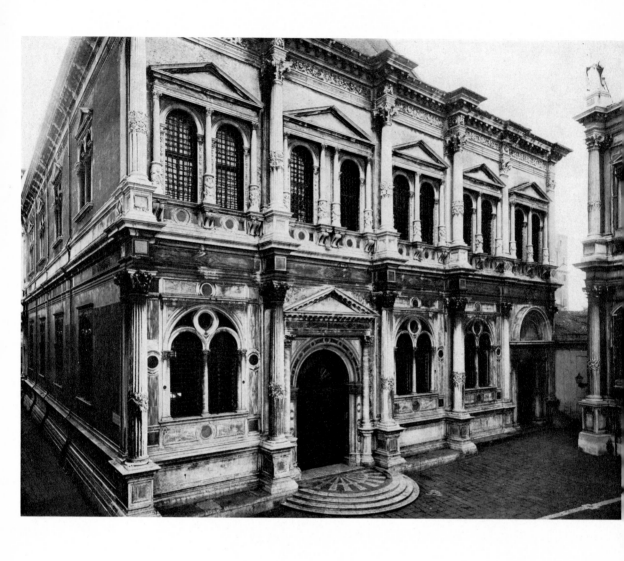

342 and 343. Scarpagnino: Venice, Scuola di S. Rocco, façade, begun 1536, and staircase, after 1544

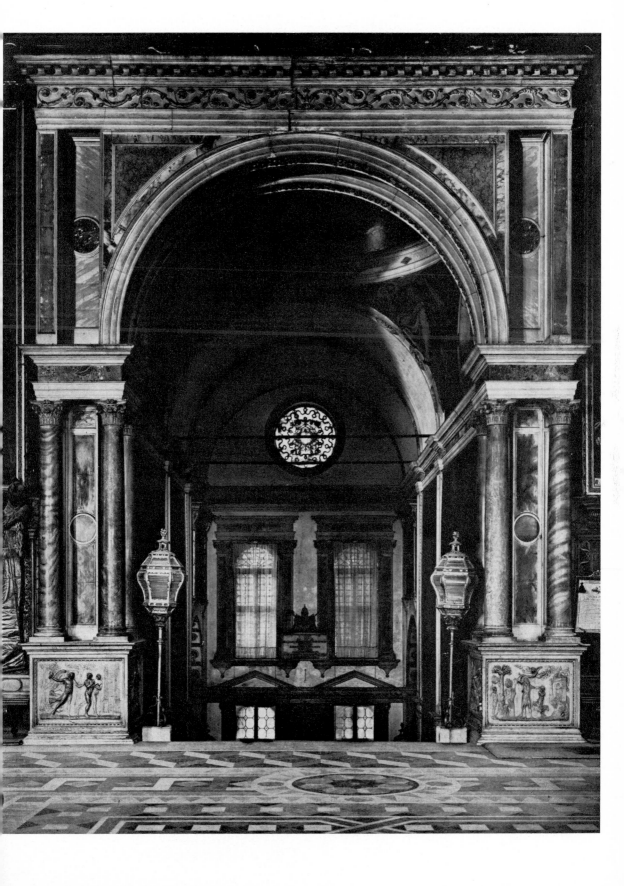

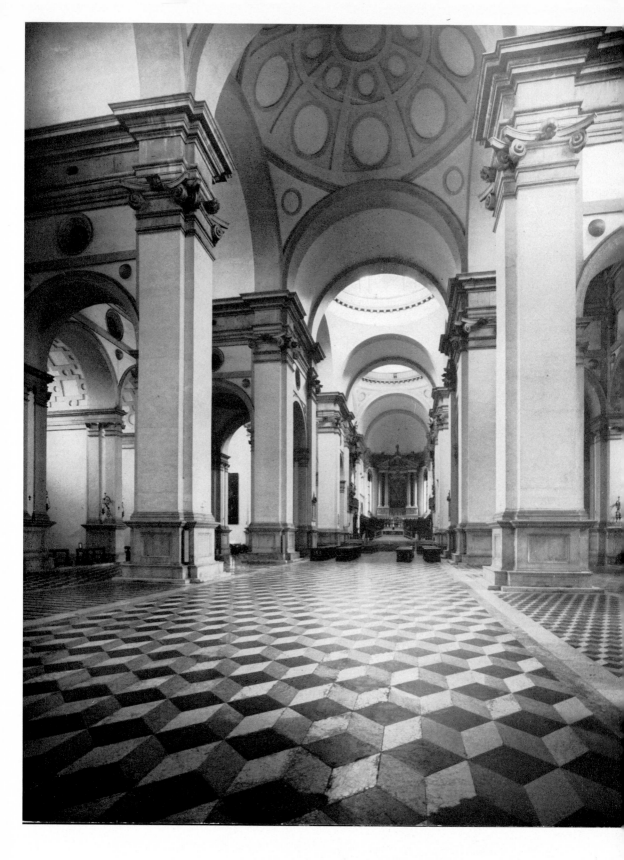

344. Andrea Moroni and Andrea della Valle: Padua, S. Giustina, begun 1532

345. Vincenzo Scamozzi: Sabbioneta, theatre, 1588–90

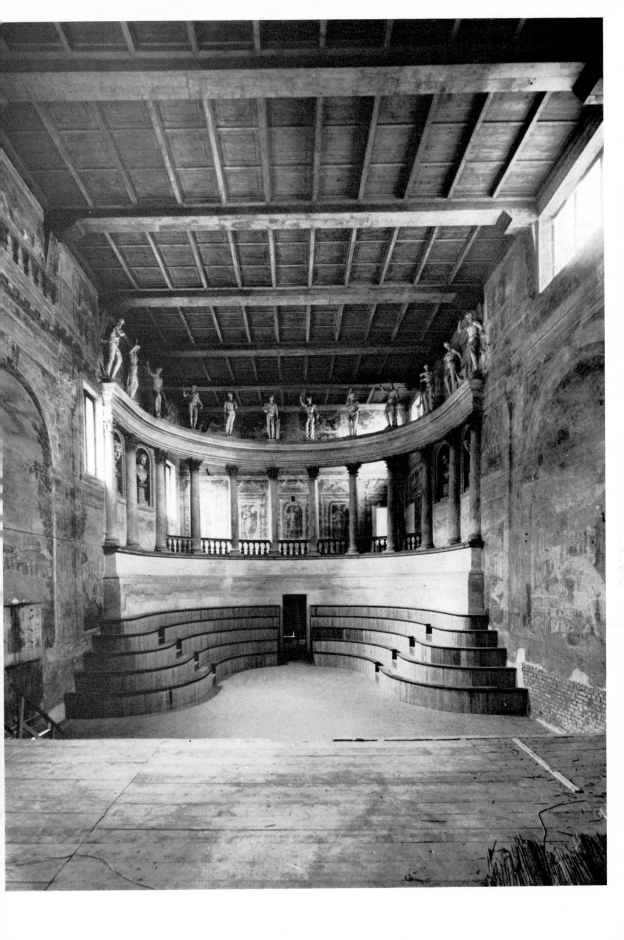

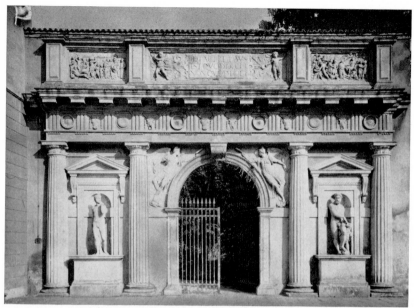

346. Bartolomeo Ammannati: Padua, Arco Benavides, 1544

347. Bartolomeo Ammannati: Rome, Palazzo di Firenze, courtyard façade, after 1550

348 and 349. Bartolomeo Ammannati: Florence, Palazzo Pitti, courtyard, begun 1560

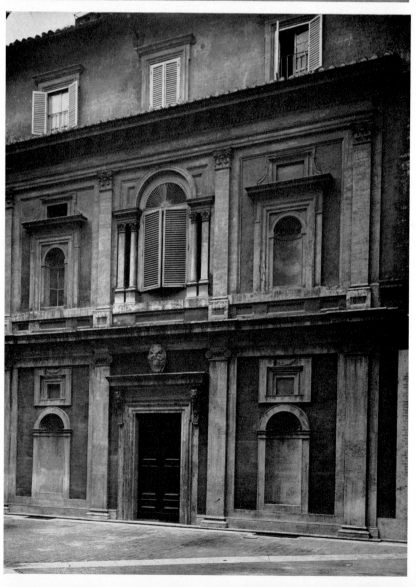

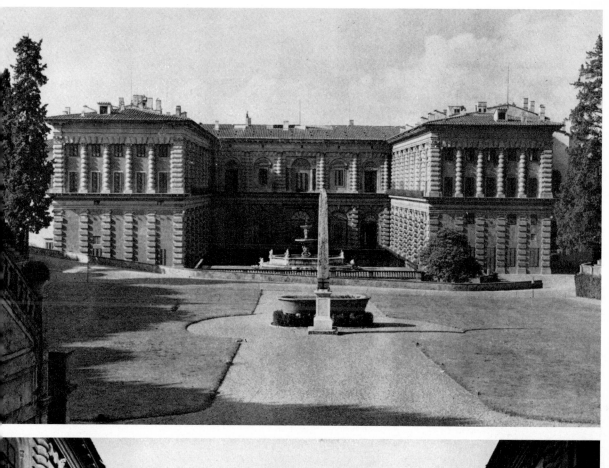

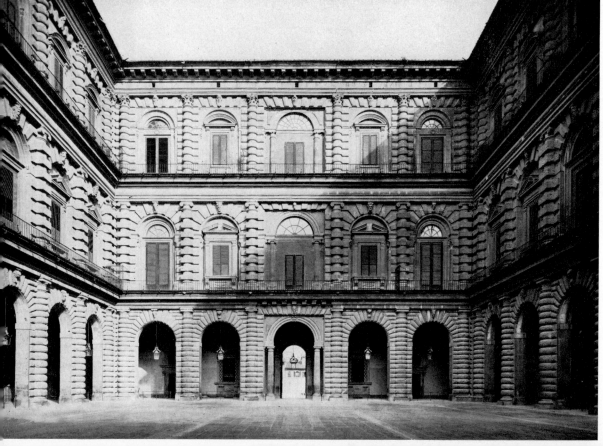

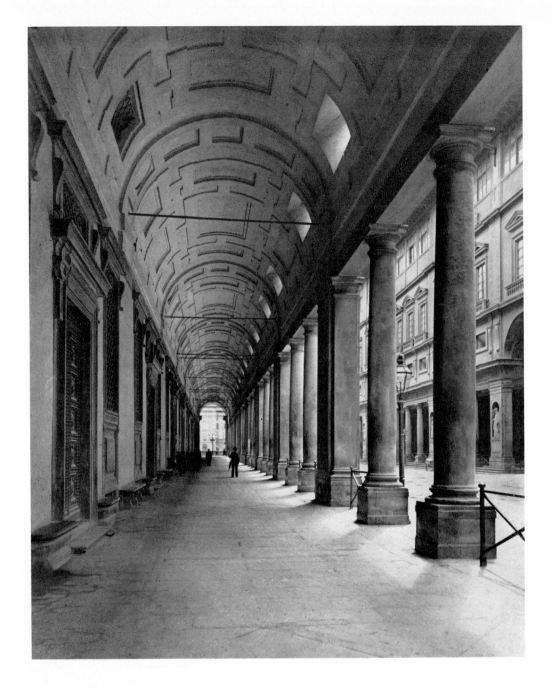

350. Giorgio Vasari: Florence, Uffizi, 1560– soon after 1580, loggia

351. Giorgio Vasari: Florence, Uffizi, 1560– soon after 1580

352. Bernardo Buontalenti: Pratolino, Villa Medici, begun 1569, painting by Utens, Florence

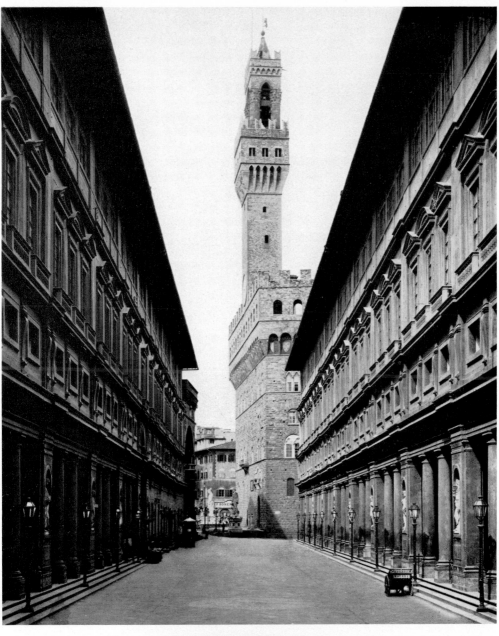

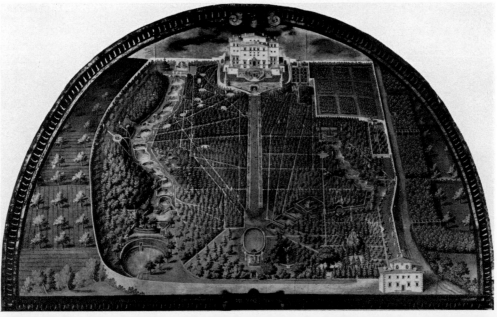

353. Bernardo Buontalenti: Florence, Uffizi, Porta delle Suppliche, after 1574

354. Bartolomeo Ammannati: Florence, Ponte S. Trinità, 1558–70 (before destruction and rebuilding)

355. Bernardo Buontalenti: Florence, S. Stefano al Ponte, steps leading to choir (formerly in S. Trinità), 1574

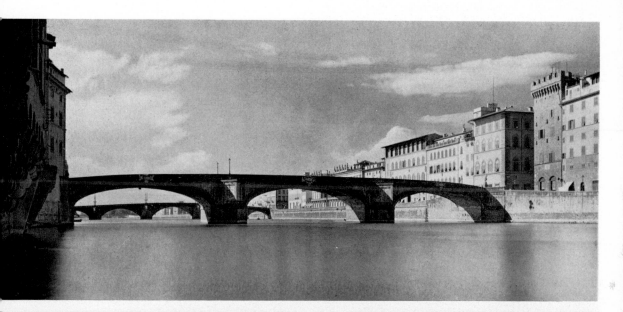

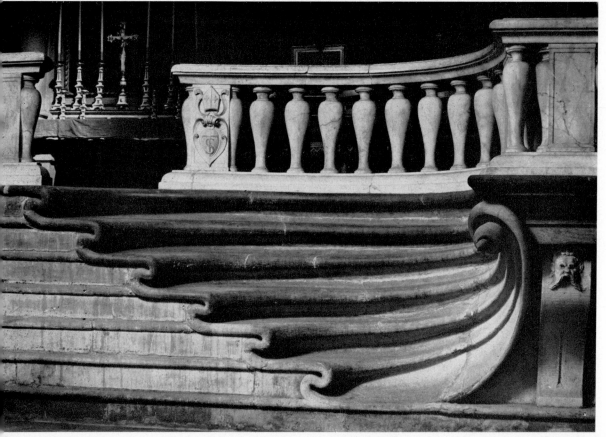

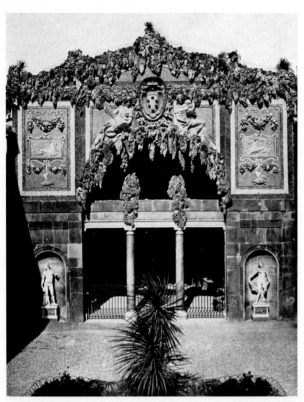

356. Giorgio Vasari and Bernardo Buontalenti: Florence, Boboli Gardens, grotto, façade, 1556–60 and 1583–93

357. Bernardo Buontalenti: Florence, Boboli Gardens, grotto, 1583–93

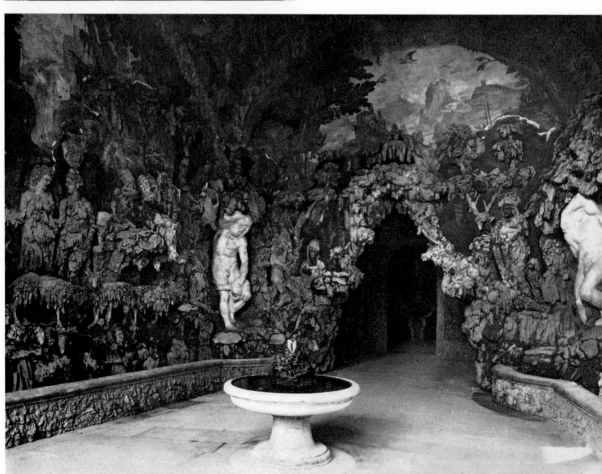

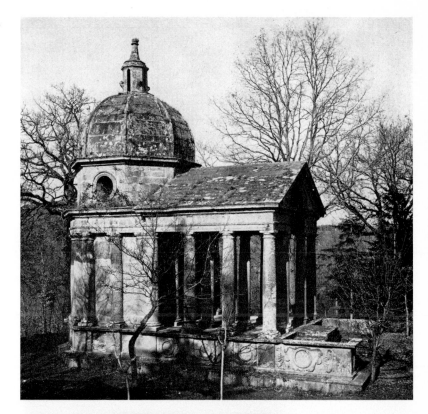

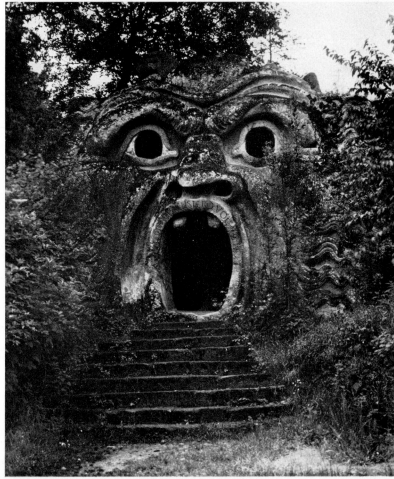

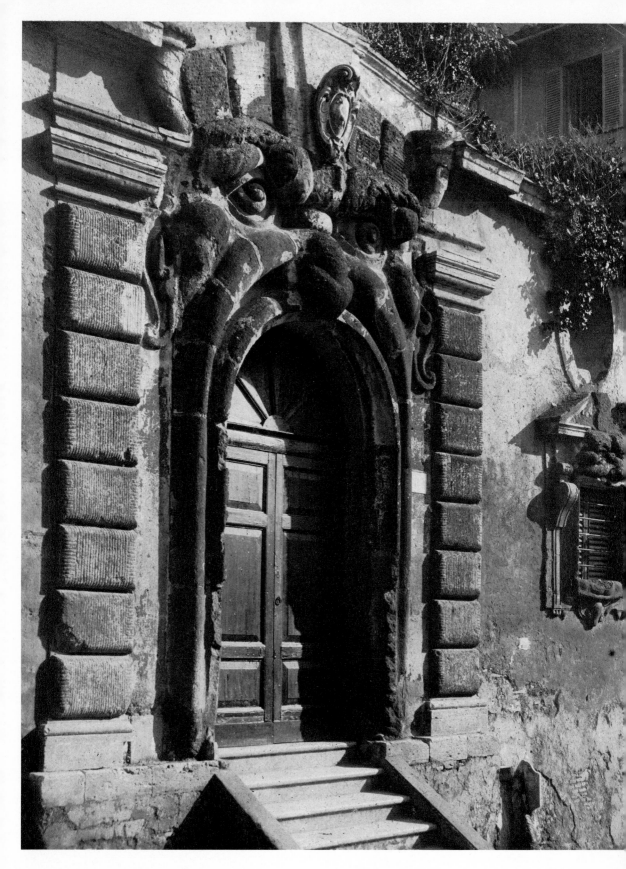

360. Federico Zuccari: Rome, Palazzo Zuccari, *c.* 1590, garden portal

INDEX

Numbers in *italic* refer to plates. Numbers in **bold** type indicate principal references. References to the notes are given to the page on which the note occurs followed by the chapter number in brackets and the number of the note: thus 350(10)[28] indicates page 350, chapter 10, note 28. Notes are referred to only if information given in them is more than purely bibliographical. Where artists' names are not indexed under the final element of the surname, a cross-reference is given under the final element.

M

R